Santa Maria Antiqua

Santa Maria Antiqua

The Sistine Chapel of the Early Middle Ages

EDITED BY
EILEEN RUBERY, GIULIA BORDI, AND JOHN OSBORNE

HARVEY MILLER PUBLISHERS

HARVEY MILLER PUBLISHERS
An Imprint of Brepols Publishers
London/Turnhout

British Library Cataloguing in Publication Data
A catalogue record for this book
is available from the British Library
ISBN 978-1-909400-53-5

© 2021, Brepols Publishers n.v., Turnhout, Belgium
All rights reserved. No part of this publication may be reproduced,
stored in a retrieval system, or transmitted in any form or by any
means, electronic, mechanical, photocopying, recording, or otherwise,
without the prior permission of Harvey Miller Publishers
D/2021/0095/73

Printed in the EU on acid-free paper

Table of Contents

INTRODUCTION *by Eileen Rubery, Giulia Bordi, John Osborne* .. 5

TIMELINE ... 11

TOPOGRAPHIC REFERENCES .. 13

LIST OF COLOUR PLATES .. 17

COLOUR PLATES .. 21

HISTORIOGRAPHY

 OSCAR MEI .. 65

 1702: The discovery of Santa Maria Antiqua

 T.P. WISEMAN ... 95

 Gordon McNeil Rushforth and Santa Maria Antiqua

 ANDREA PARIBENI ... 107

 'With Boni in the Forum'. The relationship between Gordon McNeil Rushforth and
 Giacomo Boni according to archival documentation

 ERNESTO MONACO ... 117

 Measuring Santa Maria Antiqua: from Petrignani to the present

 GIOVANNI GASBARRI ... 137

 'Ce monument est avant tout un témoin': Wladimir de Grüneisen and the
 multicultural context of Santa Maria Antiqua

TABLE OF CONTENTS

JOHN OSBORNE .. 147

Per Jonas Nordhagen, Santa Maria Antiqua, and the study of early medieval painting in Rome

TOPOGRAPHY

HENRY HURST ... 161

The early church of Santa Maria Antiqua

DAVID KNIPP .. 179

Richard Delbrück and the reconstruction of a 'ceremonial route' in Domitian's palace vestibule

ROBERT COATES-STEPHENS ... 195

The 'Oratory of the Forty Martyrs'

CONSERVATION

GIUSEPPE MORGANTI ... 215

"Per meglio provvedere alla conservazione dei dipinti …".
1984–2014: Santa Maria Antiqua 30 Years Later

WERNER SCHMID .. 233

Diary of a long conservation campaign

The palimpsests of Santa Maria Antiqua

MARIA ANDALORO ... 277

The Project

GIULIA BORDI ... 281

The three Christological cycles in the sanctuary of Santa Maria Antiqua

PAOLA POGLIANI, CLAUDIA PELOSI, GIORGIA AGRESTI .. 299

Palimpsests and pictorial phases in the light of studies of the techniques of execution and the materials employed

TABLE OF CONTENTS

ICONOGRAPHY

Per Olav Folgerø .. 319
Expression of Dogma: Text and imagery in the triumphal arch decoration

Manuela Gianandrea ... 335
The fresco with the Three Mothers and the paintings of the right aisle in the Church of Santa Maria Antiqua

Maria Grafova ... 357
The decorations in the left aisle of Santa Maria Antiqua within the context of the political history of the Iconoclastic era

Marios Costambeys ... 373
Pope Hadrian I and Santa Maria Antiqua: Liturgy and patronage in the late eighth century

RE-READING THE DECORATIVE PROGRAMME

Giulia Bordi ... 387
The apse wall of Santa Maria Antiqua (IV–IX centuries)

Eileen Rubery .. 425
Monks, Miracles and Healing. Doctrinal Belief and Miraculous Interventions: Saints Abbacyrus and John at Santa Maria Antiqua and related Roman Churches between the sixth and the twelfth centuries

Richard Price ... 449
The frescoes in Santa Maria Antiqua, the Lateran Synod of 649, and pope Vitalian

Beat Brenk ... 461
A new chronology of the worship of images in Santa Maria Antiqua

AFTERWORD

Maria Andaloro ... 485
The icon of Santa Maria Nova after Santa Maria Antiqua

INTRODUCTION

The month of January in the year 1900 was an exciting moment for those interested in the arts in Rome. On 14 January, a new opera by Giacomo Puccini, *Tosca*, had its premiere at the Teatro dell'Opera. While the arias 'Vissi d'arte' and 'E lucevan le stelle' thrilled Roman audiences, excavations undertaken a very short distance away, in the nearby Roman Forum, conducted by another Giacomo, Giacomo Boni, brought to light the remains of an amazing structure set against the slope of the Palatine Hill, a building decorated with a remarkable set of murals dating between the sixth and tenth centuries, when it functioned as a Christian church. Santa Maria Antiqua remains today the primary site for our knowledge of the pictorial arts in the early Middle Ages.

As Werner Schmid records in his contribution to this volume, the murals comprise some 332 square metres of wall surface, an extraordinary picture gallery, unparalleled anywhere else in Europe at this time. In fact, so impressive were these painted walls that the first director of the British School at Rome, Gordon Rushforth, in a letter published in *The Times* of London on 9 January 1901, dubbed the site the 'Sistine Chapel of the eighth century'. Rushforth would himself publish the first substantial description and analysis of the murals in a lengthy paper included in the first volume of the British School's new journal, and for more than a century his study has retained its value as a detailed and insightful overview of the architecture and its decorations, based on his meticulous first-hand observations.[1] His interest was shared by a great many others, with the result that the following decades witnessed considerable debate, not to mention a plethora of books and articles devoted to the site. The fervour of that intellectual climate will be explored in contributions by T.P. Wiseman, Andrea Paribeni, and Giovanni Gasbarri.

The building that would later house the church was constructed in the late decades of the first century, as can be deduced from the brick stamps datable to the reign of the Roman Emperor Domitian (81–96 CE). Its original function is one of the many puzzles that still remain unresolved after a century; but it must have almost certainly borne some connection to the Forum entrance to the imperial palace situated on the Palatine Hill directly above, since the two spaces are connected by a wide ramp, which zig-zags its way up the slope immediately beside the structure. David Knipp's contribution in this volume supports the view that it was intended as a formal 'vestibule' area for the imperial residence. There are numerous competing theories about how and when the space evolved into a Christian church, and how it functioned thereafter. These issues constitute the focus of the contributions by Henry Hurst, Beat Brenk, and Eileen Rubery. What we can say with some certainty is that at some point—and certainly by the middle of the sixth century—the building had evolved to serve religious purposes, and it began to be decorated with explicitly Christian images. It would then retain a religious function for almost five centuries.

INTRODUCTION

In the middle of the ninth century, the 'title' was transferred to a new church constructed a short distance away, Santa Maria Nova, today also known as Santa Francesca Romana. Rushforth believed that this may have been connected to an earthquake that damaged Rome in 847, but Hurst reminds us here that there is not a shred of evidence to support such a view. Although the nave and sanctuary received no new decorations after that time, the former atrium clearly did remain in use and at some point received a new dedication to Saint Anthony, until the building was abandoned for good, probably in the eleventh century. Eventually the entire edifice became buried, and at a later date a new church, dedicated to Santa Maria Liberatrice, was constructed at a higher level. In 1702 there was a brief and quite accidental uncovering of the apsidal arch and parts of the sanctuary, attracting numerous interested observers. Oscar Mei has recently discovered an important study of the building and its murals dating from that period, undertaken by Domenico Passionei and preserved in his archive at Fossombrone, so our volume opens with this substantial addition to the history of the site. But otherwise the structure remained buried until Boni brought it back to the light of day in 1900.

The precise implication of the church's name, Santa Maria Antiqua ('Old St Mary's') is again unknown—one of many unanswered questions that still puzzle those studying the building, although Giulia Bordi proposes a highly plausible solution. One suggestion is that the name derives from the icon of the *Madonna and Child*, now preserved at Santa Maria Nova; so when Santa Maria Antiqua was re-opened to the public in 2016, it was arranged for this enormous image to return briefly to what may have been its original home. That transfer is the subject of Maria Andaloro's closing essay in this volume. Of course, these little mysteries are precisely what makes this remarkable site the subject of so much interest and study. Robert Coates-Stephens's intriguing proposal in these pages tackles instead another issue, namely the original dedication of the small chapel at the entrance to the complex, known in the literature as the 'Oratory of the Forty Martyrs'.

A church of Santa Maria Antiqua in the Roman Forum is mentioned in a few early medieval sources, including the *Liber pontificalis*, which provided contemporaneous biographies of the early pontiffs, and prior to 1900 there was considerable debate among scholars regarding the building's precise location. But Boni's excavations in that year brought those discussions to a rapid conclusion. The *Liber pontificalis* entry for Pope John VII (705–7) includes the first mention of the church: 'He adorned with painting the basilica of the Holy Mother of God which is called 'Antiqua', and there he built a new ambo, and above the same church an Episcopium which he wanted to build for his own use.'[2] In one of those remarkably serendipitous moments in the history of archaeology, Boni and his team discovered part of that *ambo* (pulpit), bearing an inscription in both Latin and Greek that named Pope John and recorded his devotion to the cult of the 'Mother of God'.[3] Furthermore, one of the walls of the chapel to the left of the sanctuary bore a painted inscription naming the patron of the decorations as Theodotus, the '*primicerius defensorum* and *dispensator* of the Holy Mother of God and ever Virgin Mary who is called *Antiqua*', bringing all debate regarding the location to a satisfactory conclusion.[4]

John VII's campaign to redecorate the architectural surfaces of Santa Maria Antiqua was but one of a number that took place during the early Middle Ages; indeed, perhaps the most remarkable aspect of the site is the way in which successive campaigns of painting have been layered one over the other. The layers on the side walls of the sanctuary are studied by the

INTRODUCTION

team of Giulia Bordi, Paola Pogliani, Claudia Pelosi, and Giorgia Agresti, and in an individual contribution Bordi also presents important new insights regarding the decoration of the apse and its framing wall. Much of the painting cannot be precisely dated, but in some cases we are assisted in this task by the presence of contemporaneous figures, identified by painted inscriptions. These include a series of popes: in addition to John VII, we find images of Pope Zacharias (741–52), Paul I (757–67), and Hadrian I (772–95), all with 'square haloes' indicating portrait likenesses. Other murals have implicit dates embedded in their content, for example a series of theologians on either side of the apsidal arch, each of whom holds an unfurled scroll inscribed with a text from their writings. As first noted by Rushforth, and explored further in this volume by Richard Price, these passages were all included in the Acts of the Lateran Council of 649, convened by Pope Martin I to condemn the 'heresy' of Monotheletism, then wreaking havoc on the unity of the Christian world. The council thus serves as a probable *terminus post quem* for these images, and Price proposes a date in the pontificate of Vitalian (657–72).

The 1900 excavation prompted enormous interest among a broad range of historians, art historians, and archaeologists, but most of the subsequent activity and publication has been focused on the mural paintings, with a strong focus on issues of dating, style, and iconography, in addition to larger issues of methodology. Individual aspects of these topics are dealt with in this volume by a number of contributors, including Per Olav Folgerø, Manuela Gianandrea, Maria Grafova, Marios Costambeys, and John Osborne. With the advantage of hindsight, we can also now comprehend the impact that the discovery of this church had on the subsequent development of scholarship on topics as varied as Byzantine art history and liturgical furnishings. As Ernesto Monaco points out in his essay, much less attention has been paid, however, to the architecture, perhaps because Boni never published his excavation findings. Nonetheless, some graphic documentation does survive from the early 1900s, and it deserves better recognition. The remarkable accuracy of the drawings produced by Antonio Petrignani and others has been confirmed by recent investigations of the site.

Just over a century after the rediscovery of the church and in light of the observable deterioration of the murals, brought about primarily by the infiltration of water, the Soprintendenza Speciale per il Colosseo e l'area archeologica centrale embarked on a major conservation campaign directed by Werner Schmid, with funding generously provided by the World Monuments Fund. Schmid's contribution to this volume sets out these conservation issues in remarkable technical detail, and documents what has now been done to manage them. The colour plates section of this volume records the welcome results of the assiduous efforts by his expert team. At the same time, Giuseppe Morganti, a passionate *amatore* of Santa Maria Antiqua and, by a wonderful stroke of good luck, also the Soprintendenza architect responsible for the site, takes us from the murals to the structural issues facing the building complex, detailing what has been achieved in recent years and what still remains to be accomplished in the future. Technical analysis of plasters and pigments, undertaken by the laboratory at the Università degli Studi della Tuscia (Viterbo), has also led to new discoveries, for example that the *Annunciation* on the so-called 'palimpsest' wall was painted by the same artist or workshop as the image of Saint Anne on the right wall of the sanctuary.

This conservation campaign, intended to preserve the building and its decorations for subsequent generations, received some impetus from an international conference held in

Rome in May 2000, marking the centenary of Boni's excavation.[5] The interest in that event was remarkable, but perhaps not unsurprising given that Santa Maria Antiqua looms large in so much historical, art historical, and archaeological scholarship. As the campaign drew to a conclusion, it seemed both timely and appropriate to convene a second academic conference, conceived and organised by Eileen Rubery with the assistance of the Soprintendenza, Christopher Smith (the then Director of the British School at Rome), Giulia Bordi, and John Osborne, which was held at the British School in December 2013. This also coincided with the seventy-fifth anniversary of Rushforth's death, so his contribution to the scholarship on medieval Rome was singled out for special attention. Many of the contributions in this volume were first presented to a public audience on that occasion.

The authors and editors are grateful to Dr. Alfonsina Russo, Director of the Parco archeologico del Colosseo, and to her colleagues Irma Della Giovampaola, Stefano Borghini, Paolo Castellani and Paola Quaranta, for their kind approbation of this project. We also thank them for allowing us to publish the set of beautiful colour plates by photographer Roberto Sigismondi. The editors would also like to thank Johan Van der Beke and his colleagues at Brepols for their enthusiastic interest in seeing this volume through to completion; Christopher Smith and the staff of the British School, who provided unwavering support for both the conference and the ensuing publication; Giuseppe Morganti and his colleagues at the Foro Romano for their assiduous concern for the preservation of the structure and its decorations; Carleton University in Ottawa for its generous financial support for the 2013 gathering in Rome; and the individual contributors for their exceptional patience in seeing this long-delayed volume through the press.

With much affection and great respect, we dedicate this volume to Per Jonas Nordhagen, the 'dean' of Santa Maria Antiqua studies, as a belated gift in the aftermath of his ninetieth birthday. His work on the church, undertaken primarily in the mid-twentieth century, has been fundamental, and constitutes the launching point and model for most subsequent scholarship. We all stand not only on his shoulders, but also in his shadow.

The final word goes to Joseph Wilpert: 'On Santa Maria Antiqua […] much has already been written and discussed. Nevertheless, much still remains to be said.'[6]

<div style="text-align: right;">Eileen Rubery, Giulia Bordi, and John Osborne</div>

NOTES TO THE TEXT

1. Gordon McNeil Rushforth, 'The Church of S. Maria Antiqua', *Papers of the British School at Rome*, 1 (1902), 1–123.

2. *Le Liber Pontificalis: texte, introduction, et commentaire*, ed. by Louis Duchesne, 2 vols (Paris: Thorin, 1886–92), I, 385; English translation *The Book of Pontiffs (Liber pontificalis): The ancient biographies of the first ninety Roman Bishops to AD 715*, trans. by Raymond Davis, Translated Texts for Historians, 6, 3rd rev. edn (Liverpool: Liverpool University Press, 2010), p. 86.

3. Rushforth, 'The Church of S. Maria Antiqua', pp. 89–91.

4. Ibid., p. 43.

5. *Santa Maria Antiqua al Foro Romano cento anni dopo. Atti del colloquio internazionale (Roma, 5–6 maggio 2000)*, ed. by J. Osborne, J.R. Brandt, and G. Morganti (Rome: Campisano, 2004).

6. Joseph Wilpert, 'Appunti sulle pitture della chiesa di S. Maria Antiqua', *Byzantinische Zeitschrift*, 14 (1905), 578–83 (p. 578): 'Su S. Maria Antiqua […] molto si è già scritto e discusso. Ciò non ostante resta ancora molto da dire'.

TIMELINE

TIMELINE

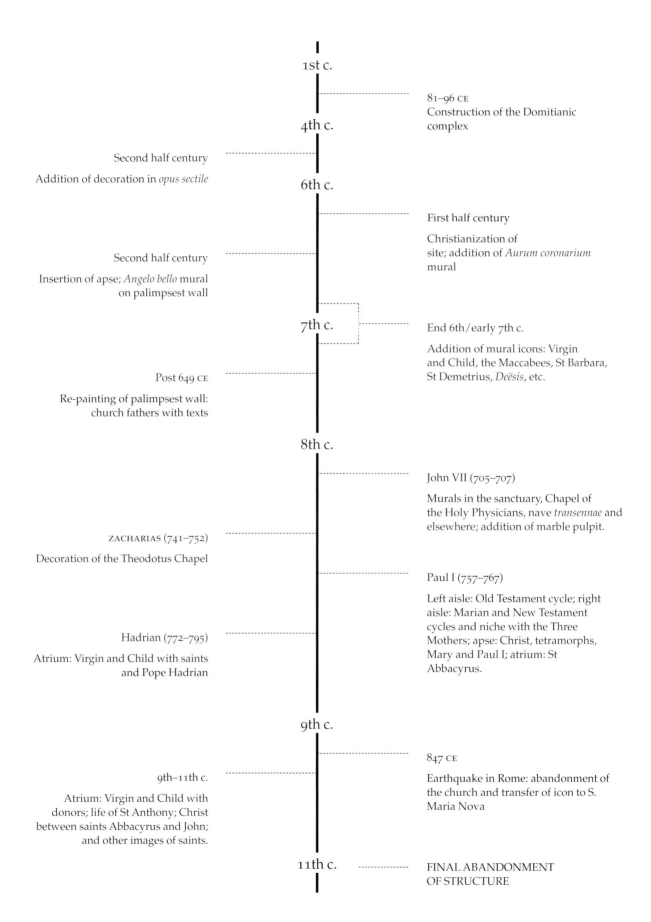

TOPOGRAPHIC REFERENCES

For the ground plan see Plate 50.

A** Atrium**
 A1 South wall
 A2 West wall
 A3 North wall
 A4 East wall

B** Narthex**
 B1 Nave enclosure, side facing narthex (fragments of *vela*)

C** Left (east) aisle**
 C1 East wall (row of saints around Christ)
 C2 North wall (extension of row of saints around Christ)
 C3 Passage to the Domitianic ramp
 → *C3.1 right wall (Harrowing of Hell - Anastasis)*
 → *C3.2 left (The Virgin and Christ-child flanked by two angels, St Peter introducing a donor (John VII?) and St Paul)*
 C4 Enclosure, east wall (*vela*)

D** East (or left) vestibule**
 D1 East wall
 D2 South wall
 D3 South side of south-east pillar (*Deësis*)
 D4 East side of south-east pillar (painting fragments)

E** Left (east) aisle**
 E1 South-east pillar
 → *E1.1. Short north side (Virgin with crossed hands)*
 → *E1.2. Short north-east side (St Demetrius)*
 → *E1.3. Long north side (1st Annunciation)*
 E2 South-west pillar
 → *E2.1. Short north side (fragment of standing saint)*
 → *E2.2. Short north-east side (St Barbara)*
 → *E2.3. Long north side (Virgin and Child enthroned and the Maccabees)*
 E3 North-west pillar
 → *E3.1. Short south side (white plaster)*
 → *E3.2. Short south-east side (white plaster, painting fragments)*
 → *E3.3. Long south side (white plaster, painting fragments, niche with Mary and Child, Daniel in the lions' den)*
 E4 North-east pillar (reconstruction)
 → *E4.1. Long south side (2nd Annunciation from south-east pillar)*

TOPOGRAPHIC REFERENCES

 E5 Low choir, east wall with bench (mainly masonry structure)
 → *E5.1. Side facing the left aisle (painting fragment)*
 E6 Low choir, west wall with bench
 → *E6.1. Side facing central nave (Old Testament scene)*
 → *E6.2. Side facing the right aisle (painting fragments)*
 E7. Low choir, north wall with bench
 → *E7.1. Side facing central nave (Old Testament scene)*
 → *E7.2. Side facing narthex (painting fragments)*
 E8 South-east column (miracle of the blind man)
 E9 South-west column (painting fragments)
 E10 North-west column (painting fragments)
 E11 North-east column (no painting fragments)

F **Right (west) aisle**
 F1 West wall
 → *H1.1. Niche*
 F2 North wall (extension of the scheme by Paul I)

G **West (or right) vestibule**
 G1 West wall
 G2 South wall
 G3 South side of south-west pillar (three saints)
 G4 West side of south-west pillar (white plaster)

H **High choir**
 H1 West wall with bench
 H2 Short eastern side of the southwest pillar
 H3 North wall with bench, west side
 → *G2.1. Side facing high choir (painted vela)*
 → *G2.2. Side facing nave (Judith and Holophernes)*
 H4 East wall with bench
 H5 Short west side of south-east pillar

J **Chapel of Theodotus or Chapel of Quiricus and Julitta**
 J1 South wall
 → *J1.1. Niche*
 J2 North wall
 J3 East wall
 J4 West wall
 J5 Passage to the sanctuary
 J6 Passage to the left (east) aisle

K Sanctuary
- K1 Apse wall or south wall
 - → *K1.1. Apse*
 - → *K1.2. Apsidal arch (including procession of popes)*
 - → *K1.3. Wall to the left of the apse or south-east pier*
 - → *K1.4. Wall to the right of the apse or palimpsest wall or south-west pier*
- K2 East wall
- K3 West wall

L Chapel of the Medical Saints/Physicians
- L1 South wall
 - → *L1.1. Niche*
- L2 North wall
- L3 East wall
- L4 West wall
- L5 Passage to the sanctuary
- L6 Passage to the right (west) aisle

LIST OF COLOUR PLATES

LIST OF COLOUR PLATES

1. Roman Forum towards the Oratory of the Forty Martyrs, Santa Maria Antiqua and the Palatine Hill
2. Atrium and façade of Santa Maria Antiqua
3. View down the Nave of Santa Maria Antiqua from the Narthex to the Apse
4. East (left) wall of Atrium
5. Niche in east wall of Atrium. St Abbacyrus with his surgical box
6. View of left (east) aisle wall (C1). From the top: Old Testament cycle; Christ flanked by standing Saints and Fathers of the western and eastern churches; dado with *vela*
7. Detail of left aisle wall. Christ enthroned, flanked (on left) by St Clement and (on right) by St John Chrysostom, St Gregory of Nazianzus, and St Basil of Caesarea
8. Passage to the Domitianic ramp, right wall (C3). Harrowing of Hell (Anastasis)
9. Passage to the Domitianic ramp, left wall (C3). The Virgin and Christ-child flanked by two angels, St Peter introducing a donor (John VII ?) and St Paul
10. Eastern (left) vestibule (D1): Fragments of the Forty Martyrs of Sebaste cycle and dado with *vela*
11. Eastern (left) vestibule (D) and entrance to the Theodotus Chapel (J)
12. Eastern (left) vestibule (D2). The three young men in the fiery furnace
13. Eastern (left) vestibule, southern side of the south-east pillar (D3). Christ between the Virgin and John the Baptist (Deësis), on the left an unidentified figure
14. South-west pillar, northern side (E2). From the top: Virgin and Child enthroned flanked by two angels; a male saint; Solomone and her sons (the Maccabees); St Barbara
15. South-east pillar, northern side (E1). Virgin and Child enthroned; St Demetrius; the Annunciation. In front of the pillar: hexagonal marble platform from the Ambo of John VII (705-707)
16. North-west pillar, southern side (E3). From the top: fragments of painting; Mary and Christ child in the niche; Daniel in the lions' den and the lower part of the figure of John VII (705-707)
17. Low choir, north-west corner (E6/E7). Old Testament battle scene painted on the bench seat
18. North-east pillar, southern side (E4). Annunciation, wall painting detached from the south-east pillar (E1)
19. View of right (west) aisle wall (F1). From the top: New Testament cycle; the three holy mothers in the niche
20. Detail of right aisle wall, niche. The three holy mothers (Anne, Mary and Elizabeth)
21. Western (right) vestibule (G2) and entrance to chapel of the Holy Physicians (L)
22. Western (right) vestibule, southern side of south-west pillar (G3). Three standing saints, two holding surgical boxes
23. View from the western vestibule across the High choir (H), the eastern vestibule (D) and the east wall of sanctuary (K2)
24. Detail of the High choir floor. Pavement of square mosaic panels with geometric motifs framed by marble bands of spolia including a slab with engraved feet
25. High choir, western side (H1). David and Goliath and Sickness of Hezekiah painted on the bench seat

LIST OF COLOUR PLATES

26 Detail of the High choir western bench (H1). David and Goliath
27 View of the Theodotus chapel (J) from the entrance
28 Theodotus chapel, south wall (J1). In the niche the Crucifixion; below, Mary and Child among SS Peter and Paul, Quiricus and Julitta, Pope Zacharias and the donor Theodotus; dado with *vela*
29 Theodotus chapel, east wall (J3). Cycle of SS Quiricus and Julitta and dado with *vela*
30 Theodotus chapel, west wall (J4). The martyrdom of St Quiricus; Mary and Child flanked by the donor family
31 Theodotus chapel, entrance wall (J2). On left, Theodotus kneeling before SS Quiricus and Julitta; on right the four saints 'whose names God knows'
32 View of the sanctuary (K) and apse wall from the High choir (H)
33 Upper section of the apsidal arch (K1). Adoration of the Cross
34 Apsidal arch (K1). Detail of Christ on the cross, the head of St John the Baptist, seraphs and angels
35 Apse and side walls (K1)
36 Detail of right side of the apse conch. Christ and a tetramorph
37 Apsidal arch, right side. The 'palimpsest wall'
38 Detail of the 'palimpsest wall'. *Maria Regina*
39 Detail of the 'palimpsest wall'. The angel to the right of *Maria Regina* and the angel Gabriel from the later Annunciation layer
40 Detail of the 'palimpsest wall'. The Church Fathers Basil and John Chrysostom holding scrolls with an extract from their works; below, dado with painted *opus sectile*
41 Detail of the apsidal arch, left side. The Church Fathers Leo the Great and Gregory of Nazianzus holding scrolls with an extract from their works; below, dado with painted *opus sectile*
42 View of west (right) wall of the sanctuary (K3) with the entrance to the chapel of Holy Physicians (L)
43 Detail of west (right) wall of the sanctuary (K3). From the top: the Christ cycle of John VII superimposed on an older layer of similar subject; *clipei* with Twelve Apostles; the stucco frieze; dado with *vela* and the head of St Anne
44 Detail of west (right) wall of the sanctuary (K3). St Anne holding the infant Mary
45 View of east (left) wall of the sanctuary (K2) with the entrance to the Theodotus chapel (J)
46 Detail of east (left) wall of the sanctuary (K2). From the top: the Adoration of the Magi, the Betrayal and the Carrying of the Cross from the Christ cycle; *clipei* with Twelve Apostles; the stucco frieze
47 Chapel of the Holy Physicians, west wall (L4). From the top: row of six saints; dado with *vela*; small jewelled cross
48 Chapel of the Holy Physicians, niche in the south wall (L1). Row of five saints; dado with *vela*
49 Chapel of the Holy Physicians, entrance wall (L2). Row of seven saints; dado with *vela*
50 Plan of Santa Maria Antiqua with topographic references

COLOUR PLATES

COLOUR PLATES

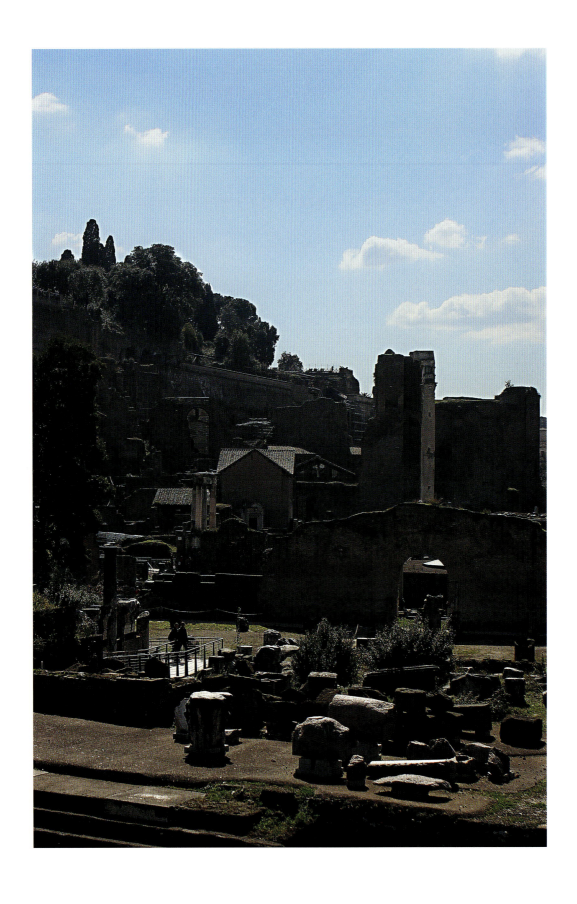

COLOUR PLATES

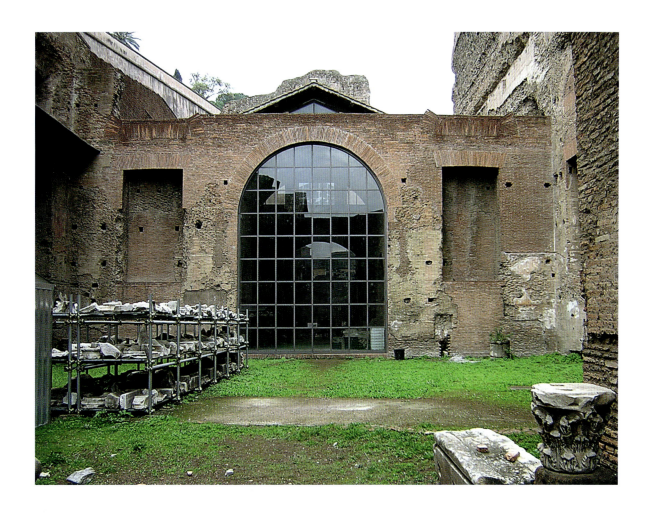

COLOUR PLATES

3

COLOUR PLATES

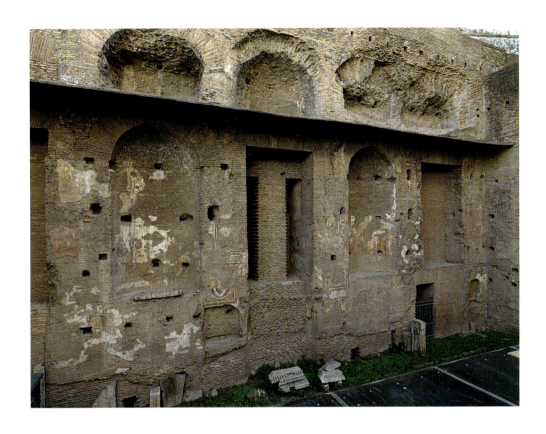

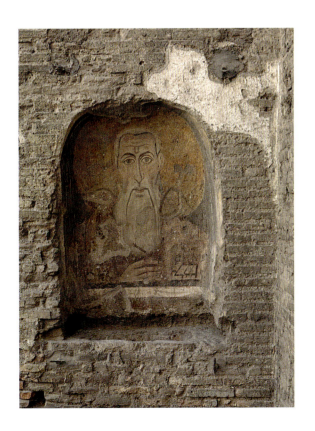

6/7

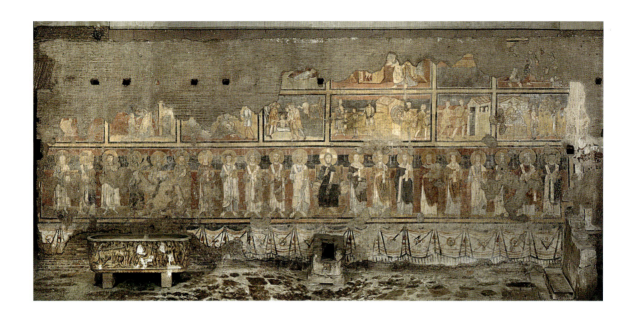

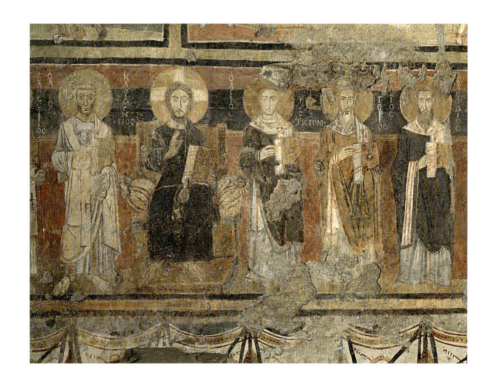

COLOUR PLATES

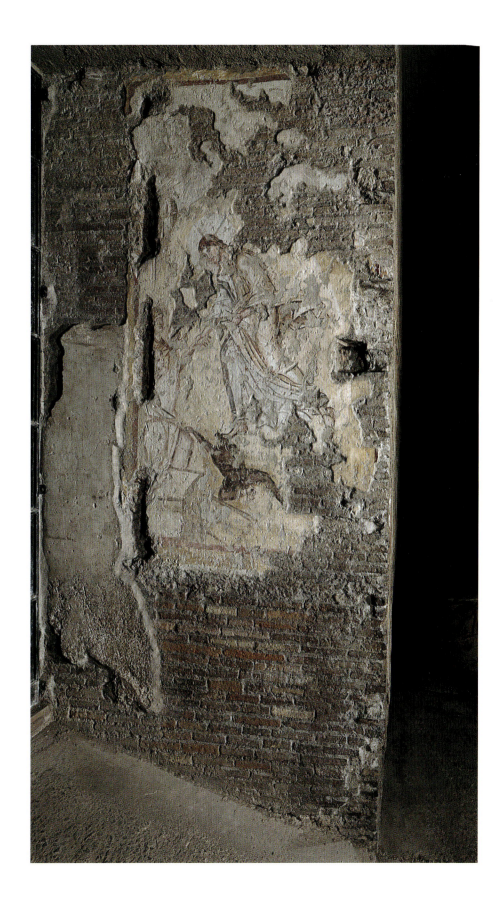

8

COLOUR PLATES

9

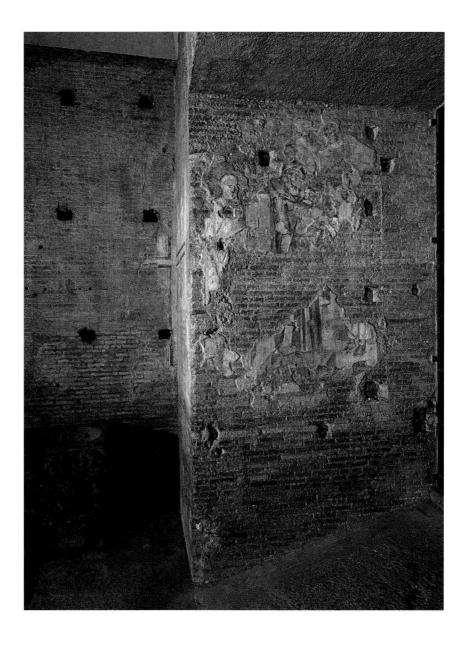

COLOUR PLATES

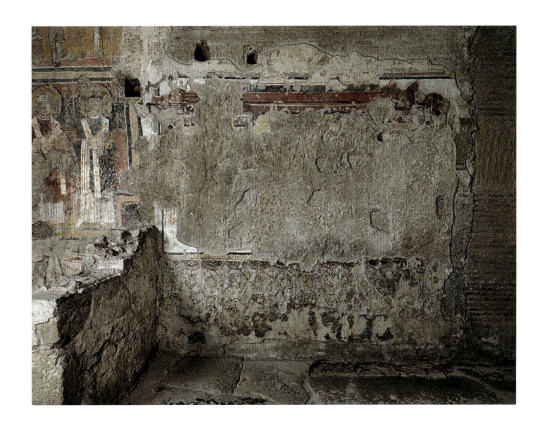

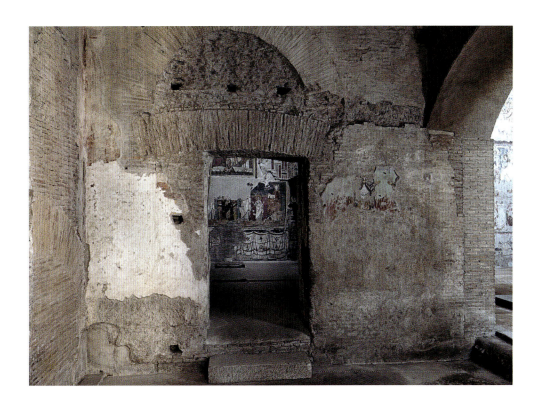

12/13

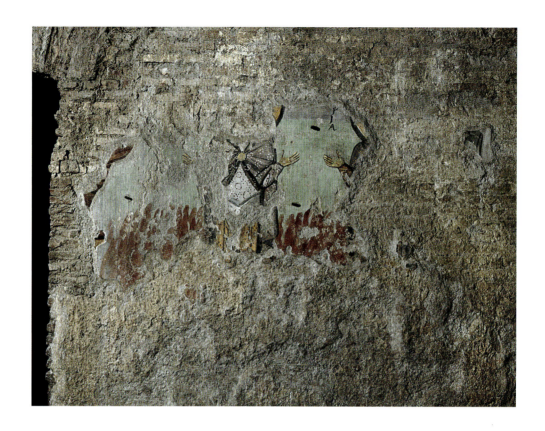

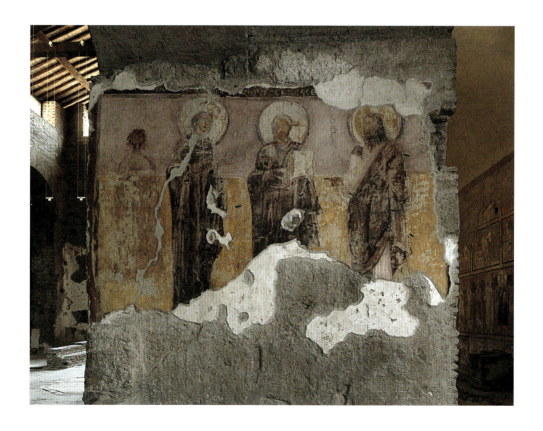

COLOUR PLATES

14

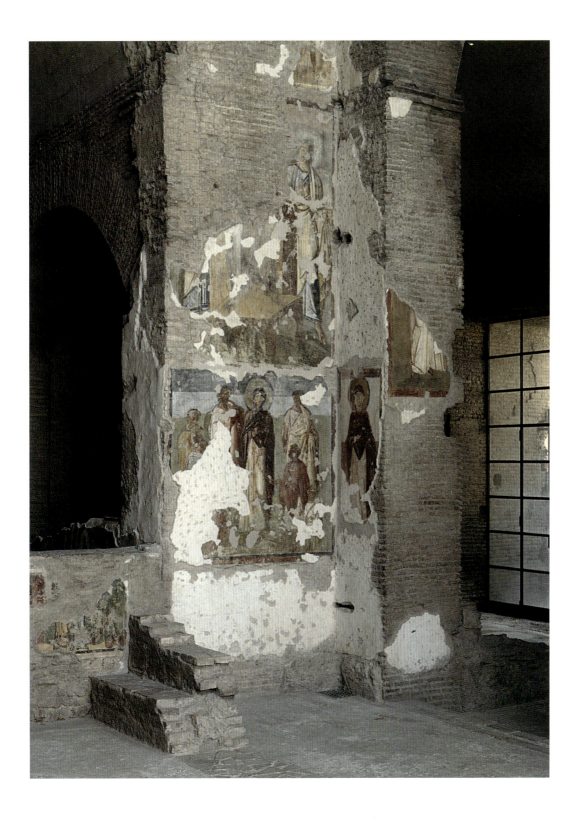

15

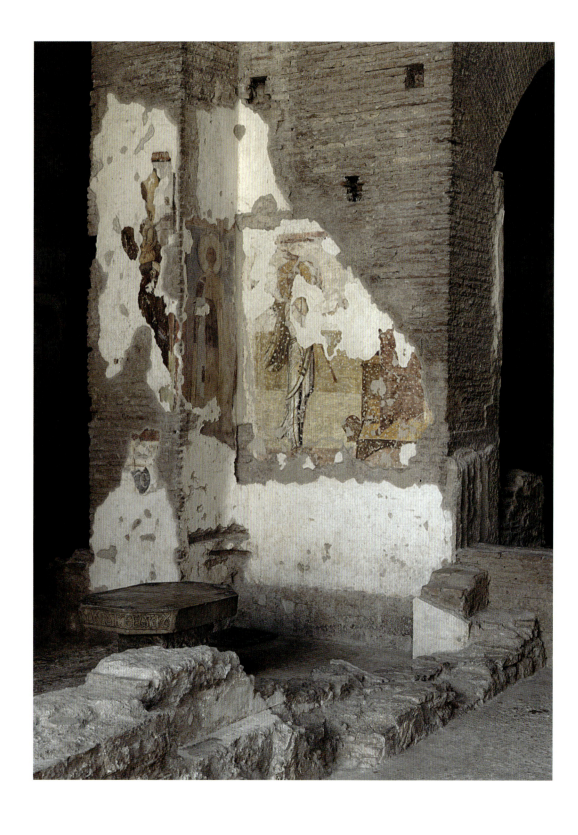

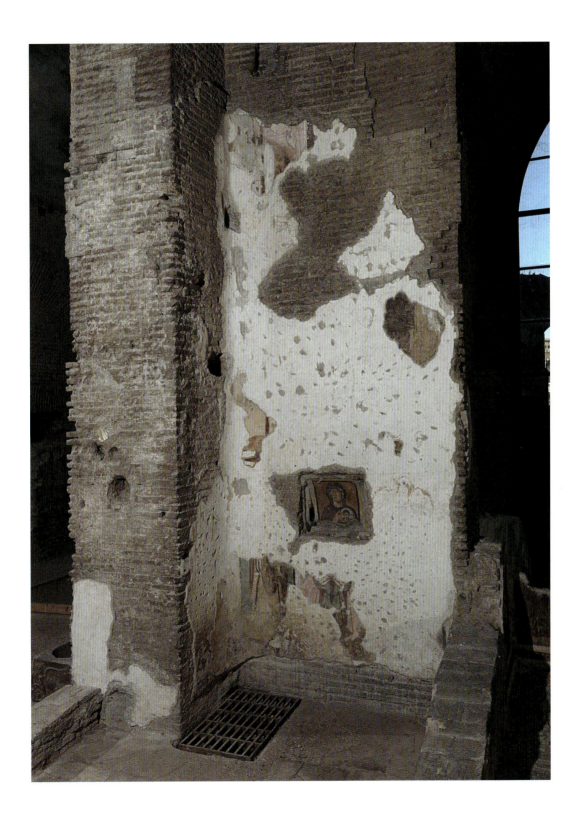

COLOUR PLATES

17/18

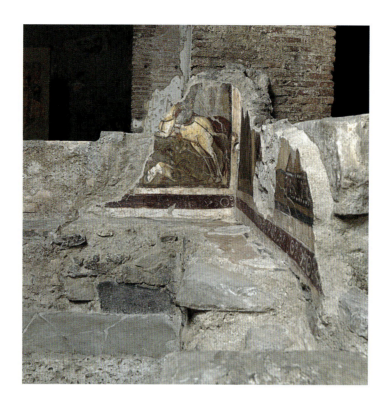

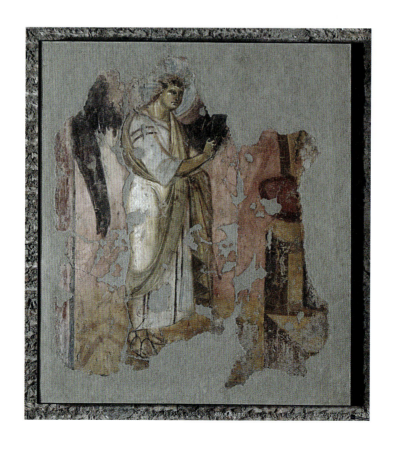

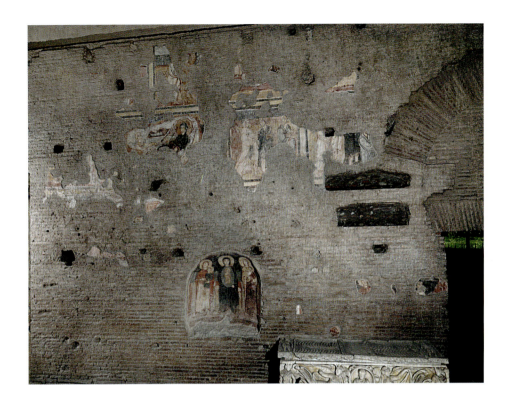

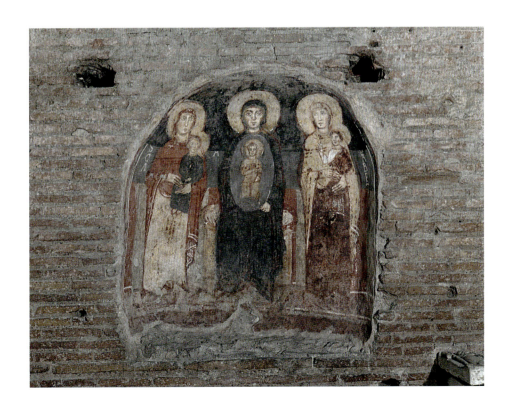

21/22

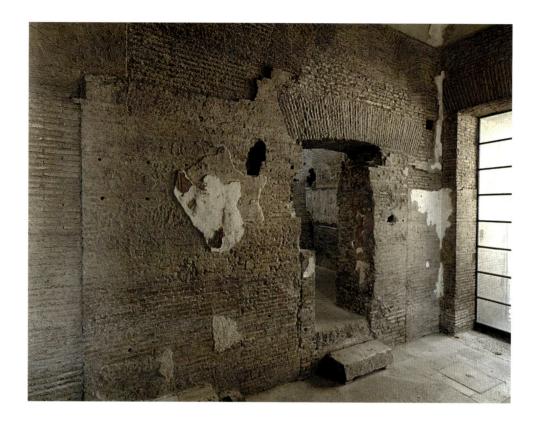

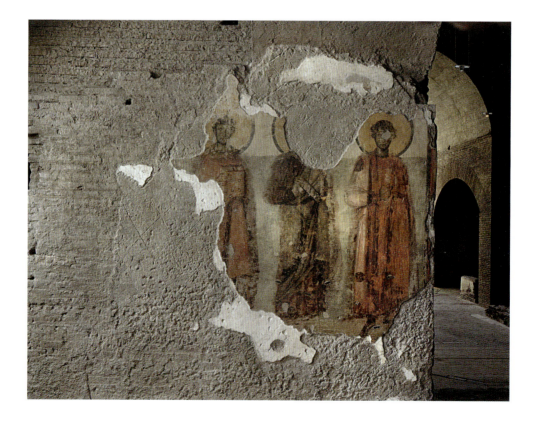

COLOUR PLATES

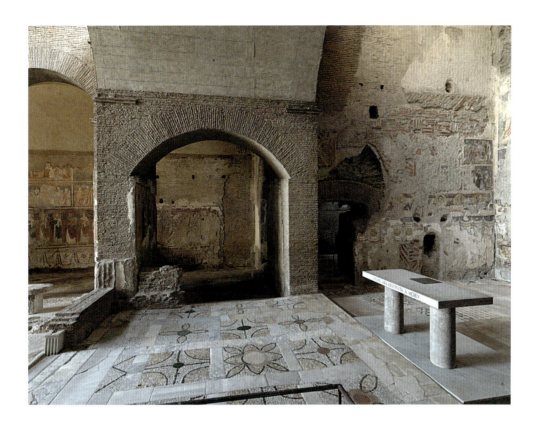

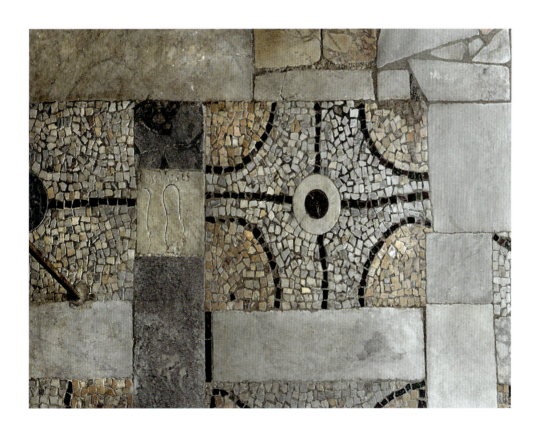

25/26

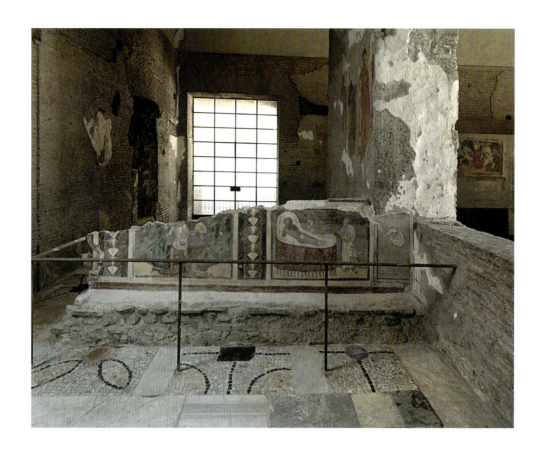

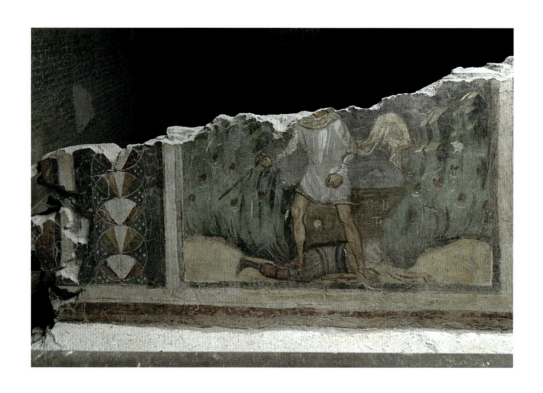

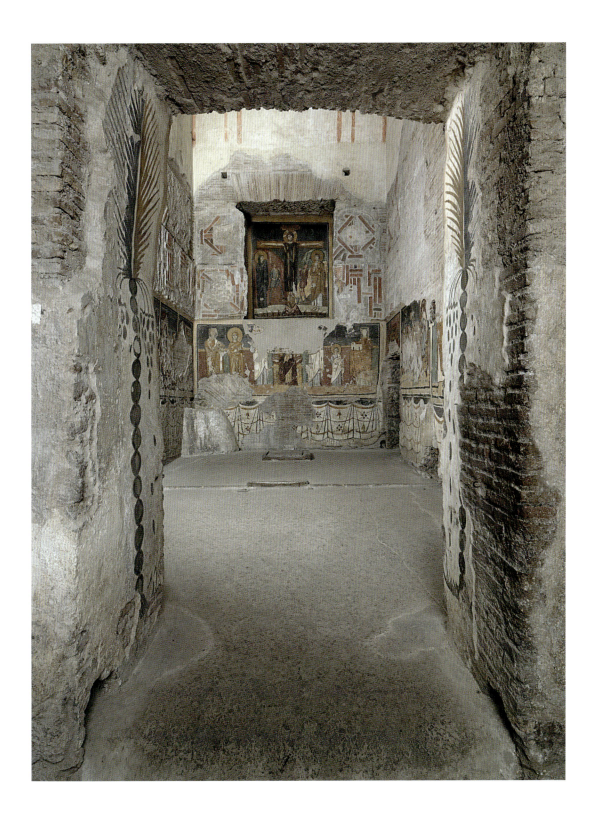

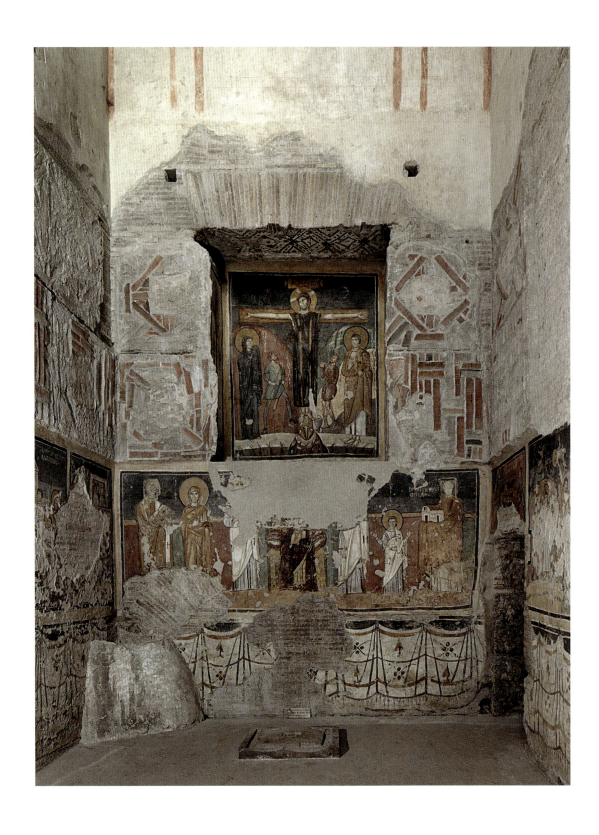

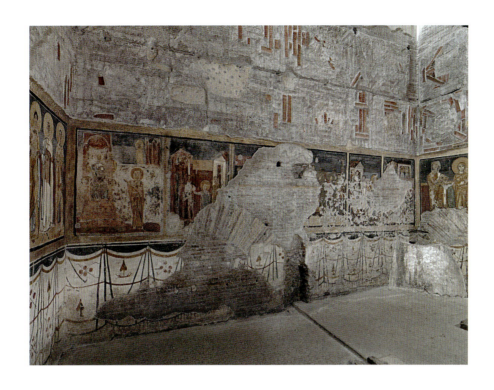
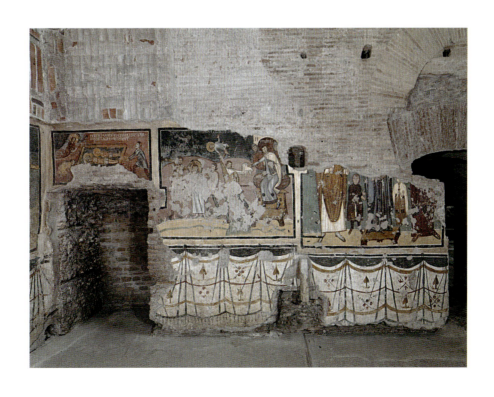

31

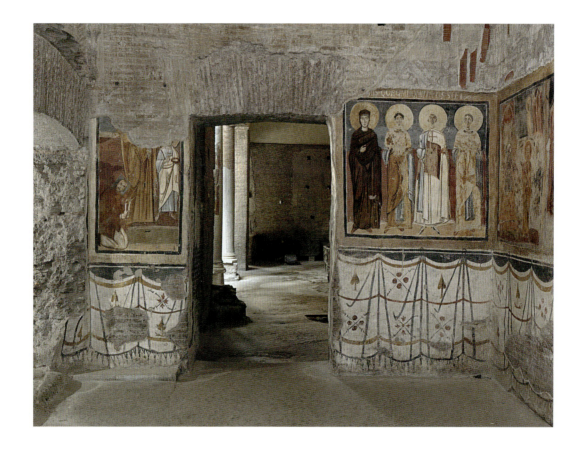

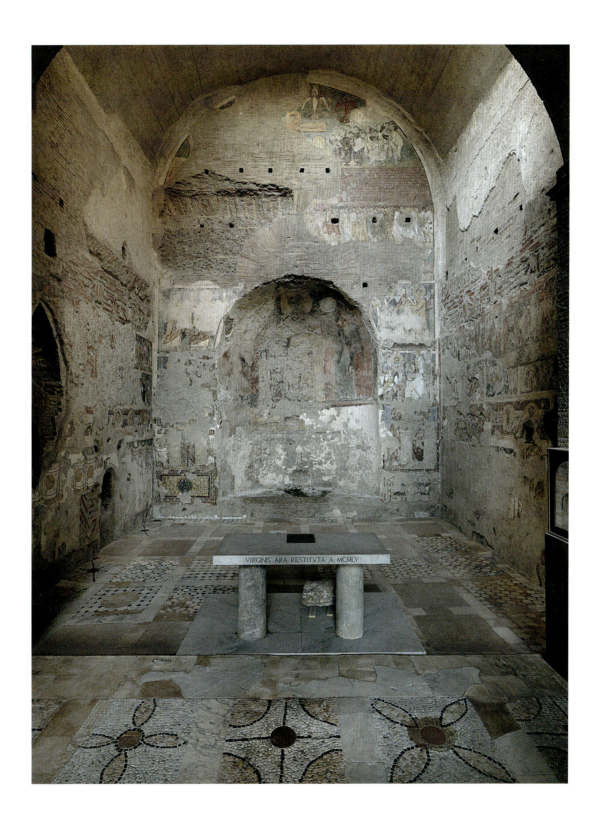

33/34

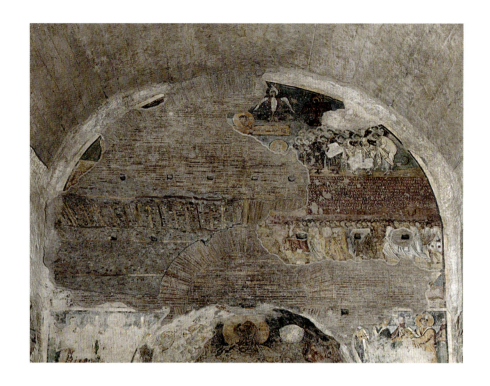

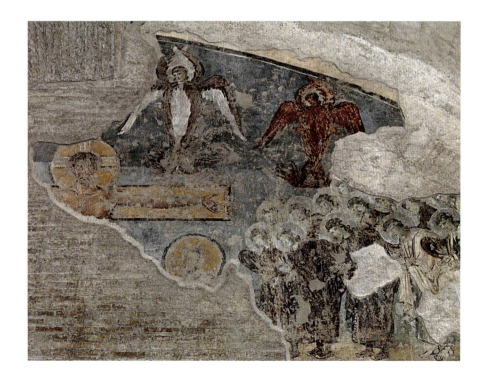

COLOUR PLATES

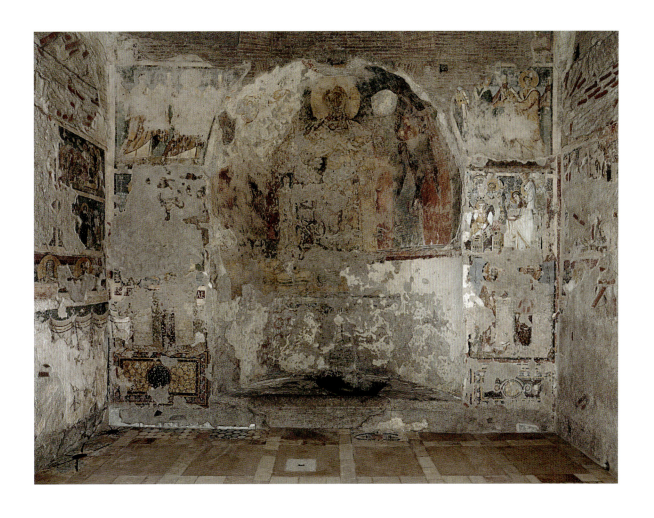

36

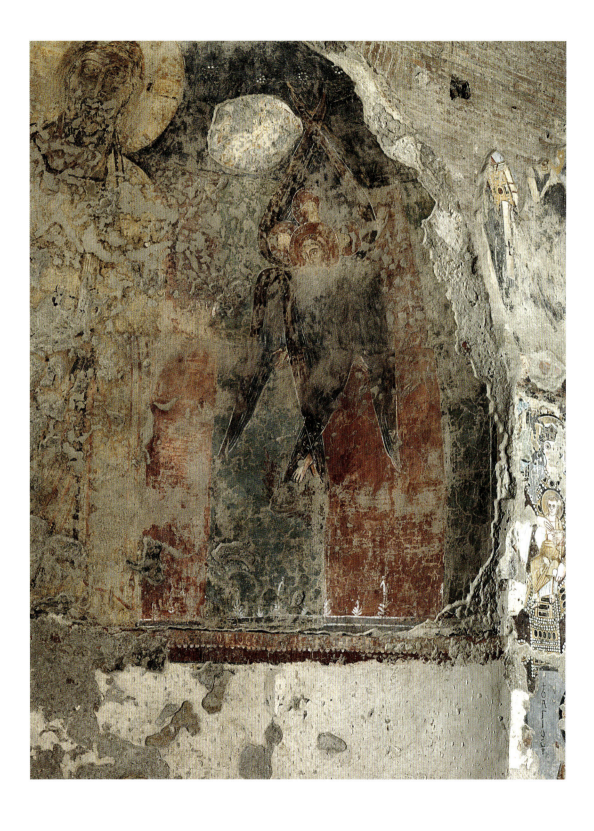

COLOUR PLATES

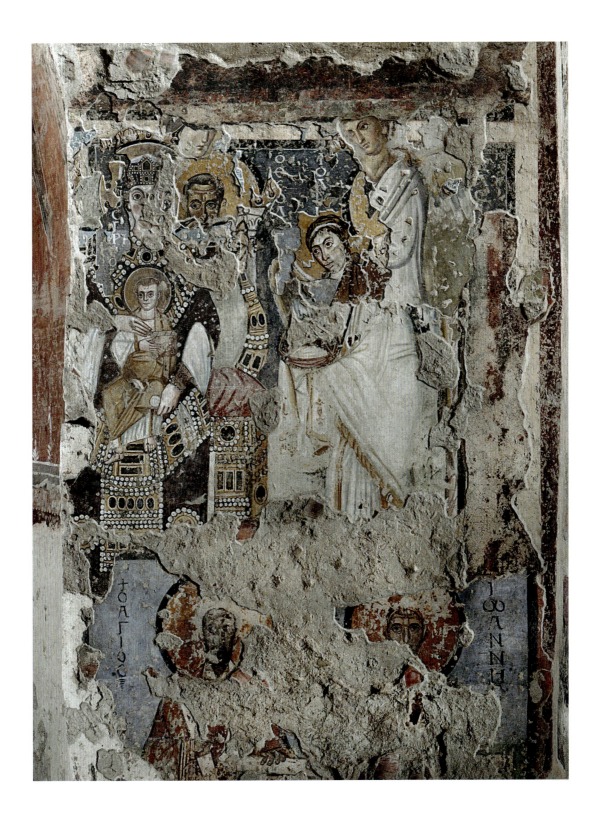

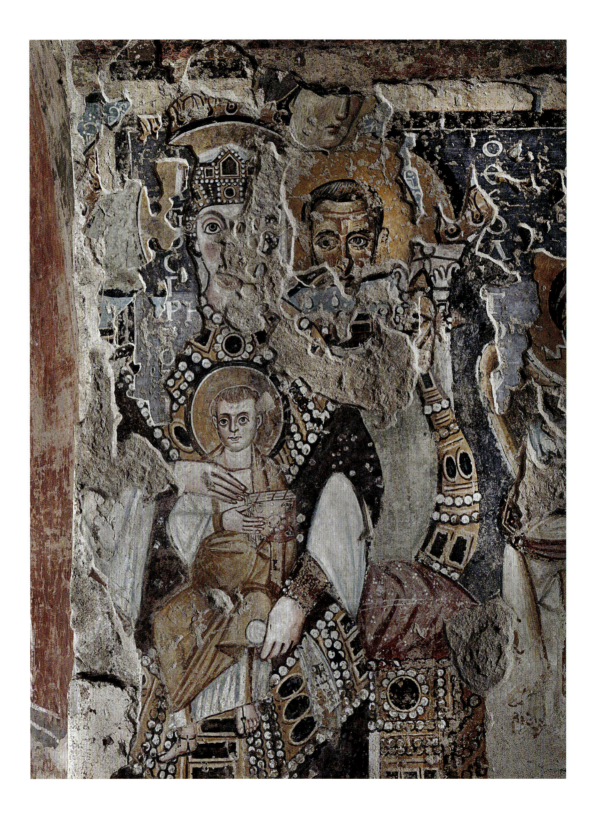

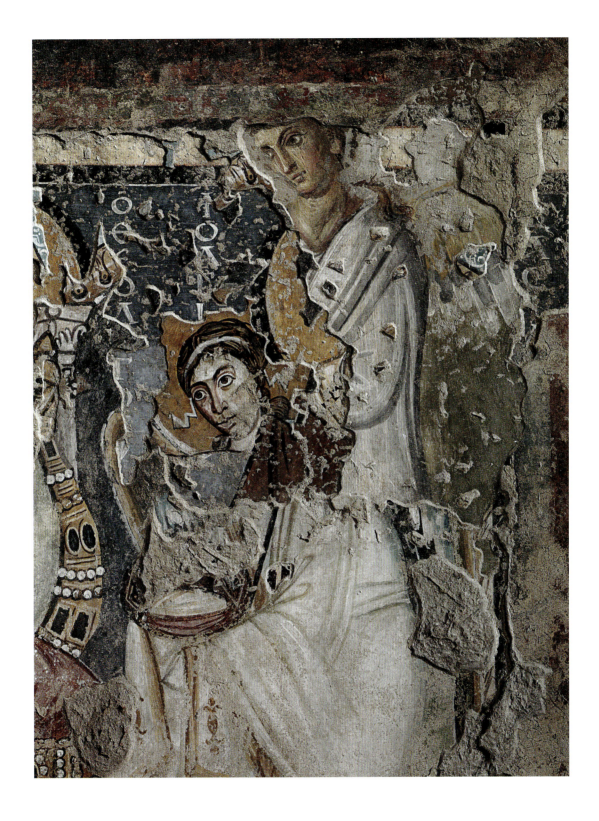

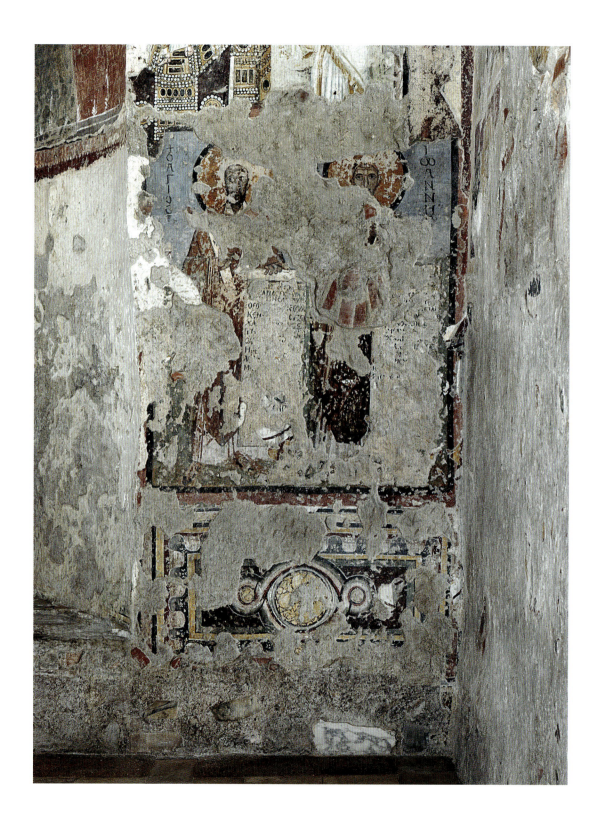

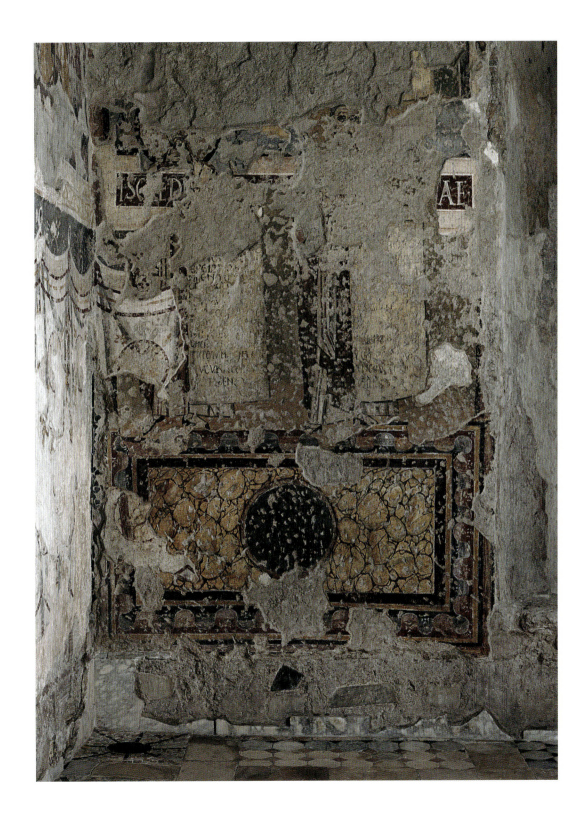

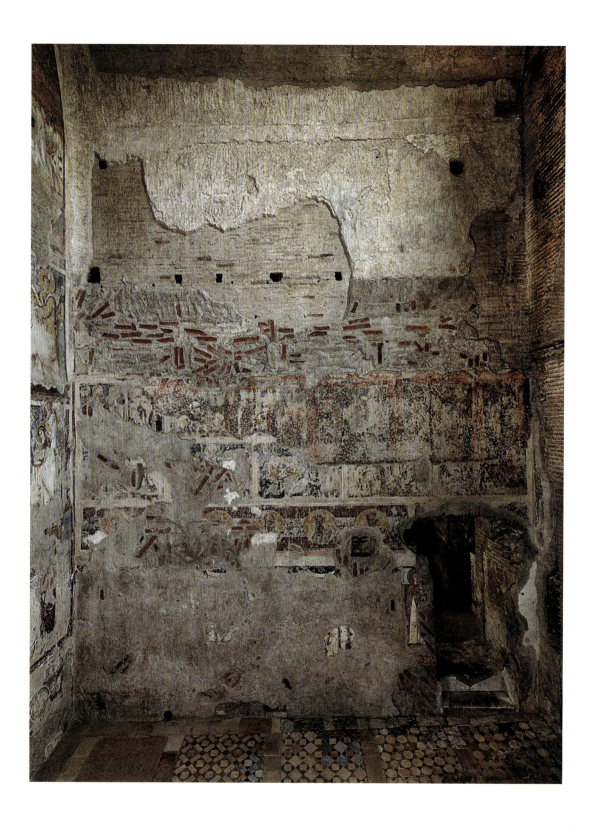

COLOUR PLATES

43

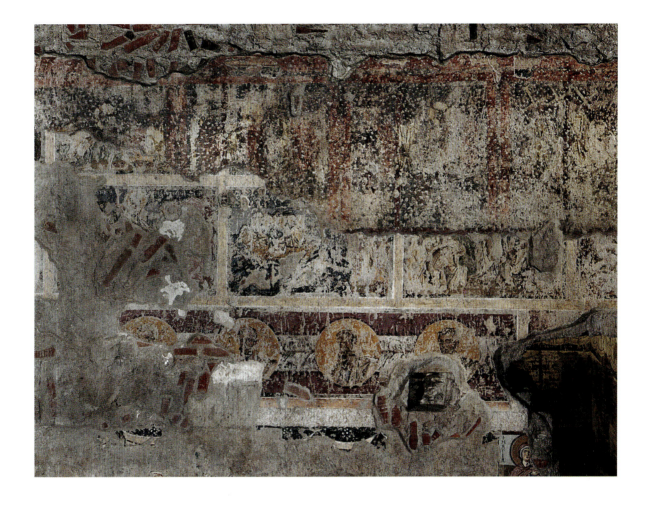

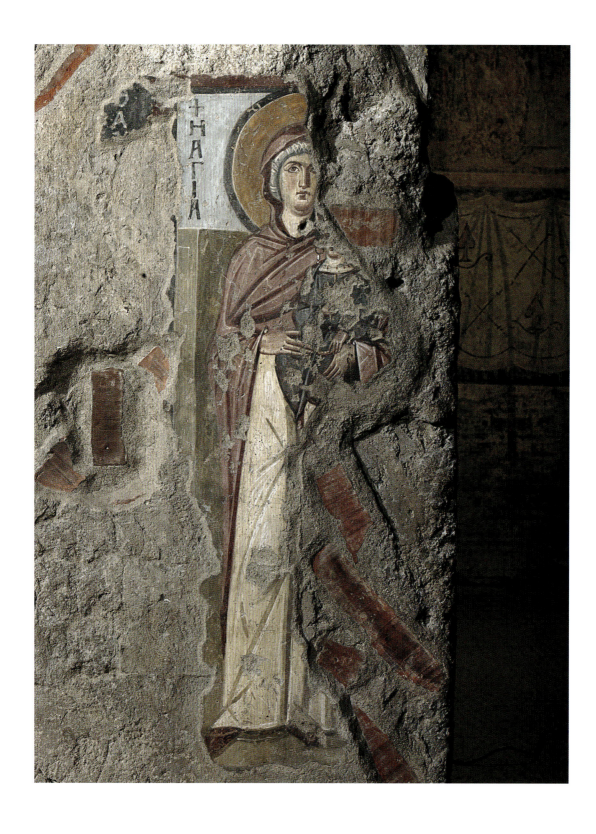

COLOUR PLATES

45

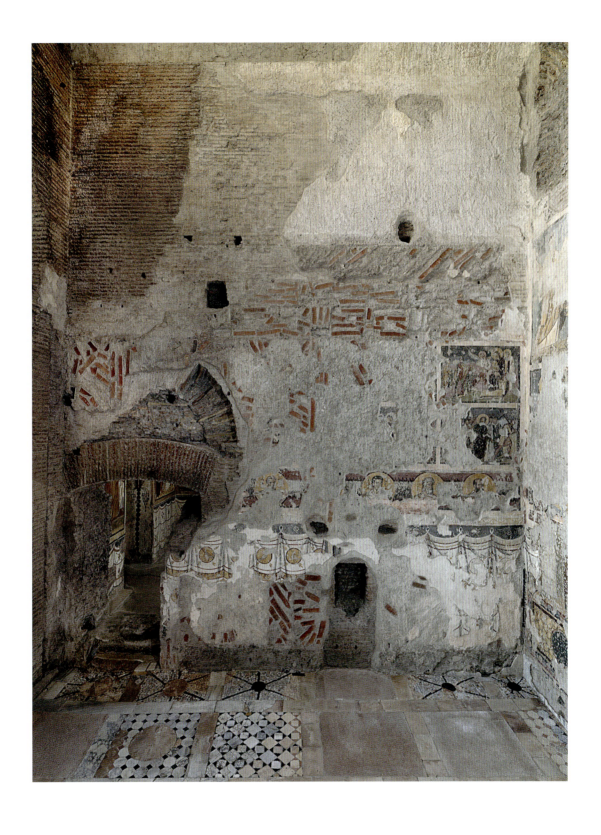

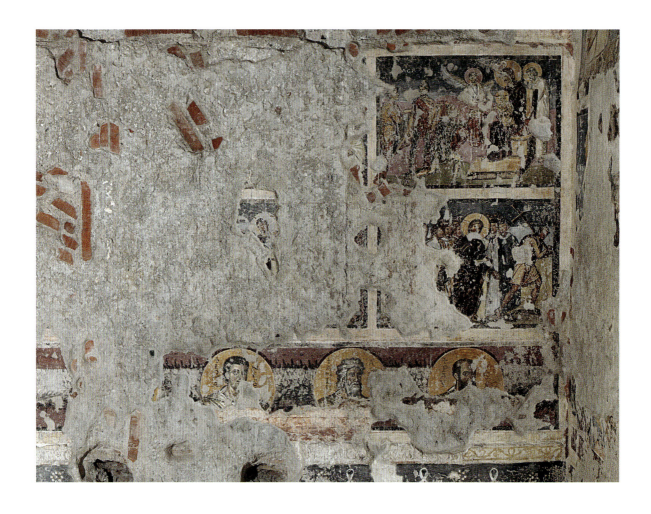

COLOUR PLATES

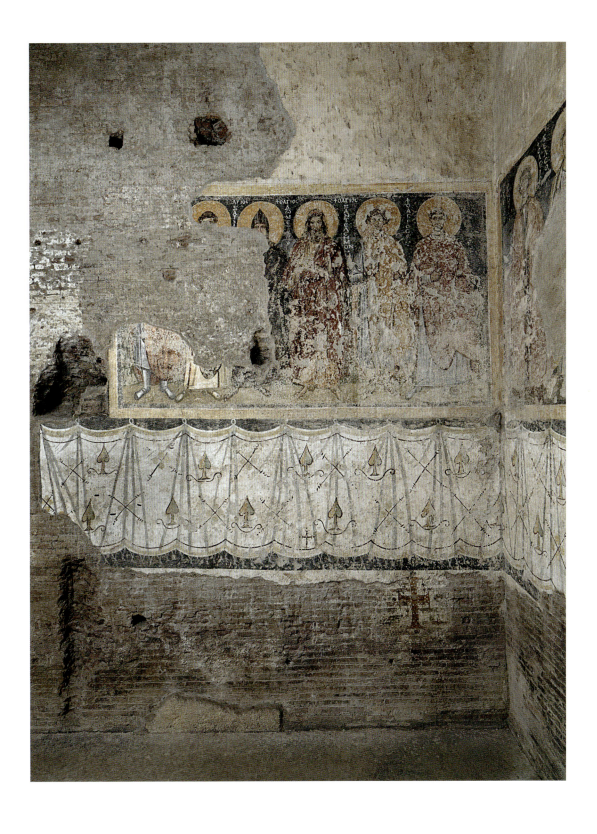

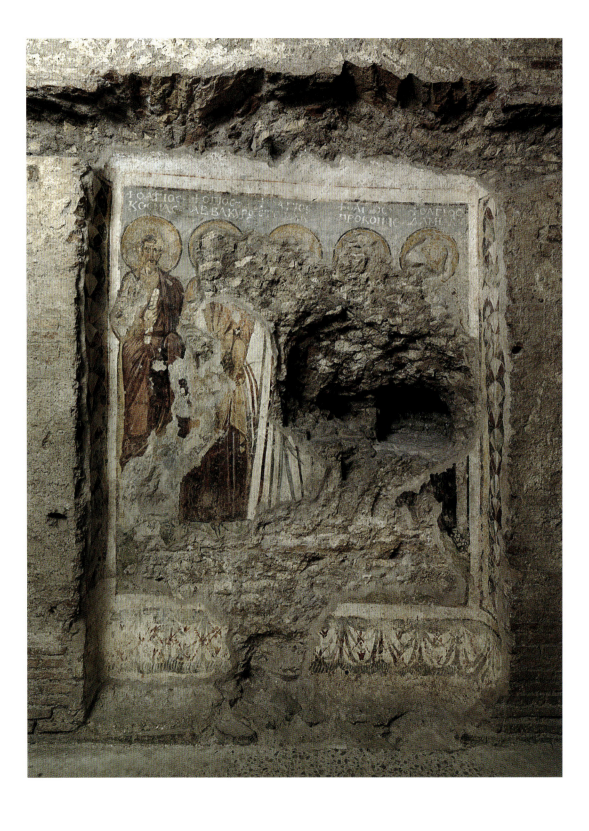

48

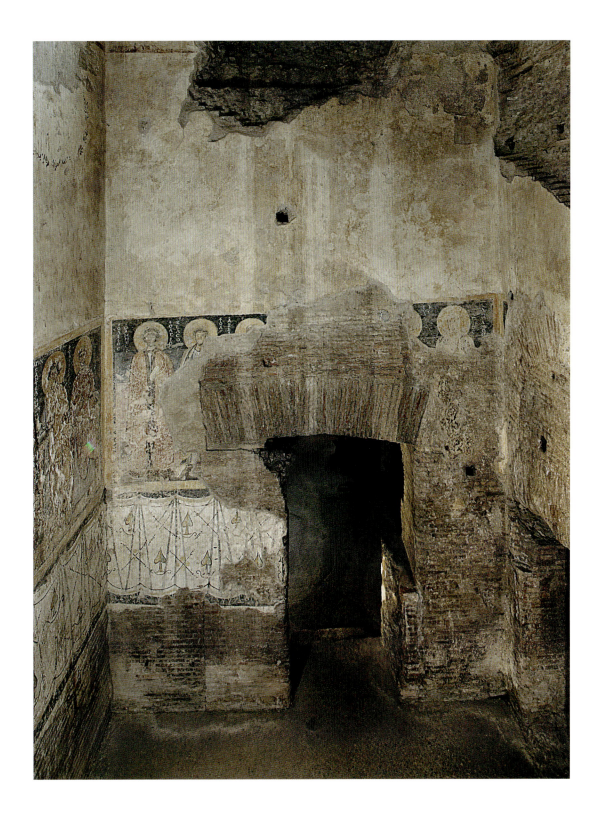

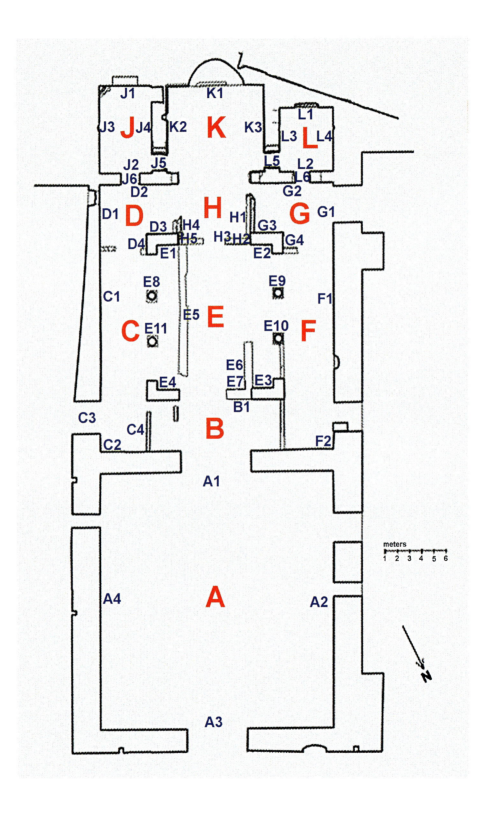

HISTORIOGRAPHY

OSCAR MEI

1702: The discovery of Santa Maria Antiqua

The apse wall of the church of Santa Maria Antiqua came to light accidentally in 1702, following the excavations undertaken by a *cavatore* (quarrier) of marble, Giovanni Andrea Bianchi, who had received permission to dig for stones in the garden of the nuns of Tor de' Specchi behind the church of Santa Maria Liberatrice. Until today, the most significant contemporaneous source to mention this event was thought to be Francesco Valesio's *Diario di Roma*, which documents the great interest generated by the discovery—including that of Pope Clement XI Albani, who two and a half months later opposed its reburial, which was already in progress.[1]

> 1702. Mercordì 24 Maggio
> […] Essendosi da un Capo Mastro muratore preso in affitto, per cavare tavolozze per fabricare, dalle Monache di Torre de' Specchi un giardino piccolo esistente dietro la Tribuna di S. M. Liberatrice, cavandovisi in questa settimana, hanno scoperta un tiro di sasso lontana dalla moderna tribuna di detta Chiesa, un'altra antichissima tribuna di una Chiesa, venti e più palmi depressa di sito con pitture del Salvatore crocifisso, di molti Santi, fra' quali la figura di Paolo I pontefice con il diadema quadro, in segno che allora era vivente, e lettere "Sanctissimus Paulus Romanus Papa", e nelli muri laterali vi è dipinta la vita di N. S., et è da notarsi che, essendo detta Pittura in alcuni luoghi caduta, vi si vede sotto altra pittura più antica e di miglior maniera. Si crede essere stata, o la Chiesa di S. M. de Inferno antica, o di S. Maria de Canaparia. Vi sono anco iscrizzioni greche di passi di Scrittura. Vi fu numeroso concorso di Popolo per vederla.
>
> Mercordì 2 Agosto.
> […] Havendo saputo N.S. che la Chiesa antichissima ritrovata, come si e scritto, dietro la Tribuna di S. M. Liberatrice da quei Cavatori, si ricopriva, ha di nuovo ordinato che si torni a cavare la terra / che v'era stata gettata.

Of exceptional importance is the watercolour that Valesio appended to his text, showing a direct view of the excavation in progress and a schematic representation of the murals on the end wall and apse, as well as the west wall of the sanctuary (Figure 1).

Further details were provided by Mariano Armellini in 1887,[2] who reported information discovered in the papers of Pier Luigi Galletti preserved in the Vatican Library,[3] and above all by Rodolfo Lanciani, who discovered a notarial document of 19 August 1702 related to a legal action brought by Duke Francesco Farnese against the nuns of Tor de' Specchi and the leaseholder of the garden of Santa Maria Liberatrice, Andrea Bianchi. The Duke charged both the nuns and the quarryman, accusing the latter—who had received permission from the Commissary of Antiquities, Francesco Santi Bartoli, to dig in the garden beside the church—of straying beyond its limits onto Farnese property. The various notes related to the buildings that had been brought to light in the excavation are of considerable interest, and the document also assists us in understanding the chronology of the various phases of activity. Particularly important is the description of the opening into the Farnese garden, and of a staircase with steps of travertine marble (to which I shall return).[4]

An unexpected addition to our knowledge of the 1702 excavation, concerning chiefly the parts that would be lost between this event and Giacomo Boni's 1900 demolition of Santa Maria Liberatrice, emerged from an accidental discovery that I made in 2016.[5] A series of handwritten sheets in the Passionei archival fonds of the Biblioteca Civica Passionei in Fossombrone, near Urbino, bears the title 'Selva per una dissertazione, che incomincia l'anno 1704, sopra una chiesa, che si scoprì in Campo Vaccino a lato di Santa Maria Liberatrice'. This dossier comprises a large number of documents, methodically compiled between 1702 and 1706 by the then twenty-something Abbot Domenico Silvio Passionei (1682–1761). He would later become the Cardinal 'Segretario dei Brevi' and the Vatican librarian.[6] The papers relate the accidental discovery of Santa Maria Antiqua in 1702, of which Passionei was an eyewitness and which he documented through descriptions, interpretive studies, and a few watercolours. Today the 194 sheets that constitute the dossier are bound in a single volume: Tome 32. The collection comprises some 115 manuscripts that belonged to Passionei, which were passed down to his nephew Benedetto after his death. Benedetto added them to six thousand volumes from his own library, which in 1784 became the core collection of the civic library in Fossombrone, which still bears his name.[7]

The dissertation on the discovery of the ancient church constitutes one of Domenico Passionei's earliest forays into archaeology. After moving to Rome in 1695, where he graduated from the Collegio Clementino in 1701, he was quickly introduced to the circle of the Roman curia by his paternal uncle, Monsignor Guido Passionei, 'Segretario della Cifra' and member of the Concistoral Congregation and Sacred College. Like Pope Clement XI Albani, Domenico Passionei came from the Marche and enjoyed a very close friendship with the pope's nephew, the future Cardinal Annibale Albani. He could also count on the support of prominent members of the Roman curia, such as the cardinals Fabrizio Paolucci and Henry Noris, Monsignor Giuseppe Maria Tommasi (later cardinal and saint), and the *letterato* Giusto Fontanini.

It is not a surprise, therefore, to find the young Domenico at the Campo Vaccino excavations in 1702, nor to learn of his intention to study the monument that was being uncovered. He had the appropriate acquaintances in the Roman curia, not to mention the financial means and the intellectual aptitude for such an undertaking. From a letter dated 31 May 1702—only a few days

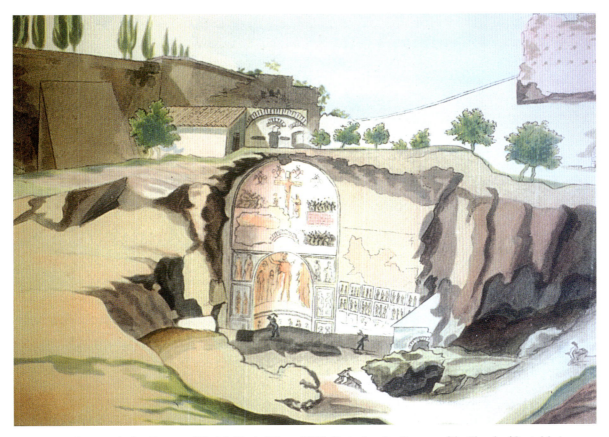

1 Watercolour, attached to Francesco Valesio's *Diario di Roma* (1702), illustrating the discovery of the Church of Santa Maria Antiqua in the Campo Vaccino

after the discovery, written by the Ferrarese poet and canon Giulio Cesare Grazzini to his fellow citizen Girolamo Baruffaldi, we learn that Passionei was at the site from the very beginning, copying the murals that had come to light:

> Si è scoperta una nova chiesa in Roma dietro a Santa M.ª Liberatrice sotterra nella quale si sono ritrovate moltissime imagini di santi col ritratto di Paolo primo Pontefice, si dice al tempo de gl'Iconoclasti, et esser per tale effetto tutta ornata di tali imagini, che si fanno coppiare diligentemente per opera di Mons. Passionei, prima che rovinino per l'aria.[8]

The first mention of the project on which Domenico Passionei was about to embark may be found in a letter written to Ludovico Antonio Muratori on 24 November 1703, in which he says that he has been 'consumed for many days on account of my dissertation, about which I will provide details at a later date'.[9] In another letter written shortly afterwards (8 December 1703) Passionei is more explicit, indicating the subject of the dissertation and requesting that Muratori check in the Biblioteca Ambrosiana in Milan for texts of the ninth-century historian Anastasius Bibliothecarius, in order to compare them with those he had found in Rome. He also asks Muratori to check the correspondence of Pope Paul I (757–67), whom he believed to have founded the church that was being excavated:

> La mia dissertazione va avanti ma con gran stenti, il soggetto della medesima è questo, fu scoperta sotto le rovine del Palatino nell'anno passato una Chiesa con molte figure fatte a penello, cerco l'origine di questa, l'autore, e l'antichità delle figure fatte da me delineare, v'è il ritratto di Paolo I col quadro dietro alla testa, indizio, ch'esso vivea.[10]

The exchange between the two continued over several months, as demonstrated by Passionei's letters, dated to 4 January, 12 and 20 February 1704,[11] and Muratori's response to the last, dated to 1 March of the same year.[12] In Passionei's last two letters, specific reference is made to the 'Circle of the Drum' ('Circolo del Tamburo'), a twice-weekly gathering of men of culture held in the house of the young abbot.[13] Frequent participants included Fontanini, the custodian of the Vatican Library Giovanni Vignoli, the physician Giorgio Baglivi, the theologians Federico Bencini and Giovanni Paolo Nurra, the future archibishop Celestino Galiani, the Neapolitan philosopher and archaeologist Biagio Garofalo, and the astronomer Francesco Bianchini.[14] Among other things, Bianchini directed the 1704–5 project to raise the Antonine Column in Piazza di Montecitorio and curated its publication, while Vignoli also published a study of this monument in the following year.[15] The presence of these individuals in the 'Circle of the Drum' gives us a sense of the value its members placed on archaeology and antiquity, a factor that undoubtedly inspired Passionei to undertake his study of the newly excavated building. It was to this erudite group that he presented his dissertation, or at least a draft of it, as documented in a letter from Baglivi to the Dutch physician and botanist Peter Hotton, written between 1703 and 1704.[16]

The manuscript codex comprises some 194 folia of various sizes and textures, almost all written on both sides. The majority are parchment sheets of a uniform size, but smaller leaves and some reused sheets are also present. The handwriting appears hasty and is exceptionally difficult to read. At times the text occupies only a single column, with annotations and additions in the other; at times it covers the entire page. Only a few pages show calligraphic handwriting, and these can be associated with Passionei's intention to make his notes into a dissertation. They also reveal revisions made in later years, but unfortunately the task was never finished, and thus the text still remains at an embryonic stage. The language used is Latin, apart from an inset on fol. 161r, brief annotations on fols 118r, 134v, and 162r, and notes on fols 170–2. At the end of the manuscript there are three watercolour drawings (fols. 183r, 184r, and 187r), plus two more in black ink on a white ground (188r, 188bis).

What emerges from the text is the particular approach taken by the young abbot to the monument, an approach that exemplifies the state of knowledge achieved by scholars of the time and the evolving tools available to them. Although barely twenty years old, Passionei demonstrates a vast cultural knowledge; moreover, he had access to the main libraries in Rome and was beginning to develop a network of correspondents that included the foremost scholars and men of letters, both in Italy and across Europe.[17]

An examination of the manuscript allows us to reconstruct the main phases in the compilation of the dossier, even if the folios are arranged in a more or less random order. Some contain notes clearly made at the site, and these probably constitute the most important evidence, since they give us an uncontaminated glimpse into the murals at the moment of their initial discovery. In addition, there are pages and pages concerning a wide variety of topics related

to the building, the fruit of Passionei's research in the libraries to which he had access, as well as reworkings of this material with a focus on the actual monument, enriched by his personal interpretations.

The watercolour drawings depict in a simplified fashion the murals on the end wall of the sanctuary: fol. 184ʳ (Figure 2; cf. Plates 31, 50: K1); the conch of the apse on fol. 183ʳ (Figure 3; cf. Plates 35, 50: K1.1); and a bust of the Virgin no longer extant on fol. 187ʳ (Figure 4). There is also a plan of the site on fol. 188ʳ (Figure 5), and the reproduction of a brick with its stamp on fol. 188bis.

The full title chosen for the dissertation is provided on fol. 129ʳ: 'De Ecclesia detecta ad Radices Montis Palatini Dissertatio Dominici Passionei Forosemproniensis: cui accedit opusculum Maffaei Vegis de Basilica Vaticana olim ab Allatio in Symmictis promissum, nunc a vero in lucem editum'. From this we learn that Passionei planned to append to his study the treatise in four books *De rebus antiquis memorabilibus Basilicae Sancti Petri Romae* (1455–7), by the fifteenth-century humanist Maffeo Vegio (1407–58), a text written on the eve of the remodelling of the Vatican Basilica by Pope Nicholas V and considered the cornerstone of Christian archaeology.[18] Had this project been completed, it would have been the first printed edition of Vegio, preceding the *editio princeps* edited in 1717 by the Bollandist, Conrad Janninck, which remained the only critical edition until 2009.[19]

Passionei had drafted an outline for his dissertation, listing all the topics that he planned to address (fol. 35ʳ):

Operis Partitio

Scopus conficiendi dissertationem

Inventio Ecclesiae

Situs qualis

Qualis Forma, Materia

Quis auctor, quo tempore, qua occasione, in cuius honorem, an restauravit vel fecit

Quo sumptu, qua magnificentia

Explicentur picturae

From the Preface on fol. 185ʳ we learn that this section would have been dedicated to the Bishop of Adria, Filippo Della Torre, a numismatist and antiquarian who frequented the main cultural circles in Rome (including probably 'the Drum'), and belonged to the same intellectual community as Passionei.[20] Both men were *protégés* of the Vatican librarian, Cardinal Noris. La Torre departed for Adria to take up his position in the diocese in June 1702, only a few days after the discovery of Santa Maria Antiqua, and this may perhaps explain why Passionei dedicated his study to him, since the two would maintain regular correspondence until Della Torre's death in 1717.

As indicated previously, the bibliographical notes included in the codex refer to various

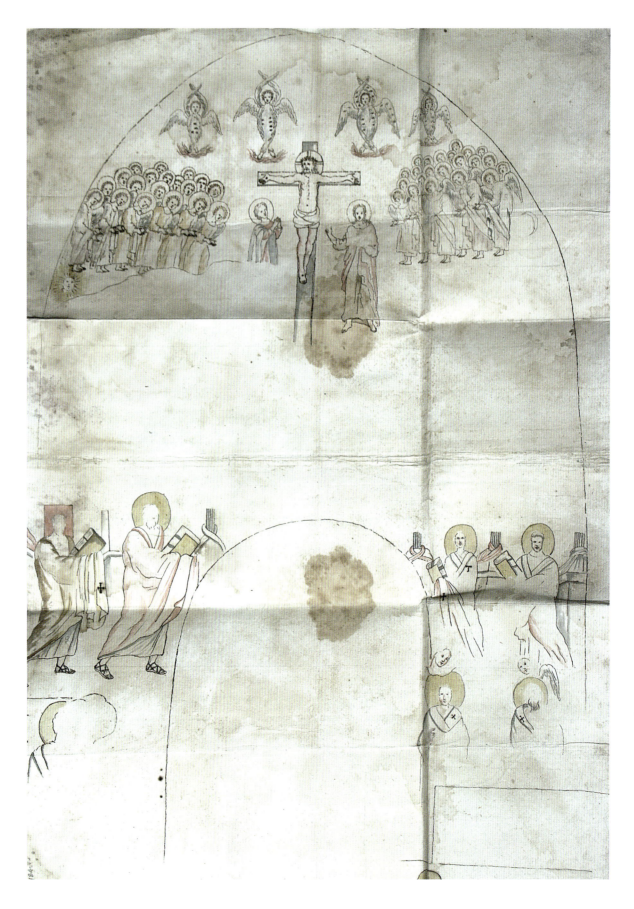

2 Watercolour drawing of the apse wall of the sanctuary of Santa Maria Antiqua, from MS 32 of the Passionei fonds, fol. 184ʳ
(Fossombrone, Biblioteca Civica Passionei)

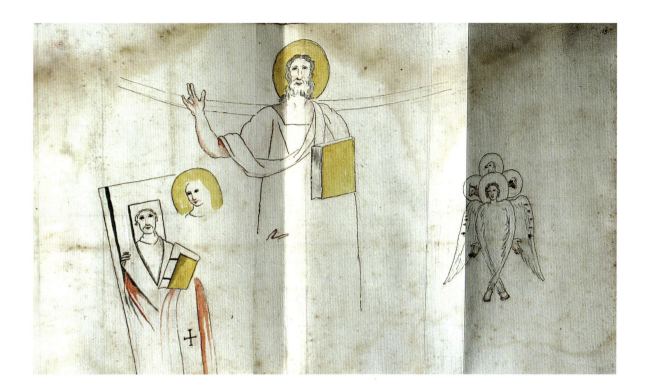

3 Watercolour drawing of the apse conch in the sanctuary of Santa Maria Antiqua, from MS 32 of the Passionei fonds, fol. 183ʳ
(Fossombrone, Biblioteca Civica Passionei)

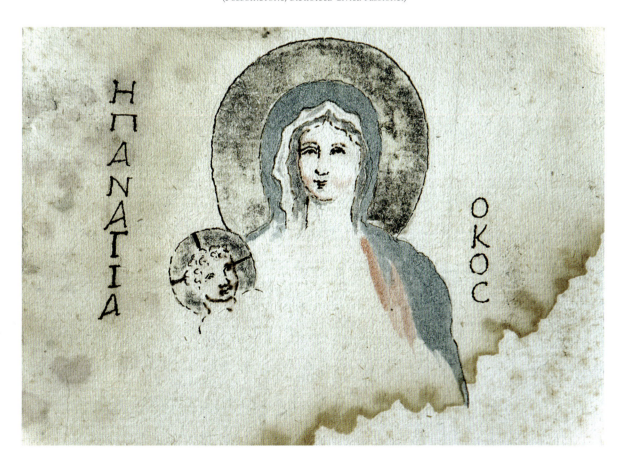

4 Watercolour drawing of the Virgin and Child, from MS 32 of the Passionei fonds, fol. 187ʳ
(Fossombrone, Biblioteca Civica Passionei)

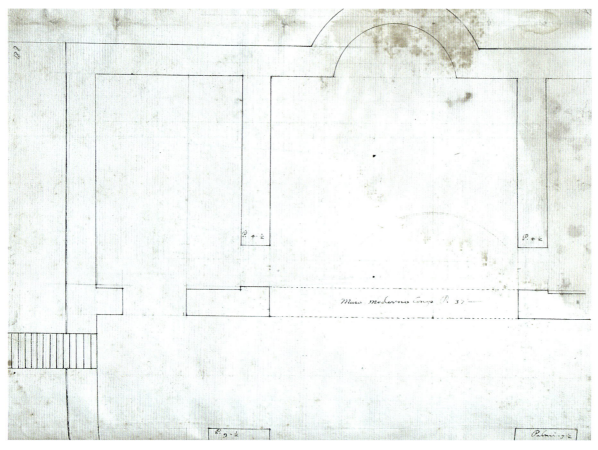

5 Plan of the structure (Santa Maria Antiqua) excavated in 1702, from MS 32 of the Passionei fonds, fol. 188ʳ (Fossombrone, Biblioteca Civica Passionei)

topics relevant to the dissertation, intended to assist in determining the ancient location of the church, its name, builder, users, historical context in the Forum in antiquity, late antiquity, and the Middle Ages, as well as to explain iconographical, art historical, and theological aspects of the murals. Thus we find information on such varied topics as the Roman temples in the Forum (fol. 105ʳ), the churches of Rome in late antiquity and the Middle Ages (fols 96, 105ᵛ), images of the saints depicted in these churches (fols 56–7), the Via Sacra (fols 19–26), the Forum (fols 44–7), Iconoclasm (fol. 75ʳ), the history of the Church (fols 12–13, 15), liturgy (fols 64–5), and more, including a list of the popes buried at the Vatican (fol. 106ᵛ).

In 1705, after three years of research, Passionei began to write the introduction to his dissertation in a more refined hand (fols 140–43ʳ; Figure 6). Unfortunately, he stopped at the fourth point of his planned *Partitio*, having frequently interspersed his description of the monument with erudite digressions in eighteenth-century style. The full text follows:

[fol. 140ʳ] Anni tres sunt, cum in ea parte Palatini montis, quae ad orientem vergit studio eorum, quibus maxima cura est, ex veterum aedificiorum nimis magno eruditorum bono statuas, marmora, toreumata exuere, cuiusdam templi parietes detegi coeperunt. Egesto ergo, qua obruta diu iacuerant rudera, huius interiorem faciem, sacris ornatam picturis conspeximus, quam ne temporis iniuria vel quod caput

Folio 140ʳ from MS 32 of the Passionei fonds, with the incipit of Domenico Passionei's dissertation on the church
(Fossombrone, Biblioteca Civica Passionei)

est, hominum negligentia intercideret, delineandam curavimus. Parietum lateralium crassitudinem quattuor fere palmorum, latitudinem septendecim, altitudinem viginta octo sedulo inquirentes deprehendimus; omnia haec lateritia sunt, quapropter alicui hac in Palatino considerandi facile occurreret illud Baronis,[21] quo antiquos Romanos domibus lateritiis habitasse docuit, et praeclarum Augusti effatum, quo gloriabatur Romam marmoream reliquisse, quam lateritiam accepisset.

Quanto olim in pretio essent lateritia aedificia ostendit Vitruvius lib. 2 cap. 8, qui magna potentia Reges non contempsisse testatur structuras lateritiorum parietum, imo cum detecti huius monumenti parietes pavimento proximiores metirer (quos olim fuisse veteris Palatii, vel cuiusdam templi reliquias ipse quodammodo Palatinus Romanorum aedificationibus celeberrimus ostendit) animadverti non ea lege extructos fuisse, qua olim sancitum erat apud Vitruvium ne crassitudines maiores, aut minores in privatis aedibus constituerentur, de qua re recte disputat Brissonius[22] in Selectis ex Iure [fol. 140ᵛ] Civili antiquitatibus lib. primo capitolo primo, unde hic nobis facilis agi, quisque consulat, aperiretur via, praevio illorum temporum usu et certa veteris architectonica regula ad dignoscendam operis vetustatem ne animum ingeniumque averteret perturbatus maiorum ordo, quam nova aedificia veterum reliquiis extructa praecipue in hoc monte induxerunt. Ne quid vero desit industriae, et labori nostro, quae in laterum figura observavimus, exponere operae praetium putamus, multos siquidem lateres, spe aliqua inveniendi consulum nomina, in quibus aliquando adnotabantur, omni cura et diligentia inspexi, usus enim figlinarum nec parvi momenti apparet in fastorum emendatione, vacuus attamen labor, quippe tantum nomina figulorum inveni, ut L. Sextilii Rufi, cuius mentio adest apud Fabretti Collectionem cap. 7 n. 326 in aliis vero nullum figulinis nomen apparet, quod semper non apposuisse certum est, aliud lateris fragmentum exhibebat Cn. Domit. quod supplevi arbitror ex alio a me in loco quodam impluvio prope S. Susannae Ecclesiam inspecto, nempe.

Opus dol[iare] ex figl[iniis] Cn. Domit. et duos quaquam versum habebat romanos palmos, huiusmodi mensurae aliud [fol. 141ʳ] aliud a Baronio in praetermissis tomi 3 Annalium editionis Romana in medium producitur in fundamentis Basilicae veteris S. Petri repertus, qui didoron ab ipso appellatur, at Magni istius viri pace dixerim, haec mensura nostris duobus palmis nomine licet, re tamen respondere non potest; doron enim Vitruvio lib. 2 cap. 3 palmus est, et hic libro 3 cap. primo quattuor digitorum, nam perperam quinque digitorum constituit Robertus Cenalis in notulis ponderum, quas in fine libri de vera mensurarum ratione oculis subiecit. Quomodo ergo et si doron vitruvianum geminetur, aequabit spatium duorum palmorum, quibus hodie nos utimur, et constare vidimus Baronianum, et Nostrum. Minime hic ideo audiendus est Salmasius in exercitationibus Plinianis tom 2 pag. 869 editionis ultimae, qui lectionem vitruvianam in qua lib. 2 cap. 3 exhibet didoron fuisse longum pede, latum semipede, suspectam putat, et Lydium loco didoron in medium proferrens nulla veterum auctoritate ductus statuit pro ingenio didoron octo pedes habere, haec tantum indicasse sufficiat, cum huius viri maximi (extens quin) nominis sententiam

abunde reiectam censemus ex iis, quae habet Johannes de Laet [fol. 141ᵛ] in suis observationibus ad lexicon vitruvianum Bernardini Baldi Antuerpia editum. Sacrum hoc monumentum extat a tergo Ecclesiae S. Mariae Liberatricis ac vero humilius iacet, quod ex fastigio interioris illius prospectus qui integer adhuc remanet, aperte deprehendi, plures quisquis descendat gradus oportet ante quam ad pavimentum deveniat. Fossorum enim industria factum est, graviori sumptui, et labori parcentium, ut a culmine fossionem inchoarent, qua propter nisi per ruinarum rudera per scalas veluti ad imum usque pervenire licet; facile autem mihi persuadeo populos tempore, quo edificatum fuit templum quoque descendendo intrasse nam imam partem passim sic detectam unde omnis altitudinis notio certo habere potest, et conterminam Boari Campi planitiem spatium 10 fere palmorum altitudinis intericitur. Attamen de hac re iudicium valde dubium, et sanis quaecumque adhiberi potest animadversio, aedificia enim, quae elapsis saeculis extructa sunt, atque iniuria temporum paula[tim?] ordinem perturbaverant, iacet a dextro latere, quod vergit ad Septemtrionem, S. Theodori Martyris ecclesia olim inq. [?] Diaconias numerata, quam non ita providet ea pietate, qua antiqua Patrum [fol. 142ʳ] nostrorum monumenta respicit Summus Pontifex Clemens XI collabentem restauravit, quamque peculiari dissertatione illustrabit Joannes Vignolius rerum Romanarum Scientissimus; miror tamen recentem quemdam scriptorem, qui hanc ecclesiam inter diaconias ab Hygino institutas fuisse asserit, postea vero saeculo VI idolorum, quibus hic honor erat, cultu sublato Gregorium Papam Divo Theodoro consecrasse; quid Higini in diaconiam institutio 2° saeculo, sexto vero semper aevi numinibus dicata esset in S. Theodori ecclesiam Gregorii consecratio? A tergo surgit, qua occasum spectat S. Anasthasiae ecclesia aevo sequiori in Palatio dicta, ut docet notitia Urbis in Mabillonianis Analectis tom. 4. Ab occidentali parte habet Hortos Farnesianos statuarum copia illustres et vel ipsis imperialis Palatii ruinis Romana redolentes maiestatem. Descriptis huc usque Ecclesiae finibus inquirendum esset de via, quae olim in nostram hanc Ecclesiam patebat, hanc hodie definire difficile erit viarum nominibus a proximis temporibus confusis, mutatisque, siquidem loca, quae detecta visitur Ecclesia stetisse olim Augustorum Palatium omnibus notum est, atque testatum, qua propter si de [fol. 142ᵛ] veteri via nobis sermo esset, Clivi sacri, unde quirites petebant, descriptionem aggrederemur, quam inanem et si ne causa suscipiendam hic arbitramur ea tamen mihi mens est templum septimo, vel octavo saeculo, quo exaedificatum fuit, ad Boarium Campum pervenisse, et facilis pateret aditus collapsis ibi, quae celeberrima olim suspiciebantur aedificia, hisce nempe saeculis horum, aliorumve magnificentiam paene attritam deprehendimus, haec numquam satis deploranda evincitur ex libri tertii Variarum Cassiodori epistula 31 editionis Paresii, quam scribit Theodoricus Rex Senatui Urbis Romae, ubi in medio haec habet = templa etiam et loca publica, quae petentibus multis ad reparationem contulimus subversioni potius fuisse mancipata cognoscimus; hic locus male acceptus fuit a Gotofredo in notis ad librum decimum quintum Codicis Theodosiani titulo primo edicto 36; quem credo ex edicto Imperatoris Asterio comiti Orientis lato errorem hausisse, ubi materia demolitionis templorum deputatur reparationi viarum, Pontum, et Aquaeductuum, Theodorici enim Epistola ut verba ipsa sonant templa ad reparationem, non ad

[fol. 143ʳ] ad destructionem concedit, quod falso contendit Gotofredus. Minime hic etiam praetereundus est Gregorius Magnus, cuius testimonium plurimum favet, et legitur in libro secundo homilia decima nona super Ezechielem = Conspicimus, inquit, Romam immensis doloribus multipliciter attritam desolatione Civium, impressione hostium, et frequentia ruinarum = Reliquum est, ut extremo loco observemus huius aedificii frontem orientem spectare more iamdudum apud Crispianos recepto, cuius rei vestigia auctores colligunt ex Constitutione quinquagesima septima, quae Clementis nomine circumferuntur, quibus adde Patrum testimonia allata a Menardo in notis ad sacramentale Gregorianum pag. 69.

After having located the discovery in both time ('anni tres sunt') and space ('in ea parte Palatini montis, quae ad orientem vergit'), and indicated the intention of his study ('Egesto ergo, qua obruta diu iacuerant rudera, huius interiorem faciem, sacris ornatam picturis conspeximus, quam ne temporis iniuria vel quod caput est, hominum negligentia interciderit, delineandam curavimus'), Passionei reports the dimensions of the sanctuary murals 'accurately' ('sedulo inquirentes deprehendimus'), with some reference to the plan. Here, however, there is some confusion, probably the result of writing three years after the discovery. He records the thickness of the sanctuary walls as 4 *palmi* (*c.* 90 centimetres),[23] the width of the space between them as 17 *palmi* (*c.* 3.75 metres), and the height of the ruined structure as 28 *palmi* (*c.* 6.15 metres). But those last two measurements are clearly wrong: the sanctuary is almost square-shaped (8 by 7.10 metres), and the structure reaches a height of about 12 metres.[24] He seems to have switched the width (*latitudo*) with the height. In fact, if we look at fol. 34, containing notes made at the time of the excavation, we find the figure reported for the width to be 38 *palmi* (*c.* 8.30 metres), and the height as 17 *palmi*, closer to the actual dimensions, even if the last figure is still much too low. Although Passionei records here only the measurements of the sanctuary, the 1702 excavation covered in fact a larger area, including parts of the two side chapels, those of Theodotus and the Holy Physicians, and also the southern part of the quadriporticus, as shown in the plan on fol. 188ʳ (Figure 5). Here Passionei records once again the measurement of the thickness of the sanctuary wall, but as 4.5 *palmi* (almost 100 centimetres), and also the width of the southern piers of the quadriporticus, some 9.5 *palmi* (*c.* 210 centimetres)

At this point Passionei turns his attention to the brickwork, showing an understanding that the original structure dated to the Roman era, and hypothesising that the remains must have belonged to the imperial palace or a temple ('quos olim fuisse veteris Palatii, vel cuiusdam templi reliquias'). But then he pushes even further, offering—perhaps for the first time in history—an extraordinarily modern account of the archaeology of the site and the stratigraphy of the walls, thus anticipating by almost two centuries the debate on this topic. His goal was to date the building ('ad dignoscendam operis vetustatem') through a study of earlier techniques and established architectural precepts ('praevio illorum temporum usu et certa veteris architectonica regula'), so that the original, '*perturbatus*' by '*nova aedificia veterum reliquiis extructa*' would not lose its '*animum ingeniumque*'. To this end he made an effort to seek out with due care and diligence ('omni cura et diligentia') those building tiles which bore brick-stamps naming consuls or potters; among these he cites in particular the stamp of 'L. Sextilius Rufus',[25] for which he provides a bibliographic reference to Fabretti's *corpus*, and a fragment of another

stamp of a 'Cn. Domit.',[26] which he compares to a similar stamp that he had seen previously near the church of Santa Susanna ('in loco quodam impluvio prope S. Susannae Ecclesiam')

Folio 141[r] is entirely devoted to an erudite digression on the metrology of Roman tiles, and then at the beginning of fol. 141[v] Passionei goes back to a description of the monument, indicating its position ('extat a tergo Ecclesiae S. Mariae Liberatricis') and its level with respect to that church ('humilius iacet'). This detail contextualises the excavation method employed by the *fossores*, who chose to dig downwards from the highest point, to save money and effort ('graviori sumptui et labori parcentium'). This detail indicates that the 1702 excavation likely resembled a deep pit opened behind the church of Santa Maria Liberatrice, with walls almost ten metres high on each side—and consequently at risk of collapse. Valesio's view (Figure 1), which shows the left side and end walls of the sanctuary, should therefore be considered misleading, in that it seems to suggest a much larger opening into the north side of the Palatine Hill, whereas towards the Forum it suggests that the earth had been removed in a sloping fashion and not, as Passionei mentions, in a vertical section. Passionei then goes on to locate the position of the structure in relation to other existing buildings, indicating the church of San Teodoro ('a dextro latere, quod vergit ad Septentrionem'), the church of Sant'Anastasia ('aevo sequiori in Palatio dicta […] a tergo surgit, qua occasum spectat'), and on the west side ('ab occidentali parte') the Farnese Gardens with their collection of antique statues ('statuarum copia illustres et vel ipsis imperialis Palatii ruinis Romana redolentes maiestatem')

Having established the location of the building, Passionei then tackles the issue of the road above it, highlighting the problems created by the passage of time and the consequent changes in street names, but emphasising what was well known thanks to documentary evidence, that this was the site of the imperial palace ('Augustorum Palatium'). He speculates that the recently excavated *templum* had been constructed in the seventh or eighth century CE, that it extended to the Forum Boarium, and that there was an easy point of access between the ruins of more ancient structures ('et facilis pateret aditus collapsis ibi, quae celeberrima olim suspiciebantur aedificia'). In support of this idea he looks to Theodoric's Letter 31, included in Cassiodorus' *Variae*, in which the Ostrogothic king states a preference for restoring ancient temples and public edifices rather than letting them decay ('templa etiam et loca publica, quae petentibus multis ad reparationem contulimus subversioni potius fuisse mancipata cognoscimus')[27]—thus implicitly rejecting the generally accepted interpretation of the passage by the editor of the Codex Theodosianus, Jacques Godefroy, who had questioned its authenticity.[28]

Folio 143[r] ends with the mention of a homily by Pope Gregory I, cited in support of Passionei's own views. This brings to a close the part of the dissertation that received a final editing by the author prior to its intended (but never realised) publication. The sections that he had planned to devote to a decription of the paintings, their theological interpretation, and to a historical reconstruction of the building were never revised and therefore never integrated into the first part of the dissertation. These texts survive in various stages of completion, and today it is not possible to judge with any precision which of them were intended to be included in the final book. They are nevertheless of enormous interest, and provide a wealth of information on what was visible at the time—and hence what has been lost between then and Boni's 1900 excavation. They also offer precious insights into the author's reception of the content of the murals, their symbolism, and historical events related to the history of the site.

Folios 101–3ʳ are dedicated to a description of the murals on the end wall of the sanctuary. Moving from top to bottom, Passionei describes the upper section of the wall with the scene of the *Adoration of the Cross*, datable to the time of Pope John VII (Figure 2; Plates 33, 50: K1.2).[29] He details with precision the mystical angelic host flanking the *Crucifixion*, describing elements such as their wings and the rays of light, and especially their clothing: the mantle ('amictus'), purplish for one group and white for the other, and a completely closed chasuble ('nullibi aperta est'):

> misticis hisce figuris caelestis Angelorum: coetus succedit, mysticas hasce figuras excipit et utraque parte celestis quaedam multitudo, quam silentio propterea praetermittendam non censemus atque cum suis distinguatur insignibus ornamentis; cuique enim alae insunt, […] praeclaro sanctitatis signo illustratur, et huic rei sunt indicio, ut creditum est, radii undique erumpentes, quorum splendore […] hoc diadema efformatur: pars violaceo amictu induta est, albo pars altera, neque, quem casulam denotare evidens est, universum enim aperuit corpus, et nullibi aperta est.

After a brief discussion of the types of clerical robes available in the centuries immediately before and after the year 1000, which he considered useful for dating the painting, Passionei moves on to describe the centre of the composition: the figure of the crucified Christ flanked by Mary and Saint John the Evangelist. In 1702 this part of the mural was better preserved than it is today (Plates 33–4) or at the time of Boni's excavation, as demonstrated both by Valesio's watercolour and, even more clearly, by the one included in Passionei's manuscript on folio 184ʳ (Figure 2). By 1900, the figure of Mary, the lower parts of the bodies of Christ and Saint John, and all the left side of the *Adoration of the Cross* had been completely lost.

However, since it is an example of a 'mirrored' composition, what is no longer extant can be easily reconstructed. Although not stated explicitly in the description, the drawing on folio 184ʳ reveals that Christ did not wear a *colobium*, as de Grüneisen had conjectured based on Valesio's sketch, and perhaps also on the basis of the *Crucifixion* in the Chapel of Theodotus.[30] Rather, Christ is naked apart from a loin-cloth (*perizoma*), as proposed by Gordon Rushforth, Joseph Wilpert, and Per Jonas Nordhagen.[31] Passionei's watercolours are not exact copies of the paintings; they are sketches, probably executed in some haste and in less than ideal conditions (for example for lack of scaffolding). Their importance, therefore, lies above all in the reconstruction of the overall composition, and not as a record of specific details. This is very evident in the treatment of the figure of Christ: in the watercolour the head is turned to the side, with long hair falling down to the shoulders, and he has a long beard and the crown of thorns, when in fact we now know that Christ looks straight ahead, has short hair and a beard, and there is no trace of a crown.[32] Similarly, the face of Saint John Evangelist, which in reality is turned towards Christ, in the drawing looks out at the viewer.

On fol. 101ᵛ the abbot addresses the subject of Christ's cruciform nimbus, making a useful and remarkably modern comparison with the apse mosaic in the church of San Vitale in Ravenna. He also cites a source where this image was reproduced: the most important of the works of Giovanni Ciampini, at the time the most advanced study of its kind, *Vetera Monimenta*

in quibus praecipue Musiva Opera sacrarum profanarumque Aedium structura ac nonnulli antiqui ritus, dissertationibus, iconibusque illustrantur (1690):

> Hanc inter Angelorum multitudinem stat Christus cruci affixus et prope crucem mater eius et discipulus, quem diligebat, uterque pallio vestitus, tamen non est, quod in harum figurarum explicatione tempus teramus. Christi caput orbiculari diademate redimitum est, […] Ecclesiae S. Vitalis Ravenna inter Musiva Ciampiniana pag: 68 tab: XVIII.

At the beginning of fol. 102r Passionei continues the description, mentioning the sun and the moon at the sides of the composition, and the multitude of the angelic host beneath. He proposes to explain the presence of the angelic host in the next chapter with reference to the Greek inscriptions.[33] He also makes another reference to Ciampini, namely the 'antiqua cruce stationali' with the crucified Christ at the centre, flanked by Mary and Saint John, and two stars above the arms of the cross. This is the so-called 'Constantinian Cross', laminated in gilded silver, dating from the thirteenth century and preserved in the museum of the Basilica di San Giovanni in Laterano. Always proceeding from top to bottom, Passionei then mentions, without going into any detail, the crowd beneath the Cross ('confusa hominum turba'), which he considers symbolic of the human race redeemed by Christ's blood.[34] He finally comes to the images of the popes flanking the apse: on the right side, Saint Martin and Pope Gregory I, the former with a purplish chasuble and the latter with a yellow one. Both wear the ecclesiastical *pallium*, so Passionei discusses it, repeating verbatim a passage from the *Life* of Pope Gregory I by John the Deacon:

> A latere dextrorsum sol, luna sinistrorsum apparet, de quibus inscriptio Graeca capite sequenti explicanda nonnulla habet; hi duo Planetae simili modo dispositi in antiqua cruce stationali a Ciampino exhibita tom: 2 pag: .48 tab: X observantur. Visitur postea confusa hominum turba, quam humanum genus pretioso Christi sanguine redemptum denotare mea fert opinio non sine causa, ut infra declarabitur. Postremo considerandae occurrunt Romanorum Pontificum imagines, eorum scilicet, qui vel fama sanctitatis vel doctrinae laude ad histam dignitatem adeo adepti sunt. A laeva, quae apud Graecos dexteram partem excellentia antecellit, stant S. Martinus et S. Gregorius Magnus hic violacea ille flava vestitus casula, pallium in utroque conspexeris, nobillissimum Ecclesiae dignitatis insigne quod (ut narrat doctrinis Diaconus in vita S. Gregorii M. cap: 14 lib: IIII) a dextero videlicet humero sub pectore super stomachum circulatim deducto deinde sursum per sinistrum humerum post tergum deposito, cuius pars altera super eundem humerum veniens, propria rectitudine non per medium corporis, sed ex latere pendet.

Folios 102v–3v are all dedicated to the *pallium*, to its liturgical significance and to the difference between the Greek and Latin versions, with quotations from a variety of sources: *De Inferioris aevi numismatibus* by Du Cange (1610–88); *De Sancti Gregorii eiusque parentum imaginibus*, composed by the founder of the Biblioteca Angelica, Angelo Rocca (1545–1620); and the *Annales*

7 Folios 119ʳ and 122ʳ from MS 32 of the Passionei fonds, with the transcription, partially in cursive font and completed in capitals, of the main inscription on the apse wall (Fossombrone, Biblioteca Civica Passionei)

ecclesiastici of Cesare Baronio (1538–1607). Halfway down folio 103ᵛ the text breaks off.

The main inscription on the end wall of the sanctuary, below the multitude of the faithful, is addressed in part on folios 119ʳ and 121ʳ, which appear to be working drafts, and again on folio 122ʳ, which is probably the original transcription made on site (Figure 7; Plate 33).[35] Passionei was thus the first to transcribe and translate the inscription, and to identify the biblical quotations: Song of Songs 3.11; Zacharias 9.11 and 14.6–7; Amos 8.9–10; Baruch 3.36; John 19.37; and Deuteronomy 28.66 (fol. 133ʳ). Following Boni's excavation, the inscription, which was unearthed on 22 March 1900, was probably transcribed by the excavator himself (as indicated by his notes, published years later in Eva Tea's book), and then translated by the Archimandrite of the abbey of Santa Maria di Grottaferrata, Father Antonio Rocchi.[36] Invited to undertake this task in a letter of 28 March, Rocchi submitted the translation to the Director General, Carlo Fiorilli, on the following 2 April.[37] But the first to publish it was Orazio Marucchi in that same year, and his transcription also included notes indicating the biblical sources, although omitting the reference to Deuteronomy.[38]

The description of the end wall of the sanctuary is completed on fol. 118ʳ, filled with notes and miscellaneous comments distributed over two columns: on the left, bibliographical references (in square frames) and biblical quotations, and on the right actual notations in Latin and Italian, which seem to have been written at the site. Following a reference to the Palatine and the Farnese Gardens ('Ne tempi dell'impero, il Palatino fu il più celebre e riguardevole,

sono oscuri i suoi siti per le coltivazioni degli horti farnesiani. Nardini: pag: 378')[39], under a solid line, from top to bottom we read:

> Post ovatam Angelorum figuram venit ornamentum; post ornamentum acies picturatae:
>
> Post imaginem Salvatoris alia pictura videtur, praecipue manus, et post hanc non alia videtur pictura.
>
> Salvator insidet basi gemmis ni alteri distincta.
>
> Post sanctos Patres in utroque latere spatium parvum rubeum in quo sunt litterae:
>
> In una Sanctae Genetricis;
>
> In alia fere nihil conspicitur
>
> Post hanc sequitur Graeca scriptura exesa
>
> S. August: habet eadem calceamenta ac habent PP supra ipsum

Following a further line of separation there are two more sentences, this time in Italian:

> Nelle due facciate laterali alla detta tribuna vi sono le immagini di San Gregorio I e di San Martino I dalla parte sinistra con i loro nomi attorno al capo;
>
> Dalla parte destra v'è San Leone II e l'istesso Paolo I, che ha intorno al capo tanto in questo luogo quanto nella tribuna il diadema quadrato.

As is also the case elsewhere in his text, Passionei uses the Latin *post* to mean 'below', listing in summary fashion the subjects of the paintings on the wall from top to bottom, beginning with the host of jubilating angels ('ovatam Angelorum figuram'), then the *ornamentum* (possibly the lengthy Greek inscription?) and the crowd of the redeemed ('acies picturatae'). At this point the young abbot focuses on the images in the apse, datable to the pontificate of Pope Paul I:[40] Christ seated on a jewelled throne, and below him other images not easily discernible, including a hand, no longer extant but readily visible in the watercolour on fol. 183ʳ, in connection with the body of the Redeemer (Figure 3). Worthy of notice here are two fingers from an open left hand, probably belonging to the Virgin who stands by Christ's side. The Virgin's right hand rests on Paul I's shoulder, while her left arm gestures towards her son, in the typical attitude of presentation attested in other churches in the city, for example at Santi Cosma e Damiano.[41] There, Saints Peter and Paul introduce the holy *anargyroi* (literally, 'without silver', a name applied to saintly physicians who did not charge for their services) to Christ, whereas in Santa Maria Antiqua it is the Virgin who presents Paul I, an iconography not encountered previously, nor again thereafter.

Passionei devotes other pages of notes to the apse, fols 114–5, but these are difficult to

decipher. They deal with the tetramorph cherubim and seraphim above the *Crucifixion*. There are biblical references to the prophets Daniel and Ezechiel, and art historical comparisons to published mosaic images, again drawn from Ciampini:

> Cum nostram de hac monumento sent[ent]iam iam igitur exposuimus, eo tandem devenimus, quo aggredi oportere iubemus explanationem ornamentorum, quibus parieti exornantur, quapropter ne haec Christianae picturis insignia vel temporis iniuria, vel quod valde simendum hominum iniuria perirent, exprimi curavimus in hanc tabulam referri invenimus, quam fideliter descriptam hic exhibemus, primum ergo nobis illustrandi occurrerunt Seraphim, qui initio huius tabulae et in abside apparent depicti. [...] quo sacrarum aedium muros huiusmodi imaginibus decorabantur, verum qui, ab Ezechiele et Daniele exprimuntur, in musivis (et cap: X) a Ciampino editis non vano conspiciuntur.

Passionei discusses the peculiar nature of these angelic creatures, characterised by bodies entirely covered with eyes ('Alae eorum splendidissima oculis refertae collucent, quomodo ab Ezechiele cap: 1 describuntur, [...] et colla, et manus, et pennae plena erant oculis'),[42] human hands, and seemingly bovine feet with fires burning beneath ('manus etiam hominis sub pennis eorum [...], planta pedis eorum quasi planta pedis vituli, et scintillae quasi aspectus aeris ardentis'). The tetramorphs in the apse are further distinguished by their four faces—man, lion, ox, and eagle ('eorum facies, hominis, Leonis, Bovi et Aquilae desuper, pennae eorum expertae desuper duae pennae cingulorum iungebantur, et duae tegebant corpora eorum')—symbolising the four evangelists ('Haec symbolica animalia ex consensu fere omnium Patrum Evangelistas designant').

On fol. 118ʳ, after a brief mention of the apse, Passionei moves to the subject of the side walls. Below the images of the Church Fathers on both sides, he records a small red band with a painted inscription: one side reads 'Sanctae Genitricis', while the other side is not legible. This is obviously the dedication to the Mother of God from the time of John VII (Plates 41, 50: K1.3),[43] placed below the Church Fathers and above the fictive curtain (*velario*), which Passionei transcribes accurately on another folio of handwritten notes (117ʳ) as follows: 'SCAE DI GENETRICI SEMPER [-----]NIS MARIAE'. This documents the lacuna that already existed (limited to the first five letters of the word *Virginis*), but is now more extensive, and he adds that the letters were painted in white, like those in the Greek inscription on the wall above ('Haec scripta sunt in rubro albo colore, sicut inscriptio Graeca').[44] Wilpert maintained that the inscription on the right side should be associated with the name of the papal donor, Pope John VII, but unfortunately there is nothing in our manuscript to support such a hypothesis.[45] Rather, on fol. 83ʳ Passionei suggests that the inscription was the same on both sides, and in his view this confirmed the dedication of the church to Mary ('An vero quod Sanctae Mariae dicatum esse, plane quodamodo fecit indicatio inscriptio haec, quae a utrisque duo lateribus visebatur, albo colore exarata; Sctae DI GENETRICI'). There follows the mention of another Greek inscription, very damaged ('post hanc sequitur Graeca scriptura exesa'), again in white letters on a red ground, which might be the one underlying the conch of the apse, to the right of the *Pantocrator*, executed in the middle of the seventh century and then covered around fifty years later by John

VII's redecoration. This has been interpreted as an accurate quotation from Isaiah 26.12.[46]

Closing the Latin section on folio 118ʳ is a sentence mentioning the image of Saint Augustine, depicted on the left side of the apse and identified by an inscription, as seen in the watercolour on fol. 184ʳ (Figure 2; Plate 35). Passionei notes that Augustine wears shoes of the same type ('eadem calceamenta') as the other popes depicted on the wall above, and takes this as a relative chronological indication. On this basis he assigns the figure to the same phase, now attributed to the campaign sponsored by John VII (705–7).[47] As stated previously, he records the names of these other popes in Italian beneath the Latin, after a separation line: to the left, Leo II and Paul I, and to the right Gregory I and Martin I. While there is no doubt about Martin I, given the identifying inscription, the other identifications raise questions. Passionei himself had no doubts about them, so it is possible that he had some evidence that has not come down to us, primarily the painted *tituli*. These must have been much better preserved in 1702 than they are today, as was the case for the figures shown on fol. 184ʳ: the two popes closest to the apse, in particular, were still almost completely visible and thus the young abbot would have had no difficulty identifying them. This applies to Gregory I, to the right of the apse, beside Pope Martin. Today only the letters 'PP ROMANUS' remain, between the figure and Martin, while the part of the inscription to the left, showing his name, has been lost, along with the saint's head; but on fol. 184ʳ we can see that this missing portion was still well preserved. There have been two possible identifications proposed in recent scholarship: Gregory I, suggested by Wilpert, Tea, and Bordi; and more recently Pope Agatho, suggested by Jean-Marie Sansterre and supported by Andrew Ekonomou and Bordi.[48] But now the evidence from Passionei would appear to support the initial suggestion of Gregory I.

A reading of the inscription accompanying the first pope on the left side of the apse probably lies behind Passionei's identification of Pope Leo II (682–3), a possibility also recently proposed on solid grounds by Bordi.[49] Previously, the names of Sylvester and Leo I had been suggested, the latter following Nordhagen's reading of a few letters.[50]

The identification of the pope at the far left as Paul I is somewhat different, as in reality it has been demonstrated that he is John VII, and thus we must suppose that the *titulus* had already disappeared in 1702.[51] Passionei was probably led into this error by the presence of a square nimbus, indicating that the pope was alive at the time of the painting, which he compared to the papal figure in the apse, Paul I, shown in a similar fashion. It was his belief that Paul I was the founder of the church, and he did not discern any stylistic difference between the murals in the apse and those on the side walls.[52]

Further details concerning what Passionei was able to observe can be gleaned from an examination of the watercolours included in the dissertation, particularly fol. 184ʳ (Figure 2). Below the four popes on the side walls flanking the apse we find figures of the Church Fathers: to the left appears part of the head and the complete *titulus* of Saint Augustine, although the rest of the figure did not survive; and to the right, on the 'palimpsest' wall (Plate 37), the complete head of the first figure, Gregory of Nazianzus, and part of the second, Basil of Caesarea, both identified by inscriptions that still survive (Plates 38–9). From what can be discerned from the watercolour, nothing was then visible of the scene of the *Aurum Coronarium*, as this was hidden underneath the layer with the Church Fathers. But above them we can distinguish the heads of Mary and the so-called *Angelo Bello* from the *Annunciation*, dating from the last third of the sixth

century and considered to be a prime example of 'perennial hellenism'.[53] This superimposing of images demonstrates that Passionei was aware that he was dealing with a case of diachronic stratification, even if he could not be precise about the details, given the short time at his disposal and the difficulty of getting close to the murals. As indicated also in Valesio's drawing, the level of the heads of the Church Fathers corresponds to the furthest penetration of the 1702 campaign. Nothing in Passionei's manuscript suggests that the excavation continued any deeper, and thus the floor of the church was never unearthed. This same conclusion was also reached at the time of Boni's excavation, from the various findings on the floor itself, including John VII's pulpit.[54]

There is nothing in fol. 184ʳ that can assist us in resolving the issue of the band below the multitude of the redeemed in the scene of the *Adoration of the Cross*, as this strip of plaster was already lost in 1702. Grüneisein's hypothesis that it featured a procession of lambs, and most recently Folgerø's alternative proposal that it depicted the dead rising from their graves, both remain possible.[55]

One other important addition to our knowledge comes from the watercolour on fol. 187ʳ, depicting the heads of the Madonna and Child framed by a Greek inscription 'Η ΠΑΝΑΓΙΑ [ΘΕΟΤ]ΟΚΟC' ('The Holy Mother of God'), now completely lost (Figure 4). Mary wears a blue mantle over a red gown, and holds the Child with her right arm; he has a cruciform nimbus. Passionei devotes only few lines to this image (fols 85ʳ, 117ʳ), but these are important for determining the nature of the image and its original position within the sanctuary of the church. On fol. 85ʳ he mentions the existence of the mural depicting Mary, and discusses the fragmentary remains of the identifying inscription: 'praetereundam minime censeo epigraphem, quam in parieti sinistro cuidam Virginis imaginuncula prefixa, legebatur, ΟΚΟC, parvas enim altera huius nominis in dextera erat, idest ϑεοτοκος ηπαναγια, Dei Mater Sanctissima, qui adeo celebris fuit 4 saeculo ob heresiam Nestorianam'. On fol. 117ʳ, the subject is again addressed with a page of first-hand notations already cited in connection with the Latin inscription to the right of the apse: 'Notandum est, quod in superiori parte templi, ubi videtur multitudo populi, subter nulla alia videtur pictura, si ubi in aliis locis et praecipue in uno, ubi quinquies iconata conspicitur. In iconae Virginis Mariae a parte sinistra post Apostolos haec habentur ΟΚΟC ΗΡΑΝΑGΙΑ; quod littera superior in ΟΚΟC deperdita est.'

This *imaginuncula* of the Madonna and Child was situated on the left or east wall of the sanctuary, towards the Chapel of Theodotus: but where exactly? On the same sheet Passionei records that no painting was visible in the upper zone ('in superiore parte templi') below the multitude of the faithful, but that in other places there were five images ('quinquies iconata'). These 'icons' in all likelihood were the scenes from the life of Christ painted in the time of John VII on the side walls of the sanctuary, at the same level as the four popes on the end wall. There were ten such panels on each side, divided into two registers of five scenes. That the side walls were uncovered in 1702, and the Christological scenes exposed, is also confirmed by Valesio's drawing. Passionei continues at this point to discuss the east (left) wall (Plates 45, 50: K2), stating that the icon of the Virgin was situated 'post Apostolos', and thus, given his use elsewhere of this preposition, presumably beneath the heads of the John VII apostles, which in turn were just below the Christological scenes. At this very point, in the centre of John VII's fictive *velum*, the presence of an image of the *Mother of God with the Child*, on a blue ground, with Christ having a cruciform nimbus, is recorded by Tea who also records some visible letters of

a fragmentary inscription: ΑΓΙΑ.[56] It seems to me that both references are to the same image of Mary and the Christ Child, given the coincidence of their position and description. Today only three letters remain from the left part of the inscription, painted in white on a blue ground, the last part of the word *haghia* ('holy')—but at the time of Boni's excavation more were preserved, as recorded by Tea and Rushforth, and above all in Wilpert's watercoloured photograph (Figure 8).[57] Here one can observe still in place parts of Mary's head and halo, her clothing, part of the Child's cruciform halo, and all four letters of *haghia*. This image of the *Theotokos*, given its position at the centre of the *velum* into which it has been inserted, should be considered contemporaneous, from the time of John VII. It is not possible to determine whether there was a corresponding image on the west wall of the sanctuary, 'in a dialogue' so to speak with this one, given the fragmentary nature of the plaster in that area (Plates 42, 50: K3). Immediately below, 88 centimetres above the floor, there is a small rectangular niche, perhaps used to house relics.[58]

Turning now to the plan of the building on fol. 188ʳ (Figure 5), we can glean further details regarding the extent of the 1702 excavation. This revealed the entire length and width of the sanctuary, on the north side reaching up to the piers of the quadriporticus. On the right side, the plan stops at the Chapel of the Holy Physicians, possibly because the edge of the folio had been reached, or perhaps because the excavation did not extend further west. On the other side, however, the sheet includes almost all of the Chapel of Theodotus, although no description of that space or its decorations is included in the manuscript. Given the nature of the 1702 excavation, we can suppose that only the uppermost parts of the walls of that chapel were exposed, given the disappearance of the roof, as well as part of the access doorway to the sanctuary, just slightly below the architrave.

On the left part of the folio, corresponding to the southern corner of the eastern aisle of the quadriporticus, there is an indication of a sixteen-step staircase connecting Santa Maria Antiqua to the Domitianic Ramp. This staircase still exists, but access to it has been walled up.[59] It leads to what was probably a latrine, the date of which is controversial but which seems to belong to the era of the Emperor Hadrian.[60] We know that the staircase came to light in 1702 and that Bianchi removed a few of its travertine steps. It was this action that resulted in the encroachment on the property of Duke Francesco Farnese, leading to the lawsuit reported by Lanciani.[61] It is very likely that the eighteenth-century excavation reached the floor of the building, at least up to the the point where the door led to the marble staircase, while elsewhere it remained more shallow, as the watercolours by Valesio and Passionei attest. Recent studies suggest that the staircase was built under Domitian, or at the latest at the beginning of the second century, but the access was blocked later on—certainly by the seventh century, if not earlier—when it was covered with murals (Plates 10, 23, 50: D1).[62] In Passionei's time the opening must have certainly existed, and the passage to the staircase must have been accessible. Its uncovering may have been undertaken by the same Andrea Bianchi in his search for the travertine steps. This irregular opening was certainly there in Boni's time, as shown in Wilpert's images (Figure 9), as well as in Tea's, although she makes no reference to the obstruction.[63] The opening was then closed by Boni as part of his restorations of the building, and another wall was added on the side of the ramp about fifty years later.[64] It is my opinion that the steps must have been no more than ten, as indicated by Tea, who was able to see the staircase, before it was blocked—not twelve, as indicated by Richard Delbrück and others subsequently.[65] The three steps that

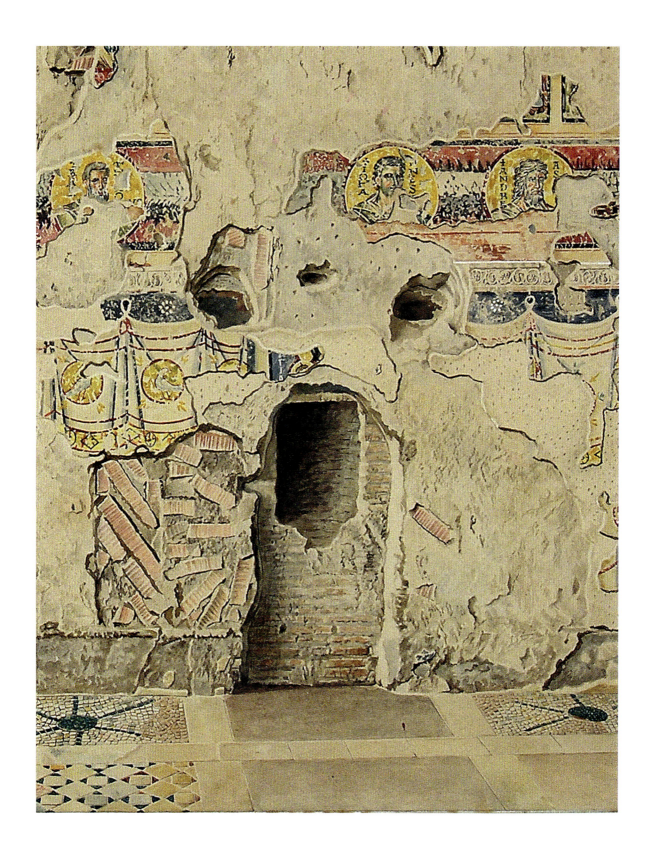

8 Detail of Joseph Wilpert's plate illustrating the east wall of the sanctuary. Above the niche are visible Christ's halo, Mary's *maphorion*, and the Greek letters 'ΑΓΙΑ' (*haghia*). (photo: Wilpert, *RMM*, IV, pl. 152)

1702: THE DISCOVERY OF SANTA MARIA ANTIQUA

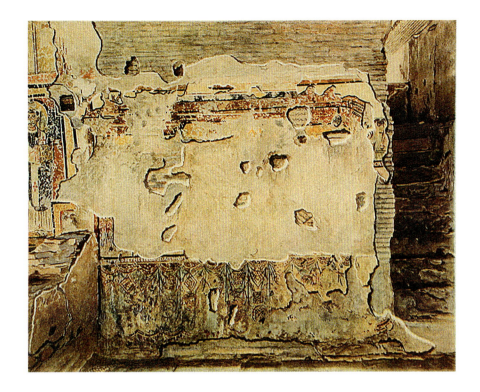

9 Detail of the east wall of the left aisle of Santa Maria Antiqua, with the irregular opening leading to the marble staircase
(photo: Wilpert, *RMM*, IV, pl. 177b)

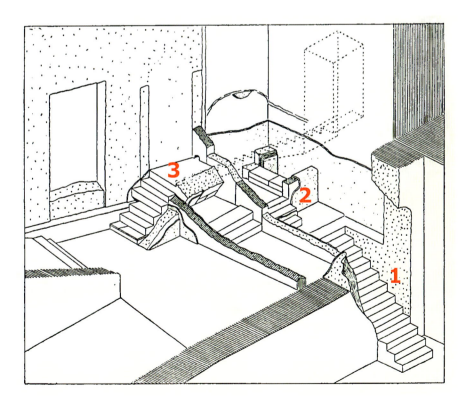

10 Reconstruction of the staircase linking the church of Santa Maria Antiqua to the Domitianic Ramp
(redrawn after Delbrück, 'Der Südostbau', p. 24, fig. 5)

11 Detail of the corner of the east wall in the left aisle of Santa Maria Antiqua: the brick wall erected in Boni's time closes the access to the marble staircase. On the right can be seen the remains of plaster, which seem to suggest the outline of three steps, and in the centre the dado with plaster that overlaps this. (photo: Oscar Mei)

are placed in the aisle in Delbrück's reconstruction (Figure 10), some trace of which should be found in the plaster at the corner between the aisle wall and that of the Chapel of Theodotus, in my view never existed. A close examination of the plaster suggests instead that the shapes are random, and it is not clear why the steps in the aisle would have been longer than those in the rest of the staircase (Figure 11). Furthermore, no plan of Santa Maria Antiqua includes these steps, including those by Petrignani and Rushforth, and in Delbrück's reconstruction they do not reach the outside wall of the Chapel, but remain of the same size as the opening itself.[66] Moreover, the plaster continued to cover the brickwork in the dado below the opening, and also that between the Chapel and the staircase, which then became the jamb of the door in question. Lastly, adding three steps in this area would be impossible, because the last step visible at the bottom of Wilpert's photograph (Figure 9)—probably the most important piece of evidence

directly above the dado, which bears traces of plaster—is too low (about 30 centimetres above the floor) to allow for three more steps.

Finally, attention should be paid to a note by Passionei mentioning a 'modern wall' about 37 *palme* long (*c*. 8.15 metres) which in the plan is indicated with two dotted lines, blocking the entrance to the sanctuary from the nave. Nothing seems to remain today of this masonry, but it should be probably considered contemporaneous with the eighteenth-century excavation and identified with the brickwork that Tea dated to that time and said was removed when the central *nicchione*—by which she means not only the apse conch but the entire area of the sanctuary—was discovered.[67]

As already discussed, at the beginning of his investigation Passionei was convinced that the church had been built by Pope Paul I, but in the course of his studies he came to a different and more accurate conclusion. On fol. 82[v] he claims instead that Paul restored a pre-existing structure, and that this role is indicated by the square nimbus, a sign that he was still alive when the apse mural was painted:

> nunc ea videamus qui de Paulo I dici possunt, plane cognitum habemus Paulum Primum Pontificem tantum restauratorem fuisse et pluribus picturis quibus labentibus annis ornata fuit Ecclesia. Sed ut certissimis argumentis ad indagandam veritatem nos conferamus, examinandum est in signo quadratu quo ipsius caput redimitum videmus.

Passionei also came to understand, for a variety of reasons, that the church had been dedicated to Mary, but he never made the connection to Santa Maria Antiqua, as fol. 83[r] demonstrates.[68] Here he writes that no image of the Madonna corresponded to the dedication inscription on the walls framing the apse, but that she appeared only in the conch together with the Saviour, beside Paul I who had restored the church under her maternal protection:

> An vero quod Sanctae Mariae dicatum esse, plane quodamodo fecit indicatio inscriptio haec, quae a utrisque duo lateribus visebatur, albo colore exarata; Sctae DI GENETRICI […] nec alicui ipsius imagini apposita erat, sed Sanctorum Pontificum ut quisque in delineata tabula pag: cernet, postposita potest quod Beata Virgo in aspide [sic] una cum Salvatore conspicitur depicta et Paulum I Pontificem complectitur et credi fas est, quod ipsum utpote restaurationem Materno prosequeretur affectu.

In June 1706 Pope Clement XI entrusted the young Domenico with a mission to take the cardinal's hat to the papal nuncio in France, Filippo Antonio Gualterio, marking the beginning of his extraordinary diplomatic and ecclesiastical career but also the end of the dissertation project to which he had dedicated so much time and energy. It is perhaps possible that Passionei never abandoned the idea of publishing his study, but the rapid succession of events, his increasing responsibilities, not to mention the vast range of his interests, did not allow him to resume the work, although his papers would be devotedly preserved in a folder for us to eventually appreciate again.

* I wish to thank the Biblioteca Civica Passionei in Fossombrone for having graciously allowed me to consult and publish the manuscript; Luca Polidori for the photographs of the manuscript; Mirna Bonazza of the Biblioteca Ariostea in Ferrara; and my colleagues Giulia Bordi, Ernesto Monaco, Henry Hurst, and Norbert Zimmerman for long and fruitful discussions about Santa Maria Antiqua, and for their many insightful comments.

1 Francesco Valesio, *Diario di Roma*, 6 vols (Milan: Longanesi, 1977–9), II: *1703–1704*, ed. by G. Scano and G. Graglia (1977), pp. 169–70, 239. Valesio's account is also reported in Francesco Cancellieri, *Storia de' Solenni possessi de' Sommi Pontefici* (Rome: Lazzarini, 1802), p. 320, note 4. See also Wladimir de Grüneisen, *Sainte-Marie-Antique* (Rome: M. Bretschneider, 1911), pp. 31–59; and Patrizia Fortini and Giulia Bordi, 'Cronaca dello scavo e della sua documentazione. 1900–1907', in *Santa Maria Antiqua tra Roma e Bisanzio*, ed. by M. Andaloro, G. Bordi, and G. Morganti (Milan: Electa, 2016), pp. 300–15 (pp. 300, 302).

2 Mariano Armellini, *Le chiese di Roma dalle loro origini sino al secolo XVI* (Rome: Tipografia Editrice Romana, 1887), pp. 358–9.

3 Vatican City, Biblioteca Apostolica Vaticana [hereafter BAV], Cod. Ottob. Lat. 7954, fol. 174r. Galletti cites BAV, Cod. Ottob. Lat. 2655, fol. 102v, part of the manuscript collection of Baron Stosch; see Wladimir de Grüneisen, *Sainte-Marie-Antique*, p. 36. For other notices of the discovery, see Giovanni Battista de Rossi, 'Roma – Antica chiesa con pitture del secolo VIII a piè del Palatino presso il Foro', *Bullettino di archeologia cristiana*, 6 (1868), pp. 16, 91–2.

4 Rodolfo Lanciani, 'Le escavazioni del Foro. IV. S. Maria Liberatrice', *Bullettino della Commissione archeologica Comunale di Roma*, 28 (1900), 25–7.

5 For Boni's excavation see Eva Tea, *La Basilica di Santa Maria Antiqua* (Milan: Società Editrice 'Vita e Pensiero', 1937), pp. 5–20; Giuseppe Morganti, 'Giacomo Boni e i lavori di S. Maria Antiqua: un secolo di restauri', in *Santa Maria Antiqua al Foro Romano cento anni dopo*, ed. by J. Osborne, J.R. Brandt, and G. Morganti (Rome: Campisano, 2004), pp. 11–30; Andrea Paribeni, 'Giacomo Boni e il mistero delle monete scomparse', in *Marmoribus vestita: Miscellanea in onore di Federico Guidobaldi*, ed. by O. Brandt and P. Pergola (Vatican City: Pontificio Istituto di Archeologia Cristina, 2011), pp. 1003–23; Fortini and Bordi, 'Cronaca dello scavo', pp. 300–15.

6 On Passionei see Stefania Nanni, 'Passionei, Domenico Silvio', in *Dizionario biografico degli Italiani*, LXXXI (Rome: Istituto della Enciclopedia Italiana, 2014), pp. 666–9; Pier Luigi Galletti, *Memorie per servire alla storia della vita del Cardinale Domenico Passionei, Segretario de' Brevi e Bibliotecario della Sede Apostolica* (Rome: Salomoni, 1762); Augusto Vernarecci, *Fossombrone dai tempi antichissimi ai nostri*, 2 vols (Fossombrone: Monacelli, 1903–14), II, 744–81; Maria Castelbarco Albani della Somaglia, *Un grande bibliofilo del sec. XVIII: il Cardinale Domenico Passionei* (Florence: Olschki, 1937); and Alberto Caracciolo, *Domenico Passionei tra Roma e la Repubblica delle Lettere* (Rome: Edizioni di Storia e Letteratura, 1968). The most complete biographical study is by Alfredo Serrai, *Domenico Passionei e la sua biblioteca* (Milan: Sylvestre Bonnard, 2004), who examines the cardinal's exceptionally rich literary, diplomatic and intellectual activity. Passionei's role in eighteenth-century archaeology and antiquarianism, however, has been much less studied: the collection of over a thousand sculptures and inscriptions brought together at the Romitorio of Monte Porzio Catone is almost unknown, and constitutes the focus of my current studies.

7 For the *fonds* Passionei in the Biblioteca Civica in Fossombrone, see Elio Sgreccia, 'Il Fondo Cardinal Passionei nella Biblioteca Civica di Fossombrone', *Studia Picena*, 40 (1973), 23–54.

8 Ferrara, Biblioteca Ariostea, Cl. I, n. 393, vol. II.

9 Passionei's letters to Muratori are preserved in Modena, Biblioteca Estense [hereafter BE], Archivio Muratoriano 74, no. 52; this letter is found at fol. 83.

10 BE, 74, no. 52, fols 7r–8v.

11 BE, 74, no. 52, fols 7r–8v, 11, 15r–16v, 24.

12 One section has been published in Oscar Mei, '"De ecclesia detecta ad radices Montis Palatini Dissertatio Dominici Passionei Forosemproniensis". La scoperta di Santa Maria Antiqua nei manoscritti di Domenico Passionei', *Mitteilungen des Deutschen Archäologischen Instituts Römische Abteilung*, 125 (2019), 257–300 (pp. 261–3).

13 On the 'Tamburo', see Caracciolo, *Domenico Passionei*, pp. 40–4; and Serrai, *Domenico Passionei*, pp. 36–7, passim.

14 *Francesco Bianchini (1662–1729) und die europäische gelehrte Welt um 1700*, ed. by V. Kockel and B. Sölch (Berlin: Akademie, 2005), pp. 41–55, 165–78; and Beatrice Cacciotti, 'La collezione Albani nel Palazzo alle Quattro Fontane: "un affare glorioso per il Papa e di benefizio per Roma"', in *Il Tesoro di Antichità. Winckelmann e il Museo Capitolino nella Roma del Settecento*, ed. by E. Dodero and C. Parisi Presicce (Rome: Gangemi, 2017), pp. 73–86.

15 Francesco Bianchini, *Considerazioni teoriche e pratiche intorno al trasporto della Colonna d'Antonino Pio collocata in Monte Citorio* (Rome: Stamperia della Camera Apostolica, 1704); and Giovanni Vignoli, *De Columna Imperatorii Antonini Pii Dissertatio* (Rome: Francesco Gonzaga, 1705).

16 Giorgio Baglivi, *Opera omnia medico-practica et anatomica*, 8th edn (Leiden: P. Breuyset & Sociorum, 1714), p. 574. This mention was cited by Christian Hülsen, 'Jahresbericht über neue Funde und Forschungen zur Topographie der Stadt Rom. Neue Reihe. I. Die Ausgrabungen auf dem Forum Romanum 1898–1902',

Römische Mitteilungen, 17 (1902), 1–97 (pp. 84–5, note 2), and is then repeated by de Grüneisen, *Sainte-Marie-Antique*, p. 37, in his chapter on the history of the excavation. Neither scholar, however, pursued the reference further nor showed any interest in Passionei.

17 In addition to Muratori and Magliabechi, Passionei had a regular correspondence with antiquarians and philologists of the calibre of Apostolo Zeno (Caracciolo, *Domenico Passionei*, p. 44), Jean Mabillon (Serrai, *Domenico Passionei*, pp. 47–52), Bernard de Montfaucon (ibid., pp. 52–3), Gisbert Cuper (ibid., pp. 55–8), Jakob Gronovius (Caracciolo, *Domenico Passionei*, p. 35), and John Hudson (ibid., p. 43).

18 Tino Foffano, 'Il "De rebus antiquis memorabilibus Basilicae S. Petri Romae" e i primordi dell'archeologia cristiana', in *Il Sacro nel Rinascimento. Atti del XII Convegno Internazionale di Studi (Chianciano–Pienza, 17–20 luglio 2000)*, ed. by Luisa Secchi Tarugi (Florence: Cesati, 2002), pp. 719–29; Fabio Della Schiava, *Il 'De rebus antiquis memorabilibus Basilicae S. Petri Romae': Edizione critica e commento* (unpublished doctoral thesis, University of Florence, 2009); Fabio Della Schiava, 'Il "De rebus antiquis memorabilibus" di Maffeo Vegio tra i secoli XV–XVII: la ricezione e i testimoni', *Italia Medievale ed Umanistica*, 52 (2011), 139–96; Fabio Della Schiava, 'Roma pagana e Roma cristiana nel primo libro del "De rebus antiquis memorabilibus" di Maffeo Vegio (1407–1458)', in *Roma pagana e Roma cristiana nel Rinascimento, Atti del XXIV Convegno Internazionale (Chianciano–Pienza, 19–21 luglio 2012)*, ed. by Luisa Secchi Tarugi (Florence: Cesati, 2014), pp. 39–50.

19 *Mafei Vegii Laudensis De rebus antiquis memorabilibus basilicae S. Petri Romae*, in *Acta Sanctorum Iunii […], illustrata a Conrado Janningo […], tomus VII seu pars II* (Antwerp: Ioannes Paulus Robyns, 1717), pp. 61–85.

20 Tiziana Di Zio, 'Del Torre, Filippo', *Dizionario biografico degli Italiani*, XXXVIII (Rome: Istituto della Enciclopedia Italiana, 1990), pp. 303–4.

21 Cesare Baronio (1538–1607), historian and cardinal, author of the *Annales ecclesiastici a Christo nato ad annum 1198* (1588).

22 Barnabé Brissons, French jurist (1531–91).

23 One *palmo* is approximately 22 centimetres.

24 The discrepancy between Passionei's figure for the height and the actual figure can be explained by the fact that the excavation did not reach the floor of the structure, stopping just below the 'palimpsest' wall, as also shown in Valesio's drawing.

25 Brick stamps of L. Sextilius Rufus are well known in Domitianic contexts, including both the Roman Forum and the Palatine, cf. *Corpus Inscriptionum Latinarum* [hereafter *CIL*] XV 1449; and Richard Delbrück, 'Der Südostbau am Forum Romanum', *Jahrbuch des Deutschen Archäologischen Instituts*, 36 (1921), 8–33 (p. 10).

26 In this instance it is probably a brick stamp from the Flavian era; cf. *CIL* XV 1094.

27 Cassiodorus, *Variarum libri XII*, III, 31, 4.

28 There is a large bibliography on the importance that the works of Theodoric and Cassidorus had on the classical tradition and Roman monuments, see principally Alessandro Pergoli Campanelli, *La nascita del restauro: Dall'antichità all'Alto Medioevo* (Milan: Jaca Book, 2015), pp. 186–251.

29 Giulia Bordi, 'Santa Maria Antiqua attraverso i suoi palinsesti pittorici', in *Santa Maria Antiqua tra Roma e Bisanzio*, ed. by M. Andaloro, G. Bordi, and G. Morganti, pp. 34–53.

30 De Grüneisen, *Sainte-Marie-Antique*, pp. 143 and 149, pl. 1.

31 Gordon Rushforth, 'The Church of S. Maria Antiqua', *Papers of the British School at Rome,* 1 (1902), 1–123 (pp. 58, 66); Joseph Wilpert, *Die römischen Mosaiken und Malereien der kirchlichen Bauten von IV–XIII Jahrhundert*, 4 vols (Freiburg im Breisgau: Herder, 1916) [hereafter *RMM*], II, p. 671; Per Jonas Nordhagen, 'John VII's *Adoration of the Cross* in Santa Maria Antiqua', *Journal of the Warburg and Courtauld Institutes*, 30 (1967), 388–90; and Per Olav Folgerø, 'The Lowest, Lost Zone in the *Adoration of the Crucified* Scene in the S. Maria Antiqua in Rome: a New Conjecture', *Journal of the Warburg and Courtauld Institutes*, 72 (2009), 207–19 (pp. 208–9).

32 On the significance of his non-traditional iconography of Christ, see Nordhagen, 'John VII's *Adoration of the Cross*', pp. 389–90.

33 On the presence of the sun and the moon, see Per Jonas Nordhagen, 'The Frescoes of John VII (AD 705–707) in S. Maria Antiqua in Rome', *Acta ad archaeologiam et artium historiam pertinentia*, 3 (1968), pp. 46–7.

34 Cf. Tea, *La Basilica di Santa Maria Antiqua*, pp. 76–7. On the symbolic significance of this scene see also Nordhagen, *The Frescoes of John VII*, pp. 50–4; and Folgerø, 'The Lowest, Lost Zone', p. 207, note 5.

35 For the inscription see most recently Antonio Enrico Felle, *Biblia Epigraphica: La sacra scrittura nella documentazione epigrafica dell''Orbis Christianus Antiquus' (III–VIII secolo)* (Bari: Edipuglia, 2006), pp. 309–10, with further bibliography.

36 Tea, *Basilica di Santa Maria Antiqua*, pp. 220–2.

37 Fortini and Bordi, 'Cronaca dello scavo', p. 306.

38 Orazio Marucchi, 'La Chiesa di S. Maria Antiqua nel Foro romano', *Nuovo Bullettino di Archeologia Cristiana,* 6 (1900), 285–320 (pp. 296–7). The first publication should not, therefore, be attributed to Rushforth ('The Church of S. Maria Antiqua', pp. 59–61), as indicated by Folgerø, 'The Lowest, Lost Zone', p. 208, note 6.

39 The reference is to Famiano Nardini's *Roma antica* (Rome: Falco, 1666).

40 Bordi, 'Santa Maria Antiqua attraverso i suoi palinsesti pittorici', p. 51.

41 Numerous studies have been devoted to the mosaics of this church, among the most recent see Ivan Foletti, 'Maranatha: spazio, liturgia e immagini nella basilica dei Santi Cosma e Damiano sul Foro Romano', in *Setkáván: Studie o středověkém umění věnované Kláře Benešovské*, ed. by J. Chlíbech and Z. Opačić (Prague: Artefactum, 2015), pp. 68–86; and Erik Thunø, *The Apse Mosaic in Early Medieval Rome: Time, Network and Repetition* (New York: Cambridge University Press, 2015).

42 The description of the tetramorphs may be found in Ezechiel 1.6–11, quoted more or less accurately by Passionei.

43 Rushforth, 'The Church of S. Maria Antiqua', p. 66; Tea, *Basilica di Santa Maria Antiqua*, p. 216; and Bordi, 'Santa Maria Antiqua attraverso i suoi palinsesti pittorici', p. 49.

44 An additional transcription may be found on fol. 120r.

45 Joseph Wilpert, 'Sancta Maria Antiqua', *L'Arte*, 13 (1910), 1–20, 81–107 (pp. 81–2); and Wilpert, *RMM*, II, 667.

46 Rushforth, 'The Church of S. Maria Antiqua', p. 74; Wilpert, 'Sancta Maria Antiqua', p. 83; Tea, *Basilica di Santa Maria Antiqua*, p. 223; and Bordi, 'Santa Maria Antiqua attraverso i suoi palinsesti pittorici', pp. 46–9.

47 Bordi, 'Santa Maria Antiqua attraverso i suoi palinsesti pittorici', p. 49.

48 In order of appearance Wilpert, 'Sancta Maria Antiqua', p. 85; Wilpert, *RMM*, II, 669–70; Tea, *Basilica di Santa Maria Antiqua*, pp. 68, 73; and Bordi, 'Santa Maria Antiqua attraverso i suoi palinsesti pittorici', p. 49. Jean-Marie Sansterre, 'Jean VII (705–707): idéologie pontificale et réalisme politique', in *Rayonnement grecque: Hommages à Charles Delvoye*, ed. by L. Hadermann-Misguich and G. Raepsaet (Brussels: Université de Bruxelles, 1982), pp. 377–88 (p. 382); Andrew J. Ekonomou, *Byzantine Rome and the Greek Popes: Eastern Influences on Rome and the Papacy from Gregory the Great to Zacharias A.D. 590–752* (Plymouth: Lexington Books, 2007), p. 268; Giulia Bordi, 'Die Päpste in S. Maria Antiqua. Zwischen Rom und Konstantinopel', in *Die Päpste und Rom zwischen Spätantike und Mittelalter*, ed. by N. Zimmermann and others (Regensburg: Schnell & Steiner, 2017), pp. 189–211 (p. 206).

49 Bordi, 'Die Päpste in S. Maria Antiqua', p. 205.

50 For Sylvester, see Wilpert, 'Sancta Maria Antiqua', p. 85; and Wilpert, *RMM*, p. 670. For Leo I, see Tea, *Basilica di Santa Maria Antiqua*, p. 73; Nordhagen, *The Frescoes of John VII*, p. 42; and Per Jonas Nordhagen, 'The Frescoes of Pope John VII (AD 705–707) in S. Maria Antiqua in Rome, Supplementum', *Acta ad archaeologiam et artium historiam pertinentia*, 29 (2018), 163–76 (pp. 165–6).

51 Marucchi, 'La Chiesa di S. Maria Antiqua', p. 299; Wilpert, 'Sancta Maria Antiqua', pp. 84–5; Wilpert, *RMM*, p. 670; and Tea, *Basilica di Santa Maria Antiqua*, p. 72.

52 As we shall see, however, he would later come to understand that the role of this pope was different.

53 Ernst Kitzinger, 'The Hellenistic Heritage in Byzantine Art', *Dumbarton Oaks Papers*, 17 (1963), 95–115; and Ernst Kitzinger, *L'arte bizantina: Correnti stilistiche nell'arte mediterranea dal III al VII secolo* (Milan: Il Saggiatore, 1989), pp. 127–34.

54 Fortini and Bordi, 'Cronaca dello scavo', p. 306; and A. Ballardini, 'Piattaforma di ambone in Santa Maria Antiqua', in *Santa Maria Antiqua tra Roma e Bisanzio*, ed. by M. Andaloro, G. Bordi, and G. Morganti, pp. 228–30.

55 Folgerø, 'The Lowest, Lost Zone'.

56 Tea, *Basilica di Santa Maria Antiqua*, p. 314.

57 Rushforth, 'The Church of S. Maria Antiqua', p. 58; Wilpert, 'Sancta Maria Antiqua', p. 15, fig. 8; and Wilpert, *RMM*, pl. 152.

58 Cf. Tea, *Basilica di Santa Maria Antiqua*, pp. 248, 315.

59 Ibid., pp. 83, 245.

60 Delbrück, 'Der Südostbau', pp. 23–4; Tea, *Basilica di Santa Maria Antiqua*, p. 251; and Luciana Borrello and Mauro Maiorano, 'Rampa domizianea. Nuovi dati dalle indagini', in *Rampa imperiale: Scavi e restauri tra Foro romano e Palatino*, ed. by P Fortini (Milan: Electa, 2015), pp. 88–101 (p. 90).

61 Lanciani, 'Le escavazioni del Foro', pp. 25–7.

62 Borrello and Maiorano, 'Rampa domizianea', p. 91. The eastern wall of the left aisle was painted between *c.* 650 and 663 CE with scenes of the Forty Martyrs of Sebaste, thus there could not have been an entry to the Ramp there at that time: see Giulia Bordi, 'Frammenti inediti dal ciclo pittorico dei Quaranta Martiri di Sebaste', in *Santa Maria Antiqua tra Roma e Bisanzio*, ed. by M. Andaloro, G. Bordi, and G. Morganti, pp. 362–3.

63 Wilpert, *RMM*, pl. 177a; Tea, *Basilica di Santa Maria Antiqua*, p. 263, fig. 16.

64 Borrello and Maiorano, 'Rampa domizianea', p. 90.

65 Tea, *Basilica di Santa Maria Antiqua*, p. 83; Delbrück, 'Der Südostbau', pp. 23–4, fig. 5; and Borrello and Maiorano, 'Rampa domizianea', pp. 91–2, and 95, fig. 18.

66 Tea, *Basilica di Santa Maria Antiqua*, pl. IV; and Ernesto Monaco, 'Per le antiche carte. Antonio Petrignani e Santa Maria Antiqua', in *Santa Maria Antiqua tra Roma e Bisanzio*, ed. by M. Andaloro, G. Bordi, and G. Morganti, pp. 318–25 (p. 321); Rushforth, 'The Church of S. Maria Antiqua', p. 18.

67 Tea, *Basilica di Santa Maria Antiqua*, p. 238.

68 Valesio also spoke of 'Santa Maria de Inferno antica, o di S. Maria de Canaparia'.

T.P. WISEMAN

Gordon McNeil Rushforth and Santa Maria Antiqua

Miss Lucas and Mr Baddeley

We begin on 21 January 1900, in an apartment at Via Lombardia 47 that belongs to two English ladies, Miss Anne Lucas, aged fifty-eight, and her sister Miss Matilda Lucas, aged fifty. Matilda Lucas is writing a long, chatty letter to her family about what she and her sister have been doing. Among other things, she describes an evening party hosted by Dr Oxenham, who was the Chaplain of the English church in Via del Babuino:[1]

> It was not a large party—the object was to talk of the new School of Archaeology which is to be opened here like the one at Athens ~ Some interesting people were there—Lord and Lady Currie—Sir William Walrond the Conservative whip, a very handsome man—M^r Strong, librarian of the house of Lords and his handsome wife, who as Miss Sellers is well known for her lectures on Greek Art ~ Her beauty is Greek but rather on the wane.

When she published a selection of her letters thirty-eight years later, Miss Lucas politely omitted the last five words.[2] At the time of Dr Oxenham's party Mrs Strong was thirty-nine, no longer the 'young Diana' whom Oscar Wilde remembered from the 1880s, but certainly a handsome woman.[3]

Miss Lucas continues:

> We made the acquaintance that evening of Mr St. Clair Baddeley and his wife ~ She is really beautiful and the sister of the lovely Miss Grant painted by Herkomer ~ Mr B is a litterary [*sic*] man.

He was indeed. He had published five books of historical romance in verse, all totally forgettable, three books of short poems, equally bad, two books of travel reminiscences, and three studies

of mediaeval Naples which purported to be real history but got a very mixed reception from historians.[4] What matters for our purposes, however, is that for the previous two years, under the influence first of Rodolfo Lanciani and then of Giacomo Boni, Baddeley had been re-inventing himself as a Roman archaeologist.[5]

Just a week before Dr Oxenham's party, on 16 January, Baddeley had given a lecture to the British and American Archaeological Society of Rome before an audience of more than a hundred people, chaired by the American and British ambassadors, on the recent excavations of the Basilica Aemilia.[6] Three months before that, in October 1899, he had been one of those present at the meeting in London when it was first resolved to pursue the project of a British School of Archaeology at Rome.[7]

That brings us back to Miss Lucas's letter. 'A propos of Archaeology', she continues:[8]

> We were down in the Forum on Friday ~ the amount of excavation since we left last March is enormous and bewildering ~ They have found numbers of skeletons and endless fragments of temples and other buildings, beautiful little bits of pavements in what look like private houses, subterranean passages, etc. ~ It will take Archaeologists all their time to name these things. [...] They are now pulling down the Church of Santa Maria Liberatrice ~ Mrs Strong does not think they will find much underneath. One cannot help feeling glad that the Archaeologist has been let into the Forum to work his will in spite of the artists who find their old subjects spoiled.

In the later selection of the letters, the sceptical opinion is attributed to *Mr* Strong.[9] In 1938 his widow was at the height of her scholarly reputation, recipient of honorific medals from both the British Academy and the City of Rome,[10] and it would not have been tactful to attribute that opinion to her. At the time, her pessimism may have been influenced by the recent experience of the Basilica Aemilia, which had been confidently expected to yield abundant works of art.[11]

As it turned out, Mrs Strong could hardly have been more mistaken about Santa Maria Liberatrice. A photograph taken on 8 January 1900, just about the time Matilda Lucas and her sister were down in the Forum, shows the church already fenced off as a demolition site, with the carts queuing up to take away the debris.[12] Six weeks later, on 20 February,[13] St Clair Baddeley was able to inform the readers of the London *Globe* that 'the Church of S. Maria Liberatrice is now no more, and the vast north-west angle of the Palatine, gloomy with the ruins of Caligula's palace and the dark grove of Ilex above them, may be almost said to frown over the Forum.' As for what was found underneath, the basilica of Santa Maria Antiqua, two photographs in the Ashby collection show work busily in progress at an early stage.[14]

As always with excavations of this period, one is astonished by how much was cleared in how short a time; it is worth remembering that Boni was quite prepared to use explosives to shift inconvenient masonry.[15] And of course, Santa Maria Antiqua was a very vulnerable site. Baddeley's next report, at the end of March, describes the *Crucifixion* on the end wall of the sanctuary: already, he says, 'a good deal of it has vanished, and exposure to the air will do it further harm'. And not only that: 'The vaulting above shows traces of a rich non-Christian mosaic. Unfortunately this is no more.'[16] It seems that evidence was being lost day by day.

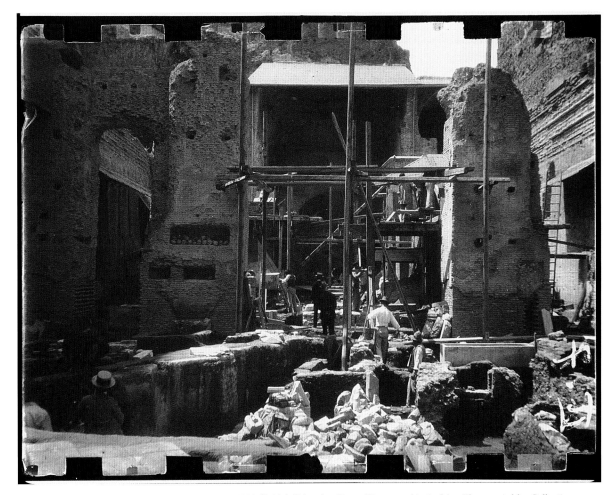

1 Excavations in Santa Maria Antiqua, spring 1900 (British School at Rome Photographic Archive, Thomas Ashby Collection, ta-II.007i, used with kind permission)

It would be good to know the identities of the gentlemen who were inspecting the site in the Ashby photographs (Figure 1). The precise date is not attested, but if it was during the Oxford University Easter vacation—roughly mid-March to mid-April—then it is likely that one of them was Gordon McNeil Rushforth, the thirty-seven-year-old Classical Tutor at Oriel College, to whom on 8 March the British School at Rome Executive Committee had offered the post of Director.[17] Rushforth accepted at once, and would surely have taken the first opportunity to come to Rome and see the new discoveries. Two years later, inaugurating the new School's research papers, he presented the first, and fundamental, edition of the texts and iconography of Santa Maria Antiqua.[18]

The Exeter archive

Full details on Rushforth, so far as they are known, may be found in my 1981 article 'The First Director of the British School'.[19] I had become interested in Rushforth by discovering so many of his books in the University of Exeter Library, and in the course of hunting out the evidence for his life I made contact with the Rev. Eric Baker, then in his seventies and rather frail. Forty

years earlier Rushforth had bequeathed to him all his papers and notebooks, and he was glad now to be able to donate them to Exeter.[20] (Baker died the following year, 1982.)

One interesting item in the Exeter archive is Rushforth's offprint of Vincenzo Federici's early description of Santa Maria Antiqua,[21] with frequent pencilled marginalia correcting Federici's transcriptions, probably done on site.[22] Otherwise there seems to be very little from the period of his directorship—not surprisingly, perhaps, since it occupied less than three years of his long life. His copy of Wladimir de Grüneisen's *Sainte-Marie-Antique* (1911) was not among the books that he bequeathed to Exeter (I assume he had already given it to Rev. Baker), so we do not know whether he made any marginal annotations on the work that effectively superseded his own.

Not long after his monograph had appeared in *Papers of the British School at Rome*, Rushforth resigned the directorship for health reasons and retired to Malvern. But he was still actively engaged with the art, archaeology, and topography of Rome, and still in close touch with Roman friends, including Thomas Ashby and Mrs Strong. Three letters from Ashby in the Exeter archive mention Santa Maria Antiqua.

The first, written from the Hotel Continental, Rome, on 6 February 1904, just about a year after Rushforth had left the city (Ashby was now Assistant Director), was evidently a reply to a query about Carpaccio's view of Rome in his great cycle of paintings for the Scuola di Sant'Orsola in Venice:

Dear Rushforth,

Enclosed extracts may help you: but I am going to buy a photo of the fresco & work it out further. So far inspection of all views I can lay hands on reveals no other apse than that of S. M. del Popolo. S. Jones says we can't afford Ludwig for the School. Have you got either of my articles on the Wyngaerde panoramas in the Bodleian (Bull. Com. 1900 & Mélanges Ecole Française 1901). If not I will send you copies. They will be of use in this connexion.

Any further information I can get shall be at your disposal. I fancy Coner is to take the entire 2nd vol. of the Papers. It won't be ready just yet, as photography of the drawings in London has been slow. As to S. M. Antiqua, Boni referred me to 3 photographers, who had been allowed to work there. One (Vasari) has only taken 3 views—general, detail column, Crucifixion. & he thinks Anderson has no more. Anderson and Mosciani I have not yet interviewed, but will do so. I don't think Boni will do any more, as he hopes to publish report soon, paintings being nearly finished copying. Can't you try Venturi? Another idea will be to see Loescher, who now runs the Bull. Com. I will try him Monday.

I can cash cheque for 12/- easily, but you may as well keep money over in case there is more in connexion with these photos.

Weather beastly,

In great haste,

Yours as ever,

T. Ashby

The second letter was from the same address, on 11 February:

Dear Rushforth,

As to the Carpaccio view, the church on left must be S. M. del Popolo?, but I don't understand the position outside the city wall, which seems to run on behind it to the river. However, the representation is incorrect—you will observe that the river (which must run between it and C. S. Angelo) is practically not indicated.

The spire looks like the Anima, and the dome like S. Agostino (Mel. Ecole Franc.) but if so their relative positions are reversed. Call the gable peeping out from the castle on the rt (under the octagonal dome) S. Salvatore in Lauro if you like. The square tower is probably in the Campus Martius somewhere, or on the edge of the Quirinal; but it is hardly safe to try to identify it. The Milizie more often I think has its 3 stories indicated. I am sorry to be rather vague, but the thing is obviously a trifle conventional.

Ashby goes on to copy out lengthy extracts from Panciroli (1625), Felini (1610), and others on Sant'Orsola. When he resumes in his own voice, it looks as if he is answering a query about which way Carpaccio imagined the ambassadors coming to Rome:

As to the passages from Muratori, vol. xxiv, they are all from the Diarium Romanum Antonini Petri (1404–1417). P. 974 only mentions entrance from north by land—not by sea—p. 803 (1407), Ambassadors from the King of France come 'per flumen ad voltam Sancti Petri Apostoli' (up the river of course—I doubt much if any traffic down stream) p. 989 (11 April 1408), 'isto die supradetto venerunt multae Galeae ut etiam multa alia Fusta, et intravenerunt de Foce de Roma, et post introitum steterunt ibi et dicebatur quod volebant capere Ostia'.

It does not seem that this diary is going to be published in the Città di Castello edition just yet.

If you can get hold of the Mélanges de Rossi, it might be interesting to compare Geffroy's article 'Une vue inédite de Rome en 1459' (p. 361). The dome might be the dome of S. Spirito (?) of Müntz in same publication 'Plans et monuments de Rome antique' (p. 137 sqq) pl. I—II (referred to p. 151)

As to S. Maria Antiqua, Moschiani has only 3 photos, as Vasari has; and Anderson has as yet taken none, tho' apparently he is shortly going to for Wilpert's history of Xtian art. So the thing seems difficult to work: unless Venturi will lend you the negatives he used for his Storia dell'Arte Italiana, & that I don't know.

I am sorry so little is to be done. Can't you talk more generally on the Xtian Basilicas of Rome? or mosaics? I don't think the Hist. & Arch. Soc. go very deep!

Yours as ever,

T. Ashby jun.

The final paragraph reveals that Rushforth wanted the Santa Maria Antiqua illustrations for a lecture, though which 'Historical and Archaeological Society' had invited him to speak is not known. In fact, he took up Ashby's idea for a lecture on mosaics, but perhaps not immediately. The text of such a lecture survives in the Exeter archive, in an envelope annotated 'King's College London'; although it is not dated,[23] the third Ashby letter may be relevant to it.

This letter is dated only 'Nov. 14', but internal evidence seems to put it in 1912 or 1913, when Ashby was well into his directorship. It is on headed notepaper from 'British School at Rome, Palazzo Odescalchi':

Dear Rushforth,

Nogara, in his book on Mosaics (the pagan ones of the Vatican & Lateran) says that vault mosaics came in not before the 4th cent. (I think). [*This paragraph crossed out.*]

No, it isn't he; it's a man named Zeiller writing in Spalato (the text to some drawings, a very fine set by a Frenchman called Hébrand) who claims the Palace of Diocletian as the first use of mosaic in a dome. I can cite to the contrary a nymphaeum on the Via Nomentana (Papers iii. 104) and there are niche mosaics in the Villa of the Quintilii. I don't remember mosaics in the cryptoporticus on the Palatine in situ, & one of our students now working on these assures me there are none.

As to S. Giovanni in Fonte, see Bollettino d'Arte (published by the Min. Publ. Instruct.) iii. (1909) 217—summarized American Journal Archaeol. 1910 p. 252.

I know of nothing new on mosaics in general, unless it be Frothingham's Monuments of Xtian Rome. Wilpert isn't out with his S. M. Maggiore yet. Stuart Jones has strong anti-Richter views (published in the Hibbert Journal some while ago). Grüneisen's huge work on S. M. Antiqua is of course out.

I wish you would come out here—I never get to see you in England, & there's lots to see & talk about.

The School is going on well—we have an active lot of students this year, better than I've known for a long time. And the new scheme seems to be pushing ahead prosperously: so that the outlook is good. I enclose a slip of a copy of Ridolfi—I've got it—paid about 4/- for it.

You ought to have a look at the two volumes of Dal Pozzo drawings (Mosaici Antichi) which are now at the British Museum, in A.H. Smith's department.

[*No signature.*]

Baddeley again

If it seems surprising that Ashby should refer to Santa Maria Antiqua in the context of Roman vault mosaics, perhaps we should remember St Clair Baddeley (Figure 2). He it was who had seen, before the traces were lost for ever, that the vault above the *Crucifixion* scene in the Sanctuary had once been decorated in mosaic, and Rushforth gave him due credit for his observation.[24] Here if anywhere is the justification for Baddeley's pride in having been an 'eye-witness' of the great discoveries.[25]

However, when Baddeley published his 'handbook for travellers' in 1904, the treatment of Santa Maria Antiqua showed no sign at all that he had read Rushforth's monograph, even as far as the title page that identified the author. 'I wish,' he wrote in the preface, 'to express obligations to the monumental volume by Mr Neville Rushforth on Sta Maria Antiqua.'[26] That shows Baddeley at his worst, a name-dropper who could not even get the name right.

He must have found it progressively more difficult to maintain his image as 'the historian and archaeologist' in the company of Rushforth, Ashby, and Stuart Jones, and by the time Mrs Strong became Assistant Director at the School in 1909, Baddeley had brought his Roman period to a close.[27] He too retired into the life of a gentleman scholar, at Painswick in the Cotswolds, but enquiries about the Rome years were evidently not encouraged.[28] There are a few letters from him to Rushforth in the Exeter archive (dated 1913, 1914, and 1930), but only on matters of local history where he could feel they were equals.

Ashby's letters to Rushforth show a very different attitude: 'I wish you would come out here, there's lots to see and talk about'. Mrs Strong felt the same. In a letter in the archive dated 14 November 1915, mainly prompted by Rushforth's article on Roman 'funeral lights',[29] she went on to write: 'A thousand thanks [too] for that interesting paper on the "wheel of life".

2 Welbore St Clair Baddeley lecturing on the Palatine, 1900 (T.P. Wiseman Archive)

Come out to Rome one winter and let us do a book together on symbolism, it is much needed.'

From Thomas Ashby and Eugénie Strong alike, the note of respect and affection is very clear. Rushforth was not only a superb scholar; he was also a man people liked. The last word can go to Sir James George Frazer, writing to Rushforth in 1915: 'I share your hope that we may meet again some day and speak of the old days when we were in Rome together.'[30]

NOTES TO THE TEXT

1. *'Every Body Comes Back to Rome': The Complete Letters of Matilda Lucas, 1871–1902*, ed. by R. Sénécal (London: Gatehouse, 2013), p. 964. Lord Currie was the British Ambassador in Rome.

2. Matilda Lucas, *Two Englishwomen in Rome 1871–1900* (London: Methuen, 1938), p. 226.

3. For near-contemporary portraits of her, see Stephen L. Dyson, *Eugénie Sellers Strong: Portrait of an Archaeologist* (London: Duckworth, 2004), plates 10–11. For Wilde's judgement, see Mario Praz, *La casa della fama: Saggi di letteratura e d'arte* (Milan: Ricciardi, 1952), p. 382.

4. For Baddeley in general, see T.P. Wiseman, 'Con Boni nel Foro: i diari romani di W. St Clair Baddeley', *Rivista dell'Istituto Nazionale di Archeologia e Storia dell'Arte*, 3rd ser., 8–9 (1985–6), 119–49; English version, with abbreviated annotation, in T.P. Wiseman, *Talking to Virgil: A Miscellany* (Exeter: University of Exeter Press, 1992), pp. 111–48.

5. Wiseman, *Talking to Virgil*, pp. 117–35.

6. Anon., 'Session 1899–1900', *Journal of the British and American Archaeological Society of Rome*, 3.2 (1900), 57–71.

7. T.P. Wiseman, 'The First Director of the British School', *Papers of the British School at Rome*, 49 (1981), 144–63 (pp. 146–7); reprinted as 'Rediscovering a Benefactor', in Wiseman, *Talking to Virgil*, pp. 149–70 (pp. 152–3) (evidence from the British School at Rome Archive).

8. Sénécal, '*Every Body Comes Back to Rome*', p. 965.

9. Lucas, *Two Englishwomen in Rome*, p. 227.

10. Gladys Scott Thomson, *Mrs Arthur Strong: A Memoir* (London: Cohen and West, 1949), pp. 112–3; Dyson, *Eugénie Sellers Strong*, pp. 185–6. There is a nice recollection of her at that time by Vittorio Gabrieli in a letter to the *Times Literary Supplement* (5288, 6 August 2004), p. 6.

11. Rodolfo Lanciani, *Notes from Rome*, ed. A.L. Cubberley (London: British School at Rome, 1988), p. 262, first published in *Athenaeum*, 13 May 1899: 'some clandestine excavations made in 1877 in the cellars of the shop No. 9, Foro Romano, have revealed that there are perfect mountains of exquisitely carved marbles lying under the houses so generously put at our disposal by Mr. Phillips; but in cases like this it is better to let the spade tell its own tale, and wait for events.'

12. Wladimir de Grüneisen, *Sainte-Marie-Antique* (Rome: M. Bretschneider, 1911), p. 51, fig. 24; *Lacus Iuturnae I*, ed. by E.M. Steinby and J. Aronen, Lavori e studi di archeologia, 12 (Rome: De Luca, 1989), p. 169, fig. 7.

13. Date given in Welbore St Clair Baddeley, *Recent Discoveries in the Forum 1898–1904* (London: George Allen, 1904), pp. 77–8; first published in the *Globe*, 22 February 1900, p. 6.

14. *Archeologia a Roma nelle fotografie di Thomas Ashby 1891–1930*, ed. by D. Campanelli (Napoli: Electa, 1989), p. 50, figs 11.2 and 11.3 (= Figure 1).

15. Lanciani, *Notes from Rome*, p. 319, first published in *Athenaeum*, 15 September 1900: 'The work of exploration is considerably hampered by the great masses of masonry, fallen from the vaulted ceiling of the Augusteum, which block the way in every direction. The archaeological stillness of the ruins is broken every night by the explosion of mines, which seem unfitted amongst the numberless Byzantine and Latin saints painted on the crumbling plaster of the Augusteum itself after its dedication to S. Maria Antiqua.'

16. Baddeley, *Recent Discoveries*, pp. 78–9, first published in the *Globe*, 30 March 1900, p. 4.

17. Wiseman, 'The First Director', p. 148.

18. Gordon Rushforth, 'The Church of S. Maria Antiqua', *Papers of the British School at Rome*, 1 (1902), 1–123.

19. Wiseman, 'The First Director'; also Andrew Wallace-Hadrill, *The British School at Rome: One Hundred Years* (London: British School at Rome, 2001), pp. 22–7.

20. See Jane Louise Renton, *Gordon McNeil Rushforth: Catalogue of his Papers held by the University of Exeter Library, with a Study of their Intellectual and Cultural Context* (unpublished MPhil thesis, University of Exeter, 1994). Reference numbers for the Rushforth material are EUL MS 30A, 147 and 227.

21. Vincenzo Federici, 'Santa Maria Antiqua e gli ultimi scavi del Foro Romano', *Archivio della R. Società Romana di storia patria*, 23 (1900), 517–62 (pp. 537–62; [pp. 23–48 of the offprint]).

22. Cf. Rushforth, 'The Church of S. Maria Antiqua', p. 111, note 1: 'Federici (*l.c.* p. 46) gives some *graffiti* here, but I confess that I can make nothing out of the traces on the wall.' By an oversight, Rushforth always refers to Federici's work as '*l.c.*' (also pp. 68, note 1; 76, note 2), with the full citation never given.

23. I now think that the date '1918' in Wiseman, 'The First Director', p. 163, is a false deduction from 'FEB 18' on the postmark on the envelope, which surely refers to the day, not the year.

24. Rushforth, 'The Church of S. Maria Antiqua', p. 21, note 1: 'I am informed by Mr. W. St. Clair Baddeley that at the beginning of the excavation of the church, in March, 1900, when the observer stood close under the barrel-vault of the sanctuary, abundant traces of mosaic could be seen on the latter, though little except the bedding of the tesserae remained. This, too, must have formed part of the pre-Christian decoration of the building.'

25. Baddeley, *Recent Discoveries*, title page.

26. Ibid., p. viii. Contrast the competing volume of E. Burton-Brown, *Recent Excavations in the Roman Forum 1898–1904: A Handbook* (London: John Murray, 1904), pp. 181–206, where Rushforth's influence is obvious, and acknowledged.

27 Wiseman, *Talking to Virgil*, pp. 144–6.

28 C.A. Ralegh Radford to TPW, 14 March 1988 (in thanks for a copy of 'Con Boni nel Foro'): 'What a fascinating story. I only knew Baddeley in his later years—after about 1925—with the Bristol and Gloucester [Archaeological Society]. He was always very cagey about Rome and showed a lack of interest in Ashby.' (We know from the diaries that Baddeley had been on excellent terms with both Ashby and his father from at least 1898 to 1905.)

29 Gordon McNeil Rushforth, 'Funeral Lights in Roman Sepulchral Monuments', *Journal of Roman Studies*, 5 (1915), 149–64; Gordon McNeil Rushforth, 'The Wheel of the Ten Ages of Life in Leominster Church', *Proceedings of the Society of Antiquaries*, 26 (1913–14), 47–60.

30 Exeter archive (dated 28 October 1915).

Giacomo Boni at the tomb of the Sepolcreto
(photo: Archivio Fotografico, Parco Archeologico del Colosseo, Serie C 699)

ANDREA PARIBENI

'With Boni in the Forum'? The relationship between Gordon McNeil Rushforth and Giacomo Boni according to archival documentation

The first words in the title of this paper closely follow a quotation chosen by Peter Wiseman for an essay he published several years ago. In that paper Wiseman described Welbore St Clair Baddeley's experience in the turbulent world of late nineteenth- and early twentieth-century Roman archaeology as he faced scholars such as Giacomo Boni and Rodolfo Lanciani.[1] 'With Boni in the Forum' was a reference frequently used by Baddeley in his diaries whenever he took note of surveys carried out in the Forum together with the director of the excavations. The quantity of documents, both published and unpublished, produced by Baddeley, together with the correspondence he maintained with Boni over his lifetime, provided Wiseman with numerous clues that enabled him to carefully establish facts, details of backstage intrigues, and the attitudes of all the characters who enlivened the early twentieth-century archaeological scene in Rome.[2]

With an ill-concealed sense of envy I must confess that whoever tries to look into relations between Rushforth and Boni (Figure 1) during those same years faces a much harder task: thanks to a few published notes we can imagine a lively and intimate relationship between the two scholars, but unfortunately it is not possible to find confirmation of this in personal papers, letters, or other archival documents. Suffice to say that in the biography written in 1932 by Eva Tea, which is considered the most important reference on Boni's work,[3] Rushforth's name occurs only once: in the transcription of a letter, unfortunately undated (but surely written in 1901 or in the first months of 1902), that Boni sent to his good friend Angelo Alessandri, a Venetian painter linked—as was Boni himself—to the circle of Anglo-Saxon and Italian artists who worked on commission for John Ruskin.[4] In the letter, Boni speaks of a crowded *soirée*

at the British Embassy, where 'a human kaleidoscope with some trowelfuls of diamonds and pearls' congregated, and all the guests competed to gain the attention of the archaeological star of the day (Boni himself), until 'Prof. Rushforth of Oxford University takes me by the arm, and together we descend the grand staircase crowded with servants dressed in trappings and frogging'.[5] The snapshot of the two archaeologists in amiable conversation on the staircase of Villa Bracciano, once the site of the British Embassy in Rome, seems indeed to convey to our eyes an image of a mutual intimacy.[6]

This feeling of intimacy was strengthened by the same Rushforth in the obituary notice he published on the occasion of Boni's death in 1925, where he states that he 'first became intimate with him [Boni] in a select company which used to gather in the hospitable rooms of Mr. Wickham Steed, then the Rome correspondent of *The Times*'.[7] Curiously enough, the same Henry Wickham Steed also wrote about Boni and the heated archaeological milieu he came to know during the years spent in Rome as *The Times* correspondent.[8]

Between these two sources—the vivd picture of the embassy's party and the memories filtered by years, in the obituary for the *Antiquaries Journal*—is a vast empty space, a *terra incognita* that archival documentation appears unable to fill.

The aforementioned letter to Alessandri (Figure 2) is one of the documents preserved in the Boni-Tea archival fonds, a remarkable collection of documents left around 1965 by Eva Tea to the Istituto Lombardo Accademia Scienze e Lettere in Milan. Still unknown at the end of the 1980s, this archive has subsequently been the subject of a prolonged and thorough study by Federico Guidobaldi, who discovered it,[9] and myself; the project will be completed with the forthcoming publication of a catalogue of the most relevant documents.[10] When I began my research on the Rushforth-Boni connection, I hoped that the Milanese archive, organised into thematic files devoted to a wide range of subjects (e.g. archaeology, gardening and landscape architecture, conservation of monuments, economy, politics) and including a huge section of correspondence, would offer me some useful evidence; but, unfortunately, the first director of the British School at Rome does not appear in the 186 thematic files catalogued for this publication.[11] The correspondence section, divided into twenty-seven files containing thousands of letters sent to Boni or written by him, still awaits a complete catalogue, but the chance of finding in it some letters by Rushforth to Boni or some drafts and/or copies of letters from Boni to Rushforth is small. But we cannot rule out the possibility of some occasional reference to Rushforth's name in the correspondence with other figures of the archaeological milieu during the first years of the twentieth century.

Another prospective source of information, the documents of the Direzione Generale Antichità e Belle Arti in the Archivio Centrale dello Stato in Rome, also provided little useful information. Rushforth's name is completely absent from the files concerning the excavation, documentation and conservation of Santa Maria Antiqua. We might have expected that, in seeking permission to publish his long essay about the so-called Basilica Palatina, Rushforth would have submitted a formal request to the director general, as was the rule when foreign scholars proposed to carry on studies and surveys of ancient monuments of Rome, but no such action appears to have been taken.[12] As Rushforth himself stresses at the beginning of his study, the text was published without pictures because 'photographs and other methods by which the appearance of the paintings has been, so far as possible, preserved being the property of the

Letter from Giacomo Boni to Angelo Alessandri, 1901 or 1902
(Istituto Lombardo Accademia Scienze e Lettere – Archivio Boni-Tea)

Italian authorities, cannot be published until the official account of the excavations has been issued.'[13] With these words Rushforth respected the rights of the Italian State in respect of the artefacts found in the excavation, the same rights that Boni himself firmly claimed on behalf of other Italian and foreign scholars, as some documents of the Archivio Centrale dello Stato demonstrate: for example, the initially adverse reaction to Joseph Wilpert's request to make watercolour copies of the paintings in Santa Maria Antiqua;[14] or the only partially favourable response (subject to a payment of a fee in support of the excavations) to Adolfo Venturi's request for photographs reproducing the frescoes, which the art historian wanted to include in the second volume of his *Storia dell'Arte Italiana*.[15] Permission to use the requested photos was eventually granted, but probably only just before the release of the book, since they do not appear in the index.[16] I cannot rule out the possibility that Venturi's resentful remark about the poor condition of the frescoes could have been prompted by Boni's dilatory attitude.[17]

In addition to Wilpert and Venturi, other scholars interested in the Santa Maria Antiqua frescoes also became irritated with the director of the Forum excavations, notably Wladimir de Grüneisen, who in his huge 1911 monograph complained that Boni, over a period of eight years and under the pretext of a forthcoming publication, had denied to all Italian and international scholars any opportunity to take pictures of the paintings and of the architectural structures, even going as far as forbidding them to take measurements and pencil sketches.[18]

Still, one may wonder why Rushforth could have been given a kind of 'fast track' to carry on his study of the church. Compared with scholars of other nationalities, he surely benefited from Boni's anglophile disposition, which blossomed thanks to the acquaintance and friendship with prominent figures such as John Ruskin, William Morris, and Philip Webb during the years spent by the Venetian archaeologist in the restoration team at the Palazzo Ducale.[19] When Boni moved to Rome to work as inspector of the monuments (1888–98), he maintained ties with the cultural milieu close to the Royal Institute of British Architects and the Society for the Protection of Ancient Buildings. Even when he began the excavations in the Roman Forum, British personalities were among his favourite respondents: perhaps it is not a coincidence that on the occasion of significant archaeological discoveries, such as the discovery of the *Lapis Niger* in 1899 and of Santa Maria Antiqua in the following year, Boni hastened to give notice to two great Englishmen, respectively John Ruskin, in a letter published later by Primo Levi, and James Frazer, in the course of a curious and informal night visit recalled in Tea's biography.[20]

The atmosphere of tension in which the debate about the topography and history of ancient and medieval Rome took place in those years should not also be overlooked: it was a very fierce *querelle* indeed, and one that required the parties to take clear sides.[21] The climax was reached just one year before the excavation of Santa Maria Antiqua, with the discovery of the *Lapis Niger*, the black stone found in the *Comitium* that was identified by most scholars as the tomb of Romulus. This discovery was hailed by Italian archaeologists and historians as a victory over the German school, founded on the scholarship of Barthold Georg Niebuhr (1776–1831) and Theodor Mommsen (1817–1903), who rejected the Romulus legend regarding the ancient origin of Rome. All the members of the Italian academic community and the most influential journals and newspapers marshalled against the so-called 'ipercritica alemanna' (German hyper-criticism) represented in Rome by Christian Hülsen, praising instead the new Roman Forum excavations conducted by Boni under the enlightened direction of Minister Guido Baccelli.

It was probably to distinguish themselves from the opinions upheld by the German Istituto di Corrispondenza Archeologica that the newly created Anglo-American schools in Rome—the American School of Classical Studies and the British School, founded respectively in 1894 and in 1900—supported the Italian archaeologists; and this approbation is clarified, for example, in 'The Condition of Historical Buildings in Italy', a long paper published in *The Times* on 9 January 1899 by Richard Norton, the new director of the American School.[22] Norton, usually a harsh critic of the Italians in his observations to the London *Times* about the mismanagement of the new archaeological sites and materials discovered in Rome, placed confidence in Baccelli's guidance of the Ministry and especially in Giacomo Boni, 'one of the most competent of the Government officials', who was praised for his diligence in the study and conservation of the Roman Forum monuments.[23] Considering that Norton's paper was published just one day before the announcement of the sensational discovery of the *Lapis Niger*, we cannot rule out that the paean bestowed on the Baccelli-Boni duo was composed with a view to achieving some political advantage. Furthermore, Norton's support of Boni was strengthened by a mutual friendship, as some letters sent in 1898 by Boni to Corrado Ricci clearly show.[24]

Academic and diplomatic English circles additionally offered a more concrete and precious support to the Forum excavations, as they made available the funds for the expropriation of the modern houses built in the area of the Basilica Aemilia: the lectures delivered by Baddeley to the Anglo-American community in Rome together with the recommendation of the British Ambassador Lord Currie induced Lionel Phillips in March 1899 to offer 500 pounds (then increased to 2400) for the undertaking of the archaeological surveys. Thanks to Tea's biography and Baddeley's diaries, we know that Philips was a wealthy Englishman coming from Pretoria in South Africa, where he had made a fortune from gold and diamond mines; less well known is his stormy political life and his involvement in the Uitlanders' uprising against Paul Kruger's government (the so called Jameson Raid of 1896) that resulted in his death sentence, later commutated to imprisonment and banishment from the Transvaal.[25] I believe that Baccelli became acquainted with Phillips's judicial troubles, and perhaps also for this reason had some hesitation in agreeing to his generous offer.[26]

It is in these conditions so favourable for relations with the Italian government that the British School was born; the initiative, undertaken in October 1899 by the Committee of the British School at Athens, to set up a British School at Rome in order 'to promote the study of Roman and Graeco-Roman archaeology in all its departments', was fulfilled a year later with the appointment of Gordon Rushforth as director.[27] As Wiseman rightly stresses, 'what had no doubt given the project its impetus and urgency was the dramatic success of Giacomo Boni's excavations in the Forum',[28] together with the goal of making a contribution, with critical studies and surveys, to the analysis of the monuments and to the interpretation of the data offered by the archaeological investigations. Given his art historical education, Rushforth promptly devoted himself to the study of the Santa Maria Antiqua frescoes, as some notes published in English newspapers in the first months of the year clearly reveal.[29] The idea of a more extensive study took shape around March 1901, together with the creation of the *Papers of the British School at Rome*, formally established at the end of June; it was in these months that the excavations were coming to an end, while graphic and photographic documentation of the architectural structures and of the frescoes was still in progress. In particular, in the summer of

1901 the notorious Byzantine coins, traditionally attributed to the Emperor Justin II (565–78), were found close to the south-eastern column of the church; it is known that coins (even their number is debated) disappeared very early, since Tea didn't know their whereabouts.[30] Some scholars even came to doubt their very existence. A letter that I have recently found among the papers of the Boni-Tea fonds in Milan sheds new light on the matter: it is a transcription of a letter sent on 17 August by Boni to Amy Allemand Bernardy, in which the archaeologist claimed to have found three coins close to the south-eastern column of Santa Maria Antiqua, attributing them, in unambiguous words, to the Emperor Justin I (518–27).[31]

Besides his correspondence with the young Bernardy, it does not appear that Boni divulged any information about this important discovery, whose impact on the history of the building and on the chronology of the frescoes remains to be assessed.[32] Even Rushforth, who in those days should have been 'with Boni in the Forum', fails to report the find, a fact that perhaps sheds light on the real substance of the relations between them: compared to the lively sharing of data and ideas between Boni and Baddeley, attested by their correspondence and other written sources,[33] Boni and Rushforth seem instead to have followed parallel but different paths. The Santa Maria Antiqua paintings were not central to Boni's scholarly interests, so it is not surprising that he delegated the art historical analysis to Rushforth, while he devoted his own energies to the preparation of the archaeological report, so often announced but never produced.[34]

Meanwhile, from 1901 until the first months of 1903—the period in which Rushforth was in Rome—Boni's mind and energies were quite completely absorbed by the excavation of the Sepolcreto close to the Temple of Antoninus and Faustina, which would offer exciting new archaeological evidence for the history of archaic Rome.[35] It should also be remembered that during this period the Campanile of San Marco in Venice collapsed (14 July 1902), with Boni's subsequent appointment as Commissario dell'Ufficio per i Monumenti del Veneto.[36] Given this new situation, it is easy to assume that his presence in Rome, and with it the opportunity to maintain relations 'with Rushforth in the Forum', was forcibly cut short.

1. Timothy Peter Wiseman, 'Con Boni nel Foro. I diari romani di W. St. Clair Baddeley', *Rivista dell'Istituto Nazionale di Archeologia e Storia dell'Arte*, s. III, 8–9 (1985–6), 119–49. For an English version, see Timothy Peter Wiseman, 'With Boni in the Forum', in *Talking to Virgil: a Miscellany* (Exeter: University of Exeter Press, 1992), pp. 111–48. For some of the issues discussed in this paper see Andrea Paribeni, 'Con Boni nel Foro? Gordon McNeil Rushforth, Giacomo Boni e la scoperta di S. Maria Antiqua', *Arte Medievale*, ser. IV, 9 (2019), 295–306.

2. See Welbore St. Clair Baddeley, *Recent Discoveries in the Forum 1898–1904, by an eye-witness* (London: G. Allen, 1904), and Baddeley's diaries now in the County Library at Gloucester, partially published by Peter Wiseman.

3. Eva Tea, *Giacomo Boni nella vita del suo tempo*, 2 vols (Milan: Ceschina, 1932).

4. For Alessandri see Francesco Valcanover, 'Alessandri, Angelo', in *Dizionario Biografico degli Italiani*, II (Rome: Istituto della Enciclopedia Italiana, 1960), p. 162; Jeanne Clegg, 'John Ruskin's Correspondence with Angelo Alessandri', *Bulletin of the John Rylands Library Manchester*, 60.2 (1978), 404–33; and Jeanne Clegg, 'John Ruskin's Correspondence with Angelo Alessandri', in *Ruskin, Venice and Nineteenth-Century Cultural Travel*, ed. by K. Hanley and E. Sdegno (Venice: Cafoscarina, 2010), pp. 69–107 (a revised version of the 1978 article). For the group of artists working on behalf of Ruskin see *Ruskin's Artists: Studies in the Victorian Visual Economy*, ed. by R. Hewison (Aldershot: Ashgate, 2000).

5. Tea, *Giacomo Boni*, II, 67.

6. The British Embassy occupied Villa Bracciano until 1946, when a Zionist attack destroyed the historic palace. The new Embassy building, designed by Sir Basil Spence, was erected on the site of the former one, close to the Porta Pia, and opened in 1971; see Miles Glendinning, '*Una lezione de civiltà*: the British Embassy in Rome', in *Basil Spence: Buildings & Projects*, ed. by L. Campbell and others (London: RIBA, 2012), pp. 172–95.

7. Gordon McNeil Rushforth, 'Obituary Notices. Giacomo Boni', *The Antiquaries Journal*, 5 (1925), 441–3.

8. Henry Wickham Steed, *Through Thirty Years, 1892–1922: A Personal Narrative*, 2 vols (London: Heinemann, 1924), I, pp. 178–84; Giovanna Farrell-Vinay, 'Profilo biografico di Henry Wickham Steed', in *Luigi Sturzo a Londra: carteggi e documenti, 1925–1946*, ed. by G. Farrell-Vinay (Soveria Mannelli: Rubbettino, 2003), pp. 115–34. Boni maintained good relations with British journalists in Rome. William J. Stillman, Wickham Steed's forerunner as *The Times* correspondent, was in close touch with Boni, as revealed by the entries in Tea's biography (Tea, *Giacomo Boni*, I, pp. 190–1, 208, 397, 468, 557; II, pp. 47, 424) and the letters preserved in the Archivio Boni-Tea. For the American journalist William Stillman and his wife, the stunning model and pre-Raphaelite artist Marie Spartali Stillman, see now Stephen L. Dyson, *The Last Amateur: The Life of William J. Stillman* (Albany: University of New York Press, 2014).

9. Federico Guidobaldi, 'Le carte dell'Archivio Boni-Tea all'Istituto Lombardo di Milano. Cenni sul ritrovamento, sulla consistenza e sullo stato di pubblicazione', in *Giacomo Boni e le istituzioni straniere: Apporti alla formazione delle discipline storico-archeologiche. Atti del Convegno Internazionale (Roma, 25 giugno 2004)*, ed. by P. Fortini (Rome: Fondazione G. Boni-Flora Palatina, 2008), pp. 23–31, with previous bibliography.

10. Andrea Paribeni and Federico Guidobaldi, *Giacomo Boni: documenti e scritti inediti. Catalogo ragionato dell'Archivio Boni-Tea (ILASL—Istituto Lombardo Accademia di Scienze e Lettere - Milano)* (Tivoli: Scripta Manent, 2020).

11. Rushforth's name is also absent in the two files related to Santa Maria Antiqua: XCII.a *S. Maria Antiqua—Documenti*, and XCII.b *S. Maria Antiqua Diaconia*.

12. Gordon M. Rushforth, 'The Church of S. Maria Antiqua', *Papers of the British School at Rome*, 1 (1902), 1–123.

13. Ibid., p. B (1).

14. See Carlo Fiorilli's letter to Boni in Rome, Archivio Centrale dello Stato [hereafter ACS], Min. P.I., AA.BB. AA., III versamento, II parte, busta 697, fasc. 1141.3: 'La S.V ha fatto bene non concedendo a Mons. Wilpert il permesso di far copiare da un acquarellista le pitture a fresco testè scoperte nella chiesa medievale presso S. Maria Liberatrice. È necessario che l'illustrazione di quelle vetuste, importantissime pitture sia intrapresa e condotta a termine a cura di questo Ministero'. In Wilpert's memoir—*Erlebnisse und Ergebnisse im Dienste der Christlichen Archäologie* (Freiburg: Herder, 1930), pp. 110–5—Boni's behaviour during the excavations is harshly criticised; see also Giulia Bordi, 'Giuseppe Wilpert e la scoperta della pittura altomedievale a Roma', in *Giuseppe Wilpert archeologo cristiano. Atti del Convegno (Roma 16– 19 maggio 2007)*, ed. by S. Heid, Sussidi allo Studio dell'Archeologia Cristiana, 22 (Vatican City: Pontificio Istituto di Archeologia Cristiana, 2009), pp. 323–58 (pp. 327–9).

15. See Boni's letter to Direzione Generale Antichità e Belle Arti of 21 February 1901 in ACS, Min. P.I., AA.BB.AA., III versamento, II parte, busta 697, fasc. 1141.15, *Roma Foro Romano Santa Maria Antiqua*; Adolfo Venturi, *Storia dell'Arte Italiana*, 11 vols (Milan: Hoepli, 1901–40), II: *Dall'arte barbarica alla romanica* (1902).

16. Venturi, *Storia dell'Arte Italiana*, II, pp. 215, 219, 381, 383, 385, 387, 389.

17. Ibid., p. 250: 'E più di tutto, se l'umidità e la luce e gli uomini non li avessero in gran parte distrutti, potremmo studiare quelli [i.e. the frescoes] delle antiche chiese cristiane del Foro Romano, specialmente i numerosi

affreschi di vario tempo scoperti sotto l'abbattuta chiesa di S. Maria Liberatrice, là dove sorgeva, tutta variopinta, dentro le altissime mura delle costruzioni imperiali, Santa Maria Antiqua.'

18 Wladimir de Grüneisen, *Sainte-Marie-Antique* (Rome : M. Bretschneider, 1911), p. 92. See also an unsigned notice in *Tribuna Illustrata della Domenica*, 30 December 1900—quoted in Tea Martinelli, 'Thomas Ashby e Giacomo Boni', in *Archeologia a Roma nelle fotografie di Thomas Ashby 1891–1930* (Naples: Electa, 1989), p. 13— in which the author complained that 'con una gelosia che può ben dirsi esorbitante e quasi ridicola, le autorità agli scavi proibiscono di prendere fotografie e schizzi di monumenti venuti in luce'. For de Grüneisen and the broader historiography of Byzantine art developed in Italy at the dawn of twentieth century after the discovery of Santa Maria Antiqua, see Giovanni Gasbarri, *Riscoprire Bisanzio: Lo studio dell'arte bizantina a Roma e in Italia tra Ottocento e Novecento. Un nuovo indirizzo della storiografia nel contesto europeo* (Rome: Viella, 2015), pp. 201–30.

19 Among the vast bibliography on this subject see Amedeo Bellini, 'Giacomo Boni ed il restauro architettonico tra istanze ruskiniane e compiutezza formale', in *Giacomo Boni e le istituzioni straniere*, ed. by P. Fortini, pp. 105–22; Marco Pretelli, 'L'influsso della cultura inglese su Giacomo Boni: John Ruskin e Philip Webb', in *Giacomo Boni e le istituzioni straniere*, ed. by P. Fortini, pp. 123–38; Myriam Pilutti Namer, 'Ruskin e gli allievi: Note su Giacomo Boni e la cultura della conservazione dei monumenti a Venezia a fine Ottocento', *Ateneo Veneto*, 3rd ser., 12 (2013), 423–35.

20 See L'Italico (Primo Levi), 'La riabilitazione del Foro Romano', *Rivista politica e letteraria* (1899), 135–7; and Tea, *Giacomo Boni*, II, 50. See also Andrea Augenti, 'Giacomo Boni, gli scavi di Santa Maria Antiqua e l'archeologia medievale a Roma all'inizio del Novecento', *Archeologia Medievale*, 27 (2000), 39–46 (pp. 39, 42).

21 Recalling the archaeological debate of those years, Henry Wickham Steed wrote that 'into the world of Roman Archaeology and of classical folklore none but hardy souls will lightly venture. The very approaches to it are guarded by high priests armed with two-edged swords, ready to slay the imprudent adventurer. Theology itself is a harmless exercise in comparison with the dangers that beset the pursuit of archaeology; and the *odium theologicum* may be the essence of charity in comparison with the *odium archaeologicum*', Wickham Steed, *Through Thirty Years*, p. 178.

22 For Richard Norton, Director of the American School from 1899 to 1907, see Francis W. Kelsey, 'Richard Norton', *Art & Archaeology*, 8 (1919), 329–35; and Stephen L. Dyson, *Ancient marbles to American Shores: Classical Archaeology in the United States* (Philadelphia: University of Pennsylvania Press, 1998), pp. 76 ff.

23 For Norton's paper, see Lanciani, *Notes from Rome*, pp. 241–7; the paper is signed by Norton 'Rome, Dec. 26'.

24 In these letters (Ravenna, Biblioteca Classense, Fondo Ricci, *Corrispondenza*, 19, nos 4223, 4225) Boni introduced his friend to Ricci, remarking that he was the son of the great Dante scholar, Charles Eliot Norton. Part of the letter is quoted in Ferruccio Canali, 'Giacomo Boni e Corrado Ricci 'amicissimi' tra Roma e Venezia. Questioni di archeologia, conservazione e restauro dei monumenti nell'Italia unita (1898–1925)', *Studi Veneziani*, 66 (2012), 575–656 (p. 581).

25 Florence Philips, *Some South African Recollections* (London: Longmans, Green 1900); and Maryna Fraser and Alan Jeeves, *All that Glittered: Selected Correspondence of Lionel Phillips, 1880–1924* (Cape Town: Oxford University Press, 1977).

26 Baddeley wrote in his diary that the offer of 500 pounds was made by Philips on 3 March 1899 after a moving conference about the Basilica Aemilia, but Italian authorities did not give a reply; a week later Baddeley told the story to Wickham Steed who 'resolved to awaken the official energies so markedly dormant': see Wiseman, 'Con Boni nel Foro', p. 130.

27 Wiseman, 'The First Director', pp. 146–7. Rushforth established himself at the beginning of 1901 in the British School's first location, at the Palazzo Odescalchi.

28 Wiseman, 'The First Director', p. 147.

29 See the reports published in *The Times* and *The Guardian* respectively on 9 January and 19 June 1901. Rushforth arrived in Rome with the reputation of a good connoisseur of fifteenth-century Italian painting: see for example his 1900 monograph on Carlo Crivelli.

30 Eva Tea, *La Basilica di Santa Maria Antiqua* (Milan: Società Editrice 'Vita e Pensiero', 1937), pp. 7, 19, 362.

31 Andrea Paribeni, 'Giacomo Boni e il mistero delle monete scomparse', in *Marmoribus vestita. Miscellanea in onore di Federico Guidobaldi*, ed. by O. Brandt and P. Pergola, Studi di antichità cristiana 63 (Vatican City: Pontificio Istituto di Archeologia Cristiana, 2011), pp. 1003–23 (pp. 1014–15). For Amy Allemand Bernardy, see Maddalena Tirabassi, *Ripensare la patria grande: gli scritti di Amy Allemand Bernardy sulle migrazioni italiane (1900–1930)* (Isernia: Iannone, 2005); further bibliography in Paribeni, 'Giacomo Boni e il mistero delle monete scomparse', pp. 1014–15.

32 Regarding this issue see now Giulia Bordi, 'Santa Maria Antiqua. Prima di Maria Regina', in *L'officina dello sguardo: Scritti in onore di Maria Andaloro*, ed. by G. Bordi and others, 2 vols (Rome: Gangemi, 2014), I, pp. 285–90 (p. 289). Even in the 'Giornale dei lavori 1900–1907' written by Romolo Artioli, there are no entries about the Santa Maria Antiqua excavations from the end of July until the beginning of October of 1901: see the transcription of the diary in Patrizia Fortini and Giulia Bordi, 'Cronaca dello scavo e della sua documentazione. 1900–1907', in *Santa Maria Antiqua tra Roma e Bisanzio*, ed. by M. Andaloro, G. Bordi, and

G. Morganti (Milan: Mondadori-Electa, 2016), pp. 300–315. Further bibliography in Paribeni, 'Con Boni nel Foro?', pp. 301, 304.

33 Wiseman, 'Con Boni nel Foro', passim.

34 Paribeni, 'Giacomo Boni e il mistero delle monete scomparse', pp. 1005–10. Even if it may be true that Boni was not particularly involved in the art historical study of the Santa Maria Antiqua paintings, he did demonstrate great dedication in caring for the architectural restoration of the monument; see Morganti, 'Giacomo Boni e i lavori di S. Maria Antiqua'; and Patrizia Fortini, 'La Rampa domizianea nei restauri di Giacomo Boni', in *La rampa imperiale: Scavi e restauri tra Foro Romano e Palatino. L'Aula nord-orientale del complesso domizianeo (cd. Oratorio dei XL Martiri) e il Lacus Iuturnae dalla demolizione della chiesa di S. Maria Liberatrice*, ed. by P. Fortini (Milan: Electa, 2015), pp. 27–37. Boni also showed great interest in the documentation and conservation of the frescoes, as the documents kept in the Archivio Centrale dello Stato show; see Giulia Bordi, 'Copie, fotografie, acquerelli. Documentare la pittura medievale a Roma tra Otto e Novecento', in *Medioevo: immagine e memoria. Atti del Convegno Internazionale di Studi (Parma, 23–28 settembre 2008)*, ed. by A. C. Quintavalle, I Convegni di Parma, 11 (Milan: Electa, 2009), 454–62 (pp. 454–8); Bordi, 'Giuseppe Wilpert', pp. 329–33; Fortini and Bordi, 'Cronaca dello scavo'.

35 Giacomo Boni, 'Scoperta di una tomba a cremazione nel Foro Romano', *Notizie degli Scavi* (1902), 96–111; Giacomo Boni, 'Foro Romano. Sepolcreto del Septimontium preromuleo', *Notizie degli Scavi* (1903), 123–70; Giacomo Boni, 'Foro Romano. Sepolcreto del Septimontium preromuleo (3° rapporto)', *Notizie degli Scavi* (1903), 375–427; Giacomo Boni, 'Foro Romano. Esplorazione del Sepolcreto (4° Rapporto)', *Notizie degli Scavi* (1905), 145–93; Giacomo Boni, 'Foro Romano. Esplorazione del Sepolcreto (5° Rapporto)', *Notizie degli Scavi* (1906), 5–46; Giacomo Boni, 'Foro Romano. Esplorazione del Sepolcreto (6° Rapporto)', *Notizie degli Scavi* (1906), 253–94; Giacomo Boni, 'Foro Romano. Esplorazione del Sepolcreto (7° Rapporto)', *Notizie degli Scavi* (1911), 158–90. In addiiton to the analysis of the materials recovered by the Sepolcreto excavation, Boni wrote some unpublished papers whose goal was to place the archeological data in a broader context, see Andrea Paribeni, 'Note dall'Archivio Boni-Tea: I materiali grafici per lo studio della *Casa Romuli*', in *Tra Roma e Venezia, la cultura dell'Antico nell'Italia dell'Unità: Giacomo Boni e i contesti* ed. by I. Favaretto, M. Pilutti Namer (Venezia: Istituto Veneto di Scienze, Lettere ed Arti, 2016), 183-211.

36 Except for a few days in October, Boni was in Venice from early July until December 1902; he also returned to Venice in March 1903, but in April he was already back in Rome; see Tea, *Giacomo Boni*, II, 101–20; and Paribeni and Guidobaldi, *Documenti inediti*, pp. 161–4; 446–52 (commentary on file CXV, 'Venezia. Campanile di S. Marco').

ERNESTO MONACO

Measuring Santa Maria Antiqua: From Petrignani to the Present

This paper reviews the history of Santa Maria Antiqua from the perspective of the surveys and descriptions that have followed the 1900 excavation led by Giacomo Boni. The story that began then is still unfinished, since it follows the history of the complex in its entirety, from its rediscovery up to the present day.[1] The essay is based on two essential premises. The first is that in recent times the drawings that documented and described the results of Giacomo Boni's 1900 excavation campaign have attracted renewed scholarly interest. This interest has been directed specifically at their documentary value, rather than their artistic merits. They provide reliable information regarding excavation contexts that are no longer replicable and structural conditions that are otherwise impossible to verify, and are therefore key sources for any critical study of Santa Maria Antiqua.

The second premise is that the recording of ancient structures has acquired an independent role in research, no longer secondary to, or considered exclusively in support of, archaeological inquiry. Those engaged in the field are 'bound [...] to historical and critical investigation, to precision not only in taking measurements but also in providing an interpretation [...] in other words, to the responsible production of works that fully adhere to the cognitive demands that the structure itself presents.'[2] A new methodological approach is developing in which the objective topographical-geometrical outline of a structure becomes the basis for the technical and critical analysis.[3] In this context, recording and analysing the features of a structure aim at illuminating both the process of material construction of the building and the parallel 'construction' of its identity. The approach adheres closely to the lesson of the architect Paolo Marconi, who envisioned a way of 'designing the past' through the application of philological tools.

When the Soprintendenza Speciale per i Beni Archeologici in Rome initiated a general survey of the basilica complex in 2003, it also undertook the organisation and analysis of the collection of relevant drawings held in the Soprintendenza's archives.[4] The authors of these graphic documents were Antonio Petrignani [hereafter AP], Leonardo Paterna Baldizzi [hereafter PB],

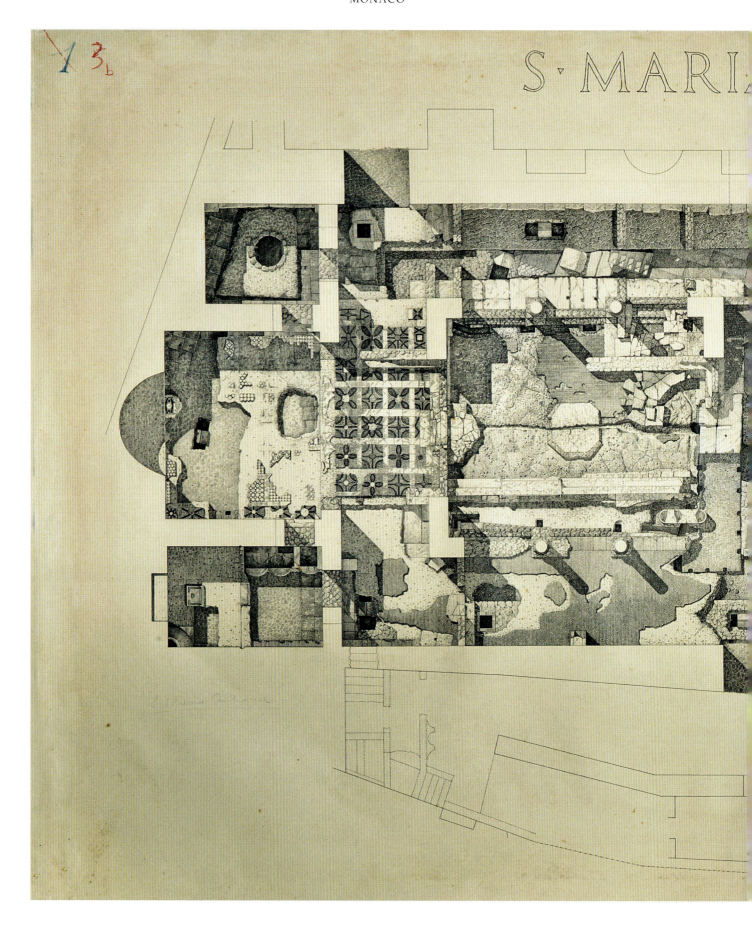

1 Antonio Petrignani: general plan showing the results of the archaeological excavations in the basilica and atrium
 (Archivi del Parco archeologico del Colosseo, segnatura 1 blu/3b rosso)

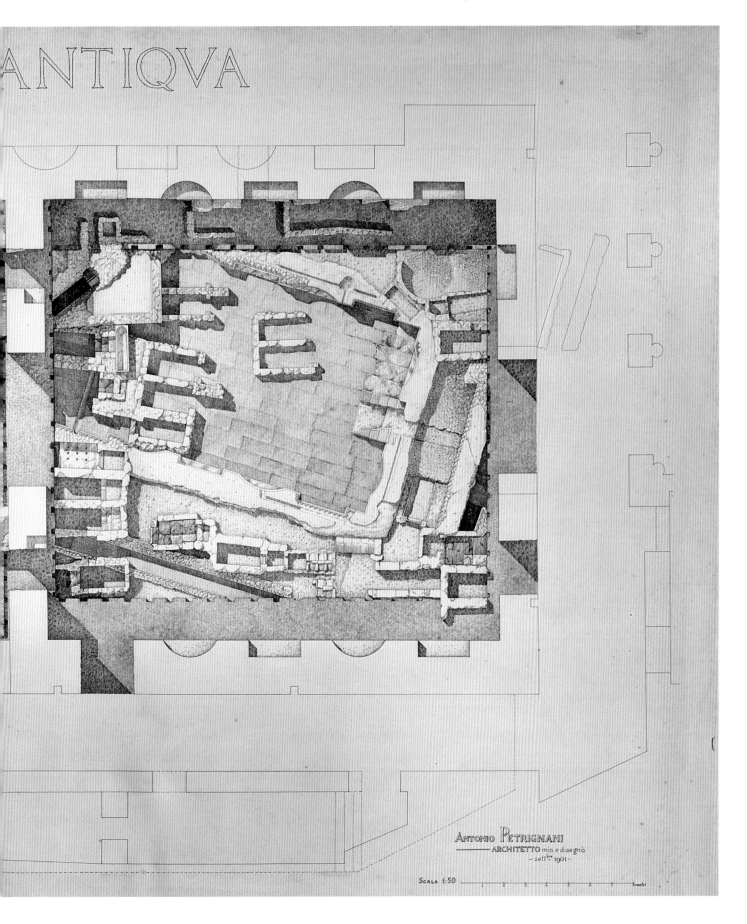

and Pietro Picca, but we owe to Petrignani and Paterna Baldizzi the most substantial descriptive materials related to the structure.[5] The Petrignani holdings consist of:

1. AP1: a 1:50 plan showing the results of the archaeological excavations in the basilica and atrium (Figure 1);

2. AP2: an axonometric drawing of the basilica seen from the north-east, produced at the end of the excavations and before the restoration work was carried out (Figure 2);[6]

3. AP3: a series of studies for the reconstruction of the arches between the central nave and the right aisle;

4. AP4: a series of line drawings of the frescoes;

5. AP5: a series of studies for the reconstruction of the original basilica;

6. AP6: a series of projects for the construction of the central roof.

The first five items in the list date between 1900 and 1902, while the last group of projects dates to 1911, when the roof was added.[7]

The Paterna Baldizzi drawings were prepared by him alone, and are limited to documentation of the mosaic and *opus sectile* flooring in the area of the sanctuary:

1. PB1.1: a drawing of the floor in 1:50 scale, dated 1 February 1901, with specific details (1:5 scale) of the areas of restoration inserted into the mosaic (Figure 3);

2. PB1.2: a drawing of the area in front of the apse, dated 2 May 1902, showing the layer under the *opus sectile* flooring, revealed by the removal of the screed (Figure 4).

In addition to these two records, there is also an additional document by Paterna Baldizzi (PB2.1) in the archive of the Accademia Nazionale dei Lincei in Rome. In his notebook, there is a measured and annotated plan, along with section sketches, of a trial excavation conducted under the flooring in the west corner of the apse.[8]

Lastly, there is Picca's 1902 axonometric drawing, which records the tombs in the late antique cemetery uncovered in the atrium.[9] This cemetery, which was included in Petrignani's general plan, is fully unpublished and otherwise largely unknown.[10]

Paterna Baldizzi's work complements and enriches Petrignani's documents. The dates of the drawings detail the evolution of the recording campaign: PB1.1 (February 1901) relates to the initial excavation of the basilica, while PB1.2 (May 1902) was made immediately before the restorations and integrations of flooring losses in the area in front of the apse.[11] The area documented by Paterna Baldizzi, moreover, is larger than that recorded by Petrignani. PB2.1 is particularly important, because it is the only drawing that includes a profile view of the increment in the height of the floor that took place between the imperial era and the laying of the mosaic flooring, complete with measurements and annotations.

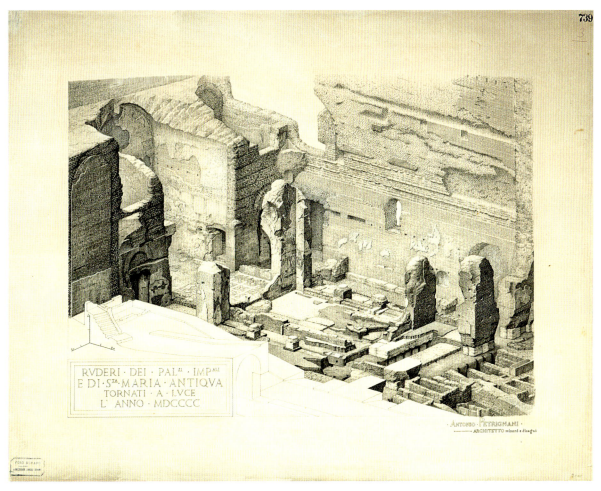

2 Antonio Petrignani: axonometric view of the basilica at the completion of the excavations and prior to restoration work, seen from the north-east (Archivi del Parco archeologico del Colosseo, segnatura 739/3)

Paterna Baldizzi and Petrignani's works are, however, clearly interrelated. Paterna Baldizzi's documents deal with a single subject in greater detail, and offer data that are not present in Petrignani's plan. While Paterna Baldizzi dated his drawings, those by Petrignani can only be dated indirectly, based on information we have about the context in which they were produced.[12] While these documents provide only fragmentary evidence, we have no other overall plan of the excavations with complete annotations of their progress. Thus, these few available records represent 'snapshots' of the entire worksite. Furthermore, Paterna Baldizzi's intervention at Santa Maria Antiqua, although limited to a single subject, is of exceptionally high quality. From the Lincei notebook we know that he was active at the site on 12 May 1902, and that on 10 and 14 May he was present for the documentation of the nearby House of the Vestals. It is possible that, given the urgency of the works at the basilica, which were completed in 1902, the situation had made it necessary to request Paterna Baldizzi's intervention in this specific area.

The campaign of documentation must be understood in the larger context of the programme of excavation conducted on the north-east slope of the Palatine Hill, for which we provide here a full list of the works undertaken.[13] Between 1900 and June 1902, a list of the most notable

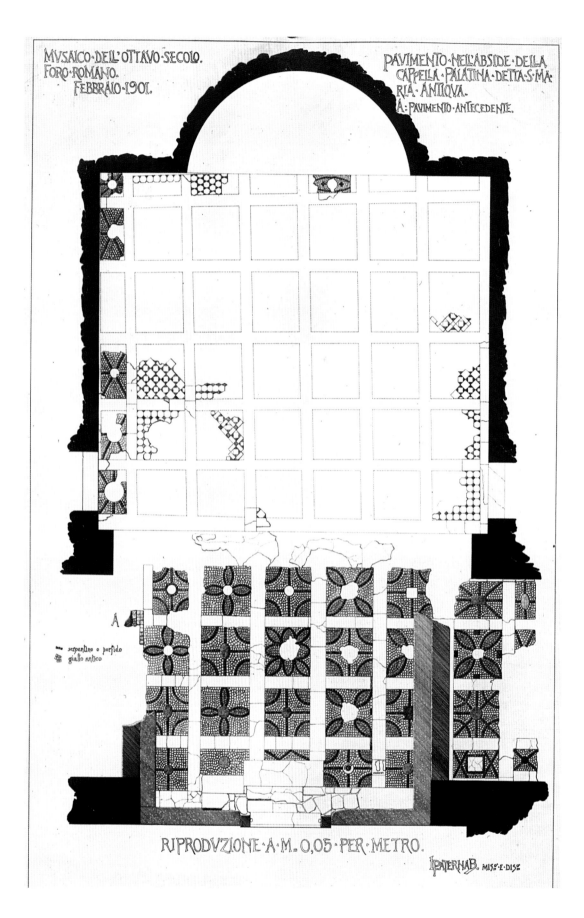

3 Leonardo Paterna Baldizzi: sanctuary and choir enclosure. Drawing of the flooring in 1:50 scale, dated 1 February 1901, with detail (1:5 scale) of restoration inserts in the mosaic flooring (Archivi del Parco archeologico del Colosseo, segnatura 738)

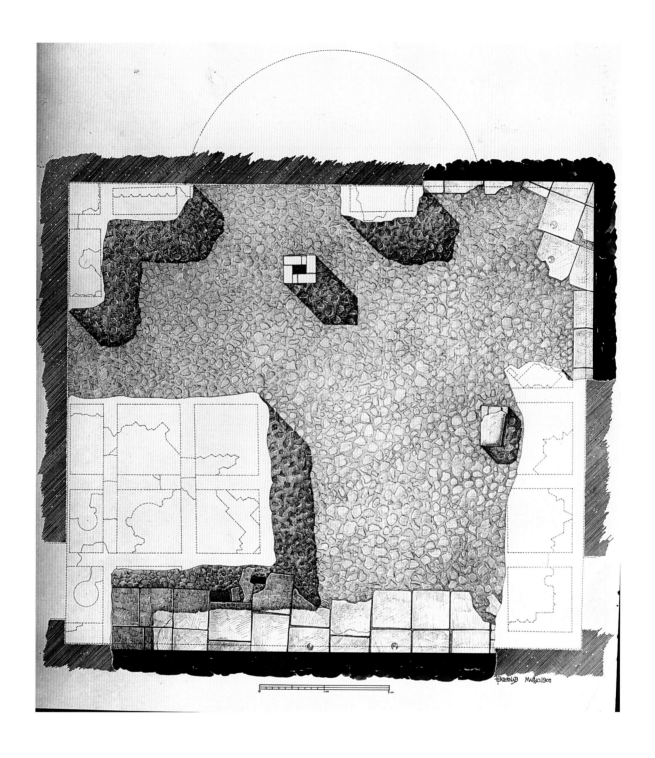

4 Leonardo Paterna Baldizzi: drawing of the area in front of the apse (sanctuary) dated 2 May 1902, showing the situation under the *opus sectile* flooring, as revealed by the removal of the screed (Archivi del Parco archeologico del Colosseo, segnatura 737/1)

interventions was reported in the official publication *L'amministrazione della antichità e belle arti in Italia*:[14]

 1 The demolition of the Church of Santa Maria Liberatrice.

 2 The uncovering of the vestibule, attic, *impluvium* and ramp of the imperial building converted to a Palatine chapel, known as 'Santa Maria Antiqua', rich in sixth-to-eighth-century paintings; the works of preservation of the paintings.

 3 The measured survey of the Forum, in the area between the Colosseum and the Tabularium (carried out by the Regia Scuola di Applicazione degli Ingegneri).[15]

 4 The uncovering of the large pool or *nymphaeum* beneath the atrium of the Hadrianic building.

 5 The reconstruction of the collapsed roof of the Palatine church of Santa Maria; The application of glazing as protection for the medieval paintings, and the consolidation of the floorings in *opus sectile* and marble mosaic. (The new walls were executed in brick with surface pock-marking, to distinguish it from the antique materials. The geometric flooring sections were completed with red and yellowish brick-like material, to convey an impression of the overall design, without compromising the authenticity of what remained of the antique work.)

 6 The reconstruction of the two collapsed imperial ramps going up the Palatine.

The preceding paragraphs summarise the contents of the drawings and place them in the context of the day-to-day operations undertaken between 1900 and 1902. We should next turn to an assessment of their merits. At the bottom of the drawings the two architects appended the notations 'measured and outlined' (Petrignani, 'misurò e delineò') and 'measured and drawn' (Paterna Baldizzi, 'misurò e disegnò'). It seems evident that the process of preparation began from a detailed survey undertaken *in situ*, leading to a subsequent graphic elaboration in greater detail, enhanced by the use of pen on heavy paper. The result is of exceptionally high quality, and in the plans the use of shadowing gives a sense of depth and of shifts in level that are not indicated numerically.[16] From a comparison with other notebooks compiled by Paterna Baldizzi (the House of the Vestals, for example), the process initially involved sketching the structures, including many details and annotations, as well as a diverse series of measurements: partial, progressive, and trilateral repeated around the same point, with a level of data density that guaranteed a reliable rendering of the features of the site.[17] This technique required careful editing of the preliminary drawings (eidotypes), and precise recording of the measurements taken *in situ*. To assemble the finite plans, a series of final checks and controls against the original were carried out. The process relied therefore on a high degree of manual skill, great sensitivity in drawing, and a thorough knowledge of the structure, all elements that are today considered part and parcel of a 'traditional survey'. This definition originated at the end of the 1980s, when computerised topographic tools became widely available, and has been further strengthened from the early 1990s as computer-assisted drawing (CAD) took hold. There is no doubt that the application of ever evolving computer technologies to the documentation of

5 Pietro Picca: medieval tombs in the atrium of Santa Maria Antiqua (Archivi del Parco archeologico del Colosseo, segnatura 36 rosso)

archaeological sites has increased our ability to describe and analyse architectural structures, a subject to which I shall return later in this essay.[18]

The accomplishments of Petrignani and the other architects working on Santa Maria Antiqua must be contextualised to fully grasp their merits. Boni's campaign of excavations was a major project, bringing to light a large surface area at the centre of the Roman Forum. The profound transformation of this landscape within an urban context raised new issues in archaeological topography, leading to the need to create cartographic documents capable of keeping accurate track of the elements that gradually came to light as the excavation progressed. The protection and preservation of the monuments was one of the principal issues concerning Boni. He wanted to transform the research area into a 'laboratory of architectural experimentation',[19] so he involved a group of specialists who would develop new techniques of documentation suitable to his aims. Boni created the hybrid position of 'architect-archaeologist', to conduct studies that would inform his plan to restore and rebuild the monuments.[20] Boni's activity in this regard was methodologically innovative, combining traditional recording with the most advanced technologies available at the time.[21]

It is beyond doubt that, in the context of the cartographic practices of the time, Marco Giammiti's plan of the Palatine and Roman Forum, commissioned in 1895, occupied a leading position.[22] In 1899 he received the further directive to carry out 'the delicate work of updating'. Giammiti's planimetric work is precise and detailed, but is completely lacking in absolute

altimetric values and in altimetric profiles. Boni indeed commented: 'I do not know how to coordinate the explorations carried out on the subsurface. The execution of the profile [...] has to be done with instruments of precision.'[23] Responsibility for the elevations and topographic verification was assigned to the Scuola di Applicazione degli Ingegneri, under the lead of Vincenzo Reina, in the context of the vast topographic and cadastral surveys carried out in post-Unification Italy. The field operations and relative graphic documents were completed by 1900, and the results were published by Boni. He indicated that the topographic records had been based on 'the most concise surveys possible, exact in their whole and allowing for subsequent integration of the details of each exploration.'[24]

When the Scuola di Applicazione degli Ingegneri finished the fieldwork in 1899, the documentation was directed at the structures that had been excavated up to that point. The area concerned is shown in a photograph taken from a hot-air balloon, in which the north-east slope of the Palatine is shown before the excavation, with Santa Maria Liberatrice still visible, as its demolition began only later, on 8 January 1900.[25] The survey would lay the cartographic foundations for the publication of the report *Media Pars Urbis* (1911).[26] Its preparation spanned an entire decade, and the stages of work are described in a 1910 article by Reina: [27]

1900: First survey of the Roman forum;[28]

1902–3: Survey of the south-west part of the Palatine;[29]

1905: Completion of the survey, following the full appropriation of the Palatine by the Italian State.

Reina commented:

With the completion of the works in summer 1906, the spontaneous idea arose of connecting the Palatine directly to the adjacent monumental area, which means first to the Roman Forum. [...] The operations in the Roman Forum took place in the 1906–7 academic year, but because of the complex intertwining of the various visible archaeological strata (for which, within the limits possible, representation was desired), it was necessary to repeatedly return to the finished work, modifying, retouching, and completing it until recently. In the following years, the survey of the remaining monumental area was carried out.[30]

How do the operations reported in Reina's account relate to Petrignani's documentary work? To answer this question, we can look at Sheet 5 of Reina's 1911 publication, representing the north-east slope of the Palatine Hill with the Domitianic buildings and the atrium of the House of the Vestals ('Survey of Block IV, covering the House of the Vestals and adjacent areas up to the apsidal side of the Basilica of Maxentius, May 1900').[31] The drawing shows structures that in May 1900 would not have been visible. The first is the Spring of Juturna, whose detailed visual reproduction and undeniable affinity with Boni's published work suggest that Reina relied on the archaeologist's excavation drawings.[32] The second structure is the courtyard of the House of the Vestals, showing evident similarities to Paterna Baldizzi's drawings. The third

structure is the Santa Maria Antiqua complex, including the initial part of the Domitianic Ramp, whose walls would be fully legible only in 1902, when they were recorded by Petrignani. It is clear, therefore, that Reina relied extensively on the work of the two architects for his survey report.

In the drawings of Block IV we can clearly discern the topographic benchmarks and the lines connecting them. Considering that by 1902 the archaeological features beneath the restored floor were no longer visible, the drawing must have been produced no later than 1901, at the same time as Boni's publication of the Sanctuary of Juturna.[33] Reina's Block IV drawing is simplified in its detailing of the area of the Spring of Juturna towards the Temple of Castor and Pollux (reburied afterwards), while the area of Santa Maria Antiqua is enhanced by the presence of the pre-Domitianic *piscina* in the atrium and by the details of the flooring. The dimensions of the *nymphaeum* and the flooring are similar to those in Petrignani's plan. Two photographs in the archives of the Soprintendenza, both dated to September 1900, show the structural and wall features also represented by Reina. This suggests that the preparation of the Block IV drawing was based as much on Petrignani's and Paterna Baldizzi's excavation drawings as on surveys conducted directly *in situ*.[34] This would also explain Reina's written remark that it was necessary 'to repeatedly return to previously finished work, modifying, retouching, and completing.'

The documentation work described thus far demonstrates that between 1903 and 1910 there was a substantial production of graphic *corpora*, which were conceptually complementary but were not published in print or map form, so ended up being largely forgotten.[35] While it is yet to be fully understood why Reina's work was not disseminated, it may be easier to address why this was also the case for Petrignani and Paterna Baldizzi. The reason is related to Boni's failure to publish his excavation of Santa Maria Antiqua, an inaction which has been critically assessed by Andrea Paribeni.[36] Boni's various announcements of an impending publication mentioned only the Palatine chapel and the frescoes, because in his opinion they were the most interesting and key to reading the whole complex. This approach led to the development of an 'architecture of paintings',[37] which created a rupture in the relationship between the structure and its decorations—a relationship that becomes even more critical in a building like Santa Maria Antiqua, where there is no chronological correspondence between the decorations and the walls that support them.[38] The significant gap between our knowledge of the painted decoration and that of the structural context was therefore determined very early on in the history of the basilica's discovery and excavation, particularly by a lack of a comprehensive programme of works.[39] This is further demonstrated by the absence of journal accounts recording the campaign. While the analysis of the paintings is supported by a large literature, scarce (albeit important) notes on the buildings were published by Eva Tea only in 1937, more than thirty-five years after their discovery.[40] Tea relied on fieldwork notes and drawings made at the time of the excavation or soon afterwards, in particular those of Boni's assistant Romolo Artioli, documenting the interventions up to 1907 in the block towards the Horrea Agrippiana, Boni's own notes on the *piscina*, and the observations by Petrignani and Paterna Baldizzi, and on a fragmentary lintel block recovered in the apse area.

Boni's notes on the *piscina* are particularly telling. He provides a detailed but nonetheless summary analysis of the masonry structure, noting that 'on the rim of the nymphaeum there

Santa Maria Antiqua and the Domitianic building. General plan (Ernesto Monaco, 2016)

are traces of a groove for the insertion of the barrier or balusters that must have fenced off the pool, which will be restored with a simple wooden barrier that makes it possible to leave open the excavation of the ancient pool. The pool now appears completely freed of the tombs and fragmentary material'.[41] It is evident that Boni and his collaborators were considering turning the site into an open-air museum, with the stratification of the complex exposed to view. This premise emerges from two of the Soprintendenza's archival photographs (September 1900), where the central hall can be seen to be still uncovered by a roof and the frescoes protected by reed mats. The nave's floor levels are in a re-composition that negotiates a compromise between the original levels and the restored ones. The *piscina* has been cleared of its tombs, and the marble fragments recovered in the excavations are grouped against the walls. The area is clearly shown after the completion of excavations and, as noted previously, this is also the time represented in Sheet 5 of Reina's survey.

It is against this background of history, form, and content that the current documentation of Santa Maria Antiqua is carried out.[42] The modern survey, like all research activity, is the continuation of a process that uses means and methods that have developed uninterrupted since the original discovery of the site (Figure 6).[43] The current recording procedures fall well within this historically determined approach: preparation of an ample supporting topographic network, detailed recording, codification of the graphic data, and now their computerised vectorisation. This approach, continuously monitored over the course of the work, has allowed to record and research a wider area, reaching beyond the basilica to reconstruct the larger topographical context around it. The impact of this operation goes beyond the archaeological and topographical fields, providing crucial information for the complex's restoration and conservation.[44]

What we measure and record is inevitably limited to the building's current state. To modern observers there is an evident—and seemingly unbridgeable—gap between the evidence presently available for study and what was documented in the early 1900s but is no longer extant. When we evaluate the documentation from that period, we can only accept that our access to the site has been considerably reduced. Recent efforts provide a documentary description of the present geometry and structural features of the complex. The use of computerised tools also creates a highly advanced database for the management and monitoring of the conditions of the structure, a base reference for further investigations of the conservation interventions (both general and targeted). In addition, the procedures of scanning and vectoring the historic drawings and graphic records lead to their constant regeneration and update, thus overcoming the material limitations imposed by interacting with the fragile original documents on paper. The transfer of a 'traditional' drawing or document into a digital format must faithfully retrace its original fabric and lines. We must take into account the drawings as objects of study themselves, maintaining a critical position that respects them as testimonies to a particular era.

Whether on the draughtsman's table or a modern computer screen, in terms of their object of study and formal content the graphic data must be made analogous by means of reciprocal integration and/or linear interpolation. In the final analysis, we can consider the most recent survey as a topographic and geometric master plan, to which the preceding historic plans can be related through reference to significant points that are common to both, in an operation of calibration and balancing that operates on the level of geometry and not on the level of

content. That this interpolation is possible on a topographic level is demonstrated by the fact that the wall geometries recorded by Petrignani are amply compatible (for their position and profile) with those derived from modern-day instruments.[45] Consequently, it has been possible to digitise and place all the structures of the site (including those now no longer visible) within the current survey with great certainty.

A survey is not only a series of measurements, but also an analysis and identification of the structures, with interesting and sometimes unexpected discoveries. This was the case for the rediscovery of an unpublished travertine block from a lintel that belonged to the imperial fabric and was partially hidden by the restorations. The block, however, was accurately reported in Petrignani's axonometry and also mentioned (although cryptically) by Tea.[46]

The digitisation of the documents discussed in this essay constitutes a rich visual reference. But in no way should it encourage an approach to the study of Santa Maria Antiqua that relies solely on hypotheses, without the objective verification that the losses have made impossible. Quite the opposite: an accurate archaeological and architectural discussion can only result from a study of the entire complex, including both the imperial and medieval interventions. The Boni restorations, moreover, should receive renewed attention: for example, focusing on the variations in the re-construction of the stone floors set against what was recorded in the early twentieth century. We must re-measure and 're-design' Santa Maria Antiqua; but this is a new chapter.

Post scriptum

The publication in 2016 of *Santa Maria Antiqua fra Roma e Bisanzio* is evidence of the continuing interest in the church. But while the study of the wall paintings contributed to what was an already rich literature on the subject, the essays addressing architectural and topographical issues opened original lines of inquiry, for example concerning the structure of the complex and the history of Boni's excavations.[47] These new paths prompt an analysis of the building that will liberate it from being merely an 'architecture of paintings'. In the same spirit we are trying to reconstruct Boni's excavations, using both the graphic documents and his notes.

As noted previously, Boni did not publish the results of his excavation.[48] Thus, Petrignani and Paterna Baldizzi's drawings are the sole substitute for a report that never was. Moreover, the structures that they record were subsequently reburied to restore the basilica's floor level, and in that process permanently hidden. So, even if Boni's excavation is officially undocumented, the drawings constitute an important source of data.[49]

Generally, architectural surveys are seen as visual aids to the written text, so the process and circumstances of their production are rarely considered. At times the archaeological analysis does not take into consideration the philological work necessary for a survey. In this paper I have introduced a concept that I shall call 'consultation', an argument that I shall develop in a future study. By analysing a series of drawings concerning the whole area of Santa Maria Antiqua we can posit that from 1900 (Reina) until 1901–2 (Petrignani and Paterna Baldizzi) Boni conducted a comprehensive survey of the site. But the drawings were never published, so they have yet to be fully included into the scholarly debate. The general plan of the area published by Christian Hülsen in 1902 and signed by the architect Gustavo Tognetti from the

office responsible for the Forum excavations, however, portrays the final state of the works and must have certainly relied on Petrignani's plan.[50]

Petrignani's work was published by Tea only in 1937, with a note penned by the architect specifying that 'these designs [plan and axonometry] with their related surveys were undertaken by me at the time of the excavation'. Even thirty-five years later, Petrignani's comment constitutes a useful link to the excavation and restoration of the site, its methodologies and process. It seems logical, therefore, to attribute the planning and completion of the restorations to Petrignani himself. His master plan, largely ignored and ultimately forgotten, formed the basis for the church plans published by Wladimir de Grüneisen in 1911, and for the 1921 study by Richard Delbrück, although neither acknowledged his contribution.[51] In their arguments, moreover, both authors refer to information and construction details that in their time were no longer visible. Since 1921 the Delbrück plan has become the standard in topographical literature, frequently cited and reprinted.[52] In addition to a re-reading of Petrignani's document, a new analysis should be undertaken of the archaeological and topographic information that it contains: for example, the interpretation of the atrium *piscina* proposed by Adriano La Regina.[53]

The surveys carried out by the Soprintendenza Archeologica di Roma (2003–16), still ongoing on some level, provide fresh insights into the complex, inviting us to re-measure and 're-design' Santa Maria Antiqua.

NOTES TO THE TEXT

1. I would like to thank Giuseppe Morganti for the friendship developed while we worked on the site.

2. Adriana Baculo, 'Relazione introduttiva agli atti del congresso', in *Architettura ed informatica. Atti del convegno internazionale 'Il rilievo e la rappresentazione dell'architettura e dell'ambiente' (Parigi, 28–29 maggio 1998)*, ed. by A. Baculo (Naples: Electa, 2000), p. 31. Translated from the original Italian text.

3. See Cairoli Fulvio Giuliani, *L'edilizia nell'antichità* (Rome: Carocci, 2006); and Cairoli Fulvio Giuliani, 'Archeologia oggi: la fantasia al potere', *Quaderni di archeologia e cultura classica*, 2 (2012), 5–48. See also his explanation of the issue in the preface to Marco Bianchini, *Manuale di rilievo e documentazione digitale in archeologia* (Rome: Aracne, 2008).

4. Surveying is still under way, and the scope has been broadened to include the surroundings of the Santa Maria Antiqua complex. The purpose of the documentation project was to prepare descriptions of the structures, in order to facilitate planning for any future interventions.

5. Petrignani, in particular, served as director of the excavation works and could sign documents on Boni's behalf.

6. Boni introduced the use of axonometry in graphic documentation 'after the example of the English and the French'. For a critical analysis of the axonometric projections, see Camillo Trevisan 'Le rappresentazioni assonometriche nei trattati di Auguste Choisy', *Parametro. Rivista internazionale di architettura ed urbanistica*, 25.225 (January/February 2005), 56–66; and Hilary Bryon, 'Measuring the qualities of Choisy's oblique and axonometric projections', in *Auguste Choisy (1841–1909): L'architecture et l'art de bâtir. Actas del Simposio internacional (Madrid, 19–20 de noviembre de 2009)*, ed. by J. Girón and S. Huerta (Madrid: Instituto Juan de Herrera, Escuela técnica superior de arquitectura, 2009), pp. 31–61.

7. For the excavation and restoration of the site, see Giuseppe Morganti 'Giacomo Boni e i lavori di Santa Maria Antiqua', *Santa Maria Antiqua al Foro Romano cento anni dopo*, ed. by J. Osborne, J.R. Brandt, and G. Morganti (Rome: Campisano, 2004), pp. 11–30.

8. Archivio Leonardo Paterna Baldizzi. Accademia Nazionale del Lincei. Roma. *Diario 9.6—1902/05/12—Roma. Santa Maria antiqua. Rilievi dell'angolo ovest dell'abside*.

9. Rome, Archivio Storico della Soprintendenza Speciale per i Beni Archeologici (formerly Soprintendenza Archeologica), drawings of the Roman-Palatine Forum, segnatura 36 rosso: 'Tombe medioevali esistenti nell'atrio della cappella palatina. Tombe medievali nell'atrio della Cappella Palatina'.

10. Andrea Augenti, *Il Palatino nel Medioevo: archeologia e topografia (secoli VI –XIII)* (Rome: L'Erma di Bretschneider, 1996), pp. 163–8 ('Appendice 2. La necropoli di Santa Maria Antiqua').

11. Dante Vaglieri, 'Gli scavi recenti nel foro Romano', *Bullettino della Commissione archeologica comunale*, 31 (1903), 3–239; at p. 8, note 1, the author quotes the official publication 'L'amministrazione della antichità e belle arti in Italia' [in translation]: 'and the geometric units of the flooring were completed with brick-like materials, red and yellowish, to give an idea of the design in its entirety, without compromising the authenticity of what survives of the antique work.' In the course of the 2013 flooring restorations, the removal of dust and incrustations brought back to view the original restoration, previously unknown apart from this written description.

12. In a report included in Eva Tea, *La Basilica di Santa Maria Antiqua* (Milan: Società Editrice 'Vita e Pensiero', 1937), p. 14 ('Relazione dell'architetto Antonio Petrignani'), the architect writes *a posteriori*: 'Quando lo scavo della chiesa fu ultimato, la veduta degli avanzi archeologici rinvenuti si presentava come sono riprodotti nel disegno assonometrico (tav. III) [Figure 2] e nella pianta descrittiva (tav. IV) [Figure 1]. La veduta assonometrica riguarda la sola chiesa, mentre la pianta comprende la chiesa e l'atrio: tali disegni con i relativi rilievi furono da me eseguiti al tempo dello scavo.' In this report, Petrignani declares that his drawings display the state of the complex 'when the excavations of the church were completed'. On the other hand, we can note significant differences between Petrignani's and Paterna Baldizzi's surveys of the sanctuary. In Paterna Baldizzi's drawing (Figure 4), this zone is completely excavated, while Petrignani's plan (1901) shows no substantial excavation below the level of the pavement. To the best of our knowledge, no final drawing was produced in which the results of the different periods of excavation were combined. Furthermore, the structures surveyed by Paterna Baldizzi are not recorded in the descriptive plan of the excavations published in Tea (*Basilica di Santa Maria Antiqua*, p. 22, fig.1), which was certainly derived from Petrignani's work.

13. Vaglieri, 'Gli scavi recenti', p. 8: 'so much work done in little more than four years!'.

14. Ibid., p. 8, note 1, where Vaglieri cites the Director General, Carlo Fiorilli: 'Estratto dalla relazione del direttore generale Carlo Fiorilli al Ministro della Pubblica Istruzione Nunzio Nasi', *L'amministrazione della antichità e belle arti in Italia* (1901), pp. 113–14.

15. As Fiorilli observes: 'This drawing [...] represents the best guide to the monuments of the Forum produced thus far'; see Vaglieri 'Gli scavi recenti', pp. 14–16, note 2.

16. In Petrignani the origin is at 45° to the right, while in Paterna Baldizzi it is from the left.

17. The surveyors used the classical system of measuring with tape and rod (*fettuccia, metro rigido*), supported by the prior application of an optical square (*squadro*

ottico) and plane table for tracing the reference axes with the technique of the Praetorian tablet (*tavoletta pretoriana*). The surveyors probably also applied the ancient technique of *coltellatio*, for which see Jean-Pierre Adam, 'Groma et Chorobate. Exercises de topographie antique', *Mélanges de l'École française de Rome. Antiquité*, 94.2 (1982), 1003–29 (p. 1022, fig. 15).

18 Anna Soletti 'Cinque criteri guida per il buon rilevatore', in *Architettura e informatica*, ed. by A. Baculo, pp. 190–5 (p. 191): 'The worship of tools is the sign of a dangerous transfer of priorities that restricts the deepening of architectural knowledge'. Later Soletti cites Le Corbusier 'The things that we possess through our work with the pencil rest within us for a lifetime; they are written, inscribed' (p. 193). In the case of Santa Maria Antiqua, it is clear that the drawings from the early 1900s continue to demonstrate, over a century later, their value as manually drawn documents. Indeed, pencil and paper assist us in the intellectual tasks of understanding and explaining what we draw.

19 Giacomo Boni, 'Rilievo eseguito dalla R. Scuola d'applicazione degli ingeneri di Roma, nell'area compresa fra il Colosseo ed il Tabularium', *Notizie degli scavi di antichità* (1900), 220–9.

20 For the technicians and architects in Boni's team, see Miriam Taviani, 'Giacomo Boni ed "I compagni di lavoro"', in *Gli scavi di Giacomo Boni al Foro Romano: Documenti dall'archivio disegni della Soprintendenza Archeologica di Roma*, I.1, ed. by A. Capodiferro and P. Fortini (Rome: Fondazione G. Boni-Flora Palatina, 2003), pp. 35–48; Elisabetta Pallottino, 'Cultura della ricostruzione a Roma tra Ottocento e Novecento. Precedenti e prospettive. Il complesso della Casa delle Vestali, del Tempio e dell'Edicola di Vesta al Foro Romano', *Ricerche di storia dell'arte*, 95 (2008), 6–29; Giuseppe Morganti, 'Radici della tutela e metodologia di restauro: Fiorelli, Boito ed alcuni scritti di Giacomo Boni', in *La festa delle arti: Scritti in onore di Marcello Fagiolo per cinquant'anni di studi*, ed. by V. Cazzato, S. Roberto, and M. Bevilacqua, 2 vols (Rome: Gangemi, 2014), I, pp. 1056–63; and Silvia Cecchini, 'La città e la sua storia. Roma tra restauro filologico e restauro scenografico', in *Gli uomini e le cose. I: Figure di restauratori e casi di restauro in Italia fra il XVIII e XX secolo. Atti del Convegno Nazionale di Studi (Napoli 18–20 aprile 2007)*, ed. by P. D'Alconzo (Naples: ClioPress, 2007), pp. 391–407.

21 For example, the photo of the Forum taken from a balloon, and the use of photographic goniometry as a first experimental approach to photogrammetry; see Laura Castriani and Elisa Cella, 'Giacomo Boni e il Foro Romano: la prima applicazione della fotografia archeologica in Italia', *Archeologia Aerea*, 4–5 (2010–11), 33–40.

22 Miriam Taviani, 'Rilievi eseguiti dalla regia scuola d'applicazione degli ingegneri di Roma' in *Gli scavi di Giacomo Boni*, ed. by A. Capodiferro and P. Fortini, pp. 51–75.

23 *Gli scavi di Giacomo Boni al Foro Romano*, ed. by A. Capodifero and P. Fortini, p. 202, Appendix 41.

24 Boni, 'Rilievo eseguito dalla R. Scuola d'applicazione degli ingeneri di Roma'. For a discussion of the issues emerging from Boni's method, see Giovanni Ioppolo, 'La nuova forma urbis Romae. Programma e relazione preliminare dei lavori (1981–83)', *Lavori della Soprintendenza Archeologica di Roma*, 6.2 (1985), 320–31. The topographic grid system described by Ioppolo is in use by the Soprintendenza Archeologica di Roma, and when Ioppolo prepared the preliminary notes for his article, the method was based on a rigorous topographic approach, which supported a survey with recording of the measurements and manual elaboration of the data. These practices were analogous to those used by Boni.

25 Boni, 'Rilievo eseguito dalla R. scuola', p. 227, fig. 5.

26 Vincenzo Reina, *Media Pars Urbis: Rilievo planimetrico ed altimetrico eseguito dagli allievi della Scuola d'applicazione per gli ingegneri di Roma, colla guida del prof. T. Barbieri e dell'ing. G. Cassinis* (Florence: Istituto geografico militare, 1911). The work consists of 18 sheets at 1:500 scale. The date is noted in the planimetric index map: *Roma—Maggio 1910*.

27 See 'Nota del socio corrispondente V. Reina', *Rendiconti della R. Accademia Nazionale dei Lincei. Classe di scienze fisiche, matematiche e naturali*, 5th ser., 19, 2nd semester, 2 (1910), 37–41.

28 Reina, *Media Pars Urbis*, p. 37, note 2: 'A summary survey of the Roman Forum in 1:500 scale had already been executed at the invitation of the General Direction for Antiquities and Fine Arts in the week from 28 May to 2 June 1900, as the theme for the final topographic exercises of the students of the School for Engineers. This survey, reduced in a smaller-scale photograph, was reproduced in the *Notizie degli scavi*, June 1900.'

29 Vincenzo Reina, 'Rilievo planimetrico ed altimetrico del Palatino eseguito dagli allievi della scuola di applicazione per gli ingegneri di Roma', *Notizie degli scavi di antichità* (1904), 43–6 (p. 43): 'operations were initiated at the beginning of December 1902, ending in the first week of June 1903'.

30 Reina, *Media Pars Urbis*, p. 37.

31 Taviani 'Rilievi eseguiti dalla regia scuola', p. 63, pl. 4; p. 61: 'this is without a doubt the drawing that is most attentive to the details, considering that it is in any case a survey at 1:500 scale'. To my knowledge, the first plan of the basilica at the beginning of the excavations was published by Marucchi, 'La chiesa di Santa Maria Antiqua', p. 286. The topographic plan is entitled 'Angolo Sud-Est del Foro Romano'; it forms part of the survey undertaken in the early 1900s (see Taviani above), and is described as such by the author. Marucchi writes: 'I am pleased to be able to offer readers a very accurate plan of this area, where are found the sacred building with the other nearby structures, now uncovered, a plan provided as a favour to our journal

32 Giacomo Boni, 'Il sacrario di Juturna', *Notizie degli Scavi di antichità* (1901), 41–144 (fig. 11).

33 An archival photo from the Soprintendenza Archeologica of the area in front of the Oratory of the Forty Martyrs shows excavation 'guardians' with a surveyor's rod. This probably documents the activity of topographic updating; see Ernesto Monaco, 'L'aula dell'Oratorio dei XL Martiri al Foro Romano. Considerazioni sulla fase originaria' in *Santa Maria Antiqua al Foro cento anni dopo*, ed. by J. Osborne, J.R. Brandt, and G. Morganti, pp. 167–86 (p. 169, fig. 4).

34 For the 'consultation', see my opinion in the *post scriptum*.

35 Reina's survey is, in many ways, a forgotten work. The same holds true for the seldom cited 'Rilievo planimetrico e altimetrico della villa Adriana eseguito dalla Scuola per gli Ingegneri', *Notizie degli scavi di antichità*, (1906), 313–7: this is widely held to be the best plan of Hadrian's Villa.

36 Of Boni's excavations, only those of the Fountain of Juturna were published at the time; see Boni 'Il sacrario di Juturna'; and Andrea Paribeni, 'Giacomo Boni e il mistero delle monete scomparse', *Marmoribus vestita. Miscellanea in onore di Federico Guidobaldi*, ed. O. Brandt and P. Pergola, 2 vols (Vatican City: Pontificio Istituto di Archeologia Cristiana, 2011), II, pp. 1003–23, (pp. 1008–9, notes 21–5).

37 For the definition see Giuseppe Morganti, 'Lo spazio di Santa Maria Antiqua' in *Santa Maria Antiqua tra Roma e Bisanzio*, ed. by M. Andaloro, G. Bordi, and G. Morganti (Milan: Mondadori-Electa, 2016), pp. 54–69 (p. 56).

38 According to Bruno Zevi, the primary elements for the evaluation of a monument are the 'dimensione metrica e dimensione artistica'; Bruno Zevi, *Storia e controstoria dell'architettura in Italia* (Rome: Newton, 2005).

39 See the analysis of archival data in Morganti 'Giacomo Boni e i lavori di Santa Maria Antiqua', esp. p. 11.

40 Tea, *Basilica di S. Maria Antiqua*, p. 1–26.

41 Ibid., pp. 235–6.

42 The subjects are, however, largely unexplored, particularly in the light of twentieth-century technological developments.

43 The survey programme, part of the 'Santa Maria Antiqua Project', was planned and directed by Giuseppe Morganti, and carried out by the author, assisted by David Andolfi, Massimo Braini, Ezio Mitchell, Emiliano Mura, and Paolo Volpe, during several campaigns on site between 2003 and 2008. Surveying and updating have been ongoing since 2010.

44 See Giuseppe Morganti's contribution to this volume.

45 The differences between the historical and current plans are essentially due to the different surveying methods.

46 Tea, *Basilica di S. Maria Antiqua*, p. 237: 'Un cuneo di travertino, nell'imposta a cornu evangeli dell'arcone fra il quadriportico e la tribuna appartenente alle costruzioni adrianee, sembra alludere alla presenza di piattabande là dove vennero poi ricostruiti i grandiosi archi a sostegno dei muri settentrionali delle tribune.' ('A triangular block of travertine, in the east abutment of the arch between the quadriporticus and the tribune pertaining to the Hadrianic [in fact, Domitianic] construction, seems to allude to the presence of a lintel where the grand arches would then be reconstructed to support the north walls of the tribune.')

47 See the essays in *Santa Maria Antiqua tra Roma e Bisanzio*, ed. by M. Andaloro, G. Bordi, and G. Morganti.

48 Paribeni, 'Giacomo Boni e il mistero delle monete', passim.

49 For another example of the parallel use of drawings and excavation notes, see Dale Kinney, 'Excavations in S. Maria in Trastevere, 1865–1869: a drawing by Vespignani', *Römische Quartalschrift für christliche Altertumskunde und Kirchengeschichte*, 70 (1975), 42–53.

50 Christian Hülsen, 'Jahresbericht über neue Funde und Forschungen zur Topographie der Stadt Rom. Neue Reihe die Ausgrabungen auf dem Forum Romanum 1898–1902', *Mittheilungen des kaiserlich Deutschen Archäologischen Instituts. Römische Abteilung*, 17 (1902), pp. 1–97 (plates I–IV).

51 Wladimir de Grüneisen, *Sainte-Marie-Antique* (Rome: Max Bretschneider, 2011); Richard Delbrück, 'Der Südostbau am Forum Romanum', *Jahrbuch des Deutschen Archäologischen Instituts. Römische Abteilung*, 36 (1921), pp. 8–33.

52 For example: Michael Heinzelmann, 'The Imperial Building Complex of S. Maria Antiqua in Rome. An Incomplete Senate Building of Domitian?', *Anales de Arqueologia Cordobesa*, 21–22 (2010–11), 57–80.

53 Adriano La Regina, 'Lacus ad sacellum Larum', in *Dall'Italia: Omaggio a Barbro Santillo Frizell*, ed. by A. Capoferro, L. D'Amelio, and S. Renzetti (Florence: Polistampa, 2013), pp. 133–50.

GIOVANNI GASBARRI

'Ce monument est avant tout un témoin': Wladimir de Grüneisen and the multicultural context of Santa Maria Antiqua

At the turn of the twentieth century the existence of a well-documented 'Byzantine' phase in the history of early medieval Rome was already acknowledged by scholars. There was a great deal of evidence that the old capital of the Roman Empire had been under the control of Byzantium for decades, and that the influence from Constantinople had not been restricted solely to politics and the military. Both historians and archaeologists were well informed about how deeply the Byzantine rule of Rome had also conditioned the city's religious and cultural customs. Such influence was becoming increasingly evident thanks to a growing corpus of archaeological materials, as well as to a considerable group of ancient texts that were already adopted as primary sources for historical investigation.[1]

In the late nineteenth century, issues concerning Byzantine Rome were rarely approached from a purely art-historical perspective.[2] Following the 'good old archaeological methodology'—as Josef Strzygowski defined it[3]—scholars preferred to evaluate late antique and early Christian works of art only for the nature and depth of their content: a valuable artistic depiction, therefore, was one capable of transmitting an adequate quantity of data to the modern viewer. In other words, works of art were examined as pictorial interpretations of textual sources, the decoding of which could disclose important information for the reconstruction of the history of early Christianity. Some of the most successful illustrated encyclopaedias of the time, such as the *Storia dell'Arte Cristiana* by Raffaele Garrucci (1812–85)[4] and *La Messe* by Charles Rohault de Fleury (1801–75)[5] were based on this methodology, which aimed to lend reliability to the discipline of art history.

This approach had the advantage of ensuring scholarly credibility to the study of late antique and early Christian visual culture, but, as a natural consequence, implied overlooking the formal qualities of the artworks. For the archaeological hermeneutics of the late nineteenth century, style could hardly be represented as quantitative data, and its evaluation seemed to

depend more on personal opinion than impartial criteria. The indifference to stylistic analysis was especially widespread amongst Christian archaeologists, who at the time were still considered the most renowned experts in the material culture of the early Middle Ages.[6] When they were required to describe the style of an early medieval work of art, most specialists usually resorted to a kind of devolutionary theory:[7] by accepting the idea of a 'degeneration of art'—which would have begun soon after the fall of the Roman Empire—it was possible to establish a direct connection between history and art. According to textual sources, under Byzantine rule Rome had been through a long period of corruption and decadence, and its artistic production seemed to confirm this trend, with the transformation of the 'good' and 'rightful' classical style into 'listless' and 'weak' Byzantine forms. The iconographic conservatism of Roman art in the Middle Ages reinforced the impression of a 'road to decadence' that appeared to have been generated strictly within the city's walls. This situation, however, was soon destined to change. In January 1900 the discovery of the extraordinary wall paintings in Santa Maria Antiqua in the Roman Forum suddenly proved that the artistic environment in Rome in the early Middle Ages had been much more complex than previously thought.[8]

The earliest archaeological studies in Santa Maria Antiqua were carried out according to the traditional philological approach, which was justified especially by the presence of an outstanding quantity of painted inscriptions, the interpretation of which became the first mandatory step in reconstructing the history of the building. This methodology was adopted by Vincenzo Federici (1871–1953) and Orazio Marucchi (1852–1931) in their reports, published only a few months after the beginning of the excavation.[9] These essays contained a very poor description of the figurative aspects of the frescoes, due at least in part to the scarcity of photographic reproductions, the circulation of which had been temporarily forbidden.[10] Evidence of this limitation is shown in the work of Heinrich Wüscher-Becchi (1855–1932), a Swiss archaeologist and amateur painter who, in the early 1900s, produced a couple of studies on Santa Maria Antiqua accompanied by self-produced graphic reconstructions of the wall paintings.[11]

Gordon Rushforth (1862–1938) and Adolfo Venturi (1856–1941) are deservedly credited with having been the first scholars who attempted to draw attention to the Greek and oriental elements in the murals. In his famous 1902 article in the *Papers of the British School at Rome*,[12] Rushforth succeeded in determining the date of some of the most relevant layers of fresco; however, as he admitted in the preface, he was unable to produce a complete overview of the wall paintings, since the publication of photographs was still forbidden. Venturi's attempt to provide a stylistic analysis of the frescoes was compromised by his poor knowledge of the correct sequence of the layers, and thus his efforts remained substantially isolated.[13]

The intervention of Joseph Wilpert (1857–1944), one of the main protagonists of Christian archaeology at the time, marked the first major turning point in this debate.[14] In the first decade of the century, Wilpert was already internationally renowned for his extensive corpus of the catacomb paintings is Rome (1903),[15] and for his use of watercoloured photographs as a primary source for archaeological studies.[16] In 1904–5 he shifted his attention to medieval frescoes and mosaics in Rome, and Santa Maria Antiqua soon became the main focus of his research. Among the numerous essays he dedicated to this subject, the most significant was perhaps the long article published in *L'Arte* in 1910, the best example of the application of the 'good

old archaeological methodology' to the newly discovered paintings in the Roman Forum.[17] Wilpert's meticulous comparison between textual sources and iconographic formulas served to support his belief in the absolute centrality of Western, Latin, and Catholic artistic roots in the formation of medieval art.[18] In Wilpert's reconstruction, Santa Maria Antiqua appeared as a locked room that had preserved a faithful reflection of the descending parabola of Roman art in the early Middle Ages—from the splendour of the late antique *Maria Regina* to the decadence of the eighth-century frescoes. Even the highest-quality paintings, for example the *Annunciation* on the 'palimpsest' wall, were interpreted as the resistance of an exclusively local tradition, rather than the manifestation of a possible influence from eastern Mediterranean visual culture. As if it had absorbed the spirit of the place where it had been built, Wilpert's Santa Maria Antiqua had bloomed and faded as a purely Roman product.

Despite Wilpert's authority, however, his theories did not remain unchallenged. In their 1902 writings, both Rushforth and Venturi had already stressed the fact that the frescoes in the Roman Forum were the outcome of a unique melting pot of influences, in which the Eastern component had played a crucial role. Without a doubt, Wilpert's strongest critic was the Russian art historian Wladimir de Grüneisen (1868–after 1935), the author of the first monograph dedicated to Santa Maria Antiqua, published in Rome in 1911 (Figure 1).[19] Due to the relative lack of information about his life and career, his contribution has often been neglected in modern literature.[20] Born near Saint Petersburg, de Grüneisen moved to Rome in September 1903 as a delegate of the Imperial Russian Archaeological Society.[21] After an unsuccessful attempt to enter the group of scholars gathered around Venturi, he started collaborating with some of the most important historians and archaeologists in Rome, among them Orazio Marucchi and Christian Hülsen (1858–1935).[22] As proven by the dating of his sketches, de Grüneisen began working on Santa Maria Antiqua shortly after his arrival in Rome. His earliest visits to the site must have been almost contemporaneous with Wilpert's, and the two likely had the occasion to meet and to work side by side. In a letter sent to Venturi in April 1904, de Grüneisen referred to his book on Santa Maria Antiqua as 'already in print', but the publication had to be delayed until 1911 due to copyright issues.[23]

Between 1906 and 1907, de Grüneisen decided to publish a series of short articles in the official bulletin of the *Società Romana di Storia Patria* to disseminate some preliminary results of his research.[24] There he revealed his intention to diverge from the traditional archaeological approach and consider the frescoes in Santa Maria Antiqua not only for their iconographic content, but specifically for their appearance—that is to say, for their style. Inspired by Alois Riegl's idea of *Kunstwollen*, de Grüneisen proposed that the most distinctive features of medieval art—for example, the simplified representation of the space, the use of repetitive compositions, the disarticulation of human anatomy, etc.—were not the visual manifestation of a political or cultural crisis, but rather a deliberate choice of artistic expression. In other words, he believed that it was possible for an artist to choose a certain kind of style intentionally, as a means to express a specific worldview.[25]

Since it was radically different from Roman classical art, this new style could not be considered local. Its origin had to be sought outside of Rome, among those Eastern civilisations whose importance in the development of medieval art had already been emphasised in Strzygowski's writings.[26] De Grüneisen gathered a vast corpus of examples from all over

1 Book cover of Wladimir de Grüneisen, *Sainte-Marie-Antique*, 1911

'CE MONUMENT EST AVANT TOUT UN TÉMOIN'

Graphic reconstruction of the conch and the apsidal arch (after de Grüneisen 1911)

the Mediterranean basin to demonstrate how artistic prototypes from Egypt, Syria, and Asia Minor had been transformed by early medieval artists into new pictorial formulas, which had proved to be perfectly suitable to convey Christian messages. These formulas, therefore, should have been interpreted as the result of a cultural conquest, as if they were alternative dialects employed for alternative contents. Therefore, a closer examination of the frescoes of Santa Maria Antiqua became essential, since the church had preserved an exceptional anthology of these dialects, combined and juxtaposed on the same walls. According to de Grüneisen, Santa Maria Antiqua was a *témoin* (witness) of a complex, multicultural society capable of conveying unique artistic values.[27]

These premises were further developed in the 1911 monograph *Sainte-Marie-Antique*, a massive tome published in French by Max Bretschneider. It was the result of a collaborative project: under the direction of de Grüneisen himself, who wrote most of the chapters, each scholar was responsible for a single section of the book. Hülsen and Federici were commissioned respectively to examine the topographical situation of the site and the surviving inscriptions. There was also a chapter dedicated to liturgy, written by Joseph David (1882–1955), and even a scientific analysis of the frescoes provided by the chemist Giovanni Giorgis (1858–1945). Unlike most previous contributions on the topic, *Sainte-Marie Antique* aimed to provide a more comprehensive study of the church and reach a deeper understanding of its artistic identity. On page after page, de Grüneisen and his colleagues were very careful to highlight the hybrid nature of Santa Maria Antiqua, as its sacred function had been expressed through bilingual inscriptions and its inner space had been gradually adapted over the centuries to resemble a Byzantine church. The coexistence of various styles on the same layers of fresco revealed that the development of Roman art in the early Middle Ages had not been teleologically pre-determined. On the contrary, it had been unexpected and unpredictable. Even the editorial concept of the book reflected this particular aspect of its subject: *Sainte-Marie-Antique* had been conceived as a richly illustrated 'paper machine', which encouraged the reader to participate actively in the research by opening folding pages and looking through semi-transparent tissue-guards. It was a 'palimpsest' book for a church that was filled with palimpsests (Figure 2).

Although the book was saluted as an extraordinary advancement in the scholarly debate,[28] de Grüneisen did not have much opportunity to continue his research on the topic. This was partly due to the Russian Revolution in 1917, which suddenly deprived him of the support from the state institutions of his motherland; after moving to Paris in the early 1920s he began to focus on classical sculpture and abandoned the study of medieval art. He was certainly still alive in 1935, when he was remembered among the founders of the *Société des Amis de Paul Gauguin*.[29]

In 1916, Wilpert published his masterpiece, *Die römischen Mosaiken und Malereien*, the outcome of his most ambitious research project, which covered the whole history of Roman art in the Middle Ages.[30] Not surprisingly, Wilpert's ideas on the centrality of the Latin tradition in the development of medieval art were highly praised by several scholars, especially in Italy. However, thanks to de Grüneisen's studies on Santa Maria Antiqua, a new multicultural Rome had begun to emerge as a concrete historical reality, despite the fact that its identity had still to be fully investigated. It was a challenging task, which remains indebted to de Grüneisen's pioneering work, and would come to inspire a new school of thinking that revalorised Byzantine influences on medieval Roman art.[31]

NOTES TO THE TEXT

1. See in particular *Le Liber Pontificalis: Texte, introduction et commentaire*, ed. by L. Duchesne, 2 vols (Paris: Boccard, 1886–92); and Hartmann Grisar, *Geschichte Roms und der Päpste im Mittelalter: Rom beim Ausgang der antiken Welt* (Freiburg im Breisgau: Herder, 1898–1901; repr. Hildesheim: Georg Olms, 1985).

2. On the scholarly rediscovery of 'Byzantine Rome', see Per Jonas Nordhagen, 'The Frescoes of John VII (A.D. 705–707) in S. Maria Antiqua in Rome, *Acta ad archaeologiam et artium historiam pertinentia*, 3 (1968), repr. as 'The Frescoes of John VII (A.D. 705–707). Problems of Chronology', in Per Jonas Nordhagen, *Studies in Byzantine and Early Medieval Painting* (London: Pindar Press, 1990), pp. 297–306; Per Jonas Nordhagen, 'Italo-Byzantine Wall Painting of the Early Middle Ages: an 80-Year Old Enigma in Scholarship', in *Bisanzio, Roma e l'Italia nell'Alto Medioevo* (Spoleto: Centro Italiano di Studi sull'Alto Medioevo, 1988), pp. 593–624, repr. in Nordhagen, *Studies in Byzantine and Early Medieval Painting*, pp. 430–71; John Osborne, 'The Artistic Culture of Early Medieval Rome: A Research Agenda for the 21st Century', in *Roma nell'Alto Medioevo* (Spoleto: Centro Italiano di Studi sull'Alto Medioevo, 2001), pp. 693–711; Antonio Iacobini and Giovanni Gasbarri, 'La scoperta di "Roma bizantina" (1880–1910). Nuove prospettive per la genesi dell'arte medievale tra Europa e Mediterraneo', in *L'Italia e l'arte straniera. La Storia dell'Arte e le sue Frontiere. A cento anni dal X Congresso Internazionale di Storia dell'Arte in Roma (1912): Un bilancio storiografico e una riflessione del presente*, ed. by C. Cieri Via, E. Kieven, and A. Nova (Rome: Bardi, 2015), pp. 127–54; and Giovanni Gasbarri, *Riscoprire Bisanzio: lo studio dell'arte bizantina a Roma e in Italia tra Ottocento e Novecento* (Rome: Viella, 2015).

3. Josef Strzygowski, review of Hartmann Grisar, *Il 'Sancta Sanctorum' in Roma*, *Byzantinische Zeitschrift*, 16 (1907), 392–3.

4. Raffaele Garrucci, *Storia dell'Arte Cristiana nei primi otto secoli della chiesa*, 6 vols (Prato: Giachetti, 1873–81).

5. Charles Rohault de Fleury, *La Messe: Études archéologiques sur ses monuments*, 8 vols (Paris: Morel, 1883–89).

6. On the development of Christian archaeology in the late nineteenth century, see Friedrich Wilhelm Deichmann, *Einführung in die Christliche Archäologie* (Darmstadt: Wissenschaftliche Buchgesellschaf, 1983); Victor Saxer, 'Cent ans d'archéologie chrétienne. La contribution des archéologues romains à l'élaboration d'une science autonome', in *Acta XIII Congressus Internationalis Archaeologiae Christianae (Split–Poreč, 25 September–9 October 1994)*, ed. by N. Cambi and E. Marin, 3 vols (Vatican City: Pontificio Istituto di Archeologia Cristiana, 1998), I, pp. 115–62; William Hugh Clifford Frend, *The Archaeology of Early Christianity: A History* (London: Chapman, 1996); Hugo Brandenburg, 'Archeologia Cristiana', in *Nuovo Dizionario Patristico e di Antichità Cristiane*, 3 vols (Genoa–Rome: Marietti, 2006), I, pp. 475–90.

7. For example, Giovanni Battista de Rossi, *Musaici cristiani e saggi dei pavimenti delle chiese di Roma anteriori al secolo XV* (Rome: Spithöver, 1872–96, 1899).

8. Giuseppe Morganti, 'Giacomo Boni e i lavori di Santa Maria Antiqua: un secolo di restauri', in *Santa Maria Antiqua al Foro Romano cento anni dopo*, ed. by J. Osborne, J.R. Brandt, and G. Morganti (Rome: Campisano, 2004), pp. 11–30; Andrea Augenti, 'Giacomo Boni, gli scavi di Santa Maria Antiqua e l'archeologia medievale a Roma all'inizio del Novecento', *ibidem*, pp. 31–9; Andrea Paribeni, 'Giacomo Boni e il mistero delle monete scomparse', in *Marmoribus vestita. Miscellanea in onore di Federico Guidobaldi*, ed. by O. Brandt and P. Pergola, 2 vols (Vatican City: Pontificio Istituto di Archeologia Cristiana, 2011), II, pp. 1003–23.

9. Vincenzo Federici, 'Santa Maria Antiqua e gli ultimi scavi del Foro Romano', *Archivio della Società Romana di Storia Patria*, 23 (1900), pp. 517–62; Orazio Marucchi, 'Scavi sotto la chiesa di S. Maria Liberatrice', *Nuovo Bullettino di Archeologia Cristiana*, 6 (1900), 170–5; and Orazio Marucchi, 'Scavi nella Chiesa di S. Maria Antiqua nel Foro romano', *Nuovo Bullettino di Archeologia Cristiana*, 7 (1901), 172–4.

10. Paribeni, 'Giacomo Boni e il mistero delle monete scomparse', pp. 1003–10.

11. Heinrich Wüscher-Becchi, 'Der Crucifixus in der Tunica manicata', *Römische Quartalschrift*, 15 (1901), 201–15; Heinrich Wüscher-Becchi, 'Die Absisfresken in S. Maria Antiqua auf dem Forum Romanum', *Zeitschrift für christliche Kunst*, 17 (1904), cols 289–300.

12. Gordon Rushforth, 'The Church of S. Maria Antiqua', *Papers of the British School at Rome*, 1 (1902), 1–123.

13. Adolfo Venturi, *Storia dell'Arte Italiana*, 11 vols (Milan: Hoepli, 1901–40), II (*Dall'arte barbarica alla romanica*), pp. 376–7, 377–82. See also Maria Andaloro, '"Sembrano due grandi petali di rosa". Adolfo Venturi e "il più bel frammento greco" in Santa Maria Antiqua al Foro Romano', in *Adolfo Venturi e la storia dell'arte oggi. Atti del Convegno (Roma, 25–28 ottobre 2006)*, ed. by M. D'Onofrio (Modena: Panini, 2008), pp. 245–54.

14. Reiner Sörries, *Josef Wilpert. Ein Leben im Dienste der christlichen Archäologie 1857–1944* (Würzburg: Korn, 1998); *Giuseppe Wilpert archeologo cristiano. Atti del Convegno (Roma, 16–19 maggio 2007)*, ed. by S. Heid, (Vatican City: Pontificio Istituto di Archeologia Cristiana, 2009); Stefan Heid, 'Joseph/Giuseppe Wilpert', in *Personenlexikon zur christlichen Archäologie. Forscher und Persönlichkeiten vom 16. bis 21. Jahrhundert*, ed. by S. Heid and M. Dennert, 2 vols (Regensburg: Schnell & Steiner, 2012), II, 1323–5.

15. Giuseppe [Joseph] Wilpert, *Roma sotterranea. Le pitture delle catacombe romane*, 2 vols (Rome: Desclée, Lefebvre & Cie, 1903).

16. Giulia Bordi, 'Copie, fotografie, acquerelli. Documentare la pittura medievale a Roma tra Otto e

Novecento', in *Medioevo: immagine e memoria*, ed. by A.C. Quintavalle (Milan: Electa, 2009), pp. 454–62; and Giulia Bordi, 'Giuseppe Wilpert e la scoperta della pittura altomedievale a Roma', in *Giuseppe Wilpert archeologo cristiano*, ed. S. Heid, pp. 323–42.

17 Giuseppe [Joseph] Wilpert, 'Sancta Maria Antiqua', *L'Arte*, 13 (1910), 1–20, 81–107.

18 Carola Jäggi, 'Die Frage nach dem Ursprung der christlichen Kunst: die "Orient oder Rom" Debatte im frühen 20. Jahrhundert', in *Giuseppe Wilpert archeologo cristiano*, ed. S. Heid, pp. 231–46.

19 Wladimir de Grüneisen, *Sainte-Marie-Antique* (Rome: Max Bretschneider, 1911).

20 Martin Dennert, 'Wladimir de Grüneisen', in *Personenlexikon zur christlichen Archaologie*, ed. by S. Heid and M. Dennert, I, pp. 618–20; Gasbarri, *Riscoprire Bisanzio*, pp. 215–30.

21 Romolo Artioli, 'Roma. Cose d'arte e di storia', *Arte e Storia*, 22 (1903), p. 134.

22 De Grüneisen is mentioned as a collaborator in Orazio Marucchi, 'Di una copertura di mummia proveniente dalla necropoli di Antinoe ed ora nel Museo Egizio Vaticano', *Dissertazioni della Pontificia Accademia Romana di Archeologia*, 2nd ser., 9 (1907), 351–76 (pp. 374–5); Christian Hülsen, 'La pianta di Roma dell'Anonimo Einsidlense', *Dissertazioni della Pontificia Accademia Romana di Archeologia*, 2nd ser., 9 (1907), 377–424 (p. 389, pl. XIV).

23 Pisa, Biblioteca della Scuola Normale Superiore, Archivio Venturi, Carteggio, VT D1 b48.1 (4 April 1904). See Gasbarri, *Riscoprire Bisanzio*, pp. 217–18.

24 Wladimir de Grüneisen, 'Studj iconografici in Santa Maria Antiqua', *Archivio della Società Romana di Storia Patria*, 29 (1906), 85–95; Wladimir de Grüneisen, 'Intorno all'antico uso egiziano di raffigurare i defunti collocati avanti al loro sepolcro', *Archivio della Società Romana di Storia Patria*, 29 (1906), 229–39; Wladimir de Grüneisen, 'Studi iconografici comparativi sulle pitture medievali romane. Il cielo nella concezione religiosa ed artistica dell'alto medioevo', *Archivio della Società Romana di Storia Patria*, 29 (1906), 443–525; Wladimir de Grüneisen, '*Tabula circa verticem*: aggiunta alla nota "intorno all'antico uso egiziano di raffigurare i defunti collocati avanti al loro sepolcro"', *Archivio della Società Romana di Storia Patria*, 29 (1906), 534–8; and Wladimir de Grüneisen, 'I ritratti di Papa Zaccaria e di Teodoto Primicerio nella chiesa di S. Maria Antiqua', *Archivio della Società Romana di Storia Patria*, 30 (1907), 479–85.

25 For example, de Grüneisen, 'Studi iconografici comparativi', pp. 445–6.

26 See in particular Josef Strzygowski, *Orient oder Rom: Beiträge zur Geschichte der spätantiken und frühchristlichen Kunst* (Leipzig: Hinrichs, 1901); and Josef Strzygowski, *Kleinasien: ein Neuland der Kunstgeschichte* (Leipzig: Hinrichs, 1903).

27 De Grüneisen, *Sainte-Marie-Antique*, p. 4.

28 See for example reviews of *Sainte-Marie-Antique* by Eva Tea in *L'Arte*, 18 (1915), 468–75; Charles Diehl in *Journal des Savants*, 2nd ser., 11 (1913), 49–56, 97–105; and Josef Strzygowski in *Byzantinische Zeitschrift*, 20 (1911), 529–32; and Gordon Rushforth, review of Wladimir de Grüneisen, *Le caractère et le style des peintures du VIe au XIIIe siècle*, The Burlington Magazine, 20.108 (1912), 367.

29 See *Journal des débats politiques et littéraires*, 6 January 1935, p. 2.

30 Wilpert, *Die römischen Mosaiken und Malereien der kirchlichen Bauten vom IV. bis XIII. Jahrhundert* (Freiburg im Breisgau: Herder, 1916). On Wilpert's contribution to the study of medieval art in Rome, see Per Jonas Nordhagen, 'Working with Wilpert: the Illustrations in *Die römischen Mosaiken und Malereien* and their Source Value', *Acta ad archaeologiam et artium historiam pertinentia*, series altera in 8°, 5 (1985), 247–57, repr. in Nordhagen, *Studies in Byzantine and Early Medieval Painting*, pp. 375–85; Sörries, *Josef Wilpert*, pp. 56–61; Fabrizio Bisconti, 'Giuseppe Wilpert: iconografo-iconologo-storico dell'arte', in *Giuseppe Wilpert archeologo cristiano*, ed. by S. Heid, pp. 249–60 (pp. 255–6, note 15).

31 For example Myrtilla Avery, 'The Alexandrian Style at Santa Maria Antiqua, Rome', *The Art Bulletin*, 7 (1925), 131–49; and Ernst Kitzinger, *Römische Malerei vom Beginn des 7. bis zur Mitte des 8. Jahrhunderts* (Munich: Warth, 1934).

Per Jonas Nordhagen in 2017 (photo courtesy Ragnhild Nordhagen)

JOHN OSBORNE

Per Jonas Nordhagen, Santa Maria Antiqua, and the Study of Early Medieval Painting in Rome

From the moment of its discovery in 1900, Santa Maria Antiqua has played an important role in the development of art historical studies, not only in the investigation of issues of style and iconography, but, perhaps more importantly, in the development of the methodologies used by historians of early medieval painting to actually practice their craft. Other papers in this volume focus on the debates and approaches taken in the first decades of the twentieth century; but this study will advance that timeline to the second half of the century, shining the spotlight on an art historian whose name has become virtually synonymous with the study of the murals in this church.

The first issue of *Acta ad archaeologiam et artium historiam pertinentia*, the journal of the Norwegian Institute in Rome, appeared in the year 1962, shortly after the Institute's foundation. The authors listed in the table of contents read like a 'Who's Who' of Norwegian scholarship on matters art historical and Italian, and included in this select company was a young scholar whose name would soon recur frequently in the pages of the *Acta*: Per Jonas Nordhagen (Figure 1). Santa Maria Antiqua, and more specifically its early medieval mural decorations, had been the focus of Nordhagen's research between 1957 and 1960, and that first article was entitled 'The Earliest Decorations in S. Maria Antiqua and their Date'.[1] At first glance this may not sound like a title that would change the course of medieval art history in Italy—but that is exactly what it did. This contribution will explore how our understanding of Santa Maria Antiqua, and more generally how art historians now approach the study of early medieval art in Italy, have been transformed as a result.

Santa Maria Antiqua is by far the single richest site in Rome for surviving wall painting from the early Middle Ages. It is enormously important—not only for art historians concerned with painting and sculpture, but also for those interested in political, religious, social, and economic history—and its decorations constitute 'documents' of primary importance for such studies, the equivalent in visual culture of the *Liber pontificalis* and other written sources. These murals have much to tell us about politics, religious controversies, liturgical practices, funerary customs,

social networks and patronage, hagiography—the list is almost endless. Their importance had been recognised since the moment of the initial excavation of the building in 1900 by the archaeologist Giacomo Boni, producing a flurry of studies in the years following its discovery, and thus Nordhagen was not venturing into *terra incognita*; quite the contrary. But for documents to be used effectively, they must be dated, and hence placed in a chronological context. The problem at Santa Maria Antiqua was that, apart from the portraits of a few historical figures, primarily popes (John VII, Zacharias, Paul I, Hadrian I), but also one lay magnate (Theodotus), who were identified by painted inscriptions, most of the 'documents' remained undated, or at least not dated incontrovertibly. Despite the many studies conducted in the first fifty years after the initial excavation, no overall scholarly consensus had been achieved, and thus the very first issue which demanded Nordhagen's attention was the chronology of the murals. As he put the matter on the first page of his study, 'the date of a considerable part of the material rests primarily on stylistic arguments',[2] and the problem was, quite simply, that these arguments had rarely produced a reliable degree of certainty.

Nordhagen boldly proposed a new approach to the study of the Santa Maria Antiqua murals, one which must have seemed quite radical to many art historians in 1962, but which half a century later would, I believe, simply be taken for granted. He announced his intention to find what he termed 'non-stylistic criteria' that would allow a more objective dating process. He then proceeded to explain what some of these criteria would be: stratigraphy, a very precise archaeological approach to documenting the superimposed layers of painting on each wall surface; 'technical factors', such as the composition of pigments and plasters; palaeography, the actual form of the letters used in the painted inscriptions, of which a great many survived; and ornament, including the forms and colours of frames and borders. 'By working exclusively with these more objective factors', he wrote, 'it seems possible to establish a reliable chronology for the church's earliest frescoes and to procure a safer basis for the discussion of the development of style.'[3] This discussion will return to that last statement, but for the moment let us consider how this startling new approach was applied to the study of Rome's single most important early medieval site.

The starting point for all attempts to decipher the enigma posed by Santa Maria Antiqua is invariably the end wall of the sanctuary area, the wall into which an apse had been carved, presumably when the building was formally converted into a church—possibly in the middle or second half of the sixth century—and in particular the wall to the right of the apse (Plates 37–39). This expanse of brickwork, dating originally from the era of the Emperor Domitian at the end of the first century CE, had been painted and repainted during a series of consecutive decorative campaigns spanning the course of a few centuries, and consequently had come to be known in the literature as the 'palimpsest' wall. This term originates from the discipline of codicology, and refers to a piece of parchment or vellum whose surface has been rubbed away, and the original writing effaced, in order that the valuable material could be re-used by the scribe as a surface on which to copy a new text. The rationale for such a practice is not difficult to determine: economy. Books were very expensive, primarily for the cost of their materials, requiring the hides of many animals. In 1900, when the excavations revealed this section of wall, with each layer of paint covering and hence concealing its predecessor, the term seemed appropriate, and subsequently the name has stuck. According to Eva Tea (admittedly writing

some decades later) the expression was first used by Giacomo Boni in a letter sent to the Italian Ministry in August 1900.[4] As Tea was Boni's assistant, her statement is certainly credible.

The 'palimpsest' wall is the key to a larger understanding of the church, since two of the layers of painting can be dated with some precision. One depicts two standing theologians, Basil and John Chrysostom, holding scrolls with texts from their writings (Plate 40). In a brilliant analysis, first published by Gordon Rushforth in 1902, these texts, as well as those on the scrolls held by their two counterparts to the left of the apse, Pope Leo I and Gregory of Nazianzus (Plate 41), can be identified as relating to the Acts of the Lateran Council of 649, convened by Pope Martin I (649–55) to oppose the heresy of Monotheletism.[5] This particular pictorial decoration can thus be dated with some precision to the middle years of the seventh century, with the Council providing a very useful *terminus post quem*. The subsequent repainting in the stratigraphic sequence, in addition, forms part of a substantial redecoration of the church that can be linked to Pope John VII (705–7), a remarkable pontiff who moved the papal residence from the Lateran palace to what the *Liber pontificalis* terms an *episcopium* at the site of the former imperial palace on the Palatine Hill, to which Santa Maria Antiqua is connected by a ramp.

We know of John VII's activities not only from a passage in the *Liber pontificalis* that mentions the church and his campaign of redecoration,[6] but also from the discovery of an image of the pope in the mural decorations of the triumphal arch, replete with the so-called 'square halo' signifying that it was intended as a portrait (Plate 35). Also uncovered in the 1900 excavation was an octagonal marble slab, bearing a carved inscription which names a 'JOHANNES SERVUS SANCTAE MARIAE' in both Latin and Greek. This last item formed part of a piece of the liturgical furnishings, from its shape probably a pulpit, and very likely the *ambo* cited in the *Liber pontificalis* passage as a papal gift.[7] These two certain points of reference (Lateran Council, John VII's pontificate) provide a solid foundation for a framework into which we can place not only the other layers on the wall, but, perhaps more importantly, many of the paintings elsewhere in the church. As a result, the 'palimpsest' wall is absolutely essential for our understanding of the chronology of the larger site.[8]

In this study, the term 'palimpsest' will also be used in a second and rather different sense. As an essential part of the process of developing an understanding of the early medieval paintings in Santa Maria Antiqua, Nordhagen also identified and developed the 'non-subjective criteria' announced as a goal in his first publication. In so doing, he moved the practice of art history, at least as it pertains to mural painting in early medieval Italy, in a new and hitherto unprecedented direction, one which has subsequently been broadly adopted by those who have followed in his footsteps. Thus the church as a whole may perhaps be regarded perhaps as a 'palimpsest' in a much broader sense: it is the place where the methodology of early medieval art history has itself been rewritten.

This 'non-subjective' approach might also be characterised as 'archaeological'. It involved a meticulous effort to examine and record as much information as possible. Nordhagen was never afraid to admit when conclusive answers were simply not available based on the surviving evidence, nor to leave significant questions open for further study. Perhaps even more importantly, he grasped the importance of creating a record that would permit future scholars to seek answers to questions that he himself had never envisaged. This is why his subsequent studies, especially his examination of the murals and plasters assigned to the pontificate of

John VII, which forms the entirety of the third volume of the Norwegian Institute's *Acta*, have been so essential for scholarship.[9] Replete with very detailed descriptions, observations, and measurements, the third volume of the *Acta* also constitutes an extensive archive of drawings, tracings, and hundreds of photographs; and there can be no doubt that it will remain the principal point of departure for all future work on the decorative campaign undertaken during the pontificate of John VII.

The concept of recording for posterity certainly had precedents. Earlier attempts to provide visual records of the material culture of early medieval Rome date back to at least the late sixteenth century, and the antiquarian activities in the catacombs conducted by the likes of Alfonso Ciacconio and Antonio Bosio. The seventeenth century produced the famous *Museo cartaceo* (or 'Paper Museum') compiled by Cassiano dal Pozzo, a member of the circle of Cardinal Francesco Barberini, an archive later acquired by King George III of England and still largely preserved in the Royal Library at Windsor.[10] But while these scattered collections of drawings provide an invaluable trove of information, they generally lack accurate information on matters such as scale, colour, condition, and often context. In other words, they were compiled to respond to the interests and issues of their day and age, but not with the intention of responding to the questions of the future. That foresight would come only in the late nineteenth century, thanks to the evolution of archaeology as a scientific discipline. Even today, some five decades after Nordhagen's publication of the John VII campaign, few other Italian sites have received the same level of extensive documentation of their early medieval murals. His study remains a beacon, setting a standard for the future that most now aspire to, but few have succeeded in achieving.

Working in the late 1950s and the 1960s, Nordhagen quickly discovered that of the many art historians whose work on Santa Maria Antiqua had preceded his, two stood out. The first was the German Jesuit scholar Joseph Wilpert (1857–1944), who had devoted much of his scholarly life to studying Rome's medieval wall paintings, and to creating an archive of documentary photographs, including his monumental study, *Die römischen Mosaiken und Wandmalereien der kirchlichen Bauten*.[11] And the second was Ernst Kitzinger (1912–2003), also born in Germany but working in America, and at the time arguably the best-known art historian of medieval Byzantium, whose 1934 doctoral thesis had attempted to make some sense of Roman wall painting of the early Middle Ages, and who continued to be actively engaged in this topic.[12] Nordhagen was too young to have met Wilpert, but he did know and very much admire Kitzinger, even when on occasion they disagreed. On many issues related to Santa Maria Antiqua Wilpert and Kitzinger had taken opposing views: for example, on the question of the extent of the redecoration of the church in the mid-seventh century, associated with the figures and texts for which Pope Martin I's 649 Lateran Council serves as a *terminus post quem*. Wilpert considered this campaign to have been extensive; Kitzinger much less so. Nordhagen proposed that solutions to this and other dating issues might be found through approaches which relied less heavily on the practice of connoisseurship, for example an analysis of the scripts used in the painted inscriptions. As he observes in that first *Acta* article: 'The best guide in this work of attribution is the *epigraphy*, as the Church Father inscriptions possess some very characteristic palaeographic features: somewhat thin, uneven letters with imprecisely placed seriphs.'[13]

It would not be fair to say that all previous scholarship on Santa Maria Antiqua had

completely ignored the painted inscriptions, and indeed Wladimir de Grüneisen's enormous 1911 monograph, *Sainte-Marie-Antique*, included an extensive 'Album Epigraphique'.[14] Wilpert had also given some consideration to this approach, but both early scholars of the church believed—today we would say erroneously—that stylistic analysis was considerably more reliable. Thus the idea of using the letter forms of inscriptions to link different groups of murals in different parts of a site—or indeed at different sites—was not at all a common practice until Nordhagen demonstrated its usefulness, deeming it 'our most important instrument in the work of identifying […] [the] decoration of the church'.[15] Just as scribes often have a unique and identifiable handwriting style, so do those who carve or paint inscriptions.

But palaeography was not the only tool in the art historian's new arsenal. Among many other things, Nordhagen was the first to observe that the plaster of John VII's murals contained a large quantity of straw, an ingredient not used by most earlier workshops engaged in the decoration of the church, and this observation has been confirmed by the detailed technical analysis of plaster compositions undertaken in recent years by Werner Schmid. There were also other similar observations about the techniques used by the different workshops, which, when put together, enabled a much more accurate relative chronology to emerge, one that was founded on objective evidence, not merely subjective opinion. In his 1968 study, Nordhagen very modestly and very succinctly sums up his results in these words: 'Though through the efforts of many scholars, the chronology of the church has, on the whole, been reliably established, many factors have been partly ignored which would have led to a safer classification of the countless scattered fragments of painting. The stratigraphy or superposition of layers has been widely exploited but never to its fullest extent, and the palaeography, as the above survey has shown, has been used sporadically but never systematically. Likewise, to be taken into account are, to a certain extent, the form and colour of the frames, the texture of the mortar, and the marks often left on the wall surface by certain instruments. This kind of evidence, which abounds at S. Maria Antiqua, constitutes a necessary corrective to the results obtained through stylistic analysis.'[16]

The result of Nordhagen's analysis was, quite simply, to take a monument for which there was no broad consensus regarding the dating of the various campaigns of decoration, and transform it into one for which the general chronology of the murals has become widely accepted. Thus the array of 'medical' saints in the Chapel of the Holy Physicians (Plates 47–9), to the right of the sanctuary (Plate 50: L), thought by Kitzinger to belong to the seventh century, but assigned by Wilpert to the time of John VII, can be shown on the basis of palaeography, technique, and ornament to be clearly associated with the latter campaign (first decade of the eighth century), a dating that remains without absolute proof but with which few would now disagree. On the other hand, Kitzinger was right about the Maccabees (Plate 14), Saint Barbara, and other related murals, which he had also placed in the seventh century.[17] In a similar fashion, a dating to the time of John VII can now be confirmed for the scenes with subjects taken from the Old Testament (Plates 25–6), painted on the walls of the High Choir enclosure, previously dated to the seventh century by Kitzinger, to the early eighth century by Rushforth and Tea, and to the later eighth century by Wilpert. One could continue this enumeration—but it shall suffice to say that questions which had previously been the subject of much controversy among prominent art historians were, for the first time, given definitive answers based on hard evidence, as opposed to the earlier heavy reliance on 'connoisseurship'.

The establishment of an accepted chronology for the early medieval mural paintings in Santa Maria Antiqua has transformed our understanding of the history of this important site, laying a firm foundation for the work of the next generation of scholars, who are now empowered to tackle questions of a different sort. Indeed, at the 2000 international conference sponsored by the British School at Rome, the Norwegian Institute, and the Soprintendenza Archeologica di Roma, which commemorated the centenary of the initial excavation, the dating of the various murals was never in serious dispute.

One of the major fields of art historical enquiry is iconography, the study of images and their meanings; and for those scholars interested in Christian iconography, the church of Santa Maria Antiqua is also a monument of considerable interest, due to the fact that it contains the earliest known depiction of a number of well-known subjects. Of these, probably the most important is the Byzantine theme of the *Anastasis* (Resurrection)—alternatively known as 'The Harrowing of Hell'. This is not a biblical story, but one that arose from discussions in patristic literature about what had happened to those good souls from the era prior to the death and resurrection of Christ. Were they damned for eternity, since they had died before the possibility of salvation? Of course, the theological answer was negative, and thus the notion developed that Christ had descended into the underworld to raise up Adam and Eve, and other just souls from previous ages—and in Byzantium this would become a standard feature of Christological narrative cycles, as well as being used independently as a popular subject for funerary monuments.[18] While it seems improbable that the first representation of the *Anastasis* anywhere in Christian art was in John VII's redecoration of Santa Maria Antiqua (Plate 8), it is certainly the earliest example of this theme to have survived.[19] This leads to a much larger and very interesting question. In Byzantine art from the eastern Mediterranean, representations of the *Anastasis* are known only from the mid-ninth century onwards, which is to say from the period after the end of Iconoclasm, the movement which sought to outlaw all figural depictions of religious figures. Was the iconography of the *Anastasis* developed after Iconoclasm? Or, had it existed already in the late seventh century, with the evidence from the eastern Mediterranean having been lost in the subsequent campaign to destroy religious images? Santa Maria Antiqua offers convincing evidence for the latter view;[20] and not only for the *Anastasis*, but also for a number of other themes, especially for Marian iconography. Nordhagen has consistently argued that pre-Iconoclastic Byzantium was an exceptionally prolific moment for iconographic innovation, and more generally for thinking about the public role of the arts. His essay 'The Absent Ruler: Reflections on the Origin of the Byzantine Domed Church and its Pictorial Decoration', also published in the *Acta* of the Norwegian Institute, draws together various strands of his thinking on this subject.[21]

Many—if not most—of the interesting iconographical problems relate to the pictorial campaign of John VII, who enjoyed a rather brief but extremely active pontificate. Perhaps the most intriguing of these is another issue that has engaged a great deal of Nordhagen's time and attention: the monumental image of the crucified Christ, adored by angels, painted on the sanctuary wall immediately above the conch of the apse (Plates 33–4). This is a painting of the highest quality, as has been remarked by all those who had an opportunity to examine it from scaffolding in recent years. Based on his meticulous observations and tracings, Nordhagen was the first to demonstrate convincingly that the figure of Christ was not dressed in a full-

length tunic (*colobium*), as most earlier scholars had believed or assumed, but rather in a simple loincloth, and also that his face was depicted in a very unusual fashion, with very thin curly hair and beard—and thus very different to the *Crucifixion* that would be found a few decades later in the Chapel of Theodotus, dating from the pontificate of Pope Zacharias (741–52) (Plate 28). Perhaps more importantly, he noted that the same unusual facial type for Christ was known only from one other source—the coins issued by the Byzantine Emperor Justinian II after he regained power in the year … 705! Are these two examples of what is apparently a unique iconographic type connected in any way? Undoubtedly they are, and this has prompted further thinking on the role of this emperor in developing and disseminating imagery. Indeed, he seems to have taken a particular interest in the visual arts, given the canons of the Quinisext Council that he had convened in Constantinople in 692, during his first period on the imperial throne. This matter was first raised by Nordhagen in a short but important article published in the *Journal of the Warburg and Courtauld Institutes*.[22]

These two examples serve to make the important point that our 'palimpsest' church has much to offer in terms of bringing evidence to bear on issues that go beyond the immediate site. It is important to remember, however, that this evidence only becomes useful—indeed it only becomes relevant—because it has been meticulously documented and placed in a tight chronological context.

This paper will conclude with some brief observations on the subject of 'style'. Despite Nordhagen's very valid reservations about the value of style as a primary dating criterion, it is a subject that has engaged his attention from the beginning, and also one that is addressed in some of his most recent publications, including articles which appeared in *Bizantinistica* in 2008 and 2012.[23] The analysis of style has been rather out of fashion in art historical circles in recent decades, and not without good reason. Nordhagen himself summed up the problem in his address to the spring 1987 Spoleto *Settimana di studi* on 'Bisanzio, Roma e l'Italia nell'Alto Medioevo'. He writes: 'It should be stated […] that there is a growing uncertainty as to the validity of traditional research on style. We believed once, rather naively, that the ability to formulate judgements of style depended simply on the training of the eye, and therefore that an art historian with the proper training could provide concise and non-subjective definitions of style, to use as the means by which to approach the problems of cultural history. Gradually, however, this optimistic view on the objectivity of the eye has been supplanted by a growing skepticism, as the positivistic trend in science has come under the fire of critics. This uncertainty must remain "a problem within the problem".'[24]

Santa Maria Antiqua has been at the centre of modern discussions about style in the early Middle Ages, for the simple reason that it was the excavation of this site, and more specifically the uncovering of the 'palimpsest' wall, that offered dramatic and convincing proof that the traditional understanding of the progress of the visual arts, first articulated by Giorgio Vasari, required radical rethinking. The Vasarian view was that the arts rapidly descended into a steep decline around the time of the Emperor Constantine, recovering only around 1300 with the painters Cimabue and, especially, Giotto. The problem with this view, as Boni and others discovered in 1900, is that the layer on the 'palimpsest' wall containing the figure of the enthroned *Maria Regina and Child*, flanked by angels, probably of the first half of the sixth century, must be earlier than the subsequent level containing an *Annunciation* that features

a much more classicising archangel Gabriel, the so-called 'Pompeian angel' or *Angelo Bello* (Plate 39).[25] Thus the stratigraphic position of the two heads of angels necessitated a complete rethinking of the broadly accepted notion of a progressive 'decline' in classical norms, and a lively debate ensued.

The obvious explanation is that something changed between the two levels and their corresponding angels—clearly, different painters or workshops were employed for the figures. The question is what, if anything, should be read into that. Is it a case of a new external and somehow more 'classicising' influence reaching Rome? If so, what was it? Most would answer affirmatively to the first question. The second, by contrast, raised much debate in the decades following the excavation. One school of thought, spearheaded by Charles Rufus Morey and his pupil Myrtilla Avery, credited the influence of Alexandria, where they believed that the classical idioms had been preserved long after they had fallen into decline elsewhere.[26] This was difficult to prove, however, and some of the manuscripts which Morey wished to ascribe to Alexandria around 600 CE were shown by Kurt Weitzmann to be Byzantine products of a much later date. The question was then taken up by Kitzinger, who suggested that the 'source' for the renewed classicism, or 'Hellenism' (as it has been termed, rather inappropriately perhaps, in much of the literature) was Constantinople itself. While no painting survives in the Byzantine capital from this period, there is evidence from other media—and in particular mosaics and silver objects, the latter having the advantage of often being very precisely datable on the basis of their control stamps. This thesis was presented at the 1958 International Byzantine Congress held in Munich,[27] where it was heard by a certain Norwegian scholar who was also delivering his own paper at the same event—and much of Nordhagen's own writing on the subject of style has sought to support and defend Kitzinger's thesis, including the most recent pieces in *Bizantinistica*, even if he is not in complete agreement with every aspect.

Clearly, Kitzinger's 'manifesto' (as Nordhagen terms it) resonated very well with the evidence Nordhagen was discovering in Santa Maria Antiqua, in particular with his own view of the Byzantine capital and its imperial court as a significant source of innovation in art and its social, political, and religious functions in the century before Iconoclasm. Indeed, Nordhagen would argue (and few, I think, would disagree) that the artists employed by John VII probably came from 'Byzantium', however defined. The same theory may also prove very useful to explain the style of the mural decorations in other early medieval Italian monuments, whose figure paintings similarly appear to hark back to an earlier age in terms of their high degree of classicism; one thinks immediately of sites such as Santa Maria *foris portas* at Castelseprio, or the Tempietto at Cividale.

Where Nordhagen disagrees with Kitzinger is on his concept of 'perennial Hellenism'— that a classicising stream was always present in Byzantine art, co-existing with other streams, and used primarily for special subject matter: angels, for example. Nordhagen takes a different approach, arguing that 'Hellenism' may always have been present in Byzantium, but that it usually lay dormant—in a recent article he uses the term 'slumbering Hellenism'[28]—until needed for use in very particular contexts, and he apparently prefers to think in terms of religious contexts rather than political ones. When we find 'Hellenism' coming to the surface in Byzantine art, in the seventh century and again in the tenth century, this is no mere accident. In this regard, Nordhagen uses the expression 'stylistic determination—a will to pursue certain

artistic ideals for the sake of bringing across particular messages'.²⁹ This is a discussion that is very much ongoing, and no final resolution is likely anytime soon. We still know very little—indeed almost nothing—about the processes that led to the employment of certain styles in the early Middle Ages, in Rome or elsewhere. Was it a function of workshop practice, and differing practices in different centres of production? What role was played by the patron? We simply have no idea.

On that fateful day in January 1900 when Giacomo Boni began the uncovering of the site that turned out to be Santa Maria Antiqua, little did he or anyone else know what a profound impact this discovery would have: not merely for our understanding of the history of the Roman Forum in the early Middle Ages; nor even for our broader understanding of the arts of medieval Italy, the Mediterranean world, and Byzantium in the years immediately prior to Byzantine Iconoclasm; but, perhaps most important of all, for the way that art historians confronted by this material have, in the process, reinvented and re-written the practice of art history. Santa Maria Antiqua is indeed a 'palimpsest' church in more ways than one. And Per Jonas Nordhagen has played a central role in that process of re-writing.

* This paper was first presented at the Norwegian Institute in Rome in September 2009, on the occasion of the Institute's fiftieth anniversary jubilee. Given the dedication of the present volume to Per Jonas as a slightly belated celebration of his ninetieth birthday, it seemed both opportune and appropriate to include it here.

1 Per Jonas Nordhagen, 'The Earliest Decorations in Santa Maria Antiqua and their Date', *Acta ad archaeologiam et artium historiam pertinentia*, 1 (1962), 53–72.

2 Ibid., p. 53.

3 Ibid., p. 53.

4 Eva Tea, *La Basilica di Santa Maria Antiqua* (Milan: Vita e pensiero, 1937), p. 9.

5 Gordon Rushforth, 'The Church of S. Maria Antiqua', *Papers of the British School at Rome*, 1 (1902), 1–123 (pp. 67–73). Rushforth credits the identification of the texts in the painted scrolls to F.E. Brightman, C.H. Turner, and H.A. Wilson. See also the contribution by Richard Price in this volume.

6 *Le Liber Pontificalis*, ed. L. Duchesne, 2 vols (Paris: E. Thorin, 1886–92), I, 385: 'Basilicam itaque sanctae Dei genetricis qui Antiqua vocatur pictura decoravit, illicque ambonem noviter fecit'.

7 Rushforth, 'The Church of S. Maria Antiqua', pp. 89–91.

8 For the most recent technical analyses, see Maria Andaloro, 'La parete palinsesto: 1900, 2000', in *Santa Maria Antiqua al Foro Romano cento anni dopo*, ed. by J. Osborne, J.R. Brandt, and G. Morganti (Rome: Campisano, 2004), pp. 97–112; and Werner Schmid, 'I primi due strati dipinti della parete-palinsesto di Santa Maria Antiqua: nuove osservazioni di carattere tecnico-esecutivo', in *L'officina dello sguardo: scritti in onore di Maria Andaloro*, ed. by G. Bordi, I. Carlettini, M.L. Fobelli, M.R. Menna and P. Pogliani (Rome: Gangemi, 2014), pp. 437–42.

9 Per Jonas Nordhagen, 'The Frescoes of John VII' (A.D. 705–707) in S. Maria Antiqua in Rome', *Acta ad archaeologiam et artium historiam pertinentia*, 3 (1968).

10 John Osborne and Amanda Claridge, *The Paper Museum of Cassiano Dal Pozzo: Early Christian and Medieval Antiquities*, 2 vols (London: Harvey Miller, 1996–98).

11 Joseph Wilpert, *Die römischen Mosaiken und Wandmalereien der kirchlichen Bauten vom IV. bis XIII. Jahrhundert* (Freiburg im Breisgau: Herder, 1916). See also Per Jonas Nordhagen, 'Working with Wilpert. The illustrations in *Die römischen Mosaiken und Malereien* and their source value', *Acta ad archaeologiam et artium historiam pertinentia*, series altera 5 (1985), 247–57; and Giulia Bordi, 'Giuseppe Wilpert e la scoperta della pittura altomedievale a Roma', in *Giuseppe Wilpert archeologo cristiano: Atti del Convegno (Roma, 16–19 maggio 2007)*, ed. by S. Heid (Vatican City: Pontificio Istituto di Archeologia Cristiana, 2009), 323–58.

12 Ernst Kitzinger, *Römische Malerei vom Beginn des 7. bis zur Mitte des 8. Jahrhunderts* (Munich: R. Warth & Co., 1934).

13 Nordhagen, 'The Earliest Decorations', p. 60; for a fuller documentation of the seventh-century murals, see Per Jonas Nordhagen, 'S. Maria Antiqua: The Frescoes of the Seventh Century', *Acta ad archaeologiam et artium historiam pertinentia*, 8 (1978), 89–142.

14 Wladimir de Grüneisen, *Sainte-Marie-Antique* (Rome: M. Bretschneider, 1911).

15 Nordhagen, 'The Earliest Decorations', p. 66. See also Per Jonas Nordhagen, 'The Use of Palaeography in the Dating of Early Medieval Frescoes', *Jahrbuch der Österreichischen Byzantinistik*, 32.4 (1983), 168–73.

16 Nordhagen, 'The Frescoes of John VII' (1968), pp. 11–12.

17 Nordhagen, 'The Earliest Decorations', pp. 61–2.

18 For the underlying theology, its relevance to Christological debates in the seventh century, and its appearance in the visual arts, see Anna Kartsonis, *Anastasis: The Making of an Image* (Princeton: Princeton University Press, 1986).

19 See also Wilpert, *Römischen Mosaiken*, pl. 168/2; and Nordhagen, 'The Frescoes of John VII' (1968), pp. 80–2.

20 Per Jonas Nordhagen, '"The Harrowing of Hell" as Imperial Iconography. A Note on its Earliest Use', *Byzantinische Zeitschrift*, 75 (1982), 345–8.

21 Per Jonas Nordhagen, 'The Absent Ruler: Reflections on the Origin of the Byzantine Domed Church and its Pictorial Decoration', *Acta ad archaeologiam et artium historiam pertinentia*, n.s. 1 (2001), 319–36.

22 Per Jonas Nordhagen, 'John VII's *Adoration of the Cross* in S. Maria Antiqua', *Journal of the Warburg and Courtauld Institutes*, 30 (1967), 388–90.

23 Per Jonas Nordhagen, 'The Use of Antiquity in Early Byzantium. Ernst Kitzinger's Thesis on the "Perennial Hellenism" of Constantinople', *Bizantinistica*, 9 (2008), 61–71; and most recently in a response to Beat Brenk, Per Jonas Nordhagen, 'The Presence of Greek Artists in Rome in the Early Middle Ages. A Puzzle Solved', *Bizantinistica*, 14 (2012), 183–91.

24 Per Jonas Nordhagen, 'Italo-Byantine Wall Painting of the early Middle Ages: an 80-year old enigma in scholarship', *Bisanzio, Roma e l'Italia nell'Alto Medioevo* (Spoleto: CISAM, 1988), pp. 593–619 (p. 593).

25 See also *Santa Maria Antiqua al Foro Romano cento anni dopo*, cover photo.

26 Avery, 'The Alexandrian Style at Santa Maria Antiqua, Rome', *The Art Bulletin*, 7 (1925), 131–49.

27 Ernst Kitzinger, 'Byzantine Art in the Period between Justinian and Iconoclasm', in *Berichte zum XI.*

Internationalen Byzantinisten-Kongress (München 1958) (Munich: Beck, 1958), IV.1, pp. 1–5.

28 Nordhagen, 'The Use of Antiquity', p. 71.

29 Ibid., p. 67.

TOPOGRAPHY

HENRY HURST

The early church of Santa Maria Antiqua

Santa Maria Antiqua contains a great deal of structural information reflecting its early history. This has been rather neglected—an omission which can partly be traced back to Giacomo Boni not publishing the findings from his 1900 excavation, but also, no doubt, because this type of evidence is so outshone by the exceptional visual imagery. If we wish to study the earliest stages of the church, however, we have to look at this evidence with as critical an eye as has been brought to the paintings and inscriptions: obviously the building needs to be understood through the integration of all categories of information. This paper focuses on the evidence for the site before a series of changes produced the *diaconia* church of the seventh and eighth centuries with which we are most familiar. The argument is that the church is within a fourth-century basilica, not sixth as previously thought, and that there are details of this building that point towards ecclesiastical use. It was established within a building complex that was probably redeveloped at the same time as the construction of the basilica (Figure 1). This is a significant departure from the traditional view of a sixth-century origin of Santa Maria Antiqua, proposed by Boni and set out by Gordon Rushforth (1902), and later elaborated by Richard Krautheimer, Wolfgang Frankl, and Spencer Corbett in the *Corpus Basilicarum Christianarum Romae*.

Traditional view in outline, and its difficulties (Figures 2, 3)

In the traditional view the church nave was seen as an open *quadriporticus* of imperial date, defined by brick piers, including those that survive at three corners, but also intermediate ones. The latter were replaced by columns when a basilica was constructed in the later sixth century. This change could be placed in or after the 570s, because one or three coins of Justin II (565–74) were found under the south-east column base.[1] The *quadriporticus* was dated by Hadrianic brickstamps from the piers and vaults of the nave and aisles: Richard Delbrück assumed that the structures were of the same date as the stamps;[2] the *CBCR* advanced the date to the Antonine era later in the second century CE.[3] Boni himself, however, dated the piers and vaults to the third or fourth century on architectural grounds, as his outline for a publication shows,[4] but Eva Tea herself followed the brickstamp dating. The entry in the *Corpus Basilicarum Christianarum*

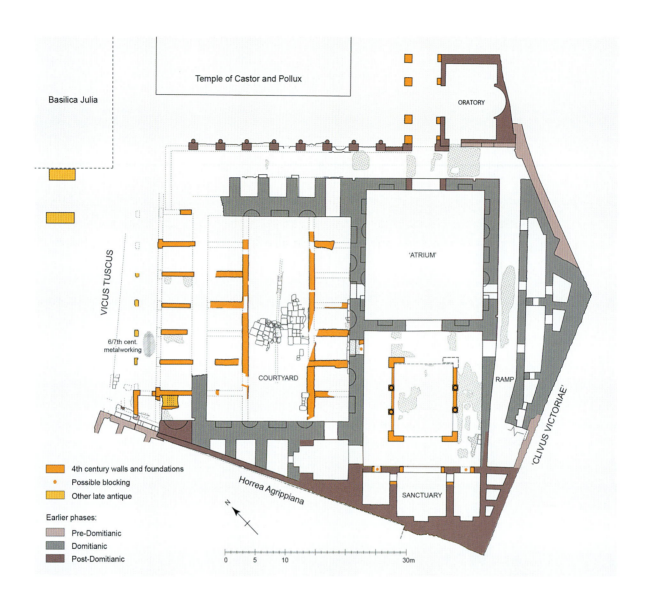

Plan of Santa Maria Antiqua in its fourth-century setting (Henry Hurst)

Romae also suggested that the new church was marked by the addition of the apse to the south wall of the room that became the sanctuary. Consequently, the painting of *Maria Regina*, which was on the same wall but earlier than the apse, was considered to be earlier than the church itself.[5]

There are many difficulties with this view. A *quadriporticus* or courtyard using the existing corner piers and the complex arrangement of the arches and vaults they carried seems disproved by evidence. Intermediate brick piers seem unlikely in this setting; and it would have been complicated to make a basilica nave by replacing them with columns, while other parts of the structure, as the corner piers and possibly the vaults they carried were retained. The coin-based dating is also questionable. It seems counterintuitive to assign a prominent image of Mary in a church carrying her name to a pre-church context. It also seems implausible to date the origin of a church that was called *antiqua* around the 630s to no earlier than the 570s.[6]

Argument for a fourth-century basilica

A first structural distinction should be made: that while the nave area had undoubtedly been an open court in earlier imperial times, containing fountains as suggested by the water-pipe trenches, the standing brick corner piers and column plinths seem not to have been associated with this use. The courtyard was bounded by the 1.8-metre-wide foundations of Domitianic date that surrounded it on all four sides, and these foundations might be expected to have carried structures (presumably columns and piers) in scale with them. The existing corner piers and plinths are half the width of the Domitianic foundations and from their construction technique, using bricks of inconsistent thicknesses and (in the corner piers) few *bipedales* courses containing some incomplete bricks, their dating looks later imperial (Figure 1). Associated with these piers and plinths was a floor of *opus spicatum*, which can still be seen in the aisles and in the nave in the area immediately adjacent to the central octagonal base. It is shown in the plan and axonometric projection by Antonio Petrignani with a larger extent in the nave, where it has since been covered by the restored floor of granite slabs and white marble associated with the surviving *schola cantorum* screens, which probably date to the seventh century (Figures 2–3). Probably because of the lower level of the earlier courtyard, the *opus spicatum* in the nave is as much as forty centimetres below that in the side aisles: there is no indication that it was of a different date.[7]

The use of *opus spicatum* suggests that the nave was then covered space. *Spicatum* could sometimes be used as a surfacing for open spaces, but in this case it was the same flooring as that of the side aisles, and travertine paving was used for contemporary open spaces, as, for example, the courtyard in the former Domitianic aula west of the church (Figure 1). The building is thus likely to have been a basilica from the time that this floor was laid. The quite complex vaulting carried by the piers also fits this interpretation. The lateral spaces on all four sides of the nave were covered by barrel vaults, interrupted on the main north-south axis of the building by taller vaults at right angles to them. A fragment of the lateral vaulting with a flat surface above it survives at the south-west corner of the western aisle, suggesting flat *terrazzo* roofing above the aisles. This would fit with a taller roof over the nave with clerestory lighting. The central roof would probably have been pitched above a timber framework, because there

was no structural provision for the lateral thrust of a vault. All this was understood by Boni and his architects, so that the overall structural character would be as they have restored the church.

As regards dating, Boni had already suggested the third or fourth century for the piers and vaults, and, as mentioned, the pier construction looks later imperial.[8] The vaults carried by the south-east and south-west piers of the nave are also cut into the walls of the tall rooms to their south (later to be the sanctuary and two flanking chapels; Figure 3). The *opus spicatum* floor of the church is also probably contemporaneous with a similar floor at the same level in a room just to its west, which belongs to the building complex added secondarily in the aula and to its west. This was previously thought to be late Domitianic because of brickstamps found in its foundations,[9] but *opus spicatum* floors in the same complex in the western area are shown from stratified coins to be no earlier than the fourth century. A possible actual date is suggested by a hoard of coins, which appears to extend to 312 and may have been sealed below one of the rooms in the western part of the complex. The composition of the hoard is reconstructed on numismatic grounds, and so not clear beyond doubt, but the case for a fourth-century date is made independently of it.[10] The brickstamps, which were previously relied upon for dating, may be discounted because the walls of these buildings evidently incorporated reused material. The same argument of reused building materials also applies to the Hadrianic brickstamps in the church structures.

How, then, should the coin(s) of Justin II, said to have come from beneath the south-east column base in the nave, be explained? As already mentioned, Tea's publication is inconsistent over whether one or three coins were present.[11] Recent discussions, summarised by Paribeni, have included the proposition that three xx *nummi* coins of Justin II among those recorded as coming from the Juturna area were really from Santa Maria Antiqua, and that they represent a deliberate foundation deposit beneath the column base, demonstrating the sixth-century date of the basilica.[12] Aside from any other considerations, this proposal requires the guess (because there is no proof) that the Juturna coins were from Santa Maria Antiqua and the further guess that they were a deliberate foundation deposit. It does not look like a strong argument.

There is, indeed, reason to question whether the columns had been replaced when Boni found them. On the western side of the nave, the columns rest directly on square plinths of brick-faced *opus caementicium*. The two column bases on the east, including that under which the coin(s) were said to have been found, stand on blocks of travertine, which they overlap, and these in turn rest on the partly destroyed brick plinths (Figure 3; this can be seen in the church now, Plate 3). How might this have come about? Boni's proposition, accepted in the *CBCR*, that the brick plinths had originally been piers, seems unlikely in view of the ugly proportions this would produce: 0.85-metre square piers set 2.8 metres apart, standing about 6 metres high and capped by segmental arches, with L-shaped corner piers. It seems more probable that there were plinths carrying columns from the outset. As to whether that meant the existing grey granite columns, there are reasons to think probably not. Where the column bases rest directly on the plinths, on the western side of the nave, the bases are several centimetres smaller. If, as is probable, the brick plinths were originally marble-veneered, they would have been larger than the bases by at least 10 centimetres on all sides. That would be easier to understand if the surviving columns had been added secondarily.

Two more pieces of evidence may bear upon this. One is the indication of a fire, shown in

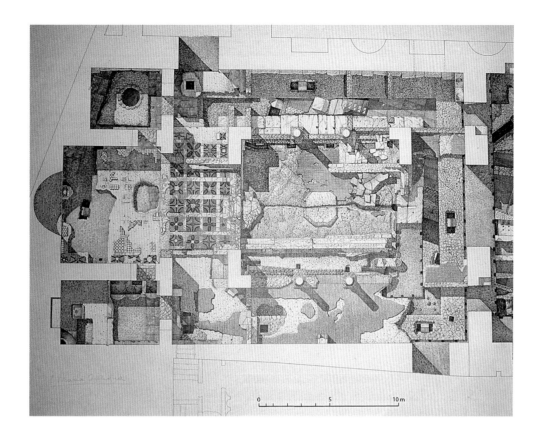

2 Southern part of Antonio Petrignani's plan of the remains of Santa Maria Antiqua as exposed during Giacomo Boni's 1900 excavations
(Tea, *La Basilica di Santa Maria Antiqua*, pl. IV)

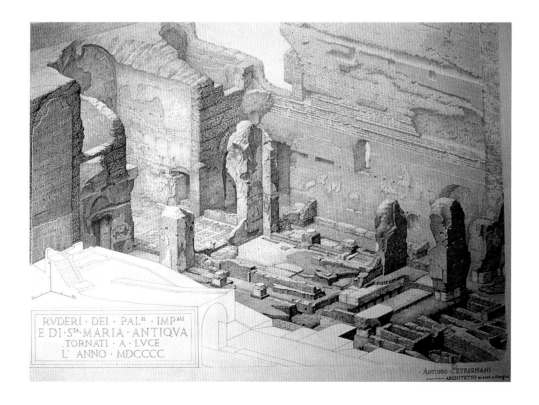

3 Antonio Petrignani's axonometric projection of the remains of Santa Maria Antiqua
(Tea, *La Basilica di Santa Maria Antiqua*, pl. III)

fragments of *opus sectile* which very probably originated from the basilica: about nine hundred fragments were found in excavations of the large *aula* west of the church in the 1980s, probably dumped there at the time of the 1900 excavations. A further ninety-seven fragments, including figurative pieces, were retained by Boni and have recently been published by Giulia Bordi and Alessandra Guiglia Guidobaldi.[13] The *aula* pieces, which are mostly non-figurative, have recently been studied and, of about three hundred 'feature' fragments (i.e. with intact edges, incisions, etc.) that were documented, twenty-eight—or just under ten percent—were recorded as being burnt, a few pieces to a degree where the calcination of the marble (requiring a temperature of 900° Celsius) occurred. This fire can be suggested to have occurred at a time when there was *opus sectile* on the walls of the basilica, but not yet frescoes (which show no sign of burning), so not earlier than the late fourth century and probably before the sixth century. After a severe fire, it is possible that the nave columns needed replacement or re-erection. Numerous fragments of column veneers, including some pieces that show burning, were found among the *opus sectile* deposits just mentioned. They could indicate that the original nave columns were of brick-faced *opus caementicium* veneered in marble, as is seen for example in the Stadium of the Domus Augustana, or more locally in the northern portico of the Domitianic complex (where only the brick-faced remains survive). The brick corner piers could have been similarly veneered.

The second piece of evidence concerns the excavation of the church in 1702. The watercolour by Francesco Valesio shows the southern part of the church including the apse exposed to its full height, and the discovery is mentioned in Valesio's *Diario di Roma*, in the entries for 24 May and 2 August of that year, reporting that re-excavation had been ordered.[14] Lanciani, from his reading of contemporary accounts, says: 'steps were taken to make the place permanently accessible, and to ensure the safety of its artistic treasures by rebuilding its roof or vaulted ceiling. However its great depth [...] the invasion of the subterranean springs and the opposition of Duke Francesco Farnese, whose gardens had been undermined by the excavations [...] led to the attempt being given up and the church became once more lost and buried under forty feet of rubbish.'[15] Looking at the stratigraphic evidence, as shown in the photographs of Boni's excavation in the church, it is clear that throughout most of the building his workmen dug out dark loamy soil with comparatively little rubble right down to the surviving floor (Figure 4). The original destruction of the church would have been a mass of mortary rubble (looking like photographs of the demolition of Santa Maria Liberatrice in 1900). The fact that all four columns and capitals in the nave survived, without great quantities of rubble from the superstructure, points to the previous sorting of the area and, given the near completeness of the columns and capitals, they look as if they had been saved for display, or actually displayed. It is possible, then, that the two columns that stand on travertine blocks on the eastern side of the nave were re-erected. A further consideration could be added, that if they had been standing on these blocks since early medieval times, it might be expected that the sixteenth-century stone robbers would have taken the blocks. The robbing may, however, have stopped just short of the columns.[16]

So, a replacement of columns in a pre-existing basilica is suggested, possibly following a fire, and there may have been a re-erection after excavation in 1702. No 'foundation deposit' would therefore be appropriate, and it seems quite possible that the Justin II coin(s) reached the spot where Boni's team found it/them in 1702.

4 Early stage in Giacomo Boni's excavation of the church, showing the dark loamy backfill. View looking south-east: the north-west nave column is visible in the foreground and the south-east pier towards the rear. The eastern screen of the low choir is beginning to emerge in the left foreground. (photo: Archivi del Parco archeologico del Colosseo)

Comment in parentheses on the destruction of the church

If Boni excavated the backfill after the excavations of 1702, it follows that the tipped-over state in which he found the columns in the backfill deposit must date from 1702. Since this is often thought, following Rushforth, to reflect the earthquake of 846/7,[17] let it be stated clearly: the earthquake had nothing to do with that. We should remember that the connection between the 846/7 earthquake and Santa Maria Antiqua is Rushforth's inference from separate passages in the *Liber pontificalis*:[18] a generic statement about the earthquake (*Vita Leonis IV*, ch. 12)[19] and passages which refer specifically to the replacement of Santa Maria Antiqua by Santa Maria Nova (such as *Vita Benedicti III*, ch. 24).[20] There is therefore no compelling reason to make that inference any more, and it would be of value to future studies of Santa Maria Antiqua to accept that.

Was the basilica a church?

Fourth-century basilicas had a variety of functions. In the present case, there are pointers towards the building being a church, without (as yet) any conclusive evidence.

Evidence for possible original nave screens (Plate 3; Figures 1–3, 6): A course of reused *bipedales* and cut parts of *bipedales* can still be seen *in situ*, running between the piers and column bases on the eastern side of the nave, at the same level as the *spicatum* floor of the east aisle. This floor abuts the *bipedales* course, so it should belong to the primary phase of the basilica.

The most normal interpretation of such a course would be that it was within a foundation or a wall. On the western side of the nave, evidence has been destroyed below the level of the *opus spicatum* floor, but Petrignani's drawings (Figures 2–3) and photographs from the time of the excavation show a brick-faced *opus caementicium* wall or foundation, about 0.4 metres wide, running between the nave piers and columns. The width of the *bipedales* on the east (0.59 metres) was greater than that of the foundation on the west, so the two structures seem not to have been exact twins, but they both occupied the same position with respect to the nave and both would be interpreted as supports for insubstantial walls or screens. Apart from these remains, there is the detail already noted, that the nave floor was about 0.4 metres below that of the side aisles, so a separation is indicated between the nave and side aisles.

Early wall and vault decoration sequence: Within the basilica and the chapels to its south, there appears to have been a single phase of Roman wall plaster decoration. All the surviving fragments *in situ* that are Roman imperial seem to be united by the nature of the preparatory layers, as well as by characteristics like the presence of organic material in the plaster,[21] and, where the evidence survived, by their earlier stratigraphic position with respect to the *opus sectile* wall decoration. This plaster is present in various areas: in the Chapel of Theodotus (Plates 28, 50: J), as polychrome painted coffering in its vaulted ceiling and as red setting-out lines with the other colour lost, on the high part of the walls; as a lump of beige preparation at a low level on the west wall, in the Chapel of the Medical Saints (Plates 47, 50: L4); in the south-eastern part of the main body of the basilica, as a fragment of a scene with architectural illusion on the east aisle wall (Plates 10, 50: D1) and as a fragment of yellow and black framing on the north wall of the Chapel of Theodotus. A figurative scene on the south-east pier, showing a ruminant's head and foot, also appears to have preparation matching that of the other Roman plaster.[22]

The *opus sectile* wall decoration that followed is seen, mainly from its preparation and often from small traces, to have been present in the sanctuary, two flanking chapels on the south and in the main body of the basilica, on the south-east and south-west piers as well as side walls. During conservation work, Werner Schmid established that the *opus sectile* preparation (most evident in the Chapel of Theodotus and the sanctuary, and described in Guiglia Guidobaldi and earlier studies)[23] was associated with the clamp holes in the Chapel of Theodotus, since these correspond to lines between areas of preparation and there are plank impressions at these divisions.[24] Timber planks were probably attached to the walls when the pre-prepared panels of *opus sectile* were set against the walls and wet mortar was poured behind them to attach them. Vertical streaks or dribbles of cement could be seen especially on the west wall of the Chapel of Theodotus (Plate 30), and dribbles also survive on the west wall of the Chapel of the Medical Saints (Plate 47). Traces of *opus sectile* preparation can also be seen on the south-east and south-west piers of the nave and on the east and west aisle walls (in the latter case as clamp holes only). The likely date of the *opus sectile*, from parallels at Rome and Ostia, would be the late fourth century.[25] Contemporaneous with it was a mosaic vault decoration, of which fragments survive in the sanctuary and in the 'bema'[26] (Figure 6: fourth-century plan): small parts of the setting were observed with colour traces, and fragments of tesserae in blue, yellow, and red glass paste were retrieved by Boni.[27]

This was followed in the sanctuary by the earliest fresco decoration, namely the red-painted

5 Excavation of *opus sectile* at the eastern edge of the '*bema*' floor, April 2015. 1) Old photograph, looking west, showing two *sectile* pieces (arrowed) surrounded by modern cement; 2) plan adapted from Leonardo Paterna Baldizzi's drawing (February 1901); 3) view looking south-west after the removal of modern tiles at the edge of the upper mosaic floor; 4) later view of same area from above, showing an amphora sherd strip in *opus sectile*. A second strip is in shadow running under the tesserae in situ. (Henry Hurst)

frame surviving at the top of the *Maria Regina* panel (Plate 37). Bordi has shown how this was part of a symmetrical composition developed on either side of the central niche (later replaced by the apse), with fragments of images probably of Saint Peter and Jesus on the left, while the frame on the right might be conjectured to have contained an image of the Virgin and Child (Plate 35). That would have been replaced with the surviving image, in different plaster, of *Maria Regina* in the guise of a Byzantine empress, resembling Theodora at Ravenna. That could therefore be of Justinianic date, replacing an image dating perhaps to the time of Theodoric.[28]

At a later date, some *opus sectile* evidently remained in place on the higher part of the sanctuary walls (Plates 42, 45) and in the Chapel of Theodotus (Plates 27–31), where it was integrated with the eighth-century fresco decoration, but in the nave it appears to have been removed before an application of white plaster, which Nordhagen dated to the mid-seventh century.[29]

Floor treatment: While the nave and aisles appear to have been floored first in *opus spicatum* and secondly in the nave with granite and marble slabs, the sanctuary and *bema* areas had more ornamental flooring, in the latter case probably first of *opus sectile* and later of *opus Alexandrinum* or *sectile-tessellato marmoreo* with a floral design (Plates 23–25, 32, 42, 45). Guiglia Guidobaldi and Guidobaldi suggested that this floor dated to the sixth century; it was earlier than the surviving screens, whose initial construction is probably no later than mid-seventh century (Figures 2–3).[30] In April 2015 an examination was made of one of the two fragments of *opus sectile* that apparently belonged to an earlier floor at its surviving east edge.[31] It was found that beneath the *sectile* there was a preparation of strips of African amphorae set in mortar, similar to that on the walls of the sanctuary and Chapel of Theodotus (Figure 5). The small area exposed requires any conclusion to be qualified, but the *opus sectile* here looks like remains of an earlier floor *in situ* that, from its preparation, would be contemporary with the *sectile* wall, so from the late fourth century. This seems likely also to have been confined to the *bema*, because the earlier *opus spicatum* floor along the east wall of the nave, which was at a lower level, was evidently still in use in association with the seventh-century fresco painting (Plate 23).

Discussion

These small fragments of evidence, considered in isolation from each other, could be interpreted in various ways. Together, however, they seem to point in a consistent direction: there seems to have been some form of separation between the nave and aisles from the first construction of the basilica. At the *opus sectile* stage of decoration, there were mosaic vault decorations above the sanctuary and *bema* spaces, but not in the side room that later became the Chapel of Theodotus. There is also the sign of a *bema* or chancel floor—only surviving as two *sectile* fragments—but clearly not extending as far as the east aisle, where later frescoes reached down to the lower *spicatum* floor (Figure 6). These details all anticipate therefore the later distinctions in this building at a time when it was uncontroversially a church. As to whether there could have been a church without an apse (since the existing apse was clearly no earlier than the later sixth century), Krautheimer said apropos of fourth-century churches that 'the Christian basilica drew three or four features which by AD 300 had become essential characteristics common to the majority of basilicas whatever their function: the oblong plan; the longitudinal axis; the timber roof [...]; finally, the terminating tribunal, *whether rectangular or in the form of an apse* [italics mine]'.[32]

The fire or fires

Having raised the possibility of a fifth-century fire in connection with loose *sectile* pieces that probably came from the basilica, it would be misleading not to say that the walls of the 'atrium' also show evidence of burning. There are varying degrees of soot discolouration on all four walls, at the main north entrance from the Forum, and on the east-side entrance from the ramp the burning has been fierce enough to distort the brickwork surface. This appears to have occurred after a secondary narrowing of the north entrance and before the first frescoes, dating to the seventh century. This 'atrium' conflagration is not as closely dated as the suggested

THE EARLY CHURCH OF SANTA MARIA ANTIQUA

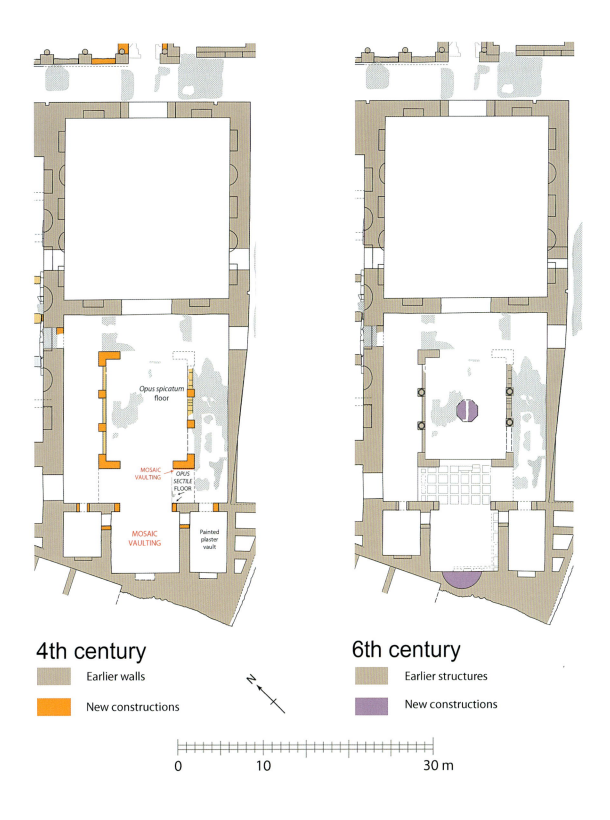

Plans showing the church in the fourth and sixth centuries (Henry Hurst)

fire in the basilica and could consequently be unrelated to it. That the two may have been connected is suggested by a need in both cases for some supply of fuel to feed a fire. Neither the basilica with *opus sectile* walls nor the 'atrium' with brick walls and possibly marble decoration seem very combustible at floor level, so the question arises of whether flammable material was deliberately introduced. The location of the fires might seem to support this, since the most severe burning in the 'atrium' seems to have been at its two entrances, while in the basilica it might be suspected that the nave, where all the *sectile* was replaced, was more severely affected than the Chapel of Theodotus and sanctuary, where some *sectile* survived. If the project had been to burn down the basilica, fires at the two 'atrium' entrances would prevent it from being extinguished. The fire may have been connected with a possible sack, so its possible historical context should come under renewed scrutiny. But this is not the place to pursue this avenue: it is sufficient to note the evidence and take account of the slightly changed view this would give of the decorative sequence in the church. If the fresco painting with Christian imagery replaced the earlier *opus sectile* that had been damaged by fire, that could be understood differently from the arbitrary replacement of undamaged *sectile*. In the first case it is easier to envisage some continuity of content—that the *sectile* might also have contained Christian images –, while in the second case it might be assumed that the change was content-led.

The sixth century

The apse cut in the south wall of the sanctuary, probably in the second half of the sixth century,[33] together with the *bema* floor, gave the church the 'Eastern plan' (Figure 6) that Rushforth first highlighted, and which has been widely accepted since.[34] Rushforth also considered the possibility that the octagonal base in the centre of the nave, about 2.5 metres across, could have been a centrally placed *ambo* in the manner of numerous Eastern churches. He noted in particular the case of Hagia Sophia, where Paul the Silentiary (*Patrologia Graeca* 86: 2259) in the sixth century describes a circular *ambo* in the centre of the nave.[35] There is much to be said for this. The interpretation sometimes advanced, that the octagonal base belonged to a fountain in the earlier courtyard can be excluded, since it stood on the *opus spicatum* floor associated with the basilica.[36] The existence of an *ambo* earlier than the time of John VII (705–7) is indicated by the *Liber pontificalis*, which reports that he renewed the *ambo*.[37] The partly surviving *ambo* on the line of the east screen of the *schola cantorum* (Figures 2–3), which was probably the structure of John VII's time and has been reconstructed by Bellini and Brunori, and their colleagues, was clearly later than the screen and seat of the *schola cantorum*.[38] This indicates that when the *schola cantorum* was first built, probably in the seventh century, there was already an earlier *ambo* in another location. Since the octagonal base is related to the *opus spicatum* floor, which was earlier than the surviving *schola cantorum* screens, it was evidently earlier than the surviving *ambo*. The only further clues to its dating would be that it seemed to have a piece of travertine as well as reused brick fragments in its facing, which suggests a constructional phase not earlier than the fifth century—fixed *ambones* are generally only known from the sixth century onwards.

The Oratory of the Forty Martyrs

Bordi has recently discussed the earliest fresco decoration of the apse in the Oratory, suggesting that it could be of the same date as the Santa Maria Antiqua apse, giving the Oratory an ecclesiastical function from the later sixth century.[39] The suggestion by Robert Coates-Stephens, that the 'Amantius' of the funerary inscription might have been the founder of the Christianised Oratory dedicated to Saint Andrew, must be seen beside the fact that the inscription was reused, so it might have come from elsewhere.[40]

Setting and review (Figures 1, 6)

The setting of the church has usually been considered palatial—Boni and his contemporaries called it the 'palatine chapel'[41]—and emphasis is often placed on its links with the ramp that led to the Domus Tiberiana. It probably was imperial property, having been within the area of a palace extension in the first century, but the palatial aspect needs some qualification. In high- and later imperial times the Domus Tiberiana, while part of the huge group of Palatine buildings, appears to have been distinct functionally as well as physically from the main imperial palace.[42] From the first to the early fourth century, the complex containing the church seems likely to have been the *Bibliotheca Domus Tiberianae*, which contemporaneous documentation indicates as a public library (e.g. Galen's *Peri Alupias*).[43] The main library space would have been the large Domitianic aula, with reception rooms to its east (the 'atrium', and the peristyle and three rooms to its south that became the church). On the west and north frontages of the complex were porticoes that probably had a commercial function: 'post aedem Castoris' ('beyond the Temple of Castor') was a location known from inscriptions of traders, including a cloakmaker and a silversmith.[44] Probably at the same time as the building of the basilica, the library and portico facing the Vicus Tuscus were replaced by three-storeyed insula-type buildings, with probable commercial space (*tabernae* with wide entrances) at ground-floor level. These were laid out in two ranges on either side of a courtyard, with a third range facing the Vicus Tuscus (Figure 1).

The fourth-century church as we would understand it seems to have had some functional characteristics, like its *opus spicatum* floor, similar to those of the nearby *tabernae*. It was inserted into the space occupied by a former courtyard and adapting to its use the previously constructed rooms, as the sanctuary and two flanking rooms, without structural alterations. Consequently, there was a mismatch of height between the body of the newly built basilica and these rooms.

The role of the 'atrium' should, however, also be taken into account. This had presumably the aspect of a grand hall, as in imperial times, and was probably still a roofed space (as confirmed later by the seventh- and eighth-century frescoes). The faces of its four walls suffered soot discolouration at the time of the fire, suggesting that they were not covered by plaster or decorative stonework at that time, but there were four strips of unburnt brick about 0.5 metres wide, on either side of the entrances from the Forum on the north and to the basilica on the south. As there are no other traces, these might suggest some matching decoration in applied marble or plaster on either side of the entrances.

Krautheimer's opinion, that there could or should not be such an early Christian building in

the Forum,[45] might now be seen as superseded by the current view of the relationship between fourth-century Christianity and paganism.[46] In his review of Constantinian Rome, Guidobaldi stresses the possibility of churches 'present in various areas of Rome, even the most central ones'.[47] This dating could also fit the foundation legend of Santa Maria Antiqua handed down from medieval times: Saint Sylvester (Pope Sylvester I, 314–35) bound the dragon that caused death and destruction and breathed foul air in this part of the Forum—an event remembered in the title of the later church of Santa Maria Liberatrice 'libera nos a poenis inferni' ('deliver us from the sufferings of hell').[48]

Moving forward past the fire(s), and the possible rebuilding in the nave represented by the granite columns, the next clear evidence of change dates to the sixth century. A Byzantine aspect is shown by the *Maria Regina* image, but Eastern associations are shown more durably by the church plan with the new apse and the possible central *ambo*. As has been observed, Eastern monks were evidently part of the church community, and the ecclesiastical buildings may also have expanded in the sixth century to incorporate the Oratory. Further major changes were to come in the seventh century: the remodelling of the basilica nave with the existing *schola cantorum* and *bema* screens; paintings in the 'atrium' and the Oratory reflecting the ecclesiastical unity of the whole complex; and a great increase in images, including those of prominent figures of the time, starting with the Lateran Council of 649 and continuing for a century and a quarter with portrayals of popes, saints and benefactors. That is the chapter after the story here.

Addendum

Further study since the above was written suggests that the 'atrium' should be regarded as part of the main body of the early church, and that this continued to be so through the church's later history. This larger building conforms better with the description as a *basilica* and with its proposed fourth-century origin.

1 Eva Tea, *La Basilica di Santa Maria Antiqua* (Milan: Società Editrice 'Vita e Pensiero', 1937), pp. 7, 19, 362.

2 Richard Delbrück, 'Der Südostbau am Forum Romanum', *Jahrbuch des Deutschen Archäologischen Instituts*, 36 (1921), pp. 8–33.

3 Richard Krautheimer and others, *Corpus Basilicarum Christianarum Romae*, 5 vols (Vatican City: Pontificio Istituto di Archeologia Cristiana (1937–77) [hereafter *CBCR*], II (1963), p. 249.

4 Tea, *Basilica di Santa Maria Antiqua*, p. 19: 'L'abbassamento delle volte'.

5 *CBCR*, II (1963), pp. 251–2, 263.

6 *De locis sanctis martyrum*: 'basilica quae appellatur sca. Maria Antiqua'. See *Codice topografico della città di Roma*, ed. R. Valentini and G. Zucchetti, Fonti per la Storia d'Italia, 81, 88, 90–91, 4 vols (Rome: Tipografia del Senato, 1940–53), II (1946), p. 121. As the *CBCR* notes [II (1963), p. 266], the epithet *antiqua* would make sense if the church were earlier than the early fifth-century Santa Maria Maggiore.

7 The *opus spicatum* in the northern part of the eastern aisle overlies a drain that seems likely to have taken water from the *piscina*.

8 Tea, *La Basilica di Santa Maria Antiqua*, p. 19.

9 Herbert Bloch, *I bolli laterizi e la storia edilizia romana: Contributi all'archeologia e alla storia romana*, Studi e Materiali del Museo della Civiltà romana, 4, (Roma: L'Erma di Bretschneider, 1947), p. 31, nos. 38–9; p. 34, nos. 35–6 (partly revising an earlier Hadrianic date, cf. Delbrück, 'Der Südostbau', p. 25). I followed that dating before taking account of the evidence cited here, see Henry Hurst, 'Area di Santa Maria Antiqua', *Bullettino della Commissione archeologica comunale di Roma*, 91.2 (1986), 470–8. Later in this essay, the complex is referred to as a 'three-storeyed *insula*-type' building.

10 It was in a pit apparently beneath the floor, cut by a later pit, and the finds were mixed: details to be provided in a future publication.

11 Tea, *La Basilica di Santa Maria Antiqua*, pp. 7 (one coin), 19 (three coins), 362 (one coin).

12 Andrea Paribeni, 'Giacomo Boni e il mistero delle monete', in *Marmoribus vestita: miscellanea in onore di Federico Guidobaldi*, ed. by O. Brandt and P. Pergola (Vatican City: Pontificio Istituto di Archeologia Cristiana, 2011), pp. 1003–23 (pp. 1010–3 with further references).

13 Giulia Bordi and Alessandra Guiglia Guidobaldi, 'Elementi di *opus sectile* parietale in marmo e in vetro', in *Santa Maria Antiqua tra Roma e Bisanzio*, ed. by M. Andaloro, G. Bordi, and G. Morganti (Milan: Mondadori-Electa, 2016), pp. 364–5.

14 Valesio, *Diario di Roma*, ed. by G. Scano, 6 vols (Milan: Longanesi, 1977), II: *1702–1703*, pp. 169–70, 239. Tea also gives the text of the entry for 24 May (*Basilica di Santa Maria Antiqua*, p. 367); for 2 August the entry reads: 'Havendo saputo N.S. che la chiesa antichissima ritrovata [...] dietro la tribuna di S. Maria Liberatrice da quei cavatori, si ricopriva, ha di nuovo ordinato che si torni a cavare la terra che v'era stata gettata.'

15 Lanciani, Letter 108 of October 1900, in *Notes from Rome*, ed. by A.L. Cubberley (London: British School at Rome, 1988), pp. 328–9.

16 Petrignani's plan and axonometric projection show that large travertine blocks had been extracted from the top of the Domitianic foundation in the northern part of the church and that the north-east pier of the nave had been demolished, evidently to remove these blocks. This was the same robbing process that can be seen throughout the complex of imperial buildings, evidently that carried out on behalf of the Deputati della Fabbrica di S. Pietro in the 1540s, following a grant by papal *breve* of 22 July 1540, cf. Rodolfo Lanciani, *Storia degli scavi di Roma e notizie intorno le collezione romane di antichità*, ed. by L. Malvezzi Campeggi, 2 vols (Rome: Quasar, 1990), II, p. 203. The travertine blocks of the Domitianic foundation beneath the columns were not robbed, because relics of the brick plinths still rested on them.

17 Gordon Rushforth, 'The Church of S. Maria Antiqua', *Papers of the British School at Rome*, 1 (1902), pp. 1–123 (p. 9).

18 Ibid., pp. 8–9.

19 *Le Liber Pontificalis*, ed. L. Duchesne, 2 vols (Paris: E. Thorin, 1886–92) [hereafter *LP*], II, p. 108.

20 Ibid., II, p. 145. In his survey of the Forum excavations Vaglieri explained the move as due to the possible flooding of the Spring of Juturna and related health dangers, see Dante Vaglieri, 'Gli scavi recenti nel Foro Romano', *Bullettino della Commissione archeologica comunale di Roma*, 31 (1903), 3–239 (p. 229); cf. Rodolfo Lanciani, 'Le escavazioni del Foro. V. Santa Maria Antiqua', *Bullettino della Commissione archeologica comunale di Roma*, 28 (1900), 299–320.

21 For these observations I am much indebted to Werner Schmid.

22 It was taken by Nordhagen to date to the seventh century, and previous writers also considered it to be early medieval: Per Jonas Nordhagen, 'The earliest decorations in Santa Maria Antiqua and their date', *Acta ad archaeologiam et artium historiam pertinentia*, 1 (1962), 53–72.

23 Alessandra Guiglia Guidobaldi, 'La decorazione marmorea dell'edificio di Santa Maria Antiqua fra tarda antichità e alto medioevo', in *Santa Maria Antiqua al Foro Romano cento anni dopo*, ed. by J. Osborne, J.R. Brandt, and G. Morganti (Rome: Campisano, 2004), pp. 48–65.

24 Werner Schmid, *Restauro dei dipinti murali e delle altre superfici architettoniche della Cappella di Teodoto: Relazione*

finale, unpublished survey for the Soprintendenza Speciale per i Beni Archeologici di Roma and the World Monuments Fund of New York, 'Progetto Santa Maria Antiqua' 2001–10.

25 Guiglia Guidobaldi, 'La decorazione marmorea'; Bordi and Guiglia Guidobaldi, 'Elementi di *opus sectile*', pp. 364–5.

26 The term *bema*, usually applied to Eastern churches, is used in *CBCR* for the rectangular area of raised floor at the southern end of the nave, in front of the sanctuary. Its use here is prejudicial to the interpretation of this space, but has become a regular convention.

27 Valeria Valentini, 'Tessere di mosaico in pasta vitrea', in *Santa Maria Antiqua tra Roma e Bisanzio*, ed. by M. Andaloro, G. Bordi, and G. Morganti, p. 366.

28 Giulia Bordi, 'Santa Maria Antiqua. Prima di *Maria Regina*', *Officina dello sguardo. Scritti in onore di Maria Andaloro*, ed. by G. Bordi, I. Carlettini, M.L. Fobelli, M. R. Menna, and P. Pogliani, 2 vols (Rome: Gangemi, 2014), I, pp. 285–90 (p. 289).

29 Nordhagen, 'The Earliest Decorations', p. 62, part of layer V.

30 Federico Guidobaldi and Alessandra Guiglia Guidobaldi, *Pavimenti marmorei di Roma dal IV al IX secolo*, Studi di Antichità Cristiana, 36 (Vatican City: Pontificio Istituto di Archeologia Cristiana, 1983); and Guiglia Guidobaldi, 'La decorazione marmorea'. The earliest painting on the surviving screens (on the outside of the eastern and northern parts of the western *schola cantorum* screens) was of imitation marble, similar to the painted imitation marble *opus sectile* dadoes in the apse and on either side. This is assigned to the third layer of decoration of the apse (see Giulia Bordi in this volume), which preceded directly the images of the Church Fathers dating to the mid seventh century (the Lateran Council of 649 or its aftermath in 657).

31 It was possible to examine the preparatory layer of the *opus sectile* during the operations of consolidation of the modern flooring. I wish to thank Giuseppe Morganti, Werner Schmid, and Giulia Bordi for having involved me in this process.

32 Richard Krautheimer, *Early Christian and Byzantine Architecture*, 4th edn (Harmondsworth: Penguin, 1986), p. 43.

33 See Nordhagen, 'The Earliest Decorations'; and Bordi in this volume.

34 Rushforth, 'The Church of S. Maria Antiqua', pp. 23–4.

35 Ibid., pp. 89, 91.

36 The octagonal base and *opus spicatum* floor beneath it is cut by a narrow trench, which runs north-to-south across the central area. The width and irregularity of this trench suggests that it was for the extraction of a lead water pipe under the *spicatum* floor, perhaps when the church was robbed in the sixteenth century. The original setting of this and other *fistulae* probably belonged to the *piscina*.

37 *LP*, I, p. 385.

38 Mario Bellini and Paola Brunori, 'Nota sull'ipotesi ricostruttiva dell'ambone di Giovanni VII', in *Santa Maria Antiqua tra Roma e Bisanzio*, ed. by M. Andaloro, G. Bordi, and G. Morganti, pp. 234–9 (pp. 234–5).

39 Giulia Bordi, 'Dall'Oratorio di Quaranta Martiri a Santa Maria *de inferno*', in *Santa Maria Antiqua tra Roma e Bisanzio*, ed. by M. Andaloro, G. Bordi, and G. Morganti, pp. 278–87 (p. 279).

40 See Robert Coates-Stephens in this volume; cited also in Bordi 'Dall'Oratorio di Quaranta Martiri', p. 279.

41 For example Vaglieri, 'Gli scavi recenti', p. 11.

42 Filippo Coarelli, *Palatium: Il Palatino dalle origini all'impero* (Rome: Quasar, 2012), pp. 466–7.

43 Ibid., pp. 467–74.

44 *CIL* VI 9872 and 9393; see Emanuele Papi 'La *turba inpia*: artigiani e commercianti del Foro Romano e dintorni (I sec. a.C.-64 d.C.)', *Journal of Roman Archaeology*, 15 (2002), 45–62 (pp. 48–50).

45 Richard Krautheimer, *Rome: Profile of a City, 312–1308* (Princeton, NJ: Princeton University Press, 1980), pp. 28–33.

46 For example, Alan Cameron, *The Last Pagans of Rome* (Oxford: Oxford University Press, 2011).

47 Federico Guidobaldi, 'Roma costantiniana', in *Costantino I: Enciclopedia costantiniana sulla figura e l'immagine dell'imperatore del cosiddetto Editto di Milano, 313–2013*, 3 vols (Rome: Istituto della Enciclopedia Italiana, 2013), I, 453–69 (p. 460).

48 See Jaakko Aronen, 'La sopravvivenza dei culti pagani e la topografia cristiana dell'area di Giuturna e delle sue adiacenze', in *Lacus Iuturnae*, I, ed. by E.M. Steinby (Roma: De Luca, 1989), pp. 148–74; J. Rasmus Brandt, 'The Oratory of the Forty Martyrs: From Imperial Hall to Baroque Church', in *Santa Maria Antiqua al Foro Romano cento anni dopo*, ed. by J. Osborne, J.R. Brandt, and G. Morganti, pp. 136–52; Adriano La Regina, 'Lacus ad sacellum Larum', in *Dall'Italia. Omaggio a Barbro Santillo Frizell*, ed. by A. Capoferro, L. D'Amelio and S. Renzetti (Florence: Polistampa, 2013), pp. 133–50.

DAVID KNIPP

Richard Delbrück and the reconstruction of a 'ceremonial route' in Domitian's palace vestibule

In 1921, when Richard Delbrück published the findings of a campaign conducted in 1914–15 in the architectural structure, part of which would later become the church of Santa Maria Antiqua, he had not yet written his seminal studies on consular diptychs and porphyry sculpture.[1] But his fascination with the trappings and *mise en scène* of imperial ceremonial was already apparent. The way objects were made, how elaborate ceremonial was planned and staged, and how these activities imprinted themselves on the architectural settings designed to serve them were of great interest to Delbrück, while his investigations were as meticulous as they were objective. The slim article he wrote on the structure he interpreted as the vestibule of Domitian's palace, which included the great hall to the west of the present church, the northern hall (atrium of Santa Maria Antiqua), the peristyle (choir, nave, and aisles), the exedra and side chambers (sanctuary and side chapels) as well as the Palatine ramp, is full of technical observations that led Delbrück to formulate intriguing suggestions concerning the vestibule's function and use.[2]

For a long time, Delbrück was also the only one to address the crucial problem of the *Zwischenzimmer* (Figure 1: g), a formal anteroom located immediately to the west of the vestibule (Plate 50: G), which must indeed have been a key space when considering any communication between the western hall (Figure 1: a) and, on the opposite side, the ramp leading up to the Domus Tiberiana on the Palatine (Figure 1: h). This antechamber, as Delbrück observed, has two large doorways, one on its north wall, opening into the western hall, and one on its east wall, communicating with what would become the western vestibule of Santa Maria Antiqua. The small, steeply vaulted space contains, moreover, on the west wall opposite the latter doorway a shallow recess with considerably lower vaulting (Figure 1: g). This arched niche would appear to have no structural function. Delbrück suggested a small chamber for repose containing a *kline* (couch bench) in a second niche in its back wall, measuring 4.30 by 2.40 metres.[3] Delbrück located accordingly the two principal doorways of the western hall itself, on the eastern sides of the north and south walls, the first one opening onto the Roman Forum, and the second onto the vestibule space in question (Figure 1: a).[4] Delbrück was convinced that the western

hall was never completed: the spectacular vaults he shows in his reconstruction drawing were not actually executed.[5] If they had been constructed, remains of building material would have been found at the site. Furthermore, it appears that incrustation had never been attached to the walls; the preparation with supporting mortar and metal hooks or marble pegs is nowhere evident.[6] His interpretation of the space was based on the observation that the entire complex had been from the start functionally connected with the Domitianic Ramp and the residences on the Palatine.[7]

Accordingly, Delbrück included a very detailed reconstruction of the way in which he presumed that traffic would have flowed within the three principal spaces: the western hall, the northern hall (now atrium of the church), and the peristyle (now the church's interior) (Figure 1). The sequence of passages follows quite naturally from the main doorways. Delbrück's Route A (Figure 1, blue) was to be used by the emperor coming from the Palatine: descending the ramp, he would have reached the principal door in the north-east corner of the peristyle.[8] He would have then proceeded along the eastern peristyle walk to the exedra's central niche, which in a later phase would be enlarged to form the apse of the church. Having reached this point, the emperor could have turned to enter the anteroom via the southern principal door of the peristyle, where, according to Delbrück, he could enjoy some rest and privacy. Another large doorway in the north wall of the antechamber would have led the emperor into the western hall, where he might have turned towards the central niche in its east wall.

Delbrück's Route B (Figure 1, red) would have admitted a fairly large number of individuals from the Forum into the peristyle court. Entering the northern hall from the spacious doorway in its north wall (6.50 metres wide), the crowd would have assembled first in the 400 square metres of this hall (now atrium) before proceeding through an equally spacious opening in the south wall into the northern arm of the peristyle. Here, those admitted would have turned left into the eastern walk, eventually reaching the exedra and its niche. Possibly passing an imperial seat or raised platform, where large groups passing in file could have greeted the emperor, they would have turned back along the western peristyle walk and once again found themselves passing through the northern hall and re-entering the Forum.[9]

All substantial traffic must have passed through the two spacious doors of the north hall (atrium), while the passage via the antechamber could only have admitted a very limited, and possibly exclusive, number of individuals when Route A was used in reverse direction—in other words, for entering the peristyle and ramp from the west hall, a possibility that Delbrück, strangely enough, did not consider. The two smaller rooms on either side of the exedra, which later became the side chapels of the church (Plate 50: J and L), were tentatively interpreted by him as guard rooms.

Delbrück's Route C (Figure 1, green) leads from the Forum into the western hall using the doorway in its north-east corner. This door, cut into the thickness of the buttress wall, is substantially narrower than the Forum entrance into the north hall. According to Delbrück, his Route C would not have admitted visitors beyond this point. Instead, they would have gathered in the western hall. He suggested that this may have been an imperial dining hall of about 750 square metres, which could have served up to 200 persons. In this context, again, Delbrück conceived of the adjacent anteroom (Figure 1: g) to the south in terms of a private dining chamber for exclusive use by the emperor.

RICHARD DELBRÜCK AND THE RECONSTRUCTION OF A 'CEREMONIAL ROUTE'

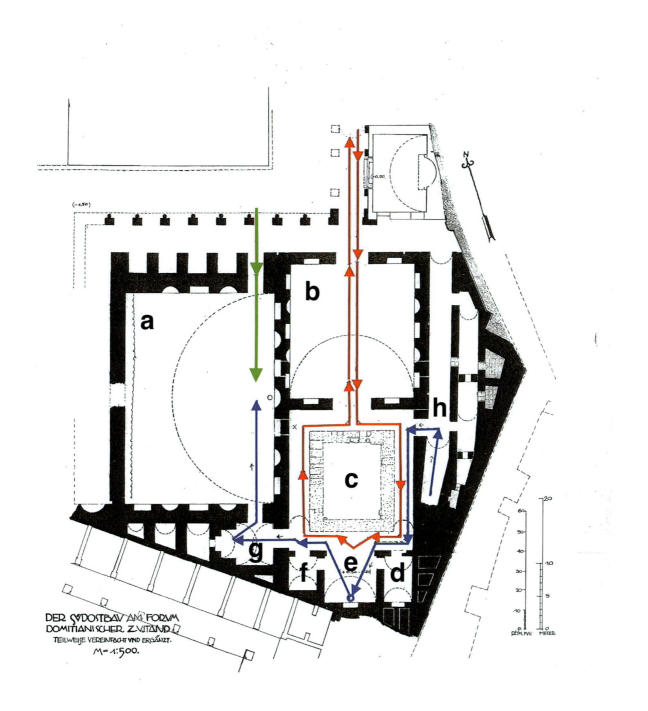

1 Plan of the Domitianic vestibule (after Delbrück, 'Der Südostbau')

Following his reconstruction of planned movements within the great building complex, I venture to suggest that Delbrück's Route A (Figure 1, blue) might in fact have been used quite effectively in the reverse direction, leading from the Forum up to the Palatine. The key to this problem is provided by the unusual layout of the antechamber, a narrow space with conspicuously large doorways. Additional space for this supplementary room happened to be available for the simple reason that the southern perimeter of the west hall, towards the Horrea Agrippiana, was diagonal, and the heavy buttress wall hence took a roughly triangular shape, its thickness sufficient to accommodate the anteroom (Figure 1). But Delbrück's suggestion of an imperial *kline* squeezed into the shallow recess in the back wall seems to me quite improbable. The key position of the antechamber, clearly designed as a principal means of communication between the two main spaces—west hall and peristyle—would appear to make it thoroughly unsuitable for repose: it must have been in fact in the centre of traffic, as the two spacious doorways clearly indicate. Strikingly, the configuration of spaces recalls the defensive character of concealed approaches encountered in much later medieval Maghribi palaces of the Zirids.[10] This architectural device would have deliberately avoided a direct connection from the Forum to the Palatine ramp, and instead, by means of a system of small and seemingly disparate passageways, would have impeded intruders accessing the space, thus making observation, control, and defence much easier.[11] Moreover, the antechamber seems far too limited to allow for anything but claustrophobic comforts. Being at the very centre of carefully planned traffic, it would have been too inconvenient to have served as imperial dining chamber: too narrow to be comfortable, it would not have allowed for the slightest display of splendour or entertainment. It appears thus that the main purpose of this room was to control access from the western hall via the peristyle to the Palatine ramp (Plate 50: entering the western walk at G1 and proceeding towards C3). This implies that the functions of the two parallel spaces—hall and peristyle—were often quite different, and traffic accordingly kept separate. As in smaller houses, in the Palatine vestibule visitors of varying status could be received in separate rooms, or perhaps a distinction would be made through differently staged approaches. Delbrück's Route A (Figure 1, blue) would have admitted a rather more exclusive group of visitors via the antechamber to the peristyle, while Route B (Figure 1, red) would have allowed for a larger crowd to be admitted into the northern hall and then, crossing the peristyle, to be swiftly led out again towards the Forum along the same path.[12] It appears to me that the reverse of Delbrück's Route A was indeed the most important and carefully designed way leading from the Forum via the vestibule to the residences on the Palatine. However, as Delbrück concluded, all this quite probably never happened, and even planning was perhaps not resumed after Domitian's death. Hadrian apparently put the great hall to the west to completely different use.[13]

Nevertheless, it appears that at least part of the building was much later employed precisely for the purpose it had originally been designed to serve. After a long period during which various portions of the complex were abandoned, adapted, or even structurally modified to serve a variety of functions, it looks as if sometime around the year 500 at least the core of the structure—the peristyle and exedra (now sanctuary and aisles of Santa Maria Antiqua)—was sumptuously redecorated in *opus sectile* and glass mosaic, and put to use once more as a palace vestibule analogous to, and quite possibly modelled on, the Chalke Gate, the vestibule to the imperial palace in Constantinople. The most likely candidate to have initiated this new phase

is the Ostrogothic king Theodoric, on his visit to Rome in March 500.

Delbrück's Route B (Figure 1, red) through the vestibule, entering from the north, should still apply to the reuse of the structure four hundred years later. Since the lavish redecoration in *opus sectile* can only be traced in the exedra, peristyle, and side chambers, the western hall was apparently not included and had possibly fallen into disuse some time earlier. Delbrück's main entrance from the Forum to the northern hall (atrium) would hence have provided the only access to the peristyle from outside. The link to the Palatine ramp remained intact via the north-east peristyle door (Plate 50: C3), while the use of the anteroom to the south-west would have been discontinued, as communication with the western hall was no longer required.[14] The space, eventually adapted to his convenience by Theodoric, would thus have been of a significantly reduced scale compared to Domitian's original plan. The large-scale *opus sectile* incrustation still traceable in the exedra (Plates 42, 45) consisted of four registers; and the upper sections of the wall and vaulting were covered with glass mosaic, of which only a few *tesserae* survive, but imprints in the supporting mortar abound in many places.[15] In the south-east side chamber (Chapel of Theodotus), a late Roman vault fresco imitating a stucco ceiling of interlocked circles was apparently never covered or painted over, but instead combined subsequently with *opus sectile* and frescoes (Plates 28–30).

Communication between Delbrück's exedra and the two side rooms (Figure 1: d–f; Plate 50: J5, L5) seems to have been modified at various times. Originally, the doorways towards the peristyle walk (Plates 11, 21, 50: J6, L6), as well as those connecting them with the exedra, appear to have been much wider, as is still evident from the masonry. The marble steps and jamb of the doorway leading from the exedra to the south-west side chamber (Plates 42, 50: L5), and the marble socle of the exedra side walls (Plates 42, 45, 50: K2, K3), were evidently executed simultaneously, using the same material in an identical fashion: this indicates that the narrowing of the door was contemporaneous with the *sectile* decoration. The doorway leading from the south-east room towards the east colonnade (Plates 11, 50: J6) was apparently walled up during the incrustation period, while the opening that communicates with the exedra (Plates 45, 50: J5) was also substantially narrowed on this side. This is clearly evident from the continuation of the *opus testaceum* as preparatory surface for the *opus sectile* on the portions of secondary masonry that are still in place. When the sanctuary and side chapels of Santa Maria Antiqua were created later, the doorways between the chapels and what had become the aisles of the nave (Plates 11, 21, 50: J6, L6) were reopened, but narrowed, and the ceilings and door jambs included in the fresco decoration as still visible. This means basically that Theodoric's version of the palace vestibule included two rather secluded spaces that were by then solely accessible via narrow doors (Figure 1: d–f) close to the imperial niche in the exedra (Figure 1: e). They were very likely intended to provide privacy for repose or devotion.[16] In Domitian's original plan, both chambers had freely communicated with the open peristyle court and were obviously designed to perform completely different functions in court ceremonials.

Of the *opus sectile* revetment that once covered vast areas of wall surface, only a fragmentary portion is preserved in the north-east corner of the presbytery (Figure 2). This area (Plates 35, 45, 50: K1/K2) consists of some remains of an intricate *sectile* pattern made up of alternating red and green *tondi* (Figure 3), each enclosed within a ring of opaque limestone. White, drop-shaped pieces are made of the same, non-translucent stone (Figure 4). Similar patterns are

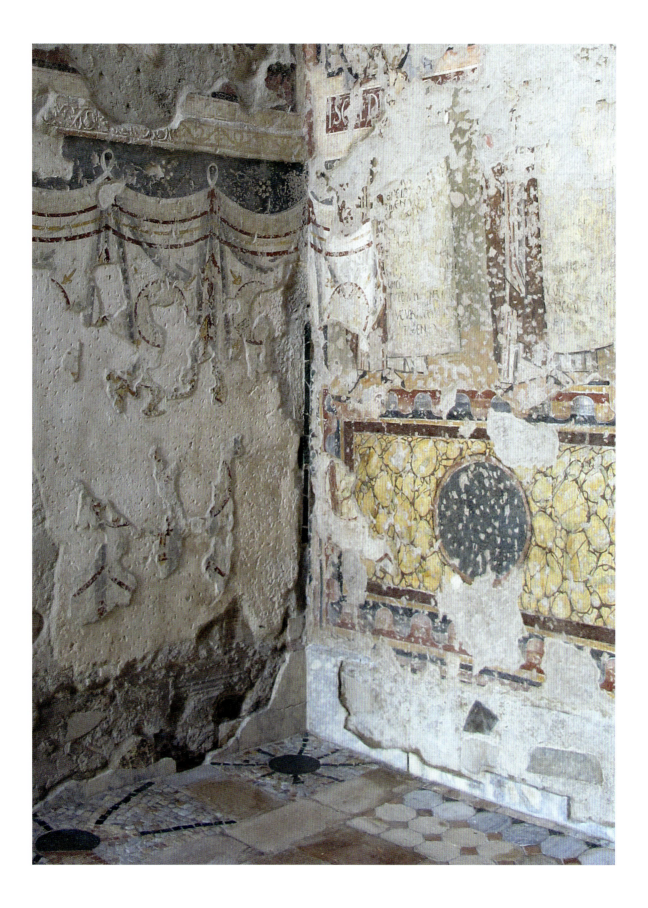

2 South-east corner of the sanctuary (photo: Giulia Bordi)

3 Detail of the south-east corner of the sanctuary with *opus sectile* fragments (photo: Eileen Rubery)

found at San Vitale in Ravenna (548) and in the apse of the Basilica Eufrasiana at Poreč (559), which would seem to support a sixth-century date for the redecoration of the vestibule.[17] As to the design of the lost *sectile* patterns, some conclusions may be drawn from the fashion in which the half terracotta tubes of the *opus testaceum*, the preparation of the wall surface to receive the pre-assembled *sectile* plates, are set into the mortar. This is most clearly visible in the upper areas of the exedra walls, where the east and west walls display conspicuously symmetrical arrangements of terracotta shims (Plates 42, 45). There is no structural need for this symmetry; it simply reflects the design and distribution of the *sectile* plating, for instance by allowing the location of the pilasters (capitals) that articulate the wall. All this is better preserved on the east wall (Plates 45, 50: K2), where four and a half compartments separated by narrow pilasters can be distinguished. The west wall (Plates 42, 50: K3), showing an identical pattern of which the northern third is lost, still contains the supporting *opus testaceum* of five pilasters. On both upper walls, evidently, the decoration comprised two superimposed *sectile* friezes of different designs. One was tall, about seventy centimetres, whereas the second frieze above was

4 Detail of the south-east corner of the sanctuary with *opus sectile* fragments of green porphyry and non-translucent stone (photo: David Knipp)

narrower, about forty centimetres. The upper panel does not appear to have included pilasters. This wall section was topped by a *rinceaux* frieze executed in glass mosaic, of which traces and numerous remnants were discovered very recently high up on the western presbytery wall.

Recent cleaning brought to light a substantial area of *opus sectile* imitation in fresco, occupying the top zone in the south-east corner of the east wall (Plates 45, 50: K2) in the sanctuary (Figure 5). This painting may record what the original pattern looked like: it was evidently added at a later date in order to patch up lost panels of an otherwise still largely intact *sectile* decoration.[18] Since the area belongs to the top layer of fresco on the wall, this inexpensive repair most likely took place during the last repainting of the presbytery, commissioned by Pope John VII around 705.[19] The white and green pattern of discs alternating with lozenges and horizontal bands beneath what looks like an architectural structure (*aedicula*) strongly recalls similar panels made of grey marble and *verde antico* in the nave of Hagios Demetrios at Thessaloniki[20] and Hagia Sophia at Constantinople (537), and much later at the Kalenderhane Camii.[21] The sixth-century comparative material would appear to suggest once again a Justinianic or pre-Justinianic date for the original *opus sectile* revetment.[22]

The conspicuous height of the space, together with the lavish wall panelling, would have indeed strongly resembled the Chalke Gate in Constantinople as recorded by Procopius.[23] In addition to the enormous height of the western and northern halls, the exedra and side rooms have extraordinarily high vaulting, considering their limited size. Planned by Theodoric as a replica—just as the Palazzo 'di Calchi' in Ravenna is based on the Chalke he had seen during

5 Detail of the east wall of the sanctuary with *opus sectile* imitation in fresco (photo: David Knipp)

his youth in Constantinople (461–71)—at a later date it might have quite possibly reminded Belisarius and Narses of Justinian's version of the Chalke (532), which probably retained a well-established layout.[24] It is thus probable that, after the Gothic War (536–52), Justinian's viceroys put the 'Roman Chalke' to the same use.[25]

The festivities in Rome mentioned by the Anonymous Valesianus (540–50) in connection with Theodoric's celebration of his tenth anniversary (500) included 'entering the palace in a triumphal procession for the entertainment of the people', and would doubtless have emulated Roman imperial ceremonial.[26] Essentially, such processions would have followed Delbrück's Route B (Figure 1, red) and all visitors would have had to advance along the peristyle walks. It is precisely for this reason that the doorways once connecting the side chambers and the peristyle (Plates 11, 21, 50: J6, L6) were closed and walled up at this time. This was simply a means to separate them from the traffic in the peristyle, in order to provide rather more secluded accommodation when needed. With the antechamber no longer used to control the traffic of people, these rooms offering security and intimacy would have become increasingly important. They responded to the need to separate different classes of visitors and to adapt existing spaces to varying functions, reflecting a hierarchical organisation of the space, or simply a desire to obtain various degrees of privacy during receptions. That these comparably modest spaces were included in Theodoric's redecoration campaign and received a splendid *opus sectile* incrustation suggests that they were conceived as integral parts of his Byzantine audience hall modelled on the Chalke. When the niche in the exedra (Figure 1: e) was revived as an audience room by Theodoric in 500, the actual *mise en scène* would not have resembled the late Roman imperial practice.[27] In the tenth century Constantine VII Porphyrogennetos (*De Ceremoniis*, II, 76–7) describes an essentially unchanged ceremonial in the palace at Constantinople: a reception in the Triconchos sees the emperor seated on his throne, 'as is his habit'. Behind him are his chamberlains; the *patrikioi* and *strategoi* are placed on either side of the throne, next to the 'small doors', as are the members of the Senate. In the Palatine vestibule, such 'small doors' might be recognized in the two narrow doorways on either side of the exedra leading into the two side chambers (J5, L5). An even later but rather telling parallel may be found in the palace of the Grand Komnenoi at Trebizond, erected shortly after 1204 and described in Bessarion's 'Encomium to Trebizond':

> The dwelling of the emperors is set up in the present acropolis […] Its west wall […] extends for the sake of the palace alone and towers above the wall of the acropolis by almost the same measure that the latter rises above the ground. […] The walls facing in other directions […] are by themselves sufficient to resist the oncoming enemy and to guard safely those that may be inside. They afford entrance by means of two gates and one postern, and for the rest are securely constructed so as to exclude and ward off attackers […] The palace rises in the middle and has one entrance provided with a staircase of steps, so that the entrance is also a way up. As one enters, one straightaway encounters on one side splendid vestibules and halls of sufficient beauty and size, capable of containing a great number of people […] High up, at the end of the building, there appears a covered imperial dais […] This, too, is screened all round with white marble, roof and all, and it separates the emperors from their subjects as with a barrier.

It is there in particular that the emperor makes his appearance, that he conducts business with his ministers, converses with ambassadors, speaks and is spoken to.[28]

The Grand Komnenoi, with their exceedingly retrospective ideology and their purposeful importation and re-employment of Justinianic capitals and other material reminders of early Constantinople, certainly selected models associated with the early Byzantine era for their palace and for Hagia Sophia at Trebizond. Obviously the audience hall of the Grand Komnenoi has no direct connection with the Roman palace vestibule, but certainly constitutes its late and close descendant, reflecting a ceremonial that had influenced the layout of Domitian's and subsequently Theodoric's Palatine audience hall, and which underwent little change throughout the Middle Ages.

NOTES TO THE TEXT

1. Richard Delbrück, 'Der Südostbau am Forum Romanum', *Jahrbuch des Deutschen Archäologischen Institutes*, 36 (1921), pp. 8–33; Richard Delbrück, *Die Consulardiptychen und verwandte Denkmäler* (Berlin: De Gruyter, 1929); and Richard Delbrück, *Antike Porphyrwerke* (Berlin: De Gruyter, 1932). I would like to express my profound thanks to the German Archaeological Institute in Rome and the Fritz Thyssen Foundation for their generous support.

2. In a letter sent to Paul Darmstädter in Berlin, dated 10 February 1915 (Rome, Archive of the Deutsches Archaeologisches Institut), Delbrück complains about the difficulties he encountered when analysing the brick walls in the western hall, due to the carelessness of the original builders: 'Wir wunderten uns anfangs über Regenrinnen, die keinen Abfluß haben und mitten in der Wand enden, sowie über Strebepfeiler, die unkonstruktiv sitzen und mit Fenstern kollidieren, bis wir in mehreren Fällen Rechenfehler im Plan feststellen konnten und allmählich dahinter kamen, dass hier der Schlendrian das gestaltende Prinzip war.'

3. Delbrück, 'Der Südostbau', p. 14.

4. Delbrück also mentions two much smaller, secondary routes, which would have led from the ramp to the western hall; but these would have been service doors, not suitable for formal court ceremonial, see Delbrück, 'Der Südostbau', p. 14.

5. Ibid., p. 21 and pl. 8. Vincenzo Federici, 'S. Maria Antiqua e gli ultimi scavi del Foro Romano', *Archivio della R. Società Romana di Storia Patria*, 23 (1900), 517–62, suggested that there had been two upper floors in the western hall. New evidence concerning the original function of the peristyle and northern hall was recently presented by Pier Luigi Tucci, 'Galen's Storeroom, Rome's Libraries, and the Fire of AD 192', *Journal of Roman Archaeology*, 21 (2008), 133–50 (p. 144).

6. Bricks and other reusable building materials could of course have been carried away at any time during the Middle Ages, as the area of the western hall apparently remained accessible. According to Lanciani, large quantities of marble were removed from the site for the redecoration of Saint Peter's in the sixteenth century: the first excavation of the site for this purpose is recorded on 2 October 1526 and included the 'Templum Divi Augusti' and S. Maria Antiqua, i.e. the church and the adjoining western hall; see Rodolfo Lanciani, *Storia degli scavi di Roma*, 4 vols (Rome: Loescher, 1902–12), I, pp. 123, 225. But where exactly this material was found is not clear. It might have been taken from Santa Maria Antiqua, where the *opus testaceum* on the sanctuary walls looks conspicuously untouched by time. Van Deman pointed out that in 1702, once again in search for marble, the apse and sanctuary of the church were excavated for a brief period, but then covered up; see Esther B. Van Deman, 'The House of Caligula', *American Journal of Archaeology*, 28 (1924), 368–99 (pp. 371–2).

7. For the vestibule providing direct access to the Palatine ramp, see Per Jonas Nordhagen, 'The Earliest Decorations in S. Maria Antiqua and their Date', *Acta ad archaeologiam et artium historiam pertinentia*, 1 (1962), 53–72 (p. 54, note 8). For a reconstruction and interpretation of the pre-existing structure built over by Domitian, Caligula's water reservoir, and the vast peristyle—part of which is still accessible via stairs below the western portion of the atrium and western aisle of the church—see Van Deman, 'House of Caligula', p. 377; on Caligula's *piscina* and its different orientation, see also Rushforth, 'The Church of S. Maria Antiqua', *Papers of the British School at Rome*, 1 (1902), 1–123 (p. 23).

8. Delbrück, 'Der Südostbau', pp. 21–2.

9. When Delbrück visited the site again in 1921, after World War I, he discovered the remains of a marble pavement in the centre of what remained of the west wall of the western hall. He concluded that this signalled the existence of another main entrance to the hall, which would have admitted visitors coming from the direction of the Capitoline Hill; see Delbrück, 'Der Südostbau'. Ernest Nash and Herbert A. Cahn ('Der Wohnpalast der Cäsaren auf dem Palatin', *Antike Kunst*, 1.1 (1958), 24–9) based their reconstruction of the western façades of the vestibule and Domus Tiberiana, stemming from their vague representation on a coin of Domitian (95/96 CE), on Delbrück's 1914 findings, which seemed supported by Pirro Ligorio's sixteenth-century plan (now in the Bodleian Library, Oxford) showing the portico and central opening just where Delbrück placed them. Nash recognised the façade in the numismatic image which, in his view, proved that the entire complex was oriented towards the Capitoline Hill. See also Alessandro Capannari, 'La Casa Tiberiana sul Palatino', *Ateneo*, 6 (1874), 1–8.

10. For instance, the eleventh-century palaces at the Qal'a of the Banu Hammad: Qasr al-Manar, Dar al-Bahr; see Lucien Golvin, 'Note sur le décor des façades en Berbérie Orientale à la période Sanhagienne', in *Études d'orientalisme dédiées à la mémoire de Lévi-Provençal* (Paris: Maisonneuve & Larose, 1962), pp. 585–8; and Lucien Golvin, *Le Maghrib central à l'époque des Zirides* (Paris: Persée, 1957), pp. 186–7, figs 16–21, plates 9–10.

11. A side entrance from the street analogous to the passage via the western antechamber can perhaps also be found in the House of Symmachus on the Caelian Hill around 390 CE (in an adapted second- or third-century building), although the entrance there consisted of a large court and an adjacent apsed rectangular vestibule. I am grateful to Carlos Machado for bringing this to my attention. Rushforth had already pointed to the similarities between the plan of Santa Maria Antiqua and the House of Symmachus, see Rushforth, 'The Church of S. Maria Antiqua', pp. 21–2. A portal hall with military functions was suggested by Birgitta Tamm, *Auditorium and Palatium: a study on assembly-rooms in Roman palaces during the 1st century B.C. and first century A.D.* (Stockholm: Almqvist & Wiksell, 1963), pp. 79–85.

12 For public appearances in Domitian's vestibule, see Aulus Gellius, *Noctes Atticae*, IV, 1,1: 'In vestibulo aedium Palatinarum omnium fere ordinum multitudo apparientes salutationem Caesaris constiterant'. Both Giuseppe Lugli, *Mons Palatinus* (Rome: Università di Roma, Istituto di Topografia Antica, 1960), pp. 180, 184, nos 313, 334, 334a with note 1), and Axel Boethius ('The Reception Halls of the Roman Emperors', *Annual of the British School at Athens,* 46 (1951), 25–31 (p. 29)), conceived of the northern hall (atrium) as a space for the reception of a greater crowd and compared the succession of rooms to Constantine's *Magnaura*.

13 On the possible meaning of the partitioning walls set up under Hadrian in the western hall, see Delbrück, 'Der Südostbau', p. 8; Henry Hurst, John Osborne, and David Whitehouse, 'Santa Maria Antiqua. Problemi e proposte' in *Roma: Archeologia nel centro*, ed. by A.M. Bietti Sestieri, M. Agostinelli, and L. Attilia, 2 vols (Rome: De Luca, 1985), I, pp. 93–6 (p. 95); Hurst, 'Area di Santa Maria Antiqua', p. 476. Parts of the building possibly suffered in 455, when the imperial residences were plundered by the Vandals under Geiseric; see Procopius, *Gothic Wars*, III.5; IV.9.

14 On the continued use and decoration of the main doorway connecting the ramp to the north-eastern (left) aisle in Santa Maria Antiqua, see Per Jonas Nordhagen, '"The Harrowing of Hell" as Imperial Iconography. A Note on its Earliest Use', *Byzantinische Zeitschrift*, 75 (1982), 345–8. Nordhagen points to the iconography of the *Anastasis*, a fresco placed here by pope John VII (705–7), which he connects to imperial ceremonial. John VII had moved his episcopal residence to the Palatine, very possibly the Domus Tiberiana just overhead; see *Le Liber pontificalis*, ed. L. Duchesne, 2 vols (Paris: E. Thorin, 1886–92), I, p. 385.

15 Rushforth, 'The Church of S. Maria Antiqua', p. 21, note 1.

16 Both Delbrück ('Der Südostbau', p. 14) and Richard Krautheimer (*Corpus Basilicarum Christianarum Romae*, 5 vols (Vatican City: Pontificio Istituto di Archeologia Cristiana, 1937–77) [hereafter CBCR], II, pp. 255–63) agreed that the large rectangular niche in the south wall of the south-east side-chamber, which now contains the famous *Crucifixion* fresco, is an original feature of the Domitianic structure, while the corresponding niche in the south-west chamber was cut into the wall at floor level around 705, to receive John VII's fresco depicting saints. Krautheimer presumed that the redecoration of the walls with *opus sectile* had covered the south-east room niche, but it might as well have been included in the wall revetment. What image or object originally occupied the Domitianic niche and what it would have contained during the subsequent centuries (before it became the Chapel of Theodotus) are still matters of speculation.

17 For the Basilica Eufrasiana and San Vitale, see Ann Terry, 'The *opus sectile* in the Eufrasian Cathedral at Poreč', *Dumbarton Oaks Papers*, 40 (1986), 147–64, figs 4–29.

18 Alessandra Guiglia Guidobaldi, 'La decorazione marmorea dell'edificio di Santa Maria Antiqua fra tarda antichità e alto medioevo', in: *Santa Maria Antiqua al Foro Romano cento anni dopo*, ed. by J. Osborne, J.R. Brandt, and G. Morganti (Rome: Campisano, 2004), pp. 49–65 (p. 59).

19 Per Jonas Nordhagen, 'The Frescoes of John VII (A.D. 705–707) in S. Maria Antiqua in Rome', *Acta ad archaeologiam et artium historiam pertinentia*, 3 (1968), p. 39.

20 For Hagios Demetrios, see Panaghiota Asimakopoulou-Atzaka, *The Opus Sectile Technique in Wall Decoration* [in Greek] (Thessaloniki: Kentro Byzantinon Ereunon, 1980), pl. 26.

21 For the Kalenderhane Camii, see Wolfgang Müller-Wiener, *Bildlexikon zur Topographie Istanbuls* (Tübingen: Wasmuth, 1977), fig. 155.

22 Delbrück, 'Der Südostbau', p. 27 connected a set of twenty-seven Byzantine imported pilaster capitals made of Proconnesian marble, excavated in the atrium of Santa Maria Antiqua, with the *opus sectile* panels, and tentatively dated the wall incrustation to around 400 CE. Krautheimer (*CBCR* II, p. 254, note 2) thought the capitals too heavy for use in *opus sectile*. For the incrustation, a fourth- or fifth-century date is suggested by Guiglia Guidobaldi, 'La decorazione marmorea', pp. 49–55. See also Beat Brenk, 'Kultgeschichte versus Stilgeschichte: von der "raison d'être" des Bildes im 7. Jahrhundert in Rom', in *Uomo e spazio nell'alto medioevo* (Spoleto: Centro Italiano di Studi sull'Alto Medioevo, 2003), pp. 971–1055 (pp. 999–1000). Eva Tea, *La Basilica di S. Maria Antiqua* (Milan: Società Editrice 'Vita e Pensiero', 1937), pp. 359–60, proposed to date the capitals to the time of Theodoric.

23 Procopius, *On the Buildings*, I, 10–16. On the original location of the Chalke, and its function, see Cyril A. Mango, *The Brazen House: A Study of the Vestibule of the Imperial Palace at Constantinople* (Copenhagen: I kommission hos Munksgaard, 1959); Raymond Janin, *Constantinople byzantine* (Paris: Institut français d'études byzantines, 1950), p. 112. On later echoes of the Chalke in Rome (the new bronze gate of the Lateran palace), see John Haldon and Bryan Ward-Perkins, 'Evidence from Rome for the Image of Christ on the Chalke Gate in Constantinople', *Byzantine and Modern Greek Studies*, 23.1 (1999), 286–96; Leslie Brubaker, 'The Chalke Gate, the Construction of the Past, and the Trier Ivory', *Byzantine and Modern Greek Studies*, 23.1 (1999), 258–85; John Osborne, 'Papal Court Culture during the Pontificate of Zacharias (741–52)', in *Court Culture in the Early Middle Ages*, ed. by C. Cubitt (Turnhout: Brepols, 2003), pp. 223–34 (p. 227); Richard Krautheimer, *Rome: Profile of a City, 312–1308* (Princeton: Princeton University Press, 1980), p. 121; Richard Krautheimer, 'Die Decanneacubita in Konstantinopel: ein kleiner Beitrag zur Frage Rom und Byzanz', in *Tortulae*, ed. by W. N. Schumacher,

supplement to *Römische Quartalschrift für christliche Altertumskunde und Kirchengeschichte*, 30 (1966), pp. 195–9.

24 The building, destroyed in a fire during the Nika Riots (532) and subsequently rebuilt by Justinian, had already been the second Chalke, reportedly a sumptuous structure erected by the architect Etherius for Emperor Anastasius I (491–518). Etherius' commission to rebuild the imperial gate in 498 was perhaps prompted by the damage the building had suffered when the factions set fire to it in 497: *Chronicon Paschale*, I, 608 (*PG* 92). Cedrenus stresses the scale and enormous height of the new structure (*PG* 121, 705C). Etherius' lofty remodelling of the Chalke is compared explicitly to the Capitol by an anonymous epigrammatist, who writes that the building was so large that it was thought impossible to cover it with a roof; only Etherius was able to accomplish the task, see *The Greek Anthology*, trans. by William Roger Paton, 5 vols (London: Heinemann, 1916–18), III (1917), b. IX, pp. 363–5 (no. 656): '*On the House called Chalce*: I am the house of Anastasius, the emperor [...] the architects, seeing my height, length and vast breadth, were minded to leave the huge pile unroofed; but skilled Aetherius, the most eminent master of that laborious art, devised my shape [...] stretching on all sides my vast bulk, I surpass the celebrated wonders of the Italian land. Beauty of the Capitoline hall, give place to thy betters'. On the Palazzo 'di Calchi' and the tradition of early Byzantine audience halls, see especially Richard Goodchild, 'A Byzantine Palace at Apollonia (Cyrenaica)', *Antiquity*, 34 (1960), 246–58 (pp. 254–7); Richard Goodchild, 'The "Palace of the Dux"', in *Apollonia, the Port of Cyrene: Excavations by the University of Michigan 1965–67*, ed. by R.G. Goodchild, J.G. Pedley, and D. White (Tripoli: Dept. of Antiquities, 1976), pp. 245–59 (pp. 248–9); Ejnar Dyggve, 'Intorno al palazzo sull'isola di Meleda', *Palladio*, 9 (1959), 19–26 (p. 21); Chiara Morselli and Marco Ricci, 'Nuove ricerche archeologiche a Elaiussa Sebaste', in *Ideologia e cultura artistica tra adriatico e mediterraneo orientale (IV–X secolo). Atti del convegno internazionale (Bologna 2007)*, ed. by R. Farioli Campanati and others (Bologna: Ante Quem, 2009), pp. 99–113 (pp. 105–6, figs 11, 13), dealing with a fifth-century apsed palace triclinium with side chambers; André Grabar, *Martyrium: recherches sur le culte des reliques et l'art chrétien antique*, 3 vols (Paris: Collège de France, 1946), I, p.123; and Noel Duval, 'Que savons-nous du palais de Théodoric à Ravenne?', *Mélanges d'archéologie et d'histoire*, 72 (1960), 337–71. Bishop Agnellus does not specify the precise location of the palace 'ad Calci', but tells us it was 'iuxta' (beside) the palace church (Sant'Apollinare Nuovo): Agnellus, *Liber pontificalis ecclesiae Ravennatis*, ed. by D. Mauskopf Deliyannis, Corpus Christianorum 199 (Turnhout: Brepols, 2006), p. 290, no. 119.

25 *CBCR* II, pp. 263–7. On the maintenance of the Palatine buildings until the eighth century, see Andrea Augenti, *Il Palatino nel medioevo: Archeologia e topologia, secoli VI–XIII* (Rome: L'Erma di Bretschneider, 1996), pp. 17–19; Robert Coates-Stephens, 'Byzantine Building Patronage in Post-Reconquest Rome', in *Les cités de l'Italie tardo-antique (IVe–VIe siècle): Institutions, économie, société, culture et religion*, ed. by M. Ghilardi, C. Goddard and P. Porena, Collection de l'École Française de Rome, 369 (Rome: École Française de Rome, 2006), pp. 149–66 (p. 152).

26 Theodoric is also credited for having provided annual funds for the restoration of the buildings on the Palatine Hill, see Anonymous Valesianus, Excerp. 67: 'Per tricennalem triumphans (*Theodericus*) populo ingressus Palatium, exbibens Romanis ludos circensium. Donavit populo Romano et pauperibus annonas singulis annis centum viginti milia modios et ad restaurationem Palatii seu ad recuperationem moeniae civitatis singulis annis libras ducentas de arca vinaria dari praecepit'. See also Lugli, *Mons Palatinus*, p. 209, no. 501; Bryan Ward-Perkins, *From Classical Antiquity to the Middle Ages* (Oxford: Oxford University Press, 1984), p. 159; Andrea Augenti, 'Continuity and Discontinuity of a Seat of Power: The Palatine Hill from the 5th to the 10th century', in *Early Medieval Rome and the Christian West: Essays in Honour of Donald A. Bullough*, ed. by J.M.H. Smith (Leiden: Brill, 2000), pp. 43–53 (p. 50).

27 The niche was frequently closed with an apse conch (βασιλικη ‵κονχή), like the semi-circular recess that most likely preceded the current apse. A rather close approximation of its original shape may be found in the mid-eighth-century painting of a governor enthroned, included in the cycle of Saints Quiricus and Giulitta in the Chapel of Theodotus; see Ottorino Bertolini, *Roma di fronte a Bisanzio e di Longobardi* (Bologna: Cappelli, 1941), pp. 52–9. Niches almost identical in shape and size are still extant in the western hall.

28 English translation from Cyril Mango, *The Art of the Byzantine Empire 312–1453: Sources and Documents* (Englewood Cliffs, NJ: Prentice-Hall, 1972), pp. 252–3. See also Spyridon Lampros, 'Bessarion: "Encomion of Trebizond"', *Neos Hellênomnêmôn*, 13 (1916), 188–9.

ROBERT COATES-STEPHENS

The 'Oratory of the Forty Martyrs'

In the little more than a century since its rediscovery, the complex of Santa Maria Antiqua has generated an enormous amount of bibliography, in most European languages and covering a range of disciplines and time periods. It is difficult to keep track of, or to read thoroughly, all of the relevant material, and even what one succeeds in covering tends to be rapidly forgotten as soon as a new or undiscovered article, document, book or illustration comes to light. It is not especially surprising, therefore, that the two main planks of this paper's argument have each been raised in the past (admittedly only in fleeting footnotes)—and still less surprising that, almost as soon as they were floated, by Vincenzo Federici in 1900, and Angelo Lipinsky in 1961, they disappeared from all overviews of the monuments.[1] The two questions concern the original name, or dedication, of the building which today we call the Oratory of the Forty Martyrs, a small structure situated just outside the atrium of Santa Maria Antiqua, and the identity of its founder.

The oratory was discovered beneath the baroque church of Santa Maria Liberatrice when the latter was destroyed in 1900. J. Rasmus Brandt has established that the seventeenth-century building had its crossing directly above the early medieval cult hall, which lay a full 10 metres below.[2] When the demolition was complete, the lower portion (about 5.7 metres standing) of a squat, rectangular Roman hall was discovered, measuring about 12 by 8.5 metres (Figure 1). In 1999 the hall was restored to what is estimated to have been its full original height of about 13 metres.[3] The building, which dates to the time of Domitian, or a little later, had in its original phases been revetted in marble. Its original function is unknown. The enormous apse (nearly 10 metres high) was presumably intended to house a statue, and this has suggested to some scholars—most recently, Claudia Del Monti and Ernesto Monaco—that the building originally served as a shrine to the imperial cult, although there have been various other proposals.[4]

There is no obvious reference to the building in the texts—ancient or medieval—prior to the first mention of the overlying Santa Maria Liberatrice in 1293, and our evidence for its conversion to Christian use is therefore archaeological.[5] Most prominently, this takes the form of a complex sequence of frescoes, and (more precisely) two important funerary inscriptions, at least one of which is firmly tied to the interior of the building.[6] Together, this evidence allows us to place the building's conversion to a church in the later sixth century.

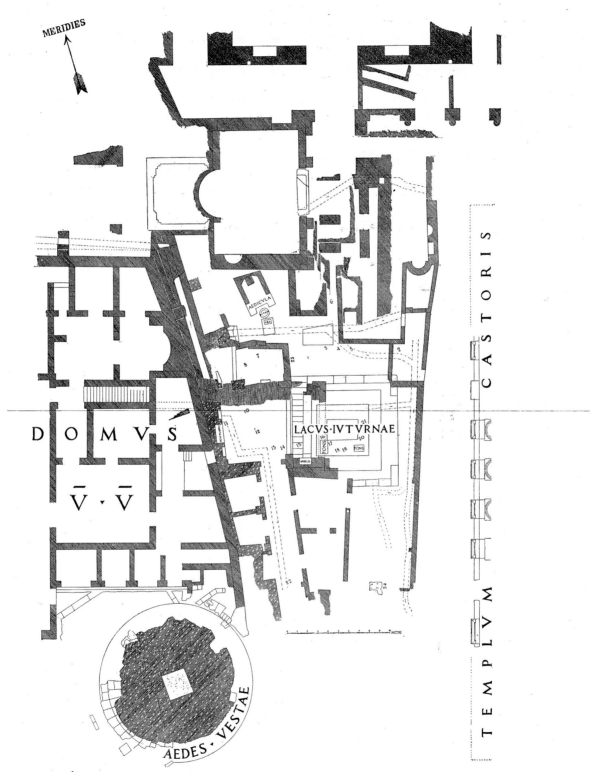

Oratory of the Forty Martyrs: Plan (after Giacomo Boni, *Il sacrario di Giuturna* (Roma: Tipografia della R. Accademia dei Lincei, 1901), fig. 13)

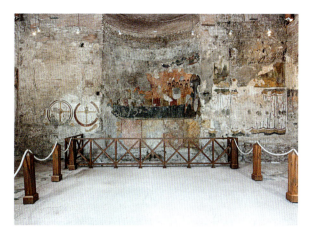

2 Oratory of the Forty Martyrs: View of the apse and adjacent walls (photo: Gaetano Alfano)

3 Oratory of the Forty martyrs: Detail of wall to left of apse, fresco of the jewelled crosses (photo: Gaetano Alfano)

The first layer of painting hardly survives at all, and consists of a fragmentary cross on the upper sector of the apse. We have no idea of the way in which the rest of the apse—and the building as a whole—was decorated, since it is now covered with later frescoes; it is quite possible, for example, that the Roman marble revetment was retained over much of the interior.[7] The next clear phase is the building's most famous décor, the fresco of the exposure of the Forty Martyrs of Sebaste in the frozen lake (Figure 2). This occupies the vertical walls of the apse, and covers the earlier cross. Below the scene of martyrdom is a band of painted *opus sectile* wall revetment. The dating of the fine jewelled crosses to the left of the apse (Figure 3) is contested: Rasmus Brandt thinks they are contemporary with the martyrdom fresco of the apse, whereas Joseph Wilpert had considered them later.[8] Since there is no point where the two paintings conjoin, there would in fact be nothing to prevent their being earlier. Again, we have no idea of what covered the side and front walls in the second phase of decoration, since these are now occupied by still later frescoes, representing (on the left wall) the same Forty Martyrs in glory and (on the right wall) unidentified scenes from the lives of other saints. There are also fragments of a votive panel to the right of the apse, and a fragmentary donor scene to the right of the door, on the counter-façade—to which we shall return. On what is now the outside of the building, but in antiquity would have been the interior of a covered porch or narthex, there are much ruined paintings of clipeate saints. In Wilpert's time many more scenes were visible here.[9]

Regarding the dating of the frescoes, almost all art historians over the last century have agreed that the apse scene of the Forty Martyrs belongs to the pontificate of Martin I (649–55), and that the final series, on the left wall, should be assigned to Hadrian I (772–95).[10] If this is accepted, we therefore need to work backwards by at least one phase from Martin I's work to date the first Christian paintings, that is, the cross of the apse and the elaborate metal-work crosses to the left, which, as noted, may also predate Martin I. The question as to precisely how far back we should go may be answered by a consideration of the two funerary inscriptions. The earlier epitaph – which, famously, is the earliest funerary inscription from the entire Forum – is that of Amantius the goldsmith (*aurifex*), who was buried on the 18 February in the fifth year after the consulship of the emperor Justin II, in 571–2.[11] The slab, which is currently fixed to the right wall inside the

oratory, was found sealing a tomb lying in isolation directly in front of the central door, that is, in the middle of the now-vanished narthex.[12] There has been some discussion regarding the precise pertinence of the slab to the grave, with modern overviews echoing Eva Tea in claiming it was found in re-use, and thus should not be used to date the burial.[13] This datum can be traced back to a 'personal communication' of Giacomo Boni, reported in a footnote to his 1911 Forum guidebook by the French archaeologist Henry Thédenat.[14] As was so often the case, Boni never actually published either his idea, or his evidence. For any more reliable details, we must go back once again to Gordon Rushforth, who stated that the slab was found in situ, covering the grave, but broken into several pieces, one of which had been replaced over the grave face-down; and only for this reason he was cautious regarding its original connection to the grave.[15] No specific evidence for non-pertinence has ever been produced—and contemporary observers of the calibre of Orazio Marucchi and Christian Hülsen accepted the integrity of the find.[16] There is certainly nothing in the stratigraphy of the tomb to prevent its being contemporary with the inscription: it does not project above the sixth-century ground level, nor were any datable objects found in it, let alone anything belonging to a date later than the sixth century.

Regarding the breakage of the slab, we should remember, as both Rushforth and Tea testify, that all tombs found at the Santa Maria complex had been looted some time after deposition – something which would easily cause breakage of the cover-slabs.[17] Moreover, most (if not all) of the tombs contained more than one burial: in other words, as is common in medieval cemeteries, later depositions continued to be made, necessitating the reopening and reclosing of the cover-slabs. Amantius' tomb, indeed, was said by Federici to have contained traces of multiple bodies ('avanzi di cadavari'), and thus may well have been reopened at least once.[18] There is literary evidence for this occurring in contemporaneous burial practice. Gregory the Great's *Dialogues* are full of stories concerning the opening and reopening of ordinary graves following prodigious dreams.[19] Agnellus of Ravenna gives an interesting anecdote regarding bishop Maximian's (mid-sixth-century) burial: when it was later moved to a higher level to combat flooding, careless workmen broke the inscribed cover-slab.[20] If our slab had been re-used, one would need to find a very good reason to explain why a broken stone had been selected to seal a tomb—especially given the vast choice of intact marbles in an area such as the Forum Romanum. Furthermore, it is significant in this regard that, despite breakage, none of the pieces of the inscription was actually missing. Should we imagine that the grave-diggers had gone to the trouble not only of choosing a broken slab for their work, but had also retrieved each and every piece (fifteen in all, according to Federici) before transporting them to a new site for their elaborate jigsaw puzzle?

All of which means that we cannot use the simple fact that the inscription was broken to conclude that it was in re-use. But there are more compelling reasons for concluding that the late sixth-century inscription belongs to the grave. In 2003, the backfill from Boni's excavations was briefly removed during the 'Post Aedem Castoris' project of Andrew Wilson, Jennifer Trimble, and Darius Arya, and the Amantius tomb was re-exposed (Figure 4). As is clear from the photograph, the floor of the tomb, composed of a distinctive pierced marble slab was, like the inscription itself, also broken. This suggests that floor and lid were indeed contemporaneous, and that the major damage to both occurred at the same time, perhaps during an earthquake or later subsidence: the collapse of the narthex itself, and especially the fall of its roof, would

Tomb of Amantius, exposed in 2003 (photo: Andrew Wilson)

be the obvious occasion. More importantly, the tomb's typology—a below-floor construction in masonry where the body was laid on a pierced slab (presumably, as Rushforth notes, for reasons of drainage)—conforms perfectly to the first phase of the main cemetery in the vestibule of Santa Maria Antiqua itself.[21] This cemetery was re-studied in great detail by Andrea Augenti, who showed quite clearly, using Boni's contemporary excavation reports and Rushforth's careful published notes, that on the basis of relative stratigraphy, tomb-type, and scarce grave-goods, this typology of burial commenced in the late sixth century.[22] The best *comparanda* for the tombs themselves came from the Monastirine basilica in Salona (Croatia), which was destroyed in 639; and the Roman church of San Saba also has a similarly intensive use of below-floor graves, dating to the last decades of the sixth century.[23] We can therefore safely conclude that Amantius' tomb should be assigned to the same phase as Santa Maria Antiqua's main cemetery, and thus that the date furnished by the inscription (571–2) matches the grave itself, and therefore the goldsmith's original burial.

Any remaining doubts regarding the pertinence of Amantius to the Forum, and to the oratory in particular, can be swept away when we consider the second funerary inscription. This, strangely, is seldom taken into account in the literature on the building. Our only source for its context is Vincenzo Federici, who catalogued the inscriptions of the entire Santa Maria Antiqua complex impeccably in Wladimir de Grüneisen's magnum opus.[24] He states that it sealed a burial inside a re-used sarcophagus, found beneath the floor of the oratory itself, on the south side. With the exception of a *loculus* burial in the north wall (which cuts an eighth- or ninth-century fresco, and is therefore very late), this below-floor burial was the only one encountered inside the church. The slab, which like that of Amantius was broken, gives us enough information to conclude that it marks the grave of one Ypolita, probably a widow, who either herself (or perhaps whose family) belonged to the 'arte argent[ar]i', the guild of silversmiths.[25] She died during the reign of the Emperor Maurice (582–602). Since both Rushforth and Federici say the sarcophagus contained more than one body, we might guess that this was a family tomb. Again, its repeated opening and reclosing might account for the breakage of the slab – although, as we observed for Amantius, the earthquake of 847 and consequent collapse of the upper portion of the oratory would hardly have helped its preservation.

The two texts of Amantius and Ypolita have much in common. Firstly, the dates: 571–2 and the reign of Maurice – a minimum interval between them, therefore, of only ten years, and an absolute maximum of twenty. The precise dating by the regnal or consular year of the Byzantine emperor is also significant. This is rare in Rome, and the few examples we have all belong to the late sixth and early seventh centuries. Just as striking is the consonance between the trades of the deceased: goldsmiths and silversmiths (again, it is very rare in early medieval Rome to have such information). Of especial interest for the choice of burial location is the fact, as Lipinsky revealed in his informative study of 1961, that these are the exact trades practiced in this area of the Forum ever since the Republic, with few (if any) periods of interruption: the Scalae Anulariae (ring-maker's stairs) immediately above the Oratory yielded a vast cache of glass paste, rings, and bronze plate in Boni's excavations; numerous goldsmiths' and jewellers' shops are recorded lining the Via Sacra in the imperial era; and by late antiquity the opposite side of the Forum was occupied by a 'Basilica Argentaria'.[26] Lastly, the close links between the two epitaphs include the fact that the man, Amantius, died in 571–2, and the only other tomb

belonging to the oratory is that of a widow, buried within about ten years afterwards: it seems by no means unlikely that Ypolita was Amantius' wife.

The burials of Amantius and Ypolita in the oratory mark a significant benchmark in Rome's funerary topography. Whereas sporadic urban burial had been a feature of the late antique landscape since the early fifth century, it is only at the end of the sixth century, following the Byzantine Reconquest of Italy, that organised urban burial in direct relation to, or association with churches becomes general.[27] Amantius' epitaph is amongst the earliest precisely dated examples of this practice, and fits extremely well with the literary and archaeological evidence, all of which points to a widespread (perhaps centrally organised) move to this practice in post-Gothic War Rome. We have briefly considered the dating for the large cemetery in Santa Maria Antiqua's atrium. The cemetery beneath the floor of San Saba belongs to the same late sixth-century date, and all of this corresponds with the literary references in Gregory the Great's *Dialogues* to his own monastery cemetery, and to church burials at the nearby San Sisto.[28]

More important for the question of the building's Christian origins is Lipinsky's little-noted suggestion that Amantius may have been, at the very least, an important member of the congregation of the oratory in which he was buried—if not its actual founder.[29] That founders and their families would expect burial in the churches or oratories they had built is a comparatively well-known tenet, which became established amongst Italian urban elites during the sixth century.[30] Indeed, within Santa Maria Antiqua itself, the Chapel of Theodotus is widely seen as a funerary offering for the patron's deceased relatives, and the below-floor burial in front of the key fresco of the donor—the only such tomb found inside the sanctuary—may well, as Arno Rettner argues, have contained the bodies in question.[31] More precisely, the positioning of a founder's tomb immediately outside the doors of a chapel, or (as in Amantius' case) in the porch or narthex, is a comparatively widespread practice, which becomes even more frequent in the above-ground aedicule-tombs of the full Middle Ages.[32] Theodotus' family tomb, significantly, lies in that part of his chapel which precedes the sanctuary, from which it was fenced off by marble screens. Gregory the Great was famously uneasy about the way in which presumptuous, ungodly characters (clerics as well as lay people) polluted the sanctity of church interiors with their own tombs (*Dial.* 4. 52–6). One story which has particularly interesting consonances with Amantius and Ypolita is that of the sinful dyer whose widow had him buried inside the Roman church of Saint Januarius (*Dial.* 4. 56). During the night, the sacristan was disturbed by screams of 'I burn!' in the empty building. When the deceased's colleagues (the *viri artis tinctorum*) reopened the tomb, they found the corpse consumed by the flames of his sin, with only the clothes remaining. In this light, one imagines that the less presumptuous might be encouraged to prefer burial outside the sacred boundaries.

The anecdote from the *Dialogues* also reveals that guilds in late sixth-century Rome—even relatively humble ones, such as the *ars tinctorum*—might have had particularly close links to specific churches, something which appears to be the case with the chosen burial-site of Amantius, Ypolita, and the *ars argentarii*. As mentioned earlier, the borders of the Forum, and this area in particular, had been associated with the makers of sumptuary goods throughout the late Republic and Empire, and Amantius' and Ypolita's family and colleagues show that the tradition continued into the early Middle Ages. One of the clearest conclusions of Cairoli Giuliani and Patrizia Verduchi's study of the sixth-century phases of the Forum piazza was that

the eastern end was home to metal-working industries.³³ It seems not unreasonable to imagine that the extremely elaborate, atypical fresco of the three crosses inside the oratory (Figure 3) reflects this activity—activity which, by this period, was directed especially towards liturgical apparatus: not only crosses, but, in the words of the *Liber pontificalis*, 'crowns and canisters'. Indeed, both Orazio Marucchi and Carlo Cecchelli have remarked on the usefulness of this fresco for imagining the rich *suppellettile* of Roman churches in these years.³⁴ The markedly exclusive character of the Forum oratory, however, is very striking: after Ypolita (and perhaps her children), there are no more burials here. We are looking at a restricted, single moment. And this might be one more element that urges us to consider them the actual founders of the building.³⁵

To sum up the situation thus far, my proposition is that the oratory was founded in or around 570 by Amantius *aurifex*, and that it was initially a private, or at least a guild chapel, before undergoing a significant change in administration in the mid-seventh century when the Forty Martyrs fresco was painted. We must now address the question of its original dedication. In whose honour was the oratory named? And did it change its title when the fresco of the Forty Martyrs was painted? The assumption made by Roberto Paribeni soon after the building's discovery that the frescoes automatically provide the dedication has been universally followed ever since, and we now tend to accept that the 'Oratory of the Forty Martyrs' is a genuine medieval designation rather than a modern label.³⁶ The problem, of course, as early scholars like Federici and Marucchi were well aware, is that not a single text in our voluminous range on early medieval Rome ever mentions an 'Oratory of the Forty Martyrs' there – and this, despite the fact that Santa Maria Antiqua is one of the most frequently cited institutions in the *Liber pontificalis*, also appearing in the Einsiedeln itineraries and the text known as *Istae vero ecclesiae intus Romae habentur* (both late eighth century).³⁷ More striking still is the fact that in the whole of Rome, no chapel or church dedicated to the Forty Martyrs is recorded before 1123, when the one in Trastevere (now San Pasquale Baylon) first appears in a bull of Callixtus II.³⁸ Admittedly, there are traces of their cult before this date: not only do frescoes depicting them survive in our oratory, but they also appear in the main church of Santa Maria Antiqua (usually assigned to the same phase of Martin I), as well as in the *diaconia* of Santa Maria in Via Lata (perhaps datable to the eighth century).³⁹ Their relics are also recorded in the catacombs of Saints Peter and Marcellinus, and in those of Saint Callixtus, in itineraries and martyrologies.⁴⁰ In fact, it seems that in the only cases where we can detect their presence prior to their first independent church in Rome, they appear to be 'inserted' in other buildings, officially dedicated to other saints—indeed, this is also common elsewhere, for example at Constantinople, Thessalonica, Asinou in Cyprus, Syracuse, and Brescia.⁴¹

At this point, I would like to propose a rather obvious solution, which surprisingly has never been made before in clear terms. In the *Liber pontificalis* biography of Leo III, shortly after the great donation list of crowns and canisters of 807, there is a record of additional gifts to Santa Maria Antiqua, followed immediately by the reference: 'And in Saint Andrew's oratory, in the same place, [he gave] two all-silk veils, adorned as above'.⁴² Scholars have always been puzzled by this 'Oratory of Saint Andrew' at Santa Maria Antiqua.⁴³ That the close link between the titular saint of this oratory and the main church of Santa Maria Antiqua lasted up to and beyond the demise of the entire complex in the 847 earthquake can be ascertained from the fact that

Andrew is represented flanking the Virgin in her new church's mosaic on the other side of the Forum (Santa Maria Nova, now Santa Francesca Romana). But physical traces of the building stubbornly evaded the archaeologists of the 1900 excavations, as noted in 1926 by Christian Huelsen.[44] Only Federici, in a brief footnote, raised the possibility that our oratory might in fact be the *Liber*'s Oratory of Saint Andrew – only to reject it, on the basis that the frescoes depicted the Forty Martyrs.[45] However, for various reasons, it is worth revisiting the possibility. The basic premise is quite simple: on the one hand, we have a textual reference to an oratory in precisely this area, which has never been found, despite it being one of the most thoroughly excavated stretches of soil in all of the Forum. On the other hand, we have a well-preserved cult building which finds no record in the sources – not even in the usually detailed *Liber pontificalis*, which refers so often to the Santa Maria Antiqua complex. The correspondence appears, to say the least, compelling.

The pre-existing character of the site is important for this question—even if, as we have seen, the precise function of the Roman hall remains uncertain. Much has been made of the supposed significance of the Lacus Juturnae for a later dedication to the Forty Martyrs, who were of course executed in a frozen lake.[46] Juturna's lake, however, was a healing lake, not a killing lake—and, what is more, rather than being shunned in the Christian period as a place of ill omen, it continued to serve as an important spot for drawing fresh spring-water, as the hundreds of early medieval jugs and pots found here by Boni testify.[47] A more fruitful cultic link at the site of our oratory might be made via the consonances between Aesculapius, whose statue adorned the Lacus (it is now displayed inside the Forum Antiquarium) and Andrew in his well-known role of thaumaturge. His power in this regard is stressed in the late sixth century by Gregory of Tours, and by Gregory the Great, in whose own monastery (as we shall see) he was credited with effecting miraculous cures and prophetic dreams. More important for our Forum oratory is the direct connection of Aesculapius sites elsewhere in the Greco-Roman Christian world to cults of Saint Andrew. The healing god's sanctuary at the foot of the Athenian Acropolis was replaced by a church almost certainly dedicated to Andrew in the late fifth century, and in the full middle ages Guido Cosmographer reveals the belief that the inhabitants of his principal cult centre at Epidauros (mistakenly identified with Dyrrachium) were converted to Christianity precisely due to the activity of Saint Andrew (*Guidonis Geographica,* 113).[48]

The frescoes in our oratory certainly represent the Forty Martyrs. This, of course, causes no problems regarding an initial dedication to Saint Andrew, since, as we have seen, nothing is known of the decorative programme prior to the introduction of the martyrs of Sebaste, with the exception of the jewelled cross of the apse vault (and perhaps the metal crosses on the end wall). Even in the later, seventh-century phase, we have no idea of the decoration of the greater part of the oratory, beyond the scene of the apse wall. The decisive zone of the apse vault, and the wall above it—as well as the building's façade, side walls, and counter façade—all remain a mystery. Admittedly, the introduction of such an apparently significant painting in such a prominent position, with no consequent change in the building's dedication, may strike us as unusual. But the aforementioned case of Santa Maria in Via Lata, whose apse also features the Forty Martyrs, serves as a striking parallel. Finally, on the question of the building's décor, there is the enigmatic donor fresco alluded to in our introduction. Now largely vanished, this is situated on the chapel's counter-façade to the right (north) of the door, and was illustrated

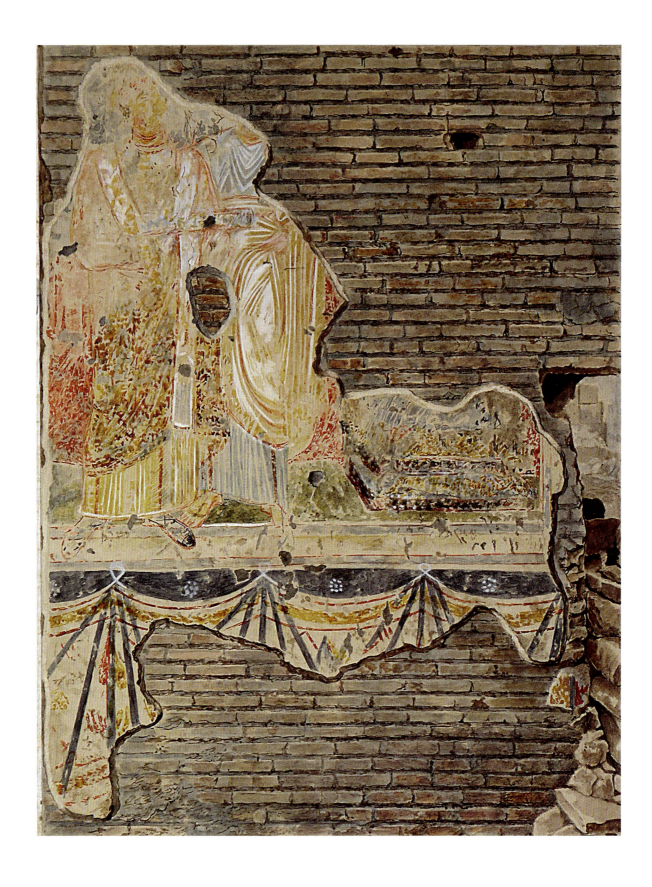

5 Oratory of the Forty Martyrs: Donor fresco to the right of the door
(watercoloured photograph after Wilpert, *RMM*, IV, pl. 197,2)

by Wilpert, who dated it to the time of Hadrian I (Figure 5).[49] It has never been satisfactorily identified, but appears to show a donor, to the left (probably a pope), being introduced to the enthroned Virgin (right) by a saint, whose white robes and bare feet suggest an apostle. Since this is the sole representation in the building of a prominent clerical donor, who is moreover honouring the Virgin through the mediation of a single male saint, the latter represented in the traditional guise of an apostle, the fresco would be a suitable record of Pope Leo III's donation of two silk cloths ('vela duo olosirica') to the oratory of Saint Andrew at Santa Maria Antiqua.[50]

Further grounds for identifying the building as the *Liber pontificalis*' Saint Andrew oratory are the striking links between the apostle and the same Forty Martyrs depicted in the fresco. Such links enable us to understand how the latter cult came to be inserted in Amantius' oratory. Tea, who posited in rather vague terms that there was a connection between Santa Maria Antiqua and the unlocated Renati monastery of Saint Andrew, noted the popularity of the apostle's cult in the original homeland of the Martyrs of Sebaste, whose inhabitants Andrew is said to have converted to Christianity, and where (in Sinope) his stone throne was kept.[51] It may also have been this link that led the very first promoter of the Forty Martyrs cult in Italy, Gaudentius of Brescia, around the year 400, to combine the relics of the martyrs of Sebaste precisely with those of Andrew in his basilica of the *Concilium Sanctorum*.[52]

But there is a still more striking connection. The apocryphal Acts of Saint Andrew, first drawn up in the late third century, but best known in our period through Gregory of Tours's version, contain an episode set on the shore of Patras, where Andrew resuscitates forty pilgrims who have died in the waves of the Adriatic:

'They sat down, with others, on the sand, and he taught. A corpse was thrown up by the sea near them. "We must learn", said Andrew, "what the enemy has done to him." So he raised him, gave him a garment, and made him tell his story. He said: "I am the son of Sostratus, of Macedonia, lately come from Italy. On returning home I heard of a new teaching, and set forth to find out about it. On the way here we were wrecked and all drowned." And after some thought, he realized that Andrew was the man he sought, and fell at his feet and said: "I know that thou art the servant of the true God. I beseech thee for my companions, that they also may be raised and know him." Then Andrew instructed him, and thereafter prayed God to show the bodies of the other drowned men: thirty-nine were washed ashore, and all there prayed for them to be raised […]. So he [Warus] was first raised and then the other thirty-eight. Andrew prayed over each, and then told the brethren each to take the hand of one and say: "Jesus Christ the son of the living God raiseth thee"'.[53]

The story was still being elaborated as late as Jacobus de Voragine's *Golden Legend*, which also states that the episode of the 'Forty saved from the waters' was included in a special hymn in Andrew's honour.[54] The consonance here with the legend of the Forty Martyrs of the lake of Sebaste is striking, and might even explain the choice of this specific cult hall for their installation in the mid-seventh century when, probably under Martin I, the fresco of their martyrdom was painted in the older oratory's apse. What better location to insert a devotional image of the Forty Martyrs than in a chapel dedicated to the very apostle credited with saving forty Christians from a watery death?

The dedication of an oratory to Saint Andrew in late sixth-century Rome also sits very well with the development of the saint's cult in Italy after the Byzantine Reconquest. It is, like the

phenomenon of urban church burial, a cultural indicator of the Rome of the time, and enables us to contextualise the original foundation of our oratory. Admittedly, Andrew's cult is known earlier in Rome. Pope Symmachus converted the great rotunda at Saint Peter's into a church consecrated to Saint Andrew around the year 500, and the Goth Flavius Valila had earlier done the same with the Basilica of Junius Bassus near Santa Maria Maggiore.[55] But there is a significant raising of the saint's profile after the Reconquest. Andrew's most prominent promoter in these years was Maximian of Ravenna, who was consecrated at the saint's principal cult-centre of Patras in 546. His attempt to obtain the saint's body directly from Justinian in Constantinople was, according to Agnellus, made with the intention of setting Ravenna on an equal footing to Rome in terms of apostolic precedence (*LibPontRav* 76). Maximian had to content himself with Andrew's beard, which he deposited in Ravenna's eponymous church after restoring it at great cost (a building that was, according to Alessandro Testi Rasponi, a converted ancient structure like the aforementioned Roman churches of Saint Andrew and our own Forum oratory).[56] In 557 this church of Saint Andrew became the city's first intra-mural episcopal burial site when Maximian was interred next to the saint's altar (and we have seen that his tombstone, like that of Amantius, was later broken).[57]

The first intra-mural church burial recorded in Naples also took place in a church dedicated to Saint Andrew, a fact that further illustrates the late sixth-century nexus of early urban church burial, lay founders, and the cult of Andrew that I propose lay behind the origin of the so-called Oratory of the Forty Martyrs. The church burial was of one 'Candida *matrona*', whose finely carved sarcophagus may still be seen in the apse of Naples' Santi Andrea e Marco dei Tavernari, the building of which she probably commissioned as well.[58] Candida's poetic epitaph ends with a formula that is identical to that of Amantius, giving the date of her death—5 September 585—according to indiction and the consular year of the reigning Byzantine emperor, in this case Maurice.[59] Unlike Amantius, however, Candida was never forgotten, and indeed by the Middle Ages the noble patroness had even been transformed into a saint, Santa Candida.

In Rome itself, the fashion for Saint Andrew in the post-Reconquest period is most evident in the case of the future pope Gregory the Great. In around 575, just a few years after Amantius' death—and also, according to the current argument, the foundation of the Oratory of Saint Andrew in the Forum—the former urban prefect and future pope converted his own house into a monastery dedicated to Saint Andrew.[60] The relics which Gregory himself (*Registrum Gregorii* 11.26) implies were deposited in the saint's altar there have their own medieval tradition: some ten years after the monastery's foundation, whilst serving as papal *apocrisarius* in Constantinople, Gregory succeeded where Maximian of Ravenna had failed and procured substantial corporeal relics of Andrew (notably, a portion of his arm), which he distributed between his own monastery and that founded by his mother on the Aventine, the later San Saba.[61] Other notable foundations dedicated to Andrew in Rome at this time include the monastery *Cata Barbara Patricia*, set up by the eponymous daughter of the Byzantine governor of Sicily, Venantius, who had been entrusted to Gregory himself on her father's death, and the monastery established (again in his own house) by Pope Honorius I at the Lateran in the 620s.[62]

Each of these promoters of the cult of Andrew in Byzantine Italy belonged to a very different social milieu from that of Amantius and Ypolita, however. The latter were not bishops, saints, patricians, former city prefects, or popes. One wonders how the impeccably upper-class

Gregory would have viewed a goldsmith having preceded him both in dedicating a chapel to Saint Andrew and even in having himself buried *in limine apostoli*, literally 'on the threshold of the Apostle'. Presumably, he would have seen it as an example of precisely the kind of hubris, of 'not knowing one's place', against which he had fulminated regarding the *ars tinctorum* at Saint Januarius.

In the mid-seventh century, as we have seen, our oratory underwent a significant transformation and its apse walls were adorned with a new fresco of the Forty Martyrs of Sebaste. The use of the building for burials by the *ars argentarii* ceased, and what new script that survives from this secondary phase is in Greek, not Latin. This material testimony for a markedly new presence in the oratory matches the changes observed elsewhere in the complex of Santa Maria Antiqua, and might relate to the arrival of Greek-speaking clerics from outside Rome. If this is the case, then it would find parallels at other contemporary religious establishments in the city. The closest analogy for the trajectory hypothesised here for the Oratory of the Forty Martyrs is to be found at San Saba. Here, a foundation of Silvia, mother of Gregory the Great, whose original dedication goes unrecorded in the early sources, but which certainly was held to have contained relics of Saint Andrew, was re-settled by eastern, Greek-speaking monks during the pontificate of Martin I.[63] In this case, the official dedication of the establishment was changed to reflect the devotion of the new arrivals, but Saint Andrew's image was retained in the building's décor, and in later sources the monastery even continued to be recorded as 'Saints Andrew and Sabas'. Two other sixth-century monasteries originally dedicated to Saint Andrew that underwent a change of personnel at the same time are the Renati, to whose dedication was added that of the *Theotokos* when Armenian monks arrived in the seventh century, and Gregory's own monastery on the Caelian, where Greek monks were established by the eighth century.[64] In all three instances we see the takeover of an original Andrean institution by *émigrés* from the East, sometimes with the overlaying of new saints and cults. But in each case, the memory of the Apostle persisted—just as it did at the *oratorium sancti Andree* of the *Liber pontificalis*' biography of Leo III, even after the Forty Martyrs of Sebaste had usurped its apse walls.

1. Vincenzo Federici, 'Santa Maria Antiqua e gli ultimi scavi del Foro Romano', *Archivio della Società Romana di Storia Patria*, 23 (1900), 517–62 (p. 520, note 2); Angelo Lipinsky, 'Orafi e argentieri nella Roma pagana e cristiana', *L'Urbe*, 24 (1961), fasc. 3, 3–13 (p. 8).

2. J. Rasmus Brandt, 'The Oratory of the Forty Martyrs: from Imperial Hall to Baroque Church', in *Santa Maria Antiqua al Foro Romano cento anni dopo*, ed. by J. Osborne, J.R. Brandt, G. Morganti (Rome: Campisano, 2004), pp. 136–52 (p. 147, fig. 16). There were traces also of intermediate phases.

3. Claudia Del Monti, 'L'aula dell'Oratorio dei XL Martiri: criteri e metodologie del restauro', in *Santa Maria Antiqua al Foro Romano cento anni dopo*, ed. by J. Osborne, J.R. Brandt, and G. Morganti, pp. 153–65.

4. Ibid., p. 161; and Ernesto Monaco, 'L'aula del Oratorio dei XI Martiri al Foro Romano. Considerazioni sulla fase originaria', *Santa Maria Antiqua al Foro Romano cento anni dopo*, ed. by J. Osborne, J.R. Brandt, and G. Morganti, pp. 167–86. Other identifications include: Domitian's Temple of Minerva, see Gordon Rushforth, 'The Church of S. Maria Antiqua', *Papers of the British School at Rome*, 1 (1902), 1–123 (p. 109, note 3), and Rodolfo Lanciani, *Notes from Rome*, ed. A. Cubberley (London: British School at Rome, 1988), p. 336; an 'ante-vestibule' combining the roles of *augusteum* and palace guardhouse, according to Kirsti Gulowsen, 'The Oratory of the Forty Martyrs: from Imperial Ante-vestibule to Christian Room of Worship', *Acta ad archaeologiam et artium historiam pertinentia*, 15 (2001), 77–91 (pp. 80–1, 85), cf. Eva Tea, *La Basilica di Santa Maria Antiqua* (Milan: Società Editrice 'Vita e Pensiero', 1937), p. 55; and Varro's Curia Acculeia, see Filippo Coarelli, *Il Foro Romano, periodo arcaico* (Rome: Quasar, 1983), p. 273, and Jakko Aronen, 'Curia Acculeia', in *Lexicon Topographicum Urbis Romae* [hereafter *LTUR*], ed. by E.M. Steinby, 6 vols (Rome: Quasar, 1993–2000), I, 329–30.

5. Bruzio in Mariano Armellini, *Le chiese di Roma dal secolo IV al XIX*, ed. by C. Cecchelli (Rome: Edizioni R.O.R.E. di Nicola Ruffolo, 1942), pp. 547, 646.

6. Further material evidence of the building's Christian transformation includes the addition of an altar and a *spolia* marble pavement adjudged 'very barbarous' by Rushforth, 'The Church of S. Maria Antiqua', p. 114; cf. the watercoloured photograph in Joseph Wilpert, *Die Römischen Mosaiken und Malereien der kirchlichen Bauten vom IV. bis XIII. Jahrhundert* (Freiburg im Breisgau: Herder, 1916) [hereafter *RMM*], pl. 201.4, and various graffiti incised on the frescoes, catalogued by Vincenzo Federici, 'L'épigraphie de l'église Sainte-Marie-Antique', in Wladimir de Grüneisen, *Sainte-Marie-Antique* (Rome: M. Bretschneider, 1911), pp. 399–447.

7. As suggested by Monaco, 'L'aula dell'Oratorio dei XL Martiri', p. 172.

8. J. Rasmus Brandt, 'Quaranta Martiri, oratorio', in *LTUR*, IV, p. 176; Wilpert, *RMM*, p. 725 and pl. 200.1 (a verdict shared by Giulia Bordi, personal communication).

9. Wilpert, *RMM*, pp. 682–4 and pl. 167.

10. Ibid., pp. 722–5, plates 197.2, 199–201; de Grüneisen, *Sainte-Marie-Antique*, p. 140; Per Jonas Nordhagen, 'The Earliest Decorations in Santa Maria Antiqua and their Date', *Acta ad archaeologiam et artium historiam pertinentia*, 1 (1962), 53–72 (p. 63); and Per Jonas Nordhagen, 'S. Maria Antiqua: the Frescoes of the Seventh Century', *Acta ad archaeologiam et artium historiam pertinentia*, 8 (1978), 89–142 (pp. 133–5). Nordhagen in fact prefers a date in the early ninth century for the scene on the left wall, see Pietro Romanelli and Per Jonas Nordhagen, *S. Maria Antiqua*, (Rome: Istituto Poligrafico dello Stato, 1964), p. 45. Tea gives a clear description of all the frescoes, with eccentric dating (*Basilica di Santa Maria Antiqua*, pp. 345–52).

11. *CIL* VI 37782; and *Inscriptiones christianae urbis Romae septimo saeculo antiquiores,* nova series, I (Rome: Befani, 1922) [hereafter *ICUR* ns], 1403: 'Hic requiscit in pace Amantiu[s] [aur]ifex qui vixit / plus min ann L depositus sub d XII [kal] [ma]rtias quinquies / pc dn Iustini pp Aug ind quarta'. The year is given as 571 by *CIL*, *ICUR*, and Salvatore Cosentino, *Prosopografia dell'Italia bizantina (493–804)*, 2 vols (Bologna: Lo Scarabeo, 1996–2000), I, p. 130—and as 572 by Rushforth, 'The Church of S. Maria Antiqua', p. 108; Orazio Marucchi, 'La chiesa di S. Maria Antica nel Foro Romano', *Nuovo Bullettino di Archeologia Cristiana*, 6 (1900), 285–320 (p. 312, note 2); Christian Huelsen, 'Die Ausgrabungen auf dem Forum Romanum 1898–1902', *Mitteilungen des kaiserlich Deutschen Archäologischen Instituts, Römische Abteilung*, 17 (1902), 74–86 (p. 83); Dante Vaglieri, *Gli scavi recenti nel Foro Romano* (Rome: Loescher, 1903), p. 201, note 1; and René Cagnat and Maurice Besnier, 'Revue des publications épigraphiques', *Revue Archéologique*, 1.1 (1903), 319–36 (p. 325). There are some variations in the transcriptions of Federici, 'Santa Maria Antiqua', p. 562 and Federici, 'L'épigraphie', p. 437.

12. Location given on Rushforth's plan ('The Church of S. Maria Antiqua', p. 18, no. 87). It has since been re-excavated.

13. Tea, *Basilica di Santa Maria Antiqua*, p. 225, followed by Andrea Augenti, *Il Palatino nel medioevo* (Rome: "L'Erma" di Bretschneider 1996), p. 164, and Monaco, 'L'aula dell'Oratorio dei XL Martiri', p. 175. As we shall see, Tea was merely reporting hearsay; in addition, at p. 121 she wrongly states that the burial was in a sarcophagus—all of which diminishes the value of her claims.

14. Henry Thédenat, *Le Forum romain* (Paris: Hachette, 1911), pp. 284, 306 note 1.

15. Rushforth, 'The Church of S. Maria Antiqua', pp. 108–9. He first states that the slab 'had been taken from some older grave', subsequently observing only that 'the grave in which it was found *may be* later' (italics mine).

16 Orazio Marucchi, 'Regione VIII. Di un importante sarcofago cristiano rinvenuto nella chiesa di S. Maria Antiqua, nel Foro romano', *Notizie degli Scavi di Antichità*, (1901), 272–8 (p. 277); Marucchi, 'La Chiesa di S. Maria Antiqua', p. 312 note 2; Hülsen, 'Ausgrabungen', p. 83; and Christian Hülsen, 'Neue Inschriften vom Forum Romanum', *Klio*, 2 (1902), 227–83 (p. 283).

17 Rushforth, 'The Church of S. Maria Antiqua', p. 105 note 1: 'Generally speaking, all the graves in and about the church were found to have been rifled in later times'. Cf. Tea, *Basilica di Santa Maria Antiqua*, p. 117: 'molte tombe portassero segni di manomissione'.

18 Federici, 'Santa Maria Antiqua e gli ultimi scavi', p. 562.

19 Gregory I, *Dialogues* 4.28, 4.53, 4.55, 4.56; *Gregorii Magni Dialogi Libri IV*, ed. U. Moricca, Fonti per la Storia d'Italia, 57 (Rome: Tipografia del Senato, 1924).

20 Agnellus, *Liber Pontificalis Ecclesiae Ravennatis*, ed. O. Holder-Egger, Monumenta Germaniae Historica Scriptores rerum Langobardicarum et Italicarum saec. VI–IX (Hannover: Impensis Bibliopolii Hahniani 1878), pp. 265–391 (p. 333).

21 Clear description in Rushforth, 'The Church of S. Maria Antiqua', pp. 104–6.

22 Augenti, *Il Palatino nel medioevo*, pp. 34–7, 163–8.

23 Monastirine typology in Rushforth, 'The Church of S. Maria Antiqua', p. 106 note 1. Most recently on the San Saba cemetery: Robert Coates-Stephens, 'S. Saba and the *Xenodochium de Via Nova*', *Rivista di Archeologia Cristiana*, 83 (2007), 223–56.

24 Federici, 'L'épigraphie', p. 440. This provenance is noted in *ICUR* ns I 1404, but not given in the few sketchy notices that actually manage to reference the inscription: for example, Vaglieri, *Gli scavi recenti*, p. 227 note 1; Cagnat and Besnier, 'Revue', p. 325; Hülsen, 'Neue Inschriften', pp. 282–3, and 'Ausgrabungen', p. 83; Tea, *Basilica di Santa Maria Antiqua*, p. 226; and Cosentino, *Prosopografia*, II, 104. Rushforth mentions the reused sarcophagus but not the inscription ('The Church of S. Maria Antiqua', p. 114).

25 *ICUR* ns I 1404: '+Hic requisci]t in pace Ypolita vi[---] / [a]rte argenti cum / [Yp]olita vixit an[nos] / [et u]num m IIII depo[sita] / dn Mau[ricio pp Aug.' *CIL* VI 37777 proposes: 'pc]dn Mau[rici anno', that is, a consular date rather than the overall reign. Hülsen proposes 'vi[dua' ('Neue Inschriften', p. 283).

26 Lipinsky, 'Orafi e argentieri' nella Roma pagana e cristiana', *L'Urbe*, 24 (1961), fasc. 1, pp. 1–8; fasc. 2, pp. 3–14; fasc. 3, pp. 3–13. See also Emanuele Papi, 'Scalae Anulariae', in *LTUR*, IV, pp. 238–9; and Chiara Morselli, 'Basilica Argentaria' in *LTUR*, I , 169–70.

27 Most recent overview in Roberto Meneghini and Riccardo Santangeli Valenzani, *Roma nell'altomedioevo* (Rome: Libreria dello Stato, 2004), pp. 103–25, especially p. 123.

28 Coates-Stephens, 'S. Saba', p. 244 note 22 (where *Dial* 4.29 should read *Dial* 4.49).

29 Lipinsky, 'Orafi e argentieri', p. 8 note 3.

30 This development is shaded in Gillian Mackie, *Early Christian Chapels in the West: Decoration, Function, and Patronage* (Toronto: University of Toronto Press, 2003), who sees episcopal practice as setting the pace in the sixth century, for example at Ravenna (p. 296 note 17), Grado (pp. 44–6), and Istria (pp. 46–52). An important example in Rome would be the oratory of Saint Christopher, built at Sant'Anastasia for the deceased parents of the future John VII, Plato and Blatta (*ICUR* II, p. 442). For later developments in Byzantium, see Natalia Teteriatnikov, 'Private Salvation Programs and their Effect on Byzantine Church Decoration', *Arte Medievale*, 7.2 (1993), 47–63.

31 Arno Rettner, 'Dreimal Theodotus? Stifterbild und Grabstiftung in der Theodotus-Kapelle von Santa Maria Antiqua in Rom', in *Für irdischen Ruhm und himmlischen Lohn: Stifter und Auftraggeber in der mittelalterlichen Kunst*, ed. by H. Meier, C. Jäggi, and P. Büttner (Berlin: Reimer, 1995), pp. 31–46 (pp. 38, 41–2). On the relevance of the chapel's frescoes to its funerary function, Natalia Teteriatnikov, 'For whom is Theodotus Praying? An Interpretation of the Program of the Private Chapel in S. Maria Antiqua', *Cahiers Archéologiques*, 41 (1993), 37–46 (which fails to mention the all-important burial), and Lesley Jessop, 'Pictorial Cycles of Non-Biblical Saints', *Papers of the British School at Rome*, 67 (1999), 233–79 (pp. 249–55). The scholars disagree as to precisely which relatives—Theodotus' wife, daughter, son, brother, or sister-in-law—are being commemorated.

32 The tombs of the popes of the fifth and sixth centuries were tellingly situated at Saint Peter's in the quadriporticus of the atrium. Whilst not founders, this practice would have been influential. For tombs of the later middle ages situated in narthexes, see Teteriatnikov, 'Private Salvation programs'; and John Osborne, 'The Tomb of Alfanus in S. Maria in Cosmedin, Rome, and its Place in the Tradition of Roman Funerary Monuments', *Papers of the British School at Rome*, 51 (1983), 240–7.

33 The chambers beneath the now-demolished east Rostra were found to have served as a workshop for the recycling of iron and lead: Cairoli Fulvio Giuliani and Patrizia Verduchi, *L'area centrale del Foro Romano* (Florence: Olschki, 1987), pp. 163–6, 187, and fig. 264.

34 Marucchi, 'La Chiesa di S. Maria Antiqua', p. 311; Carlo Cecchelli, 'SS. Quaranta Martiri', in Armellini, *Le chiese di Roma*, ed. by C. Cecchelli, p. 1423. If, however, we are to accept the dating presented in note 8, above, according to which the crosses belong to the third phase of fresco, their consonances with the *aurifex* and his family must be considered either fortuitous or the result of the memory of the oratory's founders.

35 The aforementioned *loculus* inhumation cuts a late eighth- or ninth-century fresco, and thus belongs to a far later phase.

36 According to Vaglieri, *Gli scavi recenti*, p. 200: 'il Paribeni per il primo ha emessa l'ipotesi, accettata da tutti, che l'oratorio sia dedicato ai Quaranta Martiri'. Lanciani, *Notes from Rome*, pp. 328, 336 demurred: 'The small oratory [...] was dedicated to the forty martyrs of Sebaste; at least, their images occupy the place of honour in the apse; but it is not improbable that originally the oratory itself may have been named from its founder S. Silvestri in Lacu'.

37 See the index to Roberto Valentini and Giuseppe Zucchetti, *Codice topografico della città di Roma*, II (Rome: Tipografia del Senato 1942), pp. 347, 350.

38 Christian Hülsen, *Le chiese di Roma nel medioevo* (Florence: Olschki, 1926), p. 427.

39 For the fresco in Santa Maria Antiqua: Rushforth, 'The Church of S. Maria Antiqua', p. 38; and Nordhagen, 'Frescoes of the Seventh Century', pp. 131–2. For S. Maria in Via Lata: Fabio Betti, 'La decorazione pittorica', in *Roma: Dall'antichità al medioevo. Archeologia e storia nel Museo Nazionale Romano Crypta Balbi*, ed. by M. Arena and others (Rome: Electa, 2001), pp. 450–65 (pp. 452–3); and Giulia Bordi, 'Tra pittura e parete. Palinsesti, riusi e obliterazioni nella diaconia di Santa Maria in via Lata tra VI e XI secolo', in *Archeologia della Produzione a Roma: Secoli V–XV. Atti del Convegno Internazionale di Studi (Roma, 27–29 marzo 2014)*, ed. by A. Molinari, R. Santangeli Valenzani, and L. Spera (Bari: Edipuglia, 2015), pp. 395–410.

40 For the presence of their relics in early medieval Rome, see Gulowsen, 'The Oratory of the Forty Martyrs', p. 88.

41 Their relics were translated to Constantinople by Pulcheria during Proclus' episcopate (434–47), and placed in the pre-existing church of Saint Thyrsus (Gulowsen, 'The Oratory of the Forty Martyrs', p. 87). Frescoes of the saints were painted in pre-existing churches (also dedicated to the Virgin) at Thessalonica (thirteenth century), and Asinou on Cyprus (1105–6), see Eutychia Kourkoutidou-Nikolaidou, *Acheiropoietos: The Great Church of the Mother of God* (Thessaloniki: Institute for Balkan Studies, 1989), p. 33, and Andreas Stylianou and Judith A. Stylianou, *The Painted Churches of Cyprus: Treasures of Byzantine Art*, 2nd edn (Nicosia: G. Cassoulides & Son, 1997), fig. 60. For Syracuse, see Mariarita Sgarlata and Grazia Salvo, *La Catacomba di Santa Lucia e l'Oratorio dei Quaranta Martiri* (Siracusa: Tipografia Grafica Saturnia, 2006). For Brescia, see below.

42 *Le Liber Pontificalis: texte, introduction, et commentaire*, ed. by L. Duchesne, 2 vols (Paris: E. Thorin, 1886–92), II, p. 26: 'Et in oratorio sancti Andree, ubi sopra, vela duo olosirica ornata ut supra'. These, then, were the same crimson draperies as the four donated to Santa Maria Antiqua mentioned in the preceding sentence.

43 Davis wondered whether *ubi sopra* might refer not to the immediately preceding reference to S. Maria Antiqua, but to the penultimate reference to Santa Maria Maggiore, see Raymond Davis, *The Lives of the Eighth-Century Popes* (Liverpool: Liverpool University Press, 1992), p. 219 note 170. Not only would this presuppose an error in the text, but 'ornata ut sopra' can only refer to the donation to Santa Maria Antiqua (which consisted of *vela*), not to that at Santa Maria Maggiore, which consisted instead of metal ware: 'canthara de argento [...] columnas [...] crucem cum gabata ex argento'.

44 Hülsen, *Le chiese di Roma*, p. 186: 'anche gli scavi recenti non hanno portato alla luce nessun vestigio di quel santuario'.

45 Federici, 'Santa Maria Antiqua e gli ultimi scavi', p. 520 note 2.

46 Kirsti Gulowsen, 'The Cult of the Forty Martyrs on Forum Romanum', in *Late Antiquity: Art in Context*, ed. by J. Fleischer and others, Acta Hyperborea, 8 (Copenhagen: Museum Tusculanum Press, 2001), pp 235–48.

47 Giacomo Boni, 'Il sacrario di Juturna', *Notizie degli Scavi di Antichità*, 1899, p. 97.

48 The Athenian church is identified by an inscription found on the site: Timothy E. Gregory, 'Survival of Paganism in Christian Greece. A Critical Essay', *American Journal of Philology*, 107.2 (1986), 229–42 (pp. 237–9). Guido Cosmographer (early twelfth century) is almost certainly drawing on older texts, such as the Anonymous Ravennate Cosmographer.

49 Wilpert, *RMM*, p. 724 and pl. 197.2. The fresco is also noted by Rushforth, 'The Church of S. Maria Antiqua', pp. 110–11; and Tea, *Basilica di Santa Maria Antiqua*, pp. 345–6.

50 This possible identification of the saint as an apostle, and the link between the fresco and the Oratory of Saint Andrew, I owe to Giulia Bordi (who, however, accepts Wilpert's identification of the pope as Hadrian I).

51 Tea, *Basilica di Santa Maria Antiqua*, pp. 42–7. Her linkage to the Renati monastery is based on a questionable division of the titles and provenance of its abbot, Thalassius, in the acts of the 649 Lateran Council—titles which almost certainly relate to the same, wholly independent institution, as pointed out by Guy Ferrari, *Early Roman Monasteries: Notes for the History of the Monasteries and Convents at Rome from the V Through the X Century* (Vatican City: Pontificio Istituto di Archeologia Cristiana, 1957), p. 278 note 1.

52 Gaudentius of Brescia, *Sermo 17* (PL 20, cols 959–71). The basilica does not survive.

53 Gregory of Tours, *De miraculis beati Andreae apostoli*, 24; see *The Apocryphal New Testament*, trans. by Montague Rhodes James (Oxford: Clarendon Press, 1924), pp. 337–49.

54 Jacobus de Voragine, *The Golden Legend: Readings on the Saints*, trans. by William Granger Ryan, 2 vols (Princeton: Princeton University Press, 1993), I, pp. 15–16.

55 Hülsen, *Le chiese di Roma*, pp. 179–81, 190.

56 *Codex Pontificalis Ecclesiae Ravennatis*, ed. by Alessandro Testi Rasponi (Bologna: Zanichelli, 1924), p. 195 note 1.

57 Jean-Charles Picard, *Le souvenir des évêques: Sépultures, listes épiscopales et culte des évêques en Italie du Nord des origines au Xe siècle* (Rome: École Française de Rome, 1988), pp. 347, 355. Other cases of Maximian's promotion of Andrew include the dedication of a subsidiary oratory to the saint at his foundation of Santa Maria Formosa in Pula (Istria), a site he may originally have intended for his own burial, and possibly even the dedication of Ravenna's (pre-existing) episcopal chapel to Andrew.

58 Domenico Ambrasi, 'Il cristianesimo e la chiesa napoletana dei primi secoli', in *Storia di Napoli*, 11 vols (Naples: Società Editrice Storia di Napoli, 1967–74), I, pp. 623–742 (p. 742); Cosentino, *Prosopografia*, I, 264.

59 *CIL* X 1537: '+ Hic requiescit in pace Candida CF quae vixit pl m ann L dp die IIII id sept imp dn n Mauricio pp Aug anno IIII pc eiusd ann III ind quarta'.

60 Ferrari, *Early Roman Monasteries*, pp. 138–51 (p. 142 on the approximate foundation date).

61 Sources in Coates-Stephens, 'S. Saba', p. 229 note 9. The miracles that Gregory claims were effected in his monastery thanks to the power of the saint imply, as Matthew Del Santo has pointed out to me, the presence of his relics in the same altar.

62 Barbara's monastery was probably established at the aforementioned Church of Saint Andrew founded by Valila a century earlier, see Ferrari, *Early Roman Monasteries*, p. 53; Danilo Mazzoleni, 'Osservazioni su alcune epigrafi basilicali romane', in *Ecclesiae Urbis. Atti del Congresso Internazionale di studi sulle chiese di Roma [IV–X secolo], (Roma, 4–10 settembre 2000)*, ed. by F. Guidobaldi and A. Guiglia Guidobaldi, 3 vols (Vatican City: Pontificio Istituto di Archeologia Cristiana, 2002), I, pp. 265–79. For Honorius' monastery see Ferrari, *Early Roman Monasteries*, pp. 159–62.

63 Coates-Stephens, 'S. Saba'.

64 Ferrari, *Early Roman Monasteries*, pp. 146, 276–9. John the Deacon, *Vita Gregorii* 4.82 (*PL* 75, col. 229, with note).

CONSERVATION

GIUSEPPE MORGANTI

"Per meglio provvedere alla conservazione dei dipinti ...". 1984–2014: Santa Maria Antiqua 30 Years Later

One first thinks of the architects working for the national administration for heritage preservation, particularly the archaeological Soprintendenze. In these contexts, a daily interdisciplinary cooperation is indispensable, often truly challenging but, because of this, stimulating. This leads me to believe that young architects joining the Ministry should begin their careers with at least two years of service in these units, where they will be able to develop a professional and scholarly approach that is eminently scientific – an approach that the Soprintendenze, often struggling to meet the numerous, almost overwhelming demands on their services, are unable to guarantee.[1]

Thus, Giovanni Carbonara captures the difficulties arising when we work to preserve the cultural heritage, stressing the interdisciplinary complexities involved and the need for specialists capable of creating a dialogue between their diverse areas of expertise. Among all the sites curated by the Italian archaeological Soprintendenze, Santa Maria Antiqua certainly provides an example of interdisciplinary complexity. Here the archaeological components, painted decoration, iconography, and architectural structure all form an indivisible whole. The monument is also characterised by a complete chronological continuity, from antiquity (the Domitianic and earlier structures), through the medieval era (the church and its paintings), up to the modern period (the construction of Santa Maria Liberatrice and its demolition), followed by the twentieth- and twenty-first-century excavation and restoration.

It would be impossible to neatly apportion the competencies and responsibilities for Santa Maria Antiqua among the Soprintendenze. It is indeed hard to imagine that the management of the site could be guided successfully by one individual unit, whose programmes and interventions are naturally meant to be discrete. Thus, the restoration of Santa Maria Antiqua becomes a masterclass in cooperative heritage preservation, a methodological case study of immense value. The location of the monument within the Forum, in particular, means that the Soprintendenza Archeologica must take on the lead role and act as a catalyst for the other actors, in order to turn Carbonara's thoughts into reality.

The most recent restoration programme for Santa Maria Antiqua began exactly thirty years ago, and has been conducted in two stages. A first phase from 1984 to 2000, interrupted by a gap of roughly seven years, involved major works to secure the monument through stabilisation and protection of the building and its contents, which had been left untended since the 1950s. A second stage, begun in 2001 and now mostly complete, focused primarily on the restoration of the wall paintings.[2] In 1984 Adriano La Regina, then responsible for the site on behalf of the Soprintendenza, assigned the management of Santa Maria Antiqua to two young architects: Francesco Scoppola and myself. We were at the beginning of our careers, having entered the civil service only four years earlier. As those who met La Regina will recall, however, he was not afraid to take risks and had an exceptional trust in his co-workers, even the youngest among them. The most immediate management challenge was halting the degradation of the monument, at that time threatened by failures in the roofing. Our assumption of these new responsibilities also coincided with La Regina's intensive campaign to develop collaborations between the Soprintendenza and almost every other heritage research institution active in Rome.

By 1984, the last institution still not involved was the British School at Rome, then in the last year of David Whitehouse's directorship. He was a wonderful man, who sadly passed away in early 2013. Whitehouse and John Osborne were promptly 'recruited' to begin a study of the site. The initial plan was to focus on the medieval lapidary fragments found in situ, with a view to their reassembly. But new circumstances brought in Henry Hurst, and the work then took two directions. First was the excavation of the *aula* of the so-called 'Temple of Divo Augusto', together with archaeological trials in the atrium and the nave of Santa Maria Antiqua. The second was the study of remains from the post-imperial phase, to document and date the monument's early medieval features.[3]

Meanwhile, in 1984 Scoppola and I were busy managing the conservation of the medieval structure itself. In reality, the structure is in part a 'display case' that Giacomo Boni put together around the paintings after excavating the structural remains in the early 1900s. The restoration efforts that began in 1984 were the first since Pietro Romanelli's work in the 1950s; and when these were completed in 1955, the altar still visible in the church was installed, and the success was celebrated with an Orthodox service.[4]

The common management practice in the Italian Soprintendenze was to work in stages or *perizie*, each involving budget estimates and contracts. From 1985 to 1990 Scoppola and I implemented through the *perizie* immediate actions addressing the most dangerous sources of damage to the structure and paintings, while also collecting data and documenting the state of conservation of the site.[5] During this period the Soprintendenza reached an agreement with

the International Centre for the Study of the Preservation and Restoration of Cultural Property (ICCROM) for two seasons of on-site training in restoration, using the east wall frescoes of the atrium as a case study. At the same time, a less obtrusive sheltering eave was created to protect the frescoes, built in walnut, marine plywood, and copper flashing, to replace the existing structure that was suspected of containing asbestos.

The early research efforts concerning the church and paintings were linked to the activity of the Research Office of the Ministero dei Beni Culturali. In 1984, its Director, Italo Carlo Angle, launched a major programme titled 'Restoration Theory and Practice in Italy, 1870–1970', which aimed to explore of the connection between theory and practice in a diverse series of national sites. Santa Maria Antiqua was chosen as an example of an 'individual monument' but, due to Angle's untimely passing, the project was sadly cancelled shortly after its inception.[6]

At the close of the 1990s, the preparations for the Jubilee Year brought new resources for conservation and restoration. Thanks to these we were able to conduct extensive maintenance of the roof over the chapels and the central hall, including repairing and re-laying the tiles and treating the wood beams against insect infestation. It was also possible to substitute the windows and doors with multi-glazed units offering better dust and thermal sealing, thus improving the conditions of the environment. The electrical and lighting systems were upgraded and brought to norm. On the outside, the Domitianic hall on the Vicus Tuscus was infilled to ground level, with the installation of botanical plantings to demarcate the buried elements. The wall surfaces of the Domitianic hall and atrium were also repaired, for visitor safety as well as heritage and structural protection.

At the same time, investigations were carried out regarding problems in the apse wall (Plates 32, 35, 50: K1), which has long been a source of damaging moisture. The deterioration had been noted as early as Boni's time, who thought that the problem dated back to the very construction of the church.[7] A recently discovered note by Giacomo Artioli indicates the possibility that a ventilation space (*intercapedine*) behind the apse wall dates to around the time of construction. This note complements a previous remark found in Eva Tea's records.[8] The two notes are not conclusive as to whether the ventilation space is a product of the archaeological excavations or contemporaneous with the original structure. But in the 1990s, given the evidence at hand, we felt completely justified in returning it to functionality. It first required a thorough cleaning and removal of debris, leaves, and bird droppings, which had accumulated in the ninety years since Boni's intervention.

Another readily apparent cause of the humidity affecting the apse wall was the roof drainage system, which featured a downspout finishing about twenty metres above ground level and ending in an elbow that directed the rainwater towards the wall. The very first measure therefore consisted in turning the spout outwards, to channel the water away from the wall. The Soprintendenza hired a contractor equipped to work on high-level structures and this seemed at the time to respond to the issue effectively.

Having thus achieved an improved interior environment, the conditions seemed adequate to begin the conservation work on the paintings. In 2000, to celebrate the completion of the structural repairs and the opportunity to finally begin the restoration, which coincided with the hundredth anniversary of the rediscovery of the church, the Soprintendenza co-convened with the British School an international conference.[9] The following year, the Soprintendenza

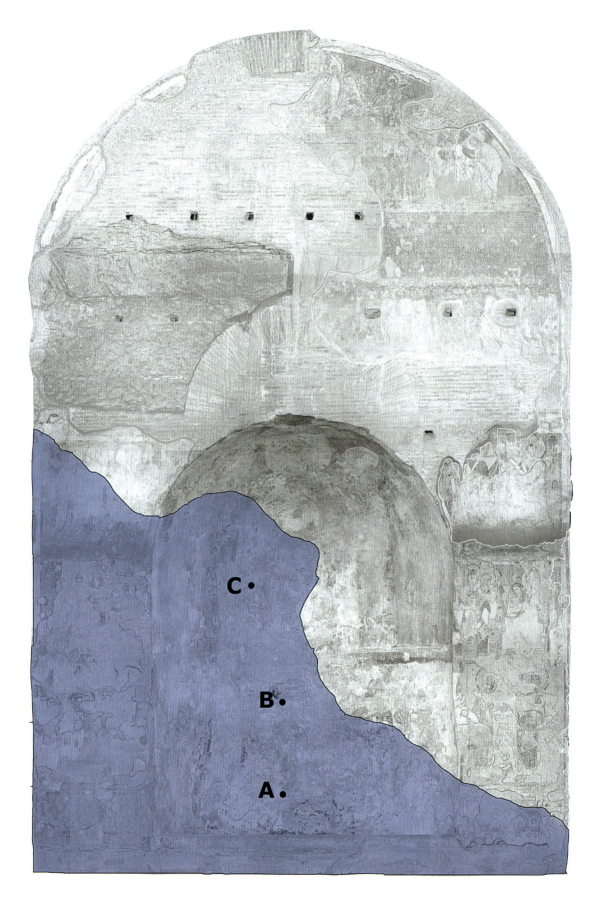

1 Rome, Church of Santa Maria Antiqua. Apse wall, showing distribution of moisture as monitored in 2004 (photo: Studio Massari)

completed a proposal to the World Monuments Fund, requesting funding for a preliminary investigation of the environmental conditions in the interior of the church and of the paintings' conservation status. The resulting study, conducted from October 2001 to April 2002, provided an analysis of these twin issues, which formed the basis of a conservation plan. Thus, began the 'Santa Maria Antiqua Project', creating a twelve-year partnership between the Soprintendenza and the World Monuments Fund to safeguard and conserve the paintings.[10]

One of the most important results of those years of research was the identification of the cause of the humidity affecting the rear side of the apse wall (Plate 50: K1). We were able to define a series of steps, consisting in individual operations of limited complexity and scope, that would fully eliminate the largest part of the moisture infiltration (Figure 1). Two investigative campaigns for hygrometric analysis of the moisture sources and evaluation of their consequences on the paintings were carried out in the rear wall. The first, in 2004, was part of an extensive investigation of the entire building. The second, in 2012, concentrated exclusively on the end wall, to determine the effectiveness of a series of measures that had been implemented in the intervening period. By comparing data, and through further research into the geological and structural characteristics, we reached extremely useful insights on the issue.[11]

The semi-circular church apse was excavated into a pre-existing Roman wall of thick *laterizio* masonry. The wall was originally directly adjacent to the side of the Palatine Hill and it was (possibly later) separated from the tufa bank by a vertical cut, leaving a thin layer of rock still attached to what is now the church wall (Figure 2). This cut was almost certainly created at the time of the Domitianic works in the Forum, to create a hollow air space that would prevent the accumulation of moisture. This is the same trench later revealed by the archaeological excavations, as noted by Artioli and Tea. The cut in the rock is roughly 12 metres long, 70 centimetres wide, and 12 metres high, except for a short entrance section roughly 2 metres in height (Figure 3). The roof is a barrel vault with small supporting under-arches. The rooftop surface is flat, and is at the same level as the highest church roof. From the outer surface, a drainage well opens through the barrel vault into the ceiling below. When the air space was examined in 2004, the floor was again partially covered with leaves and soil that had fallen down from the drainage well above (Figure 4).

The natural stratigraphy around the building consists of an upper layer of grey tufa over a lower layer of clay-shale (Figure 5). The Roman walls are constructed with a row of travertine blocks running along the base (Figure 6). In some places they were deliberately arranged to underlie the entire thickness of the wall, serving as a barrier against rising damp, indicating that the problem was well known from the outset. The 2004 hygrometric analysis identified four potential water sources for the apse wall:

1. The leaks in the roof gutters on the south-east side of the church, above the rock bank, which preceding work did not resolve. Even when the water was directed further away it still ran back down the tufa bank, entered large cracks between the tufa blocks of the Horrea Agrippiana, and from there reached the entrance end of the ventilation space.

2 Roof-level plan drawing of the Domitianic complex (documentation and drawing: Ernesto Monaco; Archivi del Parco archeologico del Colosseo)

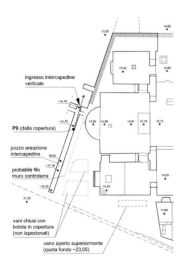

3 Diagrammatic plan showing the ventilation cavity behind the apse wall (Studio Massari, based on documentation by Ernesto Monaco)

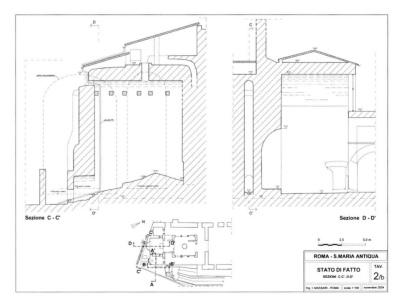

4 Section diagram showing the ventilation cavity behind the apse wall (Studio Massari, based on documentation by Ernesto Monaco)

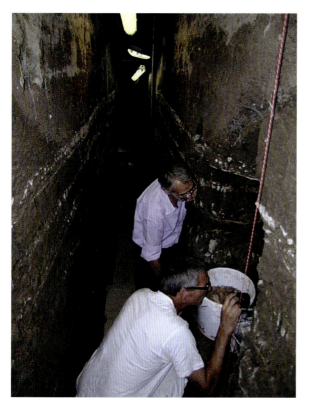

5 The ventilation cavity behind the apse wall (photo: Giuseppe Morganti)

6 The Domitianic walls, with the travertine 'cross-blocks' serving as a moisture barrier (photo: Giuseppe Morganti)

2. Additional sources of horizontal capillary action, via earth and detritus accumulated in the ventilation space.

3. Rain falling higher up, on the north-west side of the Palatine Hill, then running down over the *Clivo della Vittoria*, seeping below ground to the level of the church's east wall, and percolating laterally through the masonry.

4. Capillary action from deeper levels, moving up into the wall footings, and from the side of any footings buried against the Palatine Hill.

The 2012 hygrometric analysis showed that the wall moisture conditions have improved slightly, but are still unacceptable for the long-term preservation of the wall paintings. The problem of the gutter drainage has been addressed by the installation of continuous downspouts with extensions leading to the centre of the Horrea Agrippiana. However, it will take time to determine if this measure actually reduces the moisture levels.

We can safely say, however, that the problem of the detritus on the ventilation space floor is fully corrected. Since the 2004 investigations we have removed the last materials, achieving a measurable reduction of wall moisture. However, this step revealed an alarming new problem, previously undetected. We are now able to see that ground water emerges constantly from the natural stratigraphy, at the juncture between the clay layer and the upper tuff. The main

source is in the ventilation space on the Palatine side. Here, the water accumulates on the bare floor, its depth varying by season. It is highly likely that the site's problematic stratigraphy continues on the north side of the ventilation space, towards the church, and certainly into the hillside towards the upstream source, meaning the north-west side of the Palatine and the base of the *Clivo della Vittoria*. This means that in both cases the groundwater would be a source of water in the east side of the church. Core sampling of the ventilation space under the apse floor reveals a clay-like substrate, which blocks dispersion of the water to deeper levels, allowing undue accumulation of water and consequent flooding. The new observations confirm the existence of the water sources hypothesised above (nos 3 and 4), causing vertical seepage from upstream sources and capillary action from the sides and from beneath the wall footings. These are certainly not new problems. This is demonstrated by the Roman-era construction technique of travertine wall bases. It is also demonstrated by the construction of a drainage channel in the same period, running through the interior and along the north-west face of the Horrea Agrippiana. The channel drained downhill and intersected with what is now the ventilation space behind the apse (Figure 7).

It seems clear that the church structure is in general characterised by very 'wet feet', in which the east walls are also likely impacted by the lateral movement of water from the underground sources. We know that, in any structure, the extent of capillary action and the resulting levels of water damage are linked to the shape and size of the structure's components, as well as to the construction methods and materials employed. Hence it was necessary to undertake detailed studies to determine such information for the south-east sides of Santa Maria Antiqua. Therefore, we executed a series of core drillings at various angles, from the roof level downwards into the walls, and horizontally from the apse ventilation space inwards. From the findings we were able to prepare a more accurate plan for intervention and sectional drawings (Figure 8).

The south-east walls of Santa Maria Antiqua are built against ground for their complete length and height, and are thus subject to an amount of capillary action that can never be completely eliminated. The water at surface level is intercepted by the *Clivo della Vittoria*, but, due to the lack of a functioning draining system, it infiltrates the areas beneath it. The pronounced slope of the *Clivo* seems to help limit the amount of water reaching the east side of the church. But archaeological excavations to examine the stability of the *Clivo* have shown that it is underlain by a maze of underground canals, tunnels, sewers, and sinks (Figure 9). If the water accumulating on the surface were to succeed in eroding the channels beneath, the consequences would be very difficult to contain, and the only definitive solution would be to build a new drainage system for the *Clivo*. For the moment, however, this is not possible. Another desirable preventive measure would be to achieve control of the capillary movement of soil moisture at the foot of the walls. The massive thickness of the church walls prevents any practical insertion of horizontal water barriers into the base, but we can at least discard the hypothesis that the foundations are near any underground stream.

The sewer systems under the church, which run about 1.10 metres below the under-floor air space, are quite dry and show no signs of inward leakage or slumping (Figure 11). Discounting the 'underground stream' risk, the necessary remaining step, and indeed the only possible one to solve the moisture problem in the apse wall, is thus to drain the water accumulating on the

"PER MEGLIO PROVVEDERE ALLA CONSERVAZIONE DEI DIPINTI ..."

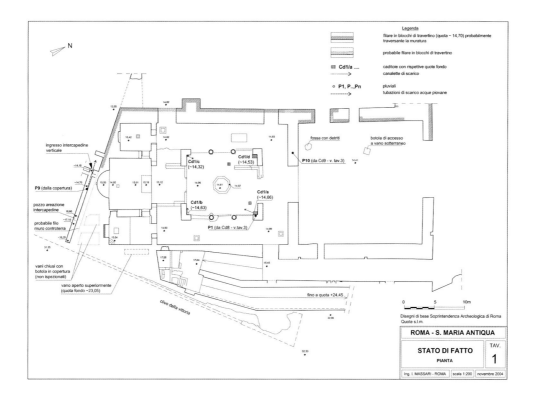

7 Location of walls with travertine cross-blocks at the base (photo: Giuseppe Morganti)

8 Summary of core borings and revealed strata (drawing: Ernesto Monaco)

9 Drainage channels, wells, tunnels, and sewers in the area behind the apse wall (drawing: Ernesto Monaco)

Indication of the two potential routes for water drainage, in red (drawing: Studio Massari)

floor of the air space. To this end, we can consider two different approaches, based in part on archival documentation concerning the historic sewer systems (Figure 10):

1 The first is to partially reactivate the ancient sewer (branch A) that leads towards the Cloaca Maxima, which the archival documentation suggests may pass near the ventilation space (Figure 12).

2 The second is to repair and reactivate the Roman drain that runs along the north-west wall of the Horrea (Figure 13), which is currently cut at various points along its length, and which seems to drain towards the church apse (branch B).

Due to technical and financial issues, our team has temporarily put on hold the proposal to reactivate the sewer leading to the Cloaca Maxima, but this option is to be re-examined as part of conservation planning concerning the Horrea Agrippiana. The reactivation would simultaneously solve three problems, permitting drainage of the apse ventilation space, of the rainwater collected from the roofs, and of the surface area of the Horrea itself. We have ascertained, however, the feasibility of the second proposal presented above, namely the repair of the Horrea drain channel. The sewer channel from this drainage leads towards the church, and archival documentation provided vague indication that it continued under the central part of the apse. Coring and surveys at the corner between the church and the Horrea tufa blocks failed to reveal its presence in this particular location; instead, we discovered that the channel actually runs towards the gap between the south-east corner of the church wall and the north-west wall of the Horrea, near the entrance to the apse ventilation gap. This placement of the sewer seems to have been selected in part to receive the water from a massive vertical rainwater pipe, found within the thickness of the church wall (Figures 14–15). Investigations have shown

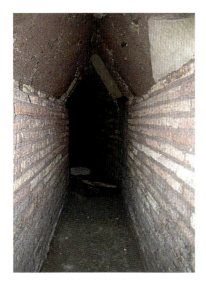

11 A section of the sewer system below the church floor (photo: Valeria Valentini)

12 Sewer channel A, showing obstruction near the connection to the Cloaca Maxima (photo: Valeria Valentini)

13 Sewer channel B, near the fork under the floor of the sanctuary (photo: Valeria Valentini)

 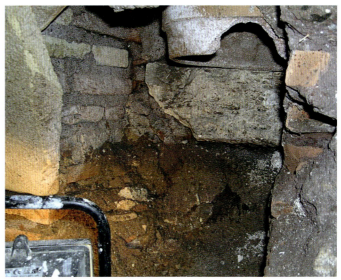

14 Sewer branch discovered under the apse wall (photo: Giuseppe Morganti)

15 Large down-drain within the thickness of the apse wall (photo: Giuseppe Morganti)

that the vertical drain is currently blocked one metre above the level of the Roman sewer, suggesting that both the vertical drain and sewer were heavily reworked during the creation of the apse ventilation space.

It would be practical to direct the drained water from the apse ventilation space, as well as from roof drain P9, into sewer drain Pzl in the church atrium (Figures 16–17). This could be partly accomplished by inserting new pipe sleeves into the Roman-era sewers under the church. There are two possible means of implementing this solution, both involving the installation of new piping by coring from inside the apse ventilation gap:

1 Proposal A (Figure 18) is to direct both the ventilation space and P9 roof water into a single drain situated in the ventilation space itself, and from there into the underground Horrea sewer leading towards Pzl in the atrium.

2 Proposal B (Figure 19) is to create two separate drainpipes for the ventilation space and P9 roof water, both leading towards a single drain inside the Roman-era sewer branch under the sanctuary, and from there via a single pipe towards the catch-basin drain Pzl.

The choice between these two options can only be made after further data is collected, particularly after the beginning of the works. In both cases, however, the costs are substantial. For now, the details of the projects are ready and the practical implications of the operations are understood. Either solution will greatly reduce the longstanding moisture problem, which has been the greatest source of damage to the wall paintings.

In a sense, this paper is a continuation of the one presented at the 2000 international congress and published in the proceedings.[12] The aim was to provide a clear summation of the works conducted over the past thirty years, in the hope that they can be seen as a conceptual and

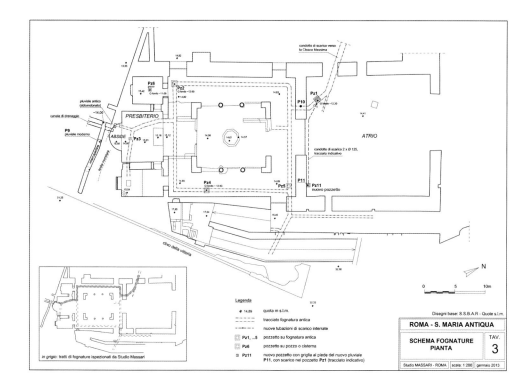

16 The sewer network below the church floor (drawing: Studio Massari)

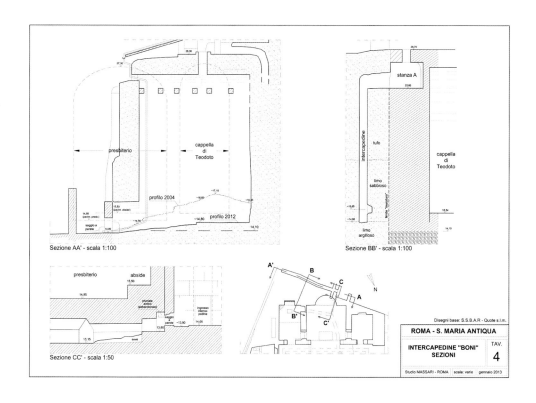

17 Levels of the sewer located below and behind the apse (drawing: Studio Massari)

"PER MEGLIO PROVVEDERE ALLA CONSERVAZIONE DEI DIPINTI ..."

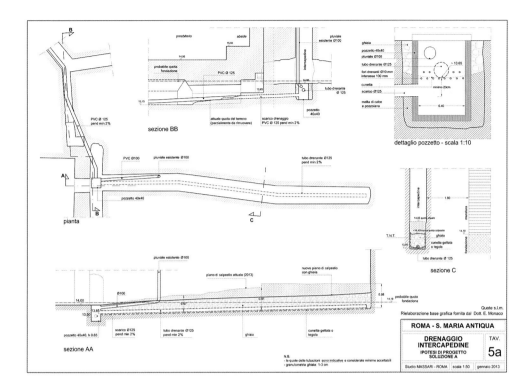

18 Proposed solution A, using a single drain (drawing: Studio Massari)

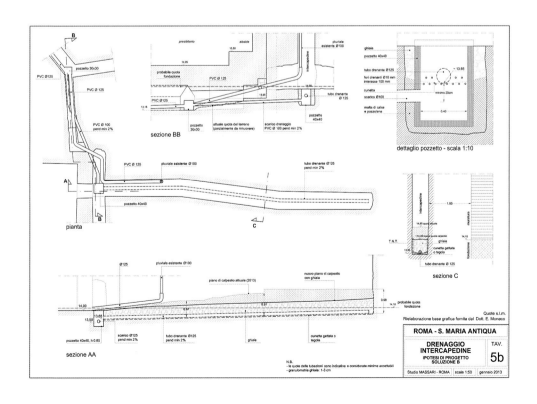

19 Proposed solution B, with the creation of two drainpipes (drawing: Studio Massari)

practical continuation of those begun more than one hundred years ago by Boni and Petrignani. These architects developed an extraordinary vision for the restoration of Santa Maria Antiqua. They did not attempt to recreate a hypothetical original structure, and instead limited their operations to inserting a frame and shell that could safely protect the paintings. Their stated intention was to 'better provide for the conservation of the paintings' ('*meglio provvedere alla conservazione dei dipinti*')

I hope that our work will be considered faithful to their example.

NOTES TO THE TEXT

1 Handout distributed during a lecture by Prof. Giovanni Carbonara as part of the June 2008 MiBAC refresher course on 'Guidelines for the assessment and reduction of the seismic risk of heritage monuments' [in translation].

2 The major works were completed in 2013, with the restoration of the flooring in *opus sectile*. The remaining objectives are maintenance work on the floor surfaces of lesser significance, and the cleaning of the sarcophagi within the church.

3 A 1985 article by Whitehouse, Hurst, and Osborne describes the programme objectives and summarises the scant knowledge and numerous unresolved questions concerning the monument. This article is still a useful source. See Henry Hurst, John Osborne, and David Whitehouse, 'Santa Maria Antiqua: problemi e proposte', in *Roma: archeologia nel centro*, ed. by A.M. Bietti Sestieri, and L. Attilia, 2 vols (Rome: De Luca, 1985) I, 93–6.

4 See Giuseppe Morganti, 'Giacomo Boni e i lavori di S. Maria Antiqua: un secolo di restauri', in *Santa Maria Antiqua al Foro Romano cento anni dopo*, ed. J. Osborne, J.R. Brandt, and G. Morganti. (Rome: Campisano, 2004), pp. 11–30.

5 The initial study and planning stage was followed by a series of projects: repair of the roof over the central space; repair of the waterproofing on the flat roofing over the *ambulacrum*; improvement of the drainage system; stabilisation and reshaping of the crests of the walls to prevent the accumulation of standing water; replacement of a number of windows originally installed in the 1950s; and, finally, installation of an electrical system for basic lighting. See Giuseppe Morganti, 'Area di S. Maria Antiqua. Restauri', *Bollettino della Commissione Archeologica Comunale*, 91.2 (1986), 478–80.

6 Again thanks to the vision of the Soprintendente La Regina, this interruption was soon resolved by the development of an internal research programme. Between 1990 and 2000, there was an almost permanent research unit devoted to the Santa Maria Antiqua paintings, consisting of a lively group of scholars and students led by Maria Andaloro. Research was also carried out in close cooperation with the Soprintendenza di Palazzo Venezia. Alia Englen played a particularly important role, and today she is still an enthusiastic supporter of the work at Santa Maria Antiqua. She joined with Maria Andaloro and her researchers in developing new research methods, stemming from the lessons originally imparted by Cesare Brandi.

7 From 1904 to 1908 the excavations proceeded in the area of the Horrea Agrippiana, ultimately achieving the isolation of the apse wall by means of a ventilation space excavated into the tufa at the rear. Research in the archives of the Soprintendenza has located the excavation journals of Romolo Artioli, dating to 1907, where we find the following note: '28 June 1907: […] In the past two days, on the platform of the church, a corridor has been excavated into the ventilation space opened into the tufa, behind the apse of the ancient structure'.

8 Tea, *Basilica di Santa Maria Antiqua*, p. 10: 'A ventilation space 10 metres deep was excavated into the tufa bedrock against the back wall, to separate the church walls from the Palatine cliff.'

9 *Santa Maria Antiqua al Foro Romano*, ed. by J. Osborne, J.R. Brandt, and G. Morganti.

10 See Werner Schmid's report on the restoration works in this volume.

11 The study relied on the technical and scientific support of the Studio Massari (chiefly engineer Ippolito Massari and architect Alessandro Massari) to address particularly the conservation issues relating to hydrology, drainage, and piping. Ernesto Monaco provided archaeological assistance, architectural analysis of the structures, and the graphic records. The Blasi Costruzioni company provided logistic and operational support.

12 See Morganti, 'Giacomo Boni e i lavori di S. Maria Antiqua'.

WERNER MATTHIAS SCHMID

Diary of a Long Conservation Campaign

In April 2001, the World Monuments Fund approved a first financial contribution towards a condition survey of Santa Maria Antiqua's wall paintings and related architectural surfaces. In September of that year, after finalising all the necessary technical and bureaucratic arrangements, the team of which I was part could work on the walls of the church for the first time. At the time, I did not know that for the ten years to come this project would be the primary focus of my professional life. It was a long conservation campaign, a continued and privileged contact with an exceptional cultural heritage, a journey of discovery of its materiality and history; it was also a time of fruitful collaboration and exchange of ideas with the art historians, archaeologists, and other colleagues who contributed variously to the advancement of our research.

The condition survey focused first on the apse wall (Plates 32, 50: K1), which represented the most complex situation in terms of the stratification of successive painting campaigns, as well as in terms of deterioration. The examination included the study of the techniques and materials employed in the various pictorial phases, the analysis of the different forms of decay, and the detailed mapping of the condition in which the paintings were found. At the same time, we began a survey of the building's climatic conditions and a preliminary investigation of the moisture content of the walls. The survey was then extended to all the wall paintings and related architectural surfaces throughout the church and atrium.

The study of the original painting techniques was conducted in close cooperation with the Faculty of Conservation of Cultural Heritage at the Università degli Studi della Tuscia (Viterbo), supervised by Professor Maria Andaloro. On the basis of the data obtained we were able to identify a number of technical characteristics that are common to a large part of the early medieval paintings in Santa Maria Antiqua. The plasters are generally prepared with almost pure lime, and are thus relatively thin. While the plasters of the oldest paintings contain inorganic filler in scarce quantities, the plasters utilised from the time of Pope Martin I (or slightly earlier) onwards are prepared almost exclusively using chopped straw and lime. Another common aspect is the use of lime milk as an added binder, not only for the final highlights, but in many cases for the intermediate applications of paint or even the ground

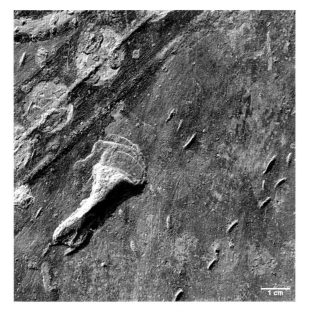

1 Palimpsest wall: impressions of fingernails in the *Maria Regina* panel (photo: Werner Matthias Schmid)

2 Chapel of Theodotus: negative voids left by decomposed straw fibres (photo: Werner Matthias Schmid)

colours.[1] The result is a paint layer characterised by a strong impasto effect and by impressions left by the bristles of the brush.

A series of indications, such as the painting execution that follows a system of consecutive *pontate* (horizontal bands of plaster, each corresponding roughly to the height of one level of scaffolding), allow us to affirm that probably all paintings were executed on wet plaster.[2] In this regard, other particularly strong clues are seen in the various impressions left by the painters during the process of execution, when the surface of the plaster was still soft. The imprint of a coarsely woven cloth, perhaps from the slip of a painter's elbow, was left in the freshly painted surface of the apsidal arch. Numerous impressions of fingernails are also visible in the *Maria Regina* panel, near the pearls adorning the Virgin and the throne (Plate 38; Figure 1). They were left by the painter's little finger, which was placed on the nearly complete painting to stabilise the hand for the final touches.

Generally speaking, the wall painting technique at Santa Maria Antiqua can be defined as lime painting executed on fresh plaster. This particular fresco technique induces formation of a continuous calcium carbonate matrix, extending from the plaster through to the final thick applications of paint. The exceptional stability of the paint layer in most areas of the fresco seems to support the identification of this binding technique. Moreover, the absence of any organic binders is indicated by the instances of straw fibres, once present in the plaster surfaces but now remaining only as negative voids (Figure 2). As would also have happened with an organic binder, the straw is completely lost, having decomposed through the contact with the wet soil that filled the church interior for virtually a millennium.

Archival photographs offered an invaluable reference for the analysis of the changes that took place in the century following the excavation of the site and its first restoration. Comparison between the photographic record and the present condition of the paintings clearly showed that the most severe deterioration corresponds to areas exposed to seepage, percolation, or

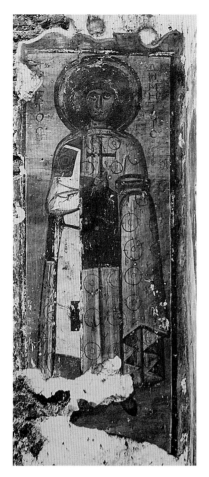 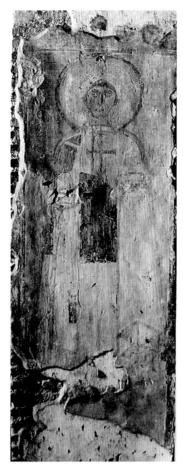

3 The figure of Saint Demetrius (a) at the time of Giacomo Boni's excavation, (b) in 1910, and (c) in 2001
 (photo: Archivio Fotografico, Parco Archeologico del Colosseo)

leakage of water. Fortunately, the vast majority of the painted surface did not experience such conditions, so the paintings remained practically unaltered.

A particularly dramatic case is the image of Saint Demetrius on the south-east pillar in the central nave (Plates 15, 50: E1.2), an area that was long subject to heavy water infiltration, caused by a clogged downpipe constructed within the original brick masonry. By 1910 the painting had already lost much of its pictorial surfaces, but a 2001 photograph demonstrates that the decay, due in part to direct erosion by water, was continuing (Figures 3a–c). Similar problems afflicted the other south pillar. In 1910, faced with the apparent lack of alternatives, the decision was made to detach most of the paintings from both pillars and transfer them to other supports.

The most extensive area of severe deterioration is on the left side of the apse wall, where investigations have shown a clear correspondence with the area of excessive water content in the wall support. The problem, which was already a major concern at the time of excavation, has in turn unleashed mechanisms of decay that led to the progressive loss of original material and the formation of thick salt deposits that completely hide what is left of the painted surface (Figure 4).[3]

The earliest photographs and Joseph Wilpert's watercoloured pictures provide a record

4 Apse wall: hatched graphic record of the area with excessive water content in the wall support
 (based on photomosaic by Tilia and Bizzarro 2002)

of the already poor condition of the apse paintings when they were unearthed, but they also allow us to identify the areas of substantial and irreversible loss. The mid to upper areas of the 'palimpsest' wall are above the level of dampness in the wall. In an image taken at the time of the excavation, the surface is still covered by soil residues, and the head of the adoring angel belonging to the *Maria Regina* stratum is not yet visible. It seems therefore that the condition was worse than it is now. A photograph from 1962 is almost identical to the one from 2001, indicating that more favourable conservation conditions had stabilised the situation for most painted surfaces at Santa Maria Antiqua (Figures 5a–c).

The walls of Santa Maria Antiqua are invaded by considerable amounts of soluble salts, which in moist areas crystallise at the surface. There they form conspicuous macro-efflorescences, thick surface deposits, and sub-surface efflorescences that lead to the loss of material. The prevailing one is sodium sulphate, a particularly damaging salt originating from the extensive use of Portland cement in the restorations of 1900–4. There are also large quantities of gypsum, which in damp areas tends to crystallise below the painted surface, provoking blisters and

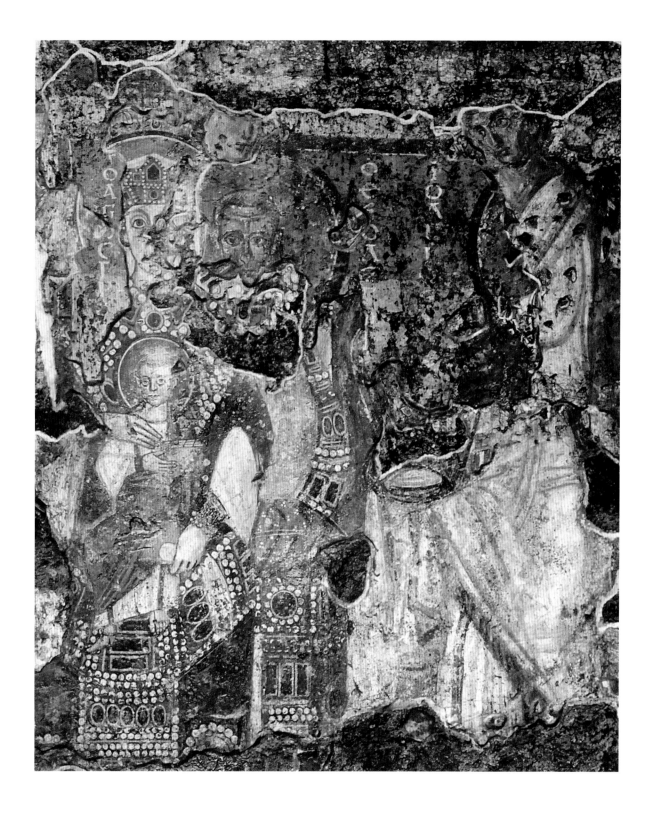

5 A detail of the palimpsest wall (a) at the time of Giacomo Boni's excavation, (b) in 1962, and (c) in 2001
(photo: Archivio Fotografico, Parco Archeologico del Colosseo)

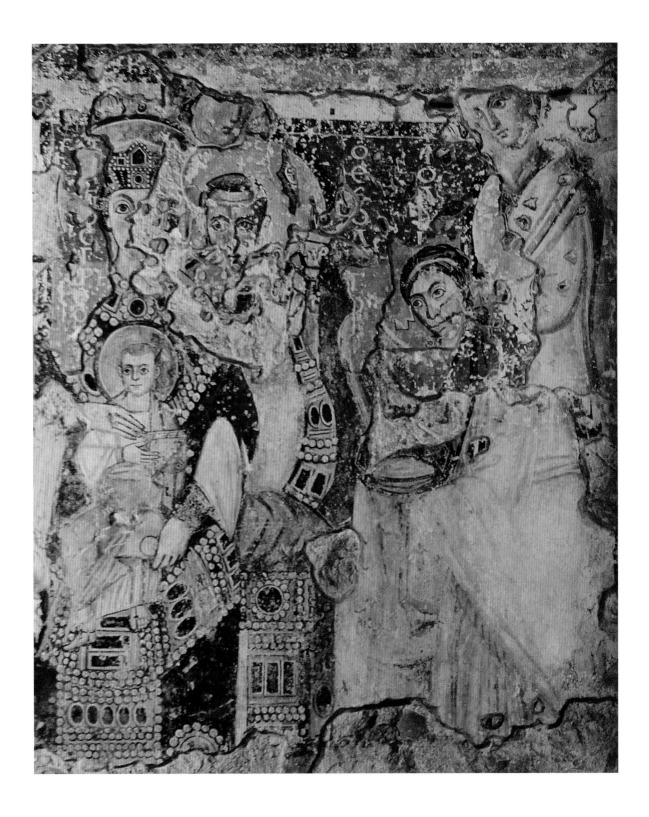

5b

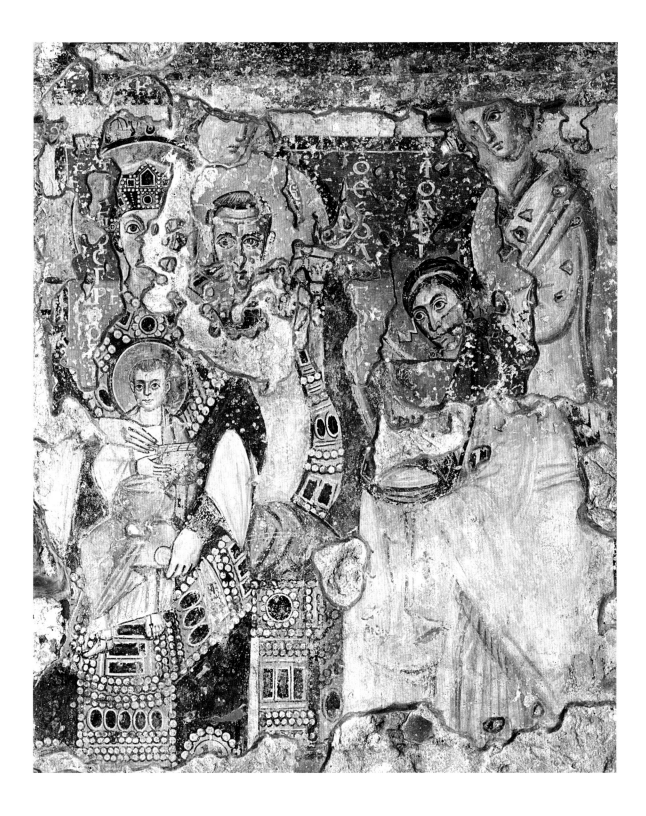

micro-losses. The majority of stratigraphic sections, taken from samples in different areas of the paintings, also revealed the presence of a thin surface deposit of gypsum. This accretion of gypsum in turn englobes particles of dust, which give it a greyish-brown tone. In areas of high moisture content, the presence of the various soluble salts represents a major cause of decay, although in the remaining areas they remain largely innocuous, given the favourable microclimatic conditions.

A monitoring campaign carried out by the Cultural Heritage Division of ENEA (the Italian National Agency for New Technologies, Energy and Sustainable Economic Development) in 2001–3 demonstrated that the microclimate of the church interior undergoes only seasonal cycles. From the records we see that the interior temperature follows the outdoor fluctuations, but there is a strong buffering effect on the daily variations in the church interior, which are reduced to less than 2°C. The relative humidity values are continuously high, rarely dropping below 70%. This is the threshold below which many solutions of soluble salts would reach saturation and begin to crystallise. The maintenance and potentially the improvement of the current microclimatic conditions are essential for the long-term conservation of the wall paintings and related interior architectural surfaces.

The first conservation of the wall surfaces was carried out at the time of Giacomo Boni's excavations. Its scope was purely conservative: the painting and plaster fragments were secured through the application of cement edging and copper cramps; soil residues were removed from the surfaces; a formalin solution was applied to prevent biological growth, and the paintings were coated with mineral wax to prevent what were considered 'risks from sudden contact with the air'.[4] It is interesting to note that no pictorial restoration was carried out. In 1906, Tito Venturini Papari, one of the most respected wall-painting restorers of those years, began the work of cleaning and stabilisation in the Chapel of Theodotus, and four years later he was asked to extend these efforts to the painted surfaces of the apse. From his cost estimates we can determine that the treatment also had an aesthetic aim. Among other operations he proposed to 'refresh the paintings with apposite distempers' and to 'revise the fills with harmonising colours'.[5] In the same year, Venturini Papari assisted Wilpert with the 'un-coverings' performed in the apse and on the 'palimpsest' wall and carried out the detachment of the paintings from the south pillars of the nave. In 1946 the Istituto Centrale per il Restauro assumed responsibilities for the future conservation of the paintings. In 1948, the panel with the Virgin and Child between saints, Pope Zacharias, and Theodotus was detached from the south wall of the Chapel of Theodotus, followed by the detachment of the *Crucifixion* from the niche above in 1954, and by the painting of Hadrian I from the west wall of the atrium in 1956. A record dated May 1959, signed by the then director Carlo Bertelli, notes further interventions in the church interior. They included cleaning and consolidation of the surfaces, as well as the 'correction of some neutral colours'.[6] Although the record does not indicate the location of these works, it is evident that they referred to the apse and apsidal arch, where the cement fills and edging were camouflaged with a beige-coloured tempera paint. The only interventions of more recent date were those carried out in the early 1980s by Carlo Giantomassi and Donatella Zari, which mainly concerned the paintings of the long wall in the left aisle, and by the International Centre for the Study of the Conservation and Preservation of Cultural Property (ICCROM), on the east wall of the atrium.[7]

Santa Maria Antiqua preserves a substantial quantity and variety of architectural surfaces, documenting the decorative and iconographic schemes from the imperial era to the abandonment of the church in the ninth century. These include: 332 square metres of wall paintings, mostly from the early medieval period, with some earlier fragments; 244 square metres of unpainted plasters, most of them dating to the pre-Christian period; 100 square metres of *opus sectile* flooring in the sanctuary and the high choir enclosure (*bema*); 57 square metres of other historic flooring. About 40% of the painting surfaces were re-treated *in situ* in the decades following the first intervention of 1900–4 and about 9% were detached and transferred to artificial supports.

During the current campaign, a first emergency stabilisation was carried out between September 2002 and December 2004. This first phase, co-financed by the Soprintendenza per i Beni Archeologici di Roma and the World Monuments Fund, responded to the dramatic situations revealed during the condition assessment. The assessment indicated that more than 60% of the painted and unpainted plasters showed severe failures in adhesion between the layers, frequently combined with severe loss of internal strength. Depending on the stratigraphy, the sequences of plasters and painting were often observed to be detached at multiple levels, sometimes with the layers completely separated from one another. Dangerous blisters had formed over large zones, with these held in place only by the cement edging and copper cramps inserted by Boni. The emergency stabilisation was executed by a team of four conservators, working towards a systematic coverage of all the church and atrium walls. A pre-mixed hydraulic-injection grout was inserted to re-establish adhesion, and an acrylic micro-emulsion diluted in lime water was used to strengthen the mechanically weakened original plasters.

Near the end of the emergency stabilisation stage, three trials of complete treatment were performed. The objectives were to experiment and test different approaches, obtaining results suitable for presentation to the project supervisors and scientific consultants. Joint decisions would then be possible on issues such as the level of cleaning, treatment of cement fills, and aesthetic presentation of *lacunae*. The trials were conducted in different locations, to examine the different cases and define a coherent conceptual approach and methodology.

In the early twentieth century, the detriments of using Portland cement in heritage contexts were still unknown. To secure the Santa Maria Antiqua paintings, Boni applied more than 1500 metres of cement edging and roughly 2000 cement fills. Venturini Papari also used Portland cement to reinforce the edges of additional *lacunae* and to prepare a bedding mortar for the detached paintings from the south pillars of the nave. Laboratory testing showed that the concentrations of soluble salts remaining in the cement are similar to those now measured in the original plasters. This indicates that the principal damaging effect of the cement—the migration of its salts—is now a completed process, with equilibrium reached. While the Portland cement, however, would no longer be a source of damage, it still presented aesthetic problems. The applications of cement showed a dark grey colour and smooth texture, giving the appearance of foreign bodies in the various contexts. The decision was thus made to replace them with a light-coloured, grainy lime mortar that mimics the structure of the abraded original plasters. Given the largely aesthetic character of the problem, some sections of firmly adhered cement edging could be left intact, where their removal would have caused unnecessary risk to the integrity of the painting. Instead, these were simply covered with lime mortar, after eliminating those parts that overlapped the original surfaces.

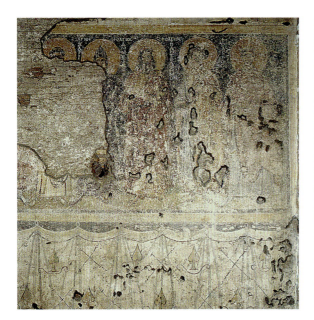 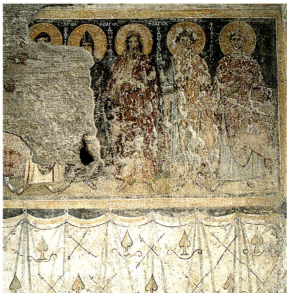

6 Chapel of the Medical Saints: detail of the paintings on the west wall (a) before and (b) after the treatment (photo: Roberto Sigismondi)

The west wall of the Chapel of the Medical Saints (Plates 47, 50: L4) provides a good example of the aesthetic improvement achieved, in large part due to the replacement of cement fills and edging (Figures 6a–b). The conservation of the chapel was conducted in 2004 as a pilot project, financed by the World Monuments Fund through the programme 'Robert W. Wilson Challenge to Preserve our Heritage'. This was the first opportunity to implement a complete conservation intervention on a large scale. A further example of the aesthetic improvement, due mostly to the replacement of cement fills and edging, is provided by the *velum* on the right side of the east wall of the Chapel of Theodotus (Plates 29, 50: J3), conserved in 2005–7 (Figures 7a–b), again under an agreement between the Soprintendenza per i Beni Archeologici di Roma and the World Monuments Fund's 'Wilson Challenge'. This new agreement made available over US$ 500,000, for treatment of about 45% of the paintings and other architectural surfaces. This generous contribution was paired with a further grant of € 1,000,000 from the Italian state 'Fondo per Roma Capitale'.

The major task in the cleaning of the paintings was the removal of the greyish-brown gypsum deposit, described above, present as a continuous patina over all the surfaces. This accreted material had formed above the thin layer of wax applied during the 1900–4 treatments. Depending on its thickness, it obscured the underlying paintings to varying extent, ranging from a slight veiling of dusty appearance to a drastic reduction in legibility. The wax applied during the first restoration was a mineral wax.[8] Compared to beeswax, it is free of chromatic and structural alteration on ageing. However, the penetration of the wax into the painted surfaces means that it has become part of the binding system. Trials have shown that removing the wax would also risk removal of pigment. Given these considerations, the decision was made to retain the wax coating, and accept the result of some slightly glossy areas due to its presence. In-depth cleaning was carried out only for the wall paintings and white plasters. On all other surfaces, including the brick masonry, only light cleaning was done, in order to

 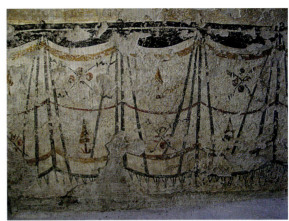

7 Chapel of Theodotus, detail of the *velum* on the east wall before (left) and after the present treatment (right) (photo: Werner Matthias Schmid)

retain the greyish gypsum patina. In fact, this patina provides an effect of chromatic unification: a sort of neutral background against which the paintings emerge as the principal elements.

From a technical point of view, the cleaning techniques differed greatly from one painting to the next. The following selection of cleaning trials illustrates the broad range of situations encountered in the various areas of the church. The *Deësis* on the southern side of the south-east pillar (Plates 13, 50: D3; Figure 8) offers an example of a 'standard' situation. The paint layer was obscured by the greyish veil of gypsum deposits. Cleaning was carried out by means of absorbent tissue soaked with a solution of ammonium bicarbonate, a reactive cleaning agent capable of dissolving gypsum without affecting calcium carbonate, the binder for the paintings.

On the east wall of the left vestibule (Plates 10, 50: D1; Figure 9) the gypsum encrustations were particularly thick. The remarkable *velum* decoration in the dado was practically invisible. The legibility of important remains of a painted architectural decoration from the pre-Christian period and of the small fragments of the cycle of the Forty Martyrs was also severely reduced. Here the cleaning was again done using ammonium salts; however, it was necessary to use cellulose poultices to attain longer contact times. As in many other areas, mechanical cleaning was used to remove soil residues left from the excavations.

During the first ten years after excavation, to address the continuous formation of whitish veils, the paintings of the Chapel of Theodotus had been repeatedly treated with beeswax-based coatings to 'revive' the colours. The accumulation of wax had in many areas developed a glossy, greasy-looking surface. Cleaning in these situations consisted in a partial removal of the wax layer by means of cotton swabs soaked with a mixture of organic solvents. This achieved the removal of the deposits of dust, absorbed by the wax, and the elimination of the opaque whitening (Figure 10).

On the paintings of the apsidal arch the Istituto Centrale per il Restauro had applied a vinylic emulsion fixative in 1959.[9] This had in fact fixed the greyish gypsum deposits, and in turn appeared to worsen the darkening of the painted surface. The removal of the stratified deposits required a combination of ammonium-salt poulticing coupled with cleaning with organic solvents (Figure 11). A similar situation was found in the apse. There, the instability of the paint layer first required systematic pre-consolidation. In the upper part, the vinylic

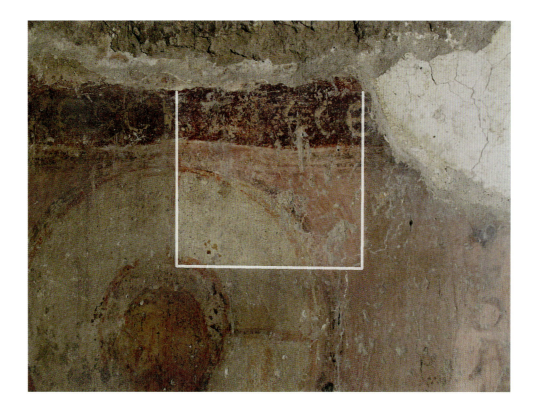

8 *Deësis* on the south side of the south-east pillar, cleaning trial (photo: Werner Matthias Schmid)

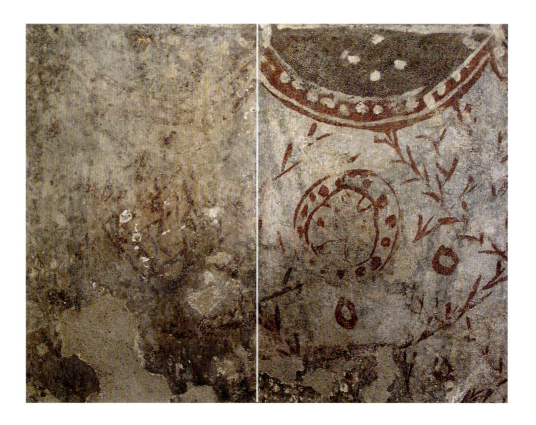

9 East wall of the left vestibule, *velum* half cleaned (photo: Werner Matthias Schmid)

10 Chapel of Theodotus, sample of uncleaned surface (photo: Werner Matthias Schmid)

11 Apsidal arch, cleaning trial (photo: Werner Matthias Schmid)

12 Apse, cleaning trial (photo: Werner Matthias Schmid)

13 Apse, sample of uncleaned surface (photo: Werner Matthias Schmid)

emulsion of the 1950s had turned opaque under the combined action of moisture and soluble salts. The emulsion had also fixed the tempera glazing, which had been applied by Venturini Papari to visually unify certain areas of colour. The image of a cleaning trial (Figure 12) reveals the presence of a yellowish glaze in Christ's halo and of a blackish one in the area of the sky.

In the central and lower parts of the apse, the fragments of painted surface were covered by a thick deposit of salts, which were first softened by poulticing and then removed mechanically. The *velum* with circular decorations was completely obscured by a thick efflorescence of salts. A photograph shows the result obtained by means of poultice cleaning (Figure 13): the whitish area is the part yet to be cleaned. There the presence of the decoration could only be identified by the original incisions, made with a compass.

After cleaning, the first element in the aesthetic presentation of the paintings was the replacement of the cement fills with lime plaster of colour and texture similar to the fabric of the abraded original plasters. This operation was referred to as 'reintegration using plaster'. Comparison with a detail of the *Crucifixion* on the apsidal arch illustrates the effect obtained through cleaning and plaster re-integrations (Figures 14a–c). The cleaning, consisting primarily of the removal of greyish-brown surface deposits, had increased colour saturation and legibility of the details. But at the same time the painting appears more fragmented, because the losses in the paint layer, revealing the surface of the original white, lime-rich plaster, have become more evident. This visual interference was mitigated through the application of neutral watercolour glazes. In the Italian conservation field, this pictorial reintegration technique is known as *acqua sporca*, or 'dirty water'. It consists of the application of a sort of non-colour that seems to return the hues of the dirt or patinas in the areas of paint loss. The effect in human perception is to 'push back' the points of loss, so that they recede behind the remains of the painted surfaces. The results from the pictorial integration of losses are illustrated by the same detail of the *Crucifixion* on the apsidal arch after the completion of the conservation treatment (Figure 14c). The same neutral glazes were also applied to the fills of new mortars in order to obtain only two levels of visual perception: the original layer of paint and the toned-back surface of the painting plasters. The greatly reduced interference from other visual elements facilitates the reading of what remains of the original painting and encourages the viewer to mentally reconstruct the missing parts.

Another important step in the conservation campaign was the 're-contextualisation' of the paintings that had been detached from the walls in the first half of the twentieth century. In the case of Santa Maria Antiqua this term has a twofold meaning. The paintings that had long been stored elsewhere were returned to their original locations. The treatment of those that had been detached but remounted *in situ* was revised, improving their aesthetical appearance by re-establishing their natural relationship with their underlying wall structures. The paintings of the southern nave pillars that had been detached in 1910 were at that time mounted on thick, angular-shaped iron and cement supports, giving the effect of easel paintings mounted on a wall. The *Saint Barbara* panel from the short north-east side of the south-western pillar (Plates 14, 50: E2.2) had been kept in storage since the 1950s. The re-contextualisation was achieved by removing the paintings from their iron supports and transferring them to new carbon-fibre supports that reproduce the thickness of the original plasters. The new supports were cut around the edges of the painting fragments in order to reveal the underlying brick masonry in

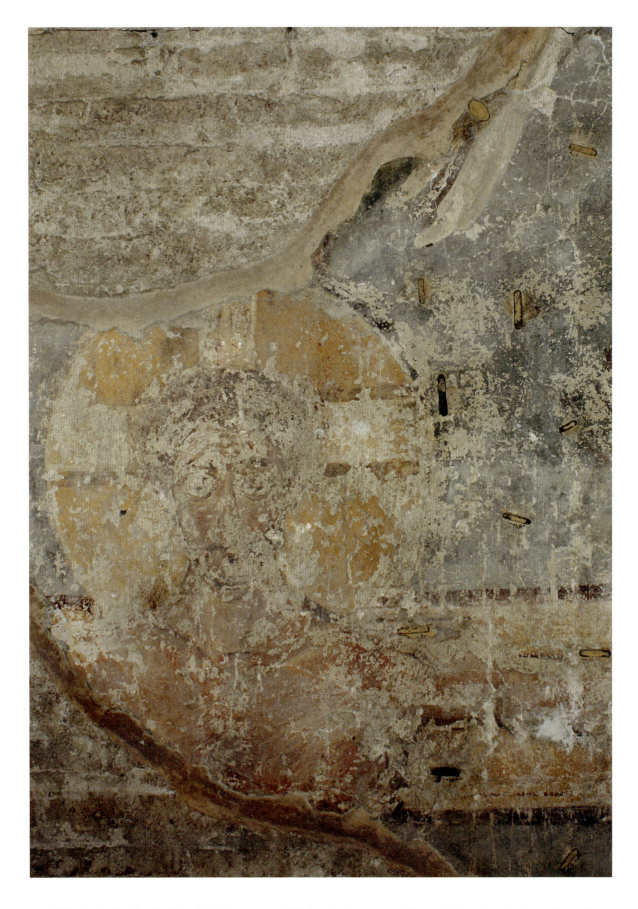

14a Apsidal arch: detail of the *Crucifixion* (a) before treatment, (b) after cleaning, removal of cement elements, and plaster reintegration, (c) after the completion of the treatment (photo: Werner Matthias Schmid)

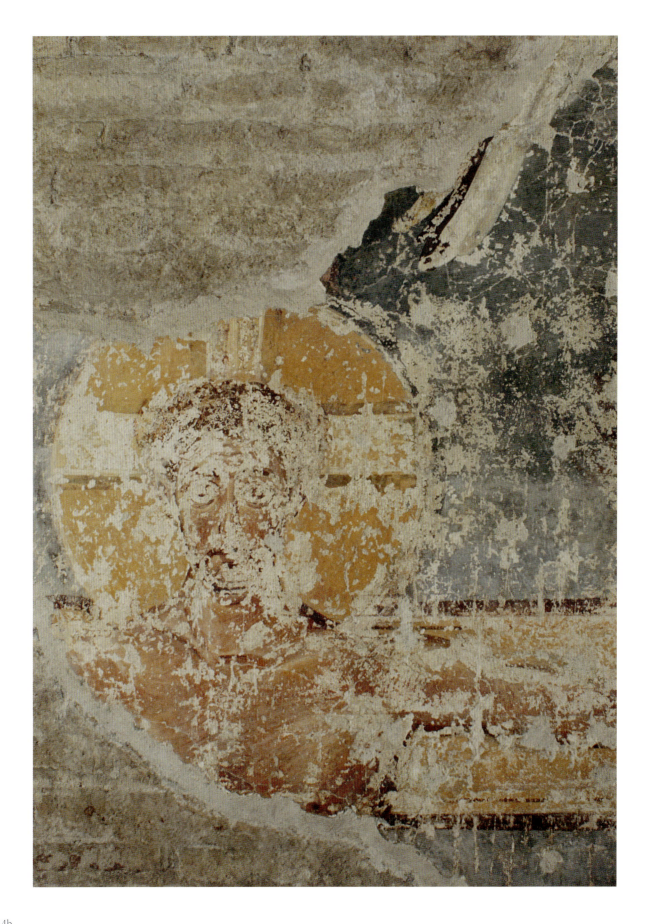

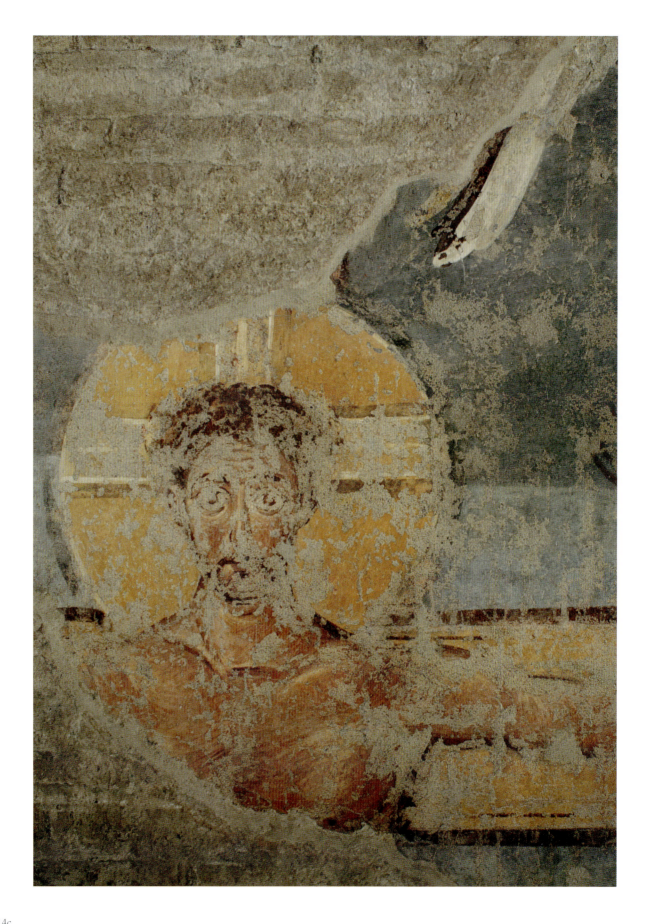

those areas. The paintings, now remounted on the wall, were then integrated applying the same aesthetic presentation concepts used for the paintings that had never been detached (Figures 15a–b). The panel with the Virgin and Child between saints, Pope Zacharias and Theodotus had been detached and transferred to canvas in 1948. It was then stored in the administrative offices of the Soprintendenza Archeologica in Rome. The treatment criteria for re-contextualization were the same as those described above. In this case the task was made more difficult by the need to obtain a perfect conjunction with the thin plaster of the *velum* immediately below and the paintings on the side walls (Figures 16a–b).[10]

In December 2013, after more than ten years of work, the conservation of the wall paintings and other architectural surfaces in the church interior was completed.[11] The last phase was dedicated to the treatment of the early medieval floorings in *opus alexandrinum* in the sanctuary and the high choir enclosure, which revealed the original colours of the marble inlays, creating a wonderful harmony with the colours of the conserved painting fragments.

This paper is a general account of the conservation campaign. More detailed information regarding original painting techniques, scientific investigation, conservation methodology, and the many small and larger discoveries made during these years is recorded by the technical reports delivered over the years, and might be the subject of future publications. For example, the retrieval of painted and unpainted surfaces in the lower part of the apse offered a reading of the painting layers that had never previously been seen, allowing for new research into the stratigraphy and dating of superimposed paintings and decorations.[12] The appendix to this article presents a selection of colour photographs showing a number of areas both 'before' and 'after treatment' (Figures 17–24), which may allow some appreciation of the overall results of the conservation campaign and a retracing of the visual changes that have occurred.

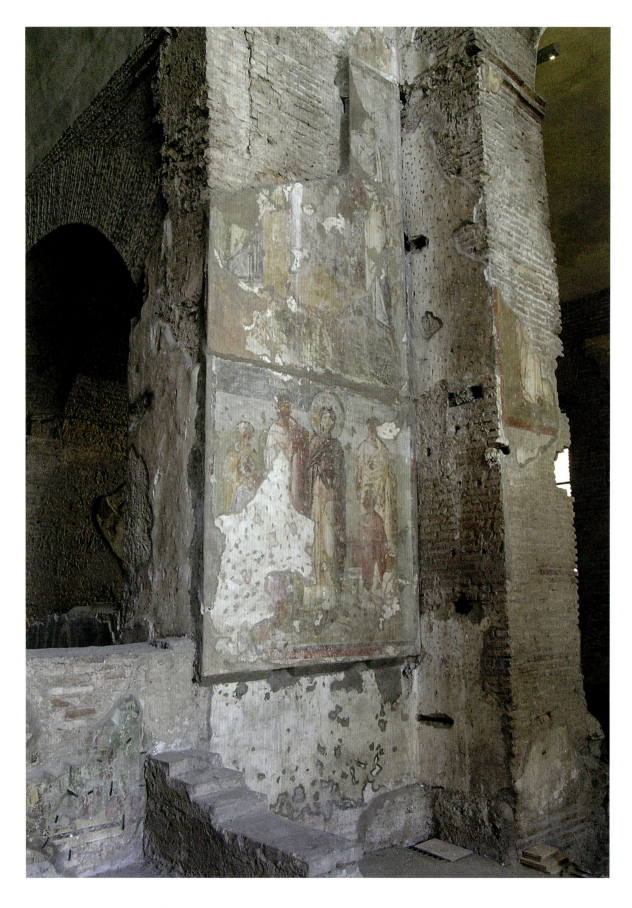

15a Nave: the south-west pillar (a) before and (b) after the 're-contextualisation' treatment
(photo: Werner Matthias Schmid)

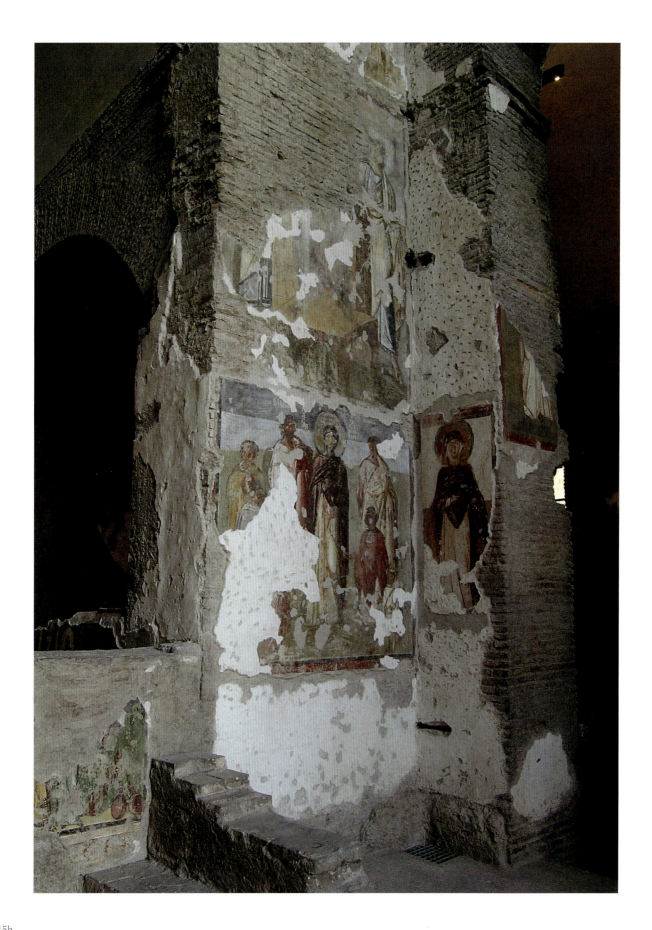

15b

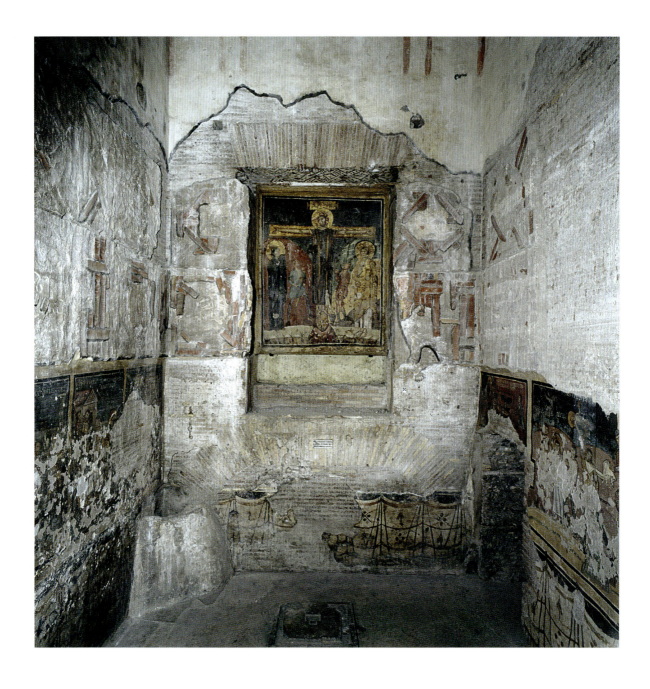

16a Chapel of Theodutus: the south wall (a) before and (b) after conservation, which included the 're-contextualisation' of the detached panel with the Virgin and Child between saints, Pope Zacharias and Theodotus (photo: Roberto Sigismondi)

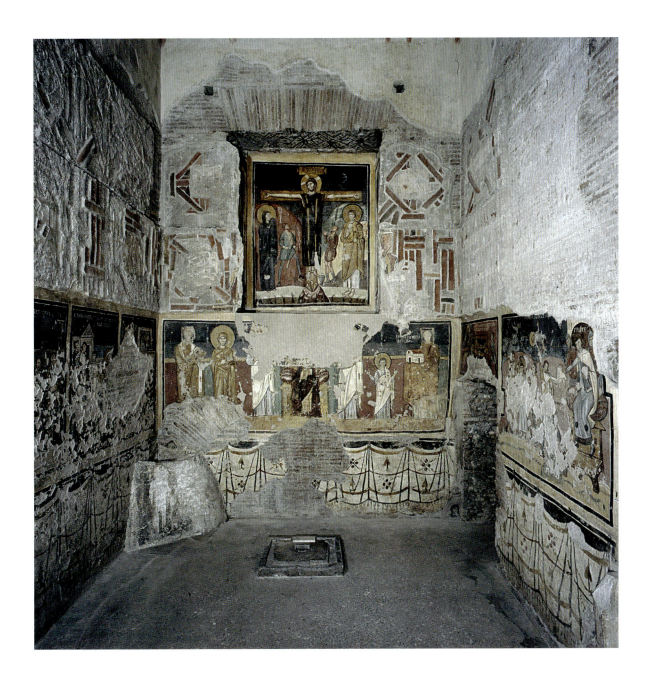

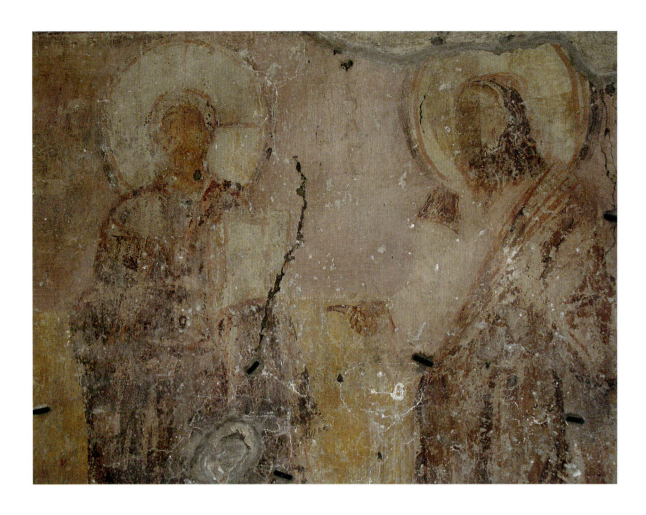

17a Left vestibule, south side of the south-east pillar: detail of the *Deësis* (a) before and (b) after treatment. For the *Deësis*, as in many other areas, the change is subtle; we have the pleasing impression that the interventions simply removed a veil of dust. (photo: Werner Matthias Schmid)

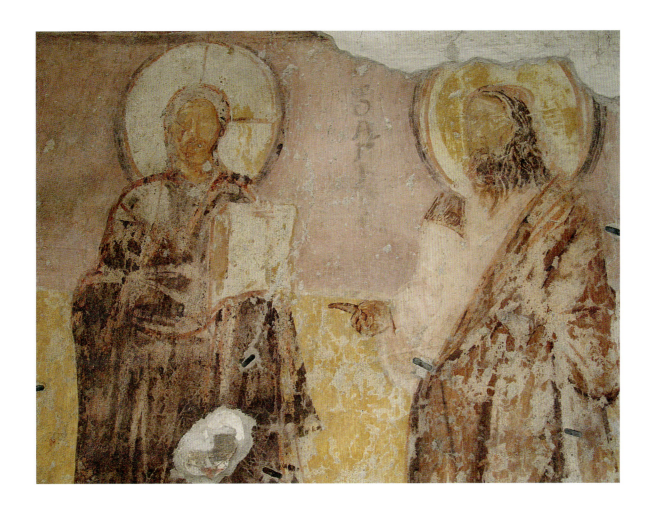

18a Left nave: detail of the *Anastasis* (a) before and (b) after treatment. The *Anastasis*, situated in the passage to the Domitianic Ramp, demonstrates more evident differences. (photo: Werner Matthias Schmid)

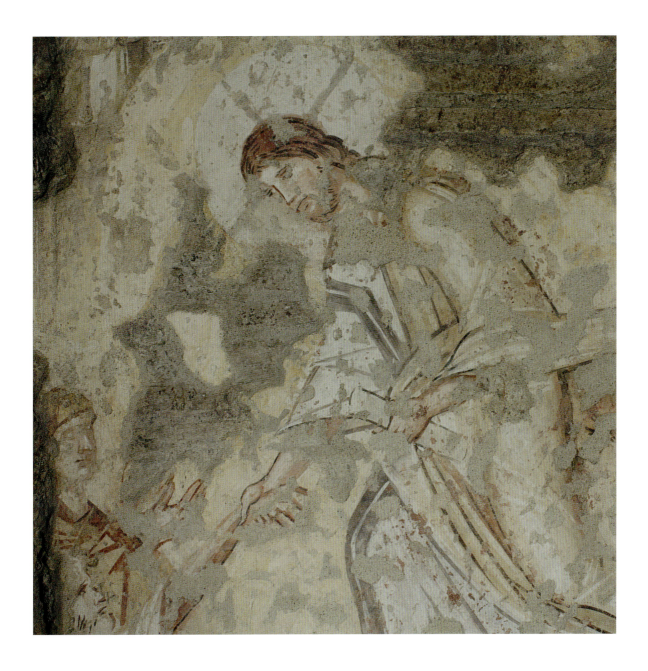

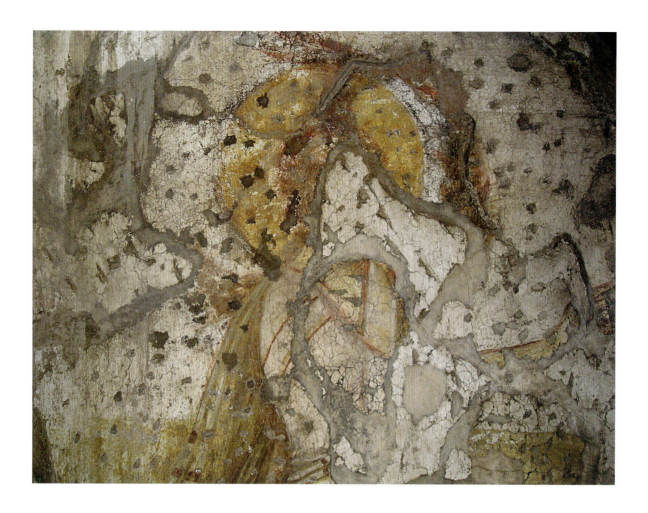

19a Nave, long, north side of the south-east pillar: detail of the first *Annunciation* (a) before and (b) after treatment. The first *Annunciation* had been detached in 1910. The cement fills dominated, and created visual confusion, making it difficult to appreciate the painting. (photo: Werner Matthias Schmid)

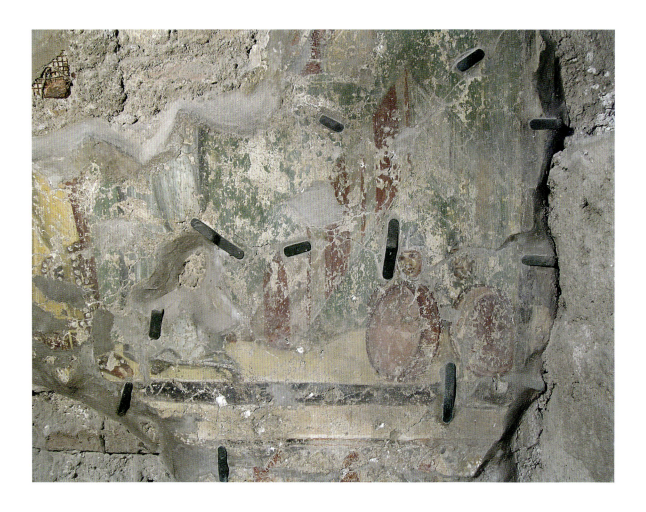

20a — High choir, north wall with bench, west side, facing the nave: detail of two fragments belonging to the *Judith and Holophernes* scheme (a) before and (b) after treatment. The many copper cramps once used to secure the fragment caused severe interference in the perception and appreciation of the painting. (photo: Werner Matthias Schmid)

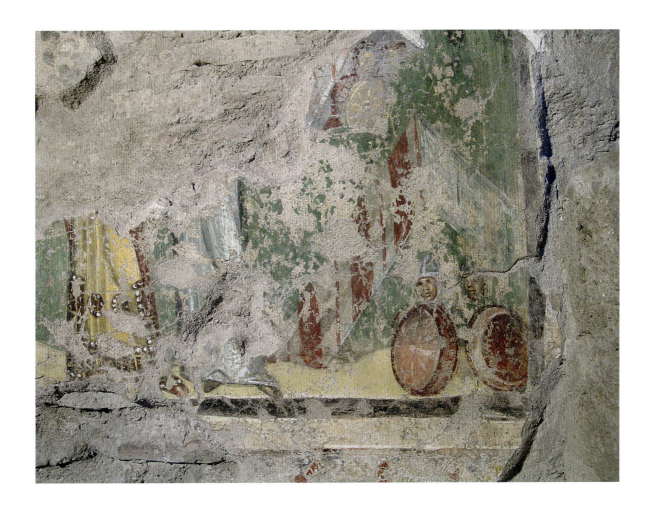

21a Sanctuary, apsidal arch: detail of the angels adoring the Cross (a) before and (b) after treatment. The rediscovery of the colour on the paintings of the apsidal arch was one of the most exciting events in the entire campaign. (photo: Werner Matthias Schmid)

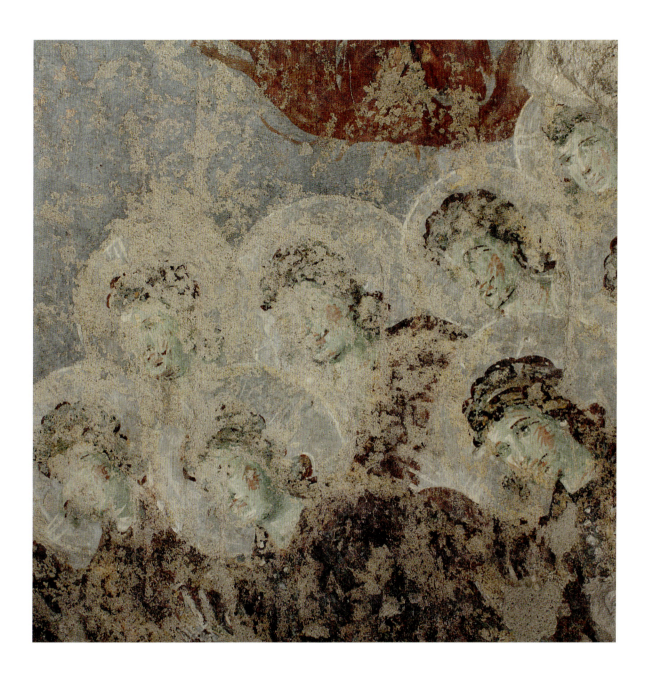

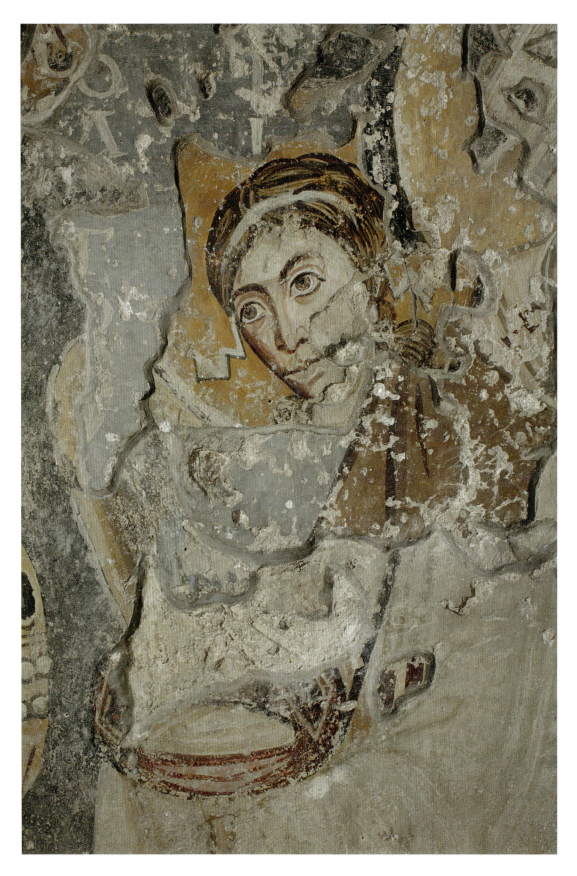

22a Sanctuary, 'palimpsest' wall: detail (a) before and (b) after treatment. Prior to the campaign, the 'palimpsest' wall was one of the areas that preserved relatively good legibility. The preliminary evaluations, however, supported by a series of cleaning trials on the light-coloured coat of the adoring angel, led to the decision that cleaning was justified. For each layer of the painting, different technical solutions were required. (photo: Werner Matthias Schmid)

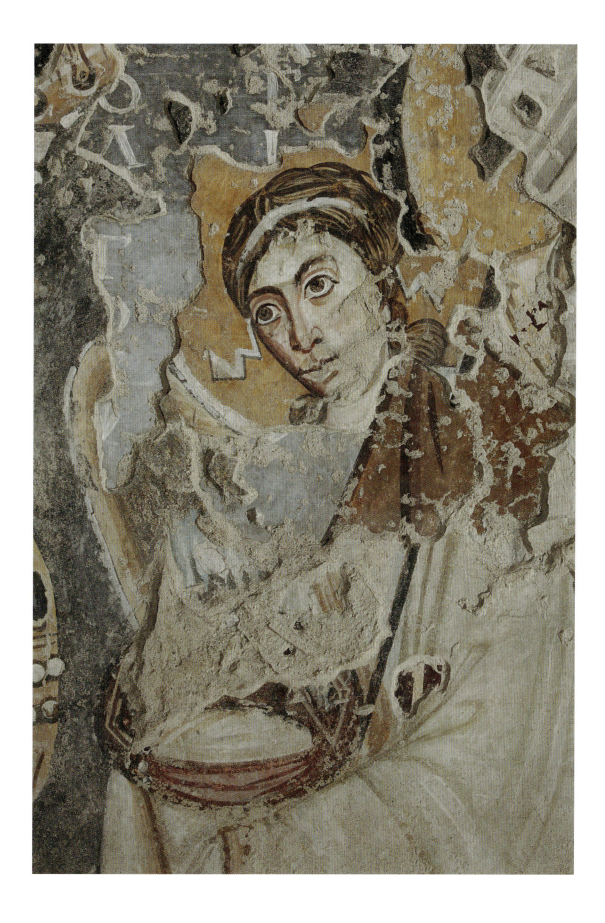
22b

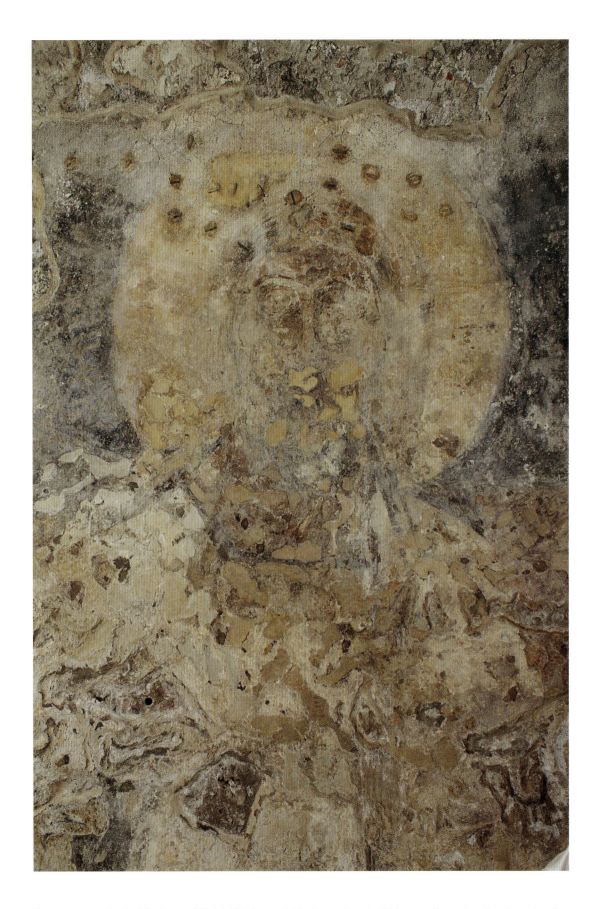

23a Sanctuary, apse: detail of the figure of Christ (a) before and (b) after treatment with two small samples of uncleaned surface still remaining. The figure presented many *lacunae*, with only a little left of the original surface, requiring numerous trials and lengthy discussion prior to the final aesthetic presentation. (photo: Werner Matthias Schmid)

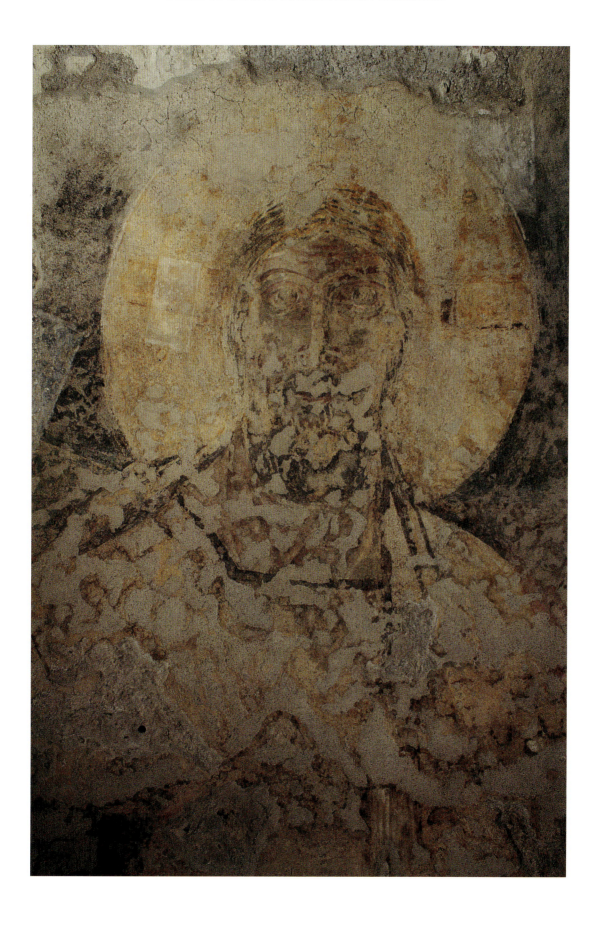

24a Sanctuary, apse, dado: detail of the post-Paul I *velum* with circular decorations and fragments of white plaster (a) before and (b) after treatment (photo: Werner Matthias Schmid)

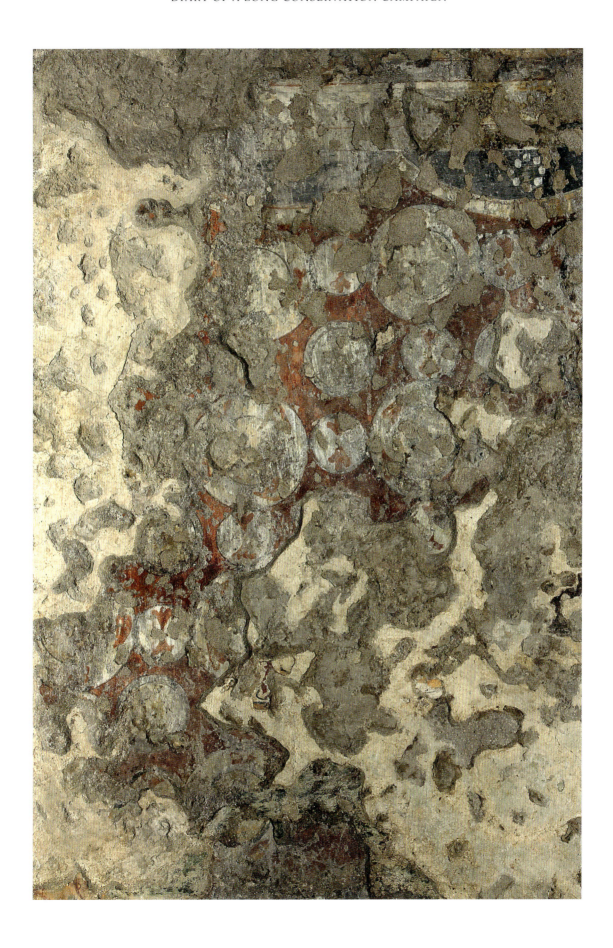

1 Diluted lime putty of 'milky' consistency.

2 The partial loss of painted plaster along the *pontate* joints (for example, in the frescoes of the apsidal arch and the Chapel of Theodotus) reveals the old painted surface of the underlying *pontata*. Of the two *pontate* meeting at the joint, the underlying one is always the higher above floor level. This proves that the different *pontate*, corresponding to successive stages of work, were painted one after the other (starting from the top). The only technical reason for such a procedure is that the painter wanted to take full advantage of the fresh lime plaster to enhance carbonation.

3 The results of the investigations into the moisture problems of the apse wall and the Chapel of Theodotus are addressed in Giuseppe Morganti's contribution to the present volume.

4 Eva Tea, *La Basilica di Santa Maria Antiqua* (Milan: Società Editrice 'Vita e Pensiero', 1937), p. 11; Giuseppe Morganti, 'Giacomo Boni e i lavori di S. Maria Antiqua: un secolo di restauri', in *Santa Maria Antiqua al Foro Romano cento anni dopo*, ed. by J. Osborne, J.R. Brandt, and G. Morganti. (Rome: Campisano, 2004), pp. 11–30 (p. 19).

5 Ibid., pp. 21–2.

6 Ibid., p. 26.

7 The ICCROM organised didactic worksites for the International Course on Mural Painting Conservation between 1982 and 1984.

8 From Eva Tea we learn that Ceresin obtained from the purification of naturally found ozokerite was used; see Tea, *Basilica di Santa Maria Antiqua*, p. 102.

9 The identification of this synthetic resin was based on observation conducted *in situ*: the resin could be softened by applications of a ketone-based solvent, and under this treatment took on a characteristic sticky consistency. This identification is certainly possible, considering that in Italian conservation and restoration practice the advent of vinylic resins occurred in the mid-1950s.

10 The transfer of detached paintings to new supports and their re-installation in the church required many innovative solutions. The tasks were carried out by the conservators Antonio Iaccarino Idelson and Carlo Serino (Equilibrarte Srl., Rome).

11 The campaign was rather discontinuous during the early years of the project. The winter temperatures also imposed breaks, meaning that activity on site was only possible for an average of about six months per year.

12 See Giulia Bordi's contribution to this volume.

THE PALIMPSESTS OF SANTA MARIA ANTIQUA

MARIA ANDALORO

The Project

This section, dedicated to the palimpsests in Santa Maria Antiqua, comprises two studies: the first is by Giulia Bordi, and the second by Paola Pogliani in collaboration with Claudia Pelosi and Giorgia Agresti. These essays form part of the *Conservation* section of the present volume, which includes the contributions by Giuseppe Morganti and Werner Schmid. These texts all relate directly or indirectly to the comprehensive campaign of conservation of the murals undertaken between 2001 and 2013.

Conservation means getting 'up close and personal' with the murals, engaging both eyes and hands directly. But any work on the decoration of the sanctuary, famous for its various palimpsest levels, required much more than that: the act of observing and studying the murals required drawing on the wealth of experience gained during previous investigations of sites in Rome and Byzantine Anatolia.[1] A thorough observation and subsequent analysis of the painted surfaces also yielded precious new insights on the different layers of paint, and central to this process was research on the techniques and materials involved in the production of the frescoes.

Although the conservator (Schmid), the art historians (Bordi and Pogliani), the chemistry specialist (Pelosi), and the laboratory technician (Agresti) followed different research paths, they all focused on the pictorial field. This approach can be defined as 'internal', in that it explores the palimpsest levels from *inside* not *outside*, in other words from the perspective of the painters, not that of the patrons. The murals were examined to identify the characteristics specific to each level. This perspective is especially relevant to conservators, whose interventions are critical actions, informed by a profound knowledge and understanding of the objects in their care; but this approach was also important for the other scholars involved in the project, whose research incorporated both material and historical evidence. The art historical aim of the project was to identify more precisely the painted levels of the palimpsest in order to associate their distinctive features with issues related to artistic culture, painterly practices, and materials used. The goal was to establish a complete profile of the workshops engaged in the decoration of the Santa Maria Antiqua sanctuary, on the so-called 'palimpsest' wall as well as the two lateral walls, between the end of the fifth and the beginning of the eighth century, when the last campaign, in the time of Pope John VII (705–7), is recorded.[2]

The successive building and decoration campaigns created the most dynamic and complex sanctuary space of any known early medieval church in Rome. The contributions to this section

of the volume, therefore, serve to connect the conservation campaign with the broader history of the complex. Additionally, they demonstrate the advantages of a collaborative dialogue between architects, art historians, conservators, chemists, and archaeologists, a dialogue that also underpins the 2016 exhibition *Santa Maria Antiqua fra Roma e Bisanzio*, organised to mark the reopening of the church after a decade of conservation works.[3]

The art historical contributions stem from a research project devoted to the study of the Santa Maria Antiqua murals that was conducted by the Università della Tuscia in Viterbo. Conceived by the author in 1998, in the culturally diverse and highly experimental atmosphere that animated the Department of Conservation, the project developed a methodological research model integrating art historical and scientific/technical approaches into a system based on archival and laboratory research.[4] The project constituted an important part of a larger research project titled 'Per una banca dati della decorazione parietale (dipinti e mosaici) a Roma e Bisanzio (IV-XIV secolo). Fonti, materiali costitutivi, modalità tecnico-esecutive'.[5] The design of the study of the murals in Santa Maria Antiqua, the core of the entire project, was presented at the 2000 conference on 'Santa Maria Antiqua al Foro Romano cento anni dopo'.[6] It was received favourably by the then Soprintendente ai Beni Archeologici di Roma, Adriano La Regina, and was conducted in collaboration with the Soprintendenza itself, the Norwegian Institute in Rome, the Samuel M. Kress Foundation, and the World Monuments Fund of New York.[7]

The result of the project is an integrated dossier that links visual analysis, historical knowledge, laboratory analysis, photographs, and mappings. Two elements should be highlighted in particular: Pogliani identifies the use of the same green pigment in the *Angelo bello* of the 'palimpsest' wall and the depiction of Saint Anne, providing scientific evidence that the same hand was responsible for both, and that they consequently belong to the same phase of decoration; and Bordi's mapping of the plaster levels provides a useful tool for recording quantitative data, while also visualising and displaying levels of understanding of an art historical nature.

NOTES TO THE TEXT

1. For Rome, see the volumes being published in the series *La Pittura medievale a Roma, 312–1431*, ed. by M. Andaloro and S. Romano (Milan: Jaca Book, 2006–); Giulia Bordi, *Gli affreschi di San Saba sul piccolo Aventino: Dove e come erano* (Milan: Jaca Book, 2008); and Giulia Bordi, 'Tra pittura e parete. Palinsesti, riusi e obliterazioni nella diaconia di Santa Maria in Via Lata tra VI e XI secolo', in *Archeologia della Produzione a Roma. Secoli V–XV, Convegno internazionale di studi* (Roma, Palazzo Massimo alle Terme - École Francaise de Rome, 27–29 marzo 2014), ed. by A. Molinari, R. Santangeli Valenzani, and L. Spera, Collection de École Française de Rome 516 (Bari: Edipuglia, 2015), pp. 395–410. For Anatolia, see Maria Andaloro, 'Project for the Knowledge, Preservation and Enhancement of Rupestrian Habitats in Cappadocia and the Data-Base of Rock Hewn Paintings', in *34. Araştırma Sonuçlan Toplantısı (Edirne, 23–27 Mayıs 2016)*, 2 vols (Edirne: T.C. Kültür ve Turizm Bakanlığı, Kültür Varlıkları ve Müzeler Genel Müdürlüğü, 2017), II, 51–70; Maria Andaloro and Valeria Valentini, 'La Banca Dati Cappadocia - Arte e Habitat rupestre. Dai corpora cartacei alle applicazioni web', in *CARE (Corpus architecturae religiosae Europae, IV–X saec.): Meaning and Use of Corpora, 24th Annual International Scientific Symposium of IRCLAMA*, ed. by M. Jurkovic, *Hortus Artium Medievalium*, 24 (2018), 74–9; Giulia Bordi, 'El Nazar a Göreme: Sulle tracce delle chiese delle origini in Cappadocia', in *'Di Bisanzio dirai ciò che è passato, ciò che passa e che sarà': Scritti in onore di Alessandra Guiglia,* ed. by A. Paribeni and S. Pedone (Rome: Bardi, 2018), pp. 113–28; and Maria Andaloro and Paola Pogliani, 'Techniques and Materials of Medieval Wall Painting in Cappadocia', in *Proceedings of the International Colloquium on Conservation of Asian Wall Paintings and the Painting Technology Exchange (Tokyo, 1–3 March 2019)*, forthcoming.

2. For the dating to the fifth century, see Giulia Bordi, 'Santa Maria Antiqua. Prima di Maria Regina', in *L'officina dello sguardo. Scritti in onore di Maria Andaloro*, ed. by G. Bordi, I. Carlettini, M.L. Fobelli, M.R. Menna, and P. Pogliani, 2 vols (Rome: Gangemi, 2014), I, pp. 285–90.

3. Conceived by this author, and curated together with Giulia Bordi and Giuseppe Morganti, the exhibition was sponsored by the Soprintendenza per i Beni Archeologici di Roma and by Electa; see the catalogue: *Santa Maria Antiqua tra Roma e Bisanzio,* ed. by M. Andaloro, G. Bordi, and G. Morganti (Milan: Mondadori-Electa, 2016).

4. Founded in 1990, the Facoltà di Conservazione dei Beni Culturali at Viterbo was the first of its kind in Italy.

5. This research programme, based at the Università degli Studi della Tuscia but also involving other institutions, was financed by the Italian Ministero dell'Istruzione, dell'Università e della Ricerca (PRIN) from 1998 to 2002.

6. Maria Andaloro, 'La parete palinsesto: 1900, 2000', in *Santa Maria Antiqua al Foro Romano cento anni dopo: atti del colloquio internazionale, Roma, 5– 6 maggio 2000*, ed. by J. Osborne, J. R. Brandt, and G. Morganti (Rome: Campisano, 2004), pp. 97–111.

7. I would also like to acknowledge and thank Irene Jacopi, director of the archaeological area of the Roman Forum and the Palatine, and Giuseppe Morganti, our constant companion in this journey, whose availability and encouragement were both generous and irreplaceable.

GIULIA BORDI

The Three Christological Cycles in the Sanctuary of Santa Maria Antiqua

The east and west walls of the sanctuary of Santa Maria Antiqua preserve a complex stratification of levels of mortar and painted plaster (Plate 32; Figures 1–4). In the middle zone of both walls (Plates 42, 45), two superimposed levels, each painted with scenes depicting the life of Christ, have been previously identified and studied (Plates 43, 46). As is well known, the upper level forms part of the substantial decorative campaign undertaken by Pope John VII (705–7).[1] This cycle comprises some twenty rectangular scenes, ten on each wall, arranged in two registers (Plates 42, 45). Beneath is a band containing a series of portrait busts of the apostles, enclosed in medallions, with a *titulus pictus* and a stylised shrub;[2] and below that, the decoration is completed with fictive curtains (Plates 42, 45). This tripartite scheme forms an integral part of the overall iconographic programme undertaken by the pope on the adjacent apse wall, dominated by the monumental *Adoration of the Crucified Christ* in addition to a series of popes and four Church Fathers (Plates 32–5). On the west wall, where the plaster of John VII's Christological scenes has fallen, one can make out fragments belonging to not one but in fact two earlier phases of decoration (Plate 43).[3] On the oldest level, a system of frames with red bands and separate uprights can be clearly discerned: five square-shaped panels plus a rectangular one in each of two registers, for a total of twenty-four scenes (Figure 2). These panels were taller than those belonging to the John VII cycle (Figure 4), and the lower register extended down to the stucco cornice, thus also occupying the space later devoted to the apostle medallions. In the upper register, faint traces of painting suggest the presence of cross-inscribed haloes in the middle of the second, third, and fourth scenes, and in the fifth there are distinct traces of three large crosses, inclined towards the left (Figure 5).[4]

Overlying this first level are traces of a second, and a close inspection of the surfaces indicates a blue-grey background and a series of dark-red vertical strips with white outlines (Figure 6). These are aligned precisely with the vertical bands that frame the scenes of the layer of John VII, and this correspondence led Nordhagen to consider them as preparatory drawings for the latter.[5] However, the comprehensive analysis undertaken by the Università della Tuscia team

1 Santa Maria Antiqua, west wall of the sanctuary. Graphic visualisation of *incrustationes* panels (yellow) (Giulia Bordi, 2019)

2 Santa Maria Antiqua, west wall of the sanctuary. Graphic visualisation of the first Christological cycle: registers and scenes (blue) (Giulia Bordi, 2019)

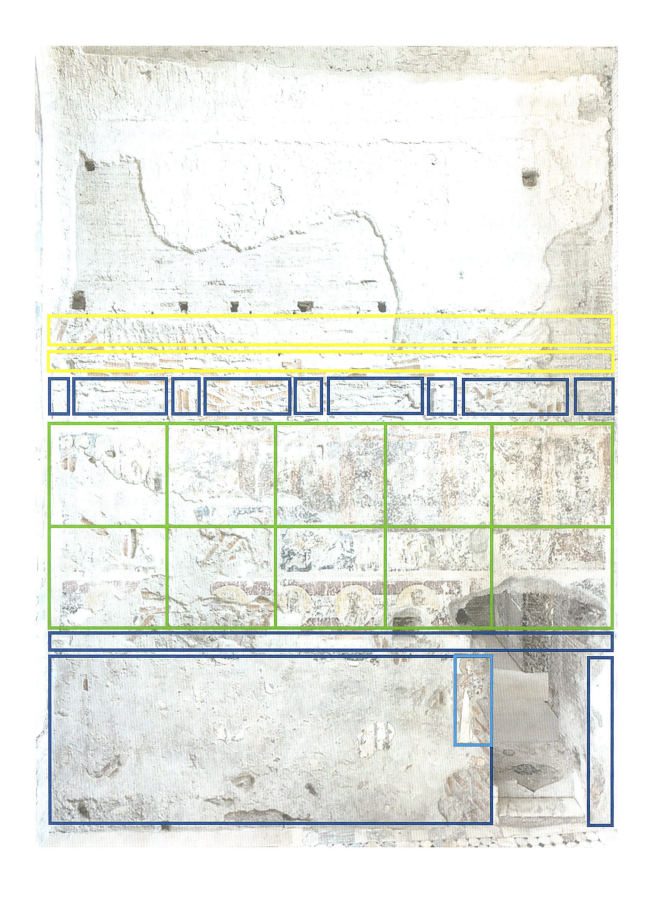

3 Santa Maria Antiqua, west wall of the sanctuary. Graphic visualisation of the second Christological cycle: scenes (green) and the panel with Saint Anne holding the infant Mary (light blue) (Giulia Bordi, 2019)

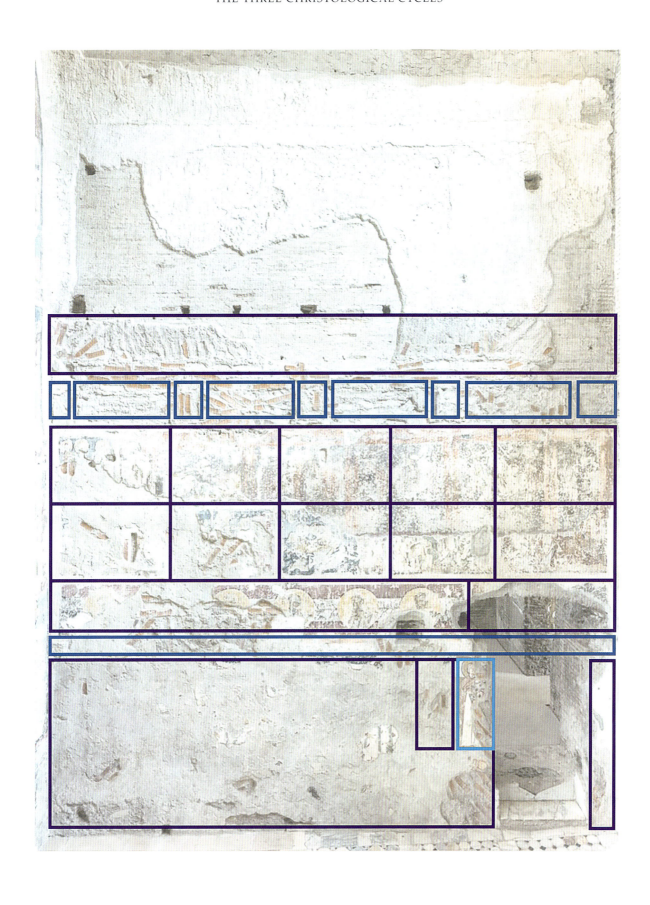

4 Santa Maria Antiqua, west wall of the sanctuary. Graphic visualisation of the John VII cycle: registers and scenes (violet)
(Giulia Bordi, 2019)

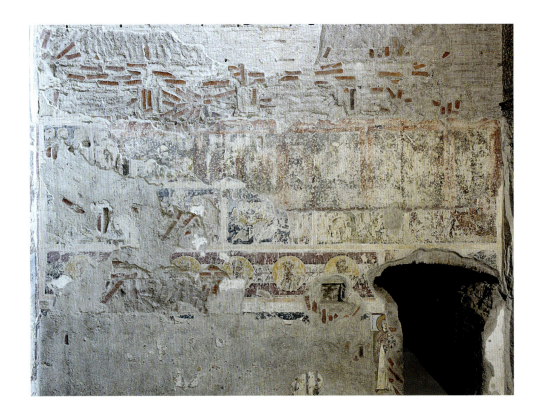

5 Santa Maria Antiqua, west wall of the sanctuary, detail (photo: Gaetano Alfano, 2015)

6 Santa Maria Antiqua, west wall of the sanctuary: the dark-red vertical border with white outlines of the second Christological cycle
(photo: Paola Pogliani, 2013)

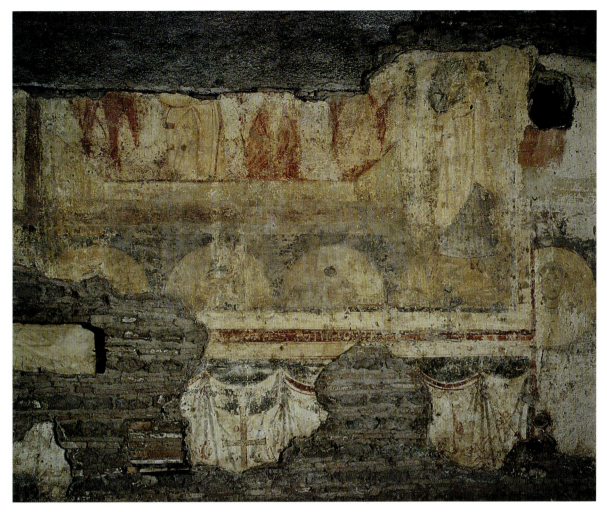

7 San Crisogono, lower church, north wall: *Three Hebrews in the Fiery Furnace* (VI c.) covered by the Christological cycle of Pope Gregory III (731–41) (photo: Giulia Bordi, 2008)

permits their recognition as a distinct level, painted on an exceptionally thin level of plaster.[6] A similar example of painting using lime added to an earlier level of plaster can be found in Rome in the lower church of San Crisogono, on the north wall. There the sixth-century decoration, of which the *Three Hebrews in the Fiery Furnace* and a section of fictive drapery beneath are still visible, was covered in the time of Pope Gregory III (731–41) with a Christological cycle along with medallion busts of saints and *vela* (Figure 7).[7] At San Crisogono, as at Santa Maria Antiqua, the pictorial 'skin' of the second layer appears as a painted veil placed over the original level, so it is very difficult for the observer to distinguish one phase from the other.

Of the new layer identified on the west wall of the sanctuary, at present we can only say that it depicted another cycle arranged in two registers, each comprising five panels (Figure 3). The faint traces of paint that survive do not permit the identification of any scene or figure, but the fact that the first and third levels were devoted to a Christological cycle leads us to hypothesise that this level too may have featured a similar subject.

On the west wall, above the figural scenes, in conjunction with the angle of the apse wall, there remains a vertical strip of plaster which rises some 120 centimetres, belonging to the first

level of decoration. In this area we can observe a tall red frame followed soon afterwards by another thinner red strip that frames a panel containing traces of green paint (Figure 8). This latter strip—previously unnoticed—appears to simulate a plaque of serpentine marble. On the east wall there is a similar 'tongue' of plaster with faint traces of paint, closed at the bottom by four bands of a frame (red, ochre, white, and red), again belonging to the earliest level (Figure 9).[8] The plaster of the third level overlaps with this fragment, and shows a frieze of astragals and, higher up, an architectural element variously identified as a tripod or an *aedicule*.[9] Alessandra Guiglia Guidobaldi has suggested that the marble *incrustationes* of the sanctuary remained in place in the two uppermost registers for a long time, as happened also in the Chapel of Theodotus, being replaced by painting only when they fell. This is attested by the insertion in John VII's time of the frieze of astragals and the tripod, painted on the east wall as an imitation of the previous decoration with marble panels.[10] One final piece of evidence, which has hitherto escaped investigation, would seem to support this view: on both walls (Plates 42, 45), in the zone above the Christological cycle, the mortar which supported the *incrustationes* panels is characterised by the presence of terracotta amphora strips, and is thus quite different from the mortar found below the cycle, used to level the wall surface when the marble decoration was removed to make room for the murals. This discrepancy would seem to confirm that this zone still preserved its *incrustationes*, integrated in painting not only at the time of John VII, on the east wall, but already when the first pictorial cycle was laid on the west wall, where I detected the presence of the fictive panel of serpentine marble.[11]

Examining the oldest Christological scenes on the west wall, today we can see only vague outlines of the figures, as if a piece of opaque glass had been placed between us and them, impeding an exact appreciation of the murals.[12] In the first register the only scene securely identifiable is the fifth panel, where the crosses carried on some figures' shoulders and inclined towards the left are clearly in evidence (Figure 5). There can be no doubt that this was the *Road to Calvary*, an exceptionally rare iconography in both the West and the East at that time.[13] The Wilpert-Tabanelli plate allows us to identify the first figure carrying the Cross as Christ, thanks to the presence of a halo, who is then followed by the two thieves (Figure 10).[14] In western Europe the *Road to Calvary* with three figures bearing crosses may be found at San Pietro in Valle, Ferentillo (late twelfth/early thirteenth century),[15] while in the East the first example known is even later, in the painted decorations of the Church of Holy Apostles at Peć (thirteenth century),[16] and then in some Russian icons ranging from the fifteenth to the seventeenth century.[17] In terms of its New Testament scenes, the Ferentillo cycle is usually regarded as one of the examples closest to the decorative tradition of Old Saint Peter's, and the presence of three figures bearing crosses at both Ferentillo and Santa Maria Antiqua could perhaps be taken as indirect evidence that the model for both was the Vatican basilica itself.[18] If so, Santa Maria Antiqua would represent the earliest known copy of the Old Saint Peter's cycle.

The *Road to Calvary* was preceded by four scenes (Figure 5). The first is covered by the layer of John VII, and consequently not visible; in the middle of the second and third, a cross-inscribed halo is clearly distinguishable; and in the fourth the same halo is visible towards the right side. Comparing what remains today with the Wilpert-Tabanelli watercoloured photograph allows us to observe details that are useful for proposing a hypothetical reconstruction of the

8 Santa Maria Antiqua, west wall of the sanctuary, upper area: a plaque of serpentine marble (photo: Giulia Bordi, 2012)

9 Santa Maria Antiqua, east wall of the sanctuary, upper area: a 'tongue' of plaster with faint traces of paint overlapped by a frieze of astragals and an architectural element (photo: Gaetano Alfano, 2015)

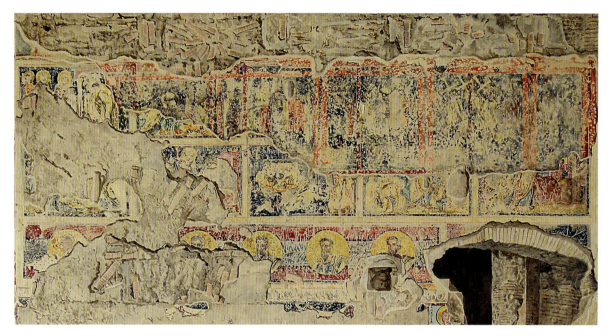

10 Santa Maria Antiqua, west wall, detail. Watercoloured photograph by Wilpert and Tabanelli (Wilpert, *RMM*, IV, pl. 153)

scenes (Figure 10). In the fourth scene, for example, we can distinguish two separate groups: on the right the figure of Christ, his head inclined, followed by a host of soldiers or guards, recognisable by the long shafts of their lances, while in front of him we can discern the outlines of two figures, followed on the left by a small crowd. Following the Gospels' narrative, this must depict either *The Mocking of Christ* or *Christ led out to be crucified*. In the third scene, Christ is in the centre, and on the left we can make out the presence of a figure dressed in red, seated on a throne, while on the right there are two standing figures followed by a small group. This could perhaps represent *Christ before Pilate*. In the second scene Christ is again in the centre, his head tilted to the left, and abutted by the head of another figure, while to the left and right there are traces of the garments of at least four other figures. This may be the *Betrayal of Judas*.

For the sixth and last scene of the register, de Grüneisen hypothesised the presence of a *Crucifixion*, but the panel is too narrow to accommodate that, and there is no trace of a cross-inscribed halo.[19] Close examination of the pictorial surface suggests the presence of three figures (Figure 5): on the left side, the face and veiled head of a woman, and drapery from the red garment of another figure beside the first; and on the right side, the drapery of a figure dressed in white. On the basis of these small but significant details I propose as a working hypothesis to identify this scene as the *Holy Women at the Sepulchre*. This proposal is supported by comparison with the Christological cycle on the nave wall of Sant'Apollinare Nuovo in Ravenna (493–526), where the *Road to Calvary*, a reference to Christ's sacrificial death, is also followed by the *Holy Women at the Sepulchre*, which stands in for the Resurrection.[20]

The complete loss of the scenes on the east wall means that any attempt to reconstruct their identity must remain tentative, although the sequence is likely to have followed a 'double parallel' cycle pattern, as Viscontini proposed using the felicitous expression coined by Marilyn Aronberg Lavin.[21] The cycle must have unfolded from the east wall with Christ's infancy and ministry (Plate 45), perhaps moving from right to left and from top to bottom across the two

registers, before crossing to the west wall where it repeated that same pattern with scenes of the Passion and the *post mortem* miracles (Plate 42). This narrative sequence was probably maintained in the first updating (second layer), but then abandoned in the phase belonging to John VII (third layer), when the Passion scenes were shifted to the second register on the east wall (Plates 45–6), and thus to a position diametrically opposed to those of the older cycle. This radical change was required by the insertion on the apse wall of the enormous *Adoration of the Crucified Christ* (Plate 33), resulting in a new direction, corresponding to Aronberg Lavin's 'wrap-around' pattern.[22]

Returning to the first Christological cycle, its insertion on the two side walls of the sanctuary involved a change of medium, going from the marble *incrustationes* to painted plaster. The existing layout was taken into account, however, comprising: a socle; then a first order with marble panels alternating with vertical strips; a tall border; a second order of marble panels separated by pilasters, probably with figures; and finally a tall border of two registers, with the mosaics above it (Figure 1). After the *incrustationes* were removed, the socle was painted with fictive marbles, in many areas coexisting with splinters of the previous stone revetment. Above it was a decoration in two registers with fictive marble frames, traces of which still remain on the east wall, to the right of the entrance to the Chapel of Theodotus. Of this decoration today are visible: a border with two bands, one red and one white, divided in the centre by a red line, and traces of green paint that probably simulated a serpentine marble veneer (Figure 11).[23]

On the west wall, however, below the image of Saint Anne, a large section of imitation *giallo antico* marble is preserved (Plate 42). In place of the moulded border which should have separated the first register from the second in the earliest level, the wall was chiselled out to provide space for a plastered stucco frieze (Plate 43). This creates a necessary break in the architectonic profile of the wall. The second register features scenes from the life of Christ. Above it, the tall border of *incrustationes* probably remained visible, with the first register partly restored in painted plaster (Figure 8), and this in turn supported the mosaic that originally covered the entire vault.

The stucco frieze, decorated with a vegetal scroll made of flowers with five petals and figs, has been variously dated to the sixth or the seventh century (Figure 12).[24] One fact is certain, however: its addition to the wall is directly connected to the first campaign of pictorial decoration. On the east wall (Plate 45), the sequence of phases has been revealed as follows: levelling mortar, plaster, stucco frieze, and application of paint. On the west wall (Plate 42) we find: levelling mortar, stucco frieze, plaster, and application of paint. The different execution sequences are probably the result of a variation in internal workshop practice, but the fact that the border on the west wall sits directly on the levelling mortar proves unequivocally that its insertion belongs to the first phase. An examination of this frieze reveals also that it was produced serially using punched designs (Figure 12). David Knipp has recently proposed, on the basis of similarities with a fragment from Chapel 'D' of the monastery of Bawît in Egypt (today in the Louvre), that the frieze must have been created around 570, at the same time as the Christological cycle, by a workshop of Coptic artists.[25] The dating of the Santa Maria Antiqua frieze will be further explored later in this study; for the moment it will suffice to say that the similarity between the two stuccoes is limited, in my opinion, solely to the presence of the fig, which at Bawît alternates with pomegranates, and to the decorative pattern of the vegetal

11　Santa Maria Antiqua, east wall of the sanctuary, to the right of the entrance to the Chapel of Theodotus: a fictive marble decoration (photo: Giulia Bordi, 2012)

scroll. Furthermore, the Coptic frieze also differs from its Santa Maria Antiqua counterpart in terms of technique, having been modelled and incised, not created using a punch. One can even see the holes created by a running drill. These shared features are not therefore sufficient to justify Knipp's proposal that an Egyptian workshop was active at Santa Maria Antiqua, and the similarity in the decorative patterns simply attests to the circulation of models across the Mediterranean. The Santa Maria Antiqua frieze thus continues to be without close comparatives, no doubt also because of the limited number of early medieval stuccoes preserved in Rome.

In the past, the dating of the earliest decoration on the walls of the sanctuary presented numerous problems, due above all to the illegibility of the pictorial cycle, and this issue is now complicated further by the identification of an additional layer between the first level and that of John VII. Wilpert dated the earliest murals to the time of Pope Martin I (649–55), although he allowed for the possibility that they were earlier or later, and de Grüneisen was undecided between the sixth and seventh centuries.[26] The first 'stratigraphic' reading of the sanctuary decoration was made by Ernst Kitzinger. Observing the sequence of plasters, he proposed that when the apse was inserted and painted, the sanctuary received an extensive decoration comprising the *Angelo bello* of the *Annunciation* on the 'palimpsest' wall, and the earliest Christological cycle on the side walls. Kitzinger dated this phase, the second after the *Maria Regina*, to the first half of the seventh century on the basis of stylistic considerations

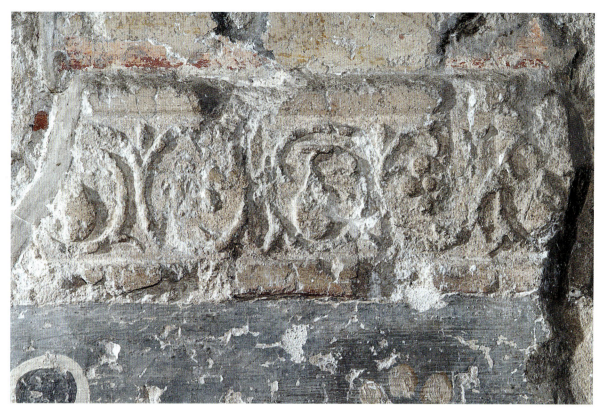

12 Santa Maria Antiqua, east wall of the sanctuary: detail of the stucco frieze (photo: Giulia Bordi, 2012)

stemming from his theory of 'perennial Hellenism'.[27] Subsequently, he revised the chronology to *c.* 630, no longer linking the second phase to the transformation of the building into a church (565–78), though this dating continued to be supported by Richard Krautheimer, on the basis of the reported discovery of two coins from the time of Emperor Justin II.[28] Per Jonas Nordhagen, who also began with the stratigraphy of the sanctuary plasters (although he worked backwards from the most recent level), associated the cycle with the phase of Martin I because, like the Church Fathers on the 'palimpsest' wall, it lies beneath the level of John VII.[29] In recent years, Knipp too, like Kitzinger, has come to regard the fragments of the Christological cycle and its vegetal-scroll frame as the earliest phase preserved on the wall, datable to about 570, and commissioned, as Tea had proposed,[30] by Narses or the Byzantine Emperor Justin II.[31] Manuela Viscontini, on the other hand, has proposed two alternative datings. The first is that the cycle belongs to the moment when the structure was transformed into a church, and that it took Saint Peter's as its model, as suggested indirectly by the inclusion in the *Road to Calvary* of three figures bearing crosses, as at San Pietro in Valle in Ferentillo.[32] The second possibility is a date of *c.* 630, as proposed by Kitzinger, the moment when liturgical links to the cult of the True Cross re-appeared vigorously in the West. Starting from the iconography of the *Road to Calvary*, Viscontini notes that, just as three crosses were erected on Calvary, three crosses were discovered by Constantine's mother, Helena, one of which was venerated as the 'True Cross' first in Jerusalem and then in Rome; and the oldest version of the *Exaltatio crucis* appeared in the time of Pope Honorius I (625–38) and was celebrated at Saint Peter's.[33] The commemoration of Helena's rediscovery of the 'True Cross' became fused with the celebration of the recovery

of the relic, which had fallen into the hands of the Persians in 612, by the Byzantine emperor Heraclius in 631.[34]

Recently, Werner Schmid has compared the plaster of the earliest Christological cycle with that of the 'painted frame' beneath the *Maria Regina* on the palimpsest wall, finding a strong similarity between the two from a morphological perspective, based on micro-stratigraphical analyses that revealed a similar composition in the two mortar samples. These differed only in the quantity of inert matter, which was greater in the plaster of the Christological cycle. Furthermore, Schmid discovered another common element in the two samples: the colour red, which under the microscope appeared in both cases to be composed of hematite. These observations led the conservator to propose, albeit hypothetically and with considerable caution, that the level preserved beneath the *Maria Regina* was contemporaneous with the earliest Christological cycle.[35] This would mean, therefore, that the sanctuary was painted in its entirety before the insertion of the apse and even before the *Maria Regina*.

In attempting to further our understanding on this matter, Pogliani, Pelosi, and the present author decided to undertake new analyses of the red pigment used in five plaster samples: the layer beneath the *Maria Regina* on the palimpsest wall (Plate 37); the first plaster level on the wall to the left of the apse (Plate 35); the first plaster level in the apse itself (Plate 35); and the first plaster level on the east and west walls of the sanctuary (Plates 45, 42).[36] The results demonstrated that the red of the frame beneath the *Maria Regina* and that of the earliest painted plaster on the wall to the left of the apse were identical, both composed of red earth (Fe_2O_3) and anatase (titanium dioxide, TiO_2), whereas the reds from the apse and the side walls of the sanctuary used only red earth. On the basis of this new information we can now exclude the possibility that that the earliest Christological cycle was contemporaneous with the decoration preceding the *Maria Regina*, for which I have previously proposed a dating to c. 500, when Theodoric came to Rome for the celebration of his *tricennalia* and restored the palace on the Palatine.[37] It is more likely, therefore, that the first Christological cycle should be associated with the insertion of the apse, as proposed by Kitzinger and reaffirmed by Knipp. This was the moment when the *tablinum* took on the appearance of a church sanctuary, receiving an apse decoration of an image of the enthroned Madonna and Child, flanked by angels and the Princes of the Apostles, with narrative scenes from the life of Christ on the side walls. I agree with Knipp that this transformation into a church took place in the sixth century, in the years when the general Narses governed Italy (565–71).[38]

The dating of the second level is more problematic, however. Only recently discovered, painted in lime, and situated between the first Christological cycle and that of John VII, we can discern only the borders framing the scenes (Figures 5–6). Following the stratigraphy of the walls of the sanctuary, as well as that proposed for the apse, this level probably belongs to the phase that Nordhagen associated with the pontificate of Martin I, in other words that which saw figures of the four Church Fathers painted on the sides of the apsidal wall (Plates 35, 40–1).[39] But, in accordance with the new reading of these figures proposed by Richard Price, who prefers a less polemical intent than their traditional interpretation as an anti-monothelete statement, I too am now prepared to move this phase to the year 663, when Constans II visited Rome, and thus to the pontificate of Vitalian (657–72),[40] having now become more inclined to believe that Martin I did not play a role as patron of the decoration in Santa Maria Antiqua.[41]

1. Per Jonas Nordhagen, 'The Frescoes of John VII (A.D. 705–707) in S. Maria Antiqua in Rome', *Acta ad archaeologiam et artium historiam pertinentia*, 3 (1968).

2. Of the *tituli picti* one can now read only: 'D[OMI]NE [...]'. See Wladimir de Grüneisen, *Sainte-Marie-Antique* (Rome: Max Bretschneider, 1911), p. 157; and Nordhagen, 'The Frescoes of John VII', p. 22.

3. The existence of a third level was discovered by the present author, together with Paola Pogliani, Manuela Viscontini, and Mariella Ranieri, during the documentation and mapping of the sanctuary levels undertaken as part of the 1997–2014 *Progetto Santa Maria Antiqua* of the Università degli Studi della Tuscia, directed by Maria Andaloro. An initial reconstruction of the walls and their three painted cycles was presented by Manuela Viscontini, 'I cicli cristologici del presbiterio di Santa Maria Antiqua', in *L'officina dello sguardo. Scritti in onore di Maria Andaloro*, ed. by G. Bordi, I. Carlettini, M.L. Fobelli, M.R. Menna, P. Pogliani, 2 vols (Rome: Gangemi, 2014), I, pp. 291–6. For the technique and the materials used see the contribution by Pogliani, Pelosi, and Agresti in this volume.

4. These were partially recorded in Wilpert's plate and in Nordhagen's tracings: Joseph Wilpert, *Die römischen Mosaiken und Malereien der kirchlichen Bauten vom IV. bis XIII. Jahrhundert* (Freiburg im Breisgau: Herder, 1916), pl. 153; Per Jonas Nordhagen, 'S. Maria Antiqua: the Frescoes of the Seventh Century', *Acta ad archaeologiam et artium historiam pertinentia*, 13 (1978), 89–142 (p. 102, figs 3–4).

5. Nordhagen, 'The Frescoes of John VII', p. 115.

6. See the contribution by Pelosi, Pogliani, and Agresti.

7. Anna Melograni, 'Le pitture del VI e VIII secolo nella basilica inferiore di S. Crisogono in Trastevere', *Rivista dell'Istituto Nazionale d'Archeologia e Storia dell'Arte*, 3rd ser., 13 (1990) [1991], 139–78.

8. Nordhagen noticed that the two 'tongues' of plaster surviving on the east and west walls presented no evidence of having been roughened for repainting, and thus hypothesised that here there was a strip placed above the Christological scenes, some 50 centimetres in height, which he dated to the pontificate of Martin I (649–55). In his view this would have featured an inscription, either commemorative or expressing some theological dogma, which John VII subsequently decided to leave visible; see Nordhagen, 'The Frescoes of John VII', p. 115; Nordhagen, 'S. Maria Antiqua: the Frescoes of the Seventh Century', p. 102; and Per Jonas Nordhagen, 'Constantinople on the Tiber: the Byzantines in Rome and the Iconography of their Images', in *Early Medieval Rome and the Christian West: Essays in Honour of D.A. Bullough*, ed. J.M.H. Smith (Leiden: Brill, 2000), pp. 113–34 (p. 122 note 23).

9. For the tripod, see Alessandra Guiglia Guidobaldi, 'La decorazione marmorea dell'edificio di Santa Maria Antiqua fra tarda antichità e alto medioevo', *Santa Maria Antiqua al Foro Romano cento anni dopo. Atti del colloquio internazionale, Roma, 5–6 maggio 2000*, ed. by J. Osborne, R. Brandt, G. Morganti (Rome: Campisano, 2004), pp. 49–65 (p. 59). For the aedicule, see David Knipp's contribution in the present volume.

10. Guiglia Guidobaldi, 'La decorazione marmorea', p. 59.

11. This suggests in turn that we need to set aside the hypothesis that the Christological cycle occupied three registers; see Viscontini, 'I cicli cristologici', p. 292.

12. In 1702, when Santa Maria Antiqua came to light for a few months, Francesco Valesio was probably able to see the cycle in a better condition. He wrote: 'nelli muri laterali vi è dipinta la vita di N.S. et è da notarsi che essendosi d.a pittura in alcuni luoghi caduta vi si vede sotto altra pittura più antica è [sic] di miglior maniera'; see Francesco Valesio, *Diario di Roma*, ed. by G. Scano, 6 vols (Milano: Longanesi, 1977), II: *1703–1704*, p. 170.

13. Gordon Rushforth, 'The Church of S. Maria Antiqua', *Papers of the British School at Rome*, 1 (1902), 1–123 (p. 74); de Grüneisen, *Sainte-Marie-Antique*, p. 139; Eva Tea, *La Basilica di Santa Maria Antiqua* (Milan: Società Editrice 'Vita e Pensiero', 1937), p. 314; and Nordhagen, 'Frescoes of the Seventh Century', p. 102. The crosses are partially visible in Wilpert's plates and Nordhagen's tracings.

14. For other possible readings of this scene see Viscontini, 'I cicli cristologici', p. 294.

15. Herbert L. Kessler, 'Il ciclo di San Pietro in Valle: fonti e significato', in *Gli affreschi di San Pietro in Valle a Ferentillo: Le storie dell'Antico e del Nuovo Testamento*, ed. by G. Tamanti (Naples: Electa, 2003), pp. 77–116 (pl. 42); and Viscontini 'I cicli cristologici', pp. 294–5.

16. Ellen C. Schwartz, 'The Original Fresco Decoration in the Church of the Holy Apostles in the Patriarchate of Peć' (unpublished doctoral thesis, New York University, 1978); and Viscontini 'I cicli cristologici', fig. 4.

17. Viscontini has observed that the Eastern examples, while much later (XV–XVII c.) than Santa Maria Antiqua, certainly belong to an iconographic tradition stemming ultimately from a second-century text, the *Gospel of Nicodemus*, which expands on the story of Christ's passion by adding further details regarding Pilate, Judas, and the two thieves, including their names (Dismas and Gestas). Viscontini notes that Lazarev identified some Russian icons from the School of Novgorod that portray this theme: an icon of the Symbol of the Faith (Moscow, Kolomienskoy Museum); an icon of Jesus at Mount Calvary (Moscow School, *c*. 1497; an icon originally from the iconostasis of the Cathedral of the Dormition, in the Monastery of Saint Cyril at Belozersk (today in the Andrey Roublev Museum, Moscow); and an icon with scenes of Christ's Passion (School of Novgorod, early XVI c.), from the cathedral of Saint Sophia at Novgorod, now in the Novgorod Museum; see Viktor N. Lazarev, 'The Bipartite Tablets of St. Sophia in Novgorod', in *Studies in*

Memory of David Talbot Rice, ed. by G. Robertson and G. Henderson (Edinburgh: Edinburgh University Press, 1975), pp. 68–82; and Viscontini, 'I cicli cristologici', p. 294 note 21.

18 Viscontini, 'I cicli cristologici', pp. 294–5.

19 De Grüneisen, *Sainte-Marie-Antique*, p. 139.

20 For the cycle in Sant'Apollinare Nuovo see most recently Clementina Rizzardi, *Il mosaico a Ravenna: Ideologia e arte* (Bologna: Ante Quem, 2011), pp. 90–103; and Carola Jäggi, *Ravenna. Kunst und Kultur einer spätantiken Residenzstadt* (Regensburg: Schnell & Steiner, 2016), pp. 187–90, both with further bibliography.

21 Marilyn Aronberg Lavin, *The Place of Narrative: Mural Decoration in Italian Churches, 431–1600* (Chicago: University of Chicago Press, 1990, repr. 1994), p. 8; and Viscontini, 'I cicli cristologici', p. 293, fig. 3.

22 Aronberg Lavin, *The Place of Narrative*, p. 9.

23 The border is terminated by a horizontal mullion that marks the end of the first register.

24 De Grüneisen includes the stucco frieze in the imperial decoration of the structure (*Sainte-Marie-Antique*, p. 134); Tea dates it to the Byzantine phase of the church (*Basilica di Santa Maria Antiqua*, p. 40); Nordhagen to the papacy of Martin I, around 650: Per Jonas Nordhagen, 'The Earliest Decorations in Santa Maria Antiqua and their Date', *Acta ad archaeologiam et artium historiam pertinentia*, 1 (1962), pp. 53–72 (p. 61); and 'Frescoes of the Seventh Century', p. 103; Peroni to the seventh century: Adriano Peroni, 'Gli stucchi decorativi della Basilica di S. Salvatore a Brescia. Appunti per un aggiornamento nell'ambito dei problemi dell'arte altomedievale', in *Kolloquium über spätantike und frühmittelalterliche Skulptur (Heidelberg 1968)*, ed. by V. Milojcic (Mainz am Rhein: Philipp von Zabern, 1969), pp. 25–45 (p. 4), followed by Laura Pasquini, *La decorazione a stucco in Italia fra tardo antico e alto medioevo* (Ravenna: Longo, 2002), pp. 76–7; while Romano has opted for the sixth century, under Justin II, see Serena Romano 'Rilevamento delle decorazioni in stucco altomedievali di Roma. S. Maria Antiqua', in *Roma e l'Età carolingia. Atti delle giornate di studio (Roma, 3–8 maggio 1976)* (Rome: Multigrafica, 1976), pp. 305–7.

25 David Knipp, 'Coptic Stuccoes at Santa Maria Antiqua', *Acta ad archaeologiam et artium historiam pertinentia*, 25 (2012), 159–75, fig. 6.

26 Joseph Wilpert, 'Sancta Maria Antiqua', *L'Arte* 13 (1910), 1–20 (p. 14); de Grüneisen, *Sainte-Marie-Antique*, pp. 139–40.

27 Ernst Kitzinger, *Römische Malerei vom Beginn des 7. bis zur Mitte des 8. Jahrhunderts* (Munich: R. Warth, 1934), p. 42.

28 Richard Krautheimer and others, *Corpus Basilicarum Christianarum Romae*, 5 vols (Vatican City: Pontificio Istituto di Archeologia Cristiana, 1937–77), II, 252–3; and Ernst Kitzinger, *Byzantine Art in the Making: Main Lines of Stylistic Development in Mediterranean Art, 3rd–7th Century* (Cambridge, MA: Harvard University Press, 1977), p. 151 note 4.

29 Nordhagen, 'The Earliest Decorations', p. 60.

30 Tea, *Basilica di Santa Maria Antiqua*, pp. 7, 19, 41.

31 Knipp, 'Coptic Stuccoes', p. 165.

32 Kessler, 'Il ciclo di San Pietro in Valle'.

33 Louis Van Tongeren, *Exaltation of the Cross: Toward the Origins of the Feast of the Cross and the Meaning of the Cross in Early Medieval Liturgy* (Leuven: Peeters, 2000), pp. 44–5, 54.

34 Viscontini, 'I cicli cristologici', pp. 294–5.

35 Werner Schmid, 'I primi due strati dipinti della parete-palinsesto di Santa Maria Antiqua: nuove osservazioni di carattere tecnico-esecutivo', in *L'officina dello sguardo. Scritti in onore di Maria Andaloro*, II, pp. 437–42 (pp. 440–1).

36 The five samples were tested with Raman spectroscopy in the Cultural Property Diagnostic Laboratory of the Dipartimento di Scienze, Università di Roma Tre, directed by Armida Sodo, whom I thank for her kind assistance.

37 Bordi, 'Santa Maria Antiqua. Prima di *Maria Regina*'.

38 Bordi, 'Santa Maria Antiqua attraverso i suoi palinsesti pittorici', p. 40. See also Robert Coates-Stephens in this volume.

39 Nordhagen, 'Frescoes of the Seventh Century', pp. 97–100, 136–8.

40 Richard Price, *The Acts of the Lateran Synod of 649*, translated with notes by R. Price with contributions by P. Booth and C. Cubitt (Liverpool: Liverpool University Press, 2014), pp. 80–1, and note 55; see also Price's paper in this volume.

41 Giulia Bordi, 'Die Päpste in Santa Maria Antiqua. Zwischen Rom und Kostantinopel', in *Die Päpste und Rom zwischen Spätantike und Mittelalter*, ed. by N. Zimmermann, T. Michalsky, S. Weinfurter, and A. Wieczorek, (Regensburg: Schnell & Steiner, 2017), pp. 189–211 (p. 201).

PAOLA POGLIANI, CLAUDIA PELOSI, AND GIORGIA AGRESTI

Palimpsests and Pictorial Phases in the Light of Studies of the Techniques of Execution and the Materials Employed

Research on the murals of Santa Maria Antiqua has benefitted from the integration of art historical and scientific studies, with a particular focus on the investigation of the painting processes and the materials employed.[1] This integration constitutes a useful approach for disentangling the complex stratigraphy of the various phases of painting, particularly in the sanctuary. Using a consistent methodological framework, the 'Progetto Santa Maria Antiqua' has examined all the painted surfaces in the church; the present paper, however, focuses on two select case-studies, which bring to the fore new and interesting elements that illuminate the pictorial cycle at large.[2]

The Christological cycle on the sanctuary wall

On the walls of the sanctuary, particularly the west wall (Plate 50: K3), stratigraphic investigation has made it possible to identify three pictorial phases, painted one over the other in successive layers (Figure 1). Two of these, the first and third levels, displayed scenes from the life of Christ, so it is highly likely that the second level also featured the same theme.[3]

The most recent and best preserved of the Christological cycles (layer III) belongs to the most extensive of the decorative campaigns undertaken in the church, that of Pope John VII (705–7).[4] The mural was executed on a single layer of plaster containing vegetal fibres, and has a fresco underpainting enhanced with brushstrokes added in lime. The mural was composed of twenty scenes arranged in two registers, enclosed by a frame with red and white borders, and set above a series of medallion portraits of the apostles, with a fictive *velum* beneath (Plates 42–3, 45–6).

Below the John VII layer, fragments of two earlier pictorial phases can be also identified. Their reading, made difficult by the state of preservation of the painted surfaces, depends principally on the traces of the framing systems that organized the figural scenes (Figure 2). The oldest cycle (layer I), of which only a few scenes can be identified, depicts the Passion and

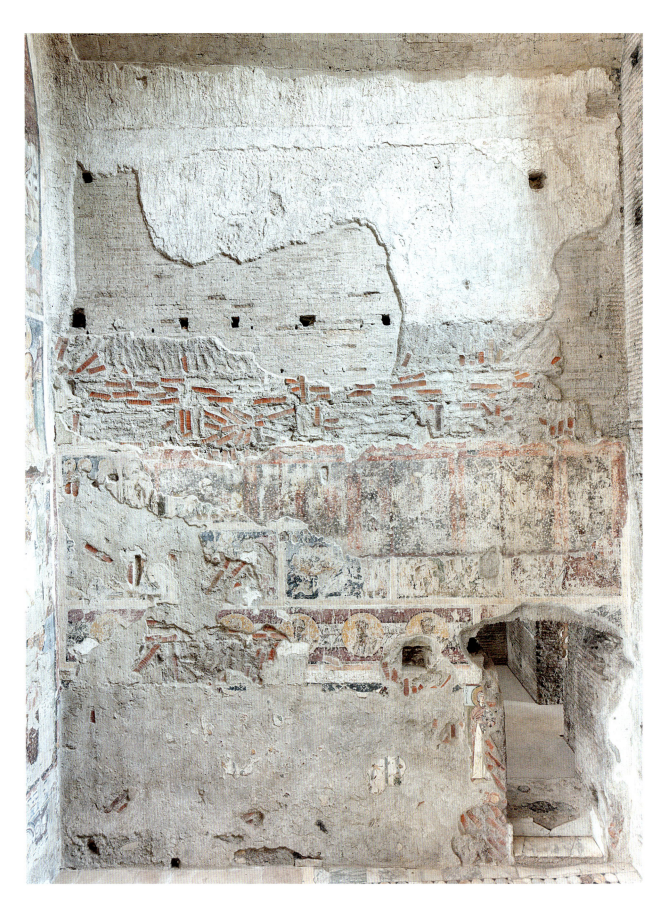

1 Santa Maria Antiqua, west wall of the sanctuary (photo: Gaetano Alfano, 2015)

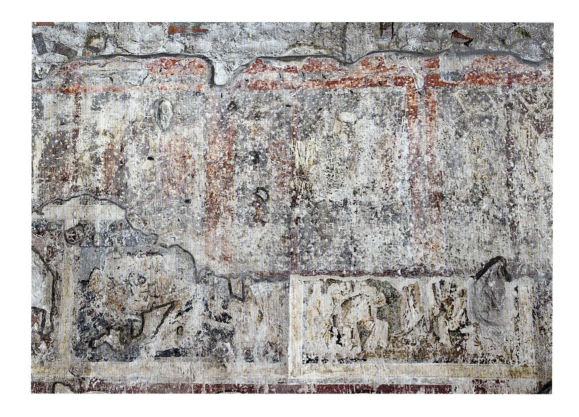

2 Santa Maria Antiqua, west wall of the sanctuary: the system of red borders that defined the spaces of the Christological cycle
(photo: Paola Pogliani, 2013)

3 Santa Maria Antiqua, west wall of the sanctuary: the dark-red vertical border with white outlines of the second phase
(photo: Paola Pogliani, 2013)

is distinguished by the use of single juxtaposed red borders that divide the space into ten panels and two rectangles, distributed over two registers.[5] It was applied on a level of mortar, followed by fresco paintings executed primarily with earth-based pigments.

Above this there are traces of a second pictorial phase (layer II) entirely painted *a secco*, using a very thin lime wash.[6] There are traces of borders and a grey-blue background that now looks like an extended 'stain', interfering with the reading of the images from the earlier cycle. Also belonging to this second phase is a system of red borders that defined the spaces intended for the narrative scenes (Figure 2). These have the same scale as the rectangles used for the same purpose in the John VII phase, which led Nordhagen to interpret them as a preparatory stage for that redecoration.[7] However, on the basis of a detailed analysis of the traces of painting on the west wall of the sanctuary, the authors of this paper are convinced that they must be attributed to a separate campaign. The best-preserved fragments reveal patches of actual painting. One example is the small section of a dark-red vertical border, composed of red ochre with white outlines in lime wash (Figure 3). This demonstrates that it was not simply a preparatory design, but rather an actual painting. In addition, the analysis of the grey ground showed that it was a background covering the entire area inside the borders, obtained from a black vegetal pigment. on which there are also faint traces of Egyptian blue, corresponding to the zones where the sky would have been depicted in the narrative scenes. This is conclusive evidence for the existence of a third pictorial cycle, which used a system of painted frames that, according to Manuela Viscontini's reconstruction, must have been organised in ten panels over two registers.[8] Unfortunately, however, nothing remains that would permit an identification of the subject matter.

The 'Angelo bello' and the image of Saint Anne

On the west wall of the sanctuary, next to the entrance to the Chapel of the Holy Physicians (Figure 1), John VII's decorative campaign preserved the painted icon belonging to an earlier phase, depicting Saint Anne holding the infant Mary (Figure 4).[9] Anyone closely examining Saint Anne's face (Figure 5) cannot help but notice its extraordinary technical and artistic accomplishment, with thick brushstrokes used to suggest her three-dimensionality, the delicate definition of the features, and the vibrant highlights. Set against the background, Anne's face has been constructed with applications of paint following methods previously encountered in the *Angelo bello* of the 'palimpsest' wall (Figure 6), defined by the use of rich strokes of lime applied in an articulated sequence.[10] The analysis of the formal techniques used to create the faces of both figures, undertaken by means of a targeted graphic and micro-photographic campaign of documentation (Figures 7–8), has revealed the presence of at least nine applications of paint, which correspond to the number of steps employed by the painter to create the faces (Figure 9). An identical grey application was used for the shadows, green for the *Angelo bello* and brown for the Saint Anne, onto which were painted the backgrounds for the pink and yellow flesh tones, with the shadows again highlighted with green and brown. Finally, the facial features were delineated in reddish brown, with black for the pupils and nostrils, and white highlights.

The similarities observed between the *Angelo bello* and the Saint Anne are not limited to the applications of paint or the structural analysis of the surfaces (Figure 9), but also include the

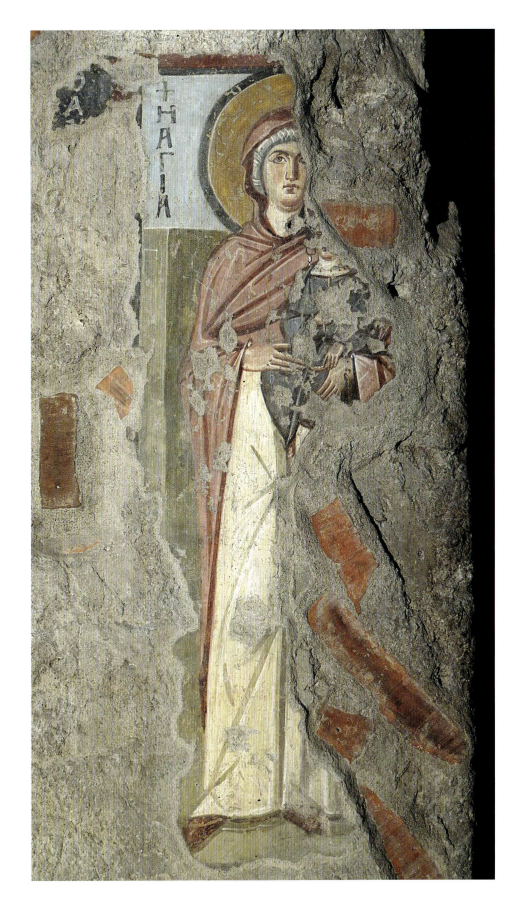

Santa Maria Antiqua, west wall of the sanctuary: panel with Saint Anne holding the infant Mary (photo: Giulia Bordi, 2013)

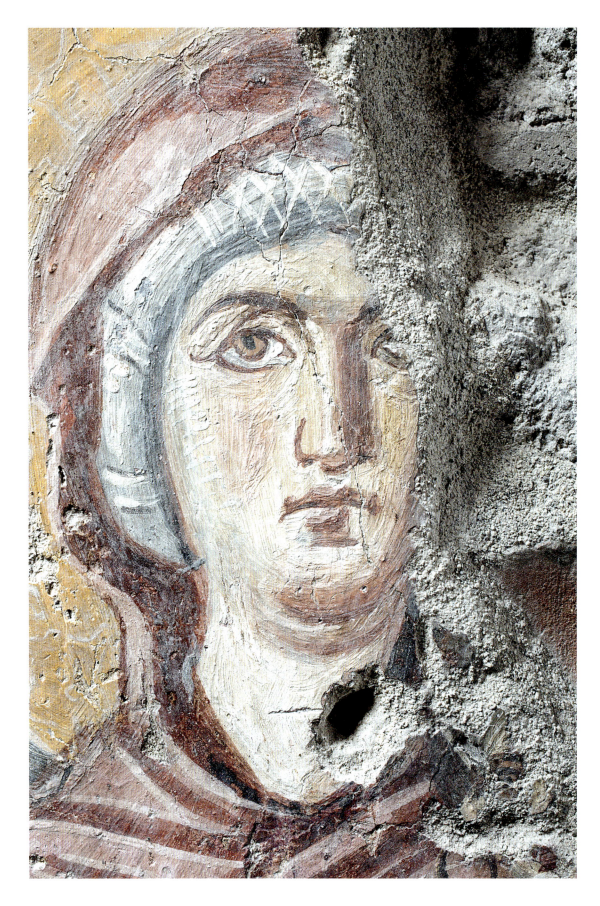

Santa Maria Antiqua: Saint Anne's face
(photo: Gaetano Alfano, 2015)

PALIMPSESTS AND PICTORIAL PHASES

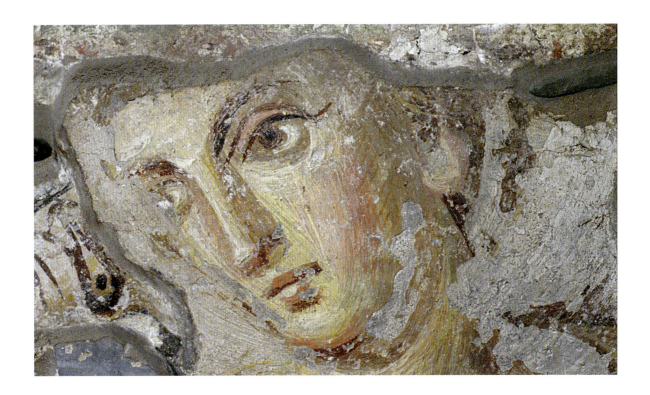

Santa Maria Antiqua, 'palimpsest' wall: the face of the *Angelo bello*
(photo: Paola Pogliani, 2000)

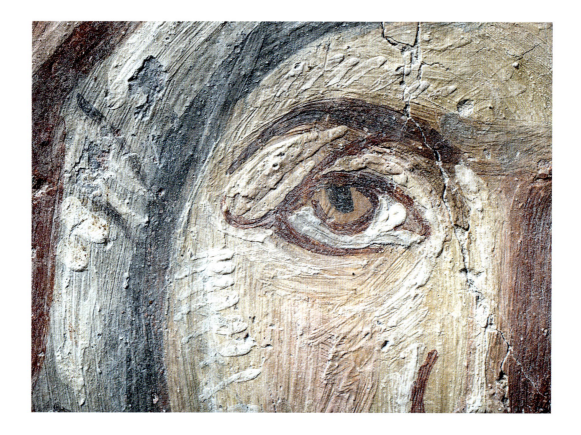

7 Santa Maria Antiqua, Saint Anne: the sequence of strokes for the the eye
(photo: Gaetano Alfano, 2015)

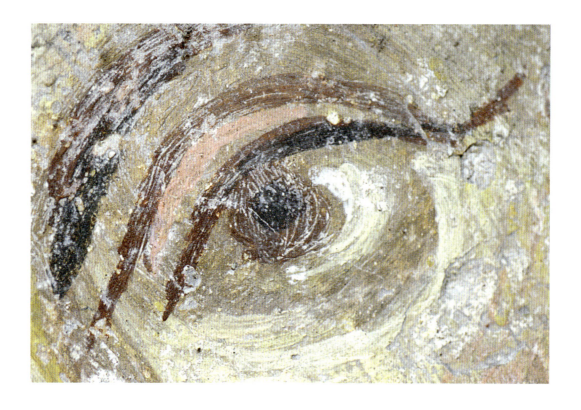

8 Santa Maria Antiqua, *Angelo bello*: detail of the sequence of strokes for the the eye
(photo: Paola Pogliani, 2000)

PALIMPSESTS AND PICTORIAL PHASES

Santa Maria Antiqua, Saint Anne and the *Angelo bello:* the colour painting sequence
(Paola Pogliani, 2013)

composition of the plaster and the types of pigment employed. The use of similar constituent materials in medieval workshops that are close in time and space is usually considered significant only for understanding the painting itself. In this case, however, the use of Egyptian blue in both examples is noteworthy, and even more so is the use of the same mixture of pigments, in identical quantities and with similar granulometry, to create the green backgrounds. This last colour is a light and slightly cold shade, readily distinguishable from green pigments derived from natural earths that are common in early medieval mural painting and more practical because usable in pure form. The green employed in the two Santa Maria Antiqua figures was created ad hoc to obtain the pastel ground that defines the space occupied by the figures. Its uniqueness is so distinctive that may be used as evidence for attributing the works to the same painter or workshop. Indeed, it is even possible to go so far as to hypothesise, following Werner Schmid, that the artist/s working on the murals with the *Angelo bello* and Saint Anne shared the same dish of pigments.

This important discovery, together with the technical analysis of the faces and of the materials employed, allows us to suggest that the Saint Anne belongs to the same pictorial context as the *Angelo bello*, for which a date is proposed in the last third of the sixth century.[11]

Paola Pogliani

The materials

The identification and analysis of the materials used in the wall paintings of Santa Maria Antiqua form an integral part of the research project undertaken by the Università degli Studi della Tuscia with the aim of investigating the techniques used to create murals in the different historical phases of the site, ranging from the sixth to the ninth century. The results of the analysis are useful to illuminate the complex stratigraphic sequence of the pictorial phases, and to clarify their chronology.[12] The examples presented below are significant in this respect.

The Christological cycles on the walls of the presbytery

Three pictorial phases are visible on the west wall of the sanctuary (Figure 2). Two of these, the oldest (phase I) and the most recent (phase III), are painted on a plaster, while the intermediate phase (phase II) is dry-painted (*a secco*) directly on the previous painting.

The plasters can be distinguished from one another by their physical characteristics. Phase I plaster is made of a white lime-rich mortar with few aggregates of quartz sand and limonite minerals (Figure 10); while the layer of the phase of John VII (phase III) is characterised by a very white mortar, rich in lime with little quartz sand, and traces of vegetable fibres and protein substances (Figure 11). Both phases exhibit fresco painting with lime finishing. The oldest painting is made with pigments based on natural earths and ochre. The red colour of the frame was obtained from red earth mixed with carbon black, probably intended to darken the hue.

10 Santa Maria Antiqua, west wall of the sanctuary, the phase I plaster: microphotographs of sample cross-sections under reflected light and ultraviolet fluorescence. Objective magnification 10× (photo: Giorgia Agresti and Claudia Pelosi)

11 Santa Maria Antiqua, west wall of the sanctuary, phase II (John VII): microphotographs of sample cross-sections under reflected light and ultraviolet fluorescence. Objective magnification 10× (photo: Giorgia Agresti and Claudia Pelosi)

12 Santa Maria Antiqua, phase II, cross-section of the mortar: microphotographs of sample cross-sections under reflected light and ultraviolet fluorescence. Objective magnification 20× (photo: Giorgia Agresti and Claudia Pelosi)

13 Santa Maria Antiqua, phase II: microphotographs of sample powder embedded with Canada balsam, under parallel and crossed polars. Objective magnification 20× (Egyptian blue grains) (photo: Giorgia Agresti and Claudia Pelosi)

The entire pictorial cycle of John VII's campaign has been examined to determine the pigments used, and the results are the following:

GREEN EARTH, CELADONITE TYPOLOGY	The pigment powder, embedded in Canadian balsam, appears heterogeneous under the optical-mineralogical microscope, with particles measuring more than 20 μm. The pigment grains are birefringent and of greenish-brown colour with irregular contours. Other grains appear smaller and transparent or green in colour. The Raman spectrum of pigment samples is characterised by medium intensity bands at 121, 134, 148 159, 166 and 496 cm^{-1} that are typical of green earths. SEM-EDS analysis revealed the presence of silicon, aluminium, iron, potassium, magnesium and sodium with the following percentages: Si (1.98%), Al (0.825%), Fe (0.428%), K (0.259%), Mg (0.242%) and Na (0.202%).
YELLOW OCHRE, GOETHITE MINERAL	The pigment powder, observed under the optical-mineralogical microscope, is characterised by grains of different colours, ranging from yellow to red and black, and transparent with dimensions of about 20 μm. All particles are birefringent except the black ones that are made of amorphous carbon. SEM-EDS analysis revealed the presence of Si (3.68%), Al (1.63%), Fe (1.25%), K (0.768%).
RED OCHRE, HEMATITE MINERAL	The pigment powder, under the optical-mineralogical microscope, appears to be constituted by red grains with irregular edges and more than 20 μm in size. The grains also contain some black particles; and when observed under crossed polars they appear birefringent. The Raman spectrum is characterised by a sharp and strong band at 291, two medium intensity bands at 222 and 407 cm^{-1}, and three weak bands at 177, 609, 659 and 1310 cm^{-1}; all bands are characteristic of hematite. SEM-EDS revealed the presence of Fe (6.04%), Si (2.06%) and Al (0.895%), in one examined point; and Fe (52.6%), Pb (3.37%), Mg (0.974%) and Si (0.665%), in a second point. All elements are typically present in red-earth-based pigments.
CARBON BLACK, VEGETAL TYPOLOGY	The pigment powder, observed under the optical-mineralogical microscope, is constituted by black particles less than 20 μm in size. The particles show irregular edges and are not birefringent if observed with cross polars. Little grains of calcium carbonate are also visible in the sample. Raman spectrum shows the two typical bands of carbon black-based pigment at 1336 and 1590 cm^{-1}.
EGYPTIAN BLUE	The pigment powder shows light blue particles, birefringent under crossed polars. The blue grains have a glassy appearance and are less than 20 μm in size. Raman spectrum gives the typical bands of Egyptian blue at 431, 465, 1086 cm^{-1}.

The second phase, as noted previously, was painted using a *secco* technique applied directly on the surface of the earlier pictorial layer. The cross section of this layer shows a thin preparatory layer of a light-grey colour (Figure 12), onto which the painting was applied. The presence of superimposed materials, such as waxes and other protective substances added during modern restorations of the paintings, prevented a conclusive identification of the binder used. The presence of lead-based pigments, however, incompatible with the fresco technique, suggests that it was an organic protein binder, whose traces have been found in the analysed samples.

The red pigment of the frames is composed of red earth and minium (red lead) (Figure 12). The presence of lead, highlighted by SEM-EDS analysis, confirmed the use of pigments incompatible with the use of lime as a binder for the painting. The analysis of this particular sample, taken from inside the pictorial field, adjacent to the frame, has highlighted a new element of great interest for the art historical studies aimed at understanding the pictorial stratigraphy of the wall. The analysis, in fact, showed also the presence of Egyptian blue applied on the grey ground, the latter made with carbon black of vegetal origin, presumably vine black (Figure 13).

The 'Angelo bello' and Saint Anne

The analysis of the mortars used in the palimpsests permits a comparison between the composition and structure of the paintings' preparatory layers. For example, it emerged that the mortars used to for the *Angelo bello* on the 'palimpsest' wall and the panel with Saint Anne on the right wall are very similar in composition and stratigraphic pattern. Both paintings were made on a single preparatory layer composed of white lime-based mortar with little quartz sand and other aggregates (Figures 14–15).

Furthermore, the cross-sections obtained from samples of the green background in the two paintings demonstrate a clear correlation. In both cases, in fact, the painting layers appear homogeneous, and composed of a mixture of yellow ochre and carbon black. It is interesting to note that the combination of yellow ochre and carbon black of vegetal origin (vine black) produces a green hue, testifying to the painters' considerable knowledge of the optical properties of pigments.

The observation of these green samples under an optical-mineralogical microscope has revealed the presence of yellow ochre, whose colour is due to the birefringent goethite grains, with green-brown and small black particles. SEM-EDS analysis, executed in two different areas, revealed the presence of Si (2.51%), Al (0.971%) and Fe (0.768%) in the first one, and of Cu (9.99%), Sn (2.63%), Si (1.82%), Al (0.679%), Fe (0.388%) and Cl (0.333%) in the second area, confirming the mixture of yellow ochre and carbon black.[13]

A further discovery obtained from this scientific analysis concerns the presence of traces of Egyptian blue in the background of both paintings. XRF analysis, performed by ENEA on the upper part of the background in the Saint Anne painting, showed the presence of Cu and Si, which are elements of Egyptian blue. In order to obtain a definite identification of this blue pigment, a micro sample was taken for laboratory analysis (Figure 16). This sample was examined under an optical mineralogical microscope and using SEM-EDS analysis. In the first case, small blue birefringent particles (about 5 μm) have been observed, showing also light pleochroism and blue-green interference colours typical of Egyptian blue. SEM-EDS further

14 Santa Maria Antiqua, mortar of the Saint Anne mural: microphotographs of sample cross-sections under reflected light and ultraviolet fluorescence. Objective magnification 20× (photo: Giorgia Agresti and Claudia Pelosi)

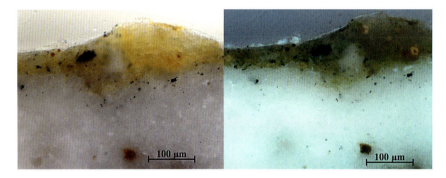

15 Santa Maria Antiqua, mortar of the *Angelo bello*: microphotographs of sample cross-sections under reflected light and ultraviolet fluorescence. Objective magnification 20× (photo: Giorgia Agresti and Claudia Pelosi)

16 Santa Maria Antiqua, Saint Anne, background: microphotographs of sample powder embedded with Canada balsam, under parallel and crossed polars. Objective magnification 40× (Small pale blue grains of Egyptian blue are visible, associated with calcium carbonate binder) (photo: Giorgia Agresti and Claudia Pelosi)

17 Santa Maria Antiqua, *Angelo bello*, background. Microphotographs of sample powder embedded with Canada balsam, under parallel and crossed polars. Objective magnification 10x (An aggregate of Egyptian blue grains is visible) (photo: Giorgia Agresti and Claudia Pelosi)

confirmed the presence of Cu and Si, elements that allow us to identify the pigment as Egyptian blue.

The pigment sample taken from the background of the Angelo bello (Figure 17) was also observed under an optical mineralogical microscope. Different kinds of particles were found: small green-blue grains, transparent particles, yellow and red grains, irregular carbon black particles, and deep blue birefringent crystals of Egyptian blue.

Claudia Pelosi and Giorgia Agresti

1. The results presented here draw on the larger 'Progetto Santa Maria Antiqua' of the Università degli Studi della Tuscia, directed by Maria Andaloro between 1997 and 2014, in which the present author, together with Giulia Bordi, Manuela Viscontini, and Mariella Ranieri, studied, documented, and mapped the painted plasters preserved in the church, and identified the technical procedures and materials used in creating the murals. This research was undertaken in collaboration with the Laboratorio di Diagnostica per la Conservazione e il Restauro 'Michele Cordaro' of the Università degli Studi della Tuscia, coordinated by Claudia Pelosi, and the X-ray fluorescence studies were made possible through a collaboration with ENEA and 'Ars Mensurae'. See Silviarita Amato and others, 'A Multi-Analytical Approach to the Study of the Mural Paintings in the Presbytery of Santa Maria Antiqua al Foro Romano in Rome', *Archaeometry*, 59.6 (2017), 1050–64 <online, doi: 10.1111/arcm.12296> [accessed 8 December 2020]. An initial campaign of studies, focusing on conservation issues and the climatic conditions of the building, formed part of a project undertaken by the Norwegian Institute in Rome.

2. For an overview of the palimpsests in Santa Maria Antiqua and the new data that emerged from the project, see Maria Andaloro, 'La parete palinsesto: 1900, 2000', in *Santa Maria Antiqua al Foro Romano cento anni dopo: atti del colloquio internazionale, Roma, 5–6 maggio 2000*, ed. by J. Osborne, J. R. Brandt, and G. Morganti (Rome: Campisano, 2004), pp. 97–111; Maria Andaloro, 'Dall'angelo "bello" ai Padri della Chiesa della "parete palinsesto"', in *Santa Maria Antiqua tra Roma e Bisanzio*, ed. by M. Andaloro, G. Bordi, and G. Morganti, (Milan: Mondadori-Electa, 2016), pp. 180–9; Giulia Bordi, 'Santa Maria Antiqua attraverso i suoi palinsesti pittorici', in *Santa Maria Antiqua tra Roma e Bisanzio*, ed. by M. Andaloro, G. Bordi, and G. Morganti, pp. 34–53; and Werner Schmid, 'Il lungo restauro di Santa Maria Antiqua e delle sue pitture', in *Santa Maria Antiqua tra Roma e Bisanzio*, ed. by M. Andaloro, G. Bordi, and G. Morganti, pp. 386–95.

3. For the reconstruction of the wall decoration, based on an analysis conducted from the scaffolding, see Manuela Viscontini, 'I cicli cristologici' del presbiterio di Santa Maria Antiqua', in *L'officina dello sguardo. Scritti in onore di Maria Andaloro*, ed. by G. Bordi, I. Carlettini, M.L. Fobelli, M.R. Menna, and P. Pogliani, 2 vols (Rome: Gangemi, 2014), I, pp. 291–6; and Giulia Bordi's contribution to this chapter.

4. Per Jonas Nordhagen, 'The Frescoes of John VII (A.D. 705–707) in S. Maria Antiqua in Rome', *Acta ad archaeologiam et artium historiam pertinentia*, 3 (1968).

5. For a detailed discussion of the dating and the various arguments proposed, please refer to Giulia Bordi's contribution to this chapter.

6. Pictorial palimpsests with phases pained in *secco* on top of earlier levels are very common in the churches of Cappadocia (Turkey), particularly in the earliest examples (VI–IX c.). These are the subject of another research project conducted by the Università degli Studi della Tuscia, focusing on their study, preservation, and research *in situ*: see Giulia Bordi, 'La chiesa di Haghios Basilios e la pittura delle origini in Cappadocia. Palinsesti pittorici', *Medioevo, natura e figura*, ed. A.C. Quintavalle, I convegni di Parma, 14 (Milan: Skira, 2015), pp. 229–38; Paola Pogliani, 'La chiesa di Haghios Basilios e la pittura delle origini in Cappadocia. Materiali e stesure pittoriche', in *Medioevo*, ed. by A.C. Quintavalle, pp. 257–64; and Maria Andaloro and Paola Pogliani, 'Techniques and materials of medieval wall painting in Cappadocia', forthcoming. A similar case may be found at the Abbey of Grottaferrata: see Maria Andaloro, 'La decorazione pittorica medioevale di Grottaferrata e il suo perduto contesto', in *Atti della IV settimana di studi di storia dell'arte medievale dell'Università di Roma 'La Sapienza'*, ed. by A. M. Romanini (Rome: L'Erma di Bretschneider, 1983), pp. 253–87; and Maria Grazia Chilosi, 'Gli affreschi duecenteschi con le storie di Mosè dell'Abbazia di Grottaferrata: storia e conservazione: Storia e lettura delle fasi esecutive degli affreschi attraverso il restauro', *Bollettino d'arte*, 94 (2009), 11–40.

7. Nordhagen, 'The Frescoes of John VII', p. 22.

8. Viscontini, 'I cicli cristologici'; and Giulia Bordi's contribution to this chapter.

9. Nordhagen, 'The Frescoes of John VII', pp. 87–90.

10. Maria Andaloro reconstructed the painting technique employed for the faces in the course of research linking the Santa Maria Antiqua paintings to early medieval Roman icons. The intention was to build a database of painting techniques in both mural and portable images that would enable closer structural comparisons; see Maria Andaloro, 'Le icone a Roma in età preiconoclasta', in *Roma fra Oriente e Occidente. Atti delle Settimane di Studio del Centro Italiano di Studi sull'Alto Medioevo, 49*, (Spoleto: Centro Italiano di Studi sull'Alto Medioevo, 2002), pp. 719–53; and Andaloro, 'La parete palinsesto', pp. 97–111.

11. See Bordi, 'Santa Maria Antiqua attraverso i suoi palinsesti pittorici', p. 43, with earlier bibliography, and her contribution to this chapter; and Maria Andaloro, 'Dall'angelo "bello" ai Padri della Chiesa', p. 188.

12. This investigation, summarised in the present contribution, was undertaken between 2002 and 2009, with further analysis in 2013. See Michela Pasquali, 'Studio dei pigmenti utilizzati nell'area presbiteriale della chiesa di Santa Maria Antiqua al Foro Romano' (unpublished Master's thesis, Università degli Studi della Tuscia, 2008); and Amato and others, 'A Multi-Analytical Approach'.

13. The presence of copper (Cu) and tin (Sn) can be associated with bronze residues of the metal cramps used during the first restoration work in the twentieth century.

ICONOGRAPHY

PER OLAV FOLGERØ

Expression of Dogma: Text and Imagery in the Apsidal Arch Decoration of Santa Maria Antiqua

Preamble: the frescoes of John VII (705–7 CE) on the apsidal arch. Symmetry and expression of dogma

The frescoes on the apsidal arch of Santa Maria Antiqua (Plates 32, 33, 50: K1.2), with the exception of the so-called 'palimpsest' wall to the right of the apse (Plates 35, 37, 50: K1.4), are all dated to the pontificate of John VII.[1] Following Gordon Rushforth's pioneering description and Wladimir de Grüneisen's later contribution, the definitive mapping of the layers of fresco and the identification of scenes, saints, and *tituli* was undertaken by Per Jonas Nordhagen.[2]

The iconographic programme may be divided into two sections, separated by a thick dark border. The upper section, at the top of the triumphal arch, features an *Adoration of the Crucified* divided into two registers, with hosts of adoring angels together with seraphim and cherubim surrounding the figure of Christ on the Cross above, and men below (Figure 1).[3] A Greek inscription, or text-*catena*, separates the two registers, and constitutes the central subject of this study. The lower section, which belongs to the same fresco layer, shows four popes and four Church Fathers symmetrically placed on two levels at both sides of the arch, two on each side. Of particular significance for the iconographical reading of the programme is the fact that the pope depicted to the far left, distinguished by a square blue halo, is the patron of the sanctuary, John VII, while the pope farthest to the right is Martin I (649–55), identified by the *titulus* 'SCS MARTINVS PP ROMANVS' (Figure 2).[4] The symmetrical positions of the two popes, at the two extremities of the arch, are an intentional tribute from John VII to Martin, the pope who convened the strongly anti-monotheletic and pro-Chalcedonian Lateran Synod in Rome in 649.[5] Moreover, John is flanked by Pope Leo I (440–61), the father of Chalcedonian Christology, clearly identified by Nordhagen's tracing of the letters in the *titulus* (Figure 3). The fourth cleric,

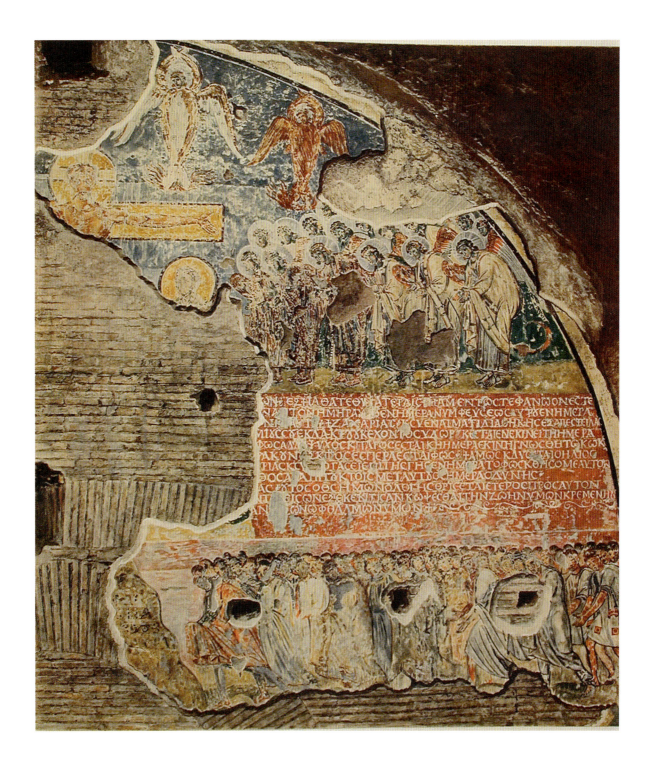

1 Santa Maria Antiqua, the preserved right side of the *Adoration of the Crucified*. Watercoloured photograph by Wilpert and Tabanelli (after Wilpert, *RMM*, IV, pl. 155)

EXPRESSION OF DOGMA

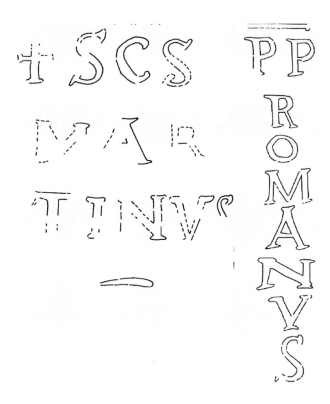

2 The *titulus* 'SCS MARTINVS PP ROMANVS' (tracing by Nordhagen, 'The Frescoes of John VII', plates 111–2, figs 13a–b)

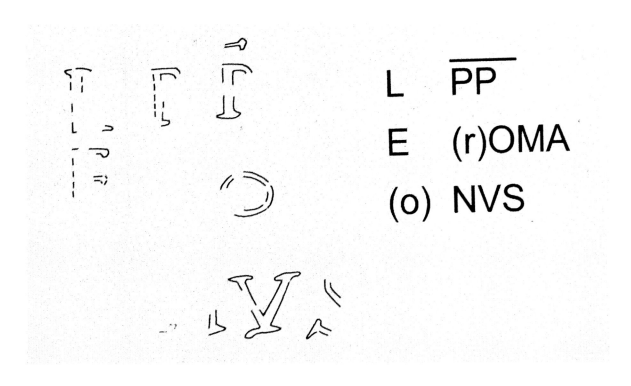

3 The *titulus* 'LE[O] PP [R]OMANVS' (tracing by Nordhagen, 'The Frescoes of John VII', pl. 109, fig. 7)

standing next to Martin I, cannot be identified; however, the *titulus* '[R]OMANV[S]' clearly tells us that he is a Roman pope.[6]

Pope John VII's programme for the apse is completely lost.[7] Previous attempts to read the soteriological meaning of the arch frescoes, however, have generally neglected one element, the area immediately below the multitude of men assembled in adoration at the foot of the Cross. What remains of this area, which must have originally spanned the entire width of the arch, was found nearly obliterated when the church was excavated in 1900–1.[8] Nordhagen described it in detail: 'An area to the extreme right end [is preserved] in its full height, showing a dark background divided into two zones [...]. Against this background [...] is the slanting right side of a yellow object.'[9] Delineated by straight black contours, the 'yellow object' seen at the point where the painted plaster breaks off is clearly tilted to the right, and angled about sixty degrees. Placed inside the broad dark border that encloses the entire *Adoration* scene on the arch, this lost strip was thus a part of, and therefore thematically linked to, the scene above it. In his reconstruction of the overall composition, de Grüneisen inserted a frieze of lambs in this place, a common feature in Roman apsidal imagery (Figure 4a).[10] Yet, since the remaining fragment shows no trace of the city walls of Bethlehem or Jerusalem that are normally found at either side of similar friezes, and from which the lambs proceed, de Grüneisen's solution must be discarded. I have argued elsewhere in favour of identifying the 'yellow slanting object', whose straight contours suggest a square shape (Figure 5), and which is located immediately below the large *Crucifixion*, as part of a sarcophagus (perhaps its raised lid), such as can be found in scenes of *The Dead Rising from their Graves* (Figure 4b).[11] Hence, it might be suggested that the lost zone once featured a *Resurrection*, the resurrection of the 'saints who slept in their graves' which took place at the moment of Christ's death on Golgotha (Matthew 27.52).

Dogma

Since this contribution focuses on the expression of dogma, it is necessary to first introduce it. In 1968, Nordhagen, following a suggestion by Rushforth, advanced the thesis that the *Crucifixion* should be read as an *Adoration of the Lamb* in which the Lamb is replaced by the Crucified Christ, a symbolic inversion (New Testament to Old) that would make the fresco an illustration of the Adoration of the Lamb from the Book of Revelation.[12] The thesis relies on a reading of the Eighty-Second Canon of the Quinisext Council (692 CE), which forbade representations of Christ in the form of a lamb.[13]

John VII and his collaborators, in their attempt to manifest the Church's official Christology, were certainly aware of the weight of the canon in the struggle against Monotheletism. Still, as James Breckenridge has stressed, the canon was but an iconographical equivalent to the Chalcedonian, anti–monotheletic Christology of the Sixth Ecumenical Council (680–1).[14] Indeed, the acts of the *Quinisextum*, after reaffirming the faith proclaimed at Chalcedon and at the Sixth Ecumenical Council, proceed in the First Canon to anathematise, name by name, the monotheletic theologians and protagonists of the seventh century, perpetuating the anti-heretical drive of the previous council. Thus, my point of departure will be that in Santa Maria Antiqua John VII, a militant anti-monothelete, was actively advocating the Christology hammered out by the Sixth Ecumenical Council, as well as its iconographical equivalent, the Eighty-Second

EXPRESSION OF DOGMA

de Grüneisen 1911

4a Reconstruction by de Grüneisen of the apsidal wall of Santa Maria Antiqua (Sainte-Marie-Antique, pl. 50)

Nordhagen/Folgerø 2008

4b Reconstruction by Folgerø and Nordhagen (2008) of the the apsidal arch, amending 'a'

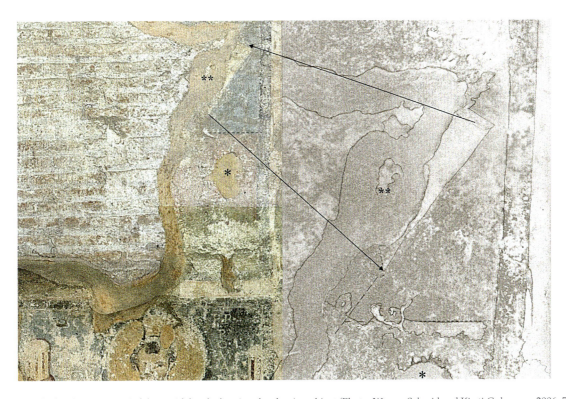

5 Left: detail of a 'photo-mosaic' of the apsidal arch showing the slanting object (Photo: Werner Schmid and Kirsti Gulowsen, 2006–7)
Right: Photograph of the extant intonaco fragment in the lowest zone of the Adoration of the Crucified covered by a tracing to enhance the contrasts (after Nordhagen, 'The Frescoes of John VII', pl. 65a)

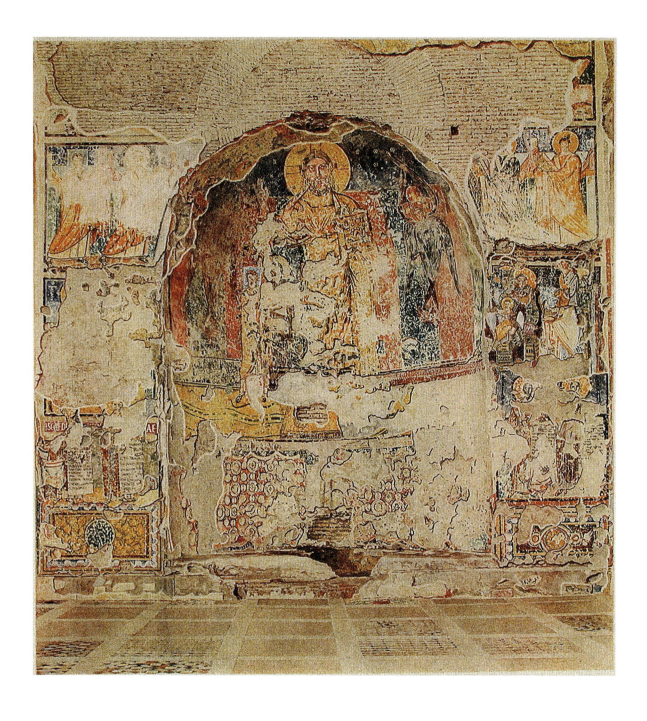

6 Apse and apsidal arch. Watercoloured photograph by Wilpert and Tabanelli. On the apsidal arch, lower zone, John VII and Martin I are shown in corresponding (symmetrical) positions. Beside John VII is another pope, probably Leo I.
(after Wilpert, *RMM*, IV, pl. 151)

Canon of the *Quinisextum*. Some doubts must remain, however, as to the existence of a direct connection between the canon and the *Adoration of the Crucified*.

Jean-Marie Sansterre was seemingly the first to suggest that in John VII's programme for Santa Maria Antiqua there is an emphasis on the Chalcedonian Christology of the Sixth Ecumenical Council. He also stressed its anti-monotheletic bias, evidenced not only by the inclusion of Leo I and Martin I on the triumphal arch, and by the fact that Leo was additionally portrayed holding a scroll with a quote from his *Tomus ad Flavianum* in a fresco, now lost, at the entrance of the Oratory of the Forty Martyrs, but also, following Anna Kartsonis, by the prominence given to the *Anastasis* panels on the church's portals.[15] The strong anti-monotheletism of John's programme has also been underlined by Charles Barber, who states that 'as a product of the Sixth Ecumenical Council, it [the programme] provides a broader demonstration of the concerns of the 82nd Canon'.[16]

The 'Exposition of Faith' professed at the Sixth Ecumenical Council does indeed celebrate Leo's name and creed:[17]

> We hold there to be two natural principles of action in the same Jesus Christ our lord and true God, which undergo no division, no change, no partition, no confusion, that is, a divine principle of action and a human 'principle' of action, according to the godly-speaking Leo, who says most clearly: *'For each form does in communion with the other that activity which it possesses as its own, the Word working that which is the Word's and the body accomplishing the things that are the body's'*.[18]

Leo's maxim, taken from his *Tomus ad Flavianum*, appears in key positions in Santa Maria Antiqua, in the strata of Martin I and John VII, indicating that they both wished to pay homage to him. For Sansterre, Leo's inclusion in the frescoes and his programmatic placement alongside John VII on the side of the triumphal arch (Figure 6), supports a reading of the decorative programme firmly rooted in the Christology of the Sixth Ecumenical Council.

Within this interpretive frame it is worth looking also at the *Resurrection of the Saints* in the lower zone of the *Adoration*. Following the programmatic positions outlined above, the Resurrection motif expresses through an image the deepest soteriological meaning of *Lógos Sarx* (Word made Flesh): God's descent, in the human nature of Christ, was the condition for man's ascent and salvation made possible through Christ's triumph over death. It has to be stressed that the reading of the arch of Santa Maria Antiqua in dogmatic terms does not exclude a parallel liturgical reading, nor does it prevent an eschatological interpretation. This highly 'cerebral' iconography must have been planned to appeal to different mindsets and contexts.[19]

The text-'catena' and its typological meaning

The right half of the Greek inscription on the triumphal arch is preserved almost in its entirety (Figure 2), while only a small fragment of plaster with a few letters remains *in situ* at the extreme left side of the wall.[20] The content of this part of the *catena* is, however, wholly lost (Figure 7). The text on the preserved right side of the *catena* has the following composition:

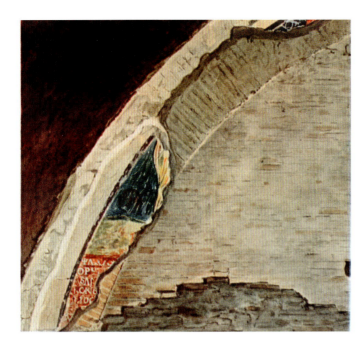

7 Left side of the apsidal arch, fragment of *catena*. Watercoloured photograph by Wilpert and Tabanelli (after Wilpert, *RMM*, IV, pl. 156,1)

1 Canticles 3.11
 a Zechariah 9.11
 b Zechariah 14.6–7

2 Amos 8.9–10

3 Baruch 3.36 (in the *catena* presented under the name of Jeremiah).
 a Zechariah 12.10/ John 19.37[21]
 b Deuteronomy 28.66

Following the transcription by Rushforth, the text was recorded by de Grüneisen in a rather mediocre 'tracing' and in a photograph.[22] It was later published in every epigraphic detail in a tracing and with an amended transcription by Nordhagen (Figures 8–9), enriched by a new reading by the Norwegian theologian Einar Molland.[23] Several scholars have since commented on it including Beat Brenk who, referring to patristic sources, found that the text is typologically related to the Passion.[24] William Tronzo was the first to notice that the verses deriving from Zechariah 14.6–7, Amos 8.9–10 and John 19.37 were constituents of the Jerusalem Good Friday rite of the seventh century.[25] No less important is Kartsonis's observation that 'the surviving selection of biblical quotes parallels the ones chosen by Cyril of Jerusalem in his Catechetical Lecture 13'.[26] This evidence shows that parts of our *catena* can unquestionably be traced to Palestine and, as I have argued elsewhere, this means that it comes from the Sabaite tradition in Jerusalem.[27]

What was the intention behind the Santa Maria Antiqua text-*catena*? The Old Testament verses, their typological meaning, as well as the meaning inherent in the way they are being linked all suggest that the message of the preserved right part of the *catena* has to do with the Passion of Christ. This holds particularly true for the linking of Zechariah 14.6–7 and Amos 8.9–

8 The catena (tracing by Nordhagen, 'The Frescoes of John VII', pl. 125)

[σαλομ]ΩΝ ⳩ ΕΞΗΛΘΑΤΕ Θ[υγ]ΑΤΕΡΑΙC ΙΗΛΜ ΕΝ ΤΩ CΤΕΦΑΝΩ ΟΝ ΕCΤΕ (i) Canticles iii. 11.
[φάνωσε]Ν Α[ὐ]ΤΟΝ Η ΜΗΡ ΑΥ[τ]ΟΥ ΕΝ ΗΜΕΡΑ ΝΥΜΦΕΥCΕΩC ΑΥΤΟΥ ΕΝ ΗΜΕΡΑ
[εὐφροσύ]ΝΗ[ς] ΑΥΤΟΥ ⳨ ✠ ΖΑΧΑΡΙΑC ⳨ Κ, CΥ ΕΝ ΑΙΜΑΤΙ ΔΙΑΘΗΚΗC ΕΞΑΠΕCΤΕΙΛΑC (ii) a. Zacharias ix. 11.
[δεσ]ΜΙΟΥC COY ΕΚ ΛΑΚΚΟΥ ΟΥΚ ΕΧΟΝΤΟC ΥΔΩΡ ⳨ Κ, ΕCΤΑΙ ΕΝ ΕΚΙΝΕΙ ΤΗ ΗΜΕΡΑ b. xiv. 6, 7.
[οὐκ ἔσται] ΦΩC ΑΛΛΑ ΨΥΧΟC Κ, ΠΑΓΟC ΕCΤΑΙ Κ, Η ΗΜΕΡΑ ΕΚΙΝΗ ΓΝΩCΘΗ ΤΩ ΚΩ Κ,
[οὐχ ἡμέ]ΡΑ Κ, ΟΥ ΝΥΞ Κ, ΠΡΟC ΕCΠΕΡΑ ΕCΤΑΙ ΦΩC ⳨ ✠ ΑΜΩC·Κ, ΔΥCΕΤΑΙ Ο ΗΛΙΟC (iii) Amos viii. 9. 10.
[μεσημβ]ΡΙΑC Κ, CΥ[σκ]ΟΤΑCΕΙ ΕΠΙ ΤΗC ΓΗC ΕΝ ΗΜΕΡΑ ΤΟ ΦΩC Κ, ΘΗCΟΜΕ ΑΥΤΟΝ
[ὡς πέν]ΘΟC Α[γ]ΑΠΙΤΟΥ Κ, ΤΟΙC ΜΕΤ ΑΥΤΟΥ ΟC ΗΜΕΡΑ ΟΔΥΝΗC ⳨
[Ιερεμί]ΑC ⳨ ΟΥΤΟC Ο ΘC ΗΜΩΝ ΟΥ ΛΟΓΗCΘΗCΕΤΑΙ ΕΤΕΡΟC ΠΡΟC ΑΥΤΟΝ (iv) Baruch iii. 36.
[καὶ ὄψο]ΝΤΑ[ι] ΕΙC ΩΝ ΕΞΕΚΕΝΤΙCΑΝ Κ, ΩΨΕCΘΑΙ ΤΗΝ ΖΩΗΝ ΥΜΩΝ ΚΡΕΜΕΝΗΝ (v) a. John xix. 37.
[ἀπέν]ΑΝ[τι τ]ΩΝ ΩΦΘΑΛΜΩΝ ΥΜΩΝ ✠ ⳨ b. Deuteronomy xxviii. 66.

9 Large inscription. Transcription: Rushforth/Nordhagen (after Nordhagen, 'The Frescoes of John VII', p. 48)

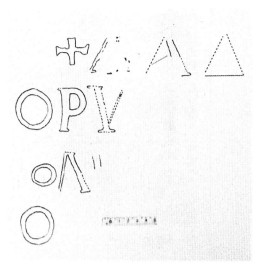

10a Tracing of left side of the inscription by Per Olav Folgerø (May 2008)

10b The same tracing with Folgerø's suggestion that the letters are 'ΔΑΔ', as an abbreviation for 'David'

10: it parallels the way they are coupled in Cyril's *Cathechesis* for Good Friday (13, 24–5) where they typologically refer to the occlusion of the sun lasting from the sixth to the ninth hour. The concluding sequence linking Baruch 3.36, John 19.37/Zechariah 12.10, and Deuteronomy 28.36 seems, however, to have Christological overtones. As highlighted by Cyril, the statement in Baruch ('He is our God, no other will be numbered beside him') proves that the one Incarnated is God.[28] Since in our *catena* Baruch is linked to the verse stating that 'they shall look on him whom they pierced' (John 19.37/Zechariah 12.10), the same sentence links the divine supremacy and the human vulnerability and suffering of Christ—his two natures. Finally, the quotation from Deuteronomy about 'life hanging', linked by Cyril to the passage in Numbers 21.9 about the brazen serpent, possibly refers to eternal life through Christ crucified.[29]

In Canticles 3.11, the verse opening the right side of the *catena*, reads: 'Go forth, O ye daughters of Jerusalem, and behold King Solomon with the crown wherewith his mother crowned him in the day of his espousals, and in the day of the gladness of his heart' (KJV) This is the only verse from Solomon's poem included in the Good Friday liturgy. In the Thirteenth Catechesis of Cyril of Jerusalem, Canticles 3.11 is typologically linked to the coronation and mocking of Christ.[30] The text appears in two surviving Italo-Byzantine manuscripts—one in the Vatican Library (Biblioteca Apostolica Vaticana, MS gr. 771, fol. 184ᵛ), and the other at Grottaferrata (*Crypt*. A. δ. II)—where its reading took place at the Good Friday Vespers.[31] In MS Vat. gr. 771 the text adheres to Matthew's story about the Burial of Christ (Matthew 27.57–61).[32]

A reconstruction of the lost parts

The letters in the first part of the *catena*, on the left side, are almost illegible, so it is not possible to draw any definite conclusions as to what was once written there. From my tracing of them (Figure 10a), however, the first three letters following the initial cross sign, which in Wilpert's drawing look almost like a triple *lambda* (Figure 8), could make sense as 'ΔΑΔ' (David) (Figure 10b). This abbreviation for David is a common usage in Byzantium. If this is the case, the left

side of the *catena* opens with a poetic verse deriving from the Psalms, while in the preserved part of the inscription on the right side, in the same position, we find the Song of Songs.

The compositional symmetry of the *Adoration of the Crucified*, in which the *catena* holds a prominent position, strengthens the hypothesis that David and Solomon should appear in corresponding positions. We find a similar symmetrical placement of the two kings in the sixth-century Rabbula Gospels, on the same folio where the Birth of Christ and his Baptism are depicted, representing his theophany and epiphany.[33] In Santa Maria Antiqua, the same logic is also evident in the symmetrical positions of popes John VII and Martin I on the arch below, which has strong dogmatic implications.

The logic in having the left side *catena* opened by the Psalms, while the right opens with Canticles, must chiefly be that David and Solomon occupy key positions in the genealogy of Christ (Matthew 1.1–17), as his human ancestors. Furthermore, this choice resonates with the highly anti-monotheletic decoration of the arch. Still, one should wonder why textual symmetry was important: after all, the inscription, set very high on the wall, would be hardly discernible in the poor lighting of the church. But the strict logic of the parallel placement, including the symmetry of texts, has an importance that goes beyond the interlinking of literal meanings. The text becomes a symbol. What does it symbolise? How does the written word become symbolic in the same manner as a painting?

The text as symbol

As Laura Kendrick has shown, great Christian exegetes such as Jerome, Origen, and Maximus the Confessor stressed that the written word symbolises the 'Incarnation of the Logos'.[34] In a series of recent publications on inscriptions in Roman medieval churches, Erik Thunø argued that the mosaic inscriptions in the lower zone of apses, such as those in Santi Cosma e Damiano (Pope Felix IV, 526–30), Santa Prassede, Santa Maria in Domnica, Santa Cecilia in Trastevere (all Pope Paschal I, 817–24), and also the inscription in hexameters on the inner west wall of Santa Sabina (Pope Celestine, 422–32), written in golden letters on blue background, signify more than their purely literal meaning. According to Thunø, the written word, on a spiritual level, signifies the *Lógos* in terms of its use in the Prologue of John; in other words, that the written word means *Lógos Sarx*.[35] Located within the highly dogmatic *Adoration of the Crucified*, the *catena* appears thus to be charged with symbolic implications that raise it far above other dedicatory inscriptions in Roman apses.

The aesthetics of letters and their symbolic content

According to Guglielmo Cavallo, the beautiful white letters on a red ground in John VII's *catena* seem to emulate such luxury manuscripts as the sixth-century Rossano Gospels, where silver letters are written on purple-stained parchment; Cavallo argues that the letter forms in this inscription also draw on the imperial ambience of Constantinople.[36] At this point, we may wonder whether it is possible to extract from the collection of biblical quotes in the *catena* any further clues that might help us to interpret the arch decoration. If, in addition to its visual splendour, the inscription takes a prominent, almost dominant place in the *Adoration of the*

Crucified, as I have argued thus far, this points to its central function in unlocking the ideas expressed in the entire painting. If the letters in the *catena* are indeed meant to allude to the glowing quality of silver lettering in manuscripts, this would constitute a very subtle device, charging the inscription with a metaphorical level of meaning that transcends the pure *littera*.

In a study of early manuscripts, John Burnam listed sources for the meaning of gold and silver letters, concluding that 'silver uniformly means speech, the ability to give expression to the words of the Supreme Being'.[37] He went on to maintain that 'if silver is God's word, the canonical texts as being God's word should be reproduced in silver letters.' Psalm 12.6 is an important topos in Biblical exegesis on silver: 'The words of the Lord are pure words: as silver tried in a furnace of earth, purified seven times.' (KJV) Scholars like Ulrich Ernst, Beat Brenk, and Herbert Kessler have called our attention to a poem addressed to Charlemagne in the Godescalc Evangelistary (Paris, Bib. nationale de France, MS lat. 1203), where the purple-stained pages symbolise 'the celestial realm through the red-coloured blood of God […], the Word of God, glimmering in the majestic lustre, promises the sparkling reward of eternal life'.[38] The letters in the manuscript are written in gold. I suspect that a similar symbolism would plausibly apply also to silver letters on purple. Moreover, the Godescalc poem tells us that symbolism is not restricted to the letters but includes the colour on which they are applied, with purple standing for Christ's suffering, his blood.

Symmetry and beauty in the expression of dogma

The constellation of iconographical elements enriching the Santa Maria Antiqua triumphal arch is the variant of a general principle of visual culture that persisted from antiquity to the modern era, that of symmetry in hieratic and dogmatic scenes. In apsidal iconography, the language of symmetry is a key aid in communicating theological, dogmatic, political, and eschatological messages. Moreover, in the search for objective factors determining the perception of beauty, symmetry has always been upheld as a key aesthetic feature.[39] Symmetry adds to the perceived truthfulness of written and visual compositions, a fact that has now been proven scientifically. For instance, symmetrical arithmetic constellations, correct as well as incorrect, will be conceived as truer than asymmetric ones, simply because they are perceived as more beautiful and easier to grasp.[40]

The Santa Maria Antiqua triumphal arch uses symmetry to express with clarity its dogmatic message, particularly in the placement of Martin I and John VII. In the *catena*, the preference for symmetry indicates that a verse from the Psalms once opened the chain of texts on the lost left side, in symmetrical correspondence to Solomon's Canticle on the right side, with all their Christological and dogmatic implications. I wish to conclude by suggesting that the barely legible text of the *catena*, its 'silver' letters on 'parchment', may have been a manifesto of Salvation through the 'Incarnation of the *Lógos*', with strong anti-monotheletic connotations and in close adherence to the visual programme of the entire arch. It is possible that the whole iconography was meant to call to mind a manuscript folio, as a supreme visual representation of dogma.

* I dedicate this chapter to my friend and tutor Per Jonas, to whom I am most grateful for all inspiration, help and advice, and, not least, for the many stories that have caused our discourse to be transcended with an element of humour.

1 The date was first suggested by Joseph Wilpert, *Die römischen Mosaiken und Malereien der kirchlichen Bauten vom IV. bis XIII. Jahrhundert* (Freiburg im Breisgau: Herder, 1916) [hereafter *RMM*], pp. 666–7; later followed by Ernst Kitzinger, *Römische Malerei vom Beginn des 7. bis zur Mitte des 8. Jahrhunderts* (Munich: R. Warth, 1934), p. 40; and restated on archaeological and palaeographical evidence by Per Jonas Nordhagen, ´The Earliest Decorations in Santa Maria Antiqua and their date`, *Acta ad archaeologiam et artium historiam pertinentia*, 1 (1962), 53–72 and 'The Frescoes of John VII (A.D. 705–707) in S. Maria Antiqua in Rome', *Acta ad archaeologiam et artium historiam pertinentia* , 3 (1968), pp. 3–12.

2 Gordon Rushforth, 'The Church of S. Maria Antiqua', *Papers of the British School at Rome*, 1 (1902), 1–123; Wladimir de Grüneisen, *Sainte-Marie-Antique* (Rome: Max Bretschneider, 1911); Nordhagen, 'The Frescoes of John VII'.

3 For a detailed description of the *Adoration of the Crucified* and its iconography see Nordhagen, 'The Frescoes of John VII', pp. 47–9, plates 52–70, 135.

4 Nordhagen, 'The Frescoes of John VII', pl. 111, 13a, and pl. 112, 13b.

5 The heresy of Monotheletism maintained that Christ had only one *thelema* (will) and one energy, not a separate human will and energy in addition to the divine will and the divine energy. From an orthodox position, this is a serious underrating of the meaning of the human nature of Christ for the salvation of mankind.

6 Nordhagen, 'The Frescoes of John VII', pl. 109, 9 ('LEO'); pl. 112 (unidentified pope '[R]OMANV[S]'). The four church fathers are: Augustine, one now destroyed, Gregory of Nazianzus, and Basil. For the *tituli* see ibid., pl. 125, 1–4. For these figures see also the contributions to this volume by Oscar Mei and Giulia Bordi.

7 The lost apse is generally assumed to have been painted with a representation of Mary, enthroned or standing with the Child in her arms, in accordance with John VII's deep devotion to the Virgin: cf. Nordhagen, 'The Frescoes of John VII', pp. 88–90.

8 As shown by the 1702 Valesio drawing, the fresco on the triumphal arch was already partially destroyed at that date, see Nordhagen, 'The Frescoes of John VII', pl. 41.

9 Ibid., p. 50.

10 De Grüneisen, *Sainte-Marie-Antique*, pl. 50.

11 Per Olav Folgerø, ´The Lowest, Lost Zone in "The Adoration of the Crucified Scene" in S. Maria Antiqua in Rome: A New Conjecture`, *Journal of the Warburg and Courtauld Institutes*, 72 (2009), 207–19: fig. 12; figure 5b in the same publication shows amendments to the '*Adoration of the Crucified*, based in part on Nordhagen's tracing of the figure of Christ, which shows that he is depicted with curly hair and a short curly beard, traits which correspond to the so-called Type B of Christ seen on the coins from the second reign of Emperor Justinian II (705–11). Moreover, Nordhagen's tracing also demonstrates that Christ does not wear the *colobium*, as de Grüneisen thought. Given that his torso is bare, he must wear a *perizoma* or loincloth; see Per Jonas Nordhagen, 'John VII's *Adoration of the Cross* in S. Maria Antiqua', *Journal of the Warburg and Courtauld Institutes* 30 (1967), 388–90, pl. 44b. With regard to the lowest zone, I have argued elsewhere that it represents the *Resurrection of the Saints*, see Folgerø, 'The Lowest, Lost Zone'.

12 Nordhagen, 'The Frescoes of John VII', pp. 96–8; Rushforth, 'The Church of S. Maria Antiqua', p. 61.

13 'In order that the perfect (*to teleion*) should be set down before everybody's eyes even in painting, we decree that [the figure of] the Lamb, Christ our God, who removes the sin of the world, should henceforward be set up in human form and images also, in place of the ancient lamb, inasmuch as we comprehend thereby the sublimity of the humiliation of God's Word, and are guided to the recollection of His life in the flesh, His Passion and His salutary Death, and the redemption which has thence accrued to the world.' Translation from Cyril A. Mango, *The Art of the Byzantine Empire, 312–1453: Sources and Documents* (Englewood Cliffs, NJ: Prentice-Hall, 1972; repr. Toronto: University of Toronto Press, 2000), p. 139.

14 James D. Breckenridge, *The Numismatic Iconography of Justinian II* (New York: The American Numismatic Society, 1959), p. 85.

15 Jean-Marie Sansterre, 'À propos de la signification politico-religieuse de certaines fresques de Jean VII à Sainte-Marie-Antique', *Byzantion*, 57 (1987), 434–40. According to Anna Kartsonis, *Anastasis. The Making of an Image* (Princeton: Princeton University Press, 1986), pp. 72–3, the two Anastasis panels at the portals were well suited for pictorial descriptions of anti-Monotheletic Christology in the wake of the Sixth Ecumenical Council: 'If this analysis is accepted, the iconography of the Anastasis may be interpreted as illustrating the main soteriological and Christological arguments canonized by the Sixth Ecumenical Council [and] applied to some extent by the Trullan Council. This image can offer a material objection to Monotheletism and Monoenergism, as well as "material proof" in favour of the Orthodox position of the subject'. John's stance on Monotheletism was first discussed in Eva Tea, *La Basilica di Santa Maria Antiqua* (Milan: Società Editrice 'Vita e Pensiero', 1937), pp. 66–7; cf. Nordhagen, 'The Frescoes of John VII', p. 96; and Per Jonas Nordhagen, 'Early Medieval Church

Decoration in Rome and the "Battle of Images"', in *Ecclesiae Urbis. Atti del congresso internazionale di studi sulle chiese di Roma (IV–X secolo)*, ed. by F. Guidobaldi and A. Guiglia Guidobaldi, Studi di antichità cristiana 59 (Vatican City: Pontificio Istituto di Archeologia Cristiana, 2002), III, pp. 1749–69 (pp. 1755–6).

16 Charles Barber, *Figure and Likeness: On the Limits of Representation in Byzantine Iconoclasm* (Princeton: Princeton University Press, 2002), pp. 49–50.

17 The Tome of Leo, quoted at the Sixth Ecumenical Council, was the Christological matrix of the Council of Chalcedon (451 CE).

18 Quoted from Norman P. Tanner, SJ, *Decrees of the Ecumenical Councils,* 2 vols (London: Georgetown University Press, 1990), I, p. 129 (italics mine).

19 Nilgen and Kartsonis both read the motif in liturgical terms; see Ursula Nilgen, 'The *Adoration of the Crucified Christ* at Santa Maria Antiqua and the Tradition of Triumphal Arch Decoration in Rome', in *Santa Maria Antiqua al Foro Romano cento anni dopo. Atti del colloquio internazionale, Roma 5–6 maggio 2000*, ed. by J. Osborne, J.R. Brandt, and G. Morganti (Rome: Campisano, 2004), pp. 129–35; and Anna D. Kartsonis, 'The Emancipation of the Crucifixion', in *Byzance et les images* (Paris: La Documentation française, 1994), pp. 151–87. Moreover, as stressed by Nordhagen, the motif has strong eschatological leanings, whether being an inverted *Adoration of the Lamb* as he suggests, or conceived in relation to other *parousian* texts. In Per Olav Folgerø, 'Tekst-katena na freskakh v tserkvi Santa-Maria Antikva v Rime (705–707): Palestinkoe vliianie ili raznoobrazie kul'turnykh traditsii v Rime 7–8 veka' ['The Text-catena in the Frescoes in the Sanctuary of S. Maria Antiqua in Rome (705–707 A.D.) A "Tracing" of Palestinian Influence and an Index of Cultural Crossover'], in *Khristianskoe iskusstvo* (Moscow, 2009), pp. 42–55, I argue that the crowds of angels, seraphim and cherubim, as well as the adoring men may reflect the 'thousands of archangels and countless of angels' in Daniel 7.10, particularly when seen in light of Cyril of Jerusalem's interpretation of this passage in his Fifteenth Catechesis about Christ's Second Advent (italics mine): 'Thus you see, O Mortal, before what a *multitude of witnesses* you shall enter into judgment. The *whole human race will be present there*. […] The *angels are more numerous*. They are the ninety-nine sheep, whereas humanity is the one sheep. After all, it is written that His ministers are a *thousand times a thousand*, not that this figure sets a limit to their multitude, but rather because the prophet could not express a larger number.' (Catechesis 15, XXIV; *PG* 33, 904B).

20 The fragment is illustrated in Wilpert, *RMM*, pl. 156, 1.

21 As demonstrated by Einar Molland—cited in Nordhagen, 'The Frescoes of John VII', p. 122—the text quotes Zechariah 12.10 in a version different from the Septuagint; cf. Alfred Rahlfs, 'Über Theodotion-Lesarten im Neuen Testament und Aquila-Lesarten bei Justin', *Zeitschrift f. d. neutestamentliche Wissenschaft*, 20 (1921), 182–99.

22 Rushforth, 'The Church of S. Maria Antiqua', p. 60; and Vincenzo Federici in de Grüneisen, *Sainte-Marie-Antique*, p. 439 and 'Album épigraphique', pl. 13.

23 Nordhagen, 'The Frescoes of John VII', p. 48, and the tracing on pl. 124; also Einar Molland, ibid., pp. 121–2.

24 Beat Brenk, review of Per Jonas Nordhagen, 'The Frescoes of John VII', *Byzantinische Zeitschrift*, 64 (1971), 392–6 (pp. 394–5 on the *catena*).

25 William Tronzo, 'The Prestige of Saint Peter's: Observations on the Function of Monumental Narrative Cycles in Italy', *Studies in the History of Art*, 16 (1985), 93–112 (p. 100).

26 Kartsonis, 'The Emancipation', p. 170.

27 For a detailed analysis of the Palestinian/Cyrillian stamp of the *catena* see Per Olav Folgerø, 'The Text-catena in the Frescoes in the Sanctuary of S. Maria Antiqua in Rome (705–707 A.D.). A Note on its Links to the Catechetical Lectures of Cyril of Jerusalem', *Bollettino della Badia Greca di Grottaferrata*, 3rd ser., 6 (2009), 45–66; and Folgerø, 'Tekst-katena'.

28 *Catechesis* 11, 15; *PG* 33, 710 AB.

29 *Catechesis* 13, 19–20; *PG* 33, 797A–B.

30 *Cat.* 13, 17; *PG* 33, 794C. Note that Cyril uses the phrase '*thugateres Ierusalem*' ('daughters of Jerusalem') as in our *catena*; cf. Molland in Nordhagen, 'The Frescoes of John VII', p. 122. Cyril here links quotations from Matthew 27.27, Psalms 108 (109).25, Matthew 27.29, and John 19.2.

31 Stefano Parenti, 'Un capitolo della hypotyposis di Teodoro di Studios in due triodia di Grottaferrata dell'XI/XII secolo', *Ecclesia Orans*, 13 (1996), 87–94.

32 Sebastià Janeras, *Le Vendredi-Saint dans la tradition liturgique byzantine: Structure et histoire de ses offices*, Studia Anselmiana, 99, Analecta Liturgica, 13 (Rome: Pontificio Ateneo S. Anselmo, 1988), p. 347.

33 Florence, Bib. Medicea Laurentiana, cod. Plut. I. 56, fol. 4b. See Massimo Bernabò, *Il Tetravangelo di Rabbula (Firenze, Biblioteca Medicea Laurenziana, Plut. 1.56). L' Illustrazione del Nuovo Testamento nella Siria del VI Secolo* (Rome: Edizioni di Storia e Letteratura, 2008), pl. VIII.

34 Laura Kendrick, *Animating the Letter: The Figurative Embodiment of Writing from Late Antiquity to the Renaissance* (Columbus, OH: Ohio State University Press, 1999), pp. 67–8.

35 Erik Thunø, 'Materializing the Invisible in Medieval Art. The Mosaics of S. Maria in Domnica in Rome', in *Seeing the Invisible in Late Antiquity and the Early Middle Ages. Papers from 'Verbal and Pictorial Imaging: Representing and Accessing Experience of the Invisible, 400–1000' (Utrecht, 11–13 December 2003)*, ed. by G. de Nie, K. F. Morrison, and M. Mostert (Turnhout: Brepols, 2005), pp. 265–79; Erik Thunø, 'Looking

at Letters: "Living Writing" in S. Sabina in Rome', *Marburger Jahrbuch für Kunstwissenshaft*, 34 (2007), 19–41; Erik Thunø, 'Inscription and Divine Presence: Golden Letters in the Early Medieval Apse Mosaic', *Word and Image*, 27.3 (2011), 279–91; and Erik Thunø, 'Inscriptions on Light and Splendor from Saint-Denis to Rome and Back', *Acta ad archaeologiam et artium historiam pertinentia*, 24 (2011), 139–69.

36 Guglielmo Cavallo, 'Le tipologie della cultura nel riflesso delle testimonianze scritte', in *Bisanzio, Roma e l'Italia*, Settimane di Studio del CISAM, 34 (Spoleto : Centro Italiano di Studi sull'Alto Medioevo, 1988), pp. 467–516 (pp. 486–7).

37 John M. Burnam, 'The Early Gold and Silver Manuscripts', *Classical Philology*, 6 (1911), 144–55 (p. 153).

38 Respectively Ulrich Ernst, 'Farbe und Schrift im Mittelalter unter Berücksichtigung antiker Grundlagen und neuzeitlicher Rezeptionsformen', in *Testo e imagine nell'alto medioevo. Atti delle Settimane di Studio (Spoleto, 15–21 aprile 1993)* (Spoleto: Centro Italiano di Studi sull'Alto Medioevo, 1994), pp. 343–415 (p. 358); Beat Brenk, 'Schriftlichkeit und Bildlichkeit in der Hofschule Karls der Grossen', in *Testo e imagine nell'alto medioevo*, pp. 631–82 (pp. 641–3); Herbert L. Kessler, 'The Eloquence of Silver: More on the Allegorization of Matter', in *L'allégorie dans l'art du Moyen Age: Formes et fonctions. Héritages, créations, mutations*, ed. by C. Heck (Turnhout: Brepols, 2011), pp. 49–64 (pp. 49–52); and Herbert L. Kessler, '"Hoc Visibile Imaginatum Figurat Illud Invisibile Verum": Imagining God in Pictures of Christ', in *Seeing the Invisible*, ed. by G. de Nie, K.F. Morrison, and M. Mostert, pp. 297–8.

39 This is emphasised in Rudolf Arnheim's classic study *Art and Visual Perception: The New Version* (Berkeley: University of California Press, 1974); cf. also Ernst H. Gombrich, *A Sense of Order*, 2nd edn (London: Phaidon, 1984). It has recently been proven scientifically by the German psychologist Thomas Jacobsen and his group in Leipzig: Thomas Jacobsen and others, 'Brain Correlates of Aesthetic Judgment of Beauty', *NeuroImage,* 29 (2006), 276–85.

40 Rolf Reber, Morten Brun, and Karoline Mitterndorfer, 'Heuristics in Mathematical Intuition', *Psychonomic Bulletin and Review*, 15.6 (2008), 1174–8.

MANUELA GIANANDREA

*The Fresco with the Three Mothers and the Paintings of the Right Aisle in the Church of Santa Maria Antiqua**

The right aisle wall of the church of Santa Maria Antiqua features a painted niche of rich and complex meaning (Plates 19, 20, 50: F1). At the centre of the composition is the Virgin enthroned, holding a mandorla within which is the full-length Child; on the left side Saint Anne holds the infant Mary in her arms, while on the right Elizabeth holds the young John the Baptist.[1] The niche belongs to the Roman wall, and is 1.29 metres high and 1.12 metres wide, with a narrow sill about 90 centimetres above the floor. At one time, an extensive narrative cycle unfolded around the niche, organised in a manner similar to the cycle of the Old Testament in the opposite aisle (Plate 6, 50: C1). The comparison is justified by the parallel organisation of the walls in rectangles and by the type of framing, with three bands in tones of yellow and black. Unlike the left aisle, however, the lower part of the right wall did not feature a depiction of male and female saints. This is demonstrated by the remaining fragments of painting, which show that the narrative scenes reached the lower zone of the wall (Figures 1, 3). The decoration definitely continued onto the adjoining short wall of the inner façade, where the surviving fragments (now impossible to interpret) were inserted into an almost identical frame. The largest possible area for the painting cycle would have been the one extending from the counter-façade to the enclosure dividing the aisle from the right vestibule: this would mean the entire length of the nave, a total surface of roughly 5. 70 by 15.50 metres. The vestibule area almost certainly had an independent decorative scheme (Plate 50: G1), since, upon reaching the enclosure in the opposite aisle, the Old Testament scenes and the saints give way to the Forty Martyrs of Sebaste (Plate 10, 50: D1).

In the west aisle, the individual paintings must have been of varying size, just as on the opposite wall, but the layout of the registers was not uniform (Figure 2). For example, the vertical frame of the highest scene falls more or less at the centre of an episode in the level immediately below. The surviving paintings, particularly their frames, indicate moreover that the panels of the two upper registers were about 1.20 metres high, like those in the left aisle.

Measuring the paintings' width is more difficult. In the case of the *Journey of the Magi*

1 Santa Maria Antiqua, right aisle, west wall, detail. (Wilpert, *RMM*, II, p. 710, fig. 304)

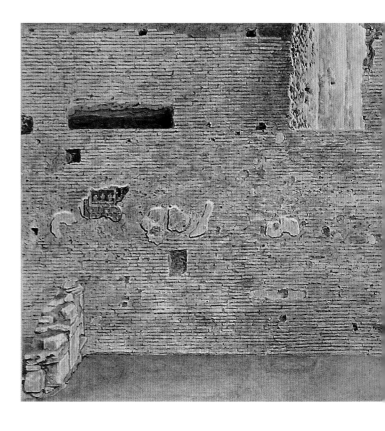

2 Graphic visualization of registers and scenes displayed on the west wall (Manuela Gianandrea and Carlo Costantini, 2016)

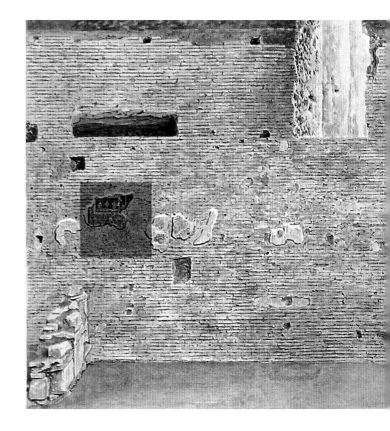

THE FRESCO WITH THE THREE MOTHERS

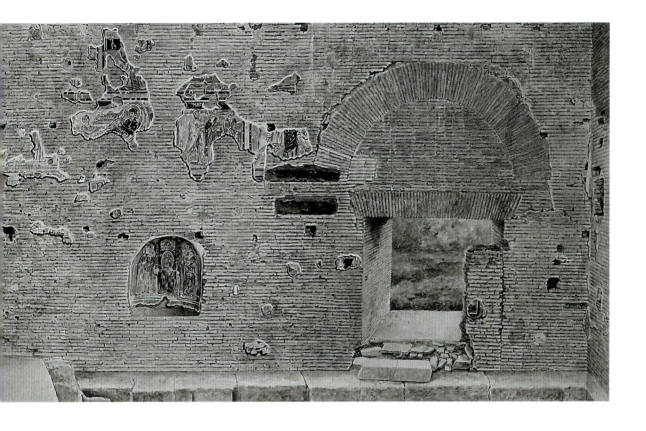

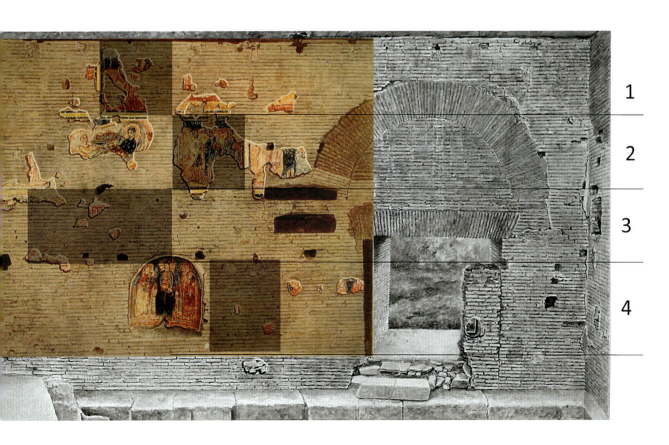

1
2
3
4

337

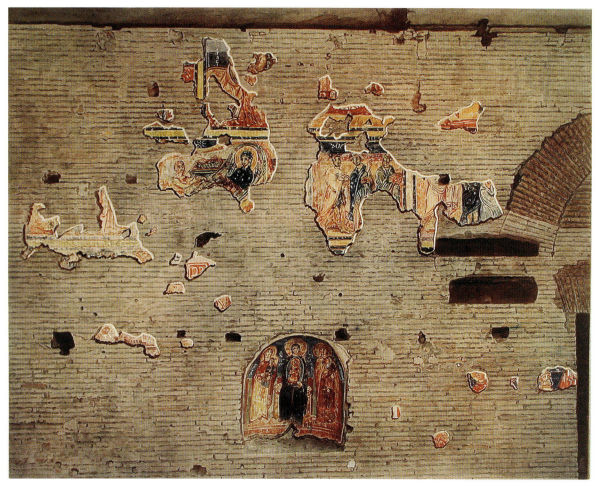

3 Santa Maria Antiqua, right aisle, west wall, detail. Watercoloured photograph by Wilpert and Tabanelli (Wilpert, *RMM*, IV, pl. 194)

(Figure 4), however, the preservation of both sides of the frame suggests an approximate dimension of 1.20 to 1.30 metres. Further indications may be gleaned from the *Meeting at the Golden Gate* (Figure 5), where the mural next to the figure of Anne still shows a thin white frame turning at a right angle and continuing upwards (Figures 1, 3, 5). This also corresponds to the border of the episode below, depicting the Magi. We thus have an idea of the right and left sides of the Golden Gate panel, which would have again measured around 1.20–1.30 metres in width. The lacunae related to the panels' width make it difficult to come up with a precise figure for the number of scenes in each register; however, the evidence available suggests at least eight to ten per row. The number of registers, in turn, can be determined by dividing the total height of the wall (*c*. 4.80 metres) by the height of the paintings (*c*. 1.20 metres), which equals four registers (Figure 2). There is also a possibility that the lowest register was wider than the others, or that there was a small skirting decoration of about 90 centimetres. In fact, we can only be sure of the two top rows, since nothing of the bottom half has survived. A fragment situated in the door opening, and which is now visible only in Joseph Wilpert's photograph (Figure 1), suggests, however, the presence of a frame there.[2] Calculations seem to match the position of the fourth register's frame with that of the fragment, and the frame would correspond also with the base

4 Santa Maria Antiqua, right aisle, west wall: a) *Journey of the Magi*; b) *Adoration of the Magi*; c) *Nativity of Mary* (?) (photo: Manuela Gianandrea)

5 Santa Maria Antiqua, right aisle, west wall: a) *Meeting at the Golden Gate*; b) *Nativity of Jesus*; c) *Nativity of Mary* (?) (photo: Manuela Gianandrea)

of the Three Mothers niche (Figure 2). Moreover, the lower border of the third register seems to be located immediately above the niche of the Three Mothers, which would then be perfectly inscribed within the height of the fourth, lowest register (Figure 2).

The pictorial organisation of the counter-façade is, on the other hand, impossible to determine (Plate 50: F2). The only legitimate hypothesis, thanks to a small fragment of frame, is that it was decorated with paintings similar to those on the right aisle wall, although we can only guess whether they were thematically related.

For the west wall's upper registers, the identification of the scenes can rely on Wilpert's photograph (Figure 1).[3] *The Meeting of Anne and Joachim at the Golden Gate* (Figure 5) can be easily spotted in a central position, thanks to the use of a traditional iconography and to the names inscribed next to the figures.[4] In the register immediately below, the *Nativity* (Figure 5), *Journey of the Magi*, and *Adoration of the Magi* (Figure 4) are all legible. The presence of these subjects has prompted many scholars to suggest that the wall was originally dedicated to the New Testament, forming a perfect counterpart to the Old Testament scheme on the left aisle.[5] But this suggestion can only be accepted for the top two registers, where we can safely recognise the episodes from the Gospels. By contrast, and as mentioned above, the painting on the bottom half of the wall is almost totally lost, with some scattered fragments that are difficult to read. From left to right in the third register, we first encounter three enigmatic female figures at the window of a tower, then part of what looks like a kneeling figure, a building (?), and other fragments completely without context (Figure 6). In the last part of the register, to the right of the Three Mothers niche, there is a haloed female head (Figure 7a), then the face of a man turned towards a mountain (Figure 7b), and finally, in the part of the wall now occupied by a door, a fragment of frame (Figure 1). The condition of the painting on the counter-façade is disastrous, with only fragmentary scraps left. These can at most be linked to the hypothetical fourth register, specifically to the frame, and perhaps to a depiction of a floor.

The presence of the episode of Anne and Joachim at the Golden Gate in the first register suggests that it was concerned with the life of the Virgin's parents, as recounted in the Apocrypha, chiefly in the Protevangelium of James (4.4) and in the Gospel of Pseudo-Matthew (3.5). The presence of the *Nativity* and the episodes of the Magi in the second register, exactly below the *Meeting at the Golden Gate*, suggests that the cycle would have continued with scenes from the Life of Mary. Given the number of scenes suggested by the extant frames, the Life of the Virgin would have possibly included her infancy, again in keeping with the Apocrypha. Following traditional narrative sequences, we should probably place the *Nativity of Mary* next to the *Meeting between Anne and Joachim*: indeed, this is supported by a fragment with a large cushion (presumably a mattress) and an extended hand belonging to a figure wearing a garment of the same colour as Anne in the Golden Gate scene (Figure 5). We can only make an educated guess about the subsequent episodes from the Life of Mary: the *Presentation in the Temple*, the *Annunciation*, the *Visitation*, the *Journey to Bethlehem*, and others, perhaps including the *Ordeal of the Bitter Water*. The *Nativity of Jesus* is then the first episode recognisable in the third register (Figure 5). It must have been larger than the other episodes, occupying the space of at least two 'standard' scenes (Figure 2), as suggested by a vertical frame from the row above, which falls roughly at the centre of the *Nativity*. In fact, the *Nativity* contains a cluster of related episodes, including the surviving Manger Scene and the apocryphal episode of the so-called 'incredulous

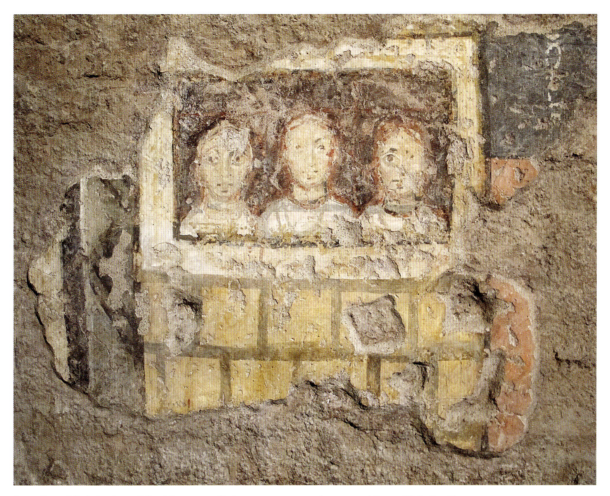

6 Santa Maria Antiqua, right aisle, west wall: three young women in a tower (photo: Giulia Bordi)

midwife'. The remaining space at the bottom and right of the register suggests that there may have been also the *Washing of the Infant* and probably the seated figure of Joseph, in accordance with standard early medieval iconography.

In the *Nativity* the Virgin, lying on straw, looks intensely at her son wrapped in swaddling bands and placed in a rectangular cradle, while a woman extends an arm towards her. This character must be the 'incredulous woman' described in the Apocrypha: according to the Gospel of Pseudo-Matthew (13.3–5), she was one of the two women who were called by Joseph to assist during childbirth, but she questioned Mary's virginity. For this, the woman was punished by having one arm paralysed. Alternatively, the woman with the extended arm could be identified as Salome, who, according to the Protevangelium of James (19.3; 20.1), was told about Mary's miraculous motherhood but was without faith and insisted on testing Mary's purity with her finger, for which she too was punished. These episodes are, with the exception of minor details, substantially concerned with the same issue, namely the miraculous incarnation of Christ in Mary's womb and his virginal conception.

The next scene in the second register can be easily identified, thanks in part to the presence of an inscription. It is smaller in size (1.20 by about 1.20–1.30 metres) and represents the *Journey of the Magi* (Figure 4), who are guided by the same star seen in the *Nativity* above. The star

341

is placed at the centre of the composition, underlining the connection with the messianic prophecies of the Old Testament. It is also possible to recognise part of an *Adoration* (Figure 4), with the first of the Magi kneeling before the Virgin and Child. The cycle's narrative sequence thus represents a strong link between the *Nativity* and the *Adoration of the Magi*, emphasising the role of the three kings through two full scenes: their journey (often omitted in decorative schemes) and their adoration of the Child. This sequence of events, however, where the *Adoration* precedes the *Presentation of Jesus in the Temple*, departs from the retelling of Christ's infancy in the principal Apocrypha (Pseudo-Matthew and the Arabic Infancy Gospel), which instead place the *Presentation* immediately after the *Nativity*. The scheme seems rather to follow the Gospel of Matthew, and thus the liturgical practices that placed Christmas and Epiphany in close proximity.[6] The Magi of the Santa Maria Antiqua cycle strangely lack the Phrygian cap, which, together with their oriental features, had characterised their iconography since their earliest appearance. They also wear short tunics and traditional hose, but with cloaks that are longer than usual, and hold large circular plates, of a type quite common in late antique and early medieval art.[7]

To find additional scenes that are sufficiently intact to allow further reflection, it is necessary to shift to the extreme left of the hypothetical 'third register'. Above the enclosure separating the aisle from the vestibule can be observed the typical framing and the faces of three young women without haloes, looking out from a barred window. From the surrounding indications of form and masonry, the window seems to be part of a sort of tower (Figure 6). To the right of this building we can still make out the letters '[---]OLA', part of an inscription that must have originally accompanied the figure on the left.[8] Given the inscription's vertical arrangement, the person could easily have been shown on foot, standing beside the tower. This fragmentary ensemble has been at times interpreted as a scene of martyrdom, at times as the 'miracle' of Saint Nicholas of Myra and the Three Girls, at times as the Pentecost, and at times as the Old Testament episode of the Three Jews in the Furnace.[9] For this last hypothesis, it seems that certain specific elements are missing, including the fire of martyrdom, the figure of the angel, the depiction of the Jews (at least their busts, if not the full figures), and finally a box instead of a window to represent the furnace.[10] Looking carefully at the inscription, it is possible to speculate that the letter preceding the 'O' was a 'C', thanks to the presence of its rounded lower section, perhaps part of the name 'Nicola'. The scene would therefore represent Saint Nicholas of Myra's celebrated charitable gesture in aid of three girls without dowry, otherwise destined to a life of prostitution.[11] In works depicting the same subject, for example the altarpieces in the Pinacoteca di Bari and the frescoes in the Crypt of the Madonna of the Miracles in Andria, the iconography of this scene shows three young women aligned in a rigidly frontal position, looking out from the window of a tower or building, ready to receive the purses of gold coins from Nicholas.[12] The Santa Maria Antiqua fresco would be a remarkably early depiction, both of this particular episode, and more generally of the life of Nicholas, for which there are otherwise no confirmed examples until at least the eleventh century, although Nancy Patterson-Ševčenko points to the existence of a ninth-tenth century source in which a 'table' with a representation of the Saint's miracles is mentioned.[13]

The cult of Saint Nicholas, however, was already widely documented and popular in the West—particularly in Rome[14]—before the ninth century, when the Latin translation of his Greek

THE FRESCO WITH THE THREE MOTHERS

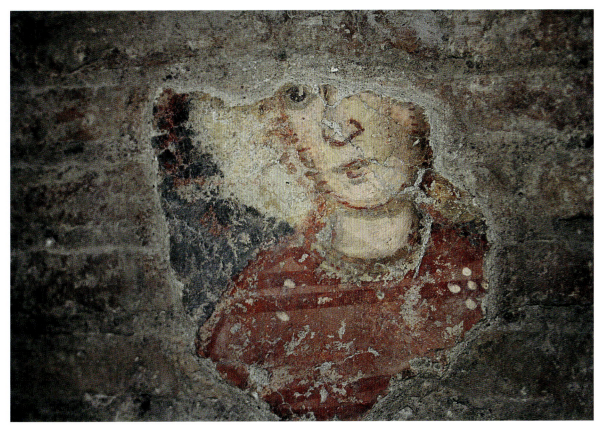

7 Santa Maria Antiqua, right aisle, west wall: a) fragment with a female face with a halo; b) fragment with a man and a mountain
(photo: Manuela Gianandrea)

Life appeared.[15] By then there were a number of oratories dedicated to him, and he is included in the row of saints depicted in the left aisle of Santa Maria Antiqua. We do not know if there were early medieval narrative cycles devoted to the saint that are now lost, or whether there were also isolated representations of episodes from his life. Certainly, it is reasonable to think that in the fifth to sixth centuries there would have already existed a rich *Life* of Saint Nicholas, even though we are now left with the sole account of the liberation of the Byzantine officers, reported in the *Praxis de Stratelatis.* By the seventh century there was also a Latin Passionary circulating in Rome that included accounts of Nicholas largely translated from the Greek, while the saint's first surviving *Vita*, by Michael the Archimandrite, probably dates to the eighth century.[16] The sum of these elements suggests that in the Greek world there had been stories and legends featuring Nicholas for a substantial period of time, and that among these, one of the first and oldest was precisely that of the poor girls, attested in Byzantine sources as early as the sixth century, which could have thus reached Santa Maria Antiqua at a very early date, thanks to Rome's links with Byzantium. This is clearly a hypothesis that cannot yet be proven, but which deserves to be considered, particularly in the light of the interpretation of the right aisle, a subject that I shall address later in this paper.

What is left of the third register unfortunately lacks any substantial fragments. Immediately to the right of the three girls we can make out the remains of a knee, and immediately to the left of the niche with the Three Mothers we see the corner of a structure, with other fragments. Furthermore, as noted previously, on this level there is no preserved framing for the panels, which makes it impossible to conclude with certainty that the wall comprised four uniform registers.

Very little survives of the potential fourth register, with only two fragments preserved to the right of the niche. In the first of these fragments, we see a face, perhaps female, featuring a halo and a pinkish-red garment (Figure 7a), very similar to those of Anne and Elizabeth in the niche. In the second fragment we can make out a male face with dark hair, probably gazing towards a mountain (Figure 7b). The two figures seem to belong to two different scenes. In his day, Wilpert thought to recognise in the fragment with the man and the mountain the remains of a *Crucifixion*.[17] But the size of the male figure seems to indicate that he had only a secondary role in the episode, unless the rest of the scene was of gigantic proportions. In addition, the mountain does not seem to be in the foreground of the episode, but rather in the background. It cannot be ruled out, therefore, that the scene concerned something else, perhaps a scene of martyrdom, or a hagiographic or New Testament subject, for example from the life of John the Baptist. The hypothesis of Christological and not hagiographic scenes at this point of the wall, however, would create a number of problems for the proposed 'miracle' of Nicholas of Myra. We can consider three hypotheses:

1. That the scene with the inscription '[---]COLA' does not refer to Saint Nicholas, but to an episode from the life of Jesus, leading to the possibility that the Christological theme ran through all the four (potential) registers. The weakest element in this suggestion rests in identifying an excerpt of the New Testament that would fit with '[---]COLA'.

2 That the scene of the three girls is indeed that of the charitable act of Saint Nicholas, which would point to a change of theme in the third register, from a Marian-Christological cycle to the lives and martyrdoms of saints. Such a scheme is not unknown in early medieval Rome, particularly in the ninth and tenth centuries, notably at the so-called Temple of Fortuna Virilis (two registers with Marian stories and two with stories of Saints Basil, Mary of Egypt, and Zosimus of Syracuse), or at Santa Maria in Pallara (New Testament episodes above, and scenes from the lives of Zoticus and Sebastian below).[18] The greatest difficulty with this hypothesis is the lack of visual connection between the Three Mothers in the niche and the hagiographic themes that would be immediately adjacent.

3 That the episode of the 'miracle' of Saint Nicholas formed part of a brief painted cycle independent from the Christological cycle, with the aisle wall therefore divided into a number of decorative spaces, which would naturally have corresponded to devotional spaces. We could thus imagine a sort of 'chapel', or more appropriately an autonomous liturgical space, perhaps again organised into a number of decorative registers and separated from the lives of Mary and Jesus by a vertical partition of the wall, perhaps something as simple as a painted frame.[19] Thanks to its extraordinary preservation, Santa Maria Antiqua represents a clear and precious testimony of the profound liturgical fragmentation that characterised Roman churches, already present in the early Middle Ages.[20] Within the remaining church we can easily recognise various devotional areas, independent altars, and even true chapels.[21] This third hypothesis would allow for the development around the niche of a theme coherent with the Three Mothers, and with the stories of Anne, Joachim, and the Virgin (which would have definitely included the *Visitation*), up to *the Nativity of Jesus* and his life. In addition, the niche would thus be positioned more or less in the middle of the narrative space devoted to Marian-Christological subjects, and not off-centre, as it would appear at first glance.

Unfortunately, the scarcity and fragmentary nature of the surviving paintings, particularly in the lower registers, does not permit going beyond the limitations of a working hypothesis. Still, on the basis of the evidence available, I am inclined to favour the third hypothesis. It is exceptionally difficult to identify the complete iconography of the New Testament scenes. It must also be remembered that a Christological cycle was already present in the sanctuary, though it was partially hidden from the worshippers' view. These areas, which were completely reconstructed during the post-excavation restoration, do not offer any certainty about their original decoration—yet such decoration did undoubtedly exist. Given the presence of the stories of Anne and Joachim, it seems plausible to imagine the subjects of the side aisle as being quite specific, in this instance the stories of the Virgin, the infancy of Christ, or the life of the Baptist. Such considerations could be assisted by a more detailed analysis of the unusual image of the niche, which must have served as the focus, from a liturgical and narrative point of view, of the programme on the wall into which it was inserted.

'The Virgin Holding the Child in Mandorla': Theological and polysemic implications of a rare (?) iconography. A reflection on the decorative programme and its commission

The rare iconography suggested in the title of this section is the depiction in a niche of the Virgin holding a mandorla that contains the Holy Infant (Plate 20). In the Latin West, one of the oldest known instances of such iconography is the wall painting discovered in 2010 in the narthex of the Roman church of Santa Sabina on the Aventine hill.[22] André Grabar has argued that this iconography is a transposition into Christian art of the portrait of the sovereign or consul on a *clypeus* (votive shield), which served a celebratory function in the imagery of imperial Rome. The depiction of the Virgin with the Child in a mandorla or circle first gained broad popularity in the Byzantine East, but was widely disseminated over time, which consequently spurred iconographic variations. The Madonna, either enthroned or standing, can hold a mandorla or *clypeus* with the Child, showing only his half-bust, or can even show the circle at breast height and with her arms open like an orator.[23] These two iconographies achieved great success, particularly in the middle Byzantine period. On the other hand, the Virgin holding an oval with the Child in full figure, as at Santa Sabina and Santa Maria Antiqua, seems to have been popular mainly before the Iconoclastic controversy.[24] The oldest instances of this iconography date to the sixth and seventh centuries, and mainly represent the variant with the Virgin enthroned holding the Child in full figure, enclosed within a mandorla. They include:

1. The decorative seals of the Emperor Maurice (582–602) and the Emperor Constantine IV (668–85);[25]

2. The decoration of the east apse of Chapel 28 of the Monastery of Apa Apollo in Bawit (Egypt), dated to the sixth century;[26]

3. The icon in the Monastery of Saint Catherine on Mount Sinai, dated to the seventh century by Kurt Weitzmann, who considered it a Palestinian-Syrian work;[27]

4. Another icon sold on the London art market and now in a private collection, again attributed to Palestinian-Syrian workmanship and dated to the sixth or seventh century;[28]

5. A miniature in a Syriac manuscript (Paris, Bibliothèque nationale de France, MS Syriaque 341), generally dated to the seventh century;[29]

6. An *Adoration of the Magi* inserted in the Etchmiadzin Gospels (989 CE) but considered older (early seventh century) and of Armenian provenance;[30]

7. The so-called *Lamina Garrucci* ('Garrucci foil'), discovered in Basilicata and dated between the seventh and tenth centuries;[31]

8. The mural painting in Santa Sabina on the Aventine hill (708–15);[32]

9. The fresco with Three Mothers in Santa Maria Antiqua, dated variably to the eighth or ninth century;

10 A painting with the Virgin and saints in the Grotto of the Shepherds, at the Sacro Speco in Subiaco, whose date oscillates between the ninth and the eleventh century;[33]

11 A Virgin in the cycle of the Crypt of Epiphanius in San Vincenzo al Volturno (Molise), executed between 824 and 842;[34]

12 An icon of early date in Constantinople. According to the Byzantine historian John Skylitzes, an ancient icon dating to the pre-Iconoclastic era was discovered at Blachernae during the works sponsored by Emperor Romanos III (1028–34). The account, of difficult interpretation, records that the Virgin was depicted as 'holding at her breast a panel, depicting Our Lord God'.[35] We do not know whether this refers to a mandorla with the Child in full figure, or a *clypeus* with only the bust of Christ. However, the evidence of a silver coin minted by the same Romanos III suggests the latter type.[36] This would in effect correspond with the form most popular in the middle Byzantine period, and also be more in keeping with the iconography called *Blachernitissa*.

13 Lastly, an interesting sculpture of the standing Virgin holding an oval, which at one time probably contained a painting of the Child, is placed above the door of the Church of Saint Mary in Deerhurst, Gloucestershire (eighth century), recently analysed by Richard Gem.[37]

Both the Bawit fresco and the Marian icon in private hands show the celebratory and triumphal aspect of the Christ in mandorla, inherited Roman imperial iconography. But the *Adoration of the Magi* from the Etchmiadzin Gospels already shows the images' polysemic force, further developed in the *Transfiguration* or *Ascension of Christ*, where the mandorla manifests the divinity of Jesus.[38] In this image Cyril Mango sees, with good reason, the figurative transposition of the *Lógos* incarnate.[39] The Virgin, holding the Child at breast and womb height, is responsible for the human nature of her son, while the halo surrounding them highlights the divine character of the event: the *Lógos* is incarnated, true God as well as true man. In this sense the image is emblematic of Christ's two inseparable natures. The iconography functions therefore as the proud vessel of the Chalcedonian doctrine and, where necessary, as the effective visual answer to the heterodox assertions of the Monophysites. Unfortunately, the scarcity of figurative examples from the vast arc of time between the sixth and the eighth century, the persistent chronological uncertainty regarding some of these examples, and the serendipitous nature of their survival do not allow for much solid speculation, only the formulation of starting points for a discussion. The first is stimulated by the first two examples in our list, with the Virgin with Child in a mandorla on the seals of two decidedly orthodox emperors: Maurice, who in the year 591 placed strong pressure on the Armenians to adhere to the Chalcedonian deliberations, including the nomination of an orthodox patriarch, and Constantine IV, who convened and presided over the very Council of Constantinople that in 680–1 sanctioned the definitive condemnation of all monophysite-derived theories.[40] In the pre-Iconoclastic period, the iconography seems to be more concentrated precisely in those territories where it

proved more difficult to contain the diffusion of Monophysitism, specifically Egypt, Syria and Armenia, or in contexts where we could hypothesise the assertion of an anti-monophysite or anti-monotheletic position on the part of the commissioner of the work, such as for the mural painting in the Santa Sabina narthex.

However, it is also true that the image must have held a more universal meaning, linked to the fundamental dogmas of incarnation and the essential union of the two natures of Christ, and thus its significance was not limited to the narrow polemic against Monophysitism or Monothelitism. In the West this would be supported by the later examples from Santa Maria Antiqua, the Crypt of Epiphanius at San Vincenzo al Volturno, and the Sacro Speco at Subiaco; in the East, by the examples from the Church of Saint Sophia at Ochrid (eleventh century), and the Monastery of Saint Anthony in Egypt (thirteenth century), to cite only the best-known instances.[41]

The insertion of the Child into the shining mandorla reiterates and reinforces certain concepts inherent to the iconography of the *Theotokos*. It provides a perfect expression of the words in the Nicene Creed, 'God from God, Light from Light, true God from true God', and makes explicit the notion of Christ as Light incarnate. In the light-filled oval, the Child is small in his humanity but immense in his divinity: thus, the mysteries of the incarnation and the virgin birth take on a fundamental and indispensable role in the history of Salvation. The iconography reveals all its polysemic force in its adaptability to different contexts, where it was necessary to emphasise the importance of the mystery of the incarnation and the union of the two natures of Christ.

I propose therefore that the concept of divinity made flesh was at the core of the decorative programme conceived for Santa Maria Antiqua's right aisle. This is supported by the fact that the *Nativity of Jesus* was awarded greater space compared to the other panels, and that within it - through the episode of the incredulous midwife—the dogma of the divine incarnation was strongly emphasised. The decision to dedicate two full scenes to the story of the Magi may have served the same purpose, particular through the presence of the rare depiction of their journey. The star, shining over the grotto in the *Nativity* and guiding the Magi in the *Journey*, can only serve to reiterate the well-known messianic prophecy of the Book of Numbers (24.17), 'there shall come a star out of Jacob, and a sceptre shall rise out of Israel'.

The profound message of the 'divine pregnancy' seems to accompany the entire narrative development of the wall, from the first scene with Anne and Joachim to the Nativity of Jesus, extending to the Three Mothers in the niche, which thus emerges as the image symbolising the entire scheme. The narrative path begins with the happy resolution of the sterility of Anne and Joachim: in giving birth to the mother of God, they are placed at the origin of Salvation. For this, Anne is again found with Mary in the niche, while the presence of Elizabeth with the infant John suggests the likely presence of scenes related to their story. The most important of these would be the *Visitation*, which again reiterates themes of infertility and miraculous birth. Both Mary and John, the 'precursor', share with Christ a supernatural birth, brought about through divine action. Similarly, their parents are united in sterility, miraculously resolved through faith and the will of God.

This theme can be linked to the function served by the right aisle of the church, which was reserved for women, as it emerges from the *Ordines romani*.[42] Joseph David and Stephen Lucey

have previously emphasised the link between this space and the strong feminine component of the decoration around it.[43] Important in this respect is the presence of Solomone, portrayed as the mother of the Maccabees, and of Saint Barbara on the south-west pillar (Plate 14). To those can be added Judith triumphantly holding Holofernes' head on one of the gates of the sanctuary turned towards the left aisle, a Virgin enthroned among angels on the same pillar as Solomone, and perhaps a female figure holding a child on the north column of the right side. A Marian-Christological cycle on the themes of fertility, pregnancy, and incarnation would therefore coherently complete the decoration of the right aisle, and the Three Mothers in the niche would become its liturgical and narrative focus.

The presence of Anne and Elizabeth with their children, alongside Mary with the Infant Christ in the mandorla, exalts the divine incarnation and the 'miraculous' pregnancy. This explanation is supported by the interpretation of the sources (the canonical and apocryphal Gospels), but above all by the writings of the Church Fathers and the hymnographers who write about the two women.[44] Anne with Mary and Elizabeth with John, respectively, establish the origin and announce the coming of Christ, whose miraculous incarnation will be at the heart of human salvation. The immaculate conception of Mary is implicitly hinted at in the first apocryphal texts through the distance between Anne and Joachim during the annunciation, and through the fact that the announcement is made by an angel.[45] Subsequent Christian writers like Epiphanius of Salamis, Andrew of Crete, and John of Damascus expanded on this aspect, emphasising Anne's saintliness, her immaculate pregnancy, and above all her crucial historic role. As John of Damascus wrote: 'Blessed are you, Anne, three times blessed […] and blessed is the fruit of your womb. It is truly a worthy thing to preach of her who gave us the plant from which Jesus was born'.[46] The same writer also composed a hymn for the birth of the Baptist in which Elizabeth's sterility is linked to Mary's virginity, one prodigy being the precursor of the other, as John is of Christ. In addition, in the hymn Elizabeth's sterility and her miraculous pregnancy are indicated as signs of healing and divine grace.[47]

Thus, the presence of a small liturgical space frescoed with Saint Nicholas saving the girls from prostitution (as well as other possible hagiographic scenes in the same vein), where again women hold a central role in the story, would be entirely consistent with the programme of the right side of the church.

From iconography to style, and back: a proposal for the dating of the paintings

The niche with the Three Mothers, and the frescoes of the right aisle wall in general, have been dated in the past to the eighth or ninth century. More recently, they have been placed among the frescoes commissioned by Pope Paul I (757–67).[48] The only certain element of this intervention, however, was the new apse, which includes Paul's portrait. While stylistic and technical considerations seem to support the dating of the right aisle decoration to around the mid-eighth century, there are no grounds to assert a direct sponsorship by Paul I, or an execution specifically during his pontificate.

Technical examinations allow a comparison between the repainted apse conch, definitely commissioned by Paul, and the right aisle wall. They revealed the use of the same type of plaster—which differs in fact from that used in the time of John VII (705–7), which was very rich

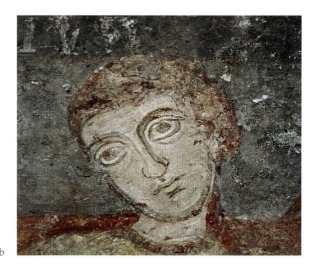
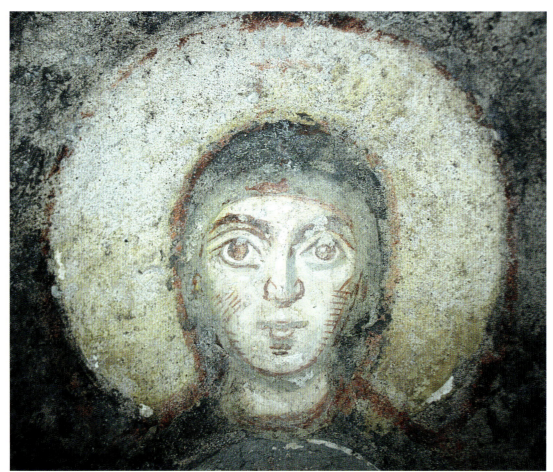

Santa Maria Antiqua: a) sanctuary, apse: detail of an angel; b) left aisle, east wall: detail of Old Testament cycle; c) right aisle, west wall, niche: Mary's face (photo: Manuela Gianandrea)

in straw—as well as a very similar colour palette.[49] In addition, the palette is nearly identical between the walls of the two aisles, which show further strong similarities both in style and in the *modus operandi,* as the painters used a grid drawn in red ochre as an aid for the correct placement of the figures.[50] A stylistic comparison between the figures of the west wall and the apse is more difficult, given the poor preservation of the latter. But what remains of the face of one of the seraphim provides reassurance in this sense (Figures 8 a–c), especially since the apse paintings would presumably be bigger and qualitatively superior.

Examination of the west wall and its niche, with the Marian-Christological stories and the supposed 'miracle' of Saint Nicholas, reveal important similarities, suggesting that they were executed over a very short period by painters working in a very similar manner. The slight differences, for example between the Three Mothers and the figures in the narrative scenes, can be explained by the different functions of the paintings. In particular, the narrative scenes are characterised by a broader and more fluid brushwork, because of their smaller dimensions and higher placement above the observer. The technical and stylistic evidence allows us reasonably to propose a dating of the side aisles that is more or less contemporaneous with Paul I's apsidal campaign. The pope's sponsorship seems to signal a point of arrival in the decoration of the church, and there is no evidence of later decorative works in the interior.[51] It is probably no accident that the attention of subsequent popes, most notably Hadrian I (772–95), concentrated on the atrium.

The broader Roman context provides no further clue to the chronological placement of Santa Maria Antiqua's right aisle frescoes, since there are no surviving paintings from Paul I's time nor from the years immediately preceding or following it. The dating to his pontificate—or, at the latest, to the pontificate of his successor Stephen III (767–72)—aligns with the iconographic choices in the decoration of the two aisles, as Maria Grafova amply confirms elsewhere in this volume. It is easier to explain the incarnation as the intended dominant theme of the cycle, with the Virgin with Child at the centre of the Three Mothers' niche, if the imagery is framed within the struggle against Iconoclasm that occupied Rome and the papacy throughout the eighth century, in particular under popes Stephen II (752–57), Paul I, and Stephen III.

The conflict surrounding the issue of the legitimacy of images became even more heated after 750, when Emperor Constantine V launched violent persecutions against the iconophiles, and after 754, when he convened a Synod in Hierìa to obtain official doctrinal validation for his iconoclastic reforms.[52] Then, in an attempt to offer a philosophical-theological grounding for the rejection of images, Constantine wrote a number of texts of decidedly monophysite flavour in which he asserted that those venerating images were heretics, because any painting bearing the image of Christ could only represent his human nature. Furthermore, since the two natures of Christ cannot be represented in a single image, sacred depictions were by default heretical, and were to be destroyed. In response, the Church of Rome held on to the tradition of images and their cult with unshakeable loyalty. A reading of the biographies of Stephen II and Paul I in the *Liber pontificalis* provides an account of a planned propaganda campaign in favour of images.[53] This plan was enacted in both words and deeds: from the almost physical relationship between Stephen II and the Lateran *Icon of the Saviour*, which he carried on his back, barefoot for Rome's salvation, to the official requests sent to Constantine V for a return to orthodoxy, to the great icon of Christ placed by Paul I in the apse of Santa Maria Antiqua.[54]

The theological reply from Rome was composed as an 'anti-iconoclastic dossier', probably assembled in the Monastery of San Saba on the Aventine between 730 and 750 by gathering the writings of the foremost iconophile Church Fathers.[55] Following the examples of Maximus the Confessor and John of Damascus, the defence of the representation of the divine was based on the dogma of the incarnation, which became the basis of iconophile theology. As John of Damascus wrote: 'I show myself God the Invisible, not as invisible, but as what is become visible to us through the presence in the body and the blood'[56]. Through the incarnation, God the invisible became 'imaginable' in the full sense, meaning not only intellectually conceivable but also open to artistic depiction. Thus, the image is no longer the illegitimate child of the *Lógos*. To deny that Christ can be depicted in art means to deny that he could assume a human bodily aspect, and such denial ultimately leads to the denial of the mystery of the incarnation. The substance of this was to say to the iconoclasts that their Christology was afflicted by Monophysitism, and therefore inherently heretical. The fresco of the Three Mothers in Santa Maria Antiqua can thus be reconsidered in the light of the anti-iconoclastic climate of the mid-eighth century: the choice of the iconography of the Virgin with Child in the mandorla gains a new significance as the manifesto of the *Lógos* incarnate, of Christ equally true God and true man.

In this context, a previously overlooked excerpt from the biography of Stephen II becomes very interesting. The passage documents the donation to Santa Maria Maggiore of 'an image of fine gold, of God's mother seated on a throne, bearing on her knees the figure of our Saviour the Lord Jesus Christ'.[57] Mary thus exhibits an image of the Child, which, given the use of the Latin term *'vultum'*, was probably enclosed in a *clypeus* or mandorla. This interpretation of Stephen II's artistic sponsorship, together with the proposed iconography of the painting in Santa Sabina's narthex and that of the Three Mothers in Santa Maria Antiqua, becomes yet another demonstration of the extraordinary vitality that the visual culture of Byzantine origin had in Rome, and which persisted even after the relations between Rome and Byzantium were compromised forever.[58]

NOTES TO THE TEXT

* My gratitude goes to Giulia Bordi, Irene Caracciolo, Carlo Costantini, Werner Schmid, and Valeria Valentini.

1 Gordon Rushforth, 'The Church of S. Maria Antiqua', *Papers of the British School at* Rome, 1 (1902), 1–123 (pp. 82–3); Joseph Wilpert, 'Sancta Maria Antiqua', *L'Arte* 13 (1910), 1–20, 81–107 (pp. 96–7); Wladimir de Grüneisen, *Sainte-Marie-Antique* (Roma: Max Bretschneider, 1911), p. 104; Eva Tea, *La Basilica di Santa Maria Antiqua* (Milano: Società Editrice 'Vita e Pensiero', 1937), p. 96; Pietro Romanelli and Per Jonas Nordhagen, *S. Maria Antiqua* (Rome: Istituto poligrafico dello Stato, 1964), p. 38; and Giulia Bordi, 'Santa Maria Antiqua attraverso i suoi palinsesti pittorici', in *Santa Maria Antiqua tra Roma e Bisanzio*, ed. by M. Andaloro, G. Bordi and G. Morganti (Milano: Electa, 2016), pp. 34–53 (p. 51).

2 Joseph Wilpert, *Die römischen Mosaiken und Malereien der kirchlichen Bauten vom IV. bis XIII. Jahrhundert* (Freiburg im Breisgau: Herder, 1916) [hereafter *RMM*], fig. 306.

3 Wilpert, *RMM*, fig. 304.

4 The inscription beside the figure understood as Joachim raises some problems, previously noted by de Grüneisen and Federici; however, the iconography of the scene suggests complete confidence in this identification; see de Grüneisen, *Sainte-Marie-Antique*, pp. 104, 459; and Rushforth, 'The Church of S. Maria Antiqua', p. 81.

5 Rushforth, 'The Church of S. Maria Antiqua', pp. 80–3; Joseph Wilpert, 'Appunti sulle pitture della chiesa di S. Maria Antiqua', *Byzantinische Zeitschrift*, 14 (1905), 578–83 (p. 581); de Grüneisen, *Sainte-Marie-Antique*, pp. 104–5; Tea, *Basilica di Santa Maria Antiqua*, pp. 282–5; Stephen John Lucey, *The Church of Santa Maria Antiqua, Rome: Context, Continuity, and Change* (unpublished doctoral thesis, Rutgers University, 1999), pp. 86–7. For a detailed study of the narrative Old Testament sequence in the left aisle, see Birute Anne Vileisis, 'The Genesis Cycle of S. Maria Antiqua' (unpublished doctoral thesis, Princeton University, 1979).

6 The festivities for the Presentation in the Temple and the Purification of Mary were celebrated in February. Among the other primary sources on the infancy of Christ, the Gospel of Luke does not mention the Magi, while the Protevangelium of James does not deal with the Presentation in the Temple.

7 On the iconography of the Magi, see Francesca Paola Massara, 'Magi', in *Temi di iconografia paleocristiana*, ed. by F. Bisconti (Vatican City: Pontificio Istituto di Archeologia Cristiana, 2000), pp. 205–11.

8 Rushforth, 'The Church of S. Maria Antiqua', p. 82, read the letters as 'OEA'; while de Grüneisen, *Sainte-Marie-Antique*, p. 105, preferred 'OLA'.

9 Rushforth, 'The Church of S. Maria Antiqua', p. 82; Wilpert, 'Sancta Maria Antiqua', p. 98; de Grüneisen, *Sainte-Marie-Antique*, p. 456; Tea, *Basilica di Santa Maria Antiqua*, p. 279; Marina Falla Castelfranchi, 'Nicola, santo', in *Enciclopedia dell'Arte Medievale* (Rome: Istituto della Enciclopedia Italiana, 1991–2002), VIII (1997), pp. 679–83.

10 Carlo Carletti, *I tre giovani ebrei di Babilonia nell'arte cristiana antica* (Brescia: Paideia, 1975).

11 Maria Chiara Celletti, 'Nicola di Mira', in *Bibliotheca Sanctorum*, (Rome: Istituto Patristico Medievale, 1961–2000), IX (1967), cols 939–48.

12 Maria Stella Calò Mariani, 'L'immagine e il culto di san Nicola a Bari e in Puglia', in *San Nicola: Splendori d'arte d'Oriente e d'Occidente*, ed. by M. Bacci (Milan: Skira, 2006), pp. 107–16; Valentino Pace, 'Iconografia di San Nicola di Bari nell'Italia meridionale medievale: alcuni esempi e qualche precisazione', in *San Nicola da Myra dal Salento alla Costa d'Amalfi: il mito di un culto in cammino*, ed. by C. Caserta (Napoli: Edizioni Scientifiche Italiane, 2012), pp. 75–84.

13 Nancy Patterson Ševčenko, *The life of Saint Nicholas in Byzantine art* (Turin: Bottega d'Erasmo, 1983), p. 158; Falla Castelfranchi, 'Nicola, santo', pp. 679–83. The paintings in the church of Santa Marina in Muro Leccese and those at San Gabriele in Airola represent earlier evidence of iconographies relating to Saint Nicholas's life. On this topic, see Marina Falla Castelfranchi, *Pittura monumentale bizantina in Puglia* (Milan: Electa, 1991), pp. 101–6; and Simone Piazza, 'Pittura "beneventana"? Questioni storiografiche alla luce di una nuova acquisizione: i dipinti della chiesa di San Gabriele sotto il monastero di Monteoliveto ad Airola', in *Medioevo: arte e storia*, ed. by A. C. Quintavalle (Milan: Electa, 2008), pp. 367–84.

14 Celletti, 'Nicola di Mira'. For Rome, see in particular Giorgia Pollio, 'Il culto e l'iconografia di san Nicola a Roma', in *San Nicola da Myra*, ed. by C. Caserta, pp. 137–44.

15 Gerardo Cioffari, 'San Nicola nelle fonti letterarie dal V all'VIII secolo', *San Nicola da Myra*, ed. by C. Caserta, pp. 31–4.

16 Albert Dufourcq, 'Le passionnaire occidental au VIIe siècle', *Mélanges d'archéologie et d'histoire*, 26 (1906), 27–65; and Gustav Ainrich, *Hagios Nikolaos. Der heilige Nikolaos in der griechischen Kirche. Texte und Untersuchungen* (Leipzig: Teubner, 1917), p. 263.

17 Wilpert, 'Sancta Maria Antiqua', p. 97.

18 Lesley Jessop, 'Pictorial cycles of non-biblical saints: the seventh and eighth century mural cycles in Rome and contexts for their use', *Papers of the British School at Rome*, 67 (1999), 233–79; Michele Trimarchi, 'Per una revisione iconografica del ciclo di affreschi nel Tempio della Fortuna Virile', *Studi Medievali*, 3rd ser., 19 (1978), 653–79; Giorgia Pollio, 'Il perduto ciclo pittorico di San Zotico a S. Maria in Pallara. Testimonianza figurativa di un perduto testo agiografico?', in *Roma e il suo territorio nel Medioevo: Le fonti scritti fra tradizione e innovazione*, ed. by C. Carbonetti, S. Lucà, and M.

19 Signorini (Spoleto: Centro Italiano di Studi sull'Alto Medioevo, 2015), pp. 499–514.

19 We cannot exclude that the liturgical area was further defined by a small wall, abutting the main wall at a right angle and projecting at a low level; however, of this there is no trace or record.

20 Franz Alto Bauer, 'La frammentazione liturgica nella Chiesa romana del primo Medioevo', *Rivista di Archeologia Cristiana*, 75 (1999), 385–446.

21 Ibid., pp. 408–15.

22 Manuela Gianandrea, 'Un'inedita committenza nella chiesa romana di Santa Sabina all'Aventino: il dipinto altomedievale con la Vergine e il Bambino, santi e donatori', in *Medioevo: I committenti*, ed. by A. C. Quintavalle (Milan: Electa, 2011), pp. 399–410; Manuela Gianandrea, 'Il nartece nei secoli altomedievali', in *Zona liminare: Il nartece di Santa Sabina all'Aventino a Roma, la sua porta e l'iniziazione cristiana*, ed. by I. Foletti and M. Gianandrea (Rome: Viella, 2015), pp. 201–16.

23 André Grabar, *L'iconoclasme byzantin: Dossier archéologique* (Paris: Collège de France, 1957), pp. 34–5; Werner Seibt, 'Der Bildtypus der Theotokos Nikopoios. Zur Ikonographie des Gottesmutter-Ikone, die 1030/1031 in der Blachernenkirche wiederaufgefunden wurde', *Byzantina*, 13 (1985), 551–64; Cyril A. Mango, 'The Chalkoprateia Annunciation and Pre-Eternal Logos', *Deltion tes Christianikes archaiologhikes Hetaireias*, 17 (1993–4), 165–70; Brigitte Pitakaris, 'À propos de l'image de la Vierge orante avec le Christ-Enfant (XIe-XIIe siècles): l'émergence d'un culte', *Cahiers Archéologiques*, 48 (2000), 45–58.

24 A special case is the painting with the Virgin and Child in the left apse of the Drosiani church on Naxos, traditionally dated to the seventh century; see Nicos Drandakis, 'Panagia Drosiani', in *Naxos: Mosaics-Wall Paintings*, ed. by Manolēs Chatzidakis (Athens: Melissa, 1989), pp. 18–27.

25 Gustave Schlumberger, *Sigillographie de l'empire byzantin* (Paris: Leroux, 1884).

26 Antonio Iacobini, *Visioni dipinte: Immagini della contemplazione negli affreschi di Bawit* (Rome: Viella, 2000), pp. 44–65.

27 Kurt Weitzmann, *The Monastery of Saint Catherine at Mount Sinai. The Icons* (Princeton: Princeton University Press, 1976), p. 51.

28 *The Cult of the Mother of God in Byzantium: Texts and images*, ed. by L. Brubaker and M.B. Cunningham (Farnham: Ashgate, 2011), pl. 6.1.

29 Valentina Cantone, 'Iconografia mariana e culto popolare nel Codice Siriaco 341 di Parigi', *Rivista di storia della miniatura*, 15 (2011), 17–25.

30 Sirarpie Der Nersessian, 'La peinture arménienne au VIIe siècle et les miniatures de l'Évangile d'Etchmiadzin', in *Actes du XIIe Congrès international d'études byzantines (Ochrid, 10–16 septembre 1961)*, 3 vols (Belgrade: Naunčo Delo, 1964), III, pp. 49–57.

31 Mario Rotili, *Arte bizantina in Calabria e Basilicata* (Cava dei Tirreni: Di Mauro, 1980), pp. 185–6.

32 See note 22.

33 Simone Piazza, *Pittura rupestre medievale: Lazio e Campania settentrionale (secoli VI–XIII)* (Rome: École Française de Rome, 2006), pp. 119–22.

34 Francesca Dell'Acqua, 'Ambrogio Autperto e la Cripta di Epifanio nella storia dell'arte medievale', in *La cripta dell'abate Epifanio a San Vincenzo al Volturno: Un secolo di studi (1896–2007)*, ed. by F. Marazzi (Cerro al Volturno: Volturnia, 2013), pp. 27–47.

35 Ioannes Scylitzes, *Synopsis historiarum*, ed. by I. Thurn (Berlin: De Gruyter, 1973), p. 41.

36 Philip Grierson, *Catalogue of the Byzantine Coins in the Dumbarton Oaks Collection and in the Whittemore Collection. III: Leo III to Nicephorus III, 717–1081* (Washington: Dumbarton Oaks, 1973), p. 142.

37 Richard Gem, Emily Howe, and Richard Bryant, 'The Ninth-Century Polychrome Decoration at St Mary's Church, Deerhurst', *The Antiquaries Journal*, 88 (2008), 109–64 (pp. 150–3).

38 Umberto Utro, 'Mandorla', in *Temi di iconografia paleocristiana*, p. 211.

39 Mango, 'The Chalkoprateia Annunciation', p. 168.

40 Joseph Laurent, *L'Arménie entre Bysance et l'Islam depuis la conquête arabe jusqu'en 886* (Paris: De Boccard, 1919), *passim*. For the Acts of the Council, see *Sacrorum conciliorum nova et amplissima collectio*, ed. by G.D. Mansi, 31 vols (Florence: Zatta, 1759–98), XI (1765), cols 190–1023. For the historical context, see Ottorino Bertolini, 'Riflessi politici delle controversie religiose', in *Caratteri del secolo VII in Occidente* (Spoleto: Centro Italiano di Studi sull'Alto Medioevo, 1958), pp. 733–89; and Francis Xavier Murphy and Polycarp Sherwood, *Constantinople II et Constantinople III* (Paris: Editions de l'Orant, 1974).

41 Ann Wharton Epstein, 'The Political Content of the Paintings of Saint Sophia at Ohrid', *Jahrbuch der österreichischen Byzantinistik*, 29 (1980), 315–29; and *Monastic Visions: Wall paintings in the Monastery of St. Antony at the Red Sea*, ed. by E. Bolman and P. Godeau (New Haven: Yale University Press, 2002).

42 *Ordo Romanus I*, in *Patrologiae cursus completus. Series latina*, ed. by J.-P. Migne (Paris: Garnier, 1895) 78, cols 943, 947.

43 Joseph David in de Grüneisen, *Sainte Marie Antique*, pp. 455–6; Stephen John Lucey, 'Art and Socio-Cultural Identity in Early Medieval Rome. The Patrons of Santa Maria Antiqua', in *Roma Felix: Formation and Reflections of Medieval Rome*, ed. by É. Ó Carragáin and C. Neuman de Vegvar (Aldershot: Ashgate, 2007), pp. 139–58 (pp. 154–7).

44 Elena Croce, 'Anna' in *Bibliotheca Sanctorum*, I (1961),

cols 1270–95; Isa Belli Barsali, 'Elisabetta', in *Bibliotheca Sanctorum*, IV (1964), cols 1079–94.

45 Protoevangelium of James 1.4; 4.1–3; Gospel of Pseudo-Matthew 2.1–3.

46 John of Damascus, *Hom. I, De Nativitate Mariae Virginis*. He reaffirms these convictions concerning Anne also in *De Fide Orthodoxa*. See Andrew Louth, 'John of Damascus on the Mother of God as a Link between Humanity and God', in *The Cult of the Mother of God*, ed. by L. Brubaker and M.B. Cunningham, pp. 153–61.

47 Manuel Nin, 'L'innografia del Damasceno per la nascita di San Giovanni Battista', *L'Osservatore Romano*, 24–25 June 2011.

48 Gordon Rushforth ('The Church of S. Maria Antiqua', p. 28) attributed the painting of the aisles to a date not before the middle of the eighth century; Wladimir de Grüneisen (*Saint-Marie-Antique*, p. 106) preferred the third quarter of the ninth century, a view shared by Guglielmo Matthiae, *Pittura romana del Medioevo: Secoli IV–X* (Rome: Palombi, 1965), p. 190. A date in the second half of the eighth century was assumed, for example, by Pietro Toesca, *Storia dell'arte italiana*, 2 vols (Turin: Unione tipografico editrice torinese, 1927), I, p. 236 note 86; Tea, *Basilica di Santa Maria Antiqua*, p. 271; and Maria Andaloro, *Aggiornamento scientifico al Matthiae* (Rome: Palombi, 1987), p. 283. Per Jonas Nordhagen thought the paintings were contemporary with the apse, see Romanelli and Nordhagen, *S. Maria Antiqua*, p. 62. See also Maria Grafova in this volume.

49 My thanks to Werner Schmid and Valeria Valentini for the information. See Schmid, 'Il lungo restauro'.

50 On the west wall, the geometric grid is still clearly visible in the niche of the Three Mothers and the panel to the right, with a male face and a mountain. The same device is also found in the Chapel of Theodotus and the panel of Pope Hadrian I. See Valeria Valentini, 'Il cantiere pittorico della cappella di Teodoto', in *Santa Maria Antiqua tra Roma e Bisanzio*, ed. by M. Andaloro, G. Bordi, and G. Morganti, pp. 270–7.

51 The only exception appears to be the ninth-century renovation of the *velarium* in the apse, to replace that of Paul I. The relatively small scale of this operation suggests that the decorative apparatus of the basilica was mainly completed by the second half of the eighth century.

52 Stephen Gero, *Byzantine Iconoclasm during the Reign of Constantine V with Particular Attention to the Oriental Sources* (Louvain: Secrétariat du Corpus, 1977); *Byzantium in the Iconoclast Era c. 680–850: A History*, ed. by L. Brubaker and J. Haldon (Cambridge: Cambridge University Press, 2011), pp. 156–247; Emanuela Fogliadini, *L'immagine negata: Il concilio di Hieria e la formalizzazione ecclesiale dell'iconoclasmo* (Milan: Jaca Book, 2013).

53 *Le Liber Pontificalis: texte, introduction, et commentaire*, ed. L. Duchesne, 2 vols (Paris: E. Thorin: 1886–92) [hereafter *LP*], I, pp. 440–67; Ottorino Bertolini, *Roma di fronte a Bisanzio e ai Longobardi*, (Bologna: Cappelli, 1941); Thomas F. X. Noble, *The Republic of St. Peter: The Birth of the Papal State, 680–825* (Philadelphia: University of Pennsylvania Press, 1984), pp. 103–12; Leslie Brubaker, *Inventing the Byzantine Iconoclasm* (London: Bristol Classical Press, 2012), pp. 46–7.

54 Eileen Rubery, 'Christ and the Angelic Tetramorphs: the Meaning of the Eighth-Century Conch at S. Maria Antiqua in Rome', in *Sailing to Byzantium*, ed. by S. Neocleous (Newcastle: Cambridge Scholars Publishing, 2009), pp. 183–220.

55 Vittorio Fazzo, 'I Padri e la difesa delle icone', in *Complementi interdisciplinari di Patrologia*, ed. by A. Quacquerelli (Rome: Città Nuova, 1989), pp. 413–56; see also Fogliadini, *L'immagine negata*, pp. 33–46.

56 John of Damascus, *Discorsi apologetici contro coloro che calunniano le sante immagini* (Rome: Città Nuova, 1997). See also Andrew Louth, 'John of Damascus on the Mother of God'; *Vedere l'invisibile: Nicea e lo statuto delle immagini*, ed. by Luigi Russo (Palermo: Aesthetica, 1999); and Christoph Schönborn, *L'icona di Cristo: Fondamenti teologici* (Cinisello Balsamo: San Paolo, 2003).

57 *LP*, I, p. 453: 'imaginem ex auro purissimo [...] Dei Genitricis in throno sedentem, gestantem super genibus vultum Salvatoris domini nostri Iesu Christi'. English translation from Raymond Davis, *The Lives of the Eighth-Century Pontiffs (Liber Pontificalis)* (Liverpool: Liverpool University Press, 1992), p. 71. See also Antonella Ballardini, '*Stat Roma pristina nomine*. Nota sulla terminologia storico-artistica nel Liber Pontificalis', in *La committenza artistica dei papi a Roma nel Medioevo*, ed. by M. D'Onofrio (Rome: Viella, 2016), pp. 381–439 (p. 432).

58 Manuela Gianandrea, 'Politica delle immagini al tempo di papa Costantino (708–715): Roma *versus* Bisanzio?', in *L'officina dello sguardo: scritti in onore di Maria Andaloro*, ed. by G. Bordi, I. Carlettini, M.L. Fobelli, M.R. Menna and P. Pogliani (Roma: Gangemi, 2014), I, 335–42.

MARIA GRAFOVA

The Decorations in the Left Aisle of Santa Maria Antiqua in the Context of the Political History of the Iconoclastic Era

Artworks may—and should—be used as historical sources. Both the general history of Iconoclasm, and of late antique and early medieval Rome, rely generally on a sparse corpus of written sources. The most promising approach, therefore, seems to be an interdisciplinary one, where scholars fill in the gaps in one field with data from others. An artwork thus becomes a legitimate source for a historical study. To the best of my knowledge, the procession of saints in the fresco on the left aisle of Santa Maria Antiqua (Plates 6, 50: C1) has been never studied in the context of the history of relations between Rome and Constantinople during the period of Iconoclasm. The third quarter of the eighth century saw an open political confrontation between the Holy See and the Empire, as the tenuous equilibrium in their relations was disturbed.[1] The aim of the present paper is therefore to investigate the frescoes in Santa Maria Antiqua to help illuminate this complex historical moment.

The rivalry between popes and emperors: politics before theology

By the middle of the eighth century, contacts between the Empire and the Holy See had already become irregular, and the popes had enough power to implement their own policy.[2] Two great problems, however, had not yet been settled: one was the controversy between iconoclasts and iconophiles; the other, the fact that the declining empire was unable to protect Rome from the threat of the Lombards.[3] As a result, Pope Stephen (752–7) resolved to seek assistance from a new political force, the Franks.[4] King Pepin and Pope Stephen agreed that the pope was authorised to rule personally over the lands of Rome and Ravenna, whereas previously these regions had been subject to the Byzantine emperor.[5] Soon the emperor had to accept an unpleasant status

quo: Rome and Ravenna were lost, and the Pope of Rome established his own state in Central Italy ('beato Petro sanctaeque Dei ecclesiae, rei publice Romanorum').[6]

Around the middle of the century the popes also began to claim both legal and hierarchical supremacy over the whole Christian Church (the pope's honorary right to be *primus inter pares* among bishops was never contested by Eastern Churches)—an idea alien not only to the early Christians, but also to eighth-century Christians. This would eventually lead to the conflict between Pope Nicholas I (856–67) and Photios, Patriarch of Constantinople (857–67), and in the longer term would set the stage for the Great Schism of the eleventh century.[7]

The personality of Stephen's brother and successor, Pope Paul I (757–67), is still in need of additional research. In the history of the papacy he is, so to speak, barely visible between his great predecessor and elder brother Stephen and his famous successor Hadrian I (772–95).[8] But in the final year of Paul's pontificate (767), the Council of Gentilly, which can be viewed as the last attempt by the empire to alienate the Franks from the papacy, failed.[9] As a consequence, the views concerning the roles of Rome and Constantinople and the attitudes towards their imperial heritage changed significantly: the Byzantines would no longer be seen as *romani*, but as *graeci*, even 'nefandissimi Graeci, inimici sanctae Dei ecclesiae et orthodoxae fidei expugnatores' ('most impious Greeks, enemies of God's Holy Orthodox Church and persecutors of faith').[10] Now Rome was the true heir of the ancient Roman Empire.[11]

The possible anti-iconoclastic meaning of the eighth-century decoration of Santa Maria Antiqua was advanced only once, by Joseph Wilpert, and he only considered the apse, whose images can be firmly dated thanks to the donor's inscription to Paul I's pontificate (Plates 35, 50: K1.1). Wilpert thought that the reason for the renovation of the apse painting—a monumental figure of Christ flanked by two six-winged hybrids of cherubim and seraphim—was not the poor state of John VII's mural, which was only a half-century earlier, but rather the result of Paul's zeal to worship the image of Christ and thus confirm his opposition to Iconoclasm.[12] Gordon Rushforth was the first to notice that the arrangement of the saints on the left aisle wall obeyed specific rules: the saints to the viewer's right are Eastern champions of orthodoxy, with the single exception of Erasmus (Plate 6); those on the left are instead the most popular saints of the Roman Church, and the first eight figures for Rushforth are arranged by ecclesiastical hierarchy (four popes, two presbyters, two Eastern monks).[13] In this context, I propose that the selection and arrangement of the saints in the left aisle was also shaped by the pope's anti-iconoclasm. It should be noted here that these murals cannot be dated precisely, but on stylistic grounds they likely belong to Paul I's papacy or the period around it.[14]

The left aisle displays a traditional Roman composition divided into four registers (Plate 6): the two top registers show a narrative sequence from the Old Testament,[15] the middle register Christ flanked by the procession of saints, and the lowest a *velum*.[16] There are other frescoes in Santa Maria Antiqua with possibly polemical iconographies, both political and theological. Two in particular stand out: the *Fathers of the Church* flanking the apse, dating to *circa* the mid-seventh century (Plates 35, 40, 41, 50: K 1.3, K 1.4),[17] and the elaborate decoration of the apsidal arch, commissioned under Pope John VII (Plates 32, 50: K 1.2).[18] In the Middle Ages, political and theological controversies were often inseparable: could the row of saints in the left aisle intentionally represent a specific political and/or theological agenda?

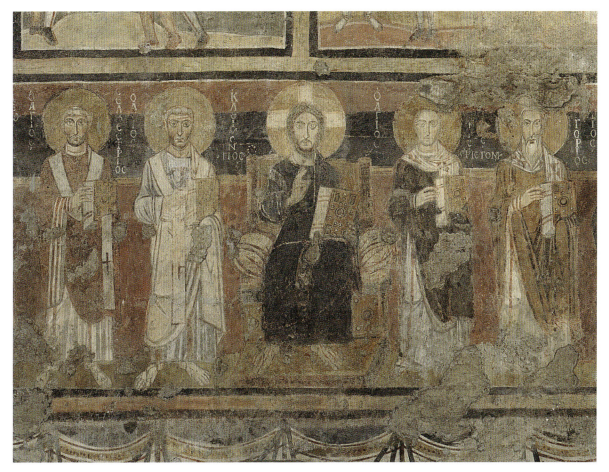

1 Santa Maria Antiqua, left aisle, east wall, detail: Christ enthroned, flanked (on the left) by Saint Clement and Saint Sylvester, and (on the right) by Saint John Chrysostom and Saint Gregory of Nazianzus (photo: Roberto Sigismondi)

The frescoes of the left aisle in the context of coeval Roman painting

A row of saints within a tripartite narrative composition is frequently found in medieval Roman art. Among the extant examples see in particular:

- In San Saba, episodes from Christ's life, possibly not contemporaneous with a row of saints that includes Sebastian, Lawrence, Stephen, and Peter of Alexandria.[19] In the apse there used to be another group of saints, including possibly Sabbas, Euthymius, Athanasius, and Gregory the Great.[20]

- A narrow three-part fragment from the church of Sant'Adriano in the Forum (now in the Crypta Balbi Museum), including two saints that look very much like those from Santa Maria Antiqua.[21]

- A row of saints from a tripartite painting in Santa Passera; the saints in the middle register include John Chrysostom, Epiphanius, Gregory of Nazianzus, Basil the Great, and Nicholas.[22]

– Santa Maria in Gradellis, featuring a row of Eastern and Western saints in full length, wearing their respective vestments, carrying codices, identifiable through vertical Latin inscriptions beside each one.[23]

What is distinctive, then, about Santa Maria Antiqua? First of all, its preservation. Most of the row of saints has survived, a fact that allows a comprehensive analysis. Not only can we address the individual figures and their role in establishing a cult of the saints in Rome, but we can also raise a broader issue: what principle guided the selection of saints for this particular group? The middle register, as noted above, shows Christ on a throne decorated with gems, his right hand raised in blessing, his left holding a codex (Plate 7; Figure 1). He is flanked on both sides by canonised prelates, martyrs, priest-martyrs, and others, for a total of twenty-two, thirteen to the right and nine to the left (Plate 6).[24] They are arranged around Christ as follows: on his right-hand side (viewer's left) there are Clement, Sylvester, Leo, Alexander, Valentine, Abundius, Euthymius, Sabbas, Sergius, Gregory, Bacchus, an unidentified saint, and possibly Mammas (Figures 2–3). On Christ's left-hand side (viewer's right): John Chrysostom, Gregory of Nazianzus, Basil the Great, Peter of Alexandria, Cyril of Alexandria, Epiphanius of Salamis, Athanasius of Alexandria, Nicholas of Myra, and Erasmus (Figure 4).

The saints on Christ's right-hand side

1. Saint Clement, Pope (88/90–97/99).[25] Inscription: 'Ο ΑΓΙΟΣ ΚΛΕΙΜΕΝΤΙΟΣ' (Figure 1). Clement is represented as an elderly short-bearded man with a tonsure in his curly grey hair,[26] dressed *all'antica*: white tunic with broad purple stripes (*tunica manicata laticlava*),[27] a cloak, a *pallium*,[28] and sandals; his left hand is covered with the cloak and holds a codex, his right hand holds an anchor, the symbol of his martyrdom.

2. Saint Sylvester, Pope (314–35). Inscription: 'Ο ΑΓΙΟΣ ΣΕΛΒΕΣΤΡΙΟΣ' (Figure 1). In the tradition of the Roman Church, Sylvester is credited with convoking a synod of 275 bishops that confirmed the decrees of the Council of Nicaea (325 CE).[29] He is also seen as initially the opponent of Constantine.[30] But we do not know if the *Donatio Constantini* had been already written at the time of Paul I. Sylvester is shown as a middle-aged man, with tonsured grey hair, a moustache and a small beard;[31] he wears a white tunic, a dalmatic with *clavi* and a dark-red *paenula* with pallium and *campagi* (half-open shoes with lacing), his left hand holding a codex, his right hand touching the book with the tips of the fingers in a blessing gesture.

3. Saint Leo, Pope (440–61). Inscription: 'Ο ΑΓ[ΙΟΣ] ΛΕΩ' (Figure 2). A notable fighter against Nestorianism and Monophysitism; his writings were important for the consolidation of the orthodox communities during the Council of Chalcedon in 451. He was venerated in both Western and Eastern Christianity.[32] Pope Leo I

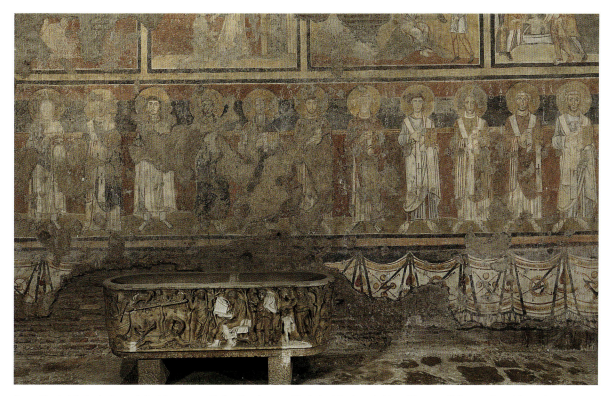

2 Santa Maria Antiqua, left aisle, east wall, detail: saints on Christ's right-hand side—Clement, Sylvester, Leo, Alexander, Valentine, Abundius, Euthymius, Sabbas, Sergius, Gregory, and Bacchus (photo: Roberto Sigismondi)

is shown as a rather young man with brown hair, a fine moustache, and a short beard;[33] he wears a white tunic, a dalmatic, a white *paenula* with a pallium, and a pair of *campagi*.

4 Saint Alexander, most probably Pope Alexander (105/7–115/18).[34] Inscription: 'Ο ΑΓΙΟΣ ΑΛΕ[---]ΔΡΟΣ' (Figure 2). A young beardless man with a clerical tonsure and brown hair,[35] barefoot, in a classical attire: a blue tunic with broad purple stripes (*tunica manicata laticlava*), and a white cloak, pallium, and sandals; his left hand hols a codex, his right hand in a gesture, perhaps oratorical.

5 Saint Valentine. Inscription: 'Ο ΑΓΙΟΣ ΒΑΛ[ΕΝ]ΤΙΝΟΣ' (Figure 2). Most likely the popular but legendary Roman saint, Valentine the priest, martyred under Claudius in 269. There were at least four churches dedicated to him, including the famous San Valentino on the Via Flaminia, built over his presumed burial site in the fourth century. In fact, the identification of the tomb as that of the saint was due to a confusion not uncommon in the Middle Ages: Valentine is the name of a church donor mistaken in the Liberian Catalogue for a saint, as were many of the benefactors and founders of Roman churches and tituli who, from the fifth or sixth century, would be venerated as saints.[36] An elderly, white-haired cleric, bearded and with a moustache; he wears a white tunic, a crimson *paenula*,

361

and *campagi*; holds a codex.[37] The face is poorly preserved; the upper part is almost lost.

6 Saint Abundius. Inscription: 'Ο ΑΓΙΟС ΑΒΟΥΝΔΟС' (Figure 2). A local priest martyred, according to the *Acta Sanctorum*, under Diocletian, together with his deacon Abondantius and other Christians.[38] He is shown as a dark-haired cleric, with beard and moustache, wearing a white tunic and a yellow *paenula*, holding a codex.[39] It is a unique and valuable piece of evidence of his early cult in Rome.[40]

7 Saint Euthymius the Great (377–473). Inscription: 'ΑΓΙΟ[С] ЄΥΘΥΜΙΟС' (Figure 2). A holy hermit, miracle-worker, and founder of the famous monastery in Palestine, he contributed to the victory of orthodoxy over Monophysitism,[41] and was influential in bringing the pious, charitable, and well-educated Empress Eudoxia back to orthodoxy.[42] A narrow-faced old man with a high wrinkled forehead and a long beard, wearing classical garments: a purple tunic and a blue cloak, sandals; holds a codex.[43] The face is badly damaged.

8 Saint Sabbas. Inscription: 'Ο ΑΓΙΟС СΑ[ΒΒΑС]' (Figure 2). The figure is almost lost, but he is likely to have been barefoot and wearing classical dress like Euthymius. He has short grey hair and a beard.[44] Mostly probably, he is Saint Sabbas (439–532), one of the last disciples of Saint Euthymius and also a prominent opponent of Monophysitism.[45] A monastery dedicated to Sabbas was founded on the Aventine Hill, most likely in the seventh century, by the monks who came from the Christian East.[46]

9 Saint Sergius. A saint with a short beard, wearing a formal Byzantine costume (a white tunic, and a *chlamys* with a blue *tablion*), holding a cross and a martyr's crown. Inscription: 'Ο [Α]ΓΙΟ[С] СЄΡΓ[ΙΟС]' (Figure 2). The preserved letters of the inscription and the juxtaposition with the nearest figure wearing the same type of costume suggest an identification with Saint Sergius, companion of Saint Bacchus. The two were high-ranking officers martyred under Diocletian, and their cult was very popular in Rome.[47] Sergius is represented with a *torques aurea*,[48] a golden neck-ring typical of the images of these two saints.[49]

10 Saint Gregory. Inscription: 'Ο ΑΓΙΟС [Γ]ΡΙΓΟΡΙΟС' (Figure 2). Most likely, Gregory the Great, Pope (590–604), venerated as a saint by both churches[50]. The preserved facial details indicate a middle-aged man with a round face, a moustache and a short beard, wearing a yellowish tunic, a dalmatic, a dark blue *paenula* with a fringed pallium (*fimbriatum*)[51] and a pair of *campagi*.[52]

11 A saint looking like Saint Sergius (9), most likely his companion Saint Bacchus, though most of the inscription is lost (Figure 2). The face is lost, although the vestments are rather well-preserved.

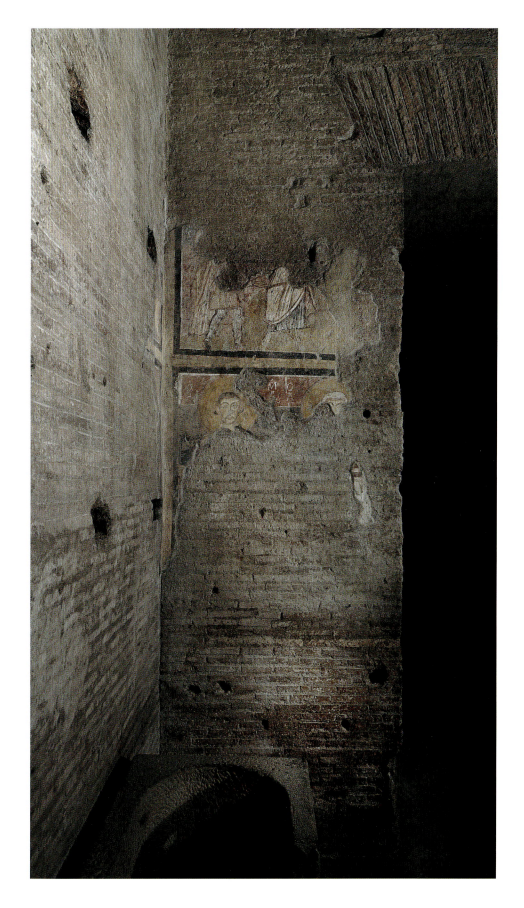

Santa Maria Antiqua, left aisle, east wall, detail: extension of the row of saints beyond the passage to the Domitianic Ramp; an unidentified saint and Saint Mammas (photo: Gaetano Alfano, 2015)

12 An unidentifiable saint (Figure 3; Plate 50: C2). Only a fragment of the halo and the letters 'O ΑΓ' to the left of it are preserved. A lay saint with thick curly hair, a short beard, and fine moustache; the body below the neck is not preserved. Inscription: 'Ο ΑΓΙΟC ΜΑ[ΜΜ]ΑC[-]' (Figure 3; Plate 50: C2). This was possibly an image of Saint Mammas, a martyr from Caesarea in Cappadocia, persecuted under Aurelian and venerated in the East as a holy healer.[53] There may have been a Roman church dedicated to him.[54]

The Saints on Christ's left-hand side

1 Saint John Chrysostom. Inscription: 'Ο ΑΓΙΟC [ΙΟΑ]ΝΝΗC ΧΡΙ[CO]CTOM[ος]' (Figure 1). A middle-aged man with a round face, a short beard, wearing a white tunic, a dark-coloured *paenula* with an *omophorion*[55] thrown over his shoulder, and *campagi*; his right hand holds a codex, and his left hand is raised in a blessing gesture.[56]

2 Saint Gregory of Nazianzus. Inscription: '[C] [ΓΡΙ]ΓΟΡΙΟC' (Figure 1). A white-haired elder, wearing a white tunic, a yellow *paenula* with an *omophorion* thrown over the shoulder, and *campagi*; holding a codex.[57] There is no surviving evidence of Roman churches dedicated at this time to either John Chrysostom or Gregory of Nazianzus.

3 Saint Basil the Great.[58] Inscription: '[Ο] ΑΓΙΟC ΒΑCΙΛΙΟC' (Figure 4). A man of the same facial type as Gregory of Nazianzus, but middle-aged and dark-haired.[59] He wears a tunic, a blue dalmatic, a dark-coloured *paenula*, and *campagi*; with an *omophorion*.

4 Saint Peter of Alexandria. Inscription: 'Ο ΑΓΙΟC ΠΕΤΡΟC [--]ΕΞΑΝΔΡΙΝΟC' (Figure 4). A Patriarch of Alexandria martyred under Diocletian and associated with the campaign against Arianism. According to one legend, following a dream in which Arius tore Christ's seamless garment, he anathematised him.[60] A white-haired but middle-aged man with a short beard and a wrinkled forehead, wearing a white tunic, a crimson *paenula* with an *omophorion*, and *campagi*.[61]

5 Saint Cyril of Alexandria, Patriarch of Alexandria (b. 376, d. 444). Inscription: 'Ο ΑΓΙΟC ΚΥΡΙΛΛΟC' (Figure 4). An opponent of Nestorianism.[62] He wears a blue tunic, a yellow *paenula* with an *omophorion*, and *campagi*; holding a codex.[63]

6 Saint Epiphanius of Cyprus. A monk from Palestine, Bishop of Salamis, one of the most fervent participants in the dispute on Origen's doctrine.[64] Inscription: 'Ο ΑΓΙΟC ΕΠΕ[ΙΦ]ΑΝΙΟC' (Figure 4). Another narrow-faced bearded old man, wearing a classical costume: a blue tunic with broad purple stripes (*tunica manicata*

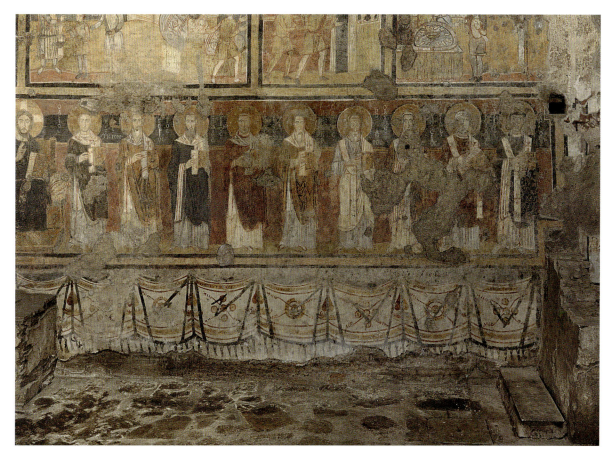

4 Santa Maria Antiqua, left aisle, east wall, detail: saints on Christ's left-hand side—John Chrysostom, Gregory of Nazianzus, Basil the Great, Peter of Alexandria, Cyril of Alexandria, Epiphanius of Salamis, Athanasius of Alexandria, Nicholas of Myra, and Erasmus (photo: Roberto Sigismondi)

laticlava), a white cloak with an *omophorion* loosely hanging down over the chest, and sandals.[65]

7 Saint Athanasius of Alexandria. A Patriarch of Alexandria (b. 296, d. 373), one of the prominent opponents of Arianism.[66] Inscription: 'Ο ΑΓΙΟC [Α]ΘΑΝΑCΙΟC' (Figure 4). A grey-haired old man wearing a white tunic, white dalmatic, yellow *paenula* with an *omophorion*, and *campagi*; the lower part of the face and most of the figure are lost.[67]

8 Saint Nicholas.[68] Inscription: '[Ο] [Α]ΓΙΟC ΝΙΚ[ΟΛ]ΑΟC' (Figure 4). Most facial features are lost, but the man is apparently round-faced and short-bearded; wearing a white tunic, a blue dalmatic, a crimson *paenula* with an *omophorion*, and *campagi*.[69]

9 Saint Erasmus.[70] Inscription: 'Ο ΑΓΙΟC ЄΡΑCΜΟC' (Figure 4). A round-faced, dark-haired, tonsured, beardless cleric,[71] wearing a white tunic, a blue dalmatic, a blue *paenula*, with an *omophorion*, and *campagi*.

Why do the saints of the left aisle of Santa Maria Antiqua represent a unified Church?

The foregoing survey of the saints depicted on the left aisle wall reveals that the saints on Christ's right-hand side are those venerated by the Roman Church, while those on his left-hand side are mostly Eastern holy bishops, notable theologians, and advocates of orthodoxy. The following analysis highlights the key characteristics of each group, bringing forth a general interpretation of the whole composition.

The first group comprises popes, local saints, and saints from the Christian East who could equally belong in the second group, but are presumably placed in the first due to their popularity in Rome (Figures 2, 3). Some are not, strictly speaking, historical.

The second group shows instead saints who were mostly theologians, many of whom had not been popular in Rome before the decoration of Santa Maria Antiqua (Figure 4). Interestingly, Saint Erasmus, a legendary Italian saint, is included in this group and is depicted wearing an Eastern omophorion. Most of the individuals in this group are not just champions of orthodoxy, but also opponents of various heresies seen as threatening the unity of the Church.

Taken together, both groups seemingly stand for the Church 'one and indivisible', opposing some formidable adversary. In the third quarter of the eighth century, the identification of this dangerous opponent is immediately obvious: it is the heresy of Iconoclasm, spreading dangerously from Constantinople. Presumably, the main armour of the Western Church was its firmness in the orthodox faith, while the main weapon of the Eastern Church was its theological erudition. Emile Mâle has written: 'In these frescos, whose creation was authorised by the Pope, Rome put together her own saints and those from the East, equally lovingly. She was intentionally respectful towards those whose images were destroyed in Constantinople, confirming that both Churches make up the whole.'[72]

My proposal here is therefore that the choice of saints for the left aisle of Santa Maria Antiqua could possibly reflect the desire of the patron (most likely Pope Paul I) to strongly emphasise his orthodoxy in the face of both the iconoclast threat and its political supporter, the Byzantine emperor.

1. For example, in 745 Pope Zacharias was a successful mediator in the negotiations between the emperor and Ratchis, the King of the Lombards. A treaty of peace was signed, and the Pope was granted some lands in the south of Italy by the emperor: see Vera von Falkenhausen, 'I bizantini in Italia', in *I bizantini in Italia*, ed. by G. Pugliese Carratelli (Milan: Scheiwiller, 1982), pp. 1–136 (p. 38). This cooperation was not compromised by the fact that Constantine was a convinced iconoclast, unlike the pope.

2. Not even Emperor Leo III the Isaurian ever tried to actually put his iconoclastic edicts into practice either in central Italy, or in Calabria and Sicily, recaptured since 731–2; see Alfred Lombard, *L'empereur Constantin V* (Paris: Alcan, 1902), p. 66; and Von Falkenhausen, 'I bizantini', pp. 38–9.

3. David H. Miller, 'Byzantine-Papal Relations during the Pontificate of Paul I: Confirmation and Completion of the Roman Revolution of the Eighth Century', *Byzantinische Zeitschrift*, 68 (1975), 47–62 (pp. 48–9).

4. For more details, see Jan T. Hallenbeck, *Pavia and Rome: The Lombard Monarchy and the Papacy in the Eighth Century* (Philadelphia: American Philosophical Society, 1982), pp. 63–96.

5. *Le Liber Pontificalis, texte, introduction, et commentaire*, ed. by L. Duchesne, 2 vols (Paris: Ernest Thorin, 1886–92) [hereafter *LP*], I, pp. 440–62 (*Vita Stephani II*).

6. *Codex epistolaris Carolinus*, ed. by W. Gundlach, *Monumenta Germaniae Historica, Epistolae* III (Berlin: Weidmann, 1892), pp. 469–657 (p. 489). For the political circumstances, see Hallenbeck, *Pavia and Rome*, pp. 72–3; Thomas F. X. Noble, *The Republic of St. Peter: The Birth of the Papal State. 680–825* (Philadelphia: University of Pennsylvania Press, 1984); and Thomas F. X. Noble, 'Topography, Celebration, and Power: The Making of a Papal Rome in the Eighth and Ninth Centuries', in *Topographies of Power in the Early Middle Ages*, ed. M. de Jong and F. Theuws (Leiden: Brill, 2001) pp. 45–91. In the records of the Papal Chancellery the name of Emperor Constantine V appears for dating purposes until 772, and then sometime before 781 the emperor's name is replaced by the pontiff's. On coins, the pope's name and profile portrait are used from 775, following the death of Constantine V (Von Falkenhausen, 'I bizantini', p. 40).

7. John Meyendorff, 'Rim i Konstantinopol', in John Meyendorff, *Rim, Konstantinopol, Moskva*, trans. L.A. Uspenskaya (Moscow: PSTGU, 2005), pp. 13–43 (pp. 26–8).

8. *LP*, I, pp. 463–7. Apart from the Council of Gentilly, Paul's pontificate seems to have lacked other notable historical events; his biography in the *Liber pontificalis* is very short, written records are scarce, and there are none in Greek (cf. Miller, 'Byzantine-Papal Relations', p. 47). Baumont construes Paul I as a weak and secondary figure: Maurice Baumont, 'Le pontificat de Paul Ier', *Mélanges d'archéologie et d'histoire*, 47 (1930), 7–24; but his reading of the sources is a mere retelling, and the attempt at reconstructing the pope's personality is not convincing. On the other hand, Miller ('Byzantine-Papal Relations', pp. 47–62) tries to present Paul as a strong, independent, and canny politician.

9. The Acts of the Council are lost and other evidence is scarce. See Michael McCormick, 'Textes, images et iconoclasme dans le cadre des relations entre Byzance et l'Occident carolingienne', in *Testo e immagine nell'alto medioevo. Atti della XLI Settimana di Studi sull'Alto Medioevo (Spoleto 15–21 aprile 1993)* (Spoleto: Centro Italiano di Studi sull'Alto Medioevo, 1994), pp. 95–158 (pp. 113–31).

10. Citation from a letter of Paul I, see *Monumenta Germaniae Historica, Epistolae* III: *Codex Carolinus*, p. 536.

11. In his article concerning a new approach to the contacts between Rome and Constantinople in the ninth century, John Osborne suggests that the cultural exchange again became intense in the mid-ninth century after the restoration of icons in Byzantium, see John Osborne, 'Rome and Constantinople in the ninth century', in *Rome across Time and Space: Cultural Transmission and the Exchange of Ideas, c.500–1400*, ed. by C. Bolgia, R. McKitterick, and J. Osborne (Cambridge: Cambridge University Press, 2011), pp. 222–36.

12. See Wilpert, *Die römischen Mosaiken und Malereien der kirchlichen Bauten vom IV. bis XIII. Jahrhundert* (Freiburg im Breisgau: Herder, 1916) [hereafter *RMM*], pp. 702–3.

13. Gordon Rushforth, 'The Church of S. Maria Antiqua', *Papers of the British School at Rome*, 1 (1902), 1–123 (p. 34). A similar point of view was expressed independently in a personal communication to me by Dmitry E. Afinogenov, who also suggested that the saints on the right hand are chosen to represent different ranks of holiness: five saintly bishops, two priests-martyrs, two holy monks, and two martyrs.

14. Wilpert, *RMM*, pp. 702–3. The dating of the left aisle needs some comment. Rushforth, the first publisher of the monument, among other valuable insights attributed the narrative scenes of the left aisle to a date not before the middle of the eighth century, suggesting that the row of saints belongs to the same layer of mortar: see Rushforth, 'The Church of Santa Maria Antiqua', p. 28. Wladimir de Grüneisen's dating—the third quarter of the ninth century—does not appear to be correct: Wladimir de Grüneisen, *Sainte-Marie-Antique* (Rome: Max Bretschneider, 1911), p. 106. A dating to the second half of the eighth century was proposed, for example, by Pietro Toesca (*Storia dell'arte italiana*, 2 vols (Torino: Unione tipografico editrice torinese, 1927), I, p. 236, note 86), and Eva Tea (*La Basilica di Santa Maria Antiqua* (Milano: Società editrice 'Vita e Pensiero', 1937), p. 271). Nordhagen thought it was contemporaneous with the apse, see Pietro Romanelli and Per Jonas Nordhagen, *S. Maria Antiqua* (Roma: Istituto poligrafico dello Stato, 1964), p. 62; and Per Jonas Nordhagen, 'Italo-Byzantine Wall Painting of the Early Middle Ages:

an 80-Year Old Enigma in Scholarship', in Per Jonas Nordhagen, *Studies in Byzantine and Early Medieval Painting* (London: David Brown, 1990), pp. 444–76 (p. 465). Guglielmo Matthiae shared de Grüneisen's opinion that the frescoes belonged to a local ninth-century school, see (*Pittura romana del medioevo. Secoli IV-X, con aggiornamento scientifico di M. Andaloro*, 2 vols (Rome: Palombi editori, 1987), I, p. 190).

15 For a detailed study of the narrative Old Testament sequence in the left aisle, see Birute Vileisis, 'The Genesis Cycle of S. Maria Antiqua' (unpublished doctoral dissertation, Princeton University, 1979).

16 The recent study by La Mantia is dedicated to the system of proportions of the fresco of the left aisle: Serena La Mantia, '"Santi su misura": la parete di Paolo I a Santa Maria Antiqua', in *L'VIII Secolo: un secolo inquieto. Atti del Convegno internazionale di studi (Cividale del Friuli, 4–7 dicembre 2008)*, ed. by V. Pace (Cividale del Friuli: Comune di Cividale del Friuli, 2010), pp. 149–61.

17 For the Lateran Council of 649 and its connections with the frescoes of Santa Maria Antiqua, see in particular Beat Brenk, 'Papal Patronage in a Greek Church in Rome', in *Santa Maria Antiqua al Foro Romano cento anni dopo*, ed. by J. Osborne, J.R. Brandt, and G. Morganti (Rome: Campisano, 2004), pp. 67–82, and the contribution by Phil Booth to this volume.

18 On the image, see Per Jonas Nordhagen, 'The Frescoes of John VII (A.D. 705–707) in S. Maria Antiqua in Rome', *Acta ad Archaeologiam et Artium Historiam pertinentia* 3 (1968), pp. 39–54. On its possible political meaning, see Per Jonas Nordhagen, 'Constantinople on the Tiber: the Byzantines in Rome and the Iconography of their Images', in *Early Medieval Rome and the Christian West. Essays in Honour of D.A. Bullough*, ed. J.M.H. Smith (Leiden: Brill, 2000), pp. 113–34 (p. 130).

19 Paul Styger, 'Die Malereien in der Basilika des Hl. Sabas auf dem kl. Aventin in Rom', *Römische Quartalschrift*, 28 (1914), 49–96 (pp. 54–60). See also Giulia Bordi, *Gli affreschi di San Saba sul piccolo Aventino. Dove e come erano* (Milan: Jaca Book 2008), pp. 107–9.

20 Styger, 'Die Malereien', p. 81; Bordi, *Gli affreschi di San Saba*, pp. 114–6.

21 Giulia Bordi, 'L'affresco staccato dalla chiesa di S. Adriano al Foro romano. Una nuova lettura', *Studi romani*, 48.1–2 (January–June 2000), 5–25 (pp. 15–21).

22 Stefania Pennesi, 'Santa Passera', in *La pittura medievale a Roma, 312–1431. Corpus e Atlante*, ed. by M. Andaloro and S. Romano (Milan: Jaca Book, 2006–), *Atlante* I, pp. 125–34.

23 Matthiae, *Pittura romana del Medioevo*, p. 185; and Jacqueline Lafontaine-Dosogne, *Peintures médiévales dans le temple dit de la Fortune Virile à Rome* (Brussels: Institut historique belge de Rome, 1959), pp. 46–8.

24 For a survey of the saints' vestments, see de Grüneisen, *Sainte-Marie-Antique*, pp. 179–85.

25 Saint Clement has been venerated in Rome since at least the fourth century, when the San Clemente basilica was built, see de Grüneisen, *Sainte-Marie-Antique*, pp. 517–8.

26 The earliest preserved image, dating from the time of Pope Leo (440–61), is in San Paolo Fuori le Mura, in one of the medallions with the portraits of the popes; see Gerhart B. Ladner, *I ritratti dei papi nell antichità e nel medioevo*, 3 vols (Vatican City: Pontificio Istituto di Archeologia Cristiana, 1941), I, fig. 29. The next is in Sant'Apollinare Nuovo in Ravenna, on the south wall of the nave (sixth century).

27 See de Grüneisen, *Sainte-Marie-Antique*, p. 181.

28 A long, rather narrow band of white cloth decorated at the end with crosses and a fringe. Bishops of the early Church wore it draped on the chest and thrown over the left shoulder; see Joseph Braun, *Die liturgische Gewandung in Occident und Orient* (Freiburg im Breisgau: Herder, 1907), pp. 642–51, fig. 297.

29 *Bibliotheca Sanctorum*, 16 vols (Rome: Istituto Giovanni XXIII nella Pontificia Università Lateranense, 1961–2013), XI, cols 1077–82 (1078). Medieval Rome had at least seven churches and oratories dedicated to Saint Sylvester, see de Grüneisen, *Sainte-Marie-Antique*, pp. 552–4. Among them was the monastery of Saints Sylvester and Stephen (now San Silvestro in Capite) founded by Pope Paul on his own family estate: see *LP*, I, pp. 464–5; and Marina Falla Castelfranchi, 'I monasteri greci a Roma', in *Aurea Roma: Dalla città pagana alla città Cristiana*, ed. by S. Ensoli and E. La Rocca (Rome: L'Erma di Bretschneider, 2002) pp. 221–6 (p. 225).

30 See, for instance, Richard Krautheimer, *Rome: Profile of a City, 312–1308* (Princeton: Princeton University Press, 1980), p. 114.

31 The earliest representations are: a mosaic from 509–14 in the Roman church of Santi Silvestro e Martino ai Monti, see Wilpert, *RMM*, fig. 96; and the medallion on the south nave wall of San Paolo fuori le mura, see Giulia Bordi, 'I dipinti della navata. La serie dei ritratti papali', in *La pittura medievale a Roma, 312–1431. Corpus e Atlante*, ed. by M. Andaloro and S. Romano (Milan: Jaca Book, 2006–), *Corpus*, I, pp. 379–95 (p. 390, fig. 34).

32 *Bibliotheca Sanctorum*, VII, cols 1232–80. There were two churches dedicated to Pope Leo I in Rome, see de Grüneisen, *Sainte-Marie-Antique*, pp. 537–8.

33 The earliest image was the one on the southern wall of San Paolo fuori le mura, see Bordi, 'I dipinti della navata', p. 395, fig. 47. There is another image of Leo in the presbytery, to the left of the apse, as one of the Church Fathers condemning Monothelitism.ратным нимбом, Иоанн, конечно, а затем - папа

34 Rushforth ('The Church of S. Maria Antiqua', p. 32) suggests that Pope Alexander was included due to the confusion (since the sixth century) between him and a martyr of the same name, whose tomb and basilica

on the Via Nomentana were very popular; see also *Bibliotheca Sanctorum*, I, cols 792–801. In the eighth century this merging was taken for granted, so the Pope is shown with a martyr's cross in his hand; see de Grüneisen, *Sainte-Marie-Antique*, p. 507.

35 On the earlier image from San Paolo fuori le mura (fifth century) see Bordi, 'I dipinti della navata', p. 381, fig. 7. He is beardless and tonsured, wearing a tunic and a *pallium*. There is another surviving image is in the left aisle of Santa Maria Antiqua.

36 *Bibliotheca Sanctorum*, XII, cols 896–7. He became even more popular after the restoration of the basilica by Pope Theodore (642–9), see Rushforth, 'The Church of S. Maria Antiqua', p. 32.

37 The earliest images are: (possibly) a seventh-century fresco from the Roman *coemeterium Valentini*, where the saint is shown wearing a tunic, with a crown and a book (Raffaele Garrucci, *Storia dell'arte cristiana nei primi otto secoli della Chiesa*, 6 vols (Prato: Gaetano Guasti, Francesco Giachetti editori, 1872–80), II, p. 93, fig. 84); the one in the left aisle of Santa Maria Antiqua, and a mosaic medallion in the San Zeno Chapel in Santa Prassede.

38 De Grüneisen, *Sainte-Marie-Antique*, pp. 503–4. There are no other traces of his cult in Rome of the time; it was only in the eleventh century that his relics were transferred from the original burial site; see Rushforth, 'The Church of S. Maria Antiqua', pp. 503–4; and *Bibliotheca Sanctorum*, I, cols 34–5.

39 This is his only extant image: see *Lexikon der christlichen Ikonographie*, ed. E. Hirschbaum and G. Bandmann, 8 vols (Rome: Herder, 1968–76), V, col. 15.

40 The extant medieval church of Santi Abbondio e Abbondanzio at Rignano Flaminio is known to have been built on the site of an ancient church, but neither the foundation date nor the original dedication are clear: see Michele Trimarchi, 'Sulla chiesa di santi Abbondio e Abbondanzio a Rignano Flaminio', *Mélanges d'archéologie et d'histoire*, 92 (1980), 205–36.

41 Rushforth, 'The Church of S. Maria Antiqua', p. 31; and de Grüneisen, *Sainte-Marie-Antique*, p. 530.

42 *Bibliotheca Sanctorum*, V, cols 329–33.

43 Early images are in the monastery of Saint Jeremiah at Saqqara (fifth/sixth century), see Klaus Wessel, *Koptische Kunst: die Spätantike in Ägypten* (Recklinghausen: Aurel Bongers, 1963), fig. 10; the Laura of Saint Euthymius at Chirbet-el-Mard (seventh century), see Andreas Mader, 'Ein Bilderzyklus in der Gräberhöhle der St. Euthymios-Laura auf Mardes (Chirbet El-Mard) in der Wüste Juda', *Oriens Christianus*, 34 (1937), 27–58, fig. 2, and *Lexikon der christlichen Ikonographie*, VI, cols 201–3. On the façade of the Oratory of Forty Martyrs near Santa Maria Antiqua there is a medallion with his portrait dating from 705–7, see Nordhagen, 'The Frescoes of John VII, plates 104–5. There may have been another image of Saint Euthymius in the apse of the lower church of San Saba (late eighth/early ninth century), see Styger, 'Die Malereien', p. 79.

44 The earliest image is in the left aisle; there may have been another formerly in the apse of San Saba, see Styger, 'Die Malereien', p. 79.

45 *Bibliotheca Sanctorum*, XI, cols 533–6.

46 See, for instance, Falla Castelfranchi, 'I monasteri greci', pp. 222, 224. A connection with the Laura of Saint Sabbas in Palestine is possible, but the monastery on the Aventine Hill could have already existed in the time of Gregory I (590–604); see Francesco Gandolfo, 'Gli affreschi di San Saba' in *Fragmenta picta. Affreschi e mosaici del Medioevo romano*, ed. by M. Andaloro and others (Rome: Argos, 1995), pp. 183–8 (p. 183); Bordi, *Gli affreschi di San Saba*, pp. 57–66.

47 There were at least four ancient churches dedicated to them: de Grüneisen, *Sainte-Marie-Antique*, pp. 550–1.

48 Wilpert, *RMM*, p. 709.

49 For example, the icon of Sergius and Bacchus now in the Kiev Art Museum. See Viktor N. Lazarev, *Istoriya Vizantijskoj jivopisi*, 2 vols (Moscow: Iskusstvo, 1986), II, fig. 76. The two saints are represented invariably as young warriors in formal Byzantine dress, sometimes with golden torques: for the latter see *Lexikon der christlichen Ikonographie*, VIII, cols 329–30. De Grüneisen (*Sainte-Marie-Antique*, pp. 550–1) suggests that the episode in their *Vita*, where the saints are dragged by the chains on their necks, may come from misunderstanding the torques in the images. In addition to the Kiev icon, another early image may be found on a sixth-century silver cup, now in the British Museum; see John. B. Beckwith, *The Art of Constantinople* (London: Phaidon, 1961), fig. 69.

50 His cult has been known in Rome since the reign of Pope Gregory III (Rushforth, 'The Church of S. Maria Antiqua', p. 30 note 1). There were three churches dedicated to him (de Grüneisen, *Sainte-Marie-Antique*, pp. 530–1). Wilpert suggests that St. Gregory was placed between Sergius and Bacchus because a church dedicated to them was built on the Forum by a pope of the same name, Gregory III (731–41); see Wilpert, *RMM*, p. 709.

51 See de Grüneisen, *Sainte-Marie-Antique*, p. 181.

52 An early image once existed in the Roman monastery of Sant'Andrea, but only an inaccurate copy from the late sixteenth century survives: see Gerhart B. Ladner, 'The So-Called Square Nimbus', in *Images and Ideas in the Middle Ages: Selected Studies in History and Art*, 2 vols (Rome: Edizioni di Storia e Letteratura, 1983), I, pp. 115–66 (p. 123 note 35). Another depiction may be found on the reverse of the Boethius diptych (*c.* 487), to which a scene of the *Resurrection of Lazarus* and images of Saints Gregory, Jerome, and Augustine were added between 602 and 770 (Matthiae, *Pittura romana del Medioevo*, p. 254); for the picture see Wilpert, *RMM*, fig. 297. Since the eighth century, his portraits have been

abundant in illuminated manuscripts: see *Lexikon der christlichen Ikonographie,* VI, cols 433–7). A mural in San Saba may also portray him, see Styger, 'Die Malereien', p. 79.

53 De Grüneisen, *Sainte-Marie-Antique,* p. 540. The image in question is the earliest, the others not predating the tenth century, *Lexikon der christlichen Ikonographie,* VII, cols 483–5.

54 It is debatable whether a church of Saint Mammas ever existed in Rome, and the reference in Rushforth's footnote ('S. Maria Antiqua', p. 29, note 2) appears to be erroneous. See also *Bibliotheca Sanctorum,* VIII, cols 592–612.

55 A long, narrow band of fabric, which differs from a Roman Catholic *pallium* by having Greek crosses all along and the edge decorated, without a fringe: see Braun, *Die liturgische Gewandung,* pp. 664–74 (image on p. 665, fig. 300). On p. 669, Braun refers to the recently (at that point) discovered images of bishops with *omophoria* in Santa Maria Antiqua.

56 The earliest surviving images are: in Santa Maria Antiqua, among the Church Fathers to the right of the apse; an image in the Laura of Saint Euthymius (Mader, 'Ein Bilderzyklus', fig. 2); another from the second half of the ninth century that was among the frescoes of Faras (Nubia), see Kasimierz Michalowski, *Faras: Die Kathedrale aus dem Wüstensand* (Zürich: Benziger, 1967), pp. 234–7, fig. 50; one in the Roman church of Santa Passera, see Pennesi, 'Santa Passera', pp. 125–34; a mosaic image in the nave of Hagia Sophia, see Christopher Walter, *Art and Ritual of the Byzantine Church* (London: Birmingham Byzantine Series, 1982), pp. 172–3.

57 The earliest images are in Santa Maria Antiqua, on the 'palimpsest' wall to the right of the sanctuary, dating to 705–7, see Nordhagen, 'The frescoes of John VII', pl. 45; and in the left aisle. Gregory is also portrayed in Santa Passera (Pennesi, 'Santa Passera', pp. 25–34), and in a mosaic from the nave of Hagia Sophia (867–86) (Lazarev, *Istoriya,* II, fig. 125).

58 In medieval Rome, there were at least two churches dedicated to Saint Basil, but these are possibly later than the eighth century: see de Grüneisen, *Sainte-Marie-Antique,* p. 513.

59 The image to the right of the apse in Santa Maria Antiqua (after 649) may be the earliest. Others may be found in the Laura of Saint Euthymius in Chirbet-el-Mard (seventh century), see Mader, 'Ein Bilderzyklus', fig. 2; in Santa Passera, see Pennesi, 'Santa Passera', pp. 125–34; among the lost mosaics in Hagia Sophia, see Walter, *Art and Ritual,* pp. 172–3; and perhaps in the passage through the west wall of the atrium of Santa Maria Antiqua, presumably from the tenth or eleventh century, see John Osborne, 'The Atrium of S. Maria Antiqua, Rome: A History in Art', *Papers of the British School at Rome,* 55 (1987), 186–223 (pp. 216–9).

60 *Bibliotheca Sanctorum,* X, cols 762–70.

61 This is possibly the earliest preserved image; the next oldest ones are in Tokali Kilise in Cappadocia, from the tenth century (*Lexikon der christlichen Ikonographie,* VIII, cols 175–6) and in the Roman church of San Saba (seventh/eighth century), see Styger, 'Die Malereien', pp. 54–60.

62 *Bibliotheca Sanctorum* II, cols 1308–15.

63 The earliest images are in the Rotunda of Saint George in Thessaloniki, from the fifth century (*Lexikon der christlichen Ikonographie,* VI, cols 19–21), and the lost mosaic from Hagia Sophia (Walter, *Art and Ritual,* pp. 172–3).

64 *Bibliotheca Sanctorum,* IV, cols 1258–64.

65 The earliest images are the ones in the left aisle of Santa Maria Antiqua and in Santa Passera (Pennesi, 'Santa Passera', pp. 125–34).

66 *Bibliotheca Sanctorum,* II, cols 522–47. For a Roman church with this dedication, see de Grüneisen, *Sainte-Marie-Antique,* pp. 510–11.

67 Besides the image from the left aisle, the oldest one is from Chirbet-el-Mard (Mader, 'Ein Bilderzyklus', fig. 2; and *Lexikon der christlichen Ikonographie,* V, cols 268–9). There may also have been one in the original apse of the Roman church of San Saba (Styger, 'Die Malereien', p. 79); as well as a lost mosaic from Hagia Sophia (Walter, *Art and Ritual,* pp. 172–3).

68 There have been about ten Roman churches and oratories dedicated to Saint Nicholas, but some of these post-date the eighth century, see de Grüneisen, *Sainte-Marie-Antique,* pp. 543–4.

69 There is another image in Santa Passera (Pennesi, 'Santa Passera', pp. 125–34); and again a lost mosaic from Hagia Sophia (Walter, *Art and Ritual,* pp. 172–3).

70 One of the most venerated martyrs in southern Italy. There were several Roman churches dedicated to Erasmus, see de Grüneisen, *Sainte-Marie-Antique,* p. 528.

71 Usually represented as beardless and tonsured, in a bishop's mitre and with a crosier; in addition to the image in question and the fresco sequence from Santa Maria in Via Lata, there are later images dating to the twelfth century, see *Lexikon der christlichen Ikonographie,* VI, cols 156–8.

72 Emile Mâle, *Rome et ses vieilles églises* (Paris: Flammarion, 1942 ; repr. Rome: École Française de Rome, 1992), p. 113.

MARIOS COSTAMBEYS

Pope Hadrian I and Santa Maria Antiqua: Liturgy and Patronage in the Late Eighth Century

The renewal of Rome in the Carolingian age is a staple of early medieval history, and no pope is more closely associated with it than Hadrian I (772–95). This is not so much because of his apparently close relationship with Charlemagne,[1] but rather because his pontificate seems to witness a quantum leap in documented architectural and artistic patronage in the city, a trend continued by his successors Leo III (795–816) and Paschal I (817–24). This impression of a surge in expenditure depends mainly on one source, the collection of papal biographies known as the *Liber pontificalis*, large sections of which, especially for this period, are concerned with keeping track of papal spending on Roman churches: new foundations, re-roofings, extensions, altars, curtains, candelabra, and all manner of liturgical furniture.[2]

For some years now, however, the narrative surrounding the renewal of Rome has looked too simple to accurately portray a city that in the late eighth century was still complex and diverse, notwithstanding the relative collapse in its population. Robert Coates-Stephens has shown how attention to the actual material records reveals that the *Liber pontificalis* is neither comprehensive nor empirically reliable on such matters.[3] More specifically, Franz Alto Bauer and Florian Hartmann's dissection of the *Liber pontificalis's Vita* of Hadrian has exposed its problematic nature as a source.[4] As a result, Hadrian's architectural patronage now raises many more issues than it used to do.

Focusing on Santa Maria Antiqua in this period offers a further opportunity to move beyond the traditional, text-driven model of papal architectural achievement. Although the church does not feature in the *Liber's* biography of Hadrian at all, we have material evidence of his intervention there. In fact, I will argue that at Santa Maria Antiqua Hadrian took advantage of his family connections with the church, as well as of its distinctive place in Roman liturgical life, to formulate a message about papal authority that suited the new congregations of late eighth-century Rome, which included northern pilgrims and Carolingian envoys as well as indigenous Romans.

The absence of Santa Maria Antiqua from Hadrian's biography is a pointed demonstration

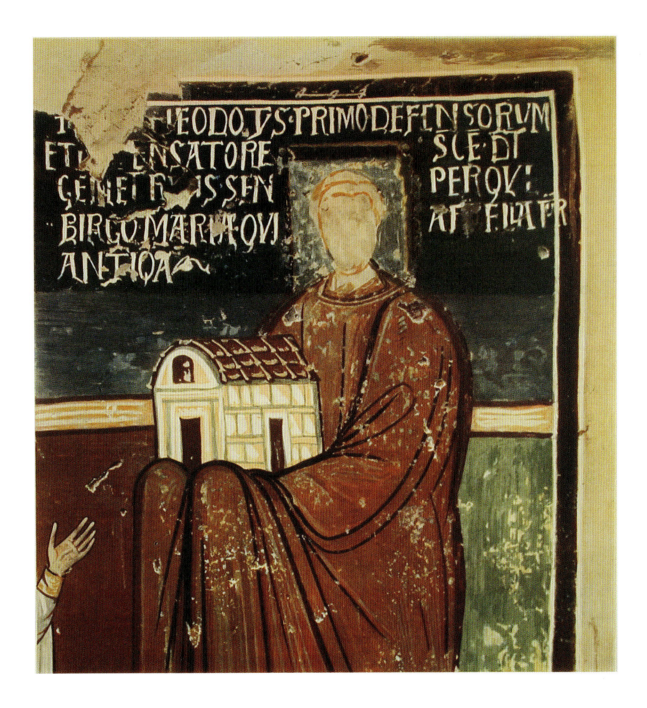

1 Santa Maria Antiqua, Chapel of Theodotus: detail of Theodotus (watercoloured photograph after *RMM*, IV, pl. 182,2)

of the *Liber*'s limitations, because of all the churches in Rome, Santa Maria Antiqua was arguably the one with which he had the greatest personal connection. The biography does include that on the death of his parents Hadrian was raised by his uncle Theodotus 'dudum consule et duce, postmodum vero primicerio sanctae nostrae ecclesiae' ('formerly consul and *dux*, but later *primicerius* of our holy church').[5] That very Theodotus easily ranks as the most prominent non-papal patron of Santa Maria Antiqua, being the sponsor and one of the subjects of the frescoes in the so-called Chapel of Theodotus, which was dedicated to the Eastern martyrs Quiricus and Julitta (Plates 27–31). In the chapel's donor portrait (Figure 1; Plate 28), which dates the fresco to the pontificate of Zacharias (741–52), Theodotus calls himself 'PRIMO DEFENSORUM ET D[ISP]ENSATORE S[AN]C[TA]E D[E]I GENETR[IC]IS SENPERQUE BIRGO MARIA QUI APPELLATUR ANTIQUA' ('*primicerius* of the *defensores* and *dispensator* of the Holy Mother of God and ever Virgin Mary which is called *Antiqua*'). As Hadrian's biography relates, he had been a secular civil servant before becoming a church administrator. One convincing proposal is that the chapel was created in order to commemorate, if not to house, Theodotus' deceased wife and son, and that the figures in the murals represent not only them but, in one case, Hadrian himself as a boy.[6] There is then a strong possibility that Hadrian was Theodotus' closest surviving male heir, inheriting not only his wealth but also his responsibility as patron of the chapel.[7]

Theodotus' patronage at the church shows how, already by the mid-eighth century, Santa Maria Antiqua was the setting of an encounter between private devotion and public worship. To see how this combination had developed by Hadrian's time, we need to observe three basic features of the church. Firstly, from the pontificate of Zacharias (741–52), if not earlier, Santa Maria Antiqua was a *diaconia*. Secondly, by the late eighth century the church seems to have been a *statio* (station) in one or more of the liturgical processions through the city.[8] Lastly, the church appears in the Einsiedeln collection of pilgrim itineraries, whose original can be dated to the 760s, as a recommended pilgrimage site.[9] These features have mostly been ignored in the vast literature on Santa Maria Antiqua, in favour—perhaps understandably—of its remarkable extant decoration. The second half of the eighth century did indeed witness the decoration of most of the available space within the complex (apart from some ninth-century additions carried out under Paschal I), including a mural dating from Hadrian's pontificate that originally occupied part of the west wall of the atrium, and which is of particular interest here (Plate 50: A2).[10] It depicts a Virgin and Child flanked by three figures on each side (Figures 2–3). To their right stands an unnamed bishop or pope, followed by an unidentified saint and then Hadrian himself, with a square nimbus and clutching a codex. To their left is a pope identified as Sylvester, followed by two martyrs holding their crowns. I will return to this fresco shortly, to examine what it might tell us of Hadrian's patronage of Santa Maria Antiqua.

Hadrian's personal interest in Santa Maria Antiqua is apparent in a number of other ways. For one, the earliest unequivocal evidence that it was a *diaconia* is Theodotus' description of himself as *dispensator* (administrator of a *diaconia*) in the donor portrait mentioned above.[11] If, as seems likely, Hadrian inherited not only Theodotus' wealth but also some of his duties, he may have taken on the role of *dispensator* as well. Hadrian seems indeed to have been more concerned with the *diaconiae*'s core function as providers of food and support for the poor. One indication that such formerly public responsibilities were being taken up by ecclesiastical institutions is the fact that most *diaconiae* seem to have occupied buildings that had once been

2 Santa Maria Antiqua, the western wall of the atrium, 1901 (Photo: Archivio Fotografico del Parco archeologico del Colosseo)

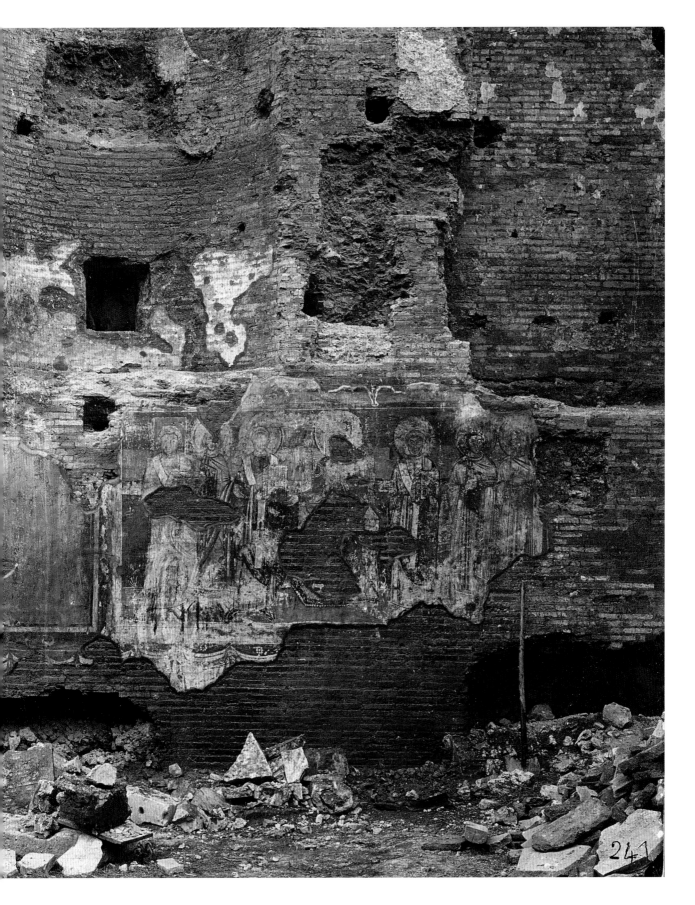

public property.[12] Hadrian's biographer records his rebuilding of *diaconiae* at Santa Maria in Cosmedin and Santi Sergio e Bacco 'in Capitolio' (in the old Temple of Concord), as well as his establishment of three new ones around the Vatican.[13] He also relates that the pope provided food daily for a hundred poor people at the Lateran, 'where these poor are depicted' ('ubi et ipsi pauperes depicti sunt'),[14] indicating that images played a fundamental role in highlighting the pope's agency.

Hadrian's close concern for liturgy is evident from his dispatch to Charlemagne of the so-called *Hadrianum* mass-book, although there is no mention of the liturgical practices undertaken at Santa Maria Antiqua in this text. All we have is the aforementioned statement in the text entitled 'Istae vero ecclesiae intus Romae habentur', dating from the second half of the eighth century, which describes Santa Maria Antiqua as a place where a 'puplica [sic] statio' ('public station') was to be performed. This at least indicates that the church was integrated into Rome's liturgical calendar.[15] Precisely how, though, is unclear. Santa Maria Antiqua does not feature as either a *collecta* or a *statio* in the *ordines* that describe the papal processions for the major feasts, such as the Marian ones instituted by Sergius I (687–701), which proceeded from Sant'Adriano to Santa Maria Maggiore. The most likely explanation for the reference is that the church was a stop on one of the less formal, 'popular' processions (as John Baldovin calls them), which are attested, for example, in the Padua Sacramentary, and probably did not involve the popes.[16]

The incorporation of Santa Maria Antiqua into popular (or at least non-papal) devotional processions is in line with some of the changes characterising church architecture and planning at the time. These aimed at defining more rigidly the areas of the building where the clergy and laity should each perform their devotions. The installation of a *schola cantorum*, as well as hindering access to the mural decoration in the presbyterium, which could now be fully appreciated only by the clerical celebrants, confined the laity to the aisles and atrium.[17] The remains of a secondary altar in the left aisle, built in front of—and therefore after—Paul I's mural there, attests to the use of the space for the laity's private devotions.[18] The *missa specialis*, recited by a single priest for a specific devotee, was becoming an increasingly common feature of lay spirituality by the eighth century, as surviving Roman mass-books testify.[19] There have been suggestions that some frescoes—such as the Three Mothers in the west aisle (Plate 20), or the figures bearing candles on the east wall of the atrium—were votive, or meant to portray lay donors.[20] Minor altars of this kind were certainly present in other churches—not least Saint Peter's—and were described in the seventh-century pilgrim guide *Notitia ecclesiarum urbis Romae* as 'a collection of sanctuaries'—that is, places with multiple *loci* of devotion. This might suggest that also at Santa Maria Antiqua secondary altars were aimed especially at pilgrims.[21]

Hadrian's interest in devotional practices is particularly evident in his preoccupation with the cult of Roman martyrs. Paul I is credited with having been the first pope to systematically move the relics of martyrs from their resting places in the suburban catacombs to the altars of the city's churches.[22] Contemporaneous inscriptions at Paul's own foundation of San Silvestro in Capite testify to the sheer number of saints he had transferred[23]—and he seems to have been quite happy to see these relics translated further afield, judging from the accounts of installation of Roman martyrs' remains in Frankish altars, which first appear at this time.[24] Hadrian, on the other hand, reported in a 779/780 letter to Charlemagne that a 'terrifying revelation' ('per revelationem territi') had prompted him to forbid any further relic exports.[25] But both the

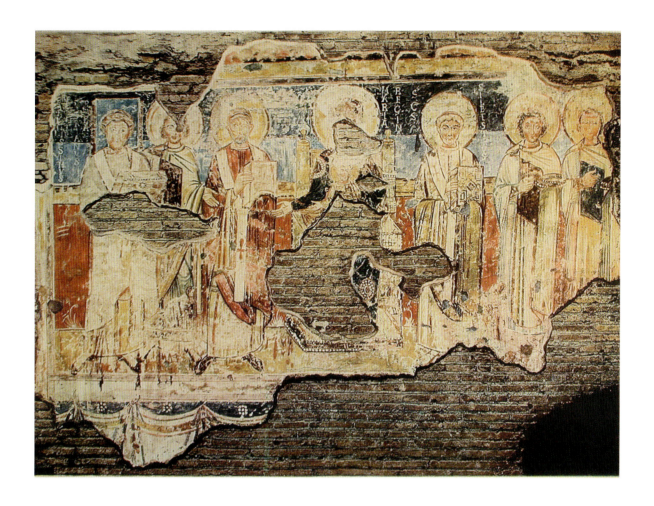

3 Santa Maria Antiqua, mural formerly on the western wall of the atrium: Maria Regina enthroned with saints and Pope Hadrian I (watercoloured photograph after *RMM*, IV, pl. 195))

inscription listing the relics at Sant'Angelo in Pescheria, associated with Theodotus,[26] and the long list of relics provided by Hadrian for liturgical use to John VII's Marian oratory at Saint Peter's suggest that he almost certainly did not intend to end the translations into Rome.[27] A similar provision of relics to Santa Maria Antiqua, another Marian dedication with a strong association with John VII, is therefore fully plausible. So, while the ban did nothing to abate the northern-European demand for Roman relics—Alcuin repeatedly asked in letters of this period that travellers to Rome bring relics back with them[28]—it could now only be satisfied either with contact relics or by visiting the shrines in Rome directly.

The veneration of relics, combined with evidence of the church's status as a *diaconia* and of its multiple liturgical functions, suggests that by the later eighth century Santa Maria Antiqua was an important pilgrimage destination. Its appearance in two of the pilgrim itineraries preserved in Codex Einsidlensis 326 (nos. 7 and 8) confirms this.[29] This clearly has implications for our interpretation of the church's decoration from that period, which is very likely to have been commissioned with pilgrims in mind.[30] Especially significant in this respect, *prima facie*, is the decoration in that part of the church to which visitors would have had readiest access: the atrium. The circumstantial evidence therefore invites us to pay fresh attention to Hadrian's most prominent intervention at Santa Maria Antiqua: the mural painted originally on the atrium's west wall.[31]

The mural's very location indicates the tension between Hadrian's own devotional connection with Santa Maria Antiqua and his liturgical authority as pope. For one thing, the atrium, and the space immediately outside it, must have been important for the church's role as a *diaconia*: if large numbers sought help, they could only be comfortably accommodated there. The spate of buildings and rebuildings of other *diaconiae* recorded in Hadrian's biography suggests that in commissioning decoration at Santa Maria Antiqua his motivation was not purely parochial, but followed a broader pattern of activity across the city.[32]

In the context of murals of this sort it is quite unusual to find three popes represented. The fact that Sylvester was named in an accompanying inscription indicates Hadrian's early interest in his predecessors, and may also be relevant to the identity of the pope standing to the Virgin's right who, I propose, is Gregory I. For this identification, we ought to remember that among the most likely intended viewers of a mural in the atrium were those who benefitted from the *diaconia*'s services: paupers and pilgrims. The food and other alms they received derived ultimately from the papal estates around Rome. These patrimonies are mentioned in the sources for a number of different pontificates, but up to the year 800 three popes in particular are the most referenced. In the *Liber pontificalis*, the most extensive records concerning papal wealth belong to the biographies of Sylvester and Hadrian; to these we should obviously add Gregory I, over half of whose letters concern estate administration.[33] In Rome, Gregory's cult had only really become established through the activities of the Greek-speaking monks who arrived in the city in the mid-seventh century, and Hadrian was undoubtedly his most assiduous promoter.[34] It was he, for instance, who first had a selection of Gregory's letters copied (the forerunner of the surviving *Registrum*),[35] and he demonstrably used some of them as models.[36] Hadrian may also have ordered a consistent celebration of Gregory's feast in the Roman liturgy, which would explain its presence in the missal he sent to Charlemagne (though it is absent from some other surviving earlier Roman sacramentaries, and a few later ones).[37] Furthermore, Hadrian seems to

have followed Gregory's lead in taking special measures to celebrate the date of his accession to the pontificate.[38] Finally, of Hadrian's three diaconial foundations around Saint Peter's, one was 'placed next to the *hospitalia* of Saint Gregory', and was dedicated to Sylvester. There are good circumstantial grounds, therefore, for Hadrian having thought of Gregory as a pope worthy of association, especially in the context of charitable provision. Gregory was already present at Santa Maria Antiqua among the western saints in Paul I's eastern aisle mural, identified in Greek and depicted with a short beard and holding a book, as in the atrium mural.[39] In the late eighth century, Gregory would have been a significant choice also for other reasons: he was the pope who had Christianised the English people, just as Sylvester was traditionally credited with helping to Christianise the Roman Empire, so these precedents certainly resonated with the contemporary Christianisation of the Saxons.

Hadrian must have been conscious that his mural would be seen by three crucial groups: the clergy, the poor of Rome for whom the *diaconiae* catered, and foreign visitors, perhaps even those who had liberated Rome from the Lombard threat. (There is no evidence that Charlemagne ever visited Santa Maria Antiqua: but a mural depicting Hadrian, Gregory, and Sylvester would have spoken to his agenda directly). Hadrian's mural had something to say to all of them. The *Maria Regina* was a direct riposte to Iconoclasm, fully in line with opinions expressed at the Second Council of Nicaea (787), and so cast Hadrian as an arbiter of dogma (in the manner of John VII at the same church). By placing himself alongside Sylvester and Gregory, moreover, Hadrian was presenting himself as a manager of Rome's resources for the benefit of the poor. The depiction of Gregory also spoke, with greater originality, to English pilgrims, and Hadrian's association with renowned forebears was novel in papal portraiture. Hadrian was appealing to traditions about the Roman bishop as a figure of political authority that were only then taking shape (and are best exemplified by the *Constitutum Constantini*). In contrast to his uncle's example, he had himself portrayed not simply as a patron of Santa Maria Antiqua, but as someone who brought into the church the wider responsibilities of the papacy. At the same time, his family's historical association with Santa Maria Antiqua gave a particular pointedness to his message. In whatever way he came by the vast funds that his biographer records him showering on other churches in Rome, and whatever the role of Carolingian support in that activity, at Santa Maria Antiqua Hadrian was fulfilling a privately inherited responsibility, and quite possibly with privately inherited wealth. The church's rich decoration does not, therefore, attest to a 'Carolingian renewal of Rome'. Rather, it provided the opportunity to take a traditional site of patronage and recast it to address the various audiences that visited the city by the late eighth century. Hadrian sought to present himself as a figure who brought together the traditional duties of the Roman clergy and an image of the papacy as the fountainhead of legitimate Christianity: a pope, that is, not just for Rome's Carolingian overlords, but for visitors to Rome and Romans in equal measure.

1 See for instance Joanna Story and others, 'Charlemagne's Black Marble: The Origins of the Epitaph of Pope Hadrian I', *Papers of the British School at Rome*, 73 (2005), 157–90.

2 The importance of the *Liber* in this sense is noted by Sible De Blaauw, 'Reception and Renovation of Early Christian Churches in Rome, *c*.1050–1300', in *Rome across Time and Space*, ed. by C. Bolgia, R. McKitterick, and J. Osborne (Cambridge: Cambridge University Press, 2011), pp. 151–66 (p. 152). The idea of a Carolingian 'revival' of Christian architecture is associated most strongly with the work of Richard Krautheimer, notably 'The Carolingian Revival of Early Christian Architecture', *The Art Bulletin*, 24 (1942), 1–38, and in *Rome: Profile of a City, 312–1308* (Princeton: Princeton University Press, 1980), pp. 109–42. See also Franz Alto Bauer, *Das Bild der Stadt Rom im Frühmittelalter: Papststiftungen im Spiegel des Liber Pontificalis von Gregor dem Dritten bis zu Leo dem Dritten*, Palilia, 14 (Wiesbaden: Reichert, 2004); and Caroline Goodson, 'Revival and Reality: the Carolingian Renaissance in Rome and the Basilica of S. Prassede', *Acta ad archeologiam et artium historiam pertinentia*, 20 (2006), 163–92.

3 Robert Coates-Stephens, 'Dark Age Architecture in Rome', *Papers of the British School at Rome*, 65 (1997), 177–232.

4 Franz Alto Bauer, 'Il rinnovamento di Roma sotto Adriano I alla luce del *Liber Pontificalis*. Immagine e realtà', in *Il Liber Pontificalis e la storia materiale. Atti del colloquio internazionale*, ed. by H. Geertman (= *Mededelingen van het Nederlands Instituut te Rome— Antiquity, 60/61* (2001/2002)), pp. 189–203; Florian Hartmann, *Hadrian I* (Stuttgart: Hiersemann, 2006), pp. 82–91.

5 *Le Liber Pontificalis*, ed. L. Duchesne, 2 vols (Paris: E. Thorin, 1886–92) [hereafter *LP*], I, 486 (*Vita Hadriani*, ch. 2).

6 Arno Rettner, 'Dreimal Theodotus? Stifterbild und Grabinschrift in der Theodotus-Kapelle von S. Maria Antiqua', in *Für irdischen Ruhm und himmlischen Lohn: Stifter und Auftraggeber in der mittelalterlichen Kunst. Festschrift Beat Brenk*, ed. by H.-R. Meier, C. Jäggi, and P. Büttner (Berlin: Dietrich Reimer, 1995), pp. 31–46.

7 The purpose of the chapel as a commemoration of deaths in Theodotus' close family has been argued by Natalia Teteriatnikov, 'For whom is Theodotus praying? An interpretation of the program of the private chapel in S. Maria Antiqua', *Cahiers Archéologiques*, 41 (1993), 37–46, and Lesley Jessop, 'Pictorial cycles of non-biblical saints: the seventh- and eighth-century mural cycles in Rome and contexts for their use', *Papers of the British School at Rome*, 47 (1999), 233–80.

8 It appears in the text known as 'Istae vero ecclesiae intus Romae habentur', published in *Codice topografico della città di Roma*, ed. by R. Valentini and G. Zucchetti, 4 vols (Rome: Istituto Storico Italiano per il Medio Evo, 1940–53), II, 121–31, at the end of which the reader is told: 'In his omnibus basilicis per certa tempora puplica statio geritur'. For the date of this text, see Donatella Bellardini and Paolo Delogu, 'Liber Pontificalis e altre fonti: la topografia di Rome nell'VIII secolo', in *Il Liber Pontificalis e la storia materiale*, ed. by H. Geertman, pp. 205–24 (p. 213 note 49).

9 On the nature of the Einsiedeln Itinerary, see Riccardo Santangeli Valenzani, '"Itinerarium Einsidlense". Probleme und neue Ansätze der Forschung', in *Vedi Napoli e poi muori: Grand Tour der Mönche*, ed. by P. Erhart and J. Kuratli Hüeblin (St Gallen: Stiftsarchiv St. Gallen, 2014), pp. 33–7; current consensus dates the text to the latter years of Paul I's pontificate (761–7).

10 Described by John Osborne, 'The Atrium of S. Maria Antiqua, Rome: A History in Art', *Papers of the British School in Rome*, 55 (1987), 186–223 (pp. 194–7).

11 Suggested dates for the change vary widely. David Knipp, 'The Chapel of Physicians at Santa Maria Antiqua', *Dumbarton Oaks Papers*, 56 (2002), 1–23 (p. 7), places it as early as *c*. 600. A more plausible date, coinciding with the time of Theodotus' inscription, is proposed instead by Roberto Meneghini and Riccardo Santangeli Valenzani, *Roma nell'alto medioevo: Topografia e urbanistica della città dal V al X secolo* (Rome: Libreria dello Stato, Istituto poligrafico e zecca dello stato, 2004), p. 161.

12 Meneghini and Santangeli Valenzani, *Roma nell'alto medioevo*, p. 76.

13 *LP*, I, pp. 507, 512, 505–6.

14 Ibid., I, p. 502.

15 Valentini and Zucchetti, *Codice topografico*, II, pp. 121–31.

16 John Francis Baldovin, *The Urban Character of Christian Worship: the Origins, Development and Meaning of Stational Liturgy* (Rome: Pontifical Oriental Institute Press, 1987), pp. 158–62.

17 This is the thesis of Stephen J. Lucey, 'Palimpsest Reconsidered: Continuity and Change in the Decorative Program at Santa Maria Antiqua', in *Santa Maria Antiqua al Foro Romano cento anni dopo*, ed. by J. Osborne, J.R. Brandt, and G. Morganti (Rome: Campisano, 2004), pp. 83–96 (p. 92). Whatever the exact date of the *schola cantorum* decoration, it is in line with the gradually increasing separation between the officiating clergy and the laity in liturgical practice throughout the eighth-century West; see Franz Alto Bauer, 'La frammentazione liturgica nella chiesa romana del primo medioevo', *Rivista di Archeologia Cristiana*, 75 (1999), 385–446 (pp. 440–5).

18 *Corpus Basilicarum Christianarum Romae,*, ed. by Richard Krautheimer and others, 5 vols (Vatican City: Pontificio Istituto di Archeologia Cristiana, 1937–77), II, 265.

19 Arnold Angenendt, '*Missa specialis*. Zugelich ein Beitrag

zur Entstehung der Privatmessen', *Frühmittelalterliche Studien*, 17 (1983), 153–221.

20 Osborne, 'The Atrium of S. Maria Antiqua', pp. 197–9, plate XVI a–b.

21 Valentini and Zucchetti, *Codice topografico*, II, 94–9; and Bauer, 'La frammentazione liturgica', pp. 433–4.

22 *LP*, I, 464. But the earliest recorded translation is actually that of *Primus* and *Felicianus* to Santo Stefano Rotondo by Pope Theodore (642–9); see ibid., I, 332.

23 Nicolette Gray, 'The Palaeography of Latin Inscriptions in the Eighth, Ninth and Tenth Centuries in Italy', *Papers of the British School at Rome*, 16 (1948), 38–162 (p. 51 note 10).

24 Julia M.H. Smith, 'Old Saints, New Cults: Roman Relics in Carolingian Francia', in *Early Medieval Rome and the Christian West: Essays in Honour of Donald A. Bullough*, ed. by J.M.H. Smith (Leiden: Brill, 2000), pp. 317–39 (p. 335).

25 *Monumenta Germaniae Historica, Epistolae*, III: *Codex Carolinus*, pp. 592–3 (no. 65).

26 *LP*, I, 514 note 2.

27 Gray, 'The paleography of Latin inscriptions', pp. 53–4, no. 12; and Bauer, 'La frammentazione liturgica', p. 404 note 50.

28 Alcuin, *Epistolae*, nos. 11, 97, and 146 in *Monumenta Germaniae Historica, Epistolae*, IV, ed. by E. Dümmler (1895), pp. 37, 141–2, 235–6. See also Marios Costambeys, 'Alcuin, Rome, and Charlemagne's Imperial Coronation', in *England and Rome in the Early Middle Ages: Pilgrimage, Art and Politics*, ed. by F. Tinti (Turnhout: Brepols, 2014), pp. 255–80.

29 Valentini and Zucchetti, *Codice topografico*, II, pp. 191, 195.

30 For the number of pilgrims see Riccardo Santangeli Valenzani, 'Hosting Foreigners in Early Medieval Rome', in *England and Rome in the Early Middle Ages*, ed. by F. Tinti, pp. 69–88. On the contribution of pilgrims to Roman wealth, see Neil Christie, 'Charlemagne and the Renewal of Rome', in *Charlemagne: Empire and Society*, ed. by J. Story (Manchester: Manchester University Press, 2005), pp. 167–82 (p. 174).

31 Hadrian should be seen not simply as the presiding pope but as the wall painting's sponsor, because, although fragmentary, the mural does not show any losses that might indicate the presence of alternative donor figures. There seems to have been an attempt to balance the group of figures symmetrically: the surviving mural shows three figures to either side of the Virgin, with Hadrian standing to the viewer's far left and, crucially, with empty space beyond him. On the other side of the Virgin, despite the fact that the rightmost figure is truncated, there is no evidence of the loss of any figures beyond the three still visible.

32 *LP*, I, pp. 507, 512.

33 Robert Markus, *Gregory the Great and his World* (Cambridge: Cambridge University Press, 1997), pp. 206–9.

34 Alan Thacker, 'Memorializing Gregory the Great: the Origin and Transmission of a Papal Cult in the 7th and Early 8th Centuries', *Early Medieval Europe*, 7 (1998), 59–84 (pp. 72–4).

35 *PL* 75, col. 223B (John the Deacon, *Vita S. Gregorii Magni*, IV, ch. 71).

36 Horst Fuhrmann, 'Das Papsttum und das kirchliche Leben im Frankenreich', in *Nascita dell'Europa ed Europa Carolingia: Un'equazione da verificare. Atti delle Settimane di studio del CISAM*, 27 (Spoleto: Centro Italiano di Studi sull'Alto Medioevo, 1980–1), pp. 419–56 (pp. 428–9).

37 Thacker, 'Memorializing Gregory the Great', pp. 72–3.

38 Hadrian gave Saint Peter's a massive candelabrum (1365 candles) that was to be lit at Easter, Christmas, the feast of Saints Peter and Paul, and on the 'natale pontificis'; see *LP*, I, p. 499.

39 Rushforth, 'The Church of S. Maria Antiqua', p. 30, cf. p. 103.

RE-READING
THE DECORATIVE PROGRAMME

GIULIA BORDI

The Apse Wall of Santa Maria Antiqua (IV–IX centuries)

From the moment of its discovery, the fame of Santa Maria Antiqua has been transmitted primarily through images of the 'palimpsest' wall and its complex stratification, with the result that it has replaced the traditional liturgical and visual focus of a basilica church on the apse (Plates 32, 50: K1). The state of conservation of the apse murals has been seriously compromised by the high level of humidity, probably attributable to the breakage (already in late antiquity) of a drainage spout built into the thickness of the wall.[1] This area, as a consequence, has been somewhat neglected in modern scholarship, particularly in comparison to other parts of the church where the paintings survive in much better condition. Furthermore, because the theophany painted in the apse during the pontificate of Paul I (757–67) is more complete (Plate 35), and hence more legible, little attention has been paid to the fact that the apse is itself also a palimpsest, just like its more famous neighbour.

Beginning with the studies of Gordon Rushforth, Wladimir de Grüneisen, Ernst Kitzinger, and Per Jonas Nordhagen, various hypotheses have been formulated regarding the subject depicted in the conch of the apse between the sixth and ninth centuries.[2] Only Joseph Wilpert has attempted to come to terms with the stratified nature of the decorations (Figure 1), demonstrating an extraordinary sensibility for understanding fragments of painted plaster—though he did resort to the removal of small sections in an attempt to determine what lay beneath (Figures 2a–b).[3] The present study is the fruit of a research project, initiated before the 2012 commencement of a campaign to conserve the apse, that has progressed in subsequent years in parallel with the work of Werner Schmid and Valeria Valentini.[4]

By examining the plaster levels layer by layer, and identifying each individual application on the basis of the materials and the technique employed, it was possible to assign each level to one of the six documentable interventions in the apse and the seven on its framing wall, for a total of ten levels (Figures 3a–b). What follows is a hitherto unpublished journey into the apse and its arch, stemming from this mapping of the painted plasters. This 'reading' of a pictorial palimpsest requires keen attention to the dynamics of the wall, including the obliterations, updates, and re-incorporations of earlier levels, following a logic that in many cases is analogous to the process of 'reuse' that is frequent in architecture and sculpture.[5] Indeed, the church of

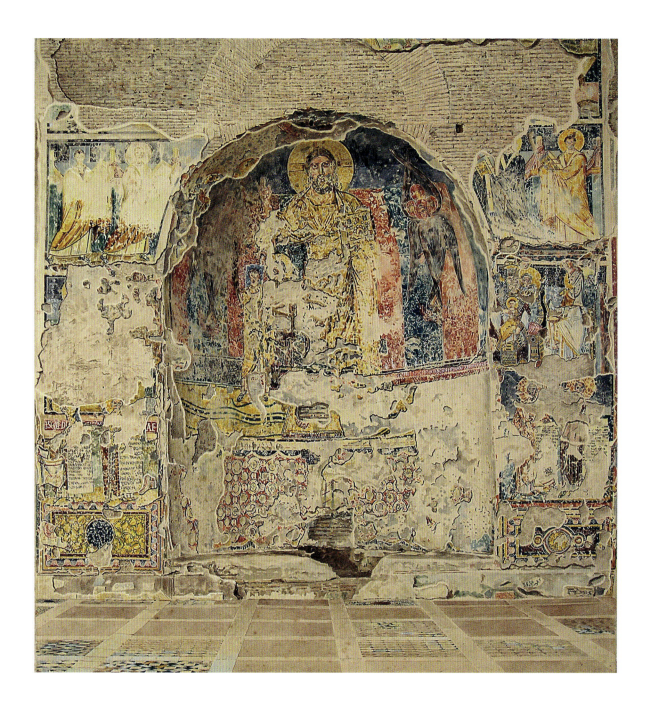

1 Apse wall. Watercoloured photograph by Wilpert and Tabanelli
(*RMM*, IV, pl. 151)

2 Apse. Watercoloured photographs by Wilpert and Tabanelli: (a) an angel and Saint Peter (*RMM*, IV, pl. 141,3); (b) an angel's face (Pontificio Istituto di Archeologia Cristiana Archive)

Santa Maria Antiqua is the perfect place to introduce the concept of 'reuse' in the field of mural painting: in the Middle Ages, painted plasters too could be regarded as *spolia*, both in terms of their actual physical redeployment, or because of their liturgical, ideological or political significance.[6]

The journey begins in the fourth century, when the end wall of the most southerly chamber of the Domitianic complex was adorned with rich *incrustationes* and mosaics.[7] The marble revetment, traces of whose mortar remain in the foundation levels of the subsequent applications, along with a few fragments of *crustae* still visible in the lower south-east corner (at the bottom), corresponding to the dado of the apsidal wall (Plate 41), rose to a height of about six metres, above which there was a decoration in mosaic. Of the latter, some traces of the mortar bed survive in the south-west corner (at the top), along with a few *tesserae* (Plate 33).[8] In the boxes containing materials from Giacomo Boni's excavation, recently rediscovered in the storage deposit of the Parco Archeologico del Colosseo, a number of marble fragments and bits of polychrome glass were found, and these can shed some light on the original decoration. They came from the Chapel of Theodotus (Plates 28, 50: J), where the *opus sectile* decoration probably remained in place until the definitive abandonment of the church in the tenth or eleventh century. The head of a young man, along with other pieces, demonstrates that the walls of the three end chambers had figural decorations of the highest quality, datable to the second half of the fourth century.[9]

In the southern chamber of the Domitianic building, the space that would later be transformed into the sanctuary of the church, the surface of the end wall was interrupted by a substantial rectangular niche (Plate 35; Figures 3a, 4a). To its right, a mural was painted in the first half of the sixth century, depicting an enthroned image of *Maria Regina* holding her infant Child, to whom two angels offered crowns (Plates 37–8; Figures 6b, 19b). From the moment of its discovery in 1900, this scene of the so-called *Aurum coronarium* has been considered the earliest

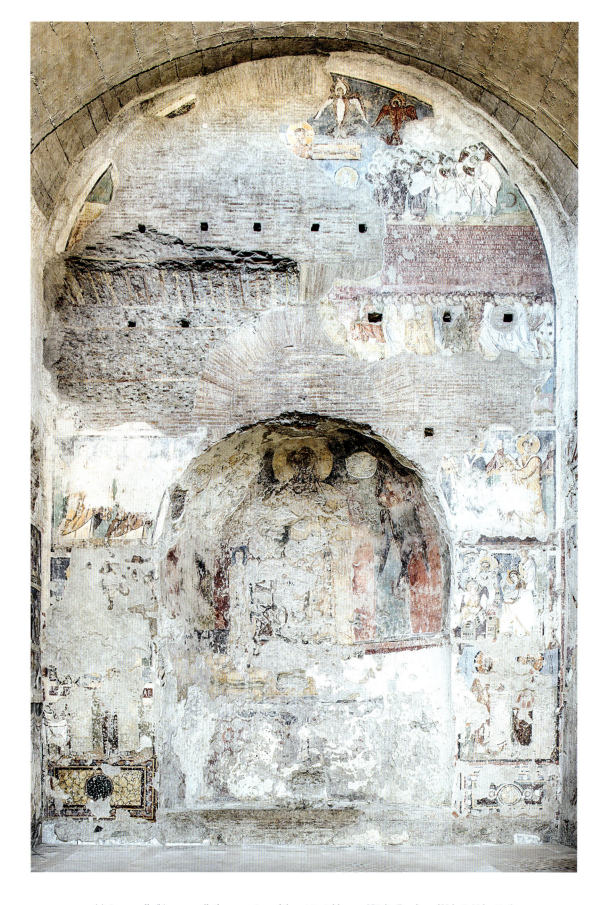

3a (a) Apse wall; (b) apse wall, the mapping of the pictorial layers (Giulia Bordi and Valeria Valentini)

THE APSE WALL OF SANTA MARIA ANTIQUA (IV–IX CENTURIES)

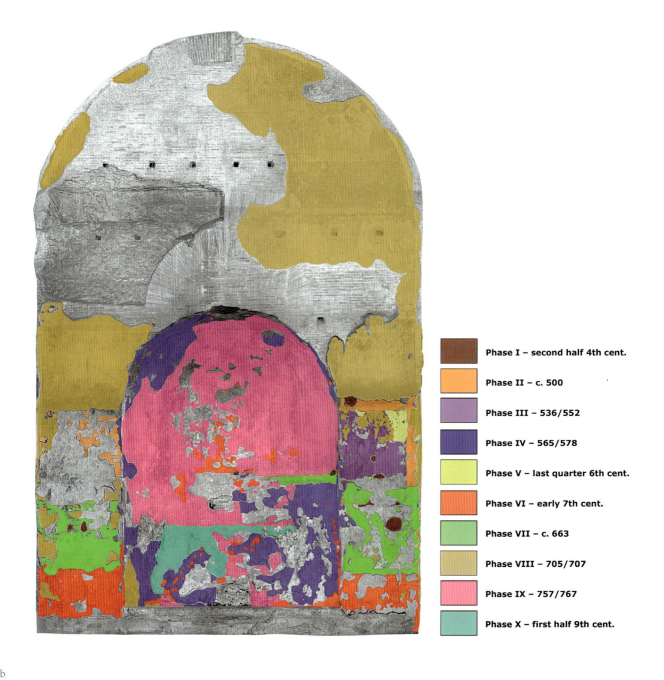

Phase I – second half 4th cent.
Phase II – c. 500
Phase III – 536/552
Phase IV – 565/578
Phase V – last quarter 6th cent.
Phase VI – early 7th cent.
Phase VII – c. 663
Phase VIII – 705/707
Phase IX – 757/767
Phase X – first half 9th cent.

evidence of a Christian presence at the site, and its dating has been assigned to one of two moments: either to the first three decades of the sixth century or to the years of the Byzantine reconquest of Italy, in other words either to an Ostrogothic or Greco-Constantinopolitan context.[10]

On the wall to the left of the apse (Figures 3a, 19a), which has not survived in a good state of preservation because it has suffered a large number of plaster removals over time, there was another painting, a pendant to the *Maria Regina*, of which only a few traces of pigment survive (Figure 5a). There I have identified the figures of Saint Peter and an enthroned Christ, and we can speculate that Peter was perhaps accompanied by Paul, creating the iconography of the *Maiestas Domini* between the Princes of the Apostles.[11] This image, however, does not belong to the same decorative campaign as the *Maria Regina*, but rather to an earlier phase, of which I have also found traces on the corresponding wall to the right: two large bits of a border with four polychrome bands that emerge beyond the head of the *Maria Regina* and to the right of the offering angel (Figures 5c, 19b).[12]

The layer of the *Aurum coronarium*, although at the same level as its border, is actually laid inside a depression in the surface obtained by removing the plaster of a previous figuration (Figures 6a–b; Plate 37). The *Maria Regina*, therefore, was conceived as an image inserted within a pre-existing frame, which is materially and stratigraphically consistent with the image of Christ between Peter and Paul painted on the corresponding wall to the left of the niche (Figures 5a–c). Moreover, the *Maria Regina* may have been created as a substitute for an earlier image of the Madonna and Child enthroned with angels that was the original pendant to the *Maiestas Domini* (Figures 4a–b).

This unusual removal of the first layer of plaster suggests that the older image may have been destroyed for political reasons, in much the same way as the *damnatio memoriae* of the Ostrogothic king Theodoric affected the mosaic decorations of Sant'Apollinare Nuovo in Ravenna under Bishop Agnellus (557–70), but we cannot discard the possibility that this was done for devotional motives, or simply due to a change in fashion.[13] In the second and third phases, then, these two images opened two illusionistic 'windows', two *emblemata*, in the pre-existing marble fabric. On the basis of comparisons with the mosaics of Christ and the Madonna and Child between angels in Sant'Apollinare Nuovo in Ravenna, as well as with

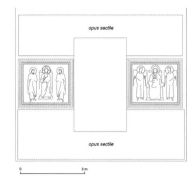
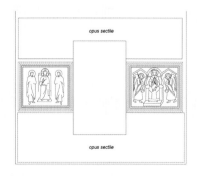
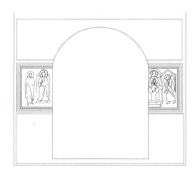

4 Graphic visualisation of the walls to the left and right of the apse (Giulia Bordi and Valeria Valentini): (a) phase II; (b) phase III; (c) phase IV

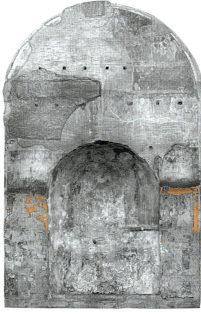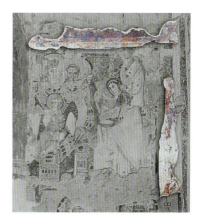

5 (a) Wall to the left of the apse: Saint Peter and the enthroned Christ; (b) apse wall, the mapping of layer II; (c) wall to the right of the apse, a border with four polychrome bands (Giulia Bordi)

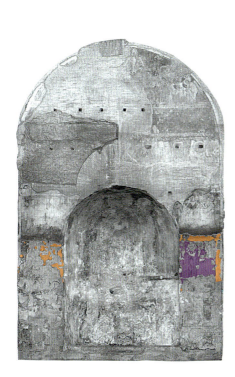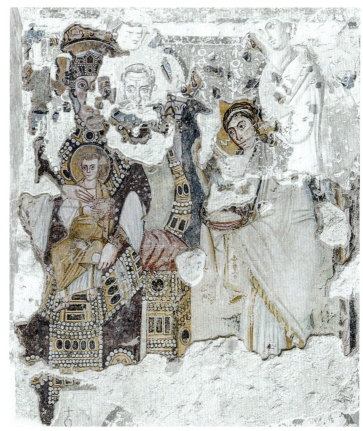

6 a) Apse wall, the mapping of layers II-III (Giulia Bordi); (b) wall to the right of the apse, *Maria Regina* and the offering angel

ivory panels in Berlin and Etchmiadzin, and with the cover of the Saint-Lupicin Gospels (Paris, Bibliothèque nationale de France, MS lat. 9384), I have proposed a date around 500 CE for the first set of images, when Theodoric came to Rome to celebrate his *tricennalia* and restored the imperial palace on the Palatine hill.[14] In this first phase, the structure that would later become Santa Maria Antiqua was probably a chapel created inside the Forum-level reception rooms connected by the ramp to the palace above.[15] The insertion of the *Aurum coronarium* probably took place in the second quarter of the sixth century. In previous studies I have not excluded the possibility that that this may have happened in the period of Ostrogothic rule, in the time of King Theodahad (534–6), who in 535 arrested, exiled, and in the end probably murdered his cousin and co-regent Amalasuintha.[16] But now I am more convinced that the *Maria Regina*—seated on a lyre-backed throne with the Child on her lap, flanked by angels offering crowns, hieratic and frontal, splendidly garbed in a golden loros that is itself decorated with randomly scattered gems and pearls[17]—is an expression of purely 'Byzantine' devotion and must thus be linked to the years of the Justinianic reconquest (536–52), between the first re-entry of Belisarius and the imperial army into Rome on 9 December 536 and the final triumph of Narses in July 552.

The substitution is thus charged with profound political significance. As Bissera Pentcheva has demonstrated, the concept of *Maria Regina* belonged to the political and religious orbit of Constantinople, where its development—as recent studies on the *Akathistos* hymn have shown—found its origins in the second half of the fifth century, following the Council of Chalcedon (451).[18] It was at this time that the cult of Mary took on a civic identity under the patronage of the imperial family.[19] The *Maria Regina* of the 'palimpsest' wall, dressed in the imperial loros, represents the visual translation of the Virgin praised in the stanzas of the *Akathistos*: Theotokos-Temple of the Incarnation, but also protectress of the empire, of the emperor, and of the city of Constantinople, whose active presence could rout all their enemies.[20] In Santa Maria Antiqua she also became the protectress of the newly reconquered city of Rome, the first powerful witness to the game of mirrors between 'Old' Rome and 'New' Rome that would soon transform the Roman Forum into the Byzantine Forum. The dedication to Santa Maria Antiqua may well have been introduced at this time, perhaps with the intent to create in Rome a 'twin' for the chapel established in the fifth century in the imperial palace of Daphne in Constantinople, dedicated to the *Theotokos protoktistos* and located close to the throne room according to the tenth-century *De Cerimoniis* (I, 1, 5).[21] It seems unlikely to be a coincidence that both were dedicated to the Mother of God with the epithets *protoktistos* and *antiqua* ('the first founded'). If this relationship is accepted, we may finally have found the meaning of *antiqua*, and this would also reinforce the connection between the foundation of the church and the patronage of the Byzantine imperial administration.

In the second half of the sixth century the niche wall was broken to insert an apse (Figures 3a, 4c). The earliest layer covering the conch and the hemicycle corresponds to the so-called 'whitewash level', also found on the flanking walls where it was intended to cover the original decorations (*Maria Regina* between angels, and Christ between Peter and Paul), which had been irreparably damaged by the removal of so much brickwork (Figure 8a).[22] The presence of this level can also be documented on other walls of the structure outside the sanctuary, creating a sort of 'level zero' intended to unify the entire space by obliterating all the previous decorations, now deemed inappropriate for the new programme. The upper regions of the

7 Lower church of San Crisogono. The last section of the south wall. Madonna and Child between angels and Saints Peter and Paul (photo: University of Tuscia Archive)

apsidal arch, however, still retained their original fourth-century marble *incrustationes* and mosaics (Plate 33).

The level of plaster applied to the apse conch soon received a figural decoration. Its iconography is known to us in part thanks to Wilpert's activities, undertaken on 18 December 1909: on the left side, portions of the figures of an angel and Saint Peter (Figure 2a), and on the right, the face of another angel (Figure 2b).[23] In these fragments Wilpert recognised the iconography of the Virgin enthroned between angels and the Princes of the Apostles, an abbreviated version of the theme represented in the Justinianic Basilica Eufrasiana at Poreč.[24] This hypothetical reading was subsequently accepted by de Grüneisen, Nordhagen, and Pace, but rejected by Brenk.[25] Because the church is dedicated to Mary, it seems logical to propose a Marian iconography for the apse, combining into a single theophany the two earlier themes, now partially destroyed (Figure 8b). Although the subject of the original apse mosaic of Santa Maria Maggiore, dating from the pontificate of Sixtus III (432–40), remains unknown, we can nevertheless look to the lower church of San Crisogono for a Roman depiction of the Madonna and Child between Saints Peter and Paul datable to the sixth century (Figure 7).[26] This little-known painting is preserved in the last section of the south wall, and is comparable to the fragments preserved in the apse of Santa Maria Antiqua in terms of its appearance and pictorial *ductus*.

The opening of the apse marks the transformation of the southernmost chamber of the Domitianic hall into the church of Santa Maria Antiqua, traditionally assigned to the reign of Emperor Justin II (565–78) on the basis of the reported discovery of three coins bearing his image, found under the second column of the arcade separating the central nave from the eastern (left) aisle.[27] In addition to the three coins, which were lost after their discovery,[28] other elements support an approximate dating to this time—the years in which Italy was administered by the

8 Apse wall, the mapping of layer IV (Giulia Bordi and Valeria Valentini): (a) preserved fragments of plaster; (b) original extension and hypothetical reconstruction

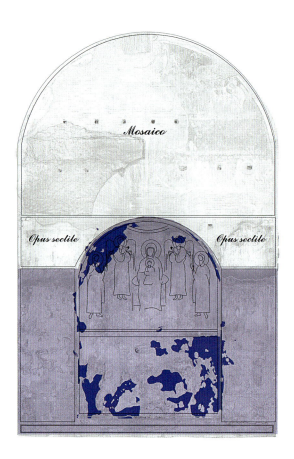

9 Apse wall, the mapping of layer V (Giulia Bordi Valeria Valentini): (a) preserved fragments of plaster; (b) original extension and hypothetical reconstruction

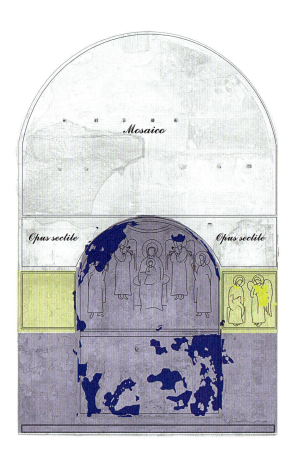

 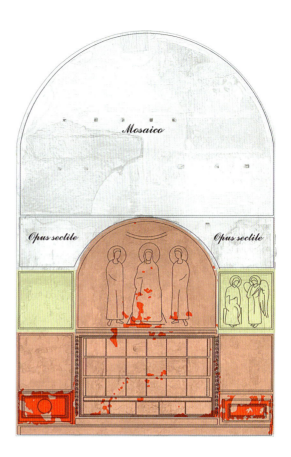

10 Apse wall, the mapping of layer VI (Giulia Bordi and Valeria Valentini): (a) preserved fragments of plaster; (b) original extension and hypothetical reconstruction

imperial general Narses—for the transformation of Santa Maria Antiqua and the foundation of the so-called 'Oratory of the Forty Martyrs'. As Robert Coates-Stephens has noted, Santa Maria Antiqua would thus belong to a group of churches dedicated to the *Theotokos* in the years immediately following the Byzantine reconquest, a group that the *Liber pontificalis* overlooks, presumably because their patronage was imperial, not papal.[29] Datable to the same span of years, or very shortly thereafter, are two funerary inscriptions found in the Oratory of the Forty Martyrs: those of the goldsmith (*aurifex*) *Amantius*, buried in the fifth year after the consulship of Justin II (571–2), and a certain *Ypolita*, a member of the corporation of silversmiths, who died in the reign of Emperor Maurice (582–602). According to Coates-Stephens, these two, husband and wife, may have been the founders of the Oratory.[30] General Narses, moreover, resided 'in Palatio' and also died there, as recorded by Agnellus in the *Liber Pontificalis Ecclesiae Ravennatis* and thus it is very likely that Santa Maria Antiqua was founded during the years of his Palatine residency (556–71).[31] Indeed, it cannot be excluded that he was the actual founder of the church, given his profound devotion to the Mother of God, without whose blessing he would not enter into battle—as we are told by the historian Evagrius Scholasticus in his *Historia Ecclesiastica*.[32]

In the last quarter of the sixth century, shortly after the decoration of the apse, the *Annunciation* with the famous *Angelo bello* was painted on the right side on the so-called 'palimpsest' wall (Plates 37, 39; Figures 9a, 19b), possibly accompanied by another image on the corresponding left wall, though no trace of the latter survives (Figures 9b, 19a). The *Angelo bello*, selected by Ernst Kitzinger as the poster figure for his notion of 'perennial Hellenism', constitutes the first

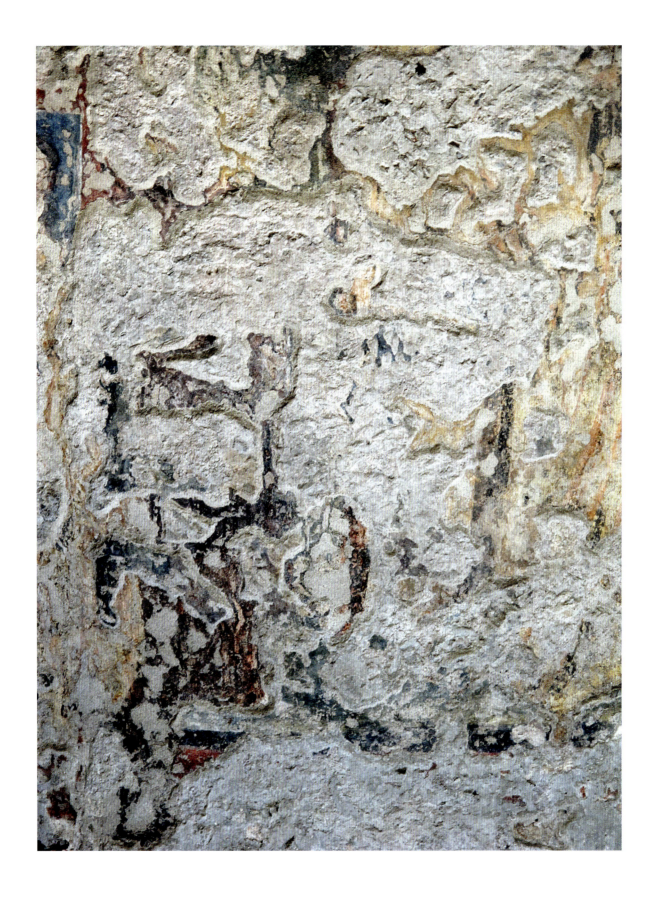

11a Apse (layer VI): (a) garments pertaining to two figures; (b) red frame enclosed within two black bands; (c) a grassy ground
(photos: Giulia Bordi 2015)

11b

11c

spark of an explosion of 'iconic' images that transformed Santa Maria Antiqua in the last quarter of the sixth and first half of the seventh century.[33] On the right wall of the sanctuary the same workshop would paint an image of Saint Anne holding the infant Mary in her arms (Plates 44, 50: K3),[34] followed on the south-east and south-west piers of the church by other mural 'icons' depicting Solomone and the Maccabees (Plates 14, 50: E2.3), Saint Barbara (Plates 14, 50: E2.2), the *Annunciation* (Plates 15, 50: E.1.3), Saint Demetrius (Plates 15, 50: E.1.2), the *Deësis* (Plates 11, 50: D3), and other subjects, in a sequence whose dating today seems more expansive than the 649–55 range proposed by Nordhagen.[35]

Shortly after the addition of the *Annunciation*, probably in the early decades of the seventh century, the apse and its framing wall received a new pictorial covering (phase VI), as is apparent from an examination of the preserved plaster levels (Figure 10a). There is clear evidence for this decorative campaign, which has not been previously considered, in the gaps in the level of Paul I. In the apse itself there are a few traces of painted plaster in the central *lacuna*, visible to the right of the figure of Pope Paul, where we can discern the garments of two individuals (Figure 11a). Purplish-brown drapery folds belong to a figure placed at the centre of the apse, which seems to occupy the same space as the figure of Christ in the later level, while the celestial robe belongs to a figure further to his right. The painting is of high quality and displays many similarities with the *Annunciation* on the adjacent 'palimpsest' wall. The two figures stand on a grassy ground, also observable in some of the other smaller gaps (Figure 11c), and the preserved fragments suggest that this second level had fewer figures than the first. This figural decoration is separated from the painting in the dado, with no continuity of the plaster, by a broad red frame enclosed within two black bands (Figure 11b). The dado preserves traces of a very refined decoration of fictive marble *incrustationes*—similarly not previously noted[36]—and on the basis of my reconstruction this must have comprised four vertical registers of, in turn, imitation Numidian yellow (*giallo antico*), green porphyry (*serpentino verde*), polychrome *breccia*, Thessalian green (*verde antico*), and other types of marble, with an alternation of coloured and speckled varieties (Figures 13a–e). The decoration was bordered on both sides by a lively garland of green leaves (Figure 12c), adorned with alternating yellow and red flowers, similar to the one in Santa Maria in Via Lata (Figure 12b), in the painting of the *tempietto* with praying saint now displayed in the Museo Nazionale Romano Crypta Balbi (Figure 12a) and dated to the end of the sixth or the early decades of the seventh century.[37]

The dado of imitation marble also appears on the side walls, with no continuity in the plaster, and following the recent conservation campaign there is no doubt that both belong to the same phase, one which preceded the figures of the four Church Fathers holding scrolls, traditionally dated to about the year 650, from the pontificate of Martin I (649–55) (Figures 16a–b).[38] What was depicted in the space between the *Annunciation* and the dado remains completely unknown, as the plaster remains sealed beneath the upper layer (Figure 10b). But the dimensions suggest two possibilities: either another figural panel, or an upward extension of the dado with additional registers of fictive marble revetments, similar to those in the apse hemicycle. The second option seems more plausible, given the general economy of the decoration.

To summarise, in the early decades of the seventh century the apse was repainted, probably with three figures, perhaps not unlike the mosaic in the Panagìa Angeloktisti church at Kiti, on Cyprus, also dated to the beginning of the seventh century.[39] In the centre there was possibly a

new image of Virgin and Child, flanked either by two angels (as at Kiti), or by Saints Peter and Paul (as in the earlier phase IV). The three-figure format also occurs in Rome at Sant'Agnese fuori le mura, from the time of Pope Honorius I (625–38), where the apse mosaic depicts Saint Agnes flanked by two popes.[40] On the wall to the right of the hemicycle was the slightly earlier *Annunciation*, and at the bottom of both this wall and the apse itself the dado featured a fictive polychrome marble revetment. Phase VI corresponds to the moment when the official images of the Emperor Phocas and his wife Leontia arrived in Rome (25 April 603) and were received by the Senate, the pope, and the clergy at the Lateran palace before being transferred to San Cesario on the Palatine Hill, as recorded in a letter of Pope Gregory I.[41] A few years later, on 1 August 608, the exarch Smaragdus erected an honorific column to Phocas in the Forum.[42] The last imperial monument in Rome, it marks a watershed moment in the transition from the Roman Forum to the Byzantine Forum, which had once again become a theatre for imperial *adventus* and other ceremonies. As evoked by Coates-Stephens, in this setting we can easily imagine the procession bearing the icons of the imperial couple coming from the Lateran, and probably passing through the Santa Maria Antiqua complex, repainted for the occasion, before ascending the imperial ramp.[43]

Turning now to phase VII, on the two flanking walls were added the figures of the four theologians (Figures 14a–b): on the left, Pope Leo I and Gregory of Nazianzus, and on the right Basil of Caesarea and John Chrysostom (Plates 40–1; Figures 16a–b). Each holds a scroll bearing a text from their writings, and in 1902 the philologist Frank Edward Brightman observed that these passages had been quoted in the Acts of the Lateran Council of 649, convened to oppose the Monthelete heresy.[44] This reading has been adopted in all subsequent literature, leading

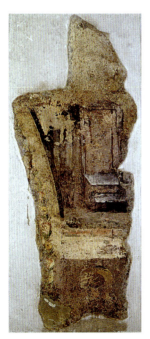

12 (a) Museo Nazionale di Roma *Crypta Balbi*, the tempietto with praying saint from Santa Maria in Via Lata; (b) garland of green leaves with yellow and red flowers, detail; (c) Santa Maria Antiqua, apse hemicycle, right side, garland of green leaves with yellow and red flowers (photos: Giulia Bordi 2014)

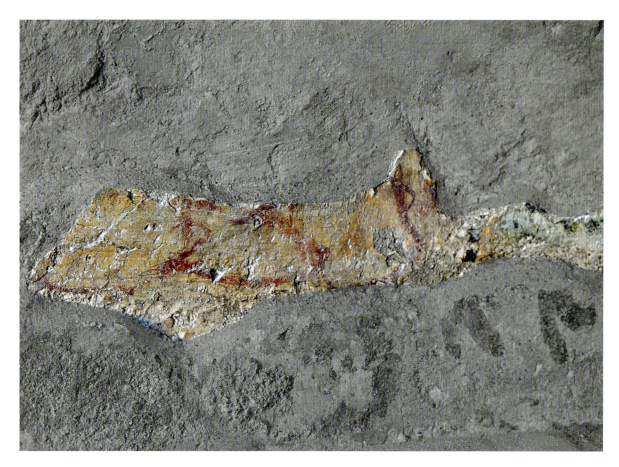
13a

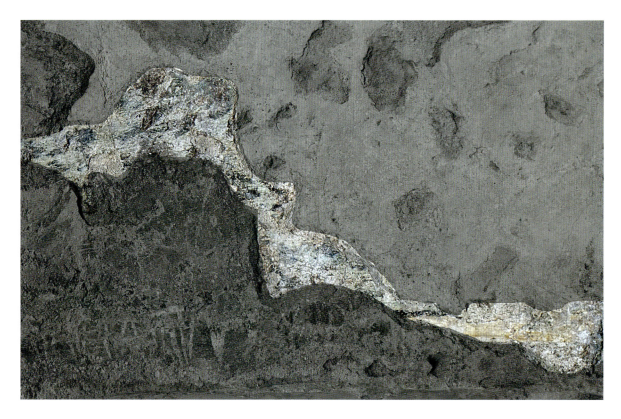
13b

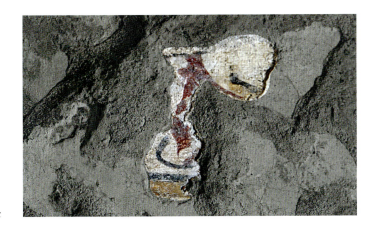

13c

13d

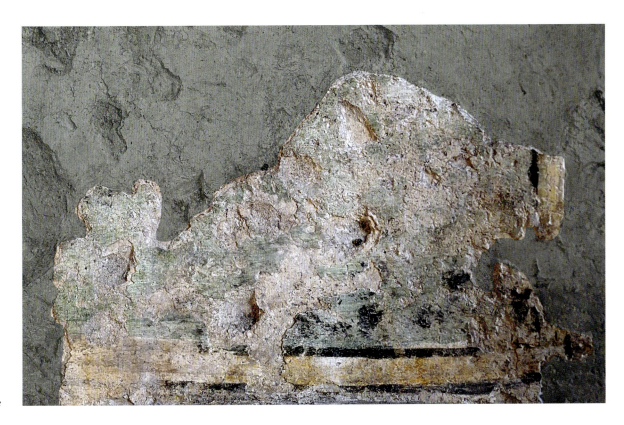

13e

13 Apse dado zone (layer VI), decoration of fictive marble *incrustationes* (Giulia Bordi): (a) Numidian yellow; (b) green porphyry; (c) polychrome *breccia*; (d) polychrome marble; (e) Thessalian green

to the dating of this phase to the years 649–53, or at least to the pontificate of Pope Martin I.⁴⁵ Based on a close reading of the layers, both paintings seem to have functioned as true 'posters', inserted between the *Annunciation* and its potential pendant scene on the left, and the dado zone with its fictive *incrustationes*. In the apse, both the conch and the hemicycle bear no trace of paintings belonging to this phase, with the exception of a band some ten centimetres high with a Greek inscription written in white letters on a red ground, of which only one third survives (Plate 36; Figures 14b, 17). This band was painted on a thin layer of plaster which corresponded in both height and length to the phase VI border separating the upper zone from the dado. From this we can conclude that the additions traditionally assigned to the years 649–54 did not substantially alter the existing decorative programme, but merely added the four Church Fathers on the flanking walls, and in the apse itself the inscription in the space previously occupied by a border.⁴⁶ The inscription is very fragmentary and has been transcribed on a number of occasions, beginning with Rushforth.⁴⁷ Based on the reading proposed by Wilpert in 1910, the text has been interpreted as a reference to a verse from the Gospel of John (14.27), spoken by Jesus to his disciples before going to the Garden of Gethsemane: 'Peace I leave with you; my peace I give to you.'⁴⁸ More recently, the verse has been used to support the suggestion that the apse above depicted a Christological subject.⁴⁹ The transcription proposed here ('[---]ON KYPIE O ΘEOC EMΩN THN CHN EIPINHN [-]OC EIMH [---]') confirms the reading initially proposed by Rushforth, with a few additions.⁵⁰ But clearly the reference is not to John 14.27; rather, these words constitute an exact quotation of the first part of a verse from Isaiah 26.12: 'O Lord, thou wilt ordain peace for us' (New Oxford Annotated Bible)⁵¹ This is an invocation for reconciliation, which aligns perfectly with the new understanding of the four patristic texts proposed by Richard Price elsewhere in this volume. In Price's view, of these passages, which were all taken from the *florilegium* employed at the 649 Lateran Council, only two, those of Leo I and John Chrysostom (Figures 16a–b), directly refer to the two 'operations' of Christ, while the other two, those of Basil of Caesarea and Gregory of Nazianzus (Figures 16a–b), refer to the nature of 'will' between the Father and the Son, a subject on which both the dyotheletes and monotheletes were in agreement.⁵² The scrolls, therefore, are not posters for the anti-monothelete views of Martin I and Maximus the Confessor, as believed for more than a century, but instead celebrate the common ground shared by the Roman and Constantinopolitan traditions, perhaps reflecting the climate of de-escalation and compromise that coincided with the 663 visit to Rome of Emperor Constans II, during the pontificate of Vitalian (657–72).⁵³ It is generally accepted that the emperor resided on the Palatine during his twelve-day visit to the city,⁵⁴ and he probably visited Santa Maria Antiqua, since its location had a natural connection to the imperial palace. Price's interpretation, moreover, reinforces a view that has been circulating for some time, that Martin I did not play a prominent role in the decoration of Santa Maria Antiqua.

The journey through the levels of the apse wall leads to phase VIII, linked to the activity of Pope John VII (705–7), son of the *curator palatii* Plato, and responsible for the transfer of the seat of his *episcopium* to the Palatine.⁵⁵ He was probably the first pontiff to be associated with Santa Maria Antiqua as a patron, since we have no prior evidence of papal connections to the church. The research undertaken by Nordhagen highlights the fact that John's image and name can be found in six locations there, indicating the broad scope of his work at this site.⁵⁶ Analysis of the plaster leads to the conclusion that the pictorial intervention under John VII did not include

the central area of the apse, but only its periphery, and primarily the wall framing the conch (Figures 15a–b). In the upper zone, he removed the marble revetment and mosaics of the second half of the fourth century, and replaced them with the majestic *Adoration of the Crucified Christ*, flanked by Mary and Saint John and surrounded by a host of angels, seraphim and cherubim (Plates 33–4).[57] Beneath this was a lengthy series of biblical quotations in Greek, followed by a crowd of acclaiming figures, some of which emerged from their sarcophagi, according to Per Olav Folgerø's convincing hypothesis (cf. Matthew 27.52).[58] Moving down the wall to the next level, flanking the top of the apse conch, we find the figures of four popes: John VII and Martin I, at the left and right extremities respectively, accompanied by two others whose identities have prompted considerable speculation (Plate 35).[59] I have recently proposed that they are Leo II on the left (Figure 18a)[60] and Gregory I or Agatho on the right (Figure 18b).[61] Below the four popes are four Church Fathers, three of whom can be identified from their painted inscriptions: Augustine on the left (Figure 19a), and Gregory of Nazianzus and Basil on the right (Figure 19b). On the basis of my reconstruction, the missing figure next to Augustine may have been Leo I.[62] Finally, above a dado painted with fictive drapery, we find the dedication to the Mother of God in large white letters on a red ground: 'S[AN]C[T]A D[E]I [GENI]T[RI]CI SEMP[ERQUE VIRGINI MAR]IAE' (Figure 19a). Wilpert believed that this painted inscription continued on the adjacent wall, where the patron would have been named (Figure 19b).[63]

In the apse hemicycle itself, the only bits of painting securely attributable to the time of John VII are the remains of the painted curtain (Figure 15a), visible in the lower left corner, and the effacement of the inscription from *c.* 663, whose letters were whitewashed and covered in red. These two elements—the transformation of the inscription into a thick red border, and the addition of the fictive curtains—are John VII's only alterations to the apse itself, which, unlike the surrounding wall, remained otherwise untouched, including the existing image of the Mother of God (Phase VI) in the conch (Figure 15b). The painted dedicatory inscription (Figure 19a) and the image of John VII with the 'square halo' (Figure 18a) would normally have been placed inside the apse, following the Roman practice, so their placement on the framing wall confirms that the papal intervention did not include the main area of the apse hemicycle. The pope's firm intention must have been therefore to retain the existing image of the Virgin and Child between angels (or the Princes of the Apostles), a potent confirmation of his appropriation of the sanctuary.

As Nordhagen has shown, John VII, *servus Dei Genitricis*, preserved all the pre-existing Marian images in the church, significantly for example the image of Saint Anne with the infant Mary painted on the west wall of the sanctuary (Plates 44, 50: K3), and the Virgin and Child with crossed hands on the north-east pier (Plates 15, 50: E1.1) They were thus spared destruction and incorporated into the new decorative programme.[64]

A possible thematic relationship between John VII's repainting of the apse wall and the earlier figures of the Church Fathers, traditionally assigned to the era of Martin I (phase VII), has been proposed by Nordhagen, who has explored it on several occasions. Indeed, he has based his understanding of the Santa Maria Antiqua murals on the decorative campaigns of these two popes. His reading focuses on the pro- and anti-Byzantine messages that he identified in the two sections of the apse wall. Above, the *Adoration of the Crucified Christ* follows the provisions of Canon 82 of the Council 'in Trullo' of the year 692, and uses the same facial type of Christ

14　Apse wall, the mapping of layer VII (Giulia Bordi and Valeria Valentini): (a) preserved fragments of plaster; (b) original extension and hypothetical reconstruction

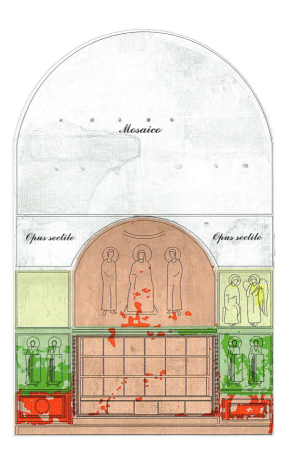

15　Apse wall, the mapping of layer VIII (Giulia Bordi and Valeria Valentini): (a) preserved fragments of plaster; (b) original extension and hypothetical reconstruction

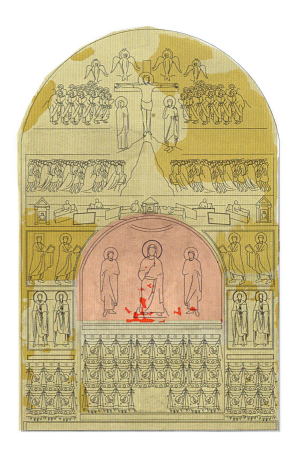

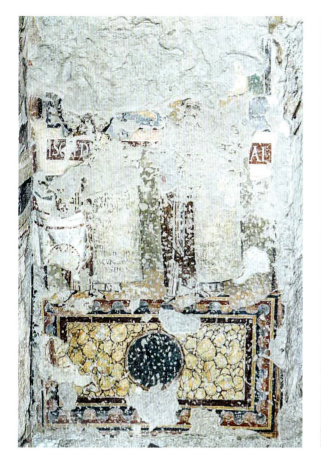
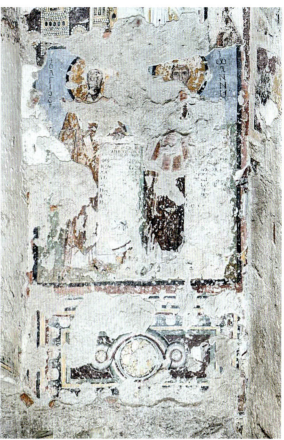

16 Apse wall: (a) left side, pope Leo I and Gregory of Nazianzus; (b) right side, Basil of Caesarea and John Chrysostom (photos: Gaetano Alfano 2016)

17 Apse hemicycle, Greek inscription (photo: Gaetano Alfano 2016)

that was employed on coinage from the second reign of Emperor Justinian II (705–11) (Plate 34). This choice seems to reflect a clear adherence to Constantinopolitan dictates, in contrast to the area below, where Nordhagen identifies the figure of Martin I, martyr for orthodoxy, as a clear signal of opposition to the emperor.[65] But in recent years, the renewed attention paid to the Sixth Ecumenical Council of 680–1 has diminished the importance previously accorded to both the Lateran Council (649) and the Council 'in Trullo' (692). This places John VII's programme in a different perspective, now seemingly less ambiguous.

As I have argued elsewhere, in addition to his own image and that of Martin I, John VII also chose to have represented Pope Leo II—instead of Leo I as Nordhagen believed.[66] Leo I is included in the zone immediately beneath the papal figures from John VII's campaign, and his counterparts on the 'palimpsest' wall are the Greek theologians Basil of Caesarea and Gregory of Nazianzus (Plate 35; Figures 18–19). In my proposal, Leo I was included by John VII in his capacity as author of the *Tomus ad Flavianum* and champion of Chalcedonian orthodoxy.[67] But the pope standing by John should be, in my opinion, identified as Leo II (682–3), 'a man of great eloquence, competently versed in holy scripture, proficient in Greek and Latin', according to the *Liber pontificalis*.[68] It was Leo II who arranged for the translation into Latin of the Acts of the Sixth Ecumenical Council (680–1) and for their approval by the Western bishops. This affirmed the 'supernational' ecclesiology of his predecessor Pope Agatho (678–81), for whom the barbarian West, Christianised by the evangelising efforts initiated by Gregory I's mission to the Anglo-Saxons, had its unifying centre in the papacy. This view justified the extension of the Roman Church's sphere of influence and reinforced the role of the pope as *vicarius Petri*, custodian of the faith, and guarantor of orthodoxy, whose action was key in determining the outcomes of councils.[69]

By a stroke of good fortune, this reading has found confirmation in Oscar Mei's discovery among the papers of Abbot Domenico Silvio Passionei (1682–1761) of a document titled 'Dissertazione, che incomincia l'anno 1704, sopra una chiesa che si scoprì in Campo Vaccino a lato di Santa Maria Liberatrice', dedicated to the accidental discovery of the church of Santa Maria Antiqua in 1702. Passionei's watercolour drawings and accompanying notes confirm that the figure depicted on the apse wall beside John VII was indeed Leo II, and his counterpart to the left of Pope Martin I was Gregory I.[70] The presence of Gregory I, whose posthumous memory was cultivated chiefly by the Eastern circle in the Roman Church, as Alan Thacker and Phil Booth have recently demonstrated,[71] attests to John VII's awareness that the new universal ecclesiology, in which the Christian *imperium* under the jurisdiction of the *sedes apostolica* included the various Christianised *gentes*, had its roots in Gregory's evangelical missions. The four Church Fathers can be thus viewed as John VII intended them, as symbols of the defeat of Monotheletism achieved at the Sixth Ecumenical Council, rather than a reference to the Lateran Council of 649. They were selected from the list of nine *auctoritates* cited in the *Liber pontificalis* because on their writings had been founded the doctrine of two 'wills' and two 'operations' that triumphed in 680–1. For the Church of Rome, this Council represented 'a real victory for the papacy', in the words of Paolo Delogu, combining the victory over Monotheletism, the reconciliation with the Byzantine emperor, the recognition of the primacy of Rome among the patriarchal sees, and the identification of Pope Agatho as the 'Prince of the Apostles' based on Saint Peter's confession of faith (Matthew 16.18–9).[72]

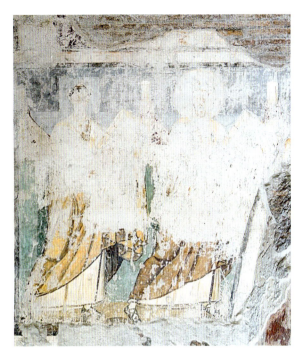 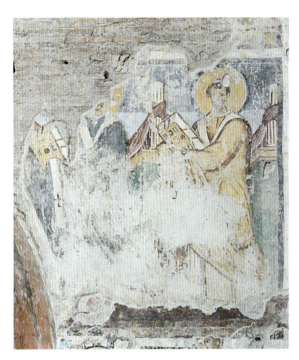

18 Apsidal arch: (a) left side, John VII and Leo II; (b) right side, Gregory the Great and Martin I (photos: Gaetano Alfano 2016)

In this new light, John VII's inclusion of Martin I should not be interpreted as a reference to his martyrdom for orthodoxy or a reflection of pro-imperial sentiment, as Nordhagen has variously proposed.[73] Instead, he is present as the pope who defended orthodoxy at the 649 Lateran Council in his role as the successor of Saint Peter. At Santa Maria Antiqua, John thus inserted himself into the line of popes who, beginning with Gregory I and following Peter's profession of faith, advanced the preeminent position of the *sedes apostolica et Romana* with regard to the other patriarchates, making it not only the spiritual centre of the western kingdoms, but also of the empire. The pope was the primary defender of the orthodox faith.

As a Greek pope, John VII could not fail to look to his predecessors—Gregory I, Martin I, and Leo II—and his political actions were aimed at mediating between the 'barbarian' West and the imperial East through a universal ecclesiology that relied on the papacy to guarantee the purity of the Christian faith. Placing the celebration of the Sixth Ecumenical Council at the centre of his new programme constituted a radical change of perspective. From an initially ambivalent position, one which sought conciliation while simultaneously opposing the imperial views, John, who was described by his biographer as 'terrified in his human weakness',[74] shifted to a celebration of the triumph of the Roman Church.[75] Such understanding of the papal position echoes also in Rosamond McKitterick's recent work, where she attributes to the time of Pope Agatho the continuation of the *Liber pontificalis*, a project intended to promote the role of the papacy as the defender of orthodoxy against Byzantium.[76] This idea would fully come to fruition with Pope Constantine's journey to Constantinople in 710.

On the apse wall of Santa Maria Antiqua, John VII celebrates therefore the dogmatic victory of the Roman Church over Monotheletism; but the real victory was the affirmation of Roman ecclesiology. This informs the image of Mary painted in the apse, flanked either by angels or by

19a (a) Wall to the left of the apse, Saint Augustine; (b) wall to the right of the apse, Gregory of Nazianzus and Basil (photos: Gaetano Alfano 2016)

THE APSE WALL OF SANTA MARIA ANTIQUA (IV–IX CENTURIES)

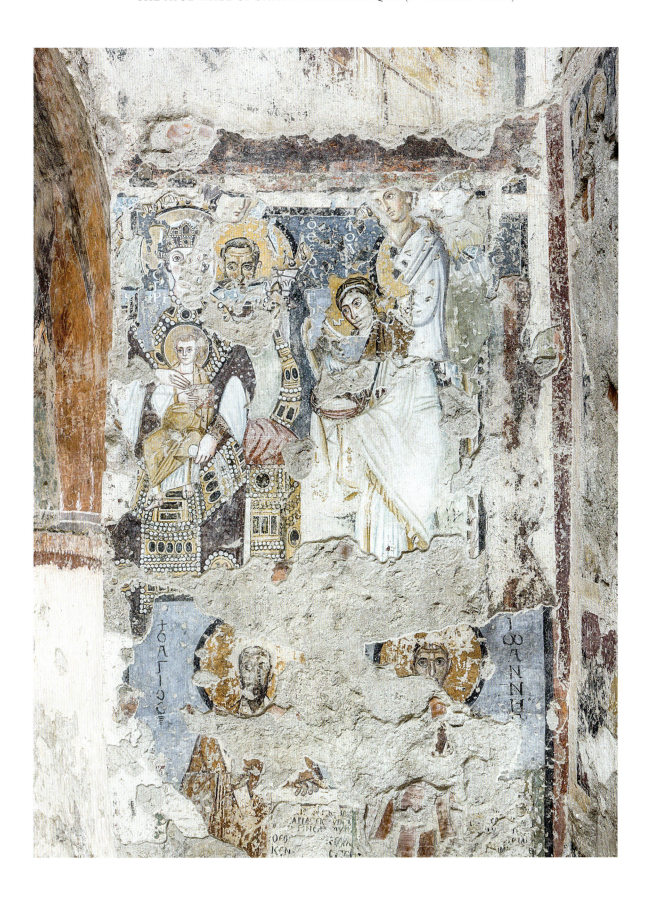

19b

Saints Peter and Paul, and similar to the one John had depicted on the left wall of the passage from the east aisle to the Palatine ramp (Plates 9, 50: C3). The apse Virgin, dating to the early decades of the seventh century, was enshrined by John in his new programme; and as had been the case at his funerary chapel in Saint Peter's, the pope declared himself to be the *servus* of Mary, or more exactly of the one who gave birth to the Church of Christ.[77] The imposing *Adoration of the Crucified Christ* (Plate 33), closely linked to the Good Friday liturgy celebrated in Jerusalem in the seventh century, as has been frequently noted, as well as to the catechism of Cyril of Jerusalem, should be seen, as Delogu recently observed, as a visual representation of the dogma of the two natures and two wills of Christ, reaffirmed at the 680 Council in Constantinople, in which the Word, displayed in its human nature, expresses, still living, an awareness and acceptance of the highest divine will, and is consequently glorified by angels and adored by.[78]

Phase IX in the apse features the figure of the Blessing Christ between angelic powers, into whose presence Pope Paul I is introduced through the Virgin Mary's intercession (Plate 35; Figure 3a). It is significant that Paul I's intervention in the apse was the opposite of John VII's: he retained the complex imagery on the framing wall (Figures 20a–b), but he dramatically altered the iconographic programme by inserting an apsidal theophany/*parousia*. The apse mural is today reduced to a shadow of its former self, and although the recent conservation campaign has wisely attempted to stitch together the fragile plaster fabric of the hemicycle, broken and disfigured by plaster losses, the Wilpert-Tabanelli watercoloured plate remains indispensable for identifying the protagonists (Figure 1).[79] Of the figure of Christ we discern the large haloed head and the outline of the body dressed in a golden garment (Figure 3a), while only few traces remain of Mary's purple robe. The blue 'square halo' indicates the presence of the donor pope. Of the tetramorphic cherubim, the one on the left has almost entirely disappeared, but the one on the right preserves the only face that remains appreciable (Plate 36). The figures stand on a golden ground furrowed by a wavy green band with three stripes, perhaps intended to be a stylised representation of the Jordan River (Figures 1, 3a).[80] They are set against a tall curtain with alternating red and green swags, behind which a starry sky opens up—a setting that has thus far received very little attention.

In Paul I's programme, Mary, although retaining a supporting role, cedes the central place in the apse to Christ. This is a radical iconographic choice that can be explained only in the light of the changed political circumstances of the mid-eighth century. Eileen Rubery has noted that the papacy countered the doctrine of Iconoclasm that swept Byzantium after the Council of Hieria (754) by reaffirming Roman support for images, and placed in the apse the figures that, in the view of the iconoclasts, were the most impossible to represent: Christ and the angels.[81] Similarly, Gaetano Curzi sees in the apse the vision inspired by Isaiah 6.1–12, and interprets the Virgin displaced from the centre as the one who leads the pope to contemplate the theophany.[82] But the hypertext on the apsidal wall pushes us further, to an intertextual reading of the iconographic programme devised by John VII, into which Paul I knowingly positioned himself.[83] The apse wall requires reading on multiple levels: dogmatic, liturgical, and political. It is an imposing orthodox representation of the Incarnation of the Word, founded on the tradition of the Roman Church.

The presence of the curtain behind the theophany/*parousia* can be understood in relation to the miniature with the *parousia* that closes Book V of Cosmas Indicopleustes's *Topography*

THE APSE WALL OF SANTA MARIA ANTIQUA (IV–IX CENTURIES)

20 Apse wall, the mapping of layer IX (Giulia Bordi and Valeria Valentini): (a) preserved fragments of plaster; (b) original extension and hypothetical reconstruction

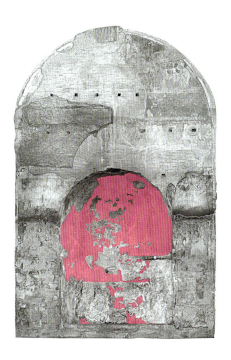
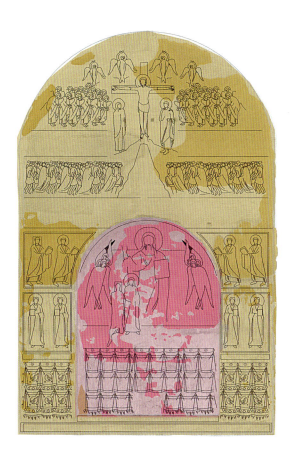

21 Apse wall, the mapping of layer X (Giulia Bordi and Valeria Valentini): (a) preserved fragments of plaster; (b) original extension and hypothetical reconstruction

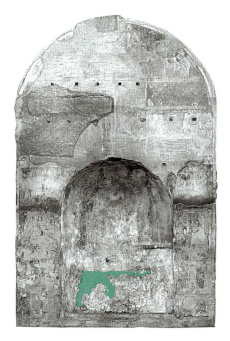
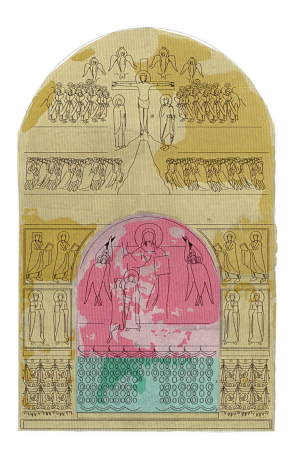

(Vatican City, Biblioteca Apostolica Vaticana, MS gr. 699, fol. 89r; IX century), which was designed, according to Herbert Kessler, following the bipartite structure of the Hebrew tabernacle.[84] In the uppermost section Christ sits enthroned in the *sancta sanctorum*, and behind his shoulders is a rich golden fabric decorated with a trellis pattern. Below the figure of Christ there is a tripartite hierarchy of beings: celestial, terrestrial, and the dead.[85] The curtain functions both as a background and as part of the iconography, since in Pauline exegesis the tent is the Flesh of the Lord and Christ is the Temple Veil (Hebrews 10.19–20).[86] Indeed, in the Christian tradition the rending of the veil of the Jewish Temple at the moment of Christ's death opens the *sancta sanctorum* and the path to Salvation for the faithful (Matthew 27.51, Mark 15.38, Luke 23.45). Through Christ and the Temple Veil, the Christian can gain access to heaven, which is indicated in the Santa Maria Antiqua apse by the blue background beyond the curtain. The iconography thus represents the Incarnation of the *Logos* as a veil through which divinity and heaven become visible and accessible, and the Christian church as the new Tabernacle. The theophany in the apse dialogues directly with the *Adoration of the Crucified Christ* depicted on the wall above the conch, creating a vertical axis that culminates with the eucharistic sacrifice performed on the altar (Plate 32).

The *Maiestas Domini* in the apse is an original iconography developed by Paul I, and one that would not be repeated. It condenses into a single powerful image the visions of Ezekiel (1.1–28) and Isaiah (6.1–12), the concept of Christ as Veil of the Temple, and a theophany with echoes of the Second Coming in the standing figure garbed in a golden robe and raising an arm in benediction (Revelation chs. 4–5). The latter figure is specifically Roman: it is the Christ of the Petrine *traditio legis*, known from the apse mosaic of the church of Santi Cosma e Damiano.[87] This is a surprising formula, which in my opinion also served to reinforce a new political message: Rome had moved beyond its traditional support for images towards a more direct confrontation with the Byzantine emperor's iconomachy. The intended audience for the image was thus expanded to include both the East and the West. The parallel substitution in the apse of the figure of Mary with Christ reflected a shift in political prerogatives that dated back to Paul's brother, Pope Stephen II (752–57), who in 753 had carried in procession the Lateran *Acheiropita* as a *palladium* in defence of the city, then being threatened by the Lombard king Aistulf.[88] At Santa Maria Antiqua, as I attempted to show elsewhere, the two brothers 'de via Lata' translated into powerful images their political project, conceived by Stephen II and carried out by Paul.[89] The project was the creation of the *respublica Romanorum* under the protection of the Frankish King Pippin, although it soon gave way to the notion of direct papal sovereignty over the Patrimony of Saint Peter, and the acquisition of imperial powers and rights.[90] Indeed, I have suggested that it was Stephen himself who decorated the left aisle of Santa Maria Antiqua with the phalanx of Church Fathers, popes, and saints who flank an enthroned figure of Christ (Plates 6, 50: C1)—the last being in my view a copy of the *Acheropita* that the pope had carried in procession (Plate 7).

As already discussed, Justinian II (685–95, 705–11) had placed the image of Christ on his coins to reinforce his role as vicar on earth. But this practice was subsequently repudiated by the iconoclast emperors, and this allowed Stephen II and Paul I to adopt the image themselves.[91] To legitimise this shift in prerogatives and roles, in the new apse decoration of Santa Maria Antiqua the Virgin is shown in the act of introducing Pope Paul into Christ's presence. She

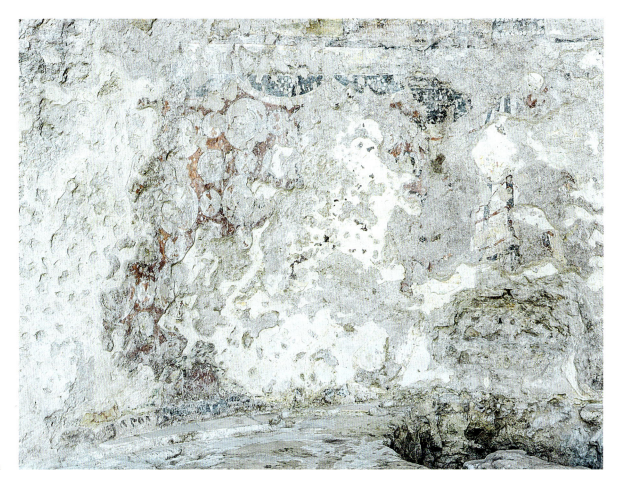

(a) Apse hemicycle, fictive textile adorned with beaded *rotae*; (b) Vatican Museums, cruciform cushion from the *Sancta Sanctorum*; (c) Catacomb of San Gennaro at Naples, Crypt of the Bishops, painted dado (photo: Marianna Cuomo 2019)

places her right hand on the pope's shoulder and raises the left, palm open, towards her Son.[92] The pope, like John VII before him, is represented as the *servus Mariae*, hence servant of the Church, but in light of this formal presentation he is also *servus Christi*, the formula used by Justinian II on his coinage—an appropriation that implies the acquisition of the prerogatives of imperial sovereignty.

The mapping of the pictorial layers in the apse hemicycle allows us also to gain a better understanding of the sequence of fictive draperies. The one corresponding to the same level as Paul I's campaign is not the fictive curtain decorated with interlinked *rotae*, but rather the drapery decorated with four *orbiculi* alternating with four vegetal motifs, with a fifth circular motif in the centre, preserved in the centre of the hemicycle, which Nordhagen believed to belong to the phase of John VII (Figures 20a, 22a).[93]

The tenth and last decorative phase was revealed through the mapping of the apse hemicycle, and features an 'updating' limited to that space alone (Figures 21a–b): the fictive fabric adorned with beaded *rotae*, interlinked and displaying vegetal motifs forming a cross against a red background (Figures 1, 22a). This layer clearly overlaps with that of Paul I, a correspondence that is not always felicitous, for example in the depiction of Christ's jewelled footstool, where the long string of pearls is awkwardly covered by the upper border of the curtain.

This specific curtain design is not otherwise attested in Rome in the eighth or ninth centuries, so for comparisons we need to look further afield, for example to Naples. The painted dado in the Crypt of the Bishops in the Catacomb of San Gennaro (Figure 22c) displays a similar pattern of interlinked beaded roundels with birds alternating with other non-linked roundels, and this helps date the Roman curtain to the ninth century.[94] The Byzantine samite cruciform cushion of the jewelled cross from the *Sancta Sanctorum* chapel at the Lateran palace, now in the Vatican Museum, provides an additional point of comparison for this design (Figure 22b).[95] It also attests to the diffusion in the first half of the ninth century of a particular taste for fabrics that finds supporting evidence in the biographies of the Roman popes from Hadrian I to Leo IV. In them are listed numerous sets of altar *vestes* and *vela* decorated 'with roundels and wheels' ('*cum orbicolis et rotas*').[96] This taste is also reflected in contemporaneous sculpture design, for example on various slabs from liturgical screens.[97]

The identification of this tenth and last painted level from the Santa Maria Antiqua apse hemicycle pushes the chronology of pictorial interventions in the church interior beyond the pontificate of Paul I, and documents the continuity of '*cultus et decor*' into the first half of the ninth century, almost to the dramatic abandonment of the interior of the building in 847.

NOTES TO THE TEXT

1 See Giuseppe Morganti's essay in this volume.

2 Gordon Rushforth, 'The Church of Santa Maria Antiqua', *Papers of the British School at* Rome, 1 (1902), 1–123 (p. 67); Wladimir de Grüneisen, *Sainte-Marie-Antique* (Rome: M. Bretschneider, 1911), pp. 142–5, pl. 1c, L; Ernst Kitzinger, *Römische Malerei vom Beginn des 7. bis zur Mitte des 8. Jahrhunderts* (Munich: R. Warth, 1934), pp. 40–3; Per Jonas Nordhagen, 'The Earliest Decorations in Santa Maria Antiqua and their date', *Acta ad archaeologiam et artium historiam pertinentia*, 1 (1962), 53–72 (p. 57); and Per Jonas Nordhagen, 'The Frescoes of John VII (A.D. 705–707) in S. Maria Antiqua in Rome', *Acta ad archaeologiam et artium historiam pertinentia*, 3 (1968), p. 54.

3 Joseph Wilpert, 'Sancta Maria Antiqua', *L'arte*, 13 (1910), 1–20, 81–107 (pp. 12, 82–3, 96); Maria Andaloro, 'La parete palinsesto: 1900, 2000', in *Santa Maria Antiqua al Foro Romano cento anni dopo*, ed. by J. Osborne, J. R. Brandt and G. Morganti (Rome: Campisano, 2004), pp. 97–112 (pp. 98–101); and Giulia Bordi, 'Giuseppe Wilpert e la scoperta della pittura altomedievale a Roma', in *Giuseppe Wilpert archeologo cristiano*, ed. by S. Heid (Vatican City: Pontificio Istituto di Archeologia Cristiana, 2009), pp. 323–42.

4 Valeria Valentini has been my constant travel companion on this journey. She is a conservator who deals with the physical aspects of works of art, while also paying attention to the image, and I am an art historian focusing on the pictures, but also paying attention to their materiality. Our different approaches were combined to investigate the layers of the apse wall from the scaffolding, in that process rediscovering its more stratified palimpsest.

5 Giulia Bordi, 'Tra pittura e parete. Palinsesti, riusi e obliterazioni nella diaconia di Santa Maria in via Lata tra VI e XI secolo', in *Archeologia della Produzione a Roma. Secoli V–XV, Convegno internazionale di studi (Roma, Palazzo Massimo alle Terme - École Française de Rome, 27–29 marzo 2014)*, ed. by A. Molinari, R. Santangeli Valenzani, and L. Spera (Bari: Edipuglia, 2015), pp. 395–410 (pp. 395–6).

6 Giulia Bordi, 'Santa Maria Antiqua attraverso i suoi palinsesti pittorici', in *Santa Maria Antiqua tra Roma e Bisanzio*, ed. by M. Andaloro, G. Bordi, and G. Morganti (Milan: Mondadori-Electa, 2016), pp. 34–53 (p. 35).

7 Nordhagen, 'The Earliest Decorations', pp. 54–5; Richard Krautheimer, Wolfgang Frankl, and Spencer Corbett, 'S. Maria Antiqua', in *Corpus Basilicarum Christianarum Romae*, 5 vols (Vatican City: Pontificio Istituto di Archeologia Cristiana, 1937–77), II (1962), p. 256; Alessandra Guiglia Guidobaldi, 'La decorazione marmorea dell'edificio di Santa Maria Antiqua fra tarda antichità e alto medioevo', in *Santa Maria Antiqua al Foro Romano cento anni dopo*, ed. by J. Osborne, J. R. Brandt and G. Morganti (Rome: Campisano, 2004), pp. 49–65.

8 Valeria Valentini, 'Tessere di mosaico in pasta vitrea', in *Santa Maria Antiqua tra Roma e Bisanzio*, ed. by M. Andaloro, G. Bordi, and G. Morganti (Milan: Mondadori-Electa, 2016), p. 366.

9 Giulia Bordi and Alessandra Guiglia Guidobaldi, 'Elementi di *opus sectile* in marmo e in vetro', in *Santa Maria Antiqua tra Roma e Bisanzio*, ed. by M. Andaloro, G. Bordi, and G. Morganti (Milan: Mondadori-Electa, 2016), pp. 364–5.

10 For the *status quaestionis* on the various dates proposed for the *Aurum coronarium* see most recently Valentino Pace, 'Alla ricerca di un'identità: affreschi, mosaici, tavole dipinte e libri a Roma tra VI e IX secolo', in *Roma e il suo territorio nel Medioevo. Le fonti scritte fra tradizione e innovazione. Atti del convegno internazionale di studio dell'Associazione italiana dei Paleografi e Diplomatisti (Roma, 25–29 ottobre 2012)*, ed. by C. Carbonetti, S. Lucà, and M. Signorini (Spoleto: Fondazione Centro Italiano di Studi sull'Alto Medioevo, 2015), pp. 471–98 (pp. 474–81); Giulia Bordi, 'Santa Maria Antiqua. Prima di Maria Regina', in *L'officina dello sguardo, scritti in onore di Maria Andaloro*, ed. by G. Bordi, I. Carlettini, M.L. Fobelli, M.R. Menna, and P. Pogliani, 2 vols (Rome: Gangemi, 2014), I, pp. 285–90 (pp. 289–90, notes 24–5; and Maria Lidova, '*Maria Regina* on the Palimpsest Wall in S. Maria Antiqua in Rome. Historical Context and Imperial Connotations of the Early Byzantine Image', *Iconographica*, 16 (2017), 9–25.

11 Bordi, 'Santa Maria Antiqua. Prima di Maria Regina', pp. 285–7. Carlo Bertelli had earlier advanced the hypothesis that a depiction of Christ between angels may have formed a pendant to the *Aurum coronarium*, without however examining the fragments preserved on the left side; see Carlo Bertelli, *La Madonna di Santa Maria in Trastevere* (Rome: Eliograf, 1961), p. 54.

12 Around the angel there are traces of a precise incision to remove the image, leaving only the border; see Bordi, 'Santa Maria Antiqua. Prima di Maria Regina', p. 285.

13 On the *damnatio memoriae* of Theodoric see Giuseppe Bovini, 'Osservazioni sul frontone del Palatium di Teodorico figurato nel mosaico di S. Apollinare Nuovo di Ravenna', *Beiträge zur älteren europäischen Kulturgeschichte*, 1 (1952), 206–11; Giuseppe Bovini, *Edifici di culto d'età teodoriciana e giustinianea a Ravenna* (Bologna: Pàtron, 1970), pp. 119–29; Emanuela Penni Iacco, *La basilica di S. Apollinare Nuovo di Ravenna attraverso i secoli* (Bologna: Ante Quem, 2004), pp. 36–79; and Clementina Rizzardi, *Il mosaico a Ravenna*, pp. 98–106. See also Bordi, 'Santa Maria Antiqua. Prima di Maria Regina', pp. 286–8.

14 Anonymus Valesianus, *Pars posterior, Excerpta, 67* (Monumenta Germaniae Historica, Auctores Antiquissimi, IX), ed. by T. Mommsen (Berlin: Weidmann, 1894), p. 324. Bordi, 'Santa Maria Antiqua. Prima di Maria Regina', pp. 288–9.

15 Krautheimer, Frankl, and Corbett, 'S. Maria Antiqua',

16 269; and Bordi, 'Santa Maria Antiqua. Prima di Maria Regina', p. 289.

16 Arnold H. M. Jones, *Prosopography of the Later Roman Empire* [hereafter *PLRE*] II: *A.D. 395–527* (Cambridge: Cambridge University Press, 1980), pp. 1067–8; and Bordi, 'Santa Maria Antiqua attraverso i suoi palinsesti pittorici', p. 40. For Theodahad and Amalasuintha see most recently Massimiliano Vitiello, *Theodahad: A Platonic King at the Collapse of Ostrogothic Italy* (Toronto: University of Toronto Press, 2014); and Massimiliano Vitiello, *Amalasuintha: The Transformation of Queenship in the Post-Roman World* (Philadelphia: University of Pennsylvania Press, 2018).

17 I owe this description of the *Maria Regina* to Maria Andaloro, see Giulia Bordi and Maria Andaloro, 'La Maria Regina della "parete palinsesto"' in *Santa Maria Antiqua tra Roma e Bisanzio*, ed. by M. Andaloro, G. Bordi, and G. Morganti, pp. 154–9 (p. 155), in a friendly counter to the position taken by Valentino Pace, who sees the 'overabundance of ornament' as an indication that the figure dates from the Ostrogothic period: cf. Pace, 'Alla ricerca di un'identità', pp. 474–5.

18 Bissera V. Pentcheva, *Icone e potere: La Madre di Dio a Bisanzio* (Milan: Jaca Book, 2010), pp. 23–30.

19 Pentcheva, *Icone e potere*, 12–17; Toniolo has suggested that the author of this hymn was Basil, Bishop of Seleucia (444–68), author of a homily on the Mother of God (*PG* 85, cols 427–9): Ermanno T. Toniolo, *Akathistos, inno alla Madre di Dio: Edizione metrica, commento al testo, mistagogia* (Roma: Centro di cultura mariana "Madre della Chiesa", 2017), pp. 80–4, 91–6 (p. 96). For a dating to the second quarter of the fifth century see also Vasiliki Limberis, *Divine Heiress: The Virgin Mary and the Creation of Constantinople* (London: Routledge, 1994), pp. 89–97; and Leena M. Peltomaa, *The Image of the Virgin Mary in the Akathistos Hymn* (Leiden: Brill, 2001), pp. 113–15.

20 Pentcheva, *Icone e potere*, p. 14. See also Robert Coates-Stephens, 'Sulla fondazione di S. Maria in Domnica', in *Scavi e scoperte recenti nelle chiese di Roma. Atti della giornata tematica dei Seminari di Archeologia Cristiana* (Roma, 13 marzo 2008), ed. by H. Brandenburg and F. Guidobaldi (Vatican City: Pontificio Istituto di Archeologia Cristiana, 2012), pp. 77-91 (84-7).

21 Constantine Porphyrogennetos, *The Book of Ceremonies*, trans. by Anne Moffat and Maxeme Tall (Leiden: Brill, 2012), p. 7; Kenneth G. Holum, *Theodosian Empresses: Women and Imperial Dominion in Late Antiquity* (Berkeley: University of California Press, 1982), p. 143; Pentcheva, *Icone e potere*, p. 12.

22 Eva Tea calls this plaster *opus albarium*, following Pliny's terminology; see Eva Tea, *Basilica di Santa Maria Antiqua* (Milan: Società editrice 'Vita e Pensiero', 1937), p. 40. Nordhagen, however, calls it 'whitewash' ('The Earliest Decorations', pp. 57, 62).

23 Wilpert, 'Sancta Maria Antiqua', p. 82.

24 Ibid., pp. 82–3. He dated it, however, to the campaign of John VII.

25 De Grüneisen, *Sainte-Marie-Antique*, p. 4 (also assigning it to John VII); Nordhagen, 'The Earliest Decorations', p. 57; Nordhagen, 'Frescoes of the Seventh Century', pp. 95–6, fig. 2; and Valentino Pace, 'Immagini sacre a Roma fra VI e VII secolo', *Acta ad archaeologiam et artium historiam pertinentia*, 18 (2004), 139–56 (pp. 144–5). Beat Brenk maintains that the figure of Mary was never depicted in the apse, see Beat Brenk, *The Apse, the Image and the Icon: A Historical Perspective of the Apse as a Space for Images* (Wiesbaden: Reichert, 2010), p. 106.

26 Anna Melograni, 'Le pitture del VI e VIII secolo nella basilica inferiore di S. Crisogono in Trastevere', *Rivista dell'Istituto Nazionale di Archeologia e Storia dell'Arte*, 3rd ser., 13 (1990), 139–78 (pp. 153–8, figs 17–19); for the identification of the Princes of the Apostles, see Bordi, 'Santa Maria Antiqua attraverso i suoi palinsesti pittorici', p. 53 note 36.

27 Tea, *Basilica di Santa Maria Antiqua*, pp. 7, 19, 41. Following a careful reading of Giacomo Boni's correspondence, Andrea Paribeni has cast doubt on the attribution of the three coins to Justin II, preferring Justin I (518–27): Andrea Paribeni, 'Giacomo Boni e il mistero delle monete' scomparse', in *Marmoribus vestita. Miscellanea in onore di Federico Guidobaldi*, Studi di antichità cristiana 63 (Vatican City: Pontificio Istituto di Archeologia Cristiana, 2011), pp. 1003–23. Should Paribeni's thesis be accepted, this would place the conversion of the structure into a church some fifty years earlier than previously thought, but without any alteration to the sanctuary, where the large rectangular niche would have served in place of an apse.

28 John Osborne has noted that two XX *nummi* coins from the reign of Justin II were discovered by Richard Reece in a box labelled as having come from the Fountain of Juturna, and that there may have been some confusion: John Osborne, 'The Atrium of S. Maria Antiqua, Rome: a history in art', *Papers of the British School of Rome*, 55 (1987), 186–223 (pp. 188–9, note 11).

29 Robert Coates-Stephens, 'Byzantine Building Patronage in post-Reconquest Rome', *Les cités de l'Italie tardo-antique (IVe-VIe siècle)*, ed. by M. Ghilardi (Rome: École française de Rome, 2006), pp. 149–66 (pp. 156–8); Robert Coates-Stephens, 'The Forum Romanum in the Byzantine Period', in *Marmoribus Vestita. Miscellanea in onore di Federico Guidobaldi*, ed. by O. Brandt and P. Pergola (Vatican City: Pontificio Istituto di Archeologia Cristiana, 2011), pp. 385–408 (pp. 405–8); and Coates-Stephens, 'Sulla fondazione di S. Maria in Domnica', p. 81.

30 See the contribution by Coates-Stephens in this volume. On the Oratory of the Forty Martyrs see Giulia Bordi, 'Dall'oratorio dei Quaranta Martiri a Santa Maria *de inferno*', in *Santa Maria Antiqua tra Roma e Bisanzio*, ed. by M. Andaloro, G. Bordi, and G. Morganti (Milan: Mondadori-Electa, 2016), pp. 278–87.

31 Agnelli Ravennatis, *Liber Pontificalis Ecclesiae Ravennatis* (Corpus Christianorum Continuatio Mediaevalis, 199), ed. by D.M. Deliyannis, (Turnhout: Brepols, 2006), ch. 95; Tea, *Basilica di Santa Maria Antiqua*, p. 41; Federico Guidobaldi, 'Roma. Storia, urbanistica, architettura (da Costantino a Gregorio VII)', in *Enciclopedia dell'arte medievale*, 12 vols (Rome: Istituto dell'Enciclopedia Italiana, 1991–2002), X, pp. 69–70; Federico Guidobaldi, 'Le residenze imperiali della Roma tardoantica', in *Mélanges d'Antiquité tardive. Studiola in honorem Noël Duval*, ed. by C. Balmelle, P. Chevalier, and G. Ripoll (Turnhout: Brepols, 2004), pp. 37–45 (p. 45); and Coates-Stephens, 'Byzantine Building Patronage', p. 158.

32 Evagrius Scholasticus, *Historia Ecclesiastica—Kirchengeschichte* (Fontes Christiani, 57), ed. by A. Hübner, (Turnhout: Brepols, 2007), II, ch. IV, 3; *PLRE* III, 926–8; Coates-Stephens, 'Byzantine Building Patronage', p. 158.

33 Ernst Kitzinger, 'The Hellenistic Heritage in Byzantine Art', *Dumbarton Oaks Papers*, 17 (1963), 95–115; and Ernst Kitzinger, *Byzantine Art in the Making: Main Lines of Stylistic Development in Mediterranean Art, 3rd–7th Century* (Cambridge, MA: Harvard University Press, 1977), pp. 113–20.

34 See the contribution by Pogliani, Pelosi, and Agresti in this volume.

35 Nordhagen, 'Frescoes of the Seventh Century', pp. 89–141.

36 Wilpert, 'Sancta Maria Antiqua', p. 12: 'Non può stabilirsi ciò che era dipinto nella parte inferiore dell'abside; gli avanzi che si veggono lasciano sorgere solamente un po' di fondo verde con un pezzo di un ornato a foglie in bei colori'; and Joseph Wilpert, *Die römischen Mosaiken und Malereien der kirchlichen Bauten vom IV. bis XIII. Jahrhundert*, 4 vols (Freiburg im Breisgau: Herder 1916) [hereafter *RMM*], II, p. 662. Nordhagen similarly did not notice the presence of the imitation marble *crustae*, and interpreted the garland, with yellow and red flowers and green leaves, as a frame for the decoration of the apse dado belonging to the phase of the Church Fathers (Nordhagen, 'The Earliest Decorations', p. 59; and Nordhagen, 'Frescoes of the Seventh Century', pp. 98–100).

37 Bordi, 'Tra pittura e parete', p. 399.

38 Wilpert considered both sections of fictive marble to be earlier than the level of the Church Fathers; see Wilpert, 'Sancta Maria Antiqua', p. 12; and *RMM*, II, 663. Kitzinger (*Römische Malerei*, pp. 41–2) maintained that the imitation marble on the left side of the apse wall was contemporaneous with the first decoration of the apse, but that its counterpart on the right belonged to the Church Fathers level. Nordhagen upheld the contemporaneity of the two panels, assigning both to the Church Fathers, see 'The Earliest Decorations', pp. 58–9.

39 Arthur H. S. Megaw, 'Mosaici parietali paleobizantini di Cipro', in *Seminario Internazionale di studi su 'La Grecia paleocristiana e bizantina' (Ravenna, 7–14 aprile 1984)*, ed. by Raffaella Farioli Campanati (Ravenna: Edizione del Girasoli, 1984), pp. 173–98 (pp. 184–92 and fig. 6).

40 See most recently Antonella Ballardini, '*Habeas corpus*. Agnese nella basilica di via Nomentana', in '*Di Bisanzio dirai ciò che è passato, ciò che passa e che sarà': Scritti in onore di Alessandra Guiglia*, ed. by S. Pedone and A. Paribeni, 2 vols (Rome: Bardi edizioni, 2018), I, pp. 253–79 (fig. 7).

41 Gregorii I papae, *Registrum epistolarum, Libri VIII-XIV* (Monumenta Germaniae Historica, Epist. II), ed. by L.M. Hartmann, (Berlin: Weidmann, 1899), XIII, 1, pp. 364–5. See most recently Coates-Stephens, 'The Forum Romanum', pp. 394–5; and Alessandro Taddei, '*Smaragdos patrikios*, la Colonna dell'imperatore Foca e la Chiesa di Roma. Committenze artistiche e Realpolitik', in *Il potere dell'arte nel Medioevo: Studi in onore di Mario D'Onofrio*, ed. by M. Gianandrea, F. Gangemi, and C. Costantini (Rome: Campisano, 2014), pp. 531–50 (p. 532).

42 Coates-Stephens, 'The Forum Romanum', pp. 397–401; and Taddei, '*Smaragdos patrikios*', pp. 535–9.

43 Coates-Stephens, 'The Forum Romanum', pp. 401–2.

44 Rushforth, 'The Church of S. Maria Antiqua', pp. 68–73.

45 According to Beat Brenk and Eileen Rubery, Pope Martin I commissioned these images against the Monothelete heresy between 650 and 652, the years in which the exarch Olympios was present in Rome and northern Italy. Asked by Emperor Constans II to have Martin arrested, as he was accused of having ascended to the papal throne without imperial approval, the exarch abandoned his mission, rebelling against the emperor and allying himself with the pope; see Beat Brenk, 'Papal Patronage in a Greek Church in Rome', in *Santa Maria Antiqua al Foro Romano cento anni dopo*, ed. by J. Osborne, J. R. Brandt and G. Morganti (Rome: Campisano, 2004), pp. 67–81 (pp. 78–9); and Eileen Rubery, 'Conflict or Collusion? Martin I and the Exarch Olympius in Rome after the Lateran Synod of 649', *Studia Patristica*, 52 (2012), 339–74.

46 Nordhagen, 'The Earliest Decorations', p. 61; and Nordhagen, 'Frescoes of the Seventh Century', p. 93.

47 Rushforth, 'The Church of Santa Maria Antiqua', p. 74. The only actual tracing is the one published by Vincenzo Federici in de Grüneisen, *Saint-Marie-Antique*, p. 435, no. 107, pl. VIII, I.

48 Wilpert, 'Sancta Maria Antiqua', p. 83.

49 Rubery has suggested that the theme depicted in the apse conch was the *Mission of the Apostles*, a subject known to have been chosen for the apse of the Lateran palace *triclinium* by Pope Leo III (795–816), see Eileen Rubery, 'Papal Opposition to Imperial Heresies. Text as Image in the Church of Sta. Maria Antiqua in the Time of Martin I (649–54/5)', *Studia Patristica*, 50 (2011), 3–29 (p. 12).

50 Rushforth, 'The Church of Santa Maria Antiqua', p. 74: 'ON KNY[--]O ΘEOC E I I [-]N THN CHN EI[?] INHN [-]OC EIM[-------]'.

51 In the absence of two-thirds of the inscription, any reconstruction must remain tentative.

52 Richard Price, *The Acts of the Lateran Synod of 649, with contributions by Phil Booth and Catherine Cubitt* (Liverpool: Liverpool University Press, 2014), 80–1, note 55; see also his contribution in this volume.

53 Ibidem; and *Le Liber Pontificalis* [hereafter *LP*], Life 78. 2–3; ed. L. Duchesne, 2 vols (Paris: E. Thorin, 1886–92), I, p. 343.

54 Pasquale Corsi, *La spedizione italiana di Costante II* (Bologna: Pàtron, 1983), pp. 153–4; and Augenti, *Il Palatino nel medioevo. Archeologia e topografia (secoli VI-XIII)* (Rome: L'Erma di Bretschneider, 1996), p. 48.

55 *LP* 88.1 (ed. Duchesne, I, p. 385). See also Augenti, *Il Palatino nel medioevo*, pp. 56–8; and Andrea Augenti, 'Il potere e la memoria. Il Palatino tra IV e VIII secolo', *Mélanges de l'Ecole française de Rome. Moyen-Age, Temps modernes*, 111.1 (1999), 197–207 (pp. 201–3). The recent excavations of the *Domus Tiberiana* have brought to light some early medieval structures that may have been part of John VII's *episcopium*: see Francesca Carboni, 'Un complesso altomedievale nel cuore della *Domus Tiberiana*', in *Santa Maria Antiqua tra Roma e Bisanzio*, ed. by M. Andaloro, G. Bordi, and G. Morganti (Milan: Mondadori-Electa, 2016), pp. 86–95. For the political implications of the move to the Palatine, see Lucrezia Spera, 'La cristianizzazione del Foro romano e del Palatino prima e dopo Giovanni VII', in *Santa Maria Antiqua tra Roma e Bisanzio*, ed. by M. Andaloro, G. Bordi, and G. Morganti (Milan: Mondadori-Electa, 2016), pp.103–6.

56 Images of the pope can be found: on the apse wall (Plate 35, 50: K 1.2); in the chapel dedicated to the Virgin in the main nave, adjoining the north-west pier (Plate 16, 50: E 3.3); in the images of Madonna and Child enthroned placed at the two main entrances to the complex, namely the passage from the Oratory of the Forty Martyrs into Santa Maria Antiqua, and the entry to the church from the Palatine ramp (Plate 9, 50: C 3.2). Cf. Nordhagen, 'The Frescoes of John VII', pp. 42, 77, 80–1, 84–5. The pope's name appears at both ends of the base of the pulpit, see Antonella Ballardini, 'Piattaforma di ambone in Santa Maria Antiqua', in *Santa Maria Antiqua tra Roma e Bisanzio*, ed. by M. Andaloro, G. Bordi, and G. Morganti (Milan: Mondadori-Electa, 2016), pp. 228–30 (figures on p. 229).

57 Thanks to the recent discovery of the watercolour drawings of abbot Passionei, we can gain a better sense of the upper part of the arch wall; see Oscar Mei's contribution to this volume.

58 Per Olav Folgerø, 'The Lowest, Lost Zone in the Adoration of the Crucified scene in S. Maria Antiqua in Rome: a new conjecture', *Journal of the Warburg and Courtauld Institutes*, 72 (2009), 207–19. See also his contribution in this volume.

59 The various hypotheses are summarized in Giulia Bordi, 'Die Päpste in S. Maria Antiqua. Zwischen Rom und Kostantinopel', in *Die Päpste und Rom zwischen Spätantike und Mittelalter*, ed. by N. Zimmermann, T. Michalsky, S. Weinfurter, and A. Wieczorek (Regensburg: Schnell & Steiner, 2017), pp. 189–211 (pp. 196–8).

60 Ibid., p. 205.

61 Bordi, 'Santa Maria Antiqua attraverso i suoi palinsesti pittorici', p. 49; and Bordi, 'Die Päpste in S. Maria Antiqua', p. 206.

62 Nordhagen, 'The Frescoes of John VII', pp. 40–1; and Bordi, 'Die Päpste in S. Maria Antiqua', p. 204.

63 Wilpert, 'Sancta Maria Antiqua', pp. 81–2.

64 Nordhagen, 'The Frescoes of John VII', pp. 88–90.

65 Ibid., pp. 95–8.

66 Ibid., p. 42.

67 Bordi, 'Die Päpste in S. Maria Antiqua', p. 204.

68 *LP* 82.1 (ed. Duchesne, I, p. 359): 'Vir eloquentissimus, in divinis scripturis sufficienter instructus, greca latinaque lingua eruditus'. English translation from Raymond Davis, *The Book of Pontiffs* (Liber Pontificalis). *The ancient biographies of the first ninety Roman bishops to A.D. 715*, rev. 3rd ed. (Liverpool: Liverpool University Press, 2010), p. 76.

69 Michele Maccarrone, *Romana Ecclesia-Cathedra Petri*, ed. by P. Zerbi, R. Volpini, and A. Galuzzi, Italia sacra 47–8, 2 vols (Rome: Herder, 1991), I, pp. 89–90; and Bordi, 'Die Päpste in S. Maria Antiqua', pp. 201–5.

70 See Oscar Mei in this volume.

71 Alan Thacker, 'Memorializing Gregory the Great: the origin and transmission of a papal cult in the seventh and early eighth centuries', *Early Medieval Europe*, 7 (1998), 59–84 (pp. 65–72); Phil Booth, 'Gregory the Great and the East', in *A Companion to Gregory the Great*, ed. by M. Del Santo and B. Neil (Leiden: Brill, 2013), pp. 122–30; and Phil Booth, *Crisis of Empire: Doctrine and Dissent at the End of Late Antiquity* (Berkeley: University of California Press, 2014), pp. 106–15.

72 Paolo Delogu, 'Il papato tra l'impero bizantino e l'Occidente nel VII e VIII secolo', in *Il Papato e l'Europa*, ed. by G. De Rosa and G. Cracco (Soveria Mannelli: Rubbettino, 2001), pp. 55–79 (p. 65).

73 Nordhagen, 'The Frescoes of John VII'; Per Jonas Nordhagen, 'Constantinople on the Tiber: the Byzantines in Rome and the iconography of their images', in *Early Medieval Rome and the Christian West. Essays in honour of Donald A. Bullough*, ed. by J.M.H. Smith (Leiden: Brill, 2000), 113–34; and Per Jonas Nordhagen, 'Early Medieval Church Decoration in Rome and "the Battle of Images"', in *Ecclesiae Urbis*,

Atti del congresso internazionale di studi sulle chiese di Roma (IV–X secolo) (Roma, 4–10 settembre 2000), ed. by F. Guidobaldi and A. Guiglia Guidobaldi, 3 vols (Vatican City: Pontificio Istituto di Archeologia Cristiana, 2002), III, pp. 1749–69.

74 *LP* 88.4 (ed. Duchesne, I, p. 386): 'humana fragilitate timidus'. English translation from Davis, *The Book of Pontiffs*, pp. 86–7.

75 Bordi, 'Die Päpste in S. Maria Antiqua', pp. 206–8.

76 Rosamond McKitterick, 'The Papacy and Byzantium in the Seventh and Early Eighth-Century Sections of the *Liber Pontificalis*', *Papers of the British School at Rome*, 84 (2016), 241–73 (pp. 255–73).

77 Bordi, 'Die Päpste in S. Maria Antiqua', p. 208.

78 Paolo Delogu, '*Theologia picta*: Giovanni VII e l'Adorazione del Crocifisso in Santa Maria Antiqua', in *Ingenita curiositas: Studi sull'Italia medievale per Giovanni Vitolo*, ed. by B. Figliuolo, R. Di Meglio, and A. Ambrosio (Battipaglia: Laveglia Carlone Editore, 2018), pp. 258–85 (p. 279).

79 *RMM*, IV, pl. 151.

80 Eileen Rubery, 'Christ and the angelic tetramorphs: the meaning of the eighth-century apsidal conch at S. Maria Antiqua in Rome, in *Sailing to Byzantium. Papers from the First and Second Postgraduate Forums in Byzantine Studies*, ed. by S. Neocleous (Newcastle: Cambridge Scholars Publishing, 2009), pp. 183–220 (p. 188).

81 Ibid., pp. 183–220.

82 Gaetano Curzi, 'Reflexes of Iconoclasm and Iconophilia in the Roman Wall Paintings and Mosaics of the 8th and 9th Centuries', *Ikon*, 11 (2018), 9–20 (p. 10).

83 For the apse wall as a hypertext, see Bordi, 'Die Päpste in S. Maria Antiqua', pp. 189–92.

84 Maja Kominko, *The World of Kosmas: Illustrated Byzantine Codices of the Christian Topography* (Cambridge: Cambridge University Press, 2013), pp. 69, 184–9.

85 Herbert Kessler, 'Gazing at the Future: The *Parousia* Miniature in Vatican Cod. gr. 699', in *Spiritual Seeing: Picturing God's Invisibility in Medieval Art* (Philadelphia: University of Pennsylvania Press, 2000), pp. 88–103 (pp. 89–91).

86 Kessler, 'Gazing at the Future', 99–100; Alexei Lidov, 'The Catapetasma of Hagia Sophia and the Phenomenon of Byzantine Installations', *Convivium*, 1.2 (2014), 40–57; and Alexei Lidov, 'The Temple Veil as a Spatial Icon: Revealing an Image-Paradigm of Medieval Iconography and Hierotopy', *Ikon*, 7 (2014), 97–108.

87 On the Santi Cosma e Damiano mosaic see most recently John Osborne, 'The Jerusalem Temple Treasure and the Church of Santi Cosma e Damiano', *Papers of the British School at Rome*, 76 (2008), 173–81; Ivan Foletti, 'Maranatha: spazio, liturgia e immagini nella basilica dei Santi Cosma e Damiano sul Foro Romano', in *Setkávání. Studie o středověkém umění věnované Kláře Benešovské*, ed. by J. Chlíbech and Z. Opačić (Prague: Artefactum, 2015), pp. 68–86; and Erik Thunø, *The Apse Mosaic in Early Medieval Rome: Time, Network and Repetition* (New York: Cambridge University Press, 2015).

88 *LP* 94.11 (ed. Duchesne, I, p. 443).

89 Giulia Bordi, '*In parte virorum* e *in parte mulierum*. Personaggi e scene dell'Antico Testamento in Santa Maria Antiqua a Roma', in *Re-reading Hebrew Scriptures: Old Testament Cycles in Medieval Wall Painting. Proceedings of the International Conference (Milan, 16–18 October 2018)*, ed. by F. Scirea, forthcoming.

90 David H. Miller, 'The Roman Revolution of the Eighth Century. A Study of the Ideological Background of the Papal Separation from Byzantium and Alliance with the Franks', *Mediaeval Studies*, 36 (1974), 79–133 (pp. 120–32); and Delogu, 'Il papato tra l'impero bizantino e l'Occidente', pp. 73–6.

91 James Breckenridge, *The Numismatic Iconography of Justinian II (685–695, 705–711 A.D.)* (New York: The American Numismatic Society, 1959), pp. 63–5, 78, 90; and Hans Belting, *Likeness and Presence: A History of the Image before the Era of Art* (Chicago: University of Chicago Press, 1994), pp. 134–9.

92 We can recover these details from the 1704 Passionei watercolours discovered by Oscar Mei (see his contribution to this volume, fig. 3). The Virgin, shown in the act of presenting Paul I to Christ, has an important model and precedent in the apse mosaic of Santi Cosma e Damiano, in the presentation of saints Peter and Paul by the two saintly *anargyroi*. But in Santa Maria Antiqua, Mary's head is inclined to the left, suggesting that her gaze is directed towards Paul I, and not towards the faithful like those of the Princes of the Apostles. This iconography remains a *hapax* in early medieval painting. The only other image known to me in which Mary stands to the right of her son in a multi-figured theophany occurs in the lost apse of Santa Susanna, the work of Pope Leo III. There, the role of intercessors for the pope and Charlemagne was assigned to saints Susanna and Gabinus; see most recently Thunø, *The Apse Mosaic*, p. 57, fig. 36.

93 Nordhagen, 'The Frescoes of John VII', p. 54. My gratitude goes to Werner Schmid for his assistance in working out the plaster levels in this zone.

94 Umberto M. Fasola, *Le catacombe di S. Gennaro a Capodimonte* (Rome: Editalia, 1975), p. 222, fig. 138. I am grateful to Marianna Cuomo for drawing this comparison to my attention.

95 Paola Colella and Lucinia Speciale, 'Cuscino cruciforme della croce gemmata', in '*Dilettissimo frati Caesario Symmachus*'. *Tra Arles e Roma: le reliquie di san Cesario, tesoro della Gallia paleocristiana*, ed. by C. Sintès, U. Utro, and A. Vella (Vatican City: Musei Vaticani, 2017), pp. 208–9.

96 Maria Andaloro, 'Immagine e immagini nel *Liber Pontificalis* da Adriano I a Pasquale I', in *Il Liber Pontificalis e la storia materiale, Atti del colloquio internazionale (Roma, 21–22 febbraio 2002)*, ed. by H. Geertman [= *Mededelingen van het Nederlands Instituut te Rome*, 60–61 (2001–2)], 45–103 (pp. 63–6).

97 For example, the choir enclosure in Santa Sabina, dated to 824–7; see Margherita Trinci Cecchelli, *Corpus della scultura altomedievale*, VII, *La diocesi di Roma*, t. IV (Spoleto: Centro Italiano di Studi sull'Alto Medioevo, 1976), pp. 207–8, pl. 77. Also, San Giovanni a Porta Latina, first quarter of the ninth century; see Alessandra Melucco Vaccaro, *Corpus della scultura altomedievale*, VII, *La diocesi di Roma*, t. III (Spoleto: Centro Italiano di Studi sull'Alto Medioevo,1974), pp. 94–5, pl. 13; and Santa Maria in Cosmedin, mid-ninth century: ibid., pp. 155–7, pl. 43.

EILEEN RUBERY

Monks, Miracles and Healing. Doctrinal Belief and Miraculous Interventions: Saints Abbacyrus and John at Santa Maria Antiqua and Related Roman Churches between the Sixth and Twelfth Centuries

Introduction

The church of Santa Maria Antiqua is a unique, highly decorated, complete site of Christian worship, established in the second half of the sixth century in what was almost certainly a guardroom to the imperial palaces on the adjacent Palatine Hill.[1] The church is first mentioned in a pilgrim's itinerary from the first half of the seventh century,[2] and the earliest surviving Christian image, depicting *Maria Regina*, is found on the so-called 'palimpsest' wall on the right side of the triumphal arch in the sanctuary (Plates 37–8, 50: K 1.4). There Mary is shown enthroned, wearing a crown-like headdress, and clothes decorated with pearls and cabochon gems.[3] Her Byzantine style probably reflects the varied but largely Eastern backgrounds of Justinian I's conquering army, led by the eunuch general Narses, who occupied the Palatine, including this complex, in the 550s.[4]

As time passed and Rome became more secure, so presumably less in need of a massive military presence on the site, the complex appears to have gradually developed into a church dedicated to Mary. Initially it remained an imperial possession, but eventually, probably during the time of Pope John VII (705–7), whose *Life* was the first to mention both the church and the extensive decorations he undertook, the building passed into the hands of the papacy.[5] John VII was also known for his intense devotion to the cult of Mary.[6]

A striking feature of Santa Maria Antiqua is the presence of at least four, and, as I shall suggest, probably five, images of the otherwise relatively obscure medical saint Abbacyrus, frequently depicted together with his companion John of Edessa, whose cult was first established in Alexandria.[7] These frescoes can be variously dated between the sixth and the eleventh or twelfth centuries.[8] In addition, Sophronius, Patriarch of Jerusalem (634–8), after being cured of an eye problem by Abbacyrus and John of Edessa at their cult site outside Alexandria, wrote a panegyric recording some seventy miracles performed by them.[9]

A further unique feature of this church is the presence of two mid-seventh-century murals on either side of the apsidal arch of the conch in the main sanctuary, usually known as the Lateran Synod panels (Plates 40–1, 50: K 1.3-4). These depict four Church Fathers: Pope Leo I and Gregory of Nazianzus (on the left; Plate 41), and Basil of Caesarea and John Chrysostom (on the right; Plate 40), each holding a scroll on which was inscribed in Greek an extract from their works, as recorded in the Acts of the Lateran Synod of 649.[10]

Sophronius' spiritual disciple, Maximus the Confessor, is known to have been a key figure in the organisation of the events surrounding the Lateran Synod of 649, which debated issues around the nature of Christ and the controversial doctrines of Monotheletism and Monoenergism proposed by the Roman emperors in the middle of the seventh century. The presence of these panels suggests that this complex had important links with the 'Greek' monks who were at the centre of the theological debates in this period.[11] Sophronius' own spiritual father, John Moschus, as well as being present in Alexandria when Sophronius wrote his *Panegyric* on the miracles of Cyrus and John, subsequently travelled to Rome, where he completed *The Spiritual Meadow*, and then died.[12] Sophronius then fulfilled the promise he had made to Moschus that he would take his body back to the East for burial.[13]

Both John Moschus' and Sophronius' texts reflect their authors' concerns around potential heresies, but each reveals different priorities. Sophronius' *Miracles* includes issues around orthodoxy, his stories generally limiting cures to those who believe in the 'correct' cult, as was very much the situation in his reported cases of healing at the shrine of Cyrus and John outside Alexandria. In contrast, Moschus' *Spiritual Meadow* devotes much time to demonstrating the Mother of God's power to defend 'orthodoxy' (i.e. the Chalcedonian Christian faith) from 'heresies' (i.e. the imperially-supported proposals around Monotheletism and Monoenergism). For example, on several occasions Mary is reported to have prevented those holding what she perceived as 'heretical' beliefs from entering 'her' churches, insisting that supplicants rejected their heretical beliefs before they partook of what she considered to be orthodox communion.[14]

From the writings of these and other 'Greek' monks, it is clear that they were much exercised about proposals promulgated by the Roman emperors to modify the Christian doctrine on the nature of Christ. These proposals, initially adopted and supported by Emperor Heraclius (610–41) and his Patriarch, Sergius, were also adopted following Heraclius' death by his son, Emperor Constans II (641–68); and these doctrinal concerns were to have crucial influences on the outcome of the monothelete debate, concerns that came to a head at the Lateran Synod of 649, presided over in Rome by Pope Martin I (649–54/5).[15] These activities, in turn, led to major political consequences, including the eventual death of Pope Martin following his trial in Constantinople and subsequent exile to Cherson (Crimea).[16] If nothing else, this demonstrates

how easily cultic, doctrinal and political concerns could become intertwined with spiritual matters within a circle of small but powerful elites at this time.

Against that background, this paper explores the role played by the church of Santa Maria Antiqua, its images, and the origins and features of the cult site of the two medical saints, Abba (or 'Father') Cyrus and John of Edessa, which developed in this structure. I shall suggest that, over time, the complex became increasingly linked to activities around the use of the healing powers of some of the medical saints whose images were depicted on its walls. I will then consider how the cultic and doctrinal interests of these 'Greek' monks, when they travelled to Rome, probably accompanied by relics of Saints Abbacyrus and John, may have combined to encourage the establishment of the cult of Abbacyrus, not only in Santa Maria Antiqua but also in a number of other Roman churches.

The origins of the cult of Cyrus and John

The *Encomium* to Sophronius' *Panegyric* records the successful outcomes of some seventy cures effected by Abbacyrus and John at their cult site outside Alexandria. These are said by Sophronius to have been reported personally and verbally to him by those who had benefitted from the help of the saints. In the fifth century, evidence of continuing pagan worship in Alexandria had begun to worry both the Roman emperors and Patriarch Cyril of Alexandria (414–44), who reports in three short statements how he became concerned that his Christian flock were visiting the cult site dedicated to the pagan goddess Isis at Menouthis, outside Alexandria. Christians were apparently visiting the site hoping to be healed of their maladies, and indeed it was sometimes reported that this had happened.[17] At that time, Isis was reputed to possess great healing skills and to know of many health-giving drugs. She had a reputation for being well-versed in healing, especially while supplicants slept, a practice commonly called 'incubation'. While Cyril was considering what he should do about these events, he reports that he had a vision in which Christ ordered him to use the relics of the medical saint Abbacyrus, and to establish a competing Christian healing cult site. These relics had been kept in the basilica of Saint Mark at Alexandria following the monk's martyrdom in the time of the Emperor Diocletian.

According to one version of the legend, the Sabaite monk Cyrus had originally run a 'surgery' (*ergasterion*, literally a 'workshop' but presumably in this context, a site for treating the sick) in Alexandria, which was dedicated to the Three Young Men in the Fiery Furnace, Shadrach, Meshach, and Abednego, whose story is recounted in the Book of Daniel (3).[18] Cyrus is reported to have ministered to the sick, charging no fee, so he was an *anargyros* (literally, 'someone without silver', in other words, someone who did not take payment for his work of healing). He is also reported to have successfully converted many supplicants from pagan superstition.

John was a senior official in the army at Edessa, who had heard of Cyrus' piety and actions, and had left the army to join him in Alexandria. There they worked together, healing and helping the sick and needy. According to their legend, the two men were martyred at Canopus, near Alexandria, on 31 January in the time of the Emperor Diocletian (284–305), together with three virgins, Theopista, Theodora, and Theodoxia, as well as their mother Athanasia.[19] A touching image of their martyrdom is found in the tenth/eleventh-century Menologion of Basil II.[20]

But when Patriarch Cyril went to fulfil Christ's orders and collect Cyrus' relics, he found Cyrus' bones were mixed in the same coffin with those of his companion. Ever resourceful, he took all the relics and established a shrine dedicated to both men at Menouthis, previously the site of the cult of Isis *medica*. The location is then mentioned briefly in a fifth-century biography of Severus,[21] after which there is silence until the 'Greek' monk Sophronius visited Alexandria in the seventh century.

The area around the new shrine is, even today, known as Aboukir—a corruption of the name of Abbacyrus—and over time it must have developed into a significant local healing site. The record of Cyril's actions in establishing the shrine depends primarily on Sophronius' later account, but the survival of the name 'Aboukir', coupled with the earlier actions of Cyril's uncle Theophilus, his predecessor as Patriarch of Alexandria, who, following the guidance contained in edicts from the Emperor Theodosius I, had destroyed the Alexandrian Serapion in 391, suggests that we can be fairly confident about this recorded sequence of events. The presence of images of the two saints in Santa Maria Antiqua and records of their veneration in additional churches in Rome suggest that, in time, the cult developed a significant following there.[22]

The actions of the Greek monks and the two medical saints

In the early seventh century, Sophronius and John Moschus were staying in Alexandria, where Sophronius began to suffer from a serious eye complaint. When the Alexandrian physicians failed to cure him, he was advised by the locals to visit the cult site of Saints Abbacyrus and John; and, after following their advice, he was cured. In gratitude, Sophronius recorded the seventy miracles that had been effected at the site and had been reported to him personally.

Some years later, in June 633, a Pact of Union defining the nature of Christ, aimed at securing agreement from both monophysites and dyophysites, was promulgated by Cyrus, Patriarch of Alexandria, and local anti-Chalcedonians.[23] This compromise doctrine, part of a series of variations on the concept of the nature of Christ, was called Monoenergism. It retained Christ's two natures but, controversially for those following established orthodoxy, limited his energies to one.[24]

Sophronius' spiritual disciple, Maximus the Confessor, vividly describes Sophronius' opposition to this Pact in the twelfth of his *Opuscula theologica et polemica*, calling it, 'an impious doctrine',[25] and Sophronius also raised his concerns with Sergius, Patriarch of Constantinople.[26] When Sergius was appointed Patriarch of Jerusalem in 634, he even included some 'tactful' criticism of the Pact in his Synodical Letter; this does not seem, however, to have either adversely affected his candidacy for appointment as patriarch, or attracted much subsequent attention.[27] But Maximus took these doctrinal issues very seriously, and soon became a key figure in the subsequent vigorous campaign mounted by the 'Greek' monks, focusing untiringly on getting this novel doctrine declared heretical.[28]

By 645/6 Maximus, having successfully persuaded the exarch in Carthage, set out for Rome, where he persuaded Pope Theodore I (642–9) to convene a synod at the Lateran Basilica to discuss the monothelete proposals in more detail.[29] Unfortunately, since Pope Theodore died shortly before the Council could meet, it fell to his successor, Pope Martin I, to preside over

this event. In addition, it may not have helped matters that Martin did not have time to seek approval for his appointment from the emperor, as custom required. The Synod duly declared Monotheletism and all its variants heretical.[30] Maximus and his supporters composed—exceptionally, in Greek[31]—the first draft of the Acts of the Synod, emphatically concluding that Monotheletism (and its earlier version, Monoenergism, as well as any other variants they had come across) were heretical. Pope Martin then took immediate and active steps to distribute copies of the outcome widely across the empire.[32]

The precise role that Santa Maria Antiqua played in these events is not clear, but it was probably a significant one.[33] A few years later, in 655, at Maximus' trial in Constantinople, when asked by 'the Lord Troilus' if he had anathematised the *Typos* (one of the documents issued by the emperor outlining his doctrinal position), Maximus admits that he has frequently done that. Asked where he anathematised it he replies: 'In the Church of the Saviour and in that of the Mother of God.'[34] Allen and Neil make the reasonable assumption that the 'Church of the Saviour' is the Lateran Basilica (given this is the name by which the Synod is referred to in contemporary literature). The two most likely candidates for the 'Church of the Mother of God' are Santa Maria Maggiore and Santa Maria Antiqua. Allen and Neil assume the reference is to Santa Maria Maggiore, but give no reason for this choice.[35] Given the presence in Santa Maria Antiqua of the two fresco panels in the sanctuary (Plates 40–1), each inscribed with extracts in Greek from the Acts of the Lateran Synod, I shall suggest that this church is instead the more likely candidate. Of the two other potential options dedicated to Mary, the Pantheon had only been consecrated as a church at the beginning of the seventh century, and Santa Maria in Trastevere, although long-established, is situated at the periphery of Rome. Neither is known to have been used for the discussion of doctrinal issues at this time, and so both are unlikely to be the site mentioned by Maximus. Santa Maria Maggiore cannot be discarded as a possibility, but lacks any positive evidence of links with the monothelete dispute.

The transfer of the cult of Cyrus and John from Alexandria to Rome

Following Sophronius' miraculous cure, John Moschus set out from Alexandria to journey to Rome, where he completed *The Spiritual Meadow* before dying, probably in 634.[36] On hearing of his death, Sophronius travelled to Rome himself, to fulfil a promise he had made to take John's body back to the East if he should die elsewhere. Sophronius' demonstrable enthusiasm for the cult of Abbacyrus and John, a cult that he had done so much to promote via his *Panegyric*, together with his broad perspective and the frequent mention in his 'miracles' of the wider geographical area from which pilgrims journeyed to Alexandria to seek help from the saints, must surely make him a prime candidate for the importation of the cult to Rome, where it became established in the seventh and eighth centuries. Furthermore, as someone who had personally benefitted from the saint's miraculous healing and had reported many other of their miracles in detail, we can be reasonably certain that when Sophronius left Alexandria to travel to Rome, he would have been allowed to take with him some relics and/or lesser materials, such as *brandea*, oil from lamps, candles from wax placed near the saints' tomb, or dust from the site. All these varieties of contact relic were considered capable of nucleating new centres or stimulating episodes of healing—providing, of course, that the saints themselves

were favourably disposed. Sophronius would anticipate that further successful miracles would and could then be used to validate new cult sites in Rome, generating in turn additional healing miracles and enhancing the reputation of Abbacyrus and John.

The establishment of the cult of Saints Abbacyrus and John in Rome

There are at least five sites in or near Rome where evidence exists for an active cult of Cyrus and John in the early Middle Ages. In addition to Santa Maria Antiqua, these are: an oratory at the *domusculta* of Saint Cecilia outside Rome on the Via Tiburtina,[37] the *diaconia* of Sant'Angelo in Pescheria,[38] the Oratory of Saint Abbacyrus in the 'xenodochium qui appellatur a Valeris',[39] and the church of Santa Passera on the Via Portuense.[40] Ascertaining the date at which each site was established is not easy. There are frequent distortions of Abbacyrus' name and it is also difficult, in general, to identify the date of establishment of a cult, since the date of first mention in the *Liber pontificalis* usually relates to a papal donation, rather than to the initial foundation.[41] No other source specifically mentions either of our two monks in this connection.

As the cult gained currency in Rome, active sites dedicated to the saints' veneration gradually became more or less evenly distributed across the city, a development which would have eventually permitted convenient access wherever one lived. This development happened seemingly in three stages: the first in the seventh century (Santa Maria Antiqua), the second by the eighth century (*domusculta* of Saint Cecilia, Sant'Angelo in Pescheria), and the last by the beginning of the ninth century (*xenodochium a Valeris*, Santa Passera).

Santa Maria Antiqua remains the earliest recorded site for the veneration of Cyrus and John in Rome, and also contains the greatest concentration of surviving frescoes that can be linked to that cult. Specific mention of relics occurs at the *domusculta* of Saint Cecilia and at Sant'Angelo in Pescheria. Significant frescoes survive only at Santa Passera and Santa Maria Antiqua. I shall deal with the probable date of the frescoes of the saints in Santa Maria Antiqua below.

The development of the cult of Abbacyrus, John, and related saints in Santa Maria Antiqua, and its transfer to other sites in Rome

A study of the murals in Santa Maria Antiqua demonstrates that by the end of the eighth century the cult of Abbacyrus and John was well established there, and was on track to become established in Rome more broadly. A pilgrim wishing to visit Santa Maria Antiqua and coming from the Roman Forum, would cross the atrium (Plate 50: A), enter the left aisle (Plate 50: C), and proceed to the east vestibule (Plate 50: D). On the left wall of the atrium two frescoes depicting Abbacyrus are prominently displayed (Plates 4, 50: A4): the first, low down on the wall and in a shallow niche, depicts the saint alone (Plate 5),[42] while the second, higher up on the wall and clearly from a later date, depicts Abbacyrus and John flanking an image of Christ (Figure 1).[43]

The niche fresco depicts the saint holding a surgical probe that he has clearly just removed from a medical box resting on the ledge in front of him. On the right inner border of the niche we can read his name in Greek, inscribed vertically in white letters against a blue background. A date in the mid-eighth century, first proposed by Joseph Wilpert, has been generally accepted, and is consistent with palaeographic similarities to other painted inscriptions associated with

Santa Maria Antiqua, atrium, east wall. Above: Christ flanked by Cyrus and John; in the niche below: Saint Abbacyrus with his medical box (photo: Gaetano Alfano 2009)

the redecoration of the church under Pope Paul I (757–67)—in other words, probably at least a century after Abbacyrus' cult arrived in Rome, if it was indeed brought there by Sophronius.[44]

The mural is a fine example of a 'typical' depiction of a Greek saint in a fresco, and its date is consistent with the gradual growth of interest in Cyrus and John within the complex. One can suppose that it formed part of a simple set of 'pictorial signs' devised to attract and direct visitors. Cyrus' face has the characteristic ascetic 'Greek monk' aura, emphasised by his long, narrow features and long narrow, slightly curled beard, flowing down onto his chest. The horizontal shelf on which the medical box appears to rest has an indentation that perhaps originally accommodated a small relic.

The second mural, at a higher level on the wall, is reminiscent of the iconography of a *Deësis* (intercession), in which Christ is flanked by Mary and John the Baptist (Figure 2). A poorly preserved dedicatory inscription at the base identifies the two saints. The position of this rectangular fresco probably reflects the fact that, over time, the floor of the Forum had risen. This would fit with the tenth-century dating that has been proposed, based on comparisons with other murals in Rome and its environs.[45] Both figures of Abbacyrus are adjacent to one of the original entrances to the church, a fact that supports their interpretation as signposts, inviting pilgrims in and directing them across the atrium, where they would enter the church through its left door and proceed up the left aisle to the more consecrated areas. As they approached the sanctuary, pilgrims would be expecting access to the saints to offer their prayers and requests, perhaps even engaging in 'incubation' overnight if they wished.

Having reached the relatively small east vestibule (Plate 50: D), the visitor would be confronted by a series of murals: on the exterior wall to the left, a series of scenes from the story of the Forty Martyrs of Sebaste (Plates 10, 50: D1); on the end wall to the right of the entrance to the Chapel of Theodotus, an image of Shadrach, Meshach, and Abednego, i.e. the three young men in the Fiery Furnace from Daniel 3 (Plates 11–12, 50: D2),[46] an iconography present in Abbacyrus' *ergasterion* in Alexandria; and lastly, on the south face of the pillar separating the aisle from the central nave, a *Deësis* with Christ flanked by the two primary intercessors for humankind, Mary and John the Baptist (Plate 13).[47] This last mural also includes a rather poorly preserved, un-nimbed and unnamed onlooker, standing on the left side of the scene, beyond Mary (Plates 13, 50: D3).

The *Deësis* recalls one of the stories in Sophronius' *Panegyric*. In the thirty-sixth miracle, Sophronius recounts the story of the encounter between Christ, Mary, the Baptist and a supplicant, the sub-deacon Theodorus, who was undertaking incubation at the Menouthis shrine, hoping to recover from gout.[48] Initially, Theodorus resists the advice of the guardians of the site to take communion blessed by the saints before praying for a cure. But after a number of unsuccessful visits, he finally agrees to take communion and then, while praying in front of them, he finally has a vision of 'a perfect temple of awesome and striking appearance, so high that it touched the heavens themselves'.[49] Entering this temple he saw 'a very large and wonderful icon' of Mary and John the Baptist, both interceding with Christ.' Abbacyrus and John, who were also part of the vision, instruct Theodorus to take oil from the lamps in the Tetrapylon at Alexandria and rub it on his feet, and then to return to the cult site where his gout would be cured. Theodorus was indeed healed, and the report describes the unpleasant snakes that crawled out of his feet as he applied the miraculous oil.

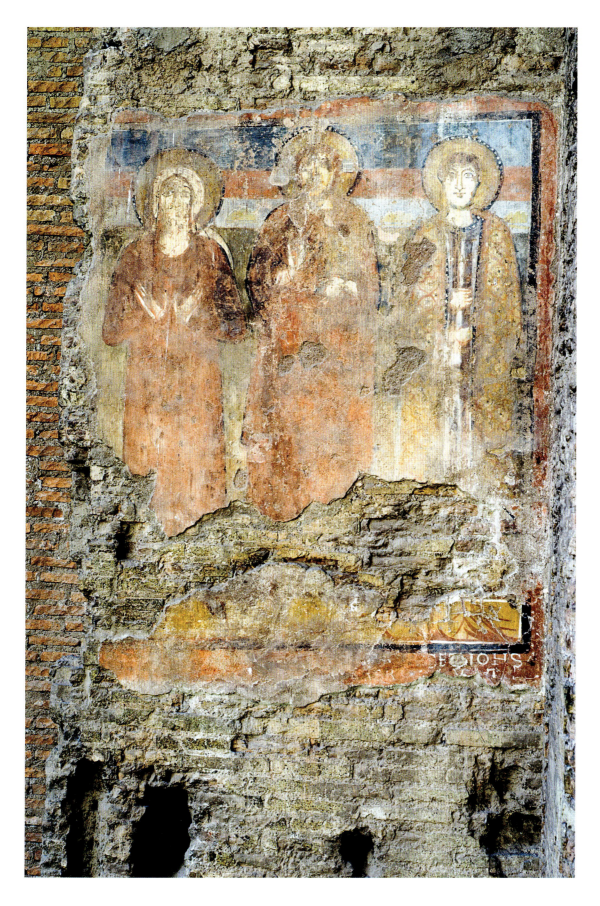

Santa Maria Antiqua, atrium, east wall: Christ flanked by Cyrus and John
(photo: Gaetano Alfano 2009)

3 Santa Maria Antiqua, Chapel of the Medical Saints, south wall niche. Watercoloured photograph by Wilpert and Tabanelli (Wilpert, *RMM*, pl. 145,4)

Abbacyrus and John's initial refusal to engage with Theodorus adds an interesting angle to the story. In John Moschus' *Spiritual Meadow*, supplicants are often repelled from entering a church of the wrong denomination by a vision of the Virgin Mary. Clearly Theodorus was from a non-Chalcedonian Christian sect and his allegiance caused problems until he agreed to accept the saints' Chalcedonian communion; only then could he be cured. The story confirms that cult sites at this time were often linked to specific doctrines.

The *Deësis* in Santa Maria Antiqua is usually dated to the middle of the seventh century (Plate 13), making it roughly contemporaneous with the arrival of the cult of Abbacyrus and John in Rome. It can be hypothesised that the idea was to recreate in Rome the Alexandrian surgery where Cyrus and John healed the sick, so that local petitioners could imagine themselves actually attending the original space where the saints had performed their most powerful miracles. The hope would have been that in so doing they would attract the spirits of the two saints, in a positive mood and motivated to ease the pilgrims' ailments. In this connection it may not be chance that this space, uniquely, can also be accessed directly from the Palatine Ramp leading to the imperial quarters via a short staircase. These 'private' steps would have permitted elite members of the administration working in the palace on the Palatine to have direct, and perhaps more private, access to this small cult room, without having to pass through the rest of the church. This would have been a powerful space for petitioners to pause, address the saints, and ask for their assistance, before progressing to the right side of the church

where, as we shall see, they could directly address images of the saints while also taking part in incubation-related activities.

The medical saints in the 'Chapel of the Holy Physicians'

Murals elsewhere in Santa Maria Antiqua suggest that an even more extensive and intimate relationship existed between the cult of Cyrus and John, the church, pilgrims, and the residents of Rome. If our supplicant left the eastern vestibule and crossed in front of the sanctuary to enter the western vestibule (Plate 50: G) through a rather narrow gap limited on the right by a low wall, they would have found themselves at the top of the right aisle, decorated with the same mosaic floors as the sanctuary. Once inside this space, the supplicant could turn left and enter the room to the right of the sanctuary (Plate 21), commonly known as the Chapel of Holy Physicians or Medical Saints (Plate 50: L). All four walls of this space were originally decorated with images of saints (Plates 47–9),[50] although nothing now remains of the figures on the left wall.

The end (southern) wall has a large painted niche, strongly suggesting that it would have formed the focal point of any religious activity carried out in this room. The fresco depicts five standing nimbed saints, each named beside their halo in a Greek inscription written in white letters (Plate 48; Figure 3). Unfortunately, the central and lower areas of the three figures on the right are now severely damaged by a large cavity in the wall. The saints are, from left to right: Cosmas, Abbacyrus, Stephen, Procopius, and Damian. Stephen, the protomartyr, is not generally regarded as a healing saint, nor is Procopius, a military saint. The latter's presence may perhaps be explained by Santa Maria Antiqua's proximity to the base of the imperial administration in Rome, and hence also of its imperial troops, which means that many of those frequenting the church up to the time it was handed over to the papacy are likely to have been soldiers.

The figure at the far left is Saint Cosmas, depicted wearing a brown tunic covered by a red *chlamys* pinned at his right shoulder (Plate 48; Figure 3). His usual companion, Saint Damian, appears at the far right, although only his head survives. The figure beside Cosmas is Abbacyrus, and his name can be clearly read above his head. He is dressed in a purple tunic, with a brown overgarment extending as low as his knees. Unfortunately, his face is badly damaged. His companion, Saint John of Edessa, is not included in the group.

On initial inspection it seems odd that the medical saints Cosmas and Damian, who have their own church nearby across the Forum, are placed at either end of the row. But careful inspection of the figure of Saint Stephen, standing in the middle, reveals that he is swinging a censer, which has just reached the end of its upward trajectory and is situated in front of Abbacyrus (Plate 48; Figure 3). I suggest that this fresco was intended as a two-dimensional rendering of a three-dimensional relationship: Stephen, a deacon, is leading a small procession, in which Abbacyrus and Procopius form a pair following him, and Cosmas and Damian bring up the rear, also walking together as a pair. As this procession walks forward, it can be thought of as leaving the niche and entering the physical space of the chamber, where petitioners may have been lying on the floor, praying and (hopefully) enjoying dreams initiated by the saints. In other words the pilgrims would have been undergoing the healing process known as 'incubation',[51]

and each would be hoping to receive a personal visit. By depicting a procession that is moving away from the wall and into the room, the niche images can be considered as promising a more intimate link between petitioners and saints than would normally be the case if the pilgrims faced a row of saints standing on the wall, and this might support and strengthen their hopes of an effective outcome. Pilgrims undertaking incubation in this space would probably lie on the floor in front of the niche, possibly reaching up to touch the feet of the saints as they prayed in front of their image. It should be noted that the lower border of the fresco is painted with fictive curtains (*vela*), but this strip is uncharacteristically narrow and reaches down right to the ground (Plate 48).

This interpretation allows us to understand more clearly why the figures are arranged in this particular fashion: Cosmas and Damian form a pair, walking together and bringing up the rear of the small procession; Abbacyrus (another 'medical' saint) is paired with Procopius (a military saint), reflecting the nature of those who visited the Forum; the central figure is Saint Stephen, whose cult was prominent in Rome. He leads the procession into the 'Chapel', so that the saints ideally end up among the pilgrims, prostrate on the ground in front of the images. Since Cosmas and Damian had their own church nearby, they may have been included in Santa Maria Antiqua to 'welcome' through their established fame the new medical saint Abbacyrus and the military saint Procopius into their shared cultic zone.

The remaining three walls of this 'Chapel of the Medical Saints' are decorated with numerous images of standing saints, although, unfortunately, many of these frescoes have suffered damage, and their identifying inscriptions are difficult to read (Plates 47–9). Both Abbacyrus and John appear at the left end of the wall opposite the niche fresco, in a group of seven saints located over the doorway leading to the western vestibule (Plate 49). There the pair are separated by Saint Celsus, who in the medieval tradition was usually paired with Saint Nazarius, since both their bodies were discovered by Saint Ambrose near the walls of Milan.[52] According to their legend, the Emperor Nero had ordered that the two saints be drowned by being thrown out of a ship at sea, but they miraculously survived. Celsus was possibly included in the fresco to respond to the concerns of pilgrims and other visitors about sea voyages and drowning, thus widening the appeal of the site. But since it is not clear when or where many of the elements of the legend of Nazarius and Celsus developed, the image must be interpreted with caution. Finally, Cosmas and Damian are also present, named and depicted together at the left end of the row. The figure of Abbacyrus is almost entirely lost, but fortunately the first three letters of his name survive by the edge of his halo, which permit us at least to identify the figure, although not what he was wearing. John of Edessa, at the far end of the fresco, is dressed in a richly decorated, bright red semi-circular cloak embellished with swirls of white patterning. Such a garment is consistent with the appearance of someone from an elite background (Figure 4).

No figures survive on the left wall leading into the sanctuary, but a single fragment of Greek text clearly refers to a female, so possibly this space originally contained images of the four women who were martyred with Cyrus and John.[53] Their names—Theopista, Theodora, and Theodoxia, along with their mother, Athanasia—are recorded in various manuscripts, including the later Menologion of Basil II, but more significantly, their names are also included in the stone panel still preserved in Sant'Angelo in Pescheria that records a gift of relics in the

Santa Maria Antiqua, Chapel of the Medical Saints, west wall: Saint John of Edessa
(photo: Gaetano Alfano 2009)

5 Santa Maria Antiqua, west vestibule, south side of south-west pillar: Three saints (photo: Roberto Sigismondi)

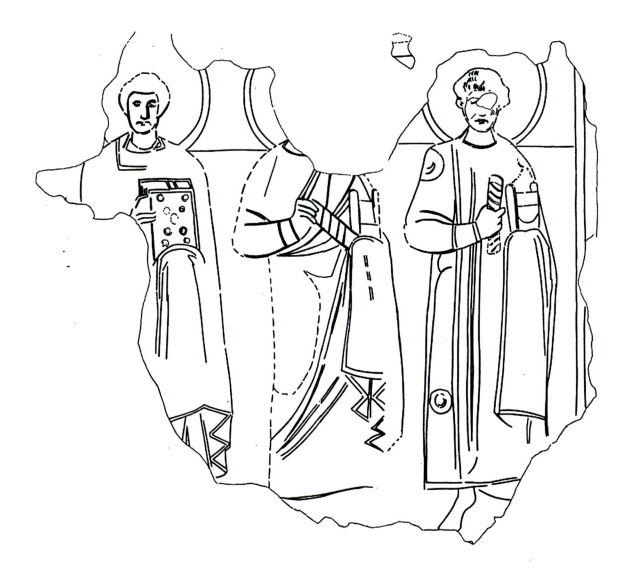

6 Santa Maria Antiqua. Three saints in the west vestibule. Tracing by Per Jonas Nordhagen ('The Frescoes of John VII', fig. 10)

year 755, and that also includes the names of Abbacyrus and John.[54] The final wall (Plate 47), facing the exit from this space into the sanctuary, contains a further row of saints, some named and others now lacking inscriptions.

The western vestibule and the mural with three standing saints

The western vestibule (Plate 50: G) and its mural of three standing saints (Plate 22; Figure 5) has received relatively little attention in earlier treatments of Santa Maria Antiqua, perhaps because none of the figures are identified by inscriptions. However, several features suggest that this space was an important cornerstone for the network of images linked to the cult of Abbacyrus and John. Attention has already been drawn to the unusually narrow entrance into the vestibule from the high choir or *bema* (Plate 50: H), which is consistent with a possibly elite or specialised use. It is worth recalling again that this vestibule is the only part of the two aisles into which the mosaic floor extended. Furthermore, the fresco on the outer surface of the wall, separating the vestibule from the *bema*, has a similar border pattern to that along the edge of the entrance into the vestibule, and this pattern is also found along the borders of both the panel with the *Sickness of Hezekiah* in the nave and the niche in the end wall of the 'Chapel of the Medical Saints' (Plates 25, 48). This suggests that all of these images were part of the same campaign, with a common origin and perhaps a linked meaning. These murals are assigned, on the basis of style and palaeography, to the pontificate of John VII, the pope who could have been the first to take over responsibility for the Santa Maria Antiqua complex from the imperial administration.

The western vestibule clearly performed an important function, since its floor is covered by the continuation of the mosaic of the *bema*, so probably the frescoes painted on its walls were also significant. In the late 1950s, Per Jonas Nordhagen was able to trace medical boxes held by the two figures closest to the nave of the church, painted on the wall facing the main altar (Figure 6). Nordhagen describes the figure on the right as beardless and dressed in the clothes of a soldier or court official, holding a white scroll in one hand and the surgical box in the other.[55] These aspects are consistent with, but not necessarily indicative of, an image of John of Edessa. The middle figure lacks a head but wears an undergarment and over-tunic that are similar to those worn by Abbacyrus in the niche fresco in the Chapel of the Medical Saints (Plate 48).

Entrance into the space is limited by the low *transenna* frescoed with part of the story of Hezekiah, which reduces the entrance from the *bema* to a gap less than half-metre wide (Plate 25). One possible reason for creating such a narrow passage could be that, with the left side of the church dedicated mostly to male saints—and therefore perhaps attended mainly by male pilgrims, the right side, mostly decorated with female figures, allowed female pilgrims to congregate in a space somewhat sheltered from men.

In the western vestibule (Plate 50: G) only a single mural survives. It depicts three standing saints (Plate 22), all nimbed and facing the main altar of the church. The two outer ones are dressed in red/orange garments, while the central one wears shades of blue and a purple undergarment with a lighter-coloured overgarment of a purplish-brown hue. There is also enough space beyond the damaged edge of the fresco at the left end for at least one—possibly even two—additional figures. Nordhagen's tracings suggested the two figures on the right (wearing blue and red respectively) both held medical boxes (Figure 6),[56] and the recent campaign of

restoration has confirmed this. The form of the medical boxes is not easy to make out, but careful inspection suggests that they resemble closely those held by Cosmas and Damian in images of their martyrdom from the Menologion of Basil II (BAV, MS Vat. gr. 1613, fol. 152): oblong containers with a looped handle attached at the two top corners. The third figure on the left had no medical box, but instead held a large codex embellished with gemstones.

Although the two figures with medical boxes are not named (Figure 5), one is dressed in a red cloak similar to that worn by John of Edessa in the Chapel of the Medical Saints (Plate 49; Figure 4), and the other is dressed in shades of purple tinged with brown or blue highlights, also similar to a figure depicted and named and in the adjacent chapel (Plate 48). Thus it is at least possible that they were originally intended to represent Abbacyrus and John. They are the two medical saints most frequently depicted at the site. In contrast, there are only two images of Cosmas and Damian. The identification would be further supported by the fact that Cyrus and John are that the only two named saints to hold medical boxes in Santa Maria Antiqua.

Finally, it is worth exploring what the images can tell us about Santa Maria Antiqua as a whole. It has been observed that there is indeed a route that would have allowed pilgrims to seamlessly walk around the church, stopping at the different holy spaces. After entering from the Forum and crossing the atrium with the niche image of Abbacyrus, pilgrims could next enter the left aisle, from which they would then proceed to the eastern vestibule (possibly decorated to recall the *ergasterion* in Alexandria). Having prayed there, they could move to the western vestibule, from whence they were able to access the Chapel of the Medical Saints. Here they would find the most accessible images of Cyrus and John and 'incubate' as the saints walked towards them in an illusionistic procession. The chapel is particularly suitable to an overnight 'incubation', but as the space is quite limited, the vestibule may have been conveniently turned into an emergency 'overflow room'. As for the dating of the three standing figures (Figure 5), Nordhagen includes them among Santa Maria Antiqua's seventh-century images—if his proposal is accepted, the figures could have been made at the time of the Lateran Synod of 649, or shortly afterwards.

The story of Hezekiah

One further image may have been linked to this cultic activity in Santa Maria Antiqua: the episode from the life of King Hezekiah (2 Kings 20; Isaiah 38), depicted on the inner side of the *transenna* (Plate 25). There were originally at least three scenes on this wall, but only two survive, a *David and Goliath* and the *Sickness of Hezekiah* (Figure 7), both identifiable from painted inscriptions. Hezekiah, having fallen ill, was informed by the Prophet Isaiah that God had told him to warn the king that he needed to prepare for death. But Hezekiah refused to accept this fate, drawing God's attention to the many good things he, as king, had done at God's request in the past. Hezekiah argued his case so well that he persuaded God to relent, and he then instructed Isaiah to tell Hezekiah that he had changed his mind and had decided to extend the king's life by fifteen years. Hezekiah lived, and he was even able to father new children.

It is not clear what a pilgrim would make of this story,[57] and a closer reading of the biblical text seems initially to focus on an argument between Hezekiah and Isaiah. But an alternative reading could be that pilgrims were invited to have faith that God was open to persuasion,

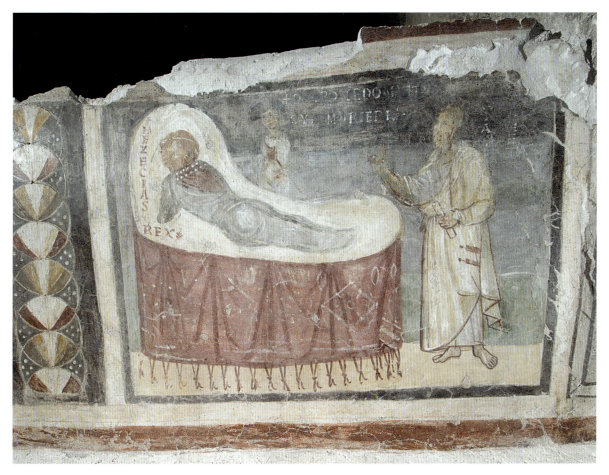

7 Santa Maria Antiqua, high choir, west side: *Sickness of Hezekiah* painted on the transenna (photo: Gaetano Alfano 2009)

an encouraging and hopeful message that would advertise the effectiveness of the site, since unheard prayers and refused healings did tend to feature quite frequently in stories about miraculous cures. The fifteen-year respite from death granted to Hezekiah would surely have sent a strong message of solace and hope, and may explain the unusual choice of an Old Testament episode to illustrate and support cultic activity. Alternatively, the presence of a king as a prime mover in the story might have been attractive in a church that was probably still under imperial control when the frescoes were painted. However the story is interpreted, the *Sickness of Hezekiah* was certainly worth illustrating, since it implied that 'incubation' and prayer might not just ameliorate sickness and pain, but could also avert near-certain death.

The characteristic border pattern of intersecting circles around the edge of the fresco (Figure 7) and also along the niche facing the nave is usually dated to the time of Pope John VII, and this has recently been confirmed by technical analysis of the pigments.[58] It is in John VII's *Life* from the *Liber pontificalis* that we find the first mention of Santa Maria Antiqua, and thus his campaign of decorations was undertaken about fifty years after the arrival of the Greek monks in Rome for the Lateran Synod of 649, and around seventy years after the putative arrival of the relics of the Saints Abbacyrus and John (634) with Sophronius. This would have left plenty of time for the development of a successful cult site, ripe for further development by Pope John VII after he obtained control of the church.[59]

The 'female' focus at Santa Maria Antiqua

One striking aspect of the murals discussed above is the strong focus on male as opposed to female images, which might indirectly suggest that most of the images in the church are of male saints. On the contrary, female imagery concerning the needs of women at a cult site devoted to healing is indeed present and raises interesting issues. If a pilgrim, having gone through the area near the sanctuary devoted to Cyrus and John, was to return towards the atrium along the right aisle (Plate 50: F), they would enter a more 'feminine' area. In a niche carved into the wall there are the three Holy Mothers: Mary, glowing as she holds the Child, Anne with the Infant Mary, and Elizabeth with the Infant John the Baptist (Plate 20). This unusual iconography beautifully highlighted the importance of the female lineage for the birth of the Saviour. Congregations in early medieval churches were of course separated by gender, and in Rome the right aisle was the women's side (*pars mulierum*), which may help explain the iconographies chosen for this area.[60]

A second niche, set into one of the masonry piers of the nave, in a space that seems to have been transformed into a small oratory, is entirely occupied by the bust images of Mary and Christ (Plates 16, 50: E3.3). This fresco is strategically placed so that a woman lying down and facing the altar, in labour, could reach over, touch the fresco, and pray to the Christ Child. It seems an ideal site for a Christian mother to give birth, overlooked by the Mother of God and cared for by the church. These features not only demonstrate an interest in depicting and supporting women, but also point to a design of the church oriented to fulfil specific functions, namely to create a male route on the left and a female route on the right. Both areas are associated with significant cultic activity and both also support the conclusion that interior church space was 'gendered'.

Observations on the function of Santa Maria Antiqua

Perhaps the most striking aspect with regards to Santa Maria Antiqua's spatial arrangement is the marked lack of focus on the usual functions of a building of this type, namely the organisation and performance of liturgy and, probably less frequently, the celebration of the Eucharist. Instead, what survives today is a complex that focuses heavily (but not solely) on the cult of Abbacyrus and John. Its imagery has also a notably strong focus on the Old Testament, through the story of Hezekiah (Figure 7) or from the fresco with Salomone, depicted with her sons, the Maccabees (Plate 14). We also know that, by the early eighth century, Santa Maria Antiqua was not only a busy and versatile cult site, but had become a *diaconia* (welfare station), a church specifically provisioned to support pilgrims and the poor. This happened under the supervision of the *primicerius defensorum* Theodotus, depicted in the chapel to the left of the sanctuary, formally dedicated to Saints Quiricus and Julitta, but usually named after him (Plates 27–31; 50: J).

It difficult to see how a normal church service could have been organised in the structure we see today, given that so much of its space is divided into sub-units that constrain the movement of people. For example, the routes down the aisles are divided into a number of smaller spaces and, as discussed above, there appears to be also a gendered differentiation of the spaces. The

introduction of the cult of Cyrus and John may have furthered this development, either around the time of Sophronius' visit to Rome in 634, or the Lateran Synod in 649. Later, the popularity of the cult of Cyrus and John, and continued links with 'Greek' monks who venerated them, may have prompted a further breaking down of the interior into different spatial units. As the notion of a *diaconia* developed, it would have been quite natural for the site to become one of the earliest to take on such responsibilities: the complex was well placed geographically to develop into a major site for spiritual and material aid.

Appendix: Description of the vision seen by sub-deacon Theodorus before he was cured of his gout by the saints (Sophronius, 'Panegyric', Miracle 36)

In the centre the Lord Christ was represented in colours. To the left of Christ, there was Our Lady Mary, Mother of God, perpetual Virgin, and to his right John, the Baptist and precursor of the Saviour himself, who in the womb had announced Him by his quickening (in effect the same as if he had spoken, since, as he was enclosed in the womb, no one would have been able to hear him).[61] Also present were some of the glorious choir of apostles, some prophets, and a group of martyrs. Among them were found the martyrs Cyrus and John themselves. These latter stand before the image, prostrating themselves at the feet of the Lord, knees bent and head resting on the ground, interceding so that the young man should be cured.

NOTES TO THE TEXT

1. Gordon Rushforth, 'The Church of S. Maria Antiqua', *Papers of the British School at Rome*, 1 (1902), 1–123; Wladimir de Grüneisen, *Sainte-Marie-Antique* (Rome: M. Bretschneider, 1911); 'S. Maria Antiqua', in Richard Krautheimer and others, *Corpus Basilicarum Christianarum Romae*, 5 vols (Vatican City: Pontificio Istituto di Archeologia Cristiana, 1937–77) [hereafter *CBCR*], II, pp. 249–68; and Eileen Rubery, 'The Papacy and Maria Regina Imagery in Roman Churches between the Sixth and Twelfth Centuries', in *The Oxford Handbook of Mary*, ed. by C. Maunder (Oxford: Oxford University Press, 2019), pp. 265–88.

2. *De locis sanctis martyrum*: 'Basilica quae appellatur Sancta Maria Antiqua', in *Codice topografico della città di Roma*, ed. R. Valentini and G. Zucchetti, 4 vols (Rome: Istituto Storico Italiano per il Medio Evo, 1940–53), II, 101–31 (p. 121).

3. Joseph Wilpert, *Die römischen Mosaiken und Malerein der kirchlichen Bauten vom IV. bis XIII. Jahrhundert* (Freiburg im Breisgau: Herder, 1916) [hereafter *RMM*], pl. 151.

4. Andrea Augenti, *Il Palatino nel Medio Evo* (Roma: 'L'Erma' di Bretschneider, 1996), p. 18.

5. *Le Liber Pontificalis: texte, introduction, et commentaire*, ed. by Louis Duchesne, 2 vols. (Paris: Ernest Thorin, 1886–92) [hereafter *LP*], I, 385; English translation in R. Davis, *The Book of Pontiffs (Liber Pontificalis). The ancient biographies of the first ninety Roman bishops to AD 715*, 3rd rev. ed. (Liverpool: Liverpool University Press, 2010), p. 86. Gifts of an ambo and a chalice are specified.

6. Eileen Rubery, 'Pope John VII's Devotion to Mary', in *Origins of the Cult of the Virgin Mary*, ed. C. Maunder (London: Burns & Oates, 2008), pp. 155–99 (pp. 163–4, 168, and figs 6, 8); Rubery, 'The Papacy and Maria Regina Imagery'; and Eileen Rubery, 'From Catacomb to Sanctuary, The Orant Figure and the Cults of the Mother of God and Saint Agnes in Early-Christian Rome, with Special Reference to Gold Glass', *Studia Patristica*, 73 (2015), 169–314 (pp. 162–74).

7. For the prominence of their cult in early medieval Rome, see now Maya Maskarinec, 'Saints for all Christendom: Naturalizing the Alexandrinian Saints Cyrus and John in Seventh- to Thirteenth-Century Rome', *Dumbarton Oaks Papers*, 71 (2017), 337–65.

8. Rushforth, 'The Church of S. Maria Antiqua', pp. 98–9; and John Osborne, 'The Atrium of S. Maria Antiqua, Rome: a history in art', *Papers of the British School at Rome*, 55 (1987), 186–223 (pp. 199, 205–7).

9. Sophronius of Jerusalem, *Panégyric des SS Cyr et Jean*, trans. by P. Bringel, Patrologia Orientalis, 51 (Turnhout: Brepols, 2008), fasc. 1, no. 226, para 1 and 3.

10. Rushforth, 'The Church of S. Maria Antiqua', pp. 68–73; Per Jonas Nordhagen, 'S. Maria Antiqua: the Frescoes of the Seventh Century', *Acta ad archaeologiam et artium historiam pertinentia*, 8 (1978), 89–142 (pp. 97–9); and Eileen Rubery, 'Conflict or Collusion? Martin I and the Exarch Olympus in Rome after the Lateran Synod of 649', *Studia Patristica*, 52 (2012), 339–74.

11. See Rubery, 'Conflict or Collusion?'.

12. John Moschus, *The Spiritual Meadow*, trans. by J. Wortley (Kalamazoo: Cistercian Publications, 1992).

13. Phil Booth, *Crisis of Empire* (London: University of California Press, 2014), p. 232, note 21, discounts the proposal that he died in 619.

14. For John Moschus, the heretical sect is usually the Nestorians since 'Monotheletism' only gathered momentum later: see Moschus, *Spiritual Meadow*, pp. 17–19.

15. Rubery, 'Papal Opposition'.

16. *LP*, I, p. 338; *Book of Pontiffs*, p. 69; and Rubery, 'Papal Opposition'.

17. Sophronius, *Panégyric,* para 1 and 3; *PG* 77, cols 1100–5; repr. in *Spicilegium Romanum*, III: *SS. MM. Cyri et Iohannis laudes et miracula LXX*, ed. by A Mai (1840), pp. 248–52. See also Dominic Montserrat, 'Pilgrimage to the Shrine of SS Cyrus and John', in *Pilgrimage and Holy Space in Late Antique Egypt*, ed. by D. Frankfurter (Leiden: Brill, 1998), pp. 257–79 (p. 258)

18. This Old Testament story is depicted elsewhere in Santa Maria Antiqua, in the eastern vestibule (Plate 12).

19. As with most such hagiographic stories, variations abound, but its establishment in Alexandria and subsequent transfer to Rome are clear; see *PG* 87.3, cols 3677–80.

20. Vatican City, Biblioteca Apostolica Vaticana, MS gr. 1613 < https://digi.vatlib.it/view/MSS_Vat.gr.1613> [accessed January 2020], fol. 360.

21. André Bernand, *Le Delta égyptien d'après les textes grecs*, I, *Les confins Libyques* (Cairo: Institut français d'archéologie orientale du Caire, 1970), p. 208.

22. Maskarinec, 'Saints for all Christendom'.

23. Booth, *Crisis of Empire*, pp. 205–11, and note 90.

24. Monoenergism was relatively swiftly followed by Montheletism, and the Lateran Synod also covered a number of other variants. In this paper, for the sake of simplicity, the term 'Monotheletism' is used to cover all variants of this 'novel' doctrine current during the dispute.

25. Booth, *Crisis of Empire*, pp. 205–10; Maximus the Confessor, *Opuscula* 12, in *PG* 91, 143 C–D.

26. Sergius of Constantinople, *First Letter to Honorius*, trans. in Pauline Allen, *Sophronius of Jerusalem and Seventh Century Heresy* (Oxford: Oxford University Press, 2009), pp. 186–92. See also Booth, *Crisis of Empire*, pp. 205–10, and note 90.

27. Synodical Letter 2.6.2; English translation in Allen, *Sophronius of Jerusalem*, 144.

28. For more detailed discussion, see Rubery, 'Papal Opposition'.

29 Maximus the Confessor, 'Dispute with Pyrrhus', in *PG* 91, 222A–B; and Booth, *Crisis of Empire*, pp. 196–8.

30 Rubery, 'Papal Opposition'. The transcript and translation into English of the proceedings plus subsequent discussion and conclusions can be found in Richard Price, *The Acts of the Lateran Synod of 649* (Liverpool: Liverpool University Press, 2014).

31 Normally the Acts of a local synod in Rome would have been written in Latin and then translated into Greek. The fact the first draft was in Greek is generally taken as strong evidence of the major influence exerted by these 'Greek' monks on both the proceedings and the conclusions of the Synod.

32 A translation of Pope Martin's letter is published by Price, *Acts of the Lateran Synod*, pp. 389–91.

33 Pauline Allen and Bronwen Neil, *Maximus the Confessor and his Companions: Documents from Exile* (Oxford: Oxford University Press, 2002), p. 21. This record was written before September 656 (note there is a misprint in Allen and Neil at p. 35, where the date is given as 856, not 656 as is clear from the context), thus it is near-contemporary with the events.

34 Ibid., pp. 48–74 with the *Relatio Motionis*, which Allen and Neil accept as an eyewitness account of the trial of Maximus and his disciple Anastasius in Constantinople.

35 Ibid., p. 180 note 52.

36 The place of Moschus' death has been the subject of some debate: see Booth, *Crisis of Empire*, pp. 106–8, 232 note 21; and most recently Philipp Winterhager, 'Rome in the Seventh-Century Byzantine Empire: A Migrant's Network Perspective from the Circle of Maximos the Confessor', in *From Constantinople to the Frontier: The City and the Cities*, ed. by N. Matheou, T. Kampianaki, and L. Bondioli (Leiden: Brill, 2016), pp. 191–206 (p. 200 note 35).

37 *LP*, I, p. 434 (life of Pope Zacharias, 741–52); see also Maskarinec, 'Saints for all Christendom', pp. 354–5.

38 Where a list of relics deposited in 755 includes both Abbacyrus and John; see Maskarinec, 'Saints for all Christendom', p. 355.

39 Known only from the 807 donation list of Pope Leo III; see *LP*, II, p. 25. See also Maskarinec, 'Saints for all Christendom', p. 357.

40 Daniele Manacorda, 'La chiesa di Santa Passera a Roma e la sua decorazione pittorica medievale', *Bollettino d'Arte*, 6th ser., 88 (1994), 35–58; and Stefania Pennesi, 'Santa Passera', in *La pittura medievale a Roma, 312–1431. Atlante* I, ed. by M. Andaloro (Milan: Jaca Book, 2006), 125–31. The dedication to Abbacyrus and John is first recorded in 1265, but the architecture suggests a construction date in the first half of the ninth century

41 Luigi Cavazzi, *La diaconia di S. Maria in Via Lata e il monastero di S. Ciriaco* (Rome: Pustet, 1908), pp. 278–307, makes an impressive but unsuccessful attempt to clarify.

42 Osborne, 'The Atrium of S. Maria Antiqua', p. 199 and pl. 18; and Maskarinec 'Saints for all Christendom', pp. 256–7 and fig. 5.

43 For a good colour reproduction, see Maskarinec, 'Saints for all Christendom', fig. 6; see also Osborne, 'The Atrium of S. Maria Antiqua', pp. 205–9, and plates 22–3.

44 Wilpert, *RMM*, p. 713; and Osborne, 'The Atrium of S. Maria Antiqua', p. 199. Sophronius was born in 560 in Damascus and died on 11 March 638 in Jerusalem.

45 Osborne, 'The Atrium of S. Maria Antiqua', pp. 208–9.

46 Nordhagen, 'Frescoes of the Seventh Century', pp. 112–14.

47 Ibid., pp. 109–11.

48 For the full text refer to the Appendix in this essay.

49 Sophronius, *Panégyric*, Miracle 36; see Jean Gascou, *Sophrone de Jérusalem* (Paris: De Boccard, 2006), pp. 125–36. English translation by Eileen Rubery.

50 Rushforth, 'The Church of S. Maria Antiqua', pp. 76–81; Per Jonas Nordhagen, 'The Frescoes of John VII (A.D. 705–707) in S. Maria Antiqua in Rome', *Acta ad archaeologiam et artium historiam pertinentia*, 3 (1968), pp. 55–66; and Maskarinec, 'Saints for all Christendom', pp. 350–4.

51 This function of the space has been proposed by David Knipp, 'The Chapel of Physicians at Santa Maria Antiqua', *Dumbarton Oaks Papers*, 56 (2002), 1–23.

52 Jacobus de Voragine, *The Golden Legend: Readings on the Saints*, trans. William Granger Ryan, 2 vols (Princeton: Princeton University Press, 1992), II, pp. 18–21.

53 Nordhagen, 'The Frescoes of John VII', p. 63.

54 Maya Maskarinec, *City of Saints: Rebuilding Rome in the Early Middle Ages* (Philadelphia: University of Pennsylvania Press, 2018), pp. 180–1, and fig. 3.

55 Nordhagen, 'Frescoes of the Seventh Century', pp. 124–6.

56 Ibid., fig. 10.

57 The traditional interpretation of these murals, first suggested by Rushforth ('The Church of S. Maria Antiqua', p. 63), is that they served as 'types' of Christ's own death and resurrection. See also Ann van Dijk, 'Type and Antitype in Santa Maria Antiqua: The Old Testament Scenes on the Transennae', in *Santa Maria Antiqua cento anni dopo*, ed. by J. Osborne, J.R. Brandt, and G. Morganti (Rome: Campisano, 2004), pp. 113–27.

58 Werner Schmid and Valeria Valentini, 'Alcune considerazioni sulle techniche pittoriche dei dipinti murali altomedievali di S. Maria Antiqua al Foro Romano', in *Castelseprio e Torba: Sintesi delle ricerche e aggiornamenti*, ed. by P.M. De Marchi (Mantua: Soprintendenza per i Beni Archeologici della Lombardia, 2013), pp. 415–21 (p. 413).

59 Pope John VII was a second generation immigrant from Greece. His father had worked for the emperors and been responsible for the maintenance of the stairs accessing the Palatine Hill and its palaces.

60 John Osborne, 'Images of the Mother of God in Early Medieval Rome', in *Icon and Word: The Power of Images in Byzantium. Studies presented to Robin Cormack*, ed. by A. Eastmond and L. James (Aldershot: Ashgate, 2003), pp. 135–56 (pp. 141–3).

61 This is an allusion to the Visitation (Luke 1. 39–45). Elisabeth, pregnant with John, felt her child quicken with joy when she came face-to-face with Mary, who herself was carrying Jesus. It was considered as a sign of the prophetic mission of the precursor.

RICHARD PRICE

The Frescoes in Santa Maria Antiqua, the Lateran Synod of 649, and Pope Vitalian

Of the frescoes of Santa Maria Antiqua, a special interest attaches to those that relate to the Lateran Synod of 649, a meeting of just over one hundred bishops (almost all of them Italian) under the chairmanship of Pope Martin I (649–53). The synod attempted to solve the monothelete controversy—the dispute between those whom we call monoenergists and monotheletes, who asserted a single operation and will in Christ, and those, called dyoenergists and dyotheletes, who affirmed two operations and two wills (Plates 35, 40, 41, 50: K1.3-4). The synod duly defined that Christ has two wills and two operations, corresponding to his two natures, human and divine, and anathematised the upholders of one will and one operation, including the then Patriarch of Constantinople, Paul II, his two predecessors Sergius and Pyrrhus, and all those who did not condemn them.[1]

The monothelete controversy and the Lateran Synod

Accounts from the end of the seventh century up to the present time have described the controversy and the work of the synod in simple, black and white terms. The doctrine of one operation and one will in Christ had developed within the non-Chalcedonian (monophysite[2]) churches as a natural corollary of their belief in one nature in Christ. In the 630s, first Monoenergism and then (as a more sophisticated replacement) Monotheletism were adopted by the Byzantine Church, under pressure from the Emperor Heraclius, despite the doctrine's incompatibility with the Chalcedonian belief in the two natures in Christ, as a compromise that would hopefully lure non-Chalcedonians back into the imperial Church and thereby strengthen the empire against its Persian and Muslim enemies. The longstanding champions of the pure dyophysite doctrine canonised at Chalcedon were the Church of Jerusalem and all the Western Churches, under the leadership of Rome. They first condemned the new doctrine as a betrayal of Chalcedon, showing that its denial to the incarnate Word of a second, human operation and will was a relapse into Apollinarianism, which denied Christ a human soul. The Lateran Synod was held

under Pope Martin in 649 to confirm and enact the anti-monothelete stance of orthodoxy.

This picture has been largely demolished by historians during the last fifteen years, though it will take time for the word to get around.[3] The following account is now on offer. Monotheletism and Monoenergism (the doctrines of one will and one operation in Christ) were misrepresented by their opponents: monotheletes and monoenergists did not deny Christ a human will or operation, but simply insisted that they were united to, and in harmony with, the divine will and operation, in such a way that it was proper to speak of one will and one operation, with both divine and human components.[4] Their beliefs and formulae were not taken over from the miaphysites, but developed within the Chalcedonian tradition itself.[5] The language of one operation was not imposed on the whole Church, but simply employed in the context of reconciliation (or attempted reconciliation) with the non-Chalcedonians, according to the principle of 'economy'—the use of less than precise terminology in theology for the sake of Church unity.[6] Monotheletism was never formally adopted by Church or state, but appeared in the *Ekthesis* issued by Emperor Heraclius in 638 (or 636 according to a plausible modern theory) as a still uncontroversial tenet that told against Dyoenergism.[7]

Indeed, the *Typos* issued by the Emperor Constans II in 648 actually forbade any further debate on the question of the number of wills and operations in Christ, on the grounds that it led to strife and division. The document implied that neither position was heretical and avoided expressing a preference. The timing of this document was an embarrassment for the Roman see, where plans for a synod to condemn the Church of Constantinople for Monotheletism were already well advanced. But it failed to derail the synod, where the *Typos* was condemned on two grounds. It was interpreted as denying to Christ *both* one will and two wills, in other words as denying him the possession of any will or operation whatsoever.[8] More reasonably, it was criticised for placing heresy (Monotheletism) on a par with orthodoxy (Dyotheletism).[9] The implication was that anything less than a condemnation of Monotheletism, and the Monoenergism that had paved the way for it, constituted a betrayal of orthodoxy sufficiently serious to be itself heretical. Other passages in the Acts accuse the monotheletes of falling by implication into every possible Christological heresy: of making Christ merely human, of denying the reality of his human nature, of dividing the two natures, and of fusing them. The charge being made is not that Monotheletism was necessarily Apollinarian, but that it could be Apollinarian, or Nestorian, or Arian, or Docetist. Every possibility is allowed save the most natural one—that the monotheletes were sound Chalcedonians, who wished to stress the harmony of will in Christ.[10]

The perverseness of this treatment of Monotheletism raises the question of the real motive behind Roman intransigence. We must remember that the anti-monothelete campaign was led by monks from Palestine traumatised by the disaster of the Muslim conquest. The question that arose in their minds was why God had abandoned the Christian empire, and the answer they adopted, in accordance with longstanding Christian belief, was that God would not protect a Christian state that had fallen into heresy.[11] When Pope Martin wrote to Constans II, announcing the work of the synod, he declared:

> It is always the case that the preservation of the state goes together with the flourishing of the orthodox faith. For when your serenity has a correct faith in the Lord, who arms

his creation to ward off the enemy, he will deservedly give aid to your authority in conquering your enemies.[12]

This is relevant for the charges of treason brought against Pope Martin and Maximus the Confessor. We know of the judicial proceedings against them only from dyothelete sources, which dismiss the charges as baseless, but recent historians think it probable that they had indeed given their support to the attempted usurpations by two Byzantine generals in the West—Gregory in Africa and Olympius in Italy.[13] Inevitably, the Byzantines considered this high treason, but Martin and Maximus would have acted under the patriotic conviction that only if a new and orthodox emperor came to power would the empire recover God's favour.[14]

Texts and frescoes in Santa Maria Antiqua

By far the longest of the sessional acts of the Lateran Synod is that of the final, fifth session, dominated by the reading out of a series of *florilegia*, mainly consisting of passages from the orthodox Fathers that could be used in support of the doctrine of two wills and two operations in Christ, but supplemented by two *florilegia* that illustrate how Monoenergism and Monotheletism had first appeared in the writings of heretics, both monophysites and Nestorians. The patristic appeal had first appeared during the Nestorian controversy, but dominated the proceedings neither of Ephesus (431 CE) nor of Chalcedon (451 CE). It is more to the fore in the Acts of the Second Council of Constantinople (553 CE), and reached its apogee during the monothelete controversy, when both sides assembled collections of supportive texts. The reliance on *florilegia* at the Lateran Synod is all the more striking because of its ineffectiveness. For its *florilegia* contain just two passages that use the expression 'two wills', and in both cases the reference is simply to the clash of wills at Gethsemane, not to duality in Christ's ontological make-up.[15] The position with the expression 'two operations' is not much better: four passages are cited, of which only two (both dating to the sixth century) attempt a general statement about Christ.[16] The fact that the *florilegia* fail to carry the day is doubtless why they were supplemented in the published record (in a way unusual in conciliar acts) by long speeches put in the mouths of the pope and the metropolitans. But the prime importance attributed to the patristic appeal remains highly significant. It does not mean that theology had become wholly repetitive and unoriginal, but that it was appreciated that a synod or pope could only require assent to doctrines that had strong support in the councils and the Fathers.

This brings us to the frescoes of Santa Maria Antiqua. For there we find inscribed on the apsidal wall four patristic citations from the *florilegia* of the synod of 649, two on the left and two on the right, each on a scroll held by the Church Father from whom it is taken (Plates 40–1; Figures 1–2). These citations did not constitute a celebration of the synod itself, since very few of those who saw them would have recognised the source. But were they carefully selected as providing support for the doctrinal stance of the Roman see? And if so, for its stance at what date? Or what other purpose may they have had? Let us take a look at them. The four passages are all in Greek, and run as follows, if we proceed from the viewers' left to their right:

1 For each form in communion with the other operates what is proper to it, the Word

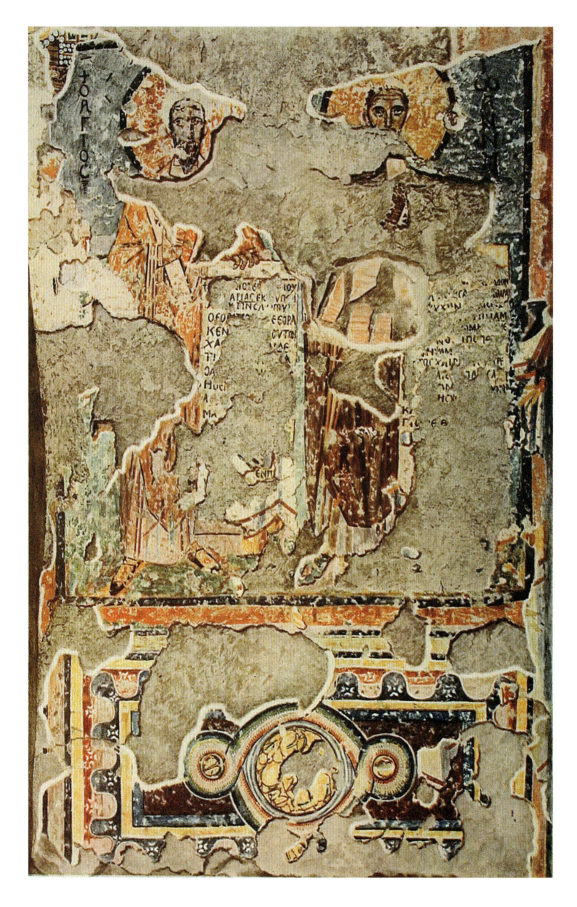

1 Santa Maria Antiqua, apsidal arch, the 'palimpsest' wall: the Church Fathers Basil and John Chrysostom holding scrolls with an extract from their works (Watercoloured photograph after Wilpert, *RMM*, IV, pl. 142)

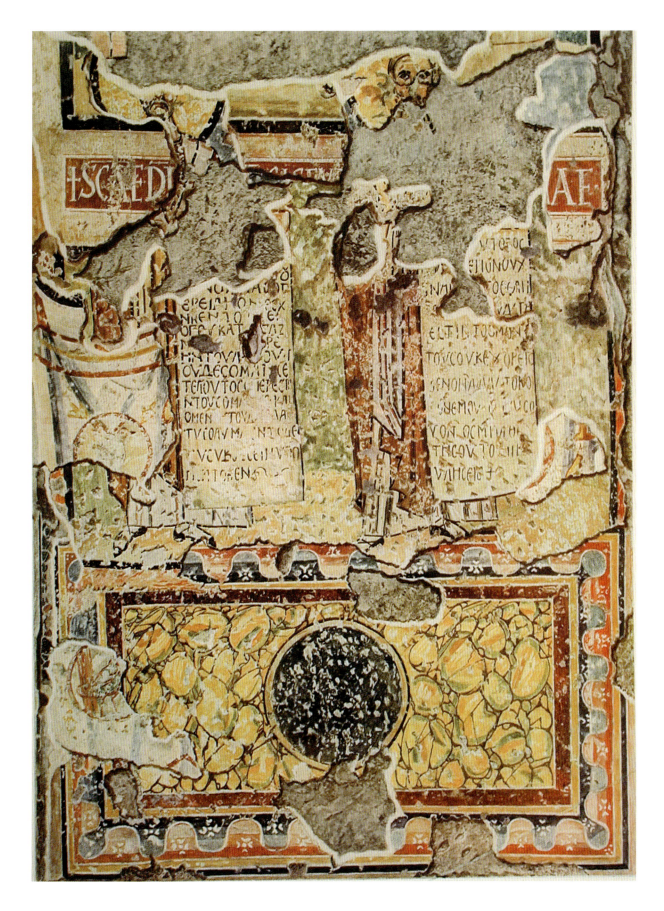

2 Santa Maria Antiqua, apsidal arch, left side: the Church Fathers Leo the Great and Gregory of Nazianzus holding scrolls with an extract from their works (Watercoloured photograph after Wilpert, *RMM*, IV, pl. 142)

performing what is the Word's, and the body accomplishing what is the body's. The first of these shone forth with miracles, while the latter succumbed to injuries.

In the Acts this comes as the third citation in the fourth section of the *florilegia*, titled 'On the natural operations of Christ our God', and is taken from the Tome of Pope Leo, in the original fifth-century Greek translation (Plates 41, 50: K1.3; Figure 2).[17] This was a key passage in the monoenergist controversy, since it explicitly attributes an operation to Christ's body (or manhood) distinct from that of his Godhead. In the context of the seventh-century debate this was powerful support for the doctrine of two operations in Christ. This citation was of particular weight, since it came from a document (Tome of Leo) that had been formally approved by name in the Chalcedonian Definition.[18] It was because of this passage that Monoenergism was only defensible on the principle of 'economy' or accommodation.[19]

2 […] with the result that the inference is as follows: '[I came down] not to do my own will' [John 6.38], for my own will is not separate from yours, but there is a community of mine and yours; as we have one Godhead, so too we have one will.

In the Acts this comes second in the second section of the *florilegia*, titled 'On the natural wills', and is taken from Gregory of Nazianzus' Fourth Theological Oration (Plates 41, 50: K1.3; Figure 2).[20] This extract is from a passage in which Gregory discusses two key sayings of Christ relating to his will—John 6.38, 'I have come down from heaven not to do my own will but the will of him who sent me,' and Matthew 26.39, 'Father, if it is possible, let this cup pass from me, yet not as I will but as you will.' Gregory's discussion was repeatedly cited by both monotheletes and dyotheletes. On the one hand, he interprets the verse from John as stating that Christ as God lacked a will of his own, and the verse from Matthew as relating to a conflict not between two wills in Christ himself but between God's will and that of ordinary human beings (with whom Christ chose to identify himself); this gave support to Monotheletism. On the other hand, in this same passage Gregory says of Christ's will that it 'was not opposed to God but wholly deified', and the dyotheletes pointed out that a 'deified' will could only be a human will, since the will of Christ's Godhead was not 'deified' but divine by nature. But how can we account for the citation on the fresco not of the sentence in Gregory that implies Dyotheletism but of the sentence that sounds monothelete? This makes no sense in the immediate context of the confrontation between Rome and Constantinople at the time of the Lateran Synod.

3 'He who has seen me has seen the Father' [John 14.9], not the figure nor the form (for the divine nature is free of composition) but the goodness of will, which, corresponding to the essence, is perceived to be alike and equal, or rather identical, in the Father and the Son.

In the Acts this is the first passage cited in the same second section of the *florilegia*, and is from Basil of Caesarea's *On the Holy Spirit* (Plates 40, 50: K1.4; Figure 1).[21] The relevance of the passage for the monothelete controversy, and the reason for its citation at the synod, was that it states the principle that will corresponds to substance or nature. So just as in the Trinity the one nature implies oneness of will, so in Christ, God and man, the duality of nature implies duality of will. But who, visiting the church and seeing this inscription, would have understood this?

A less informed reader would take the passage to support Monotheletism.

> 4 Hearing this, I cleansed my soul from disbelief, shed a doubtful mind, and recovered conviction. I touched the body, rejoicing and trembling, I opened with my fingers also the eye of the soul, and was then aware of two operations.

In the Acts this is the twenty-ninth citation in the fourth section of the *florilegia*, 'On the natural operations of Christ our God', and is from 'John Chrysostom', in fact Pseudo-Chrysostom, Sermon on Thomas the Apostle (Plates 40, 50: K1.4; Figure 1).[22] The usefulness of this passage for the dyoenergist cause is obvious, but the citation is misleading: in its context the reference is to two operations not in Christ but in doubting Thomas, who perceived the risen Christ with the eyes both of the body and of the mind. This citation is typical of patristic *florilegia* at their worst—confusion between genuine and falsely attributed works, and distortion through taking textual excerpts out of context.

How are we to account for the selection of these four passages? They are effective against Monoenergism, but worse than useless against Monotheletism. This suggests that a promotion of the Dyotheletism of the Lateran Synod was not their purpose. A possible answer is to be found in the fact that each of these citations is on a scroll held by a Church Father, and the four Fathers selected are Pope Leo (of foundational importance in Rome itself) and three of the very greatest and most esteemed of the Greek Fathers—Basil the Great, Gregory the Theologian, and John Chrysostom. As for the particular passages inscribed, it could be suggested that they were chosen not for their content, but simply because they were brief enough to fit onto the scrolls. In this case, it is not the texts but their writers that were celebrated on the frescoes of Santa Maria Antiqua. But another explanation may well seem more satisfactory, which will be discussed below.

The frescoes and Pope Vitalian

The Exarch of Italy, Olympius, was given the task of crushing the revolt against imperial authority that the Synod of 649 constituted. Instead, he formed an alliance with Pope Martin and rebelled against Constans.[23] His revolt came to an inglorious end when an expedition against the Arabs in Sicily was defeated and Olympius died of some ailment soon afterwards. But Calliopas, his successor as exarch, took control of Rome in 653 and had Martin put under arrest and carried off to Constantinople for trial. His election had never been confirmed by Constantinople, and so he was treated not as a pope under accusation but as a mere former *apocrisiarius* (nuncio) of the Roman see. The Roman Church was instructed to elect a new pope, and Eugenius I was finally installed in August 654, while Martin was still alive. He received a synodical letter from the new Patriarch of Constantinople, Peter (654–66), but the letter, in the words of the *Liber pontificalis* (77.2) 'failed to be explicit about the operations and wills in our Lord Jesus Christ'.[24] In others words, it kept strictly to the letter of the *Typos*, with its ban on any further debate on wills and operations. The *Liber pontificalis* also makes it clear that Eugenius would have accepted the synodical letter, were it not for the pressure exerted on him by a massive demonstration of 'people and clergy'. His pontificate failed therefore to achieve reconciliation with Constantinople.

The situation changed with the election of his successor Vitalian in 657. At Session XIII (28 March 681) of the dyothelete Third Council of Constantinople, discussion took place of a letter sent to Vitalian by Peter of Constantinople in response to a letter from the pope announcing his election. Peter's letter was denounced at the council for its fraudulent citations from the Fathers—that is, for including a monothelete *florilegium*. The record of this session gives the opening of the letter: 'Spiritual joy was bestowed on us by the letter of your like-minded and holy brotherliness.'[25] The implication is that Vitalian's letter re-established communion between Rome and Constantinople. Constans II showed his appreciation by sending lavish gifts and confirming the privileges of the Roman see—as we learn from the *Liber pontificalis* (78.1), which omits, not surprisingly, the doctrinal rapprochement. This reconciliation between Rome and Constantinople was crowned by the visit made to Rome by Constans II in person in 663, of which the *Liber pontificalis* gives the following account:

> [Constans] came to Rome on 5 July […] The apostolic man [Vitalian] went to meet him with his clergy at the sixth mile from Rome and welcome him. On the same day the emperor travelled to Saint Peter's for prayer and there presented a gift; on Saturday to Saint Mary's and again he presented a gift. On Sunday he proceeded to Saint Peter's with his army, all with wax tapers, and on its altar he presented a gold-wrought pallium; and mass was celebrated. Again on Saturday the emperor came to the Lateran, and bathed and dined there in the basilica of Vigilius. Again on Sunday there was a *statio* at Saint Peter's, and after mass was celebrated the emperor and the pontiff bade farewell to each other.[26]

Let us take a look again at the four texts selected for inclusion in the frescoes celebrating four great Fathers of the Church in Santa Maria Antiqua. Two of them insist on two operations in Christ, one being the key text from the Tome of Pope Leo, and the other a text attributed to John Chrysostom, the most venerated of the past bishops of Constantinople. The citation from Leo asserts continuity with the championship of Chalcedonian Christology by the Roman see; the citation from Chrysostom brings out the concord between the two greatest sees of East and West on a question which was no longer central to the doctrinal debate, which at this date was concentrated on will(s) in Christ.

The question of will in Christ was, however, the subject of the remaining two passages, from Basil the Great and Gregory the Theologian. Both passages insist on the identity of will between the Father and the Son, which was accepted by everyone. It remains, however, highly significant that there was cited the passage from Gregory that was most debated during the monothelete controversy—the second of the four passages given above –, not the statement that invited a dyothelete interpretation but one which spoke of 'one will'. We may detect a deliberate intention to play down the monothelete versus dyothelete controversy, and celebrate what was shared between the Roman and Constantinopolitan traditions.

Surely the context for this cannot have been the Lateran Synod itself. In contrast, this selection of texts suits well the policy of Pope Vitalian at this stage of his pontificate—when he had achieved reconciliation with Constantinople—while at the same time the two dyoenergist texts selected could protect Vitalian from criticism by his own clergy for betraying the tradition stemming from the Dyoenergism of Pope Leo. Further support for this suggestion may be found

in a text inscribed within the apsidal conch of Santa Maria Antiqua, immediately adjacent to the four panels and considered to be of the same date as the scrolls (Plates 36, 50: K1.1). The text runs: 'The Lord God give us your peace, give us your peace, Amen.'[27] This stress on peace does not fit the immediate context of the Lateran Synod, at which the peace of the Mediterranean world was deliberately disrupted in the interests of supposed orthodoxy, but it obviously fits extremely well the climate of reconciliation between Rome and Constantinople in the early years of Vitalian's pontificate.

I would conclude that the most probable context for these frescoes and inscriptions in the church is the period of Vitalian's pontificate when he had made peace with Constantinople, and if a more specific date be requested, the obvious occasion for their creation would have been the climax of this process—the visit of Constans II to Rome in 663. This date deserves therefore to replace 649 as the probable date of the four patristic frescoes on the apsidal wall of Santa Maria Antiqua.

1 For the first critical edition of the Greek and Latin versions of the Acts see *Acta Conciliorum Oecumenicorum* [hereafter *ACO*], Series Secunda I, *Concilium Lateranense a. 649 celebratum*, ed. R. Riedinger (Berlin: De Gruyter, 1984). For an English translation with introduction and commentary see Richard Price, *The Acts of the Lateran Synod of 649*, with contributions by Phil Booth and Catherine Cubitt (Liverpool: Liverpool University Press, 2014).

2 It is still a matter of debate whether this term should still be used, or replaced by the new coinage 'miaphysite'. In favour of replacement is the Oriental Orthodox dislike of 'monophysite' as pejorative, but it is hard to see that 'miaphysite' is any better, save for being untraditional. 'Monophysite' need not be seen as any more pejorative than 'monotheist'.

3 The major studies are by Heinz Ohme, 'Motive und Strukturen des Schismas im monenergetisch-monotheletischen Streit', *Annuarium Historiae Conciliorum*, 38 (2006), 265–96; Heinz Ohme, 'Oikonomia im monenergetisch-monotheletischen Streit', *Zeitschrift für antikes Christentum*, 12 (2008), 308–43; and Heinz Ohme, 'Was war die Lateransynode von 649? Was sollte sie sein?', *Annuarium Historiae Conciliorum*, 48 (2016–17), 109–57. See also Phil Booth, *Crisis of Empire: Doctrine and Dissent at the End of Late Antiquity* (Berkeley: University of California Press, 2013), pp. 186–224. Friedhelm Winkelmann, *Der monenergetisch-monotheletische Streit* (Frankfurt am Main: Peter Lang, 2001) gives an account of all the relevant sources and documents and a prosopography of those involved.

4 See Price, *The Acts of the Lateran Synod*, pp. 87–96; and Richard Price, 'Monotheletism: A Heresy or a Form of Words?', *Studia Patristica*, 46 (2010), 221–32.

5 See Karl-Heinz Uthemann, 'Ber Neuchalkedonismus als Vorbereitung des Monotheletismus: Ein Betrag zum eigentlichen Anliegen des Neuchalkedonismus', *Studia Patristica*, 29 (1997), 373–413.

6 See Ohme, 'Oikonomia'.

7 See Price, *The Acts of the Lateran Synod*, pp. 196–8. For the redating of the *Ekthesis* to 636 see Booth, *Crisis of Empire*, pp. 239–41.

8 *ACO* ser. 2, I, p. 214, §14–18; Price, *The Acts of the Lateran Synod*, p. 266.

9 *ACO* ser. 2, I, pp. 210–2; Price, *The Acts of the Lateran Synod*, pp. 264–5.

10 Price, *The Acts of the Lateran Synod*, pp. 92–4.

11 The most famous statement of this belief are the words of Nestorius addressed in public to Theodosius II, 'Help me destroy the heretics, and I shall help you destroy the Persians', Sokrates, *Hist. Eccl.* VII, 29.5, in Sokrates, *Kirchengeschichte*, ed. G.C. Hansen (Berlin: Akademie, 1995), p. 377.

12 *PL* 87, 145A; Price, *The Acts of the Lateran Synod*, p. 416.

13 See Wolfram Brandes, 'Juristische Krisenbewältigung im 7. Jahrhundert? Die Prozesse gegen Papst Martin I. und Maximos Homologetes', *Fontes Minores*, 10 (1998), 141–212.

14 It might seem more plausible to attribute these local revolts in the West to a quest for autonomy, but everyone will have remembered that it was at Carthage that Heraclius had launched his successful revolt against Phocas in 610.

15 The passages are *ACO*, ser. 2, I, p. 282, §15 from Pseudo-Athanasius and p. 292, §34 from Severian of Gabala.

16 The passages are *ACO*, ser. 2, I, p. 312, §29 (Pseudo-Chrysostom) and §33 (Ephraem of Antioch), and p. 314, §34 (John of Scythopolis) and §35 (Anastasius of Antioch). The last of these was untypical, in that Anastasius more often spoke of one operation in Christ.

17 *ACO* ser. 2, I, p. 298, §29–32, trans. Price, pp. 333–4. For the Greek translation in the Acts of Chalcedon see *ACO*, 2, I, p. 28, §12–14.

18 See *ACO*, II.1, p. 325, §12–16; translated into English by Richard Price and Michael Gaddis, *The Acts of the Council of Chalcedon*, 3 vols (Liverpool: Liverpool University Press, 2005), II, p. 203.

19 For the importance of Leo's Tome in the monoenergist controversy see Price, *The Acts of the Lateran Synod*, pp. 240–2. The language of each nature 'performing' its own operation seemed to monophysite critics to imply a Nestorian separation of the natures, and this criticism is repeated today by many Orthodox writers. But Leo is simply following a standard metaphysical principle that defined 'nature' as something with a distinctive operation. See Henry Chadwick, *Boethius: The Consolations of Music, Logic, Theology, and Philosophy* (Oxford: Oxford University Press, 1981), pp. 191–2.

20 *ACO* ser. 2, I, p. 270, §12–14, trans. Price, p. 314. From Gregory Nazianzen, *Orationes*, 30.12.

21 *ACO* ser. 2, I, p. 270, §6–8, trans. Price, p. 314. From Basil, *De spiritu sancto* 8.21.

22 *ACO* ser. 2, I, p. 312, §7–9, trans. Price, p. 342. From Pseudo-Chrysostom, *In S. Thomam apostolum* (*PG* 59.500).

23 See Eileen Rubery, 'Conflict or Collusion? Pope Martin (649–654/5) and the Exarch Olympius in Rome after the Lateran Synod', *Studia Patristica*, 52 (2012), 339–74.

24 *Le Liber Pontificalis: texte, introduction, et commentaire*, ed. by L. Duchesne, 2 vols (Paris: E. Thorin, 1886–92) [hereafter *LP*], I, p. 341; English translation from Raymond Davis, *The Book of Pontiffs (Liber Pontificalis). The ancient biographies of the first ninety Roman bishops to AD 715*, rev. 3rd ed. (Liverpool: Liverpool University Press, 2010), p. 69.

25 *ACO*, ser. 2, II.2, p. 610, §1–4.

26 *LP*, I, p. 343; translation from Davis, *Book of Pontiffs*, pp. 69–70.

27 Isaiah 26.12. On this transcription of the text and the different interpretations proposed in the past for this inscription see the contribution of Giulia Bordi elsewhere in this volume.

BEAT BRENK

A New Chronology for the Worship of Images in Santa Maria Antiqua

There is perhaps no other monument of early medieval art that has presented as many challenges to scholars as Santa Maria Antiqua. Although its frescoed interior is superbly preserved in comparison to other sites of this era, the written sources referring to it are in many ways ambiguous or downright obscure, and thus it has been impossible to prove conclusively that Santa Maria Antiqua was founded by either the Byzantine garrison in Rome or by one of the popes. It is also difficult to understand how it came to acquire the simultaneous veneration of the Mother of God, the Holy Mothers (Anna, Elizabeth, and Solomone), and the medical saints. Scholars have also had problems understanding the theological and doctrinal positions that underlie the private ex-voto frescoes. Last but not least, while traditional stylistic analysis brought most scholars to the conclusion that the frescoes with Greek inscriptions were the work of Constantinopolitan painters, no conclusive evidence for this has so far been presented. At the 2003 gathering in Spoleto, I proposed to change the traditional direction of the debate by focusing on the history of the cult of the saints and on theology, instead of dealing uniquely with the history of style and the stages of 'Hellenism'.[1] In the present paper I shall present a new chronology of the forms of piety in Santa Maria Antiqua, distinguishing between private votive images and official ecclesiastical images.

In the absence of reliable written sources, scholars have been forced to resort to more or less credible hypotheses in order to explain some aspects of Santa Maria Antiqua. Unfortunately, some of these hypotheses have been hard to relinquish even after they proved untenable. But a hypothesis is simply a vehicle, a sort of a makeshift raft to save one's life from shipwreck; it is a temporary measure. Needless to say, all answers depend on the quality of the questions. As soon as a purely art historical approach is put aside and attention is directed at the religious, cultic, and dogmatic features of the seventh and eighth centuries, following the insightful scholarship of the likes of Averil Cameron, Arnold Angenendt, and Phil Booth, the research takes an entirely different direction. Eileen Rubery, elsewhere in this volume, also approaches this issue from a

slightly different angle by focusing on the role played by the cult of the medical saints Cyrus and John, and their possible links to the Lateran Council panels through the 'Greek' monks John Moschus, Sophronius of Jerusalem, and Maximus the Confessor. Per Jonas Nordhagen, of course, must be credited with the thorough investigation of the layers and the exhaustive photographic documentation of the frescoes in Santa Maria Antiqua.[2] His careful descriptions and analysis will forever remain a foundational source for scholars dealing with this site.

Phase I: the foundation of Santa Maria Antiqua during the sixth century

The uncertainty about Santa Maria Antiqua starts with its very foundation. It is not mentioned in the *Liber pontificalis*, nor in any other source. This may suggest that the church was not a papal foundation; but the *Liber*, as is well-known, is far from complete. But if it is not a papal foundation what else could it be? After all, there is no other early medieval church in Rome in which so many popes are depicted in the wall paintings, including Martin I (649–53), John VII (705–7), Zacharias (741–52), Paul I (757–67), and Hadrian I (772–95). Nevertheless, we still do not know who founded Santa Maria Antiqua nor when.

Robert Coates-Stephens pointed to two nearly forgotten funerary inscriptions from 572 and 582 that had been discovered in front of the Oratory of the Forty Martyrs (Figure 1) but which came originally from its interior.[3] The oratory served during the last third of the sixth century as a mausoleum for wealthy individuals, possibly linked either to the emperor or to the imperial garrison. The deceased Christian silversmiths that are mentioned in the inscriptions obviously belonged to a high social stratum. As the mausoleum was installed at the foot of the Palatine Hill in a second-century imperial cult room, it was imperial property and its use must have required the permission of the emperor or the imperial garrison. It cannot be considered as an isolated building; its (first) imperial phase was related to the palace, and its (later) ecclesiastical phase was surely part of a larger complex, the church of Santa Maria Antiqua, itself standing on imperial property. Thus the foundation must be dated before the earliest funerary inscription in the oratory, that is before 572. Coates-Stephens observes correctly that Santa Maria Antiqua 'became a church as a result of Byzantine patronage'.[4] The imperial residence on the Palatine could be reached by a ramp which was accessible from the left (east) aisle (Plate 50: C). Scholars have consequently spoken of the site as 'a vestibule of the Imperial palace'.[5]

Similar churches with an adjacent mausoleum include the sixth-century cathedrals of Poreč and Santa Eufemia in Grado.[6] Legally speaking, Santa Maria Antiqua is not comparable to other churches in the Forum, for example the churches of Santi Cosma e Damiano (founded by Pope Felix IV in 526–30) or Sant'Adriano (founded by Pope Honorius between 625 and 638), because it was installed in a former imperial building, on imperial territory, whereas both Santi Cosma e Damiano and Sant'Adriano were built on state property by popes, although requiring an imperial permit.[7]

The earliest mention of Santa Maria Antiqua occurs in the *Liber pontificalis* under Pope John VII: 'He adorned with painting the basilica of the holy mother of God which is called Antiqua'.[8] But why is the church called *antiqua* when we know that the oldest church of the Mother of God in Rome is Santa Maria Maggiore? Does the term *antiqua* signify a church or an icon or something else completely? Among the most recent churches dedicated to the Virgin, Santa

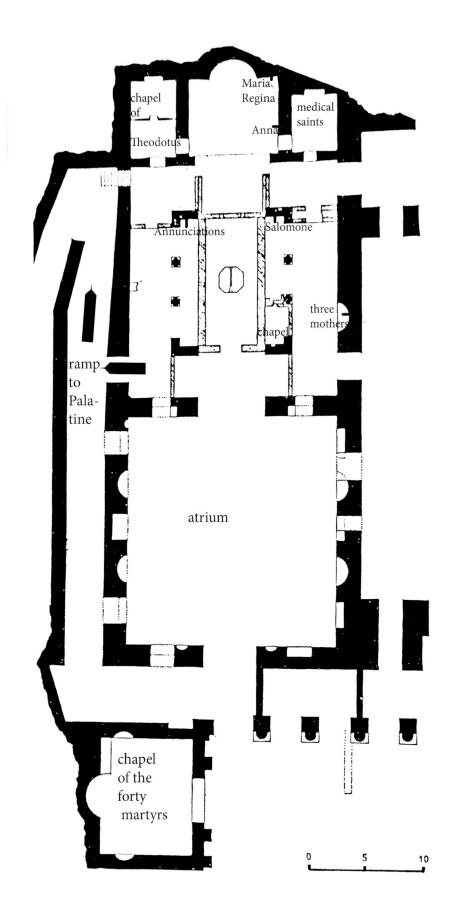

1 Plan of Santa Maria Antiqua and the Oratory of the Forty Martyrs (captions by Beat Brenk)

Maria Antiqua was certainly older than the Pantheon, and it could be that the term *antiqua* simply reflects that earlier foundation date. But this is just another hypothesis. The situation becomes even more complicated when we read the inscription in the Chapel of Theodotus (Plates 28, 50: J1) which states that Theodotus was the *primicerius defensorum* of 'sanctae Dei Genetricis semperque birgo Maria qui appellatur antiqua'.[9]

The question whether this title should be applied to the church in the time of Pope Zacharias (741–52), or earlier, to the Maria Regina represented in the fresco on the so-called 'palimpsest' wall (Plates 37–8, 50: K1.4), is troublesome; and when we look further at the 'palimpsest' wall frescoes, additional complications arise. The oldest layer of this wall shows the veneration of the Maria Regina with the Child by two angels offering crowns.[10] The fresco, created before 572, was a private ex-voto in a space that was possibly the guard-room of the palace troops residing on the Palatine, as it controlled access to the ramp leading to the Palatine Hill. Afterwards, it was converted into a church with a thoroughly Eastern ground-plan, comparable to the sixth-century church of Qasr ibn Wardan in eastern Syria.[11] The elevation of the building, however, remained purely 'Western'.

Archaeology offers no convincing evidence for a sixth-century dating. According to Andrea Paribeni, the gold coins found in the excavation under the second column on the left side belong to the period of Emperor Justin I (518–27), not Justin II as reported by others.[12] This gives us only a terminus post quem for the church of 518. Gold coins never enable us to date buildings exactly because they remain in circulation for many centuries. Richard Krautheimer believed that the coins had been identified as coming from the time of Justin II (565–78), and on that basis he suggested a date for the church's marble pavements in the second half of the sixth century.[13] Even if the pavement in the presbytery were dated to the sixth century (which is possible, but not certain), it is impossible to prove that this pavement belongs to the church; it could have been installed previously by the imperial garrison.[14]

It seems that the Maria Regina fresco was privately worshipped because it belonged to a non-ecclesiastical room not to a church decoration. It certainly was not a 'cult image', it had no function in the official liturgy; but it expressed an official theological issue, namely the two natures of Jesus Christ. The imperial dress of the Virgin and the angelic guard point to her as a Theotokos (Mother of God).[15] Later on, the Maria Regina was 'amputated' by the construction of the apse and covered with another ex-voto mural, the Annunciation (Plate 37), once again expressing the two natures of Christ.[16] As the church was constructed before 572, the Maria Regina fresco must be dated before 572 as well, whereas the Annunciation came later.

In the middle of the eighth century, another Maria Regina was painted in Santa Maria Antiqua, in the private chapel of Theodotus (Plates 28, 50: J1). It is clear that considerable attention was devoted to this particular Marian iconography.

Phase 2: The first half of the seventh century. What sort of images of the Virgin Mary were worshipped in Santa Maria Antiqua before and after 640?

We know that Santa Maria Antiqua was not completely destroyed by the earthquake in 847. Some church furniture was still preserved and, possibly, so were some icons. The plinth of the ambo of John VII is still preserved in situ, but the ambo itself was taken away; and surely

the silver ciborium from 795 mentioned in the *Liber pontificalis* was also removed.[17] It appears that an over-life-sized icon (Figure 2) was transported to Santa Maria Nova (Santa Francesca Romana), where it remains today.[18] The *Liber pontificalis* records that Santa Maria Nova was founded by Pope Leo IV (847–55) as a successor to Santa Maria Antiqua.[19] The hypothesis that the large icon of Santa Maria Nova was transferred from Santa Maria Antiqua is not only obvious but also inevitable. How else could a recent church, founded only in the middle of the ninth century, have acquired such a prominent icon? Some scholars find it troubling that this icon is not a Maria Regina, but apparently rather a Dexiokratousa-Hodegetria. From the surviving fragments, it could even be simply an image of a mother and child adopted as an ancient image of Mary. Obviously, various types of icons and images of the Virgin were worshipped in Santa Maria Antiqua: among the seventh-century frescoes that Nordhagen highlighted in this regard is the Virgin 'with the crossed hands' (Plate 15),[20] the Virgin Eleousa,[21] and the Enthroned Virgin with Angels (Plate 14).[22] Furthermore, the tiny private chapel to the right of the schola cantorum (Plates 16, 50: E3) has a niche with a sepulcrum for relics with a square image of the Virgin with the Child datable to the early eighth century.[23] The inscription 'H AGIA MARIA' is similar to the inscription of the Hodegetria in the Apse of Kiti in Cyprus.[24] The absence of a nimbus proves that the iconography harks back to a model from the fifth or sixth century. The yellow background imitates a gold ground. Since the Virgin points to the nimbus of the Child, this image looks like a special version of a Hodegetria. Surely mass was not celebrated in front of this niche, and Nordhagen suggested that an oil lamp was hung in front of the image.[25] Prayers were said, and perhaps acts of proskynesis (bowing, kneeling) and adoration were also performed.[26]

The various forms of representation of the Mother of God in Santa Maria Antiqua and on the icon of Santa Maria Nova prove that this place was a vital centre for Marian veneration from the sixth/seventh centuries onwards.[27] Worship was carried out with the help of private images, ex-votos and icons, which were tolerated by the official Church because they promoted the worship of the Virgin. This was an innovation in Rome.

The earliest images of the Virgin in Rome and their functions

Kitzinger, Cameron, and Mango have shown that the worship of the Mother of God, the icons of the saints, and the rites connected with these practices developed first in the Greek East.[28] Constantinople seems to have had important relics of the Virgin already in the fifth century, and the Byzantines later created the icons of the Virgin Blachernitissa and the Chalkoprateia.[29] The veneration of the Virgin found its immediate expression in images where the Mother of God with the Child is flanked, honoured, and adored by two archangels.[30] The most important Eastern examples are found in church apses in Cyprus (Kiti and Lythrankomi), in Nicaea and Gaza, in the aisle of Saint Demetrius in Thessaloniki, and in a chapel in the Dyrrachium Amphitheatre (Albania); and there are Western examples as well, in Poreč, Ravenna, and Rome.[31]

Interestingly, in the Dyrrachium mosaic the Child is missing.[32] Instead, the Virgin carries a very large globe, and on this basis Carlo Bertelli suggested that she was Saint Helena instead of Mary.[33] Helena, however, was not depicted before the ninth century and is never flanked by two angels, so the crowned woman holding a globe must be the Virgin. Nevertheless, in the accompanying Greek inscription the two kneeling patrons do not address the Virgin but rather

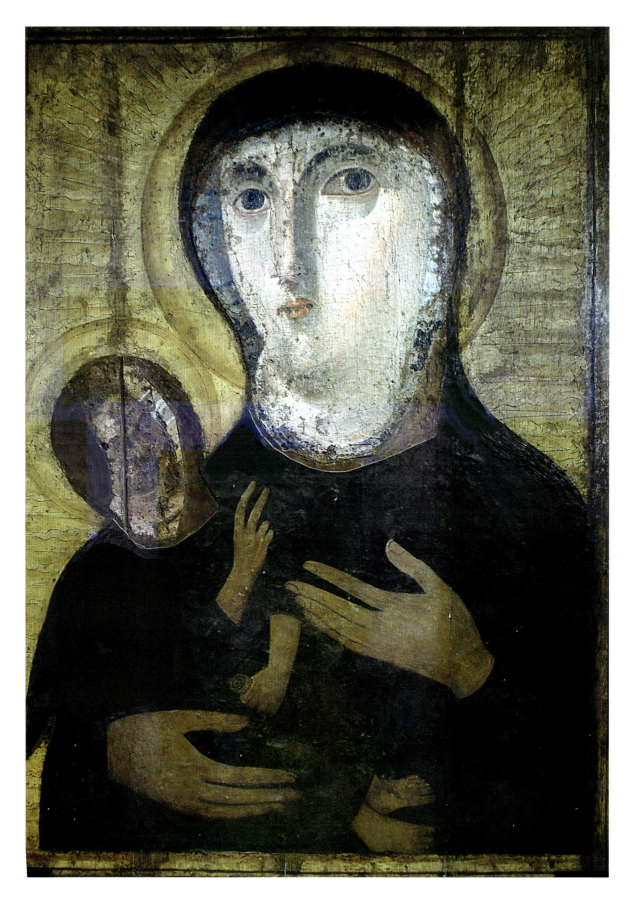

Santa Maria Nova (Santa Francesca Romana), icon of the Madonna and Child (photo: Beat Brenk)

Jesus Christ, asking him for mercy. A large medallion with the bust of Christ is represented on the adjacent wall. This mosaic helps us understand the function of the Maria Regina fresco in Santa Maria Antiqua as a likely ex-voto, although without a depiction of the patrons. Indeed, the images of the Virgin and Child in apses, and in the interior of churches and secular buildings are not necessarily indicative of the presence of a Marian cult. The central figure of these images is always Jesus Christ. It is possible that some of them expressed the worship of the Virgin, but it is impossible to offer conclusive evidence in this sense. Proclus of Constantinople explains the meaning of the Maria Regina image without mentioning it: 'Had the Word not dwelt in a womb, the flesh would never have sat on the throne [...] We do not preach a divinised man, but instead we confess an incarnate God'.[34]

Icons of the Mother of God appeared at the same time in both the East and in the West, from the late sixth and seventh century onwards, for example the two icons from Mount Sinai, one of which is now in the Chanenko Museum in Kiev.[35] These were gifts to the monastery of Saint Catherine made by wealthy pilgrims from Constantinople and elsewhere, who donated icons in thanks for having survived their arduous journey; and they owe their outstanding state of conservation to the fact that they were carefully stored upon their arrival at the monastery. If they had been kissed, touched, doused with incense, and hung at eye level in the narthex or in the aisles, their state of conservation would be much worse.

The production of icons became so important in Rome by the seventh century that the Anglo-Saxon monk Benedict Biscop, on his various journeys to Rome (beginning in 653), is recorded as having acquired 'copia [...] picturas imaginum sanctarum' ('many [...] paintings with holy figures'), which he brought back to his monastery in Wearmouth.[36] These picturas were icons that were hung on the wooden horizontal beam of the templon. When the Roman monk Augustine and his fellow missionaries met King Ethelbert in Kent in 597 they 'approached the king carrying a silver cross as their standard, and the likeness of our Lord and Saviour painted on a board'.[37] This is the earliest compelling evidence for the presence in England of an icon coming from Rome.

The first preserved and datable icon of the Mother of God in Rome is the one in the Pantheon (Figure 3).[38] When Pope Boniface IV (608–15), by permission of Emperor Phocas, converted the Pantheon into a church dedicated to the Mother of God—Sancta Maria ad Martyres—an unknown person, presumably either the pope or the emperor himself, installed a large icon of the Hodegetria, probably in a side room, where it was used by worshippers for prayer.[39] Since the Emperor donated several precious objects to the Pantheon, it would make sense to include the icon among these imperial gifts.[40] Moreover, as the Pantheon is mentioned in the lists of the stationary liturgy as if it were a cathedral, it is possible that the icon was carried around during processions and shown to the Roman public.[41] Mary's gilded hands recall Eastern rather than Western customs.[42] Even if many issues around the Pantheon icon remain open to debate, its outstanding survival as a datable, contextualised, and highly prominent icon of the Mother of God is undisputed.[43] Because of the eminent significance of the Pantheon as an ancient building, as a church dedicated to the Mother of God, and as a church destined for stationary liturgy, I presume that this icon was, in many respects, an incunabulum.

If the icon of the Pantheon was indeed one of the earliest icons of the Virgin in Rome, then the icon today in Santa Francesca Romana (Figure 2) is likely to belong to the same period,

3 Pantheon, icon of the Madonna and Child and its graphic reconstruction (photo: Beat Brenk)

namely to the early seventh century. A third early icon of the Virgin in Rome is the Madonna Avvocata, the Virgin in Santa Maria del Rosario on Monte Mario that is also known as 'the Virgin who intercedes' ('la Vergine che intercede').[44] This was the only early Roman icon which had success in later periods, and it was copied several times. The provenance of all these early icons is unknown: Rome, Constantinople, and Palestine have all been suggested, but there is little evidence to support any of these hypotheses.

Extra-large icons such as those from Santa Francesca Romana and the Pantheon, must have been donations from high-ranking (imperial?) individuals, since the popes adopted this practice only from the eighth century onwards. The icon in Santa Maria in Trastevere seems to be one of the earliest examples.[45] The average believer would carry his private protective icon, roughly twenty to thirty centimetres in size, in a bag, or have it hung somewhere in his home. It appears that these early Roman icons were not used during the official liturgy but rather reserved for private cult. This was particularly true in the case of the Madonna Avvocata from Santa Maria del Rosario.

Two other eighth-century frescoes of Maria Regina deserve discussion here, as they help us understand the function of images in the church. The Maria Regina with Child, flanked by two female saints, in the northern aisle of San Clemente (Figure 4) was painted in a niche surely destined also for private prayer.[46] Indeed, the small altar that existed formerly in front of the niche points to the use of holding private masses for the Virgin and female saints.[47] A monumental Maria Regina was also the focus of the tomb of John VII in Old Saint Peter's.[48] So when the Maria Regina appears once again in a private context in the Chapel of Theodotus (Plates 27, 50: J1), are we not entitled to assume that there was an icon of this type worshipped above all by private individuals?[49] How else can we explain that so many ex-votos, icons, and niche-images linked to new forms of Marian worship featured so prominently in Santa Maria Antiqua? While the broad subject of the veneration of the Virgin exceeds the scope of this study, I wish to draw attention to those forms of worship that employed images and icons, a new phenomenon that occurred during this period. This cannot be considered a proper 'cult': a cult is an official ecclesiastical business, whose practice is chiefly manifested in liturgy, prayers, and processions. With these images, however, we are dealing with a purely individual practice.[50]

In order to better understand the Maria Regina as a private ex-voto, we need only look to the church of Santa Susanna. An important recent discovery in the church (Figure 5) sheds some light on the private use of images during the eighth century.[51] In the second half of that century, a wealthy member of the religious community at Santa Susanna took care that the fresco depicting Maria Regina flanked by two female saints, topped by an arch with the images of the two Johns, would be removed from the wall and placed inside a sarcophagus. Clearly, this ex-voto painting was part of a private prayer niche in the church and held a protective significance for the patron. The fragments buried in the sarcophagus, like a relic, tell us something of the enormous power attributed to images in this period.[52]

The elements presented so far suggest that a new form of worship of the Mother of God, based on icons, was initiated at the Pantheon. Most likely, this spark ignited a practice that then extended to Santa Maria Antiqua, where the Virgin was already being venerated privately in a guard-room with the Maria Regina image.

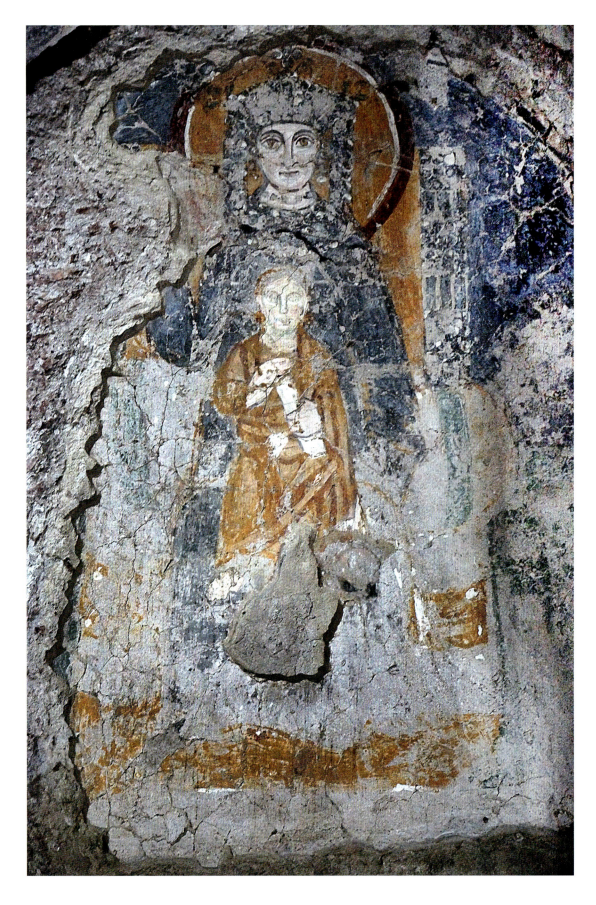

4 San Clemente, lower church, right aisle. *Maria Regina* and Child (photo: Beat Brenk)

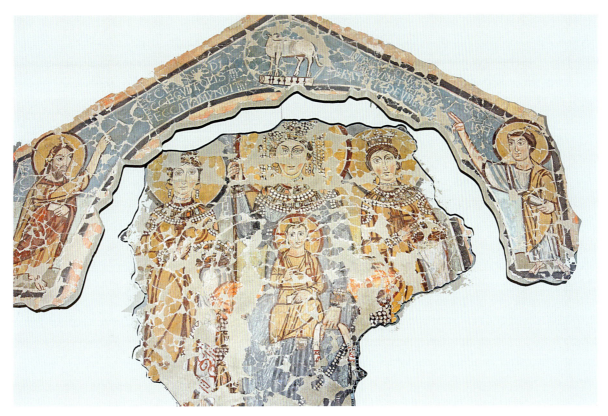

5 Santa Susanna. *Maria Regina* between female saints, and the Lamb between Saint John the Baptist and Saint John the Evangelist, re-assembled mural fragments (photo: Beat Brenk)

The meaning of the Annunciation scene

During the seventh century, depictions of the Annunciation proliferated dramatically. The first Annunciation in Santa Maria Antiqua was painted over the Maria Regina on the famous 'palimpsest' wall (Plates 37, 50: K1.4).[53] Shortly afterwards, two further depictions of this theme were added, both on the left-side pillar of the presbytery. On the front side (Plates 15, 50: E1.3), the earlier one dates to the period of Pope Martin I, while the second (Plates 18, 50: E4.1) corresponds to the redecoration carried out some fifty years later under Pope John VII.[54]

The Annunciation is the scene that best illustrates both the human and the divine natures of Jesus Christ, because John the Evangelist's statement (John 1.14) that the word became flesh ('verbum caro factum est') refers both to Gabriel's message to the Virgin and to the actual incarnation. Orthodox Christians, presumably including the patrons of these frescoes, wanted to defend and disseminate the theological doctrine of the two natures of Jesus Christ (Dyophysitism), established at the Council of Chalcedon in 451. The doctrine was proclaimed in response to the monophysites, who held that Christ had a single nature, a position that the Council condemned as heretical. The ex-voto images of the Annunciation, therefore, must have been chosen by patrons supporting the dyophysite doctrine, in all likelihood opponents of Byzantine Monotheletism living in Rome.[55] This is only a hypothesis, but it offers a plausible explanation for the conspicuous proliferation of Annunciation scenes in Santa Maria Antiqua. It is admittedly difficult, if not impossible, for an artist to represent convincingly the two

wills of Jesus Christ in an image. We must therefore entertain the possibility that artists fell on the Annunciation as the most effective solution to illustrate the doctrine of the two natures of Christ. If this hypothesis should turn out to be correct, it would indicate that the earliest Annunciation scenes in Santa Maria Antiqua reflected the ongoing discussion between imperial-Constantinopolitan monophysites and Palestinian-papal dyophysites.[56] An important point in this discussion was reached with Sophronius' Synodical Letter (634), where he wrote that 'divine acts were performed according to the divine nature, and the human acts were performed according to the human nature'.[57]

If these supposed opponents of Monophysitism could get away with painting anti-monophysite and anti-monothelete declarations next to the administrative centre of imperial Byzantium in Rome, then we must assume that the members of this Greek administration had turned away from the imperial doctrine and had sided with the papal party.[58] The frescoes in Santa Maria Antiqua could only originate in an atmosphere of reconciliation and mutual respect. At any rate, the imperial administration on the Palatine had no reason to oppose Monophysitism and Monotheletism; they left it to the Palestinians living in Rome and to the Romans themselves—in other words, to the Pope. Pope Theodore (642–49) was called from Jerusalem to Rome to strengthen the position of the Roman Church against Monotheletism, and he assisted with the preparations for the Lateran Council of 649 at which this 'heresy' was condemned.[59] In Booth's words, he was 'a Hellenophone pope with significant ties to Palestine',[60] and the first of a series of pontiffs of eastern Mediterranean origin.

Sophronius of Jerusalem's fundamental work on this theological issue was his Synodical Letter of 634, in which he assigned a decisive role to the previously cited passage from John's Gospel.[61] The biblical text is discussed in considerable detail. A contemporary of Sophronius, Germanus of Constantinople, in a homily on the theme of the Presentation of the Virgin in the Temple, observed: 'the Word has married the flesh'.[62] In a list of wondrous deeds, Sophronius similarly called the Annunciation 'the conception without seed',[63] and elsewhere he wrote 'the fleshless becomes flesh […] and the bodiless one is embodied as we are; and the one revealed as always God in truth becomes a human being'.[64] Sophronius expressed similar thoughts in his sermon on the Annunciation written between 634 and 638,[65] and also in his Oratio de Hypapante,[66] but in the Synodical Letter he developed his arguments in greater detail.[67] In his sermon On the Annunciation, Andrew of Crete wrote in a similar vein that 'Gabriel […] mediates between divinity and humanity'.[68] I thus contend that the first Annunciation in Santa Maria Antiqua, which covered the Maria Regina on the 'palimpsest' wall, was painted during the decade of the 630s. The other representations of the Annunciation followed immediately afterwards. If this hypothesis is correct, we have to assume that the apse of the church was not constructed when the former imperial building was converted into a Christian basilica (before 572), but only during the 630s. In other words, the sixth-century church did not have an apse, but preserved the original rectangular niche. Be that as it may, the apparent multiplication of Annunciation scenes finds its explanation only in the context of the doctrinal conflict between the Byzantine emperor, the patriarch, and Sophronius of Jerusalem.

Later, during the Lateran Council of 649, the quotation from John 1.14 played an important role. As the Church Fathers depicted on the 'palimpsest' wall carry scrolls with texts from the florilegium included in the Acts of the Council (Plates 40, 50: K1.4),[69] we may assume

that there was a direct link between the various images of the Annunciation and the Lateran Council, and that the painted ex-votos perhaps expressed the dyothelete doctrine in a more 'popular' way.[70]

Phase III: from the private worship of the Mother of God to the worship of the Holy Mothers during the seventh century

The church of Santa Maria Antiqua was barely completed when the veneration of the Virgin and of the saints was drastically transformed. The new element was the introduction of images of Holy Mothers such as Solomone (Plates 40, 50: E2.3), Anne, and Elizabeth, together with the Virgin Mary herself (Plates 20, 50: F1.1). Their Greek inscriptions point to Greek-speaking patrons. The fact that ex-voto images were installed means that there was either a relic or an icon present, guaranteeing redemption and salvation to the believers. As no source ever mentions relics in Santa Maria Antiqua, we may assume that there was instead a miraculous image, most probably an icon of Maria Regina or of the Hodegetria, before which believers could express their gratitude.

What was the meaning of the other ex-votos? The icon-like fresco of Mary's mother, Saint Anne (Plates 44, 50: K3), marks an innovation in Rome.[71] It constitutes the earliest evidence for the veneration of the saint in the West, although her veneration in Constantinople had commenced already under Justinian I (527–65).[72] In the second century, the author of the Protevangelium of James had explored the issue of Anne's childlessness or sterility, and compared her and Joachim with her daughter Mary and Joseph. Anne's childlessness was discussed by the eighth-century Byzantine homiletic Kosmas Vestitor in his sermon On the Holy Joachim and Anna.[73] That her prayer—after twenty years of sterility—was heard by God was interpreted as an important step in the history of Salvation, leading to the incarnation of Jesus Christ. In popular belief, Anne was invoked by sterile married couples who wished to have children.[74] The fresco of Saint Anne measures only 116 by 39.5 centimetres and looks like an icon, but it is in fact an ex-voto whose donor is unknown. Anne's face is painted in a technique that resembles encaustic, very similar to the famous Sinai icon of the Virgin, and it may be that the fresco was copied from a real icon, or that it simply imitated the technique typical of icons.[75] Since this layer of decoration was covered by a later layer added under John VII, which however deliberately left the image of Saint Anne visible, the mural must date to the second half of the seventh century. In a homily on the presentation of the Mother of God, Germanus of Constantinople wrote that Anna changed her continuous sterility into happy fertility.[76]

To a later period belongs the niche in the right aisle with the representation of three Holy Mothers (Plates 19, 20).[77] The pregnancies of Anne, Mary, and Elizabeth were all foretold by angels, and the mothers are represented with their children: Anne with Mary, Mary with Jesus, and Elizabeth with John the Baptist. In his Oratio in SS. Deiparae Annuntiationem, Sophronius compares Anne with the Mother of God and calls her a pure virgin, infertile like her daughter, who would miraculously give birth to a son without ever having lain with a man.[78]

A third fresco in Santa Maria Antiqua deals again with the theme of motherhood. It depicts the mother of the Maccabees, Solomone, with her seven sons (Plate 14), a large panel in which any reference to their martyrdom (4 Maccabees 5.1–17.6) is strictly avoided.[79] It looks rather

like a family photo celebrating fertility. Interestingly, Solomone is dressed like the Mother of God with a dark violet maphorion, and is the only person with a halo. The worship of the Maccabees seems to have started in the fourth century.[80] The synagogue of Antioch, for instance, was constructed over the tombs of the seven Maccabees, and some relics were brought to Constantinople in 551.[81] Around 570, the so-called 'Pilgrim of Piacenza' visited Antioch and described nine Maccabee tombs, above which were hung the instruments of their martyrdom.[82] A late medieval inscription in the Roman church of San Pietro in Vincoli records that Pope Pelagius (I or II?) placed their bodies there ('corpora sanctorum condens ibi Machabaeorum').[83] This inscription cannot be a later invention since the Martyrologium Romanum mentions the passion of the seven brothers in Antioch on the first of August, and states that their relics had been brought to San Pietro in Vincoli. The inscription 'AGIA SOLOMONH'[84] on the Santa Maria Antiqua fresco denotes her as a forerunner of the Mother of God, drawing thus a direct comparison with Mary. The inscription is the same as the one on the icon-like representation of the Virgin in the schola cantorum, already mentioned here. In other words: Solomone was the actual addressee of the prayers of the believers, and most probably of married couples wishing for children. The fresco is usually dated to the seventh century. The images of Mary, Anne, Elizabeth, and Solomone glorified mothers who were granted fertility for their faith.

Phase IV: the introduction and meaning of Eastern medical saints under Pope John VII

David Knipp has demonstrated convincingly that an impressive group of Eastern medical saints was introduced to the diaconicon of Santa Maria Antiqua (Plates 47–50: L1-4) in the time of Pope John VII.[85] He suggested that the possible model for the fresco in the niche (Plates 48, 50: L1.1), depicting five medical saints, was Egyptian or Palestinian, and most probably a triptych.

As the diaconicon was reserved for the clergy, and as the paintings there are not a private ex-voto, it must have been the clergy who were responsible for the choice of this subject. It follows that the veneration of medical saints had become a prerogative of the Church. I am not certain that the diaconicon would have been a place for incubation, as Knipp proposed, since incubation usually took place in the narthex and atrium. Barachisius, Dometius, Panteleimon, John of Edessa, Celsus, Abbacyrus, Cosmas, Damian, Stephen, Prokopios all carry boxes with surgical instruments (Plates 47–9). Cosmas and Damian came from Arabia and made their careers in Syria.[86] John and Abbacyrus were Egyptian doctors and remained unknown in the West until the seventh century.[87] Sophronius was healed from an eye disease during his visit to their shrine at Menuthis, near Alexandria, and between 610 and 614 he wrote an account of their miracles.[88] It is possible, though not provable, that Sophronius introduced the cult of Cyrus and John in Rome; at a later moment, both saints were represented in the atrium of the church (Plates 4, 50: A4).[89] Altering Knipp's conclusion slightly, I propose that the establishment of a cult of Eastern medical saints in Santa Maria Antiqua had its roots in a predominantly Eastern monastic environment. The administration on the Palatine was Byzantine, but the wave of immigrants from Egypt, Syria, and Palestine brought completely new cultural references to Rome. Syria was conquered by the Arabs in 635, Palestine in 638, and Egypt in 641: the number of refugees to the West was considerable. John Moschus travelled with Sophronius from Antioch

to Alexandria, and when the Persians invaded Egypt in 614 they both fled to North Africa and then to Rome, where Moschus wrote his Pratum spirituale (Spiritual Meadow), in which he recorded anecdotes from the monasteries in Palestine and Egypt.[90]

In the second Secretarius of the Lateran Council of 649 there is a petition subscribed by thirty-six Greek-speaking abbots, priests, and monks who had established themselves in Rome ('plurimi reverendissimi abbates, presbyteri et monaci Graeci, jam per annos habitantes in hac Romanae civitate, nec non in praesenti adventantes') where we find the earliest mention of Greek monasteries in the city, as Jean-Marie Sansterre has pointed out.[91] The document mentions four individuals by name: 'Joannes, Theodorus, Thalassius, Georgius'. These were highly prominent personalities: abbot John was the leader of the monastery of Saint Sabas, southeast of Bethlehem; Theodore was the hegoumenos (abbot) of a laura near Carthage; Abbot Thalassius came from Armenia, and was probably the leader of a monastic community on the Esquiline, the so-called Monastery of Renatus; and George came from Cilicia, and was the leader of the monastery ad acquas Salvias near San Paolo Fuori le Mura (now Santi Vincenzo e Anastasio alle Tre Fontane). Thirty-fourth on the *petitio* addressed to Martin I is no less than Maximus the Confessor, who had lived in Rome since 646 and was the actual father of the Acts of the Lateran Council. The monks, priests, and abbots mentioned in the Secretarius, coming from middle-eastern regions like Syria, Palestine, and Egypt, formed an entire front against Byzantine Monotheletism at the time when Pope Theodore (642–49) was invited to the papal cathedra; however, none of them came from Constantinople.

It is difficult to imagine that in such an atmosphere a monothelete or monophysite from Constantinople would have consented to an ex-voto in Santa Maria Antiqua, by far the only church in the Mediterranean to have murals painted in different styles. It is impossible to tell where the artists came from; but it is possible to define the meaning of some of the frescoes and their religious background, which is never Constantinopolitan. Kitzinger's thesis that the frescoes depicting Solomone and Saint Anne were painted by Constantinopolitan painters is, therefore, unsupported. This thesis was developed in opposition to scholars like Myrtilla Avery and, particularly, Charles Rufus Morey, who developed the history of late antique art uniquely as a history of style.[92] Morey believed that the various forms of Greek Hellenism in Attica, Asia Minor, and Alexandria were important sources of early Christian art. For Kitzinger, however, 'Hellenism' meant Constantinople *tout court*.[93] He introduced the problematic concept of 'perennial Hellenism' in late antique art, developing a thesis of Alberto de Capitano d'Arzago.[94] Other possible sources of 'Hellenism' were excluded categorically, in the belief that Constantinople 'ultimately assumed undisputed leadership in the arts'.[95] Kitzinger believed firmly in the 'importance of Constantinople as a center and guardian of the Hellenistic tradition in pre-Iconoclastic art',[96] and many scholars followed suit.[97] Kitzinger's thesis was based mainly on silver plates from the time of the Emperor Heraclius (610–41) in Constantinople.[98] Instead of regarding it as a living tradition, I prefer to consider the 'Hellenism' of the seventh-century silver plates a socially and intellectually ambitious 'antique' form of (sometimes imperial) rhetoric, which was chosen deliberately for politically important issues. A historian like Niketas Choniates, for instance, used Greek literature from Homer to late antiquity as a matter of course. Kitzinger's theory is also hampered by the absence of frescoes or mosaics preserved in Constantinople that give compelling evidence for either 'Hellenism' or 'Classicism'.[99]

Moving on from this debate, this essay is not, as I clarified in the introduction, focused on the history of style, but on the various forms of worship and doctrine in Santa Maria Antiqua. All the theological and doctrinal issues discussed here do not point to Constantinople but rather to Palestine and Egypt. There is no way to connect the paintings in the church with Constantinopolitan monophysite and monothelete theology. The people in Rome who were involved in the fight against these 'heresies' came from Palestine: Sophronius, Maximus, and Pope Theodore. It could well be that some of the frescoes in Santa Maria Antiqua were painted by refugee artists from these places, though there is no conclusive evidence to support the hypothesis.

In Rome there is at least one monument that deserves our attention because of its possible connection with Palestine: San Saba (Cella Nova) on the Little Aventine Hill. Around the middle of the seventh century, a certain John from the Sabas monastery near Jerusalem lived in San Saba in Rome. As Coates-Stephens has noted, 'early references to Cella Nova belong unequivocally to the seventh century, and therefore represent contemporary evidence for the arrival of Greek-speaking monks on the Aventine at this time.'[100] Monks from San Saba were sent from Rome to Constantinople to participate in the ecumenical councils of 680–1 and 787,[101] a fact that contributes to demonstrate a potential link between San Saba and the Byzantine capital. But, according to Booth, 'the settlement of Moschus himself at Cella Nova is, of course, pure speculation'.[102] Booth explored the possible relationship between Moschus and Cella Nova in a surprising way: 'Moschus included within the Spiritual Meadow a seemingly original tale that celebrated [Pope] Gregory's generosity toward a Palestinian monastic pilgrim at Rome […] but within the context of the Meadow's composition at Rome, it perhaps also constitutes something of a foundation myth for the community at Cella Nova, a retrospective (and portentous) celebration of papal patronage of eastern monks in exile'.[103] These considerations suggest the likelihood that painter-monks from Palestine were responsible for the frescoes preserved in San Saba, giving us a possible source also for the frescoes in Santa Maria Antiqua.[104]

1. Beat Brenk, 'Kultgeschichte versus Stilgeschichte: von der "raison d'être" des Bildes im 7. Jahrhundert in Rom', in *Uomo e spazio nell'alto medioevo*. (Spoleto: Centro Italiano di Studi sull'Alto Medioevo, 2003), pp. 971–1053.

2. Per Jonas Nordhagen, 'The Earliest Decorations in Santa Maria Antiqua and their date', *Acta ad archaeologiam et artium historiam pertinentia*, 1 (1962), 53–72; Per Jonas Nordhagen, 'The Frescoes of John VII (A.D. 705–707) in S. Maria Antiqua in Rome', *Acta ad archaeologiam et artium historiam pertinentia*, 3 (1968); and Per Jonas Nordhagen, 'S. Maria Antiqua: the Frescoes of the Seventh Century', *Acta ad archaeologiam et artium historiam pertinentia*, 8 (1978), 89–42.

3. In addition to his contribution to the present volume, see also Robert Coates-Stephens, 'The Forum Romanum in the Byzantine Period', *Marmoribus Vestita. Miscellanea in onore di Federico Guidobaldi*, ed. by O. Brandt and P. Pergola (Vatican City: Pontificio Istituto di Archeologia Cristiana, 2011), pp. 385–408. For the Oratory, see J. Rasmus Brandt, 'The Oratory of the Forty Martyrs: From Imperial Hall to Baroque Church', in *Santa Maria Antiqua al Foro Romano cento anni dopo: atti del colloquio internazionale, Roma, 5–6 maggio 2000*, ed. by J. Osborne, J. R. Brandt, and G. Morganti (Rome: Campisano, 2004), pp. 137–52; and Ernesto Monaco, 'L'aula dell'Oratorio dei XL Martiri' al Foro Romano. Considerazioni sulla fase originaria', *ibid.*, pp. 167–86.

4. Robert Coates-Stephens, 'Byzantine Building Patronage in post-Reconquest Rome', *Les cités de l'Italie tardo-antique (IVe–VIe siècle)*, ed. by M. Ghilardi (Rome: École française de Rome, 2006), pp. 149–66 (p. 158). See also Jean-Marie Sansterre, 'Jean VII (705–707): idéologie pontificale et réalisme politique', *Rayonnement grec. Hommages à Charles Delvoye*, ed. by L. Hadermann-Misguich and G. Raepsaet (Brussels: Editions de l'Université de Bruxelles, 1982), pp. 377–88 (p. 384), who notes that the church was 'fréquentée par les fonctionnaires impériaux qui résidaient dans le palais'.

5. Andrea Augenti, 'Continuity and Discontinuity of a Seat of Power: the Palatine Hill from the fifth to the tenth century', *Early Medieval Rome and the Christian West. Essays in Honour of Donald A. Bullough*, ed. by J. Smith (Leiden: Brill, 2000), pp. 43–53 (p. 50).

6. For Poreč: Ann Terry and Henry Maguire, *Dynamic Splendor: The Wall Mosaics in the Cathedral of Eufrasius at Poreč*, 2 vols (University Park, PA: Pennsylvania State University Press, 2007), pp. 4–5, 164–6. For Grado: Gisella Cantino Wataghin, Letizia Ermini Pani, and Pasquale Testini, 'La cattedrale in Italia. Schede', in *Actes du XIe congrès international d'archéologie chrétienne (Lyon, Vienne, Grenoble, Genève, Aoste, 21–28 septembre 1986)*, ed. by N. Duval, 3 vols, Publications de l'École française de Rome, 123 (Rome: École française de Rome, 1989), I, pp. 89–229 (p. 196).

7. For Santi Cosma e Damiano, see Phil Booth, 'Orthodox and Heretic in the Early Byzantine Cult(s) of Saints Cosmas and Damian', in *An Age of Saints? Power, Conflict and Dissent in Early Medieval Christianity*, ed. by P. Sarris, M. Dal Santo, and P. Booth (Leiden: Brill, 2011), pp. 114–28; and Beat Brenk, 'Zur Einführung des Kultes der heiligen Kosmas und Damian in Rom', *Theologische Zeitschrift*, 62 (2006), 303–15. For Sant'Adriano, see Filippo Coarelli in the *Lexicon Topographicum Urbis Romae*, ed. E.M. Steinby, 6 vols (Rome: Quasar, 1993–2000) [hereafter *LTUR*], I, pp. 170–3. According to Filippo Coarelli (*LTUR*, I, pp. 131–2) the atrium, and perhaps also the building in which Santa Maria Antiqua was later installed, formed part of the library of the *Domus Tiberiana*. See also Richard Delbrück, 'Der Südostbau am Forum Romanum', *Jahrbuch des deutschen archäologischen Instituts* 36 (1921), 8–33 (p. 21), and the contributions by David Knipp and Henry Hurst elsewhere in this volume.

8. *Le Liber Pontificalis: texte, introduction, et commentaire*, ed. by L. Duchesne, 2 vols. (Paris: Ernest Thorin, 1886–92) [hereafter *LP*], I, 385; trans. in Raymond Davis, *The Book of Pontiffs (Liber Pontificalis): the ancient biographies of the first ninety Roman bishops to AD 715*, 3rd rev. ed., Translated Texts for Historians, 6 (Liverpool: Liverpool University Press, 2010), p. 86.

9. Hans Belting, 'Eine Privatkapelle im frühmittelalterlichen Rom', *Dumbarton Oaks Papers*, 41 (1987), 55–69.

10. Nordhagen, 'The Earliest Decorations'; and Beat Brenk, *The Apse, the Image and the Icon. An Historical Perspective of the Apse as a Space for Images* (Wiesbaden: Reichert, 2010), pp. 79–81, 101–3.

11. Brenk, 'Kultgeschichte versus Stilgeschichte', p. 1005, fig. 20.

12. Andrea Paribeni, 'Giacomo Boni e il mistero delle monete scomparse', in *Marmoribus Vestita. Miscellanea in onore di Federico Guidobaldi*, ed. by O. Brandt and P. Pergola (Vatican City: Pontificio Istituto di Archeologia Cristiana, 2011), pp. 1003–23.

13. Richard Krautheimer and others, *Corpus Basilicarum Christianarum Romae*, 5 vols (Vatican City: Pontificio Istituto di Archeologia Cristiana, 1937–1977) [hereafter *CBCR*], II, 259–68; see also Federico Guidobaldi and Alessandra Guiglia Guidobaldi, *Pavimenti marmorei di Roma dal IV al IX secolo* (Vatican City: Pontificio Istituto di Archeologia Cristiana, 1983), pp. 280–348.

14. A. Guiglia Guidobaldi, 'La decorazione marmorea dell'edificio di Santa Maria Antiqua fra tarda antichità e alto medioevo', in *Santa Maria Antiqua al Foro Romano cento anni dopo: atti del colloquio internazionale, Roma, 5–6 maggio 2000*, ed. by J. Osborne, J. R. Brandt, and G. Morganti (Rome: Campisano, 2004), pp. 49–62.

15. Averil Cameron, 'The Theotokos in Sixth-Century Constantinople', *Journal of Theological Studies*, 29 (1978), 79–108 (p. 94); and Richard Price, 'Theotokos. The Title and its Significance in Doctrine and Devotion', in *Mary: The Complete Resource*, ed. by S. J. Boss (London: Continuum, 2007), pp. 56–74.

16 Beat Brenk, 'Papal Patronage in a Greek Church in Rome', in *Santa Maria Antiqua al Foro Romano cento anni dopo: atti del colloquio internazionale, Roma, 5–6 maggio 2000,* ed. by J. Osborne, J. R. Brandt, and G. Morganti (Rome: Campisano, 2004), pp. 67–81, figs 2–6.

17 *LP*, II, 14 (life of Leo III, 795–816): 'cyborium ex argento purissimo'.

18 Ernst Kitzinger, 'On Some Icons of the 7th Century', in *Late Classical and Medieval Studies in Honor of Albert Mathias Friend Jr.*, ed. by K. Weitzmann (Princeton: Princeton University Press, 1955), pp. 132–50. In a digression on the icon in Santa Francesca Romana, Kitzinger notes that the view that this 'Madonna was painted in Rome and reflects a mingling of currents peculiar to the Roman school receives support from a comparison with the two indubitably Eastern panels on Mount Sinai' (p. 136).

19 *LP*, II, 145 (life of Benedict III, 855–8): 'Fecit autem in basilica beatae Dei genitricis qui vocatur Antiqua, quam a fundamentis Leo papa viam iuxta Sacram construxerat, vela'. Later, in the life of Pope Nicholas II (858–67) (ibid., II, 158), we read: 'Ecclesiam autem Dei genitricis semperque virginis Mariae, que primitus Antiqua, nunc autem Nova vocatur, quam domnus Leo IIII papa a fundamentis construxerat, sed picturis eam minime decorarat, iste beatissimus praesul pulchris ac variis fecit depingi coloribus'.

20 Nordhagen, 'Frescoes of the Seventh Century', pp. 103–4, and fig. 5. The mutilated Greek inscription on the red frame reads 'MATTION'. See also the important contribution by Per Jonas Nordhagen, 'Icons Designed for the Display of Sumptuous Votive Gifts', *Dumbarton Oaks Papers*, 41 (1987), 453–60, figs 2–4.

21 Nordhagen, 'Frescoes of the Seventh Century', p. 130; and Robert P. Bergman, 'The Earliest *Eleousa*: A Coptic Ivory in the Walters Art Gallery', *The Journal of the Walters Art Gallery*, 48 (1990), 37–56.

22 Nordhagen, 'Frescoes of the Seventh Century', pp. 122–4, and fig. 9.

23 See Adolf Weis, 'Ein vorjustinianischer Ikonentypus in S. Maria Antiqua', *Römisches Jahrbuch für Kunstgeschichte*, 8 (1958), 19–68; and Franz Alto Bauer, 'La frammentazione liturgica nella chiesa romana del primo medioevo', *Rivista di Archeologia Cristiana*, 75 (1999), 385–446.

24 Arthur H. S. Megaw and Andreas Stylianou, *Zypern: byzantinische Mosaiken und Fresken* (Paris: UNESCO, 1963), plates 3–4; and Christa Ihm, *Die Programme der christlichen Apsismalerei vom vierten bis zur Mitte des achten Jahrhunderts* (Wiesbaden: Steiner, 1960), pp. 189–90, pl. 18.2.

25 Nordhagen, 'Icons designed for the display', p. 454.

26 Averil Cameron, 'The Language of Images: The Rise of Icons and Christian Representation', in *The Church and the Arts*, ed. by D. Wood, Studies in Church History, 28 (Oxford: Blackwell, 1992), pp. 1–42 (p. 9); and Brenk, *The Apse, the Image and the Icon,* fig. 36.

27 Nordhagen, 'Icons designed for the display'. Coates-Stephens, 'Byzantine Building Patronage', p. 160: 'Theotokos foundations not initially listed in the *Liber Pontificalis*, and which can be broadly dated to the period of Rome's Byzantine dominion, may therefore be assigned to Byzantine patronage, either public (SMA) or […] private.'

28 Ernst Kitzinger, 'The Cult of Images before Iconoclasm', *Dumbarton Oaks Papers*, 8 (1954), 96–109; Averil Cameron, 'The Theotokos in sixth-century Constantinople'; Averil Cameron, 'The Cult of the Virgin in Late Antiquity: Religious Development and Myth-Making', in *The Church and Mary*, ed. by R. Swanson, Studies in Church History, 39 (Woodbridge: Boydell & Brewer, 2004), pp. 1–21; Cyril Mango, 'The Chalkoprateia Annunciation and the Pre-Eternal Logos', *Deltion tes christianikes archaiologikes hetaireias*, 17 (1993–4), 165–70; and Cyril Mango, 'Constantinople as Theotokoupolis', in *Mother of God. Representations of the Virgin in Byzantine Art*, ed. by M. Vassilaki (Milan: Skira, 2000), pp. 17–25. See also Nicholas Constas, *Proclus of Constantinople and the Cult of the Virgin in Late Antiquity: Homilies 1–5* (Leiden: Brill, 2003); Price, 'Theotokos. The Title and its Significance in Doctrine and Devotion'; John Osborne, 'Images of the Mother of God in Early Medieval Rome', in *Icon and Word. The Power of Images in Byzantium. Studies presented to Robin Cormack*, ed. by A. Eastmond and L. James (Aldershot: Ashgate, 2003), pp. 135–51; and Gregor M. Lechner, 'Maria', in *Reallexikon der byzantinischen Kunst*, ed. by K. Wessel (Stuttgart: A. Hiersemann, 1966–), VI (2005), pp. 17–114.

29 John Wortley, 'The Marian Relics of Constantinople', *Greek, Roman and Byzantine Studies*, 45 (2005), 171–87. Averil Cameron, 'The Early Cult of the Virgin', in *Mother of God. Representations of the Virgin in Byzantine Art*, ed. by M. Vassilaki, pp. 3–15 (p. 12): 'Justin II (565–578), made benefactions in her honour at Blachernai and Chalkoprateia, the two churches in Constantinople holding her robe and her girdle'.

30 Robin Cormack, 'The Mother of God in Apse Mosaics', in *Mother of God. Representations of the Virgin in Byzantine Art*, ed. by M. Vassilaki, pp. 91–105.

31 John Osborne, 'The Roman Catacombs in the Middle Ages', *Papers of the British School at Rome*, 53 (1985), 278–328 (pp. 299–305); Eugenio Russo, 'L'affresco di Turtura nel cimitero di Commodilla, l'icona di S. Maria in Trastevere e le più antiche feste della Madonna a Roma', *Bullettino dell'Istituto Storico Italiano per il Medioevo e Archivio Muratoriano*, 88 (1979), 35–85, and 89 (1980–81), 71–150; and Brenk, *The Apse, the Image and the Icon*, p. 92.

32 Heide Buschhausen and Helmut Buschhausen, 'Durazzo und die Anfänge des Christentums in Albanien', *Zeitschrift der österreichischen Gesellschaft für Denkmal-und Ortsbildpflege*, 120 (2001), 13–15 (figs 7–9, pp. 20–2).

33 Carlo Bertelli, 'La pittura medievale a Roma e nel Lazio', in *La pittura in Italia. L'altomedioevo*, ed. by C. Bertelli (Milan: Electa, 1994), p. 238 note 36.

34 Constas, *Proclus of Constantinople*, p. 59.

35 Kurt Weitzmann, *The Monastery of Saint Catherine at Mount Sinai. The Icons. From the sixth to the tenth century* (Princeton: Princeton University Press, 1976), plates 3–6.

36 *Venerabilis Bedae Opera Historica*, ed. C. Plummer (Oxford: Clarendon Press, 1896), p. 369: 'he brought back many holy pictures of the saints to adorn the church of St. Peter he had built: a painting of the Mother of God, the Blessed Mary Ever-Virgin, and one of each of the twelve apostles which he fixed round the central arch on a wooden entablature reaching from wall to wall'. See also Suse Pfeilstücker, *Spätantikes und germanisches Kunstgut in der frühangelsächsischen Kunst: nach lateinischen und altenglischen Schriftquellen* (Berlin: Deutscher Kunstverlag, 1936), pp. 138–9; and Julius von Schlosser, 'Beiträge zur Kunstgeschichte aus den Schriftquellen des frühen Mittelalters', *Sitzungsberichte der kaiserlichen Akademie der Wissenschaften in Wien. Philosophisch-historische Klasse*, 123 (1891), pp. 66–9.

37 *Venerabilis Bedae Opera Historica*, 25

38 Brenk, 'Kultgeschichte versus Stilgeschichte', pp. 974–88.

39 Jean-Marie Sansterre, 'Entre deux mondes? La vénération des images à Rome et en Italie d'après les textes des VIe-XIe siècles', in *Roma Fra Oriente e Occidente* (Spoleto: Centro Italiano di Studi sull'Alto Medioevo, 2002), pp. 993–1050 (pp. 1000–1); Jean-Marie Sansterre, 'La vénération des images à Ravenna dans le haut moyen âge: notes sur une forme de dévotion peu connue', *Revue Mabillon*, 68 (1996), 5–21; Sible de Blaauw, 'Das Pantheon als christlicher Tempel', *Boreas*, 17 (1994), 13–26 ; Pietro Amato, *De vera effigie Mariae: Antiche Icone Romane* (Milan: Mondadori, 1988), pp. 34–9; Carlo Bertelli, 'La Madonna del Pantheon', *Bollettino d'arte*, 46 (1961), 24–32; and Rodolfo Lanciani, 'Prima relazione sui lavori intrapresi per l'isolamento del Pantheon', *Notizie degli Scavi. Atti della Reale Accademia dei Lincei: Memorie*, 9 (1881), 367–406 (p. 397). For the form and content of such prayers, see Cameron, 'The Theotokos', pp. 82–6.

40 *LP*, I, p. 317: 'in qua ecclesia princeps dona multa obtulit'.

41 Stephen J.P. van Dijk, 'The Urban and Papal Rites in Seventh and Eighth-Century Rome', *Sacris Eruditi*, 12 (1961), 411–87 (p. 432).

42 Mango, 'Constantinople as Theotokoupolis'; Hans Belting, *Bild und Kult: eine Geschichte des Bildes vor dem Zeitalter der Kunst* (Munich: Beck, 1991), p. 133; Nordhagen, 'Icons designed for the display'; Klaus Parlasca, *Mumienporträts und verwandte Denkmäler* (Wiesbaden: Steiner, 1966), pp. 136–7; George Soteriou and Maria Soteriou, *He basilike tou hagiou Demetriou Thessalonikes* (Athens: En Athenais, 1952), p. 192 plate 62; Samson Eitrem, *Opferritus und Voropfer der Griechen und Römer* (Kristiania: Dybwad, 1915), pp. 192–7.

43 Bertelli, 'La Madonna del Pantheon', p. 25. Bertelli (p. 28) calls the Pantheon Madonna a Roman work whereas the 'Madonna in S. Maria Nuova' (Santa Francesca Romana) is described as 'grecizzante' (Greek-like). David Wright, 'The Shape of the Seventh Century in Byzantine Art', *First Annual Byzantine Studies Conference (Cleveland, 1975). Abstracts*, pp. 9–28 (p. 19), assumes that the icon from the Pantheon 'could have been sent from Constantinople'.

44 Amato, *De vera effigie Mariae*, pp. 42–9; see also *Tavole miracolose: Le icone medioevali di Roma e del Lazio del fondo edifici di culto*, ed. by G. Leone (Rome: Palazzo di Venezia, 2012), pp. 42–6, figs 1–9.

45 Bertelli, *La Madonna di Santa Maria in Trastevere*.

46 John Osborne, 'Early Medieval Painting in San Clemente, Rome: the Madonna and Child in the Niche', *Gesta*, 20 (1981), 299–310.

47 F. Guidobaldi, *San Clemente: Gli edifici romani, la basilica paleocristiana e le fasi altomedievali* (Rome: Collegio San Clemente, 1992), pp. 193–7, figs 181–2; Franz Alto Bauer, 'Überlegungen zur liturgischen Parzellierung des römischen Kirchenraums im frühen Mittelalter', in *Bildlichkeit und Bildorte von Liturgie*, ed. by R. Warland (Wiesbaden: Reichert, 2002), pp. 75–103; and Arnold Angenendt, *Offertorium. Das mittelalterliche Messopfer*, Liturgiewissenschaftliche Quellen und Forschungen, 101 (Münster: Aschendorff, 2013).

48 Ann van Dijk, 'Jerusalem, Antioch, Rome and Constantinople: The Peter Cycle in the Oratory of Pope John VII (705–707)', *Dumbarton Oaks Papers*, 55 (2001), 305–28.

49 Belting, 'Eine Privatkapelle'.

50 Nordhagen, 'Frescoes of the Seventh Century', pp. 136–8 and 141–2, offers a very interesting analysis of the use of ex-votos.

51 Ursula Nilgen, 'Eine neu aufgefundene Maria Regina in Santa Susanna, Rom. Ein römisches Thema mit Variationen', in *'Bedeutung in den Bildern': Festschrift für Jörg Traeger zum 60. Geburtstag*, ed. by G. Schüssler (Regensburg: Schnell & Steiner, 2002), pp. 231–43. See also Ursula Nilgen, 'Maria Regina—ein politischer Kultbildtypus?', *Römisches Jahrbuch für Kunstgeschichte*, 19 (1981), 1–32.

52 See the comments on the Santa Susanna mural by Maria Andaloro elsewhere in this volume.

53 Nordhagen, 'Frescoes of the Seventh Century', pp. 93–5, pl. 2.

54 On the possible interventions carried out under Martin I, see Nordhagen, 'Frescoes of the Seventh Century', pp. 107–9, plates 24–5.

55 Monotheletism, or the belief in a single 'will', was a

seventh-century development of Monophysitism. See Elena Zocca, 'Onorio e Martino: due papi di fronte al monotelismo', in *Martino I Papa (649–653) e il suo tempo. Atti del XXVIII Convegno storico internazionale* (Spoleto: Cenro Italiano di Studi sull'Alto Medioevo, 1992), pp. 103–47; George Nedungatt and Michael Featherstone, *The Council in Trullo Revisited* (Rome: Pontificio Istituto Orientale, 1995); Daniel J. Sahas, *Icon and Logos: Sources in Eighth Century Iconoclasm*, Toronto Medieval Texts and Translations, 4 (Toronto: University of Toronto Press, 1986); and Brenk, *The Apse, the Image and the Icon*, pp. 101–7.

56 *PG* 98, 305. See also Sophronius of Jerusalem in *PG* 87, 3233C and 3240.

57 Phil Booth, *Crisis of Empire. Doctrine and Dissent at the End of Late Antiquity* (Berkeley: University of California Press, 2014), pp. 236–7. In his Synodical Letter from 634, Sophronius mentions Jesus Christ's 'hunger, thirst, fatigue, walking and suffering', demonstrating 'his willing and salvific condescension to the experiences of human nature', and Jesus Christ's miraculous, marvellous, and wondrous deeds, that is 'conception without seed, the transformation of water into wine, the healing of the sick'.

58 See also Eileen Rubery, 'Papal Opposition to Imperial Heresies', *Studia Patristica*, 50 (2011), 3–28; and Eileen Rubery, 'Conflict or Collusion? Pope Martin I (649–54/5) and the exarch Olympius in Rome after the Lateran Synod of 649', *Studia Patristica*, 52 (2012), 339–74.

59 Booth, *Crisis of Empire*, p. 262.

60 Ibid., p. 262.

61 *PG* 87.3, 3161B, and 3161D; Pauline Allen, *Sophronius of Jerusalem and Seventh-Century Heresy. The Synodical Letter and Other Documents* (Oxford: Oxford University Press, 2009), p. 197.

62 In his theological pamphlets, Maximus the Confessor does not address this issue before 640; see Booth, *Crisis of Empire*, pp. 265–6.

63 Allen, *Sophronius of Jerusalem*, p. 108.

64 Ibid., p. 87.

65 *PG* 87.3, 3201–3364.

66 *PG* 87.3, 3293C: 'ut exsistens in ipso Deus vere factus homo'. This text is preserved only in Latin.

67 Bartholomaeus M. Xiberta, *Enchiridion de verbo incarnate* (Madrid : Matriti, 1957), p. 643 : 'Nos [...] secundum subsistentiam Verbi ad carnem [...] convenientiam praedicamus et unum Christum et Filium incarnatum Verbum obsecramus, et unam eius subsistentiam compositam dicimus, et in duabus eum annuntiamus naturis [...] et unam Dei Verbi naturam in eo incarnatam glorificamus'. Sophronius stresses the meaning of the Nativity and of the Crucifixion because both are evidence of the human nature of Jesus Christ, see ibid., p. 645: 'quia et veraciter factus est homo et naturam nostram habuit indiminute, et circumscriptionem carnis suscepit et habitum nobis competentem indutus est [...] Idcirco esuriens cibabatur, ideo sitiens potabatur [...] sed et dum caederetur dolebat et verberatus patiebatur et dolores sustinuit corporis, manus et pedes in cruce transfixus'.

68 Andrew of Crete, *On the Annunciation*, c. 4, in *PG* 97.889.

69 Booth, *Crisis of Empire*, p. 189; and Rudolf Riedinger, 'Die Lateransynode von 649 und Maximos der Bekenner', *Atti del XXVIII Convegno storico internazionale* (Spoleto: Centro Italiano di Studi sull'Alto medioevo, 1992), pp. 111–21.

70 In a detailed analysis of these texts, however, Booth (*Crisis of Empire*, p. 190) has demonstrated that the dyothelete texts are not as dogmatic as one might expect them to be. In the late eighth century, when the Byzantine emperor, the patriarch, and Sophronius of Jerusalem had long overcome the doctrinal conflict, the *Annunciation* was painted in an apse vault of the presbytery of Santa Sofia at Benevento. The choice of the apse vault indicates that the clerics of Benevento were convinced that the *Annunciation* would be the best vehicle to represent the doctrine of the two natures of Jesus Christ.

71 Henry. M. Bannister, 'The Introduction of the Cultus of St. Anne into the West', *English Historical Review*, 18 (1903), 107–12; Eva Tea, *La Basilica di S. Maria Antiqua* (Milan: Società Editrice 'Vita e Pensiero', 1937), pp. 176–7; and Brenk, *The Apse, the Image and the Icon*, pp. 104–5.

72 Procopius, *De aedificiis* I.3; under Justinian II, after 705, the church was restored. Relics were brought from Jerusalem to Constantinople; see Bannister, 'The Introduction of the Cultus of St. Anne', p. 109.

73 Kosmas Vestitor, *On the Holy Joachim and Anna,* c. 7, in *PG*, 106.1011.

74 *Dictionnaire d'archéologie chrétienne et de liturgie*, ed. by F. Cabrol and H. Leclercq, 15 vols (Paris: Letouzy et Ané, 1907–53), I.2, cols 2162–74; *Marienlexikon*, ed. by R. Bäumer (St. Ottilien: EOS, 1988–94), I, cols 154–8; and Lothar Heiser, *Maria in der Christus-Verkündigung des orthodoxen Kirchenjahres* (Trier: Paulinus, 1981), pp. 63–75.

75 Nordhagen, 'Frescoes of the Seventh Century', pp. 100–3, plates 17–20.

76 Germanus of Constantinople, *Homily on the Feast of the Presentation of the Virgin in the Temple*, c.2, in *PG* 98, 293.

77 Joseph Wilpert, *Die römischen Mosaiken und Malereien der kirchlichen Bauten vom IV. bis XIII. Jahrhundert*, 4 vols, (Freiburg im Breisgau: Herder 1916), IV, pl. 194; and Tea, *Basilica di S. Maria Antiqua*, pp. 177, 284–5.

78 Sophronius of Jerusalem, *Oratio II in SS. Deiparae annuntiationem,* in *PG* 87.3, col. 3259.

79 Myrtilla Avery, 'The Alexandrian Style at S. Maria

Antiqua, Rome', *The Art Bulletin*, 7 (1925), 131–49 (p. 141); and Pietro Romanelli and Per Jonas Nordhagen, *S. Maria Antiqua* (Rome: Istituto poligrafico dello Stato, 1964), pl. II.

80 Cyprian, *Ad Fortunatum*, 11, in *PL* 4, col. 667, ep. 56; *PL* 4, col. 349; Ambrose, *De Iacob et vita beata* II.10–11, in *PL* 14, cols 632–5; John Chrysostom, *De Eleazar et septem pueris*, 7, in *PG* 63, cols 523–30; Gregory of Nazianzus, in *PG* 35, cols 912–33; Gregory of Nazianzus, *Third Homily on the Maccabees*, in *PG* 35, col. 627. See also Martha Vinson, 'Gregory Nazianzen's Homily 15 and the Genesis of the Christian Cult of the Maccabean Martyrs', *Byzantion*, 64 (1994), 166–92.

81 Gregory of Nazianzus in *PG* 35, col. 912.

82 Herbert Donner, *Pilgerfahrt ins Heilige Land. Die ältesten Berichte christlicher Palästinapilger (4.–7. Jahrhundert)* (Stuttgart: Verlag Katholisches Bibelwerk 1979), p. 313.

83 *Dictionnaire d'archéologie chrétienne et de liturgie*, X.1, cols 724–7 (p. 725).

84 Nordhagen, 'The Earliest Decorations', p. 62.

85 David Knipp, 'The Chapel of the Physicians at Santa Maria Antiqua', *Dumbarton Oaks Papers*, 56 (2002), 1–23. See also Nordhagen, 'The Frescoes of John VII', pp. 55–66.

86 Brenk, 'Zur Einführung des Kultes'.

87 Peter Sinthern, 'Der römische Abbacyrus in Geschichte, Legende und Kunst', *Römische Quartalschrift für christliche Altertumskunde*, 22 (1908), 196–239.

88 Booth, *Crisis of Empire*, pp. 43–89.

89 John Osborne, 'The Atrium of S. Maria Antiqua, Rome: a history in art', *Papers of the British School at Rome*, 55 (1987), 186–223 (pp. 199, 205–9).

90 Johannes Moschus, *Pratum spirituale*, in *PG* 87, 2851–3112; Booth, *Crisis of Empire*, pp. 90–116.

91 Jean-Marie Sansterre, *Les moines grecs et orientaux à Rome aux époques byzantine et carolingienne (milieu du VIe s.–fin du IXe s.)*, 2 vols (Brussels: Palais des Académies, 1983), I, p. 9. See also Booth, *Crisis of Empire*, p. 298.

92 Avery, 'The Alexandrian Style at S. Maria Antiqua'; and Charles Rufus Morey, *Early Christian Art*, 2nd ed. (Princeton: Princeton University Press, 1953).

93 Kitzinger, 'Byzantine Art in the Period between Justinian and Iconoclasm', repr. in *The Art of Byzantium and the Medieval West: Selected Studies*, ed. by W.E. Kleinbauer (Bloomington, IN: Indiana University Press, 1976), pp. 157–206 (pp. 159–72).

94 Gian Piero Bognetti, Gino Chierici, Alberto de Capitano d'Arzago, *Santa Maria di Castelseprio* (Milan: Fondazione Treccani degli Alfieri per la storia di Milano, 1948), pp. 686–7, speak of a continuous Constantinopolitan court style ('arte aulica di Costantinopoli perenne'), but dismiss evidence for a classicising pictorial current in Byzantine art.

95 Kitzinger, *Byzantine Art in the Making*, p. 1.

96 Kitzinger, 'Byzantine Art in the Period between Justinian and Iconoclasm', p. 172.

97 Nordhagen, 'The Frescoes of John VII', pp. 106–14; P.J. Nordhagen, 'Constantinople on the Tiber: the Byzantines in Rome and the iconography of their images', *Early Medieval Rome and the Christian West. Essays in Honour of Donald A. Bullough*, ed. by J.M.H. Smith (Leiden: Brill, 2000), pp. 113–34; Kurt Weitzmann, 'The Classical Heritage in the Art of Constantinople', in *Studies in Classical and Byzantine Manuscript Illumination*, ed. by H. Kessler (Chicago: University of Chicago Press, 1971), pp. 126–50; Kurt Weitzmann, 'The Classical in Byzantine Art as a Mode of Individual Expression', ibid., pp. 151–75; and Kurt Weitzmann, '*Loca Sancta* and the Representational Arts of Palestine', *Dumbarton Oaks Papers*, 28 (1974), 31–55 (p. 35): 'In Constantinople, especially at the imperial court, such classical style had survived in greater purity than in any other Mediterranean center'. See also Wright, 'The Shape of the Seventh Century', pp. 9–28.

98 Brubaker questioned the implicit assumption of Byzantine supremacy in seventh- and eighth-century Rome, and concluded that 'the frescoes of S. Maria Antiqua no longer function as a pale reflection of lost and lamented Constantinopolitan exemplars but allowed considerable autonomy'; see Leslie Brubaker, '100 Years of Solitude: Santa Maria Antiqua and the History of Byzantine Art History', in *Santa Maria Antiqua al Foro Romano*, ed. by J. Osborne, J.R. Brandt, and G. Morganti, pp. 41–6.

99 Kitzinger was fully aware of this problem, see 'Byzantine Art in the Period between Justinian and Iconoclasm', p. 166: 'The lack of tangible continuity among the monuments of hellenistic character also hampers the task of defining the style more precisely in geographical and historical terms'.

100 Robert Coates-Stephens, 'San Saba and the *Xenodochium de Via Nova*', *Rivista di Archeologia Cristiana*, 83 (2007), 223–56 (p. 226). See also Paul Styger, 'Die Malereien in der Basilika des hl. Sabas auf dem kl. Aventin in Rom', *Römische Quartalschrift für christliche Altertumskunde*, 28 (1914), 49–96; Pasquale Testini, *San Saba*, (Rome: Edizioni Roma, 1961); and Giulia Bordi, *Gli affreschi di S. Saba sul piccolo Aventino. Dove e come erano* (Milan: Jaca Book, 2008).

101 Coates-Stephens, 'San Saba', p. 230.

102 Booth, *Crisis of Empire*, p. 112.

103 Ibid., pp. 115, 147–51.

104 This was already suggested by Kurt Weitzmann, 'Various Aspects of Byzantine Influence on the Latin Countries from the sixth to the twelfth centuries', *Dumbarton Oaks Papers*, 20 (1966), 1–24 (p. 9).

AFTERWORD

MARIA ANDALORO

The icon of Santa Maria Nova after Santa Maria Antiqua

Rome, 16 March 2016: the return of the icon[1]

The weather forecast predicted the possibility of rain for the afternoon of 16 March 2016; but in the end a beautiful sky, resplendent with clouds and bursts of light, stretched above the Forum at sunset as the icon of the Virgin and Child was brought from the church of Santa Maria Nova (today better known as Santa Francesca Romana) to Santa Maria Antiqua where, with good reason, it is believed to have been housed originally (Figure 1). The physical journey covered no more than three hundred and fifty metres (Figures 2–3), but in chronological terms crossed millennia, framed by the majestic landscape of the ancient Forum: the Arch of Titus, the Basilica of Maxentius, the so-called 'Temple of Romulus', the Temple of Antoninus and Faustina, and the *Curia Senatus* (Figure 4). Before us was the Capitoline Hill, where the imposing wall of the Palazzo Senatorio, between the *Tabularium* (first century BCE) and the offices of the Mayor of Rome, has witnessed the passage of twenty-one centuries (Figure 5). Its windows open on an unparalleled view, brimming with echoes of the ancient and medieval city.[2] Walking through the Forum, with its magnificent classical and post-classical ruins, thoughts naturally turn to the historical memories elicited by the evocative archaeological landscape, a juxtaposition of monuments, ruins, and fragments of buildings that conjure up the impression of a complex bundling of layers and materials: walls, stones, and marble (Figure 6). From all of this flows information, layers of meaning, and demands for understanding that each of us must grasp and attempt to comprehend according to our own knowledge and sensibilities. There was much for Sigmund Freud to dig into here.[3] He breathed in the essence of this place and transformed it into a metaphor for the basic 'palimpsest' structure of the human mind.[4] This view of the Roman Forum formed the background for the procession of the icon, as well as for the reflections stirred in the minds of all those present (Figure 7).

But why was the icon being moved? The return to its original church was one of the primary goals of the 'Santa Maria Antiqua tra Roma e Bisanzio' exhibition project, which began the following day on 17 March 2016 (Figure 8). From that point of view, the transfer constituted

a prelude; but for the participants it became an integral part of the exhibition itself (Figure 9), where pride of place was accorded to the icon, normally displayed in the sacristy of Santa Maria Nova, on the wall above the altar (Figure 10).[5] The painting depicts the Mother of God (*Theotokos*) with her Child, and one is immediately struck by the difference between the various parts of the figures. First and foremost, there is an unbridgeable chasm between the busts and their faces: at compositional level in their proportions, and but also in the seemingly unnatural grafting of the faces of the Virgin and Child onto their respective busts. In fact, the busts are modern, whereas the faces are ancient. And although they appear completely out of place in their present setting, they retain an unquestionable magnetic force. This is a magnificent and powerful painting, evincing the strength, vitality, and beauty of the work of bygone years, and also an unusual pictorial technique that contrasts with the rest of the image: the faces are executed in encaustic. Moreover, they attest to an extraordinary conservation history, the fruit of an exceptional recovery undertaken by Pico Cellini, who recognised the existence of an earlier level beneath the thirteenth-century image that he was restoring.[6]

It was 1950 and, hidden beneath a later medieval painting, an even earlier work came to light, one unanimously considered pre-iconoclastic. This was not only a 'Madonna molto antica', as Cellini called it, but it also constituted the earliest evidence in a Christian sacred image of the moment when the icon acquired life and breath.[7] This will explain why the face of the Santa Maria Nova *Theotokos* was placed very appropriately on the cover of the English

1 Santa Maria Nova (Santa Francesca Romana). 16 March 2016, the icon of the *Virgin and Child* leaves the church (photo: Gaetano Alfano 2016)

edition of Hans Belting's *Likeness and Presence*.[8] Indeed, Belting's study has been the centre of a debate concerning the nature and extent of the phenomenon of Christian imagery sometimes known as the 'iconic turn'.[9]

Returning to March 2016, many people were in attendance to accompany the icon on its journey across the Roman Forum. At the front were Olivetan monks from the monastery attached to the church of Santa Francesca Romana, wearing their white robes (Figure 2), followed by employees of the Montenovi company, carrying the icon and escorted by City of Rome police officers (Figure 3). Then came a diverse, festive crowd, with some taking a secular interest in the event, while others considered the procession a religious ceremony (Figure 7).[10] But for all those in attendance, the transfer of the icon transcended a simple functional necessity to become a truly special moment centred on the image of the Virgin *Theotokos* with her Child: from being an object for which all the suitable transport procedures had been put in place, the image became transformed during the procession into a functioning icon. As a work of art that requires preservation, the painting benefitted from a controlled environment; but as an icon, it became the object of devotion. Burning candles and wreaths of flowers were placed around it in the church during the liturgical celebration that preceded the transfer (Figure 11). The event was recorded on film, following the procession as it wound its way through the Forum.[11]

The same festive atmosphere characterised an event that I remember well, one that took place some twenty-five years earlier. On the morning of 8 December 1991, a spontaneous

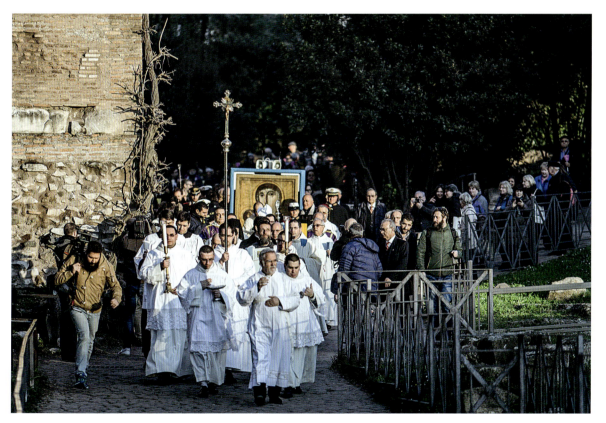

2 16 March 2016, journey of the icon along the *Via Sacra*. The procession is led by monks from the Olivetan congregation (photo: Gaetano Alfano 2016)

procession formed in the streets and alleyways of Trastevere to accompany the 'Enthroned Madonna and Child with Angels' back to the basilica of Santa Maria in Trastevere from the Istituto Centrale del Restauro located in Piazza San Francesco di Paola, where it had been brought for conservation in 1954.[12]

Forum processions and the icon

While it was not planned at the outset, the transfer of the icon on 16 March 2016, accompanied by crosses and candles, could not but evoke the Christian processions that wove the churches of the Roman Forum into their liturgical celebrations. There are two processions in particular for which the participation of the Santa Maria Nova icon is attested. The first is the *laetania* for the Feast of the Presentation in the Temple on 2 February.[13] In the form recorded in the time of Pope Sergius I (687–701), this began at the church of Sant'Adriano and ended at the basilica of Santa Maria Maggiore.[14] At a later date, the *Ordo* of Canon Benedict (1140–3) attests to a more elaborate and staged event whose significant moment was the arrival in the Forum of the eighteen *diaconiae*, each bearing an image that was carried by the clergy and people to Sant'Adriano. Meanwhile, the pope came with his cardinals and bishops to the adjacent church of Santa Martina, where he was vested, and candles were distributed, before joining the others in Sant'Adriano.[15] In the *Ordo*, the distinctive nature of the gathering at Sant'Adriano stands

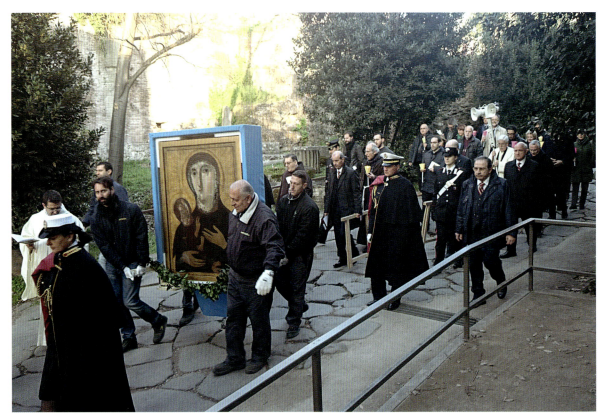

3 16 March 2016, the icon is carried by employees of the Montenovi company, flanked by police officers from the City of Rome (photo: Valeria Valentini 2016)

out, as it was enlivened by the presence of some eighteen images, among which there must have been also an icon from the *diaconia* church of Santa Maria Nova, possibly the *Theotokos* itself.[16]

The second procession was the famous one held for the Assumption, which took place on the night between the 14 and 15 of August, with its emotional and theatrical highpoint occurring at Santa Maria Nova. Outside on the church's steps, in a setting populated by monuments and memories – close to the Temple of Venus and Rome, the Arch of Titus and the Basilica of Maxentius – the meeting between the icon of the Saviour – the *Acheropita* of the Lateran[17] – and that of the Virgin took place. The two icons came together while their dialogue was recreated by the chorus of the worshippers.[18] The sources do not specify which Marian icon played this role, whether the *Salus Populi Romani* of Santa Maria Maggiore, the *Haghiosoritissa* of the *Monasterium Tempuli*, or the *Theotokos* with Child from Santa Maria Nova.[19] But my own vote goes without hesitation to the third, on the logical premise that the image of Christ would go to visit his mother in those churches that housed her image, namely Santa Maria Maggiore and Santa Maria Nova.

The first description of the Assumption procession appears in the biography of Pope Leo IV (847–55). The *Liber pontificalis* relates that on the night preceding the Feast of the Assumption the pope went in procession from the Lateran to Santa Maria Maggiore by way of the Forum, along the *Via Sacra*, stopping at Sant'Adriano and then passing by Santa Lucia in Selci.[20] Although this is the earliest reference, the procession itself was not new. It had an earlier history, as

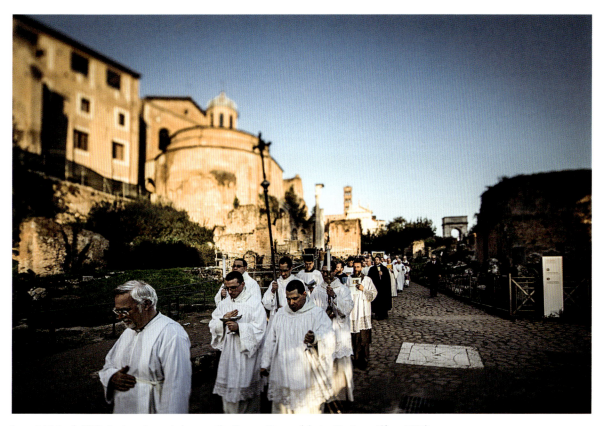

4 16 March 2016, the icon is carried across the Roman Forum (photo: Gaetano Alfano 2016)

implied by the phrase 'as is the custom' (*sicut mos est*) used in the *Liber pontificalis* passage. In fact, the *laetania* of the Assumption, along with those of the Annunciation, the Nativity of the Virgin, and the Presentation in the Temple, had been inaugurated by Pope Sergius I (687–701).[21] The procession under Leo IV, however, may not have been ordinary or routine. Following the collapse of Santa Maria Antiqua after the 847 earthquake, the pope had it replaced with a new church built nearby, on the east side of the Forum and across the *Via Sacra*, near the Arch of Titus, as the *Liber pontificalis* indicates.[22] This church was called Santa Maria Nova, and it received the property and prerogatives of its abandoned predecessor.[23] The *Liber pontificalis* also specifies the participation of the 'sancta icona' of the Lateran to the procession, the second mention of this image in the text. The first occurs in the account of the special penitential procession undertaken under Stephen II (752–57) to avert the Lombard attack.[24] This leads me to speculate that Leo IV's procession may too have had a penitential element, considering the calamity that had taken place in 847.

On the basis of a broadly shared reconstruction of the facts, following the abandonment of Santa Maria Antiqua after the earthquake the *Theotokos* and Child icon was rescued, probably very quickly. While the *Liber pontificalis* states explicitly that the new church was constructed and completed by Leo IV, this piece of information does not belong to his own biography, but rather to that of his successor Benedict III (855–8), and the name of the older church is still given as Santa Maria Antiqua.[25] The epithet 'Antiqua', however, is deliberately contrasted with Nova in the life of Pope Nicholas I (858–67), the pope who adorned the new church with pictures 'in a variety of beautiful colours' ('pulchris ac variis […] coloribus').[26] These accounts suggest that the construction of Santa Maria Nova required some years, apparently spanning the entire pontificate of Leo IV (†855) and then continuing after his death, with completion only under Pope Nicholas I. So, where was the icon during this time? On the basis of their locations in the immediate vicinity of the abandoned structure, I shall explore two possibilities: the Oratory of San Cesareo on the Palatine hill, in the area of the *Domus Augustana*, and the church of

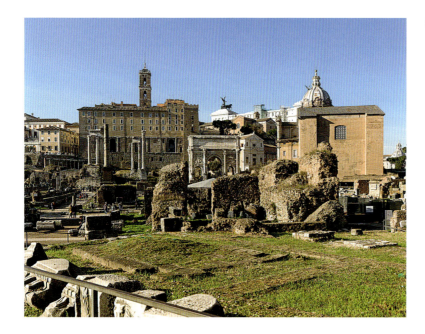

5 View of Palazzo Senatorio from the *Via Sacra* (photo: Gaetano Alfano 2016)

THE ICON OF SANTA MARIA NOVA AFTER SANTA MARIA ANTIQUA

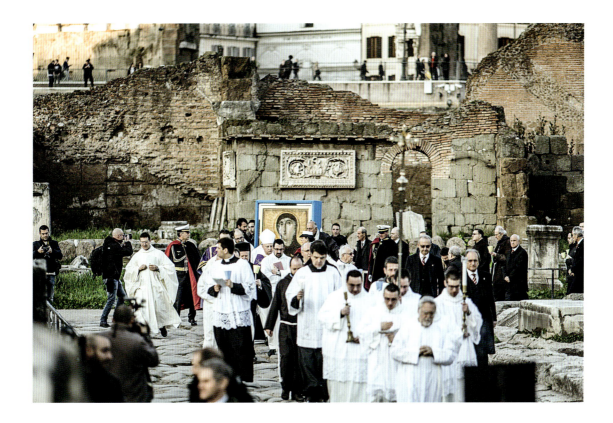

16 March 2016, icon procession across the Roman Forum, near the Basilica Emilia
(photo: Gaetano Alfano 2016)

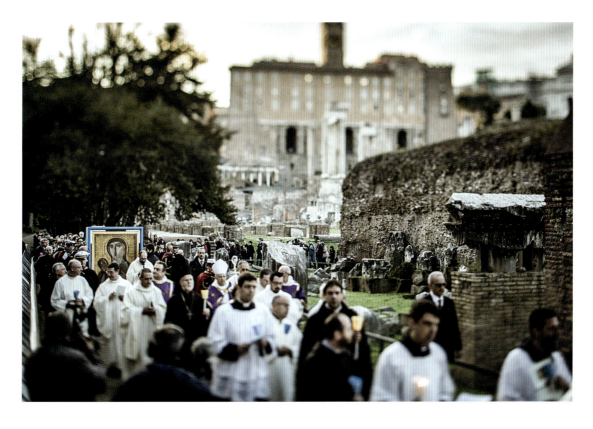

16 March 2016, the icon procession runs alongside the Temple of Castor and Pollux
(photo: Gaetano Alfano 2016)

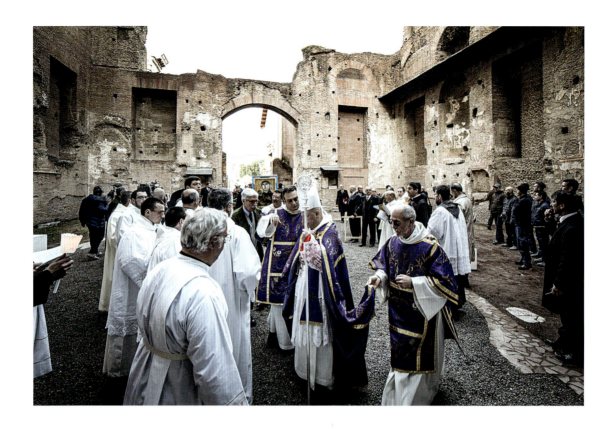

16 March 2016, the icon procession arrives in the Atrium of Santa Maria Antiqua
(photo: Gaetano Alfano 2016)

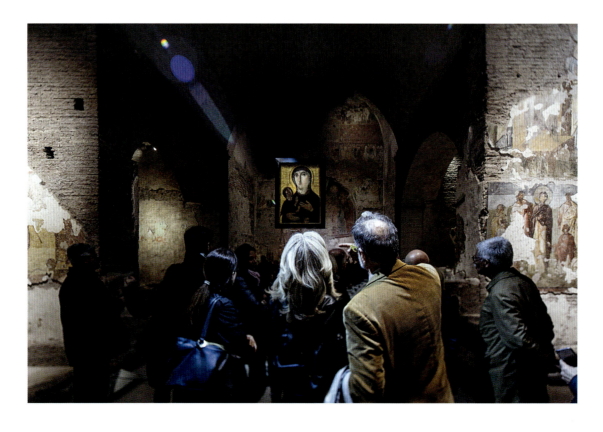

17 March 2016, the icon displayed in Santa Maria Antiqua
(photo: Gaetano Alfano 2016)

THE ICON OF SANTA MARIA NOVA AFTER SANTA MARIA ANTIQUA

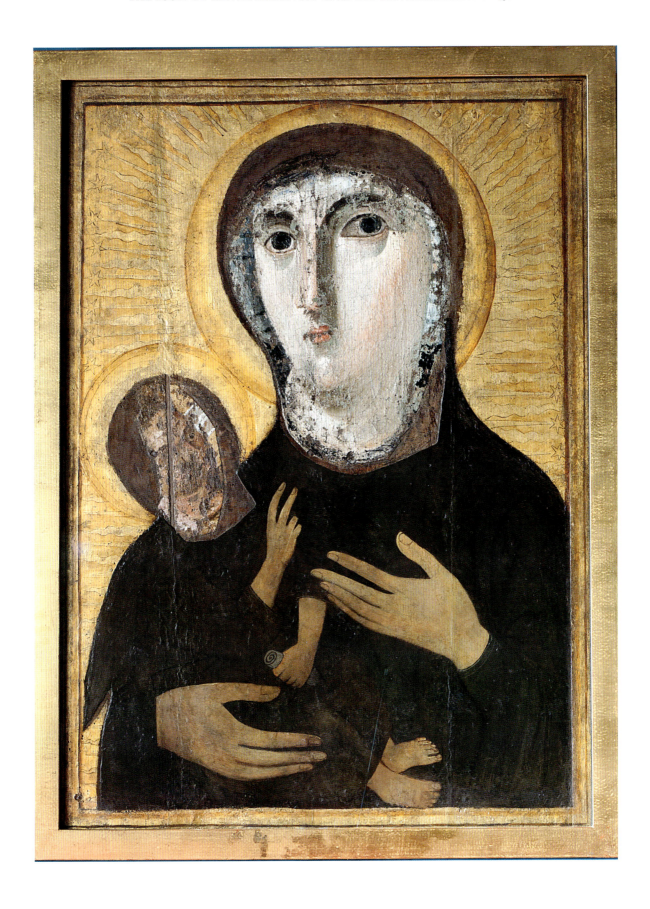

Santa Maria Nova (Santa Francesca Romana), sacristy. Icon of the *Virgin and Child*
(photo: Gaetano Alfano 2016)

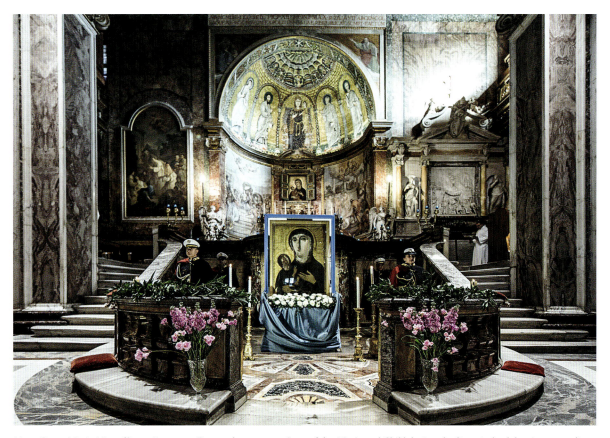

11　　Santa Maria Nova (Santa Francesca Romana), sanctuary. Icon of the *Virgin and Child* during the liturgical celebration preceding the transfer (photo: Gaetano Alfano 2016)

Sant'Adriano in the Forum.

The Oratory of San Cesareo has a complicated but significant history.[27] From the moment of its inauguration it probably functioned as a palace chapel, and it certainly did so at the junction of the sixth and seventh centuries, since in 604 it received the imperial images of Emperor Phocas and his consort Leontia, as we know from the correspondence of Pope Gregory I (590-604).[28] This episode confirms the Byzantine nature of the political and artistic climate in Rome in the aftermath of the Gothic Wars, at approximately the same moment that the apse was added to Santa Maria Antiqua, along with new mural decorations.[29] To San Cesareo Leo IV donated an altar cloth and eight *vela* ('Et in Monasterio sancti Cesarii in Palatio fecit vestem de fundato I et vela VIII').[30] But more than the gifts, which were modest, what is of interest here is the nature of the institution. According to the *Liber pontificalis*, it was a monastery from at least the year 825,[31] and I believe that it was precisely this status that may have made it unsuitable to receive the icon. As a monastery, and one housing a Greek community, it did not have the best credentials to play a significant role in papal politics, aimed at strengthening the sacred institutions of papal foundation in the most strategic zones of the Forum. Besides, San Cesareo would have appeared secluded on the Palatine Hill, while the abandoned church of Santa Maria Antiqua was being replaced with one at the easternmost border of the Forum, in an area dense with monuments and topographically at the centre of things, 'situated as if astride the *Via Sacra*, controlling urban traffic in general, and access to the Lateran more specifically'.[32]

In contrast to San Cesareo, Sant'Adriano seems a more likely candidate for the temporary storage and display of the icon (Figure 12). Like Santa Maria Antiqua, Sant'Adriano was also a converted ancient structure, the *Curia Senatus*;[33] and while its transformation dates from the pontificate of Honorius I (625–38), that of Santa Maria Antiqua had taken place a few decades earlier, probably in the time of the Emperor Justin II (565–78).[34] It is evident that Sant'Adriano and Santa Maria Antiqua shared essential aspects of their history, but they also differed in one important way: the former was a papal initiative, while the latter belonged to the context of the imperial Byzantine administration.[35]

Sant'Adriano is a church of great vitality and visibility. It was made a *diaconia* by Hadrian I (772–95) and, as noted previously, played a primary role in the development of processions, from the time of their origin through the late Middle Ages.[36] Later, in the early decades of the thirteenth century, it appears that Sant'Adriano did house the Santa Maria Nova icon for a time. This was a temporary transfer, undertaken at the request of Pope Honorius III (1216–27), in a moment when Santa Maria Nova was not functional due to fire damage to its interior. A detailed publication of these circumstances, here only summarised, can be found in a passage from Onofrio Panvinio, published by Andrea Augenti in 1996.[37] Beyond the mythical overtones and emphasis on miracles, this account provides a fundamental historical context that can help us clarify the icon's conservation history.

12 The *Curia Senatus* (Sant'Adriano) (photo: Gaetano Alfano 2016)

Preserved and discovered: the icon of Santa Maria Nova

As mentioned previously, the icon consists of two distinct parts. The first comprises the more recent figures of the *Theotokos* and her Child, painted probably at the end of the fifteenth century, and then repainted again in 1805 by Pietro Tedeschi;[38] and the second comprises the faces of the two figures, dating to a much earlier period. The faces, executed in encaustic, have been cut out of an image that is now lost, but which must have been of substantial size, proportionate to the surviving face of the Virgin. The face of the Child, moreover, reveals very evident traces of having been scorched. This fire damage, recognised immediately at the time of Cellini's discovery, finds confirmation in the known history of Santa Maria Nova. On the basis of older documents related to the history of the Frangipane family, Panvinio records that the church suffered a major fire.[39] The document makes reference to Pope Honorius III and the *Liber pontificalis* also records restoration work carried out under Honorius, including the addition of a new roof.[40] The new icon of the *Theotokos* and Child, still placed above the altar and incorporating the two faces cut out and salvaged from the earlier image, must therefore be dated to that time, the early decades of the thirteenth century (Figure 13). The history of the actual physical object and its role in processions is thus complete, thanks also to the evidence provided by its condition. It is now time to pull all the threads together.

The transfer of the icon from Santa Maria Nova to Santa Maria Antiqua for the 2016 exhibition, the brief summary of the processions in the Forum that may have included it, the facts and hypotheses concerning its display at different locations, as well as its extraordinary conservation history have not been included here as mere snippets of history. Rather, they constitute an instrument for assessing the properties of the icon: not only its power but also its dynamic and long-standing role in various aspects of Roman religious life over the course of the Middle Ages, with echoes even in the present day. The chapter of the icon's history that has been examined thus far is that after 847, when it left Santa Maria Antiqua.

Between these two phases we can place the icon's relocation from one church to the other: not a simple transfer but a truly watershed moment in the object's history.[41] From a church whose character was predominantly Greek, and one that had been established within the orbit of imperial power, remaining outside the papal sphere until the time of John VII (705–7), the icon was moved to a church that was a papal foundation in the middle of the ninth century.[42] From that moment on, the icon acquired a new role within the ebbs and flows of the religious, cultural, and devotional life of medieval Rome. We catch a glimpse of its presence in the most representative popular processions, Candlemas and the Assumption, and also as the seed giving rise to an example of twelfth-century antiquarianism. As proposed by Ernst Kitzinger in a famous study, Mary's face in the icon likely served as the model for her image in the apse mosaic of Santa Maria in Trastevere, not only in iconographic but also in stylistic terms.[43] The patron and donor of the mosaic, Pope Innocent II (1130–43), may have visited Santa Maria Nova. He was certainly very familiar with the Palatine, having sought shelter in the Frangipane fortresses there and in the Colosseum at the foot of the hill.[44] In an age that increasingly valued antiquarianism, it is not beyond the realm of possibility that Innocent II would have known the icon, particularly if we consider alongside his patronage of Santa Maria in Trastevere the additional role of *concepteur*.

13 Santa Maria Nova (Santa Francesca Romana), altar. Icon of the *Virgin and Child* (photo: Gaetano Alfano 2016)

We must also consider the icon's conservation history, an extraordinary journey marked by two key events: its survival from the earthquake of 847 and its subsequent disappearance – or, to be more precise, its recovery from Santa Maria Antiqua and then its subsequent preservation beneath a later painting of the second or third decade of the thirteenth century.

To sum up: the ancient image was damaged in a fire and the decision was made to salvage the faces of the Virgin and the Child, despite their poor condition, by cutting them out of their original support (Figure 10). It was then decided to create a new image, but to retain the original iconography (Figure 13). The result was no masterpiece and its proportions did not fit the size of the original. But the decision to maintain the salvaged parts of the original in the new image, buried under a layer of paint, transformed the icon into a reliquary: the ancient *Theotokos* and Child were invisible but present, preserved and then forgotten until their sensational rediscovery in the mid-twentieth century. The Santa Maria Nova icon went thus from maximum visibility to complete invisibility.

The icon is unique in this regard. Nevertheless, its unusual circumstances are evidence of an underlying attitude that we can observe elsewhere in the long history of Roman images, allowing us to discern a certain consistency within the larger phenomenon. On this occasion we shall explore a line of inquiry that is concerned with the memory of images and their

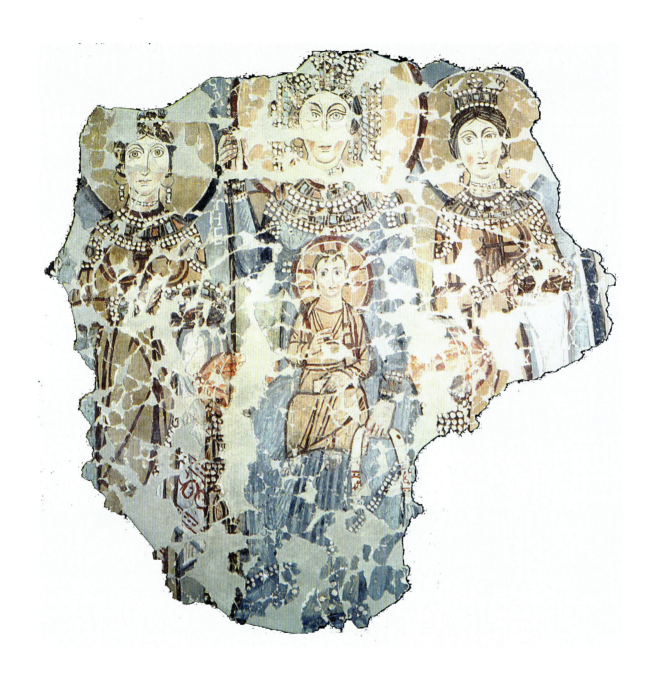

14 Santa Susanna. *Maria Regina* between female saints, re-assembled mural fragments
(photo: Maria Andaloro archive)

preservation, in response to religious and cultural needs inspired by practices of worship.

The practice of hiding an image and making it invisible leads us to the broader subject of the visibility and invisibility of images in rituals and ceremonials; for example, the various devices used to cover and uncover sacred images that the Middle Ages inherited from the ancient world. But it is also possible that the act of covering was not related to any religious practice, but rather intended simply to preserve the icon. An example in this sense is the Lateran *Acheropita* icon, carried in the penitential procession undertaken by Stephen II to counter the Lombard threat, the *sancta icona* that Leo IV followed as he guided a procession through the Forum on the night of 14 August and that rested on the steps of Santa Maria Nova to greet its Holy Mother. In the time of Pope Innocent III (1198–1216), this image was covered with a sheet of embossed silver, leaving only the face visible, which shortly thereafter was also covered with a painting on silk depicting the same subject.[45] The silver cover and the painted cloth served to conceal the original, which must by then have been very damaged from having been repeatedly carried in open-air processions and subjected to ritual cleansings.[46] At about this same time, the ancient encaustic panel from the basilica of Santa Maria in Trastevere changed its skin – and possibly also its aspect – through a substantial repainting.[47] This was done for several reasons: firstly, repainting was a common practice to refresh an image, but also to preserve one in poor physical condition by hiding it. As revealed in the 1954–55 restoration, the Santa Maria in Trastevere panel suffered large areas of loss, particularly in the lower section, in addition to other damages of various kinds. The repainting thus sacrificed the original appearance but, in return, preserved what remained.

The ancient image in Santa Maria Nova was also concealed deliberately, burying the two fragments beneath the new painting and rendering them invisible. As a result, even when the memory of this 'deposition' had been forgotten, their presence continued as material relics. This rather extreme instance of a negated image remaining physically present has one other parallel that deserves discussion: the painted fragments from the Roman church of Santa Susanna, salvaged and quite literally buried in a reused sarcophagus sealed beneath the new edifice built by Pope Leo III (795–816) around 800, never to be seen again. I had the good fortune to discover these fragments at the site on the morning of 14 September 1991, and thereafter to follow the journey leading to their restoration and re-assembly, and ultimately to their exhibition in the church's sacristy (Figure 14).[48] This discovery, widely regarded as unusual, reminded me immediately of the Santa Maria Nova icon, providing me with a useful context in which to set the new example of a 'burial' – even though in Santa Susanna it consisted of an entire pictorial composition, detached from the wall and intentionally interred. The 'deposition' of the Santa Susanna murals in a sarcophagus around 800 and the overpainting on the faces of the Santa Maria Nova icon in the early thirteenth century bear no specific connections. But it is evident that they have something important in common, as they bear witness to an idea encompassing the fields of tradition, memory, and preservation. Before the complete loss of a venerated icon, or of the murals in a small chapel, a preservation plan was put in place to prevent their physical destruction – at the price, however, of their disappearance from view. In this weaving of memory and physical preservation we find the roots of a distinctively Western attitude towards the survival of antique artworks, while other cultures do not place the same importance on the connection between the materiality of historical vestiges and their conservation.

1 The essay expands on various threads of a discussion first introduced at the 2013 Santa Maria Antiqua Conference and developed afterwards during the development of the exhibition 'Santa Maria Antiqua tra Roma e Bisanzio', displayed in the church from 17 March until 31 October 2016. This contribution forms part of a larger study in three parts: the medieval history of the icon beginning with its transfer to the church of Santa Maria Nova, following the abandonment of Santa Maria Antiqua in the aftermath of the 847 earthquake; the earlier history of the icon, from its installation in Santa Maria Antiqua until 847; and the icon in the larger context of iconic images within Santa Maria Antiqua. Only the first of these topics is addressed here.

2 For an overview of the ancient Roman Forum, see Fulvio Giuliani Cairoli and Patrizia Verduchi, *L'area centrale del Foro romano* (Florence: Olschki, 1987); and Filippo Coarelli, *Roma* (Rome: Laterza, 2008). For the Christianisation of the Forum, see Lucrezia Spera, 'La cristianizzazione del Foro romano e del Palatino. Prima e dopo Giovanni VII', in *Santa Maria Antiqua tra Roma e Bisanzio. Exhibition Catalogue (Roma, basilica di Santa Maria Antiqua al Foro romano, rampa imperiale, 17 marzo–11 settembre 2016)*, ed. by M. Andaloro, G. Bordi, and G. Morganti (Milan: Electa, 2016), pp. 96–109. For the Forum in the Middle Ages, see Mirella Serlorenzi, 'All'origine del Medioevo. Passeggiando nel Foro romano', in *Santa Maria Antiqua tra Roma e Bisanzio*, ed. by M. Andaloro, G. Bordi, and G. Morganti, pp. 110–29.

3 Sigmund Freud, *Das Unbehagen in der Kultur* (Wien: Internationaler Psychoanalytischer Verlag, 1930), pp. 14–15.

4 Maria Andaloro and Serena Romano, 'Arte e iconografia a Roma da Costantino a Cola di Rienzo: una premessa', in *Arte e iconografia a Roma da Costantino a Cola di Rienzo*, ed. by M. Andaloro and S. Romano (Milan: Jaca Book, 2000), pp. 7–9 (p. 7).

5 Pico Cellini, 'Una Madonna molto antica', *Proporzioni*, 3 (1950), 1–8; and Maria Andaloro, 'Icona con Hodigitria', in *Aurea Roma: Dalla città pagana alla città cristiana (Roma, Palazzo delle Esposizioni, 22 dicembre 2000–20 aprile 2001)*, ed. by S. Ensoli and E. La Rocca (Rome: L'Erma di Bretschneider, 2001), pp. 661–2, repr. 'La Vergine e il Bambino', in *Santa Maria Antiqua tra Roma e Bisanzio*, ed. by M. Andaloro, G. Bordi, and G. Morganti, pp. 194–6.

6 Cellini, 'Una Madonna molto antica', pp. 2–3.

7 During the same decade (1950s), other ancient icons were discovered in Rome: the icon of Santa Maria in Trastevere and the 'Haghiosoritissa del Monasterium Tempuli': Carlo Bertelli, *La Madonna di Santa Maria in Trastevere. Storia, iconografia, stile di un dipinto romano dell'VIII secolo* (Rome: n.p. 1961); and Carlo Bertelli, 'L'immagine del "Monasterium Tempuli" dopo il restauro', *Archivium Fratrum Predicatorum*, 31 (1961), 83–6. This also coincided with the rediscovery of the icons preserved in the Monastery of Saint Catherine at Mount Sinai, published by Georgios and Maria Sotiriou, *Eikones tes Monès Sina* (Athens: n.p. 1956–8). For an overview of painted icons in the age before Iconoclasm, in both Rome and the eastern Mediterranean, see Hans Belting, *Bild und Kult. Eine Geschichte des Bildes vor dem Zeitalter der Kunst* (Munich: Oscar Beck, 1990).

8 The English version of Belting's book, *Likeness and Presence. A History of the Image before the Era of Art*, trans. by E. Jephcott (Chicago: University of Chicago Press, 1994), is substantially different from the German original (see preceding note) and also the Italian translation: *Il culto delle immagini. Storia dell'icona dall'età imperiale al tardo Medioevo* (Rome: Carocci, 2001). See Andrea Pinotti and Antonio Somaini, 'Introduzione', in *Teorie dell'immagine: Il dibattito contemporaneo*, ed. by A. Pinotti and A. Somaini (Milan: Raffaello Cortina, 2009), pp. 9–35.

9 Pinotti and Somaini, 'Introduzione'.

10 The procession of the icon across the Forum was preceded by a liturgical celebration at the altar of the church of Santa Maria Nova, to which the icon had been brought from the sacristy.

11 The video 'Santa Maria Antiqua – The return of the icon', sponsored by the *Soprintendenza speciale per il Colosseo e l'area archeologica centrale*, was directed and produced by Carolina Popolani <https://vimeo.com/166928977> [accessed 2 February 2020].

12 The conservation campaign, undertaken in the years 1954–55, was the subject of a special issue of the *Bollettino dell'Istituto Centrale del Restauro* for the year 1960 (nos. 41–44, published in 1964), entitled 'Il restauro della Madonna della Clemenza' (introduction by Cesare Brandi, with texts by Carlo Bertelli and others).

13 The feast goes back to Pope Honorius I (625–38), who 'imported' it from Constantinople, where it had been established by Justinian I in 532: see Eugenio Russo, 'L'affresco di Turtura nel cimitero di Commodilla, l'icona di S. Maria in Trastevere e le più antiche feste della Madonna a Roma', *Bullettino dell'Istituto Storico Italiano per il Medio Evo*, 89 (1980–81), 71–150 (pp. 107–47).

14 Victor Saxer, 'L'utilisation par la liturgie de l'espace urbain et suburbain: l'exemple de Rome dans l'Antiquité et le haut Moyen Âge', in *Actes du XIe Congrès International d'Archéologie Chrétienne (Lyon, Vienne, Grenoble, Genève, Aoste, 21–28 septembre 1987)*, ed. by N. Duval, 3 vols (Vatican City: Pontificio Istituto di Archeologia Cristiana; Rome: École française de Rome, 1989), II, pp. 917–1033. It was on the same level as the other major Marian feasts: the Annunciation, the Assumption, and her Nativity.

15 Russo, 'L'affresco di Turtura', p. 115.

16 For the documents of 982 and 1025, attesting to

Santa Maria Nova's status as a *diaconia*, see Richard Krautheimer, *Corpus Basilicarum Christianarum Romae*, 5 vols (Vatican City: Pontificio Istituto di Archeologia Cristiana, 1937–77) [hereafter *CBCR*], I, p. 222.

17 The celebrated icon 'quae acheropsita nuncupatur', housed in the *Sancta Sanctorum* chapel, is recorded in the *Liber pontificalis* life of Pope Stephen II (752–57), hoisted on the shoulders of the pope as the centrepiece of a *laetania*, a distinctively penitential event undertaken on this occasion to avert the Lombard threat: see Maria Andaloro, 'L'acheropita in ombra del Laterano', in *Il Volto di Cristo*, ed. by G. Morello and G. Wolf (Milan: Electa, 2000), pp. 43–5.

18 Enrico Parlato, 'Le icone in processione', in *Arte e iconografia a Roma*, ed. by M. Andaloro and S. Romano, pp. 69–92 (pp. 74–84).

19 Parlato, 'Le icone in processione', p. 80.

20 *Le Liber Pontificalis*, ed. L. Duchesne, 2 vols (Paris: E. Thorin, 1886–92) [hereafter *LP*], II, p. 110.

21 *LP*, I, p. 376.

22 The damage is generally attributed to the 847 earthquake. Krautheimer, however, speaks of a landslip, see Richard Krautheimer, *Roma profilo di una città: 312–1308* (Rome: Edizioni dell' Elefante, 1981), p. 93; and *CBCR*, II, p. 252.

23 Krautheimer, *Roma profilo*, p. 93.

24 The first *Liber pontificalis* reference to the image uses the term 'acheropsita' ('not made by hand'), and the second calls it the 'sancta icona'. See Maria Andaloro, 'Il *Liber Pontificalis* e la questione delle immagini da Sergio I a Adriano I', in *Roma e l'età carolingia. Atti delle giornate di studio (3–8 maggio 1976)* (Rome: Multigrafica Editrice, 1976), pp. 69–77.

25 *LP*, II, p. 145.

26 *LP*, II, p. 158: 'Ecclesiam autem Dei genetricis semperque virginis Mariae quae primitus Antiqua nunc autem Nova vocatur quam dominus Leo IIII. papa a fundamentis construxerat sed picturis eam minime decoravit, iste beatissimus praesul pulchris ac variis fecit depingi coloribus, augens decorem, et plurimis corde puro ornavit speciebus'. For the confusion regarding terminology, see also *CBCR*, I, p. 222 note 1.

27 Andrea Augenti, *Il Palatino nel Medioevo. Archeologia e topografia (secoli VI-XIII)* (Rome: L'Erma di Bretschneider, 1996), pp. 50–5.

28 Spera, 'La cristianizzazione del Foro romano', p. 99. Gregorii I papae, *Registrum epistolarum, Libri VIII-XIV* (Monumenta Germaniae Historica, Epist. II), ed. by L.M. Hartmann (Berlin: Weidmann, 1899), XIII, 1, pp. 364–5.

29 Maria Andaloro, 'Santa Maria Antiqua tra Roma e Bisanzio. Due tempi', in *Santa Maria Antiqua tra Roma e Bisanzio*, ed. by M. Andaloro, G. Bordi, and G. Morganti, pp. 10–33; and Giulia Bordi, 'Santa Maria Antiqua attraverso i suoi palinsesti pittorici', in *Santa Maria Antiqua tra Roma e Bisanzio*, pp. 34–53.

30 *LP*, II, p. 114.

31 Spera, 'La cristianizzazione del Foro romano', p. 99.

32 Augenti, *Il Palatino nel Medioevo*, p. 56: 'posta come è a cavallo della *Sacra via*, per il controllo della viabilità urbana in generale e dell'accesso al Laterano in particolare'. The context is the church of Santi Pietro e Paolo, the history of which is connected to that of Santa Maria Nova.

33 The *Curia* dates from the time of Diocletian. For its early medieval mural paintings, see Giulia Bordi, 'S. Adriano al Foro romano e gli affreschi altomedievali', in *Roma dall'Antichità al Medioevo. Archeologia e storia nel Museo Nazionale Romano Crypta Balbi*, ed. by M.S. Arena and others (Milan: Electa, 2001), pp. 478–83. For the transformation of the Forum in the Christian period, see Spera, 'La cristianizzazione del Foro romano e del Palatino'.

34 The dating to Justin II is based on a series of coins (now lost), which were reported to have been found under the second column on the south-east side. Giacomo Boni assigned them to Justin I: see Andrea Paribeni, 'Giacomo Boni e il mistero delle monete scomparse', in *Marmoribus vestita: miscellanea in onore di Federico Guidobaldi*, ed. by O. Brandt and P. Pergola, 2 vols (Vatican City: Pontificio Istituto di Archeologia Cristiana, 2011), II, pp. 1003-23.

35 A number of scholars have linked the *Maria Regina* on the 'palimpsest' wall to this 'imperial' context: for example, see John Osborne, 'The Cult of *Maria Regina* in Early Medieval Rome', *Acta ad archaeologiam et artium historiam pertinentia*, 21 (2008), 95–106.

36 *LP*, I, pp. 509–10.

37 Augenti, *Il Palatino nel Medioevo*, pp. 186–7.

38 Cellini, 'Una Madonna molto antica', p. 1, figs 1–2.

39 Augenti, *Il Palatino nel Medioevo*, pp. 186–7.

40 *CBCR*, I, p. 222.

41 Although Santa Maria Antiqua was abandoned, the icon was recovered. The possessions and privileges of the older church passed to the new one. These included the title (*titulus*) and the icon, both properties of a sacred building in accordance with a Roman tradition for which we have authoritative testimony in the example of the Pantheon. This structure was converted into a church in 613 by Pope Boniface IV (608–15), with the approval of the Emperor Phocas, taking the name Santa Maria *ad martyres*, and receiving an icon of the Virgin and Child that still survives. The link between 'title' and image resurfaced in the modern period with regard to the church of Santa Maria Liberatrice in the Testaccio district, which takes its name from the church in the Forum that was built above the Oratory of the Forty Martyrs, and demolished in 1900 to allow Boni's

excavations. The transfer of the 'title' was determined by Pope Pius X, who may also have been responsible for the decision at the end of the first decade of the twentieth century to replicate images from the Chapel of Theodotus on the façade (although executed in mosaic instead of mural painting). See Geraldine Leardi, 'Un "ritorno al futuro", antiche immagini a nuova vita in Santa Maria Liberatrice a Testaccio', in *Santa Maria Antiqua tra Roma e Bisanzio*, ed. by M. Andaloro, G. Bordi, and G. Morganti, pp. 294–9.

42 This view is shared by Bordi, 'Santa Maria Antiqua attraverso i suoi palinsesti pittorici', pp. 49–50.

43 Ernst Kitzinger, 'A Virgin's Face: Antiquarianism in Twelfth-Century Art', *The Art Bulletin*, 62 (1980), 6–19. Those who disagree with Kitzinger claim that the Virgin's face was inserted into the existing twelfth-century mosaic of Pope Innocent II almost 200 years later by Pietro Cavallini, at which time the original icon face would have no longer been visible, but covered by the thirteenth-century repainting. An analysis of the mosaic *tesserae* undertaken as part of the 1990–91 restoration, however, as well as a series of technical considerations, exclude this possibility: see Vitaliano Tiberia, *I mosaici del XII secolo e di Pietro Cavallini in Santa Maria in Trastevere: Restauri e nuove ipotesi* (Todi: Ediart, 1996), pp. 114–19.

44 The circumstances of the life of Innocent II suggest that he would have been familiar with the area around Santa Maria Nova, particularly in the aftermath of the double papal election of 1130, when he sought refuge in the nearby Frangipane fortresses following the seizure of the Lateran by Anacletus II: see Krautheimer, *Roma profilo*, p. 189.

45 Maria Andaloro, 'L'Acheropita', in *Il Palazzo Apostolico Lateranense,* ed. by C. Pietrangeli (Florence: Nardini, 1991), pp. 81–5, and figures on pp. 80, 88.

46 Ibid., p. 84.

47 For images of the Santa Maria in Trastevere icon before restoration, see Brandi and others, 'Il restauro della Madonna della Clemenza', figs 1–2.

48 Maria Andaloro, 'Santa Susanna. Gli affreschi frammentati', in *Roma dall'Antichità al Medioevo. Archeologia e storia nel Museo Nazionale Romano Crypta Balbi*, ed. by M.S. Arena and others, pp. 643–5; Maria Andaloro, 'I dipinti murali depositati nel sarcofago dell'area di Santa Susanna a Roma', in *1983–1993: dieci anni di archeologia cristiana in Italia. Atti del VII Congresso Nazionale di Archeologia Cristiana (Cassino, 20–24 settembre 1993)*, ed. by E. Russo, 3 vols (Cassino: Università degli Studi di Cassino, 2003), I, pp. 377–86; and Maria Andaloro, 'I papi e l'immagine prima e dopo Nicea', in *Medioevo: immagini e ideologie. Atti del convegno internazionale di studi (Parma, 23–27 settembre 2002)*, ed. by A.C. Quintavalle (Milan: Electa-Mondadori, 2005), pp. 525–40.